THE
CHINA
COLLECTORS

AMERICA'S CENTURY-LONG HUNT
FOR ASIAN ART TREASURES

KARL E. MEYER AND
SHAREEN BLAIR BRYSAC

palgrave
macmillan

To Susan E. Meyer

and Marsha Melnick,

creators and critics of art

THE CHINA COLLECTORS
Copyright © Karl E. Meyer and Shareen Blair Brysac, 2015.
All rights reserved.

First published in 2015 by PALGRAVE MACMILLAN® TRADE in the
United States—a division of St. Martin's Press LLC, 175 Fifth Avenue, New
York, NY 10010.

Palgrave® and Macmillan® are registered trademarks in the United States, the
United Kingdom, Europe and other countries.

ISBN 978-1-137-27976-7

Library of Congress Cataloging-in-Publication Data

Meyer, Karl E. (Karl Ernest), 1937–
 The China collectors : America's century-long hunt for Asian art treasures /
Karl E. Meyer and Shareen Blair Brysac.
 pages cm
 Includes bibliographical references.
 ISBN 978-1-137-27976-7 (hardback)
 1. Art, Chinese—Appreciation—United States. 2. Art—Collectors and
collecting—United States—History—19th century. 3. Art—Collectors and
collecting—United States—History—20th century. I. Brysac, Shareen Blair.
II. Title.
N7340.M475 2015
709.51'075—dc23

 2014031029

Design by Letra Libre, Inc.

First edition: March 2015

10 9 8 7 6 5 4 3 2 1

Printed in the United States of America.

CONTENTS

AUTHORS' NOTE

On the spelling of Chinese names, we recall wistfully The Four Lads, a Canadian group whose 1953 swing-style song "It's Istanbul (Not Constantinople)" once topped the charts. This was their refrain: "Istanbul was Constantinople / Now it's Istanbul, not Constantinople / Been a long time gone, Constantinople / Why did Constantinople get the works? / That's nobody business but the Turks." Yet alas, in the case of China, it has become everybody's business, since name changes for both places and people have gone viral since the advent of the People's Republic in 1949.

Most of us realize that Beijing was once called Peking (and for a brief transition period, Peiping). But how many know that the celebrated trading port of Canton is now Guangzhou, and that Hong Kong in phonetically correct Mandarin is Xianggang? Or recognize Chiang Kai-shek as Jiang Jieshi? These changes became official when the People's Republic formally adopted the pinyin system of romanization in place of Wade-Giles, the method devised in late Victorian times by Sir Thomas Francis Wade, a polyglot diplomat, and Herbert Allen Giles, a linguistic scholar at Cambridge University. To compound this perplexity, the Taiwan Nationalist regime still employs Wade-Giles, as did the Metropolitan Museum through the 1990s—and early in the twentieth century, the Chinese Post Office published its own geographic lists, which were widely adopted by Protestant missionary publications. Moreover, within China itself, the same cities over time acquire many names; there are currently said to be 25 million place names in the national database—some descriptive or commemorative, others ideological or abusive (Beijing itself has had 22 names).

Our pragmatic compromise is twofold: When quoting others, we respect spellings in the original text; then in our own narrative, we initially give both pre- and post-pinyin names of places and persons and then favor current usage. Still, inconsistency is unavoidable, since our chapters are thematic and weave back and forth over two centuries. To help the reader decipher varying usages, we append an alphabetical list of key place names, with before and after usages specified.

We adhere to a similar flexibility concerning personal names. It is Chinese practice to place the family name before the given name, which sounds simple, since there are reputedly just over a hundred traditional family names. But as Frances Wood, the emeritus director of the Chinese Department at the British Library, notes in her valuable *Companion to China* (1988), in traditional usage there can also be multiple given names: "a 'milk' name, a 'study' or 'school' name, and a 'studio' name at the very least, with boys sometimes given girls' names when small so that evil spirits wouldn't realize they are treasured sons."

Here again, we respect our quoted sources and try as best we can to reconcile familiarity with correct usage. But when the Chinese emigrate, exceptions can occur. For example, the Princeton scholar and former consultative chairman of the Metropolitan Museum's Department of Asian Art follows his own styling: Wen Fong. Also, Chinese-born scholars in North America may choose a more accessible given name. Thus the Peabody Essex Museum Curator Yiyou Wang has become Daisy Wang. Where needed, we try in our index to take account of such variations. Finally, we include a selective chronology of key events in our narrative, especially helpful as a guide since our chapters can move on independent temporal tracks. Thus the section on Harvard's dominion of twentieth-century Sinology bypasses the parallel rise of such formidable collectors as J. P. Morgan, Charles Lang Freer, and John D. Rockefeller Jr., none of whom were Sons of Harvard. Still, this is consistent with the abiding appeal of an ancient civilization in which the shortest distance between points very often is a wriggling line.

A final note concerning illustrations: Owing to cost constraints, we had to limit the number of images of art objects described in the text. However, most of them are available on the relevant museums' websites.

NOTES ON SPELLING CHANGES

Modern Pinyin *Wade-Giles*

Place Names

Beidaihe (resort)	Peitaiho
Beijing(capital city)	Peking, Peiping (1928–49)
Binyang caves	Pin-yang caves
Chengde (city)	Jehol
Chongqing (city)	Chungking
Dayuan (Ferghana), formerly a country	Ta-yuan
Dunhuang (city)	Tun-huang
Fujian (province)	Fukien
Fuzhou (city)	Fuchow, Foochow
Gansu (province)	Kansu
Ganze, Gardze (city)	Kanze, Kardze
Ganzhou (province)	Kanchow
Guangzhou (city)	Canton
Hangzhou (city)	Hangchow
Hankou (city)	Hankow
Hebei (province)	Hopei, Hopeh
Heishui, Khar Khot (Mongolian) (ancient site)	Etzina, Edsina, Kharahoto
Honan (province)	Henan
Hubei (province)	Hupei

Jiangsu (province)	Kiangsu
Jiangxi (province)	Chiang-hsi, Kiangsi
Jietai Si (temple)	Chieh-t'ai-ssu
Jing River	Ching Ho River
Jinzhou (city)	Chinchow
Kaifeng (city)	K'aifeng
Kunming (city)	Yunnan-Fu
Lanzhou (city)	Lanchow, Lanchou
Longmen (caves or grottoes)	Lungmen, Lung Mên
Luoyang (city)	Loyang
Macao, Macau (port)	Aomen, Aumen
Nanjing (city)	Nanking
Qianmen (gate)	Chien-men, Ch'ien-men
Qingdao (city)	Tsingtao
Qinghua University	Tsinghua University
Qufu (city)	Ch'u-fu
Shaanxi (province)	Shensi
Shandong (province)	Shantung, Shandung
Shanxi (province)	Shansi
Shenyang (city)	Mukden, Fengt'ien
Sichuan (province)	Szechwan
Suzhou (city)	Soochow, Suchow
Tianjin (city)	Tientsin
Urumqi (city)	Dihua
Wangxia (treaty)	Wanghia, Wang-hsia
Wutai Shan (sacred site)	Wu t'ai Shan
Xiamen (city, treaty port)	Amoy, Hokkien
Xianggang	Hong Kong
Xining (city)	Sining
Xinjiang (province)	Sinkiang
Yan'an (province)	Yenan
Yangzi (river)	Yang-tse
Yantai (treaty port)	Chefoo, Chih-foo
Zhengzhou (city)	Chengchow
Zhili (now Hebei province)	Chihli
Zhou (dynasty)	Chou

Personal Names and Common Nouns

Caishen (God of Wealth)	Tsai Shen
Cixi (dowager empress)	Tsu-hsi, Tz'u-his
Daoism (religion)	Taoism
Deng Xiaoping (chairman)	Teng Hsiao-p'ing
Du Fu (poet)	Tu Fu
Gong, Yixin (prince)	Kung
Guangxu (emperor)	Kuang-hsu (emperor)
Guanyin (bodhisattva of compassion)	Kuan-yin
Guomintang (political party)	Kuomintang
Jiang Jieshi (president)	Chiang Kai-shek
Kangxi (emperor)	K'ang-hsi
Mao Zedong (chairman)	Mao Tse-tung
Pulun (prince)	Pu Lun
Puru (prince)	Puju
Qianlong (emperor)	Chien-lung
Qing dynasty	Ch'ing dynasty
Qiying (viceroy)	Keying, Ch'i-ying
Song (dynasty)	Sung
Sun Baoqi (official)	Sun Pao Ch'i
Sun Yixian (statesman)	Sun Yat-sen
Taizong (emperor) a.k.a. Li Shimin	T'ai-tsung
Tongzhi (emperor)	Tung-chih
Waiwubu (foreign affairs ministry)	Waiwupu
Wu Peifu (warlord)	Wu Pei Fu
Xianfeng (emperor)	Hsien-feng
Xuantong Emperor (Puyi)	Hsun-tung Emperor (Puyi), Hsuan-tung
Yuan Shikai (warlord, later president of China)	Yüan Shih-k'ai
Zhang Daqian (painter)	Chang Dai-Chen
Zhang Qian (envoy)	Chang Chien
Zhang Zeduan (artist)	Chang Tse-tuan
Zheng He (admiral)	Cheng Ho
Zhou Enlai (politician)	Chou En-lai

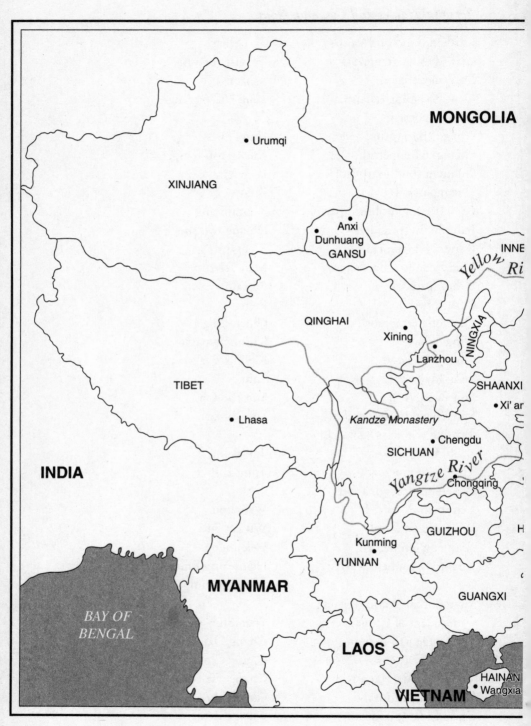

Map of major cities and sites in China

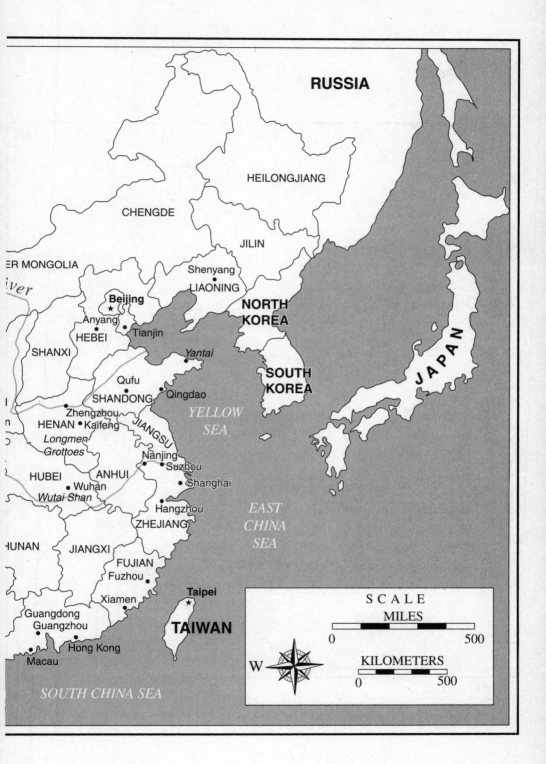

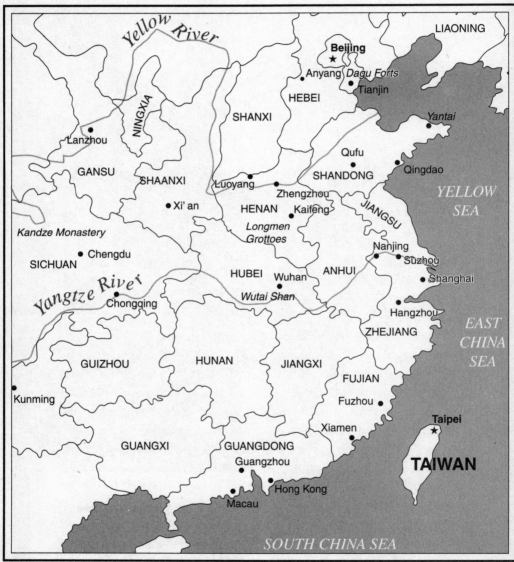

Map detail

OUR WINDING
WAY TO CHINA

Like any worthy object in a museum collection, a book deserves a provenance. The seed for ours was a fortuitous discovery in the Harvard archives during the 1990s. We were researching *Tournament of Shadows,* an earlier book recounting the Russo-British-American struggle for dominion of Central Asia. A key figure was Sir Aurel Stein, the Hungarian-born explorer of ancient Silk Road sites, whose ill-fated fourth and final expedition in 1930 was underwritten by Harvard's Fogg Museum. While sifting through the Harvard archives, Shareen came across a folder of anguished letters from a youthful Laurence Sickman to his mentor Langdon Warner at the Fogg. She called my attention to their correspondence, especially about the monumental sculpture in the vast limestone grottoes of Longmen in northern China, a sacred destination for Buddhist pilgrims a millennium ago (and now a UNESCO World Heritage site).

Larry Sickman was troubled and sought advice. He was on a shopping trip for Asian art for the recently opened (1933) and richly endowed ($11 million) Nelson Gallery in Kansas City. Longmen's maze of a thousand caves was unguarded, gangs of robbers abounded, local peasants were stealing to order, and its art treasures were surfacing in the back-alley shops of Peking (today's Beijing). What should he do? Specifically, should he try to collect fragments of a frieze depicting a royal procession led by a dowager empress? The freewheeling and engaging Langdon Warner had himself faced a similar dilemma a decade earlier at the same

massive Buddhist cave complex. His considered advice was direct and urgent: go for it, with expenses to be shared by the Fogg and the Nelson (where the procession eventually arrived).

Was it looting or preservation? During chaotic times in China, its ancient sites proved an easy target for thieves, vandals, and rival collectors. Indeed, Sickman's chief competitor, Alan Priest (also Harvard-bred), would remove a companion frieze from the same cave at Longmen portraying an emperor and his courtiers (a starred highlight at the Metropolitan Museum of Art). So what were the rights and wrongs? The question was posed afresh for us when we visited the Buddhist Silk Road site of Dunhuang, where Warner himself had attempted to remove wall paintings with the aid of primitive glue for the Fogg Museum. Our local guide pointed to the holes in the wall and sternly excoriated the "foreign devils" whom he held responsible.

This was not an alien realm for us. After obtaining a degree in art history, Shareen had a career as a producer of prime-time documentaries on cultural themes for CBS News and more recently was a contributing editor of *Archaeology* magazine. For myself, while a foreign correspondent for *The Washington Post,* I was granted a book leave to write *The Pleasures of Archaeology* and followed up as a freelancer with *The Plundered Past* (serialized in *The New Yorker*) and *The Art Museum: Power, Money, Ethics* (a 20th Century Fund Report). While writing editorials on foreign affairs for *The New York Times,* I periodically regressed into the same sphere.

Then, in 2011, having coauthored three books on global politics, Shareen and I were fortuitously discussing new projects when we were jointly invited to be Senior Associate Members at St. Antony's College, Oxford University, for the fall 2012 term—an offer that nobody with our interests could possibly refuse. (Our interlocutor was Professor William Roger Louis of the University of Texas.)

Yet there was a condition: we needed a research project. Remembering the Harvard files and our own visits to archaeological sites in China, we decided to explore how and why Western collectors became captivated by Chinese art, to the lasting benefit of American museums. The project was approved, and on arriving at Oxford we began test-drilling our proposal: meeting with scholars, auditing courses, attending conferences, and immersing ourselves in the ample shelves of the aptly named Sackler Fine Arts Library.

When we lunched with Margaret MacMillan, the Canadian-born Warden of St. Antony's College, she asked if we were familiar with the Royal Ontario Museum's Asian collection in Toronto. No, but we would

investigate, and it became a chapter. By term's end, we were persuaded that our chosen project was multilayered, mined with surprises, and featured a largely forgotten but wholly intriguing cast of obsessive collectors, ardent curators, and canny dealers. Equally important, we could find no books written for a lay audience dealing with the growth of Asian art collections in America or with China's booming art market and museum culture. So we forged ahead on our two-year quest, culminating in the volume you now hold.

Prior to arriving at St. Antony's, we asked academic friends, in particular the art historian John Onians and Frances Wood, the retired head of the Chinese Department of the British Library, to recommend Oxford authorities we should seek out. Two names recurred: Craig Clunas, the university's first professor of art to specialize in Asia; and Michael Sullivan, the veteran analyst of Chinese art. When we met the Scottish-born Craig Clunas, he said we were welcome to sit in on his course on the Ming dynasty, his favored era. A fluent lecturer, he corroborated with words and images the central theme of his widely read *Art in China* (1997), that is that the term "Chinese art" is a misnomer. In his view, the prevailing tendency to group calligraphy, sculptures, ceramics, and painting in a "homogenous totality" is a Western invention that overlooks the sheer size, antiquity, and diversity of Chinese civilization. Both in his course and in our conversations, he stressed the need for fluidity and specificity in evaluating each genre of art from China, citing his own scholarly work and his experience as a former and influential curator at the Victoria and Albert Museum in London.

No less interesting was Michael Sullivan. Canadian-born, British-bred, a Red Cross volunteer in wartime China, and a Harvard PhD, he chaired Stanford University's Asian art department for two decades before becoming an emeritus fellow at St. Catherine's College. We dropped a note at St. Catherine's, explaining our project and requesting a meeting.

A few days later, the head porter at our own college gave us his handwritten reply. Yes, indeed, Sullivan wrote, why didn't we join him for dinner at his flat in outlying north Oxford? He was then ninety-four years old and still mourning his Chinese wife, Khoan, to whom he had dedicated all his dozen-odd books. Over the years, the Sullivans acquired some five hundred modern Chinese artworks, of which the choicest were then on loan in a special gallery at Oxford's Ashmolean Museum. Hence we were not surprised that his walk-up apartment was crammed with Chinese objects, centering on a portrait of Khoan. We were welcomed by two lively Asian women, his assistants, who were busily preparing a

Sino-Italian pasta. Michael Sullivan bounded into view, an elfin fireball whose rising white hair formed a crown. Then he spoke of his sixty-year struggle against Western clichés about Chinese art, ancient or contemporary. Regarding today's avant-garde works, his special interest, the typical contradictory complaint he encountered was that it was either too imitative of Western postmodernism or too repetitious of musty traditional genres. It was altogether a memorable, and timely, evening. In October 2013, Michael Sullivan died at age ninety-six, having bequeathed the last of his cherished treasures to the Ashmolean.

From our vantage, our Oxford interlude afforded a salutary alert about the minefield that lay ahead. Our book, it needs stressing, is neither a history nor a critical analysis of art in China, although we do speculate on its allure for improbable wealthy collectors. We have no aesthetic axes to sharpen or to grind. Instead, our focus is on people, the curious catlike herd of North Americans and Europeans who have been captivated by Chinese art, however defined. Just as Napoleon favored lucky generals, we have preferred lucky collectors, curators, and dealers who have made the most of the years that were fat (1900–1949), notably the Walters father and son, Charles Lang Freer, J. P. Morgan, John D. Rockefeller Jr. and his wife Abby, Denman Ross, Arthur M. Sackler, and Avery Brundage among collectors; Langdon Warner, Laurence Sickman, Sherman Lee, S. C. Bosch Reitz, Alan Priest, and Wen Fong among curators; and C. T. Loo, Yamanaka & Co., and Otto Burchard among dealers. But we also describe the less fortunate: the multitalented George Kates, who died unknown; the lamented mandarin Duanfang, who literally lost his head; and the authenticator, Berthold Laufer, an apparent suicide. We also came upon the idiosyncratic mystic, card-holding Nazi Eduard von der Heydt, who donated substantial collections to Zurich's Rietberg Museum and Wupperthal's Von der Heydt Museum. Four Canadians get their due: the founding Royal Ontario Museum director Charles Currelly, the Anglican bishop William C. White, the fur trader–turned-dealer George Crofts, and the Presbyterian clergyman James Mellon Menzies, who specialized in oracle bones.

In our Acknowledgments, we express our gratitude to the host of scholars, young and old, and to the curators, dealers, and archivists without whose essential help our research would have taken another decade. At every point in our narrative, we have tried to take account of relevant global and economic forces, to tariffs, taxes, and caprices of a volatile art market. Yet we are also highly conscious of omissions in a necessarily selective narrative. Among major collectors whose treasures deserved more

attention than we could manage are Charles Bain Hoyt, whose ceramics are a highlight of the Asian galleries at Boston's Museum of Fine Arts; "Chicago's Grandest Spinster," Kate Sturges Buckingham, who donated hundreds of objects to the city's Art Institute in memory of her sister Lucy Mauce; Alfred F. Pillsbury, whose bronzes shine at the Minneapolis Institute of Art; and more recently the gifts of Bruce and Ruth Dayton to the same institution. As to the other limitations of our book, the reader has already been warned—and we welcome corrections from the innumerable denizens of a fascinating world to which we have only a tourist's visa.

Karl E. Meyer

CHAPTER ONE

THE RULES OF
THE GAME

An unusual commercial betrothal was proclaimed with sober understatement on September 21, 2012. Under the prosaic headline "Sotheby's Signs Deal with Beijing Company," a brief report in *The New York Times* explained that the world's premiere auction gallery had entered into a joint-venture agreement with a state-owned enterprise "to capitalize on the tremendous growth in the Chinese market." Thus in partnership with the Beijing GeHua Art Company, Sotheby's announced that it would shortly launch the first international auction house in mainland China. The two companies agreed to share tax-exempt storage facilities, with Sotheby's providing a $1.2 million investment as dowry. As a Sotheby's press release elaborated, "China and its growing class of collectors has been the single most attractive growth market for the company," leading to an agreement it described as "unique and groundbreaking."

It was indeed. Here was the nominally Communist People's Republic actively promoting the least proletarian of pastimes: auctioning fine arts to a proliferating breed of princely millionaires. True, the Sotheby's deal was but one more example of China's rightward leap from primal Maoism to state-promoted capitalism. Yet to those who professionally track the tectonic shifts in the Chinese art market—whether as collectors, dealers, or scholars—there were less obvious signals as well. For upward of a decade, Beijing has also sought the recovery of art treasures pillaged from China during chaotic times past. Simultaneously, the People's Republic

has strengthened legal measures to curb wholesale looting and the illicit export of ancient art. To that end, in 2009 Beijing secured from Washington a largely unnoticed yet significant pact barring the importation of a wide range of antiquities, including monumental sculpture and wall art at least 250 years old.

So why would China also encourage a bull market in antiquities that most analysts contend also fuels the pillaging of its patrimony? What does all this say about the changing prism through which Beijing's leaders view the Maoist era and its once-scorned imperial precursors? And how will the People's Republic deploy its new and surprising leverage as host to an exploding art market (rivaling New York and London in 2011–12)? Taken together, Beijing's cultural strategy seems a compound of opposites: a thirst for profits, a strong bid for foreign applause, but also a determined effort to score domestic points with get-it-back populism.

Thus in approving the Sotheby's deal, Beijing may also be searching for an insider's advantage in its ongoing campaign to recover prized artworks that were seized in times past as the spoils of war. The campaign was presaged in 2000 by China's offstage role in a lavish "Imperial Sale" promoted in Hong Kong by Sotheby's and Christie's. Among the latter's major offerings were two bronze animal heads (an ox and a monkey), while by coincidence Sotheby's put on the block a bronze tiger head. These were three of twelve animal heads that once adorned a zodiac fountain in Peking's Yuanmingyuan, or Garden of Perfect Brightness, the Summer Palace of the Qing emperors, from which they were very

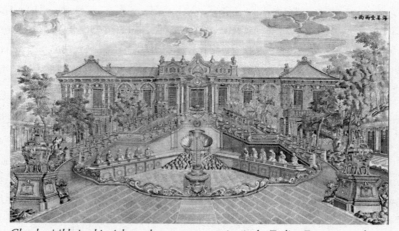

Clearly visible in this eighteenth-century engraving is the Zodiac Fountain and its twelve animal heads below the Hall of Calm Seas at Yuanmingyuan.

likely filched by Anglo-French troops in 1860 during the looting that concluded the Second Opium War. China's Bureau of Cultural Relics formally asked both auction houses to withdraw the suspect bronzes, citing the UNESCO convention on cultural property.

Beijing's protest did not persuade executives at the two auction houses, whose press aides noted that the bronze monkey had been sold previously by Sotheby's in New York in 1987 without a murmur; ditto the ox in London in 1989. Yet in a token of changing times, Hong Kong residents otherwise critical of Communist rule joined in clamorous protests over the pending "Imperial" sale. Demonstrators shouted, "Stop auction! Return Chinese relics to Motherland!" But the sale went forward.

In a symmetrical finale, the three zodiac bronzes were repatriated in a bidding war won in 2000 by the China Poly Group, a corporate offshoot of the People's Liberation Army, also a dealer in arms and real estate. The monkey and ox fetched more than $2 million at Christie's, and the tiger went under the hammer for $1.8 million at Sotheby's. This was the first time that agents of the Chinese government competed at public auction to recover art and antiquities. "Historic events took place this week," Souren Melikian reported in *The International Herald Tribune*, "that will have incalculable repercussions in the international approach to cultural monuments." A long war over title to the zodiac relics was under way. As before, Melikian, a veteran monitor of the global art market, assessed its vibrations astutely.

Following their triumphal return to Beijing, the three heads were showcased in the newly created Poly Art Museum, thereafter the chosen refuge for trophy art recovered from private collections. This represented a sharp reversal of the Great Proletarian Cultural Revolution (1966–76), when roving gangs of Red Guards smashed vitrines and bullied curators with the encouragement of Chairman Mao. It was among many turnabouts in the contorted path of Sino-Communism. Who could have imagined that the world's largest standing army would become a champion of classical culture, one of the "Four Olds" reviled only yesterday? Or does the change simply confirm an old, shrewd peasant saying: "Be like the bamboo; it bends with the wind but stands straight after the storm passes"?

Thus even as screaming youngsters denounced the "Four Olds," the Great Helmsman himself extolled archaeologists for bearing scientific witness to China's glorious past. With Mao's support, a united China, no longer beset by foreign or domestic violence, could finally undertake extensive excavations. A thousand lawful shovels were loosed on the past, crowned in 1974 by the unearthing of an entire army of terra-cotta

warriors. Accidentally discovered by a farmer near the ancient capital of Xi'an, the life-size soldiers proved to be the afterlife bodyguard of China's first emperor, an autocratic modernizer who reputedly burned books and dissident intellectuals and then gave his dynastic name (Qin, pronounced like *chin*) to a new empire. The discovery, with its sardonic overtones, fired instant interest at home and abroad. Specimen recruits from the frozen army were posted abroad to publicize a succession of exhibitions, arguably China's most benign foreign invasion.

Thereafter, excavations flourished. So did the market for Chinese antiquities. Abroad, collectors evinced a seemingly insatiable appetite for most genres of art originating in China (calligraphy excepted). More surprising was the vibrant demand within the People's Republic. By 2005, art and antiquities sales at China's eighty-odd domestic auction houses reportedly exceeded $1.5 billion, double the previous year's total. In the reckoning of James Cuno, head of the J. Paul Getty Trust, it was twenty-five times Sotheby's and Christie's combined U.S. sales of Chinese art the same year. (It later developed that the totals included buyers who did not pay for what they bid.) And Cuno's calculation did not include the local galleries and curio shops that sprouted everywhere in mainland China. By 1980, almost $2 billion worth of art had been sold at Chinese auctions, with starred works for the most part purchased by private bidders. As China's economy grew, so did the art market. In the reckoning of *Forbes* magazine, the number of Chinese billionaires rose from 64 in 2009 to 115 the following year, an 80 percent annual increase. Sales soared for fine arts in every category. In 2010, the People's Republic seemingly surpassed New York and London as host to the world's leading fine arts market, accounting for 33 percent of global sales, compared to 30 percent for the United States, 19 percent for the United Kingdom, and 5 percent for France (as calculated by Artprice, a Paris-based monitor). The news was blazoned by *China Today,* a glossy, quasi-official Beijing monthly. Indeed, the journal noted in March 2011 that of the ten highest bids ever recorded at auctions for Chinese art, only one was placed abroad (in London in 2005, for a Yuan dynasty sculpture)—an "epochal change" from leaner days past. The boom has since fluctuated, unpaid bids inflated totals, and in 2012 China slowed to a second-place finish behind the United States. Nonetheless, in ways Chairman Mao (who died in 1976) might not have imagined, his maxim that the past should serve the present has been richly realized.

YET FROM AN ARCHAEOLOGIST'S VANTAGE, the enthusiasm for collecting antiquities among newly minted billionaires has a

dismaying underside. As never before, thousands of remote sites have been subjected to "an unbridled wave of clandestine digging," in the words of Melikian. He was among the first to report (in November 1994) that "something funny" was happening in East Asian markets: "In the last few years, the flow of antiquities handled by 'clandestine' diggers who sell them in the Hong Kong art trade has not just been torrential, as it has been since the early 1980's. It increasingly includes works of art of a rarity that one expects to come out of the most important archaeological sites." True, this was a clandestine criminal enterprise. But Melikian took note of a Han-period bronze sculpture recently on the block in Hong Kong: "How 'clandestine' can you be, carting a 26-inch chunk of metal overland, all the way to the coast, in a state where policing is reputed to be vigilant?" (Note: both before and after the reversion of Hong Kong to China in 1997, auctioneers in the former British colony have operated with greater freedom than on the mainland.)

How then has the People's Republic responded to what Melikian two decades ago described as "the reckless rape of its past"? Chinese archaeologists have consistently echoed his alarm. "It really is devastating to see what is happening," Professor Wei Zheng of Peking University recently told a correspondent from *The Guardian*. "Archaeologists are simply chasing after tomb raiders." As elaborated by his colleague, Professor Lei Xingshan: "We used to say nine out of ten tombs were empty because of tomb raiding, but now it has become 9.5 out of ten." Chinese excavators pointedly cite a peasant catchphrase, "To be rich, dig up an ancient tomb; to make a fortune, open a coffin."

The reckless rape continues, notwithstanding a century of explicit prohibitions. In 1913–14, the newborn Republic of China introduced laws banning the removal of "ancient objects," followed by still stronger legislation in 1930. These measures were reinforced in 1950 by the People's Republic, which in its first years established a Bureau of Cultural Relics to ensure compliance. Even more stringent legislation in 1961 widened the definition of protected artworks to include objects "which reflect the social system, social production and the life of society in all periods." This was followed by a 1982 cultural relics law, designating all antiquities found in caves and tombs as national property and adding a new corollary: legal private ownership was henceforth permitted for works "handed down from generation to generation which belong to collectives or individuals." In effect, this constituted a tacit acknowledgment (as James Cuno and others have noted) that state-run auctions were already selling confiscated art from government warehouses

to aspiring collectors, the way led by the privileged offspring of the party elite.

Granted, China's preservationist tasks are truly monumental. By official count (1993), the People's Republic possesses 350,000 historic sites—tombs, palaces, caves, and temples—mostly unexcavated, dating from the Bronze Age (circa 3500 BCE) through a succession of imperial dynasties until 1911. No soil anywhere harbors as rich a legacy. Creditably, Beijing has substantially increased funds for security, energized in part by cultural tourism, led by the surge of visitors to Xi'an and its terracotta army. True as well, indigenous looters are on occasion exposed and punished. It made headlines a decade ago when government agents identified a group of Buddhist statues pilfered from Chengde's historic temple complex (a World Heritage Site) that Christie's was about to auction in Hong Kong. The dealer owning the relics was detained; he insisted the looters had lied to him about their origin, and he was released after restoring the statues to state custody. Subsequently, the local official responsible for guarding the site was tried, found guilty, and executed for stealing 158 artifacts, said to be the largest relic heist since the founding of the People's Republic. Yet in a May 2003 dispatch on the aborted sale, John Pomfret of *The Washington Post* also took note of a wider scandal. An anonymous market hand told him that despite the heightened security, "The looting of cultural treasures in the past twenty years has exceeded the destruction of relics during the Cultural Revolution."

Looting is not solely responsible for this destruction. Preservationists contend that it stems as well from China's headlong drive to electrify, irrigate, and modernize. They cite the Three Gorges Dam, completed in 2009, which flooded some four hundred square miles, the goal being to provide new sources of energy to a distressed region while taming the erratic waters of the Yangtze River. Yet state-funded salvaging of doomed sites was so perfunctory (critics claim) that the soon-to-be-engulfed tombs became a pillagers' paradise. Elsewhere, in such richly layered urban centers as Beijing, Shanghai, Kashgar, Lhasa, and Xi'an, historic shrines and neighborhoods have been razed with relentless zeal to make way for high-rise housing, soulless office buildings, and stereotypical stadiums.

As these episodes suggest, it is less ideology than opportunism that informs Chinese cultural policy. From Deng Xiaoping's tenure onward, Beijing's cultural cadres have discreetly diluted Maoist dogmas with the modernist views of a younger generation, along with the claims of a buoyant art market and the bonus of favorable foreign opinion. This amalgam seemingly accounts for Beijing's changing attitude to Western-influenced

paintings, films, photography, architecture, and music. Few foreigners have tracked the transition more closely than Michael Sullivan (long the doyen of British Sinologists prior to his death in 2013), who from the 1940s onward befriended, wrote about, and collected the works of living Chinese artists. This was his judgment as of 2001 (in *Modern Chinese Art*): "Much of the best work of the 20th century has political resonance, overt or oblique, that gives it a particular edge or vitality. . . . New, if erratic, freedoms, the birth of free enterprise, commercialism, and the interest of foreign critics and art galleries, began to create an art world, chiefly in Beijing and Shanghai, that looked more and more international—in style, if not in content—while new forms of art, such as performances, installations, happenings, were a stimulus to hundreds of young artists clamoring for attention."

Moreover, overseas fascination with China's effervescent art world proved an unexpected asset in post-Maoist diplomacy. With palpable symbolism, Beijing in 2002 opened its first cultural center in a Western capital: in Paris, on the banks of the Seine. The new center's offerings, from Bronze Age sculptures to conceptual art, proved so popular that its stone building (once home to Napoleon Bonaparte's descendants) acquired a modern annex in 2008, tripling floor space from 1,700 to 4,000 square meters. Other countries courted by China have likewise been awarded Confucius cultural centers. In 2011, nine such centers sponsored 2,500 activities for 600,000 visitors (by Chinese count). Ten more centers are planned. So recounted the Beijing-published *China Pictorial* (October 2012) in a thematic issue titled "A Booming Cultural Decade." The journal lauded China's recent discovery of such "soft power," explaining Beijing's tardy entry into cultural diplomacy with an egregious understatement: "After a long period of isolation, China lacked elements to represent modern culture beyond its borders."

YET CHINA'S CULTURAL OFFENSIVE has a second, less commonly publicized front. Commencing in the 1990s, Beijing's arts officials turned afresh to long-standing grievances concerning the illicit removal of perceived art treasures. Here, finally, was a cultural issue on which the People's Republic could rise above profit-tainted pragmatism to loftier grounds of principle. Nationalists and Communists alike look back indignantly to a "Century of Humiliation"(1840–1949), when China was bullied by foreigners, forced to submit to unequal treaties, sliced into zones that privileged Western traders and missionaries, and, upon losing the two Opium Wars, compelled to permit the legal importation of a soul-destroying drug.

These grievances spring from a widely agreed-upon history, but Western accounts stress a complicating counterfactual: Imperial China was itself a feudal fossil, notorious for its corruption, incompetence, and self-wounding defiance of common diplomatic usage. Moreover, following the empire's collapse in 1911, the new Republic of China's principal adversaries were homegrown warlords, indigenous Communist insurgents, and non-Western Japanese invaders. Still and undeniably, Westerners for more than a century evinced more zeal than scruple in acquiring Chinese masterworks, especially the huge friezes and monumental sculptures displayed in major North American museums. As carefully phrased by a Detroit curator, Benjamin March, in *China and Japan in Our Museums* (1929), the first comprehensive inventory of American holdings: "Probably there is no thoughtful collector in America today who does not deplore the means by which some of his most valued treasures became available, at the same time that he cherishes and reveres them as great works of art of universal moment."

Acting on this shared acknowledgment, Beijing in 2005 established a Cultural Relics Recovery Program to identify museum-quality art taken from China between the years 1860 and 1949. Chinese officials cite a UNESCO estimate that no fewer than 1.67 million Chinese relics are possessed by no fewer than two hundred museums in forty-seven countries. It is also estimated that ten times that total are now in private collections. As phrased by Xi Chensheng, an advisor to the Bureau of Cultural Relics, "Most were either stolen by invading nations, stolen by foreigners, or purchased by foreigners at extremely low prices from Chinese warlords and smuggled abroad." To obtain corroborating evidence, China next dispatched teams of investigators to examine the provenance of East Asian art in leading Western museums, libraries, and private collections.

These visits supplemented Beijing's campaign, begun in 2004, to obtain from Washington an agreement to restrict the importation of Chinese antiquities, similar to existing bilateral accords with Italy, Guatemala, El Salvador, Peru, Canada, Cyprus, Cambodia, and Mali. China's request was challenged by prominent museum directors, scholars, dealers, and collectors, on four broad grounds: (1) that Beijing had not taken adequate measures to protect its own ancient sites; (2) that priceless Chinese works were in fact safely preserved abroad during East Asia's turbulent years; (3) that the display of great works in encyclopedic galleries affirmatively stimulated interest in Chinese art; and in any case (4) that the People's Republic itself was actively encouraging a domestic market in antiquities,

thereby fueling rampant looting. These contentions were elaborated in essays collected and edited by James Cuno in *Whose Culture?* (2012).

Nonetheless, in 2009 the State Department announced its approval of a bilateral accord that substantially addresses Beijing's concerns. Its appended five-year Memorandum of Understanding (MOU) "restricts the importation to the US of cultural and archaeological materials from the Paleolithic through the Tang Dynasty (75,000 BC–AD 907), as well as monumental sculpture and wall art at least 250 years old. . . . Such archaeological materials can only come to the US if accompanied by a valid export permit or other appropriate documentation from the Chinese government."

AS OF THIS WRITING, with one exception discussed below, China has not formally sought the restitution of any major disputed works in foreign museums. Rather, it has used its market power to highlight egregious episodes of pillaging. The one exception is the loot taken in the ravaging in 1860 of the imperial garden estate Yuanmingyuan, the site of the Old Summer Palace, by Anglo-French armies besieging Peking in the final phase of the Second Opium War. On the war's 150th anniversary, the Chinese called for the return of everything stripped from the emblematic imperial residence. In Chinese eyes, it was an act of vandalism comparable to Lord Elgin's hacking the marble carvings from the Parthenon a half century earlier—and as it happens, the Briton who ordered its demolition was James Bruce, the eighth Earl of Elgin and son of the reputed despoiler of the Acropolis.

In truth, the elder Elgin earned his notoriety, whereas his son's was thrust upon him. Great Britain in 1860 was still reeling from the muddled and anguishing Crimean War (1853–56), followed by the two-year rising in India known as the Great Mutiny. Among the five thousand British troops in China were many who served in one or both prior conflicts, sharpening appetites for spoils. Moreover, the Second Opium War (1856–60) was fought as an embattled Chinese regime also coped with the Taiping Rebellion (1845–64), an apocalyptic uprising in the south, generally considered the modern era's deadliest civil war, that claimed as many as twenty million lives. A further complication was Britain's alliance with Emperor Louis-Napoléon's France. As in Crimea, it proved a sticky partnership. Its chief defender in Parliament was the aging Whig prime minister Lord Palmerston, whose jingoist language drew withering fire from such leading Liberals as W. E. Gladstone, Richard Cobden, and John Bright. Taken together, their heated exchanges about wars of choice

versus wars of necessity, or about imperial hubris versus Britain's civiliz-ing mission, would in our day make most politically literate Americans feel at home.

All these conflicting themes coalesced in the 1860 destruction of the vast Yuanmingyuan, situated around a dozen miles northwest of Peking (then already a metropolis, with a million or more inhabitants). In size, elegance, and prestige Yuanmingyuan was far more than a playground for six generations of Manchu rulers. It was to China what Versailles is to France, arguably twice over. (In fact, its buildings included those de-signed for the Qianlong emperor in the eighteenth century, after he saw images of Versailles.) Its inner core comprised a thousand or so acres of immaculate gardens, sparkling ponds, and humpbacked bridges, within which were cunningly sited a fairyland of palaces, temples, pagodas, libraries, and theaters, plus ateliers for scientists, pavilions for philoso-phers, and a make-believe village for shoppers. In design, Yuanmingyuan blended Chinese traditions with European pseudo-Baroque, the latter most evident at the Palace of Calm Seas, whose entrance embraced an elaborate zodiac fountain and water clock. As designed by the Jesuit mis-sionary Giuseppe Castiglione, long a resident artist in the Manchu court, the twelve animals in the Chinese zodiac were arrayed around the foun-tain. At noon, all spouted water in unison; otherwise each gushed at its assigned moment in a twelve-hour cycle.

Here indeed was Coleridge's stately pleasure dome, as conjured by the poet in his narcotic dream, its gardens bright with sinuous rills, its forests ancient as the hills, its walls and towers girdled round, its goldfish flash-ing in its ponds, where, warningly, "The shadow of the dome of pleasure / Floated midway on the waves." (The poem was actually inspired by the Yuan dynasty summer palace, which was farther north.) As thousands of Anglo-French troops found when they burst into the regal quarters on October 7, 1860, it was also filled with portable and royally elegant riches: jewelry, porcelain, paintings, sculpture, illuminated books, every imaginable kind of furniture, silken robes, headgear, and even Pekinese dogs (then unknown to Europe).

With a whoop, both armies carried out a command to destroy Yu-anmingyuan, as unilaterally ordered by a reluctant Lord Elgin, the Brit-ish high commissioner, in which French troops took willing part (though their commander, General Cousin de Montauban, tried to distance him-self from the resulting melee). This drastic step was meant to drive home allied anger after Chinese imperial forces reportedly seized, tortured, and killed twelve members of a European diplomatic delegation (also including

Thomas Bowlby, a correspondent for *The Times*), a flagrant violation of the codes of war as understood by Europeans.

That Elgin became their avenger was existentially ironic. He was not a fan of Lord Palmerston, whose China policies he had privately termed "stupid." He deplored "commercial ruffianism," and when ordered to legalize the sale in China of opium grown in India, he wrote in his diary, "Though I am forced to act almost brutally, I am China's friend in all this." And on being instructed in 1859 to attack and occupy Peking, he again privately dissented: "The general notion is that if we use the bludgeon freely enough we can do anything in China. I hold the opposite view." Yet sadly for Elgin, he is indelibly associated with a deed of imperial plunder that, like the ominous shadow in Coleridge's poem, still lingers over China's haunted pleasure dome. So what actually did happen?

Despite more than a century of postmortems, it is still unclear which army ignited the rampage, how the spoils were divided, and which treasures ended up where. In analyzing conflicting accounts, the University of Chicago's James L. Hevia attributed their divergence to national rivalries, questions of honor, and ongoing criticisms of the pillaging. "Neither the British nor the French, it would seem," Hevia concludes in his 2005 analysis, "wanted to be held responsible in the eyes of the other, and if a scapegoat were needed, the Chinese were conveniently at hand." Such was Lord Elgin's own justification: he insisted that the destruction of the Yuanmingyuan was meant to send an imperative message to a vacillating emperor and his scheming advisors, not to the nonoffending Chinese people. In his words, his purpose was "not to pillage, but to mark by a solemn act of retribution, the horror and indignation with which we were inspired by the perpetration of a great crime."

INSTEAD, ELGIN'S ORDER UNITED the emperor with his own people in shared outrage over (in their eyes) the pointless and humiliating devastation of a national treasure by foreign devils. As many as two hundred buildings were torched or leveled, and everything of value that could be taken, was taken (the French complained that the British had the unfair advantage of possessing cavalry horses capable of hauling the heavier prizes). Concerning the totality of destruction, there is ample and authoritative testimony. "When we first entered the gardens, they reminded one of those magic grounds described in fairy tales," recalled Colonel Garnet Wolseley, a decorated veteran of campaigns in Crimea and India. Yet on October 19, "[W]e marched from them, leaving a dreary waste of ruined nothings." (Wolseley later became the imperial specialist in small wars,

immortalized as "The Modern Major-General" by Gilbert and Sullivan.) Another credible witness is Captain Charles Gordon of the Royal Engineers, soon to be known as "Chinese" Gordon for his valor in helping the Manchus quell the Taiping rebels. "You can scarcely imagine the beauty and the magnificence of the buildings we burnt," he wrote to a friend. "It made one's heart sore to burn them. . . . It was wretchedly demoralizing work for an army. Everybody was wild for plunder." (Three years later, while commanding China's Ever Victorious Army, Gordon resigned to protest the mistreatment of war prisoners; in 1885, he perished at the hands of Sudanese jihadists, thereafter becoming Gordon of Khartoum.)

For their part, French witnesses also expressed astonishment at the magical beauty of the imperial oasis, but distinguished between the demolition of buildings (wholly regrettable) and pillaging (arguably the victors' prerogative). These views are elaborated by Comte Maurice d'Hérisson, an interpreter for the French forces who maintained that he remained an onlooker as the plunder proceeded. As excerpted by the German author Wilhelm Treue in *Art Plunder* (1960), the count asserts that the original plan was to appoint three British and three French commissioners to identify precious objects for Queen Victoria and Napoleon III as their respective shares of the customary spoils of war, then to divide the remaining booty equitably among all ranks. However, on the first afternoon, as goods were being carted from the principal royal residence, this is what happened:

> The crowd which collected to watch these proceedings was composed of French and English foot soldiers, riflemen, gunners and dragoons, of spahis, sheiks and Chinese coolies too, all watching with staring eyes and lips parched with greed; suddenly a rumor spread in all the various languages: "When they've had the best, it'll be our turn!" "To hell with that! We want our share of the cake. We've come far enough for it. Eh, Martin? Eh, Durand?" They laughed and barged forward—discipline began to give way. . . . Covetousness suddenly aroused among the Chinese a sense of patriotism; they told themselves that the hour of revenge had struck, and that—if I may be forgiven the expression—it would be the bread of life to rob the Manchurian dynasty, and not leave the whole windfall to the barbarian invaders.
>
> As soon as the soldiers heard the news, of course in a greatly exaggerated fashion, anxiety gave way to fury. First, they said, "The Chinese want to bag the lot!" and then, "The Chinese are going to burn the whole place down!" A wild mob surged around the gates. The sentries were pushed aside, and the whole crowd, soldiers and civilians, poured in on the heels of the company

that had been summoned to expel the intruders. At once, everyone took what he liked.

After the wild crowd surged through the vast Yuanmingyuan grounds, it appeared to Comte d'Hérisson that the British were better disciplined, having quickly instituted an organized system for dividing the spoils and employing carefully recorded daily auctions, while the French seemed to act impulsively on their own. He then offered a moralizing verdict in the immemorial tradition of cross-Channel badinage: "The English, of course, are well used to having their heel on the neck of Asiatic peoples; and it must not be forgotten that their army is composed of mercenaries who regard plunder as one of the elementary principles of war." Moreover, he added as a parting jab, had the British preceded the French to the Summer Palace, "Certainly, they would not have lost a moment in dispossessing His Imperial Majesty [i.e., Napoleon III] of his goods."

Then as now, others in France rose above nationalist jeering. The most oft-quoted Gallic judgment required but a single sentence. On learning of the behavior of the Anglo-French armies in Peking, Victor Hugo (who loathed Louis-Napoléon) dispatched an open letter to the French press. "We call ourselves civilized, and them barbarians," Hugo wrote from his self-imposed exile on the Channel Islands, "and here is what Civilization has done to Barbarity." (For his efforts, the modern-day Chinese have bequeathed the French literary giant a statue in Yuanmingyuan.)

Moral judgments aside, it is indisputable that, after the pillage, whole shiploads of porcelain, jewelry, furniture, paintings, clothing, swords, and statuary sailed westward. The spoils presented to Emperor Louis and Empress Eugénie Napoleon still form the core of the purpose-built collection of Chinese art at the Fontainebleau Château. In London, among the highlights of the 1861 auction season (as in many future years) were Oriental treasures bearing the premium label "From the Summer Palace." For her part, Queen Victoria was presented (among other spoils) with a cap said to have been worn by the Chinese emperor, and with a frisky Pekinese dog, the first of its breed known to reach the West. The dog's apt name was "Looty," appropriately bestowed by Victoria herself.

Loot derives from the Hindi word *lut,* which in turn originates from the Sanskrit *lotra,* meaning "rob, plunder." By 1800, the word found acceptance in its colloquial sense among Britons in both India and China, then went global following the two Opium Wars and the Indian Mutiny (as traced in *Hobson-Jobson,* the standard glossary of Anglo-Indian

words). In short, the word *loot* is very much the offspring of Europe's imperial era, as is the vexed matter of a conqueror's right to the property of a conquered people. On the one hand, victors have claimed the right to the spoils of war, a prerogative stretched to the limit by Napoleon, who filled the Louvre with looted masterpieces from Italy, Central Europe, Spain, the Low Countries, and Egypt. On the other hand, the greedy plunder of conquered peoples has long emitted a nasty odor, as classically argued by Cicero in his scourging indictment of the takeaway Sicilian proconsul Verres.

Still, there were no codified laws of wartime morality in 1860. Customary norms served as a traditional brake on the limits of conquest, but these norms were ambiguous and nonbinding. In Europe, the void was addressed by the Dutch-born jurist Hugo Grotius, who proposed a global code following the devastating Thirty Years' War. His proposal gained fresh impetus a century later with the publication in 1758 of *Le droit des gens* by the Swiss diplomat Emmerich de Vattel, who proposed establishing formal rules, binding on all belligerents, to protect the lives, rights, and property of both captured combatants and civilians trapped in occupied areas. In vain; so nebulous were the laws of war that protests of their violation remained wholly rhetorical.

Thus in 1814, when 1,500 British marines stormed Washington and torched the White House and the Library of Congress, the invaders were accused of grossly violating "the rules of civilized warfare." Moreover, contended President Madison, the Britons demolished "monuments of taste and the arts" and thus evinced "a deliberate disregard for the principles of humanity" that could have provoked a war "of extended devastation and barbarism." To which the British rejoined that their Major General Robert Ross, a veteran of the Peninsular Campaign in Spain, was rebuffed in his repeated offers to negotiate, and in any case that American armies invaded Canada four times, devastating entire towns near the frontier (episodes rarely mentioned during America's own bicentennial observances of the War of 1812).

In short, hypocrisy, double standards, pious exhortations, appeals to nonexistent laws, and backstage bargaining were the rule as soon as the word *loot* entered diplomatic discussions during the apogee of the imperial era. By 1900 most of the world's peoples and lands were under the dominion of fewer than a dozen nations—including the United States, a latecomer to the scramble for spoils, having just acquired Hawaii, the Philippines, and Puerto Rico.

What this signified for China was presaged at a tumultuous Ecumenical Conference in April 1900 at Carnegie Hall in New York, attended by a thousand delegates from missionary societies across the United States. The opening ceremony included addresses by President William McKinley, former president Benjamin Harrison, and future president Theodore Roosevelt. Missionaries were "the world's heroes," McKinley told the delegates, because they "illumined the darkness of idolatry and superstition with the light of intelligence and truth." Not only did these heroes spread the Gospel, but they also generated useful trades, promoted new industries, and encouraged the "development of law and the establishment of government." They were, in effect (a phrase not heard then) nation builders. Nowhere were their efforts more needed or desired than in China. This was underlined by a concurrent missionary exhibit in the hall showcasing a profusion of Chinese objects, enriched by more than five hundred photographs suggesting both the grandeur and poverty of the Celestial Empire: the most attention given any foreign country at the conference.

This was the bright side of American perception of the world's most populous nation. A less laudable side was evinced by Benjamin Harrison in 1888, when, upon accepting the Republican nomination, he endorsed immigration laws barring the entry of "alien races [i.e., Chinese], whose ultimate assimilation with our people is neither possible nor desirable." This was a bipartisan view. The same year, Grover Cleveland, the Democratic nominee, described the Chinese as "an element ignorant of our laws, impossible of assimilation with our people, and dangerous to our peace and welfare."

CHINESE BAFFLEMENT about such Western professions of superior virtue assuredly deepened in 1900, a year made memorable by the siege in Beijing (then called Peking by Westerners, but pronounced in Chinese as Beijing) that ended what was instantly known as the Boxer Rebellion. Viewed from America and Europe, the siege was essentially a morality play in which courageous Westerners triumphed over misguided barbarians intent on murdering innocent Christians. This basic narrative was recycled in contemporary press accounts, boys' own fiction, Hollywood films (including a 1963 epic starring Charlton Heston and Ava Gardner), and in scores of memoirs by diplomats, soldiers, clergymen, and journalists. The latter were among the thousand or so non-Chinese civilians trapped in Peking's Legation Quarter for two months

until their rescue in August 1900 by a multinational rescue force, the first of its kind.

Dozens of Americans took a leading part in this resounding finale, their role underscored by President McKinley, who earlier the same year proclaimed his celebrated "Open Door" doctrine. The doctrine decreed that all nations were henceforth to enjoy equal access to China, overriding the spheres of influence wrested by Britain, Russia, France, Germany, Italy, and Japan. (Actually, observed George F. Kennan in his 1951 book *American Diplomacy,* the doctrine was a rhetorical gambit meant to assist McKinley's forthcoming reelection; it proved neither new nor enforceable, Kennan contended, and after the U.S. annexation of the Philippines and Puerto Rico, "we set up discriminatory regimes, conflicting with Open Door principles.")

The Boxer crisis in China ignited when a rebel movement called the Harmonious Society of Righteous Fists sprang up in the poor, densely populated northeast province of Shandong. The province's treeless farmlands in 1897–1900 were parched by persistent drought even as its lowland areas were flooded by the Yellow River. This stricken area had been recently assigned to Kaiser Wilhelm II as Germany's sphere of influence, prompting an influx of Christian missionaries, railway builders, urban developers, and brewers (to whom China's most popular beer, Tsingtao, owes its origin). In 1897, two Catholic missionaries were murdered, and as reparation the kaiser demanded the right to build a new naval base and Christian churches with Chinese government funds. Otherwise, he vowed, the Chinese would feel "the iron fist of Germany heavy on their necks." As these threats resounded, the imperial bureaucracy in Peking proved unable or unwilling to provide urgently required humanitarian aid.

This was the spark. Within months, the Boxers grew into a nationwide opposition militia whose fiercer recruits believed themselves invulnerable to bullets. The movement's avowed mission was to expel or punish foreigners in general, and Christian converts in particular. In spring 1900, a year the Boxers welcomed as the new dawn of religious renewal, their numbers swelled exponentially. Though lacking coordinated leadership, writes Jonathan Spence in *The Search for Modern China* (1990), Boxers drifted into Peking, where they roamed the streets "dressed in motley uniforms of red, black, or yellow turbans and red leggings, with white charms on their wrists," and began harrying, and sometimes killing, Chinese converts. Anxiety among foreigners turned to panic when the Boxers, having slain European engineers and missionaries, ripped up railway tracks, burned train stations, and slashed telegraph lines.

All this happened as Britain was mired in the Boer War (1899–1902), commencing with "Black Week," during which legendary regiments were humbled by bewhiskered South African farmers. In the South Pacific, American forces were struggling to pacify the newly liberated Philippines and its unexpectedly ungrateful guerrillas. China, meanwhile, was still recovering from its losses to an upstart neighbor in the Sino-Japanese War (1894–95), which resulted in Tokyo's seizing control of Korea. During the same years, Russian traders and Cossacks were consolidating their mastery of Manchuria, homeland of China's ruling dynasty. Everywhere, it seemed, existing hegemons were under siege. Worried statesmen in Britain, America, and France reached anxiously for ways to reaffirm the West's traditional martial vigor as a new century dawned.

Almost as a demon-sent gift, the Boxers materialized: the perfect foil for rattled Euro-Americans and a rising Japan. While Chinese authorities dithered, Boxers seized control of the streets surrounding Peking's Legation Quarter. In June 1900, the aging Dowager Empress Cixi, grasping for popular support, rashly sided with the rebels, protesting that foreigners had been far too aggressive: "They oppress our people and blaspheme our gods. The common people suffer greatly at their hands, and each one of them is vengeful. Thus it is that the brave followers of the Boxers have been burning churches and killing Christians." At this point, a thousand or so Westerners, together with their Japanese allies and around two thousand Chinese Christians, barricaded themselves in Peking's well-defined Legation Quarter. Their quickly chosen commander in chief, unsurprisingly, was Sir Claude MacDonald, Britain's minister to the Manchu court, an immaculately groomed, wax-mustachioed veteran of colonial wars in Egypt.

After the Boxers severed lines of communication, the diplomats and their families huddled alongside Chinese Christians. Behind the existing Tartar Wall (so-called) and improvised barriers, they braved sniper fire, disease, and hunger. No less imperiled was the Catholic congregation gathered in Peking's Peitang Cathedral under the defiant and capable leadership of Bishop Pierre-Marie-Alphonse Favier. But there was no massed Boxer attack. Beyond Peking, in the walled city of Tianjin (then spelled Tientsin by the Americans and British), Boxers encircled an isolated Foreign Settlement whose numbers included a future American president, the young mining engineer Herbert Hoover. So widespread was Western dismay over a possible massacre that the leaders of eight otherwise contentious nations suspended their disputes and agreed to organize a global rescue force. It eventually grew to an army forty thousand

strong recruited from the British Empire, the newly assertive United States, Tsarist Russia, Kaiser Wilhelm's Germany, Republican France, Hapsburg Austro-Hungary, Savoyard Italy, and Imperial Japan.

On August 14, the relief force charged into the capital, where its troops rapidly dispersed the now-frantic Boxers. On its fifty-fifth day, the siege ended. The Dowager Empress and her courtiers fled. A punitive peace followed, with the victors imposing a huge indemnity on China, four times its gross income as of 1900. The now-humbled Celestial Empire dwindled into vassalage as it deferred to the demands of its foreign masters. Moreover, allied forces occupied the Forbidden City for a year after the Dowager Empress fled; during those months there was continual looting of stored artworks.

IN 1908, DOWAGER EMPRESS CIXI, China's de facto ruler since 1861, finally expired. She began her rise as a handsome Manchu concubine of the fourth rank who, on an auspicious night, was chosen to sleep with Xianfeng, the seventh Qing dynasty ruler. She bore him his only son who succeeded at age six, enabling his mother to reign as co-regent. When Emperor Tongzhi died at nineteen, Cixi contrived to become the adoptive mother and regent for her nephew, the Guangxu Emperor, and by virtue of her will and wit, she continued to dominate. Cixi survived rebellions, military debacles, and famines; she frustrated efforts at reform and lived profligately, resplendent in her dragon robes, or in her cape composed of 3,500 perfect pearls.

And yet, Cixi personified what her empire had lost: its proud sense of worth and sovereign dominion. The twelfth and last Manchu emperor, Puyi was forced to abdicate on February 12, 1912; he would later became Japan's figurehead ruler in Manchuria, and finally a gardener in Chairman Mao's People's Republic.

To triumphant Westerners, the Boxer Rebellion seemed a defining battle between the children of darkness and light, in which the latter's victory hastened the deserved dissolution of a senescent Middle Kingdom. Over time, this self-flattering scenario has also dissolved. Within post-1949 China, the fanatic Boxers were reborn as early-day anti-imperialist rebels, if sometimes misguided. For their part, European and American revisionists stress that the conflict between Chinese Christians and Boxers was mutually combative. Casualties were considerable on both sides in a civil conflict that claimed as many as 120,000 lives. As the British-based historian Odd Arne Westad notes in *China and the World* (2012),

"When in 2000 the Vatican canonized 116 Catholics who were killed by the Boxers, the Chinese Foreign Ministry referred to the same people as 'evil-doing sinners who raped, looted and worked as agents of Western imperialism.'" In America, Oberlin College amended its 1902 memorial to its graduate missionaries who perished as "massacred martyrs" at the hands of the Boxers. After an intensive faculty-student debate at Ohio's well-regarded liberal arts college, a new plaque was added in 1995, dedicated to the memory of Chinese martyrs who also perished in the century-old Boxer Rebellion.

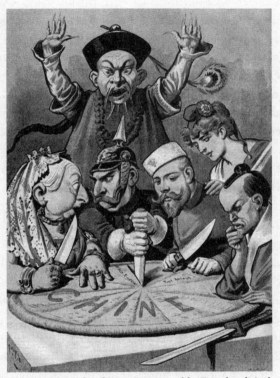

"China: The Cake of Kings," as viewed by French political cartoonist H. Meyer in 1898, the year the slicing peaked.

Overall, what is now a revisionist judgment was put forward decades ago by Harvard's Walter Langer in *The Diplomacy of Imperialism* (first published in 1935, updated in 1951). "European diplomats as a whole had no ground for priding themselves on the handling of the Boxer movement and its aftermath," wrote Langer, then preeminent in his field.

Europe's treatment of China in the whole period from 1895 to 1900 had been devoid of all consideration and of all understanding. The Celestial Empire to them was simply a great market to be exploited to the full, a rich territory to be carved up like a sirloin steak. Hardly anywhere in the diplomatic correspondence does one find any appreciation for the feelings of the Oriental or any sympathy for crude efforts made at reform. The dominant note was always that force is the father of peace and that the only method of dealing successfully with China is the method of the mailed fist.

Langer's judgment is sustained by the views privately expressed by Sarah Pike Conger, wife of Edwin Conger, the just-cited American minister. "As I am here and watch, I do not wonder the Chinese hate the foreigner," she wrote to her nephew from Peking in 1899. "The foreigner is frequently severe and exacting in this Empire which is not his own. He often treats the Chinese as though they were dogs and had no rights whatever—no wonder that they growl and sometimes bite." Among the patronizing Americans that Mrs. Conger frequently encountered, it happens, was her husband's deputy, First Secretary Herbert Squiers, a square-jawed former army cavalry officer who during the Legation siege became chief of staff to Sir Claude MacDonald, the commander in chief. Both agreed on the need to teach a lasting lesson to the Chinese, which helps explain the first secretary's takeaway role in the looting that shortly followed the arrival of the multinational relief force.

As the Boxers scattered, and as the guns fell silent in Peking, the liberators celebrated with boisterous parades, the blare of military bands, and the hoisting of flags, while terrified shopkeepers posted such signs as "Noble and good Sir, please do not shoot us!" On August 28, soldiers from the eight armies joined with the diplomatic corps in a triumphal march through the Gate of Heavenly Peace into the no-longer-sacrosanct Forbidden City. Anthems and speeches over, the liberators swept through its royal quarters, ignored the angry stares of court eunuchs, posed for photographs on once-inviolable thrones, and began grabbing what they could.

While the looting spread, "a horrific bloodbath was conducted against the Chinese out of all proportion to their presumed guilt," writes Sterling Seagrave in *Dragon Lady* (1992), his revisionist biography of the Dowager Empress. Victors' justice was instant and brutal. Grisly images of ordinary civilians gawking at severed heads are preserved on film. Most foreigners—diplomats, soldiers, clergymen—then joined in what Australia's *Sydney Morning Herald* called "a carnival of loot." That so

many nonmilitary personnel participated in this carnival; that its carnage was instantly recorded by journalists; that it persisted for weeks rather than days; and that it occurred throughout Peking, not just in a confined outlying area—all this contrasted with the sack of the Yuanmingyuan four decades earlier.

SOMETHING ELSE HAD CHANGED: the laws of war. In a landmark event often overlooked, it was none other than Abraham Lincoln who put into effect the first comprehensive, clearly defined, and civilized code of warfare. On April 24, 1863, President Lincoln signed General Order 100, which set forth in unequivocal terms the written rules regarding treatment of war prisoners, enemy-owned property, and "battlefield booty." Articles 35 and 36 expressly protected "classical works of art, libraries, scientific collections," with ultimate ownership rights to be settled in peace negotiations.

Hence President McKinley (himself a Civil War veteran) vainly ordered U.S. forces in Peking to desist from looting. No less disapproving was Germany's Field Marshal Count von Waldersee, the supreme commander of the multinational army, who subsequently wrote: "Every nationality accords the palm to some other in respect to the art of plundering, but it remains the fact that each and all went in hot and strong for plunder." This vandalism was no doubt deplorable, writes Peter Fleming, a chronicler of imperial wars in his 1959 account, *The Siege at Peking*, "[b]ut a spirit of revenge was abroad, the city was in disorder, and half-abandoned, and it may be questioned whether it was humanly possible to prevent looting in the first place, still less to stop it once it had started. It went on squalidly for months."

Still and tellingly, in major art auctions that followed, works pillaged in Peking were not identified as such. By contrast, in the case of trophies harvested by Anglo-French forces in 1860, the candid description "From the Summer Palace" helped ensure higher bids. Not so after 1900. Hardly had the pillage ceased than the provenance of its prizes was cloaked in denial. Norms had changed. This became evident in the case of Herbert G. Squiers, the American Legation's first secretary, who on departing from Peking in September 1901 also took with him "a collection of Chinese art filling several railway cars, which experts pronounce one of the most complete in existence." It consisted largely of porcelains, bronzes, and carvings, "bought from missionaries and at auctions of military loot."

So reported *The New York Times* from Peking in 1901, adding that Squiers intended to present his collection to the Metropolitan Museum

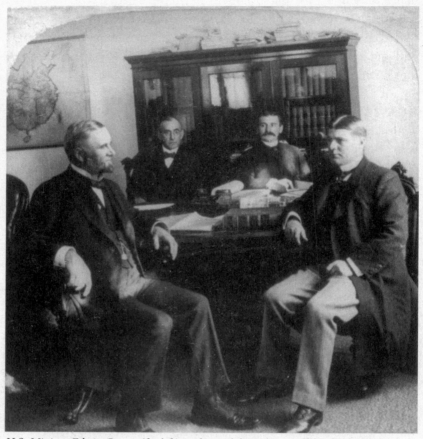

U.S. Minister Edwin Conger (far left) confers with his Peking staff, headed by Herbert Squiers (far right) and William Rockhill (back right), ca. 1901.

of Art. By all accounts, the fashionably groomed and ingratiatingly ambitious diplomat began collecting porcelains during his prior posting in Japan. Once stationed in Peking, Squiers assiduously cultivated dealers and became a knowledgeable buyer, aided by the linguistic skills of a Legation associate and the networking skills of his socialite wife, Harriet Bard Woodcock. But did he engage in looting? So press accounts asserted; it was even said that some of his choicer items were purchased from Bishop Favier, the Catholic vicar of the congregation to which Squiers belonged (the bishop denied wrongdoing, but acknowledged he did sell some things to help feed his starving flock). Eyewitnesses noticed that the first secretary was among the first to forage in the royal chambers of the Forbidden City.

In a further token of changing mores, a reporter for *The New York Times* asked a leading curator at the city's preeminent museum about the propriety of accepting "looted art." George H. Story tartly responded, "The Metropolitan Museum of Art does not accept loot." He then elaborated: "I think it is an outrage that such a suggestion should be made in connection with anything which Mr. Squiers has to give. He is a gentleman, and has one of the finest porcelain collections in the country, I am told. It would be presumed by the Museum that Mr. Squires' collection had been honestly got, he being a gentleman without question. I see no reason in the world why the collection spoken of should not be accepted."

As of 1901, as was now apparent, looting had become bad form; at least a pretense of virtue was expected of donors. Hence a century later, the Chinese People's Republic seized on this shift in formally avowed ethics to challenge Western collectors, dealers, and auction galleries. Over time, Mao's heirs learned to employ the tools of capitalism to redress the excesses of Western empire building and win nationalist applause even from non-Marxists. Hypothetically, Beijing's avenging agents may have even ventured into the dark side of outright theft.

AS RELATED EARLIER, China's aggressive recovery campaign commenced in Hong Kong when Beijing in 2000 formally urged the withdrawal from a scheduled sale by Christie's and Sotheby's of three bronze animal heads. A second round followed in 2003. The prize was a bronze boar or pig (designations differ), which was purchased privately for $1.3 million by the China Cultural Recovery Fund, using money contributed by the Macao-based entrepreneur and casino mogul Stanley Ho. The fountainhead was presented with suitable fanfare to the Poly Art Museum, and the State Administration of Cultural Heritage acclaimed Ho for his "patriotic act." Then came a third round. In January 2005, China's National Philatelic Corporation prepares the way by issuing a set of stamps depicting all twelve zodiac creatures, featuring the four already recovered together plus artistic renderings of the eight still missing. In October 2007, Sotheby's Hong Kong announces a provocative theme sale, "Lost Treasures from the Qing Palaces," featuring a horse from the zodiac ensemble. "This is stolen property," protests Xu Yongxiang, a buyer for the state-run Shanghai Museum. "It should be returned to the Chinese people through the government, not sold." Although the bronze fountainhead is expected to fetch more than $7.7 million, Sotheby's this time brokers a private sale between the consigner and Stanley Ho, who reportedly pays $8.9 million. Once again, the Macao gambling magnate is

hailed as a national hero and the horse is added to the Poly Art Museum's expanding menagerie.

All of which leads to a resonant finale centering on yet two more missing heads: a rabbit and a rat. It is February 2009 in Paris. The subject du jour in the art market is Christie's forthcoming sale of the Yves St. Laurent Collection, as selected by the late couturier's partner, Pierre Bergé. Among the works showcased at the Grande Palais are a needle-nosed rat and wide-eyed rabbit, although Christie's in its advance publicity seeks to play down their presence by emphasizing other Asian art in a sale whose offerings range from Impressionist paintings to Ottoman ceramics.

To no avail: the two animals dominate headlines when China angrily protests the presence of the bronzes. Beijing's Foreign Ministry charges that the sale violates international conventions and that it abuses both the cultural rights and sentiments of the Chinese people. Eighty-five Chinese lawyers bring suit in Paris to block the sale. Yang Yongju, publisher of *The European Times,* the flagship Chinese-language newspaper in France, speaks for the diaspora: "It is unacceptable to put stolen works up for auction." Student demonstrators wave a forest of placards. "We want the French people to understand that we are rational and our requests are legitimate," says Zhou Chao, a Chinese student at a French polytechnic institute, as he passes out protest pamphlets.

Unfazed, Christie's executives press ahead with the sale they insist is wholly within the law. When the bronzes are on the block, bidding is vigorous and both rabbit and rat are claimed by an unnamed contender who by telephone offers the equivalent in euros of $36 million for the pair. The winning bidder then reveals himself as Cai Mingchao, a collector and an agent of the National Treasures Fund—who then announces that he will not pay, since the two heads rightfully belong to China and are therefore stolen goods.

In the cacophony that followed, Western critics recalled that the zodiac fountain actually did not work well and in any case was of European design and in no ways authentically Chinese. For his part, Pierre Bergé injected human rights and offered to return the bronzes free of charge if China changed its repressive Tibetan policies. The denouement was reached in April 2013, propitiously timed for a visit to China by French president François Hollande, when French billionaire François-Henri Pinault, scion of the family whose company apparently owned the animals, promised to give them back. (The Pinaults are the owners of Artemis, which controls a number of luxury brands, including Gucci, Bottega

Veneta, and most importantly St. Laurent as well as Christie's. Artemis does nearly 10 percent of its business with mainland China.)

Given the abundance (estimated by the Chinese as 1.6 million) of imperial items, where might such claims end? A good question, still lacking a credible, logical, and just response. Absent a consensus, confusion persists. So does anger and the likelihood of possible tit-for-tat looting.

Item: In August 2010, a gang of thieves broke into three display cases at the Chinese Pavilion on the grounds of the royal family's residence at Drottningholm Palace in Stockholm. In just a few minutes they made off with a quantity of "old, beautiful Chinese objects." A Swedish antique expert stated that there was a risk that they would be transported to China, as the value of Chinese art had risen rapidly in the last few years.

Item: In January 2012, the British auction house of Woolley and Wallis put up for sale a gold box embellished with seed pearls, enamel, and glass panels with floral motifs. Its lid bears this elegant lettered inscription: "Loot from Summer Palace, Pekin October 1860 [signed] Captain James Gunter, King's Dragoon Guards." This increased its potential value by 50 percent, according to the auction house's spokesperson, who added: "Captain Gunter probably took the box from the Summer Palace as he viewed it as the spoils of war rather than act of theft—as a souvenir or reward of a great achievement." This prompted a flurry of protest in China, but the engraving indeed boosted bids. The box fetched the equivalent of $764,694, as sold to an anonymous Chinese bidder, who once again refused to pay.

Item: In April 2012, thieves broke into the Malcolm MacDonald Gallery in Durham University's Oriental Museum and snatched a large jade bowl and a porcelain sculpture, from China's Qing dynasty, with a combined value of two million pounds. The bowl, dating from 1769, was from the collection of Sir Charles Hardinge, which in turn came to Durham along with prize objects gathered by MacDonald (1901–81), son of the Labor Prime Minister Ramsay MacDonald and himself a diplomatic troubleshooter in Asia and Africa. Police later arrested two men suspected of being involved in the theft. Subsequently, both artifacts were recovered by the police.

Item: In May 2012, British police arrested two men believed to have taken part in the theft of eighteen rare and mostly jade Chinese artifacts in the Fitzwilliam Museum at Cambridge University.

Item: In September 2013, seventeen men and two women were arrested in countrywide dawn raids conducted by hundreds of British police. They were charged with conspiring to burgle the Fitzwilliam

Museum artifacts, most of which were recovered. This followed a pan-European investigation into museum thefts of rare works believed to have been "stolen to order" for Chinese collectors.

Item: In January 2013, in what Norwegian police described as a daring theft, twenty-three Chinese artworks and artifacts were stolen from the Chinese Collection of the Kode Museums in Bergen. They were from the trophies gathered by Johan Wilhelm Nortmann Munthe (1864–1935), a soldier and explorer who took part in the multinational rescue army that ended the 1900 Boxer Rebellion. This was the second time in three years that such a goal-oriented raid occurred; in 2010, thieves made off with fifty-six items. Erland Hoyersten, the director of the Bergen art museums, believes the thieves had "a shopping list" since "it's entirely clear that they knew what they were after."

Is there a message in these episodes? Can it be that objects are stolen to order? Is Beijing implicated in what could be called cultural hacking? Given China's economic and diplomatic importance, what sensible steps can be taken to resolve a historic dispute of benefit only to demagogic nationalists? A good way to start, surely, would be for Americans to come clean on how and why we have collected China—the theme of this book.

CHAPTER TWO

PACIFIC OVERTURES

Four stages can be distinguished in the odd coupling of the United States and China, the youngest and the oldest of great powers: discovery, expansion, fascination, and revision. On both sides, human impulses proved crucial. Yet a basic, impersonal, and often forgotten commercial reality precipitated America's initial swerve to the Asian Pacific. In the 1780s, although our own newly independent republic was officially neutral, its trading vessels were trapped in the cross fire of the Franco-British wars. Yankee sea captains were continuously harassed by the Royal Navy, which seized hundreds of ships, confiscated their cargoes, and subjected their crews to forced recruitment. Hence American shipowners anxiously searched for markets elsewhere, preferably as far as possible from the quarreling and bothersome Europeans. As Phineas Bond, the British consul in Philadelphia, reported in 1787, "In the restricted state of American trade it is natural for men of enterprise to engage in such speculation as are open to them, and which afford a prospect of profit."

Hopes for relief soared on two auspicious days. On May 11, 1785, the *Empress of China* returned from the Far East to New York Harbor, her hold stuffed with tea, becoming the first American mercantile vessel to reach the city of Guangzhou (then known as Canton) and its *hongs,* or trading companies. Commenting in Philadelphia, then the capital, the *Pennsylvania Packet* noted on May 16, "As the ship has returned with a full cargo, it presages a future happy period of our being able to dispense with that burdensome and unnecessary traffic which hitherto we have

carried on with Europe—to the great prejudice of our rising empire, and future happy prospects of solid greatness." The trip required fourteen months and twenty-four days, and logged 32,548 miles.

As propitious were the festivities in Salem, Massachusetts, on May 22, 1787, when the sails of the *Grand Turk* loomed on the horizon. She was the first ship from New England to trade directly with China. Leading the cheers was her financier, Elias Hasket Derby, who quickly found a promising market for his ship's cargo of tea, porcelain, silks, jewelry, artworks, and dishware. He was in every sense an adventurous entrepreneur; along with others of his vessels, the *Grand Turk* was formerly a privateer, armed with twenty-eight guns and skilled at evading the Royal Navy during the American Revolution.

Soon fleets of Yankee ships began commuting regularly to Canton, laden with Spanish bullion (gold and silver coinage), fur pelts, wheat, and ginseng (an aromatic herb grown in the Appalachians and prized in China). In time, opium acquired in India was added to the list. By the 1840s, the import and export tonnage of U.S. vessels in Canton exceeded that of the British East India Company. Young America's Pacific presence was further enhanced in 1791 when the first Yankee whaler rounded Cape Horn in search of sperm whales in Pacific waters. By 1830, the United States was the world's preeminent whaling nation. Altogether, it was a seafaring era replete with dramatic encounters, its flavor captured in Patrick O'Brien's excellent Aubrey and Maturin novels.

For owners and skippers, the hazards of the Pacific trade were amply rewarded. Remarkably, Salem in 1800 had become, per capita, America's wealthiest city, generously realizing the city's motto: "To the Farthest Ports of the Rich East." Elias Hasket Derby, the godfather of the China trade, was reputedly America's first millionaire, his affluence noted by his fellow Salem citizen (and Customs House clerk) Nathaniel Hawthorne. (More surprising, in a recent estimate of the seventy-five richest persons in recorded human history, Derby ranked seventy-second, his wealth in current dollars estimated at $31.4 billion.)

Derby's legacy was cultural as well as monetary. He was among the first Americans to prize the porcelain treasures of China. While in Canton, the captain of the *Grand Turk* commissioned a monogrammed 171-piece dinner set, a 101-piece tea service, plus a large punch bowl depicting Derby's vessel and inscribed "Ship Grand Turk" and "At Canton 1786." The bowl was originally presented to the *Grand Turk*'s officers and eventually donated by Derby's son to Salem's Essex Institute, founded in 1799, home of the first comprehensive archive of documents and memorabilia relating

This bowl was presented to the officers of the Grand Turk, *the third U.S. vessel to reach China. Donated to the Peabody Essex museum by the son of its owner, Elias Hasket Derby.*

to America's formative links with East Asia. The institute evolved into today's Peabody Essex Museum, whose collection of 1.3 million objects presently includes the actual residence of a wealthy Qing dynasty merchant, lawfully transplanted, piece by piece, from the People's Republic of China. Indeed, it is reasonable to assert that the current administration's multifaceted pivot to the Asian Pacific had its origins in the docks, the shops, and the now-ghostly former Customs House of Salem.

Boston succeeded Salem as America's premier trading port, its harbors better equipped to handle the clipper ships sailing to the Orient with their occasional cargoes of Indian opium. (A little-publicized reality is that many New England fortunes, including those of the Forbes, Russell, Sturgis, and Delano families, had roots in the opium trade. Instead, contemporary American publications commonly appended the adjective "British" when referring to the opium trade.) In May 1843, the U.S. government learned of the successful negotiation—some would say extortion—of the Treaty of Nanking by the British, which ended the First Opium War; one of the provisions granted by the Middle Kingdom opened (in addition to Canton) four more ports to trade by English merchants: Ningpo, Amoy, Fuchow, and Shanghai.

On February 27, 1845, after 211 days at sea, a fleet of four ships cast anchor at Macao. On board the frigate *Brandywine* was Newburyport, Massachusetts's own Caleb Cushing, lawyer and congressman, now "Commissioner to China and Envoy Extraordinary and Minister Plenipotentiary of the United States to the Court of that Empire." "Count"

Whig politician Caleb Cushing (Harvard, 1817) never did meet the Son of Heaven, but he secured America's first treaty with China.

Cushing's (President John Tyler thought this title added to the prestige of the event) orders were to secure the entry to all five treaty ports "on terms as favorable as those which are enjoyed by English merchants."

Born in Salisbury, Massachusetts, the precocious Cushing graduated Harvard at the age of seventeen and settled down to practice law in Newburyport in 1824. A diehard Whig, he was elected first to the state legislature and then to the U.S. Congress, before being dispatched to China. Prior to his departure, anticipating a meeting with the Celestial Emperor, the dashing Cushing outfitted himself in an imposing "Major-General's blue frock-coat with gilt buttons and some slight additions in the way of embroideries, gold striped trousers, spurs and a hat with a white plume." However, the imperial encounter between the "Count" and the Son of Heaven never took place. Cushing's request to proceed to Peking was

declined; President Tyler's letter of "peace and friendship," conveying his very best wishes for the emperor's long life, was never delivered. Instead the Celestial Emperor dispatched Viceroy Keying (Qiying), who had dealt with the British, to treat with Cushing. The ensuing agreement, known officially as "The Treaty of Peace, Amity, and Commerce, Between the United States of America and the Chinese Empire," was signed on July 3, 1844, in a temple in the town of Wanghia (Wangxia), just outside Macao. It granted Americans free access to the five ports accorded to the British, and a vital new prerogative: extraterritoriality. This meant that American citizens in China were subject only to the laws of the United States. On this provision, Cushing commented, "it was unwise to allow any control over the lives and property of American citizens in governments outside the limits of Christendom." Although the trade was now declared illegal, "a certain amount of opium smuggling continued."

Boston's merchants were free to trade in tea, china, and cotton fabric, the latter soon to be loomed in quantity in Francis Cabot Lowell's Massachusetts mills. Fast clipper ships plied the routes between China's hongs and New York and London's wharves. Writing in 1921, Harvard's Samuel Eliot Morison, the great chronicler of America's maritime history, offered a rueful epitaph to the overall decline of New England's commercial ties to East Asia: "To-day no trace remains in Boston of the old China trade, the foundation of her commercial renaissance, save a taste for li-chi nuts, Malacca joints, and smoky Souchong."

AS BOSTON'S COMMERCIAL TIES to the Far East diminished, the city featured a fitting memorial in the form of an important and innovative event, the first of its kind in New England. Cushing's landmark agreement was celebrated with the "Great Chinese Museum" (1845–47), an elaborate and path-breaking exhibition at the Marlboro Chapel on Washington Street. It followed close on the heels of a parallel venture in Philadelphia, a private museum featuring "ten thousand Chinese things," including artifacts, life-size mannequins, paintings, and re-creations of Chinese shops. The collection was assembled by Nathan Dunn, a Quaker merchant who had traveled to China, where he was based in Canton for eight years. Opening in 1838, the professed aim of the Philadelphia museum was to educate the public about Chinese culture. As Dunn was not involved in the opium trade, he had been received favorably by the Chinese, who helped him collect through agents in areas otherwise off-limits to foreigners; hence he could claim unparalleled access to works of art inaccessible to other Westerners. Before it closed in 1842, an estimated

100,000 people visited Dunn's Chinese Museum, buying 50,000 copies of the first catalog of its kind. The museum then relocated to London, where its breadth earned a favorable report from the young Queen Victoria. After Dunn's death in 1844, his curator toured England with the collection, which then was dispersed at auction and in private sales—one buyer being P. T. Barnum.

By contrast, the wider purpose of Boston's "Great Chinese Museum" was to exhibit "at a glance the Appearance, Agriculture, Arts, Trades, Manners and Customs of the Chinese, the oldest and most populous nation on the Globe." A critical reviewer dubbed the museum "the Crockery-dom," intended to appeal to visitors whose ideas of China were formed from dinnerware encounters on export porcelain.

One of the treaty mission members, the New York engineer John R. Peters Jr., provided the objects he had collected and appears to have authored the museum's catalogue. According to John Rogers Haddad, in his account of America's early encounters with China, Peters had in fact joined the Cushing delegation in the hope that under the auspices of the government he would be able to exhibit and explain to the Chinese "models and specimens of American arts and production," including time- and labor-saving devices produced by Yankee inventors. Reciprocally, Peters hoped to obtain objects and information from "the ancient nation for the benefit of our country," thus scoring a first in the cultural exchanges between China and the United States.

Americans assumed that the Chinese attributed their defeat in the Opium Wars to the superior technology of foreign weaponry and that a display of American models—a steamship, locomotive, telegraph, and gasworks—built by the mechanically gifted and enterprising John Peters would open doors to trade. As Cushing explained to Viceroy Keying:

> Your excellency is doubtless aware that all the modern improvements in the arts of war & navigation are adopted and practiced in my country quite as thoroughly and extensively as in Europe. That if your government is desirous of books on . . . engineering, ship-building, steam engines, discipline of troops, or manufacture of arms, or any other subject whatever, I shall be happy to be the means of placing them in your hands. I also tender to you models for the construction of the instruments of war as now used in Europe and America. Also the services of engineers skilled in these arts, to construct for your government ships, steamers, cannon, & arms of all sorts, either in China or in America as may be preferred.

Cushing's papers are silent as to whether Peters ever presented his models to the viceroy, but having returned to America, he was able to carry out the second part of the plan when "The Great Chinese Museum" opened its doors in Boston. Designed to display the high level of Chinese civilization, the exhibition was intended as well to persuade local entrepreneurs that the Middle Kingdom's mandarins could be ideal trading partners for Boston's Brahmins.

GUESTS GASPED AT THE GLOWING lanterns hanging from the ceiling, and at a hovering giant dragon, along with numerous paintings and scrolls. Besides Peters's chinoiseries, there were dioramas with costumed mannequins; Case One pointedly portrayed the emperor robed in imperial yellow seated on a dragon chair as he signed the Wanghia Treaty. Less felicitously, Case Five featured a wealthy man at home smoking opium. (The catalogue entry discussed the history of opium use in China and righteously claimed it was the British who had encouraged the baleful trade, in defiance of the emperor's prohibition.) Smaller cases displayed obligatory porcelains, enamels, embroideries, miscellaneous models, and utilitarian items. Highlights in the gallery included a huge seven-foot panorama of Canton, featuring portraits of prominent local merchants and Viceroy Keying. Present in the galleries were two live Cantonese, dressed in "native costume." The English-speaking T'sow-Chaong, a self-described "writing master," answered visitors' questions. Le-Kaw-hing, a former opium-addicted musician, sang and performed on various instruments, adding verisimilitude to the occasion. As a local reporter enthused, "Who would not like to visit China, walk through the streets of its cities, penetrate the mansions of its inhabitants, partake of savory bird's nest soup . . . or quaff real souchong, from real China ware, in the company with real Chinese? There are none who, if circumstances permitted, would not desire to see the many curious things which distinguish that curious people. To us, whose business, time or means, forbid so long a voyage, there is now offered a most desirable opportunity."

The museum's entrance was adorned with a carved lacquer and gilt cornice, flanked by two dragon-painted lanterns and tablets with Chinese characters, which, when translated in the catalogue, read: "Words may deceive, but the eye cannot play the rogue." Among the visitors was fifteen-year-old Emily Dickinson, then staying with relatives in Boston. Emily obtained two cards for herself and her sister Lavinia, each inscribed in calligraphy by the writing master, which (as she wrote to a

friend) she held "very precious." The music sung and played by Le-Kaw-hing "needed great command" over Dickinson's "risible faculty" to keep her sober, "yet he was so very polite" that she was "highly edified with his performance." But ultimately it was the "self denial" that had allowed him to overcome his opium addiction that she found "peculiarly interesting." The Japanese-American scholar Hiroko Uno has speculated that Dickinson's lifelong pattern of withdrawal, self-denial, and renunciation might have been prompted by her being drawn to Case Four, in which Confucianism, Daoism, and Buddhism were expounded. As explained in the guidebook, a central doctrine of Buddhism is "that all things originated in nothing, and will revert to nothing again. Hence annihilation is the summit of all bliss; and *nirupan, nirvana,* or nonentity, the grand and ultimate anticipation of all."

As Uno elaborates, any number of Emily Dickinson's poems resonate with the poet's mystical/ironical/paradoxical/universal sense of the Divine, sometimes mingled with her reflections on the material culture of the Celestial Empire, as in these lines:

> *His Mind like Fabrics of the East—*
> *Displayed to the despair*
> *Of everyone but here and there*
> *An humble Purchaser—*
> *For though his price was not of Gold—*
> *More arduous there is—*
> *That one should comprehend the worth,*
> *Was all the price there was—*

The quotations could be multiplied, suggesting that New England's premier mystical poet, living in Amherst, confiding her verse to a dresser drawer, plainly anticipated the nonmaterial allure that would draw a future generation to the aesthetics and theology of the Far East.

CHAPTER THREE

THE CRIMSON PATH

In examining America's cultural relations with China, one question persistently occurs: Why has Harvard University played so outsize a role in promoting the potent allure of the Far East? Some reasons are self-evident. The country's oldest university (b. 1636) came of age when maritime New England was the propellant of commerce with the Pacific East. In the words of Samuel Eliot Morison (Class of 1912), the years 1783–1860 formed "that magic era when America first became a world power, and Salem boys were more at home in Canton than in New York." The seaports of Massachusetts generated not just the undergraduates but also the mercantile fortunes that gave Harvard a running start in its race for primacy. Harvard saw itself in the role of educating these custodians of culture. As Mark Twain remarked: "In Boston they ask, how much does he know? In New York, how much is he worth? In Philadelphia, who were his parents?"

Yet there were other, less obvious reasons for Harvard's—and Boston's—gravitation to the Sino-Japanese world. During the spiritual anarchy of the post–Civil War, post-Darwin decades, the New England illuminati, beginning with Emerson, looked eastward in search of transcendental truths. Just as China's interest in Buddhism was waning, it exerted a magnetic pull on Boston's ruling caste. Thus when Henry Adams, shaken by his wife Clover's suicide, began his restless global travels with the artist John LaFarge in 1886, their initial goal was Japan in quest of Nirvana (so LaFarge informed a baffled young reporter as they stopped in Omaha, who shot back, "It's out of season!"). In fact, Adams (Class of

1858) and LaFarge were part, as we shall see, of a crowded brigade whose members sought to counter the vulgarities of the Gilded Age with the wisdom of the East.

A third likely reason for Harvard's liaison with the Far East is implicit in Boston's self-regarding metrocentric vernacular. From the 1850s onward, two new terms were affixed to the city and its blood-proud, Harvard-trained elite: Bostonians viewed their city as the metaphorical hub of the world, under the guidance of its own hereditary Brahmin caste, the closest approximation to an American aristocracy. Both "Hub" and "Brahmin" were coinages introduced by Oliver Wendell Holmes Sr. (Class of 1829), the witty autocrat of the breakfast table and author of the poem "Old Ironsides," not his son, the eminent jurist. As Holmes explained, he considered Boston "the thinking center of the continent, and therefore of the planet." He was careful to add that the Hindu concept of a divinely anointed caste possessed a corollary: Brahmins were expected to nourish and maintain not only temples of their faith, but cultural institutions as well. Moreover, when sons of Harvard turned searchingly to China, note was taken of the high value its mandarins accorded to excellence in the arts and literature.

The founders of the Boston Athenaeum (b. 1807), a private library that added an art gallery in 1827 for a series of yearly exhibitions of American and European painting and sculpture, reminded their fellow benefactors that as "we are not called upon for large contributions to national purpose," the savings could be used "by taxing ourselves for those institutions, which will be attended with lasting and extensive benefits" for Boston. Between 1870 and 1900, the Brahmins contributed beneficially to Harvard and to the patronage that seeded the Athenaeum, and then the Boston Museum of Fine Arts (b. 1870), the Boston Symphony Orchestra (b. 1881), plus a pride of clubs, schools, hospitals, and the final resting place for Bostonians: the impeccably landscaped Mount Auburn Cemetery (b. 1831). (A long-standing definition of a Boston Brahmin is someone with a share in the Athenaeum, a relative in McLean's [psychiatric hospital], and a plot in Mount Auburn.) During the nineteenth century, Boston also cradled outstanding journals (*The Atlantic* and *The North American Review*), publishing houses (Little, Brown and Houghton-Mifflin), and a very Bostonian religion: the heterodox but liberal Unitarians, the denomination associated with Harvard's Divinity School. Unitarian tradition was said to proclaim "the Fatherhood of God, the Brotherhood of Man, and the Neighborhood of Boston" (so writes Helen Howe, a disciple by heredity).

THE "LONGING FOR THE EAST was a symptom of the moment, especially marked in New England," writes the literary historian Van Wyck Brooks (Class of 1908). "Numbers of Boston and Harvard men were going to Japan and China in a spirit that was new and full of meaning. Oriental art was the vogue among Bostonians, and they were filling their region with their great collections." The pilgrim who led the way was Ernest Fenollosa, who in his time became America's most eloquent prophet of "one world," resulting from "the coming fusion of East and West." Writing in the 1880s, he maintained that the vigor of Western civilization arose from knowledge of means, while the East's strength lay in its knowledge of ends. "Means without ends are blind," he wrote, while "ends without means are paralyzed." This was a novel message during the Gilded Age. One can imagine the baffled expression among Harvard's faculty and students on hearing Fenollosa's Phi Beta Kappa poem, written from Japan, where he had just become a Buddhist monk:

> I've flown from my West
> Like a desolate bird from a broken nest
> To learn the secret of joy and rest.

Fittingly, Ernest Fenollosa was born in Salem, Massachusetts, in 1853, the year in which Commodore Matthew Perry's squadron set sail for the Bay of Tokyo. His father was a Spanish musician, born in Malaga, where he conducted the cathedral choir and taught the piano and violin. He therefore qualified to join a military band on a returning U.S. vessel. He liked and lingered in Salem, where he married a pupil, Mary Silsbee, the daughter of an East India shipowner, becoming an Episcopalian and a popular figure in the state's musical scene. Thus young Ernest had the means, the background, and the education that propelled him to Harvard (Class of 1874), where he fraternized with the Brahmin elite and fell under the spell of Charles Eliot Norton, America's foremost authority on the philosophy of art. Another pioneer in Asian studies was Edward S. Morse, a self-taught zoologist, originally on the staff of the Peabody Academy of Science in Salem, who pursued his researches in Japan and donated his collection of ceramics to Boston's Museum of Fine Arts (MFA) in exchange for a lifetime job as keeper of his pots. He gifted his collection of everyday objects to Salem's Peabody Museum. When Morse was asked by the Japanese to recommend a teacher of philosophy, he turned to Norton, a trustee of the MFA, who suggested Fenollosa. Such was the networking route that took young Ernest to Japan, where he

became entranced by the East, converted to Buddhism, and on his return to America became the curator of Oriental art at the MFA.

It is hard to overstate Fenollosa's influence on his Harvard contemporaries (like Henry Adams), or on his friends in Japan (like Lafcadio Hearn), or on an early generation of modernist writers (like Ezra Pound). It suffices to say that before his death in 1908, this slim, ethereal, and eloquent advocate of the East had established Boston and by extension Harvard as the intellectual capital of East Asian art.

Fenollosa's protégé and successor as the MFA's expert on Asian art was Kazuko Okakura, a transplant from Japan, who became the long-serving curator of the Chinese and Japanese department. Okakura also served as spiritual mentor, although not artistic advisor, perhaps fearing

Isabella Stewart Gardner by John Singer Sargent.

a conflict of interest, to Boston's dowager empress of Fenway Court, Isabella Stewart Gardner, whose private museum opened to the public in 1903 with an orchestral fanfare by the Boston Symphony. Her new museum featured a succession of two "Chinese rooms." The first housed Japanese screens and temple hangings, Chinese embroideries, plus a number of smaller objects. However, it was only after the opening of her museum that she met Okakura, newly arrived in Boston to advise the MFA. When Okakura died in Japan in 1913, Gardner hosted an incense-filled memorial service in the Music Room of her museum. One friend poured water over a stone on his grave on her behalf; another, Denman Ross, who occasionally acted as her unpaid agent, gave her Okakura's lunch box and teacups, while Kojiro Tomita, his curatorial successor, collected plum blossoms from his grave. Gardner dedicated the second of her Chinese rooms, the "Buddha Room," to Okakura's memory. The Chinese theme was additionally apparent in the loggia of the museum, which housed a Chinese Eastern Wei votive stele bought through Bernard Berenson from the Russian art collector Victor Goloubew.

Gardner's initial interest in the East had been prompted by hearing Morse deliver a series of lectures on Japan at Boston's Lowell Institute in 1881. She invited him to repeat them for guests in her home. In 1883, along with her husband, Jack, a railroad financier, she decamped for Asia, visiting Japan, China, and Southeast Asia. Although they traveled with a sizeable entourage of luggage carts and porters, "Tartar" maids and personal cooks, wranglers, and dragomen, they followed the usual tourist itinerary—Shanghai, Tianjin, Peking, back to Shanghai, and then on to Hong Kong, Canton, and Macao. In Peking there were visits to the Observatory, Ming tombs, the Great Wall, and the ruins of the Yuanmingyuan. A site of special interest was the Yonghegong, the so-called Lama Temple of the Tibetan Buddhist Yellow Hat sect, where her diary records her observations on the architecture, the monks' yellow robes, the chanting, and the art—carpets, cloisonné altar vessels, and the huge statue of Buddha. There were visits to missionaries and charitable organizations, and more unusually, because of Isabella's keen interest in Asian religions, there were meetings with Buddhist and Daoist monks, sandwiched between doses of shopping, buying photographs, pressing gingko leaves in souvenir albums, and penning notations in her diary. Summing up their nineteen-day stay, she wrote: "Dust and filth and every kind of picturesque and interesting thing."

Exotic travel suited the eccentric Isabella, and at home she was not above scandalizing Boston's bourgeoisie. A favorite story had her hiring a

locomotive to fetch her when she was late for a coaching party. Another had her appearing at balls with a page to carry her train. An avid baseball fan, she wore a pennant across her brow at a concert in Symphony Hall proclaiming, "Oh You Red Sox." Her motto, inscribed above her bath-tub, is revealing: "Think much, speak little, write nothing." Although he could not claim to have known her personally, perhaps the best descrip-tion of Isabella has been left by the former director of the National Gal-lery, John Walker (Class of 1930):

> [S]he was an exhibitionist. She paraded around the zoo with a lion on a leash; she sat in the front row of prizefights; she drank beer instead of sherry at Pops concerts; she wore dresses from Worth so décolleté and tight-fitting that she was conspicuous everywhere. She had innumerable friends among men but very few among ladies.

Harvard's Charles Eliot Norton (Class of 1846) served as her most important mentor. An author and the editor of the influential *North American Review,* he was the son of Andrews Norton, New England's "Unitarian Pope," and cousin to Charles William Eliot, Harvard's presi-dent (by virtue of their both being grandsons of the merchant prince Samuel Eliot, according to contemporary legend the richest man ever to die in Boston). Reputedly the most cultivated and influential man in America, "Charley" Norton was a founding member of the Dante Society, whose early presidents were Henry Wadsworth Longfellow and James Russell Lowell (Class of 1838), and whose members included Oli-ver Wendell Holmes Sr., William Dean Howells, and Isabella Stewart Gardner. Originally, their meetings, devoted to studying and revising the Italian translations of Dante by Longfellow, were held at the poet's Cam-bridge abode, "Craigie House," but were eventually moved to grander quarters at the Nortons' ancestral home, "Shady Hill." Set in a leafy park, it was there in Shady Hill's golden brown study filled with paintings and medals, books and manuscripts that Henry James was introduced to Charles Dickens.

Mrs. "Jack," as Isabella was familiarly called, was a frequent auditor of Norton's lectures in which he preached the gospel of good taste—it was once remarked that when that professor entered Heaven, he would sneer, "Oh no! So overdone." Norton launched her as a collector, sometimes act-ing as her agent. (When expenses at Shady Hill became onerous, he was not above selling her his rare books and manuscripts.) Besides Fenollosa and Gardner, Norton's acolytes in the mid-1890s included three favored

protégés: the philosopher George Santayana (Class of 1886), the art historian and collector Charles Loeser (Class of 1886), and the essayist and critic Logan Pearsall Smith, later to become the brother-in-law of another of Norton's pupils (although less favored), the art historian Bernard Berenson. Santayana, Loeser, and Smith also appear to have been gay or bisexual, though discreetly closeted. Besides the Norton trio, other important bachelors who enjoyed tea times at Fenway Park included Henry James (attended Harvard Law School), the painter John Singer Sargent, and three future benefactors of the MFA: Ned Warren (Class of 1883), who gifted the museum with a collection of ancient Greek sculpture; Dr. William Sturgis Bigelow (Class of 1871, M.D. 1874); and Denman Ross (Class of 1875, Ph.D. 1880); the latter two major donors to the MFA's Asian collection.

In the 1880s, New England's mercantile fortunes, by then invested in real estate and railway bonds, subsidized a younger generation's interests in the arts. Brahmins brought their business skills to running Boston's cultural organizations, including the MFA, where they dominated the board of trustees. As cultural historian Neil Harris comments: "Eliots, Perkinses and Bigelows took their places; almost all of the twenty-three elected trustees were descended from old Yankee families and were men of wealth. All but one were Proprietors of the Athenaeum, eleven were members of the Saturday Club, five served (or would serve) on the Harvard Board of Overseers, half were members of the Somerset or St. Botolph Clubs and quite a number were blood relations."

ONE SUCH PARAGON was William Sturgis Bigelow. The beneficiary of a substantial China trade fortune, the third in a dynasty of doctors, Bigelow was the son of the Gardners' family physician and a close friend of John LaFarge, Senator Henry Cabot Lodge, and President Theodore Roosevelt. He was also the favorite cousin of Henry Adams's wife, Clover, who, along with her husband, was an enthusiastic collector of Asian art. At his summer retreat on tiny Tuckernuck Island, off the western tip of Nantucket, described by Adams as "a scene of medieval splendor," Bigelow banned women and encouraged skinny-dipping among the men, leading Senator Lodge to exclaim in anticipation of leaving sweltering midsummer Washington, D.C., for Tuckernuck, "Surf, sir! And sun, sir! And Nakedness! Oh Lord, how I want to get my clothes off." Bigelow's three-thousand-volume library provided houseguests with tomes on Buddhism, the occult, or (it was alleged) racier fare in three languages, for the hearties who lounged about nude or in pajamas—Bigelow preferred a kimono. But for dinner, formal dress was required.

Bigelow, who had heard Edward Morse lecture, invited him to Tuckernuck and accompanied him to Japan in 1882, where "the Doctor" was to spend seven years. He became a Buddhist, and on one occasion played host to the Gardners on their 1883 trip to the Far East. At one point in their friendship, Dr. Bigelow professed to find Mrs. Jack "a gloom dispeller, corpse-reviver, general chirker-up," and in her honor christened his Chesapeake retriever Mrs. John L. Gardner, shortened to "Belle," as he "could not really use the whole name and then whistle." But he could also turn on her, echoing sentiments expressed by Berenson, who always referred to her as "The Serpent of the Charles." Bigelow wrote Lodge in an outburst of unusual candor that she was "vain, meddlesome and impulsive," with "not a very keen sense of the difference between loyalty and treachery. She would make friends with anybody or sacrifice any friend for caprice."

On October 6, 1926, *The Boston Evening Transcript* front-paged two bold headlines: Babe Ruth had hit three home runs in a World Series game, but in larger type it reported that William Sturgis Bigelow had died. The MFA's then curator of Chinese and Japanese art, John Ellerton Lodge, the son of Bigelow's best friend, Henry Cabot Lodge, clothed him in a long gray kimono with his upper body dressed in the cloak of a Shingon Buddhist priest before cremating his remains. At his request, Bigelow's ashes were divided between Mount Auburn Cemetery (founded by his grandfather, Jacob) and Japan's Homyoin-Miidera Temple, where the priests buried him in the vicinity of Lake Biwa, near the remains of his friend Fenollosa. He bequeathed his collection of Asian art, numbering more than 26,000 objects, to the MFA.

Another among Boston's bachelor aesthetes and museum patrons is the patrician figure of Denman Ross, who acquired art with the intent of leaving his collection to posterity. Professor, artist, collector, and author of influential treatises on design theory, Dr. Ross was, most importantly, trustee and benefactor of both the MFA and Harvard's Fogg Museum. Over his lifetime, he gave eleven thousand works to the MFA and 1,500 to the Fogg. Although he collected in many areas, it is his focus on Chinese art that concerns us here.

The art historian Sir Kenneth Clark once wrote, "My collection is a diary of my life, the only one that I have ever kept." The same might be said of Ross. His archived correspondence with museum administrators, curators, fellow collectors, and friends like Joseph Lindon Smith and Mrs. Gardner contains little of a personal nature. Instead it documents objects seen and collected, his trip itineraries, and admonitions

Denman Ross, a princely donor to the MFA (sketched by Sargent in 1917).

as to how his gifts were to be displayed. But as the former MFA curator James Watt recalled in an interview, in studying his donation, he realized that "Ross was a great collector. I didn't believe in 'the eye' until then, but he changed all that."

"My motive was the love of order and sense of beauty," Ross explains in his notes for an autobiography. "The collecting of works of art is simply incidental. I had the money to spend, so I spent it." When friends came to visit, "I found myself saying the same things about the same objects and telling the same stories over and over again, until I was ashamed of myself. I could not go on like that, so I gave my collections to the MFA, first as a loan and later as a gift."

Ross donated a number of Chinese paintings to the museum, notably five rare paintings depicting Lohans (followers of the Buddha who have obtained enlightenment) dating from the early Southern Song dynasty, formerly in the collection of the Daitoku-ji Zen temple complex in Kyoto (see color plates, figure 14). Painted by Zhou Jichang and Lin Tinggui, probably between 1178 and 1188 CE, they were part of a set of one hundred scrolls brought to Japan in the thirteenth century. In 1894, Fenollosa arranged a loan exhibition of forty-four of the paintings. Among Boston's cognoscenti, the exhibit caused a sensation. Ross took a visitor, his friend Bernard Berenson, to meet Fenollosa and view the collection before it was exhibited to the public. Noted for his connoisseurship of Italian painting, Berenson had a less well-known but strong interest in Buddhist art that, inspired by this exhibition, would grow into a great passion. He wrote to Mary Smith Costelloe, who was later to become his wife, that he was amazed to find "oriental art, now surpassing Dürer and now Gentile Bellini":

> They had composition of figures and groups as perfect and simple as the best we Europeans had ever done. . . . I was prostrate. Fenollosa shivered as he looked. I thought I should die, and even Denman Ross who looked dumpy Anglo-Saxon was jumping up and down. We had to poke and pinch each other's necks and wept. No, decidedly I never had such an art experience. I do not wonder that Fenollosa has gone into esoteric Buddhism.

The temple was badly in need of repair and the paintings were serving as security for a large loan from a Japanese collector, and the monks appeared to have agreed to an American sale of ten paintings. At the end of the exhibit, Ross purchased five of the best paintings, which he eventually donated to the museum; the MFA also purchased five paintings. More mysteriously, two paintings that Fenollosa claimed to have

misplaced and were never exhibited or offered to the MFA or Ross were sold by Fenollosa to Charles Freer. The curator seems to have believed he was owed a gift or commission by the temple. When the paintings were returned to Kyoto in 1908 they were deemed national treasures, and the sale has been regretted ever since.

Their purchase in 1895 marked the beginning of the MFA's collection of early Chinese painting, for many years the finest in the West. Another famous painting donated by Denman Ross is *The Thirteen Emperors* scroll (see color plates, figure 13). Before it was exhibited in Tokyo, upon the occasion of the Japanese Emperor Hirohito's enthronement in 1928, it was in the Fujian collection of the Lin family. Finally, Denman Ross acquired it in 1931 from the Japanese dealer Yamanaka.

More than seventeen feet long, executed in ink and color on silk, *The Thirteen Emperors* is probably the earliest Chinese hand scroll in any American collection. Although Ross and the MFA curator Kojiro Tomita purchased it as a Tang original by the court artist, Yan Liben (Yen Li-Pen), which is how it is listed on the MFA's website, another scholar, Professor Qiang Ning, believes that it is a later, Northern Song (960–1126 CE) copy. Portrayed are the thirteen emperors who preceded the Tang ruler Taizong, accompanied by their officials. Ning theorizes that "the motivation behind the selection of these particular thirteen emperors . . . was to legitimize the sovereignty of Emperor Taizong," who had seized the throne, murdering his older brother and forcing his father into retirement, and who was "therefore a likely candidate for patron of the portrait's original version." Each emperor is identified by an inscription. In the case of Wudi, the third in the line of Northern Zhou dynasty, who ruled from 561–78 CE, the scroll records that "he destroyed the Buddha's Law." (He acted under the influence of his minister, who was a Daoist.) Tomita asserted that "because of its extraordinary quality as portraiture, the scroll of the emperors is one of the chief masterpieces of the world."

Tomita introduced Ross to the painting in a small reproduction. As the curator recalled, Ross said, "'How can I get it?' I told him it was in China. He said, 'Try to get it.' When it came to the question of price, it was many thousands of dollars [$60,000 Depression greenbacks]. He said, 'I haven't got that much money, but now I have to get it. I will call my lawyer.' He did call and the lawyer said, 'Dr. Ross, you are a bachelor and you have enough money, but you can't spend all that amount at one time.'" Ross borrowed a substantial sum against collateral, and the museum advanced the rest. In his will, he left the MFA money to repay the loan with interest because, as Tomita recalled, "he was that type of man."

DENMAN WALDO ROSS was born in Cincinnati in 1853 to John Ludlow and Frances Walker Waldo Ross. Three other children died, so Denman reports, "I was left as the one and only child." In 1862, the family moved to Boston near his mother's Waldo relations, because, as Denman recalled, his father "did not like the idea of going into the army and leaving his wife and only child in Cincinnati with the enemy across the river." His Waldo connections included grandfather Henry, who was a business partner of Amos Lawrence. Together they invested in the booming Lawrence mills north of Boston, perhaps inspiring Henry Waldo's grandson's lifelong interest in collecting textiles. His father, also an astute entrepreneur, together with his brother Matthias Denman (after whom Denman was named), acquired substantial holdings in the still-developing Back Bay real estate market, as well as interests in a number of other businesses, including power and roofing companies and a manufacturer of linen fishing lines, a particularly lucrative trade in Boston. Hence in those pre–income tax days, John Ross amassed a considerable fortune.

Once enrolled at Harvard in 1871, Denman studied history with Henry Adams, recently lured from the nation's capital by Harvard President Charles Elliot. In his senior year, Ross enrolled in Charles Eliot Norton's course "The History of the Fine Arts, and Their Relations to Literature." Norton believed that history should follow practice, and thus although his course eschewed the pencil and paintbrush, it followed a course taught by Charles Moore on "Principles of Design in Painting, Sculpture, and Architecture." Inspired by Norton, Ross also developed an interest in the work of England's influential art critic John Ruskin and the pre-Raphaelite painters he championed and thus absorbed his mentor's firmly held belief in the moral benefits of an art education. Ross became a leading proselytizer of the Arts and Crafts movement in America.

Study at Leipzig, a doctorate under Adams with a dissertation on German land reform published in 1883, followed, but the death of his father in 1884 freed Denman from the academic practice of history. The break was definitive: "My large collection of books in the field of Ancient Law was given to Harvard College. My study, where the books had been kept was turned into a studio, extended, enlarged and rearranged for the practice of painting and for my collection of works of art." His inheritance, plus the rents derived from a large Back Bay apartment hotel, the Ludlow, built on family land across from Trinity Church, allowed him to

embark on a lifetime of traveling, studying, and writing about art, painting, and collecting.

Dr. Ross pursued his new career devoted to teaching design theory at Harvard, first in its Architectural School and then, in 1909, in the Fine Arts department. Lecturing well into his seventies, he was remembered by a student as "massive, rubicund, somewhat dogmatic in his theories of design, and occasionally short of breath, but still eager to collect, to teach, and to enjoy beauty."

He particularly liked lecturing at a summer school for artisans and schoolteachers, since he felt strongly that it was important to teach art to tradesmen and schoolchildren. Yet his teaching betrayed a strong authoritarian streak. What was once said of the Reverend Andrews Norton might properly be applied to Ross's doctrinaire classroom style: "Norton came into the classroom, not as one who was seeking the truth, but as one who had already found it." "His influence on his disciples was very powerful," one of Ross's pupils commented. "His insistence on the supreme excellence of his method was a serious weakness in his teaching, for he did not encourage his disciples to think for themselves and showed no interest in their investigations and discoveries."

Handling original works was essential to Ross's method, and he often invited students home for dinner at his high-ceilinged, art-filled house on Craigie Street for lessons in connoisseurship and the chance to view the art still en route to museums. His advice to his protégés: fix the best objects of their kind in your mind and keep them there until you run across something more beautiful, be selective and buy only the best, and do not compare different types of objects. After he retired, he continued to take an interest in promising students. Among them in 1928–29 was the newly arrived Laurence Sickman, subsequently the director of the Nelson Gallery in Kansas City, who credited Ross with being his most important artistic influence. Ross recommended to Kojiro Tomita that Sickman be given the run of the MFA's collection, and Sickman reported that Tomita was "most tolerant and obliging." Ross also advised Sickman to "learn the language but do not become a philologist, study the art, but do not become an 'aesthetic.'"

Although he was among the first Americans to collect Monet, Ross lost interest in the Impressionists, deeming them "so superficial when compared with the work of the old masters." His fierce opposition to modern art—Matisse, Picasso, and the German Expressionists—deterred the Fogg, where he was the keeper of the Ross Study Series and an honorary fellow, from collecting in this area. As a result, with the encouragement

of one of the Fogg's directors, Paul Sachs, Lincoln Kirsten, Edward Warburg, and John Walker founded the Harvard Society for Contemporary Art in Harvard Square, the inspiration for New York's Museum of Modern Art. As Walker wrote in his memoir, *Self-Portrait with Donors,* Ross "was as determined as Hitler to prevent the dissemination of what he considered decadent art."

In 1895, the MFA made Ross a trustee. (He was something of a legacy, since his uncle Matthias Denman Ross was on the founding board.) He thus joined the exclusive club of Brahmin collectors of Asian art: Dr. Charles Goddard Weld, another beneficiary of a China trade fortune, who bought Fenollosa's personal collection of Asian art and donated it to the museum, and William Sturgis Bigelow. Bowing to the Japanophilia rampant in the MFA's Asian department, Ross initially collected Japanese art but soon branched out into other parts of Asia, including China, which he visited in 1910 and 1912. His extensive collecting trips were made in the company of his cousin Louise Nathurst, but also with the painter Joseph "Zozo" Lindon Smith, who occupied a large subsidized space on the top floor of the Ludlow, and Hervey E. Wetzel (Class of 1911).

Smith was a painter whose work Ross especially admired, and in return for lessons he underwrote a joint trip to Europe in 1886 so that they might enjoy Europe's masterpieces together. It was the beginning of a lifelong friendship consolidated through travel to Mexico, Europe, and Asia, where they painted side by side. (Ross eventually became a skilled, if academic, painter.) An autumnal letter written nearly half a century later from Venice, shortly before Ross died, reflects on their shared past: "We were in the spring and prime of youth and we were doing some of the best work we have ever done and we have established a standard we have never lost. Florence and Venice we [have] known them as very few people. . . . Italy is no longer what it was. It is spoiled for me so that I shall not come again."

Edward Forbes, the director of the Fogg Museum, introduced the Harvard student Hervey Wetzel to Ross as "a gentleman of leisure." The young man evolved from student to protégé to lifelong friend, with whom Denman initially traversed Japan and China, returning via Southeast Asia, India, Egypt, and Europe in 1912–13. Denman laid down the rules: he was to have first refusal. They interviewed dealers and visited their shops. They ignored "archaeological or historical considerations," preferring to collect the best with the idea that "the aim and end of a

liberal education is to feed the imagination, not only by reading the best books but by seeing the best things."

Described by his mentor as "discriminating and very critical," Wetzel was "eagerly appreciative and enthusiastic regarding the things that he thought fine and beautiful. His taste and judgment were almost unerring." Ross had hoped that the younger man, who had inherited the wherewithal to form a major collection, would succeed him as trustee. In 1917, the MFA offered Wetzel the honorary position of curator of Persian art. He planned to devote his fortune and his time to making the MFA's Persian collection the best in the world. He also bought two adjacent houses on Louisburg Square to house a growing collection that could turn into a small museum. This was not to be. World War I intervened. Rejected for military service owing to a heart problem, Wetzel served as a volunteer at the Paris headquarters of the American Red Cross. Sensing that he might not return, he curated an exhibit at the old Fogg of his collection of Chinese, Japanese, and Korean art. He died in 1918, a victim of pneumonia. The Fogg and the MFA were each bequeathed $100,000 to purchase important works of art. Half of Wetzel's collection of Eastern art went to the Fogg, and the other half went to the MFA. Among his gifts was the great Wei dynasty Buddhist Votive Stela, dated 554 CE and still on exhibit in the MFA's China gallery. In memory of his younger friend, Ross gave the MFA a Cambodian statue.

In 1913, Denman Ross donated a large, exceptionally fine Eastern Wei stone bodhisattva (see color plates, figure 4) excavated at the White Horse Monastery at Loyang, in memory of the MFA's curator, Kakuzo Okakura. Okakura had first seen the sculpture in 1906 in China, where it had just been uncovered. He returned in 1910 hoping to buy it, but the bodhisattva had disappeared, only to surface in the Paris shop of the dealer Paul Mallon, where Ross saw it and bought it.

"Uncle Denman" became a frequent and sometimes intrusive visitor to the storerooms of the two museums. His own collections, which were stored at the Fogg, took up considerable space and were the cause of much curatorial griping. Like Bigelow, he was much given to behind-the-scenes intrigues, weighing in on such matters as the MFA's collection of plaster casts and its personnel. (One Ross letter to Harvard's president and ex officio MFA trustee A. Lawrence Lowell began: "The organization of the Museum of Fine Arts in Boston is, in my judgment, deplorable.") At the time, Ross had considerable influence on the running of the museum departments. "There was dear old Denman Ross who never let you get

away with anything," as one curator then working at the MFA ruefully remarked. "After all, Denman practically owned the place at the time." The Fogg's curator of Asian art, Langdon Warner, added, "He gloated in his discoveries and would have us know the full merits of the pictures he bought. He boasted and he loved to be agreed with. Still, it would have been a petty spirit indeed who refused that slight offering he asked. Also we found it wise to agree, for it was led by him that we came to realize that Cambodian sculpture, South Indian bronzes, and Coptic tapestries are indeed triumphs in their several fields." Ross not only advised on acquisitions, he sometimes expressed doubts as to the "maturity" of the judgments of those selecting art, doubts he expressed to Alan Priest, the future curator of the Metropolitan Museum, about to leave with Warner and Horace Jayne (see Chapter Four) on their quest to acquire wall paintings from Dunhuang for the Fogg. Although he was not a stickler for keeping his collection together, he proposed that all labels read "Ross Collection" so that "I shall be able to speak to the people of Boston long after I am dead, as a book written or a picture painted."

The MFA celebrated its benefactor's eightieth birthday with a suitable party and by filling nine galleries with a selection of the works that he had donated. On September 12, 1935, in the midst of yet another European collecting trip, he died in his hotel room in London, aged eighty-three. As a fitting final tribute, Yamanaka (the firm from which Ross had purchased *The Thirteen Emperors* scroll) provided a rare Tang pottery jar to transport his ashes home to Cambridge.

Thus it was that Fenollosa, Bigelow, Ross, and Wetzel attained their goal as collectors: an afterlife through art. It is their legacy that endures in the halls of Boston's Museum of Fine Arts.

ANOTHER LANDMARK IN NEW ENGLAND'S quest for Asia's treasures was the opening in 1896 of the Fogg Art Museum. It bears the name of William Hayes Fogg, a native of Berwick, Maine, who prospered in the China trade, heading a shipping company with a presence in five Chinese ports plus two in Japan. He and his wife, Elizabeth Perkins Fogg, traveled widely and collected "Oriental curios." From his estate, valued at $1.5 million, his widow in 1891 bequeathed $200,000 to Harvard to establish its first art museum, with the couple's curiosities providing a starter collection. The trustees of the fledgling Fogg were still feeling their way in their new Renaissance-style gallery (designed by Richard Morris Hunt) when, in 1909, they chose as director the relatively young Edward Waldo Forbes (Class of 1895). The museum he now managed comprised

a miscellany of casts, Orientalist porcelain, photographs, slides, a few prints, Greek vases, and some English watercolors. The latter were barely visible; as he used to say, the pictures were "in galleries where you could not see, adjacent to a lecture hall where you could not hear."

All this would radically change during his long tenure. His ancestry helped. Edward Waldo Forbes was a Brahmin from brow to toe; indeed, it was widely remarked that he auspiciously resembled his grandfather, Ralph Waldo Emerson. His forebears included two sea captains who pioneered the China trade, while his father, William Hathaway Forbes, partnered with Alexander Graham Bell in founding the Bell Telephone Company. As a Harvard undergraduate, Edward Forbes came under the spell of Charles Eliot Norton. Forbes then explored Europe and its starred art galleries. In 1903 he became a trustee of the Boston Museum of Fine Arts, a position he held for sixty years (a longer reign, his obituaries noted, than Queen Victoria's).

Forbes was to all intents a proper Bostonian with an educated grasp of the value and importance of great works of art. In his "Methods and Processes of Painting," a pioneering course in the field of preservation, his students learned to copy Old Masters by working in their styles with identical materials. But he also possessed a restless, unconventional streak. We owe to a family friend, the novelist Helen Howe, a glimpse of Forbes's other self. In her memoirs, she recalls seeing Forbes "wander into a formal wedding in Milton [Massachusetts], with disheveled hair and mud on his heavy boots, and a fading bunch of wild flowers in his hand, with that vague, seraphic, Emersonian look of another world." He loved music and played the harp, piano, and cello. At parties on Naushon Island, the offshore sanctuary of the Forbes family and their relations (including Secretary of State John Kerry), Edward Waldo accompanied himself on a guitar while singing old songs, of which (Howe writes) he seemed to have a "boundless supply." Back in Boston, his persona changed. The premature flower child would negotiate hardheaded deals to acquire for Harvard properties along the Charles River whose potential value, he felt, was unappreciated by university bookkeepers.

The same unconventional Forbes was evident in his choice of his key lieutenants at the Fogg. Two names stand out: Paul J. Sachs, the museum's associate director, and Langdon Warner, his much-traveled curator of Oriental art. Through both, one suspects, Forbes vicariously savored the less conventional adventures accessible to freer spirits in the art world. With the advent of Sachs (Class of 1900), the Fogg evolved into a boot camp for training a new generation of museum professionals;

Paul Sachs instructs the chosen few in his celebrated "Museum Course" in the Naumburg Room at the Fogg Museum (1944).

and through Warner (Class of 1903), the museum mounted high-risk forays into China that triggered the emigration of sculptures and paintings from Buddhist sites, precipitating a debate that still persists.

First, Sachs: In 1915, while seeking a new assistant director, Forbes lured Paul Sachs from his position at Goldman, Sachs & Co., the investment bank founded by his grandfather Marcus Goldman. His father, Samuel Sachs, became a partner with his father-in-law; both families having Bavarian roots. His father intended that his eldest son would become a partner in the family firm, but banking could not rival Paul's fascination with art. As Paul Sachs recalled, "I always wanted to be an artist, from my earliest boyhood, and instead I went to college. Yet even then my determination did not die. I had started collecting prints and drawings. For 15 years after graduation, I collected and studied, so that some day I could come back to Harvard if the opportunity presented itself."

Having accepted Forbes's offer, Sachs settled in Shady Hill, formerly the Cambridge residence of Charles Eliot Norton, with his wife, Meta, and three daughters. Here Sachs taught Fine Arts 15A, the first museum

training course offered by any American college or university. The seminar was limited to ten students and usually met on Monday afternoons for three hours, but with supplemental, far-ranging field trips to art-rich cities across the Atlantic. Agnes Mongan, who rose from being Sachs's research assistant tasked with cataloguing his drawings to become the first female director of the Fogg, recalled how future curators were trained:

> Paul Sachs would, seemingly at random, pick up from the wide shelf of the shoulder-high bookcases that lined that long room an ancient coin, a Persian miniature, a fifteenth-century German print, or a carved piece of Medieval ivory, place it in the hand of an astonished student and ask that student to comment on its aesthetic quality, its design, or its possible significance.

Simply being one of the ten students in his soon widely known "museum course" became a door opener for job-seekers in the upper reaches of the art world from 1921 to 1948. Of the 388 students enrolled, at least 160 rose to responsible positions in leading museums, most notably as directors of New York's Metropolitan Museum and the Museum of Modern Art, Washington's National Gallery, Boston's Museum of Fine Arts, Chicago's Institute of Art, San Francisco's Palace of the Legion of Honor, St. Louis's Art Museum, Kansas City's Nelson-Atkins Museum, and Hartford's Wadsworth Athenaeum.

Sachs's students brought to their calling not just a concern for scholarship and conservation but also a passion for acquisition of original works. They learned to handle and scrutinize the Fogg's treasures, thereby developing the trained eye of a connoisseur (long before that term became anathema to postmodern curators, to whom the word reeks of elitism and exclusion). This very much accorded with Edward Forbes's determination (in Sachs's words) "to make of the Fogg not only a treasure house, but also a well-equipped setting adapted for teaching purposes, that he meant it to be a workshop as well as a place of inspiration for undergraduates and mature scholars. Free from the craze for size, uncompromising when it came to quality, Forbes understood sooner than others the importance of confronting students with original works of art."

There was crucial corollary. From the 1920s onward, it became evident that a curator/director's rise commonly hinged on collection growth. In this respect, East Asia was a bargain hunter's paradise. For Director Forbes, this was not merely an aesthetic or ethical matter; it was also linked to an immediate practical problem. In 1923–24, Harvard approved a $2 million fund-raising campaign to replace the Fogg Museum's

existing and cramped building with new and spacious quarters. This meant that more premium works would be needed for display in galleries due to open in 1927. Paul Sachs became the principal fund-raiser for the Fogg's expansion and its expeditions. Though only five-foot-two, balding, and egg-shaped, he disarmed with his confident certainty and his insider gossip. He worked closely with Forbes, so much so that the pair was nicknamed "the Heavenly Twins." As the director's daughter, Rosamund Forbes Pickhard, recalled in a 1995 interview, "They were a real team of comedians together. They'd rush at [buying] newspapers, saying 'Are there any deaths'?" (Funerals were prime fund-raising opportunities.)

Both money and artworks flowed in. As a team, they worked well together. Forbes's sweetness and indecisiveness were balanced by Sachs, who was direct and forthright. As President Lowell of Harvard recalled at the opening, "If it hadn't been for the superb mendacity of Messrs. Forbes and Sachs, why the place wouldn't exist."

Still, it was not simply mendacity that enabled the Fogg Museum to fill its half-empty galleries and thus put Harvard's seal on the art and antiquities streaming from Asia. Even more potent was the Crimson mystique, especially when enhanced by ancestry and classroom epiphanies, as in the case of Grenville Lindall Winthrop (Class of 1886). In 1943, he bequeathed to the Fogg what is probably the country's finest collection of archaic Chinese jades and bronzes (see color plates, figure 3), along with an array of nineteenth-century American and European paintings and drawings. His donations, totaling some 4,000 works, was credibly reckoned as the largest gift of its kind to any American university. It was quintessentially emblematic: Grenville was the direct descendant of John Winthrop (1588–1649), the first colonial governor of the Massachusetts Bay Colony; he was engagingly eccentric, a gifted Berkshire landscape architect who wintered in a New York town house a block from the Metropolitan Museum (with the Winthrop crest proudly posted over the doorway). Here for many years his apartment was an obligatory stop for Sachs's connoisseurship students—with the collector sitting anonymously nearby to appraise their response.

As a species, collectors tend to be odd fish. Some cluster in schools, but truly interesting are the solitary swimmers who by choice seek remote and challenging latitudes. Grenville Winthrop was such a loner. As a Harvard student, he was among the many smitten by Charles Eliot Norton, the humanist titan who initiated art history as an academic subject. As Edward Forbes recalled, "If you asked anyone who was at Harvard during these years [from] what courses he received the most,

Grenville Winthrop, who endowed the Fogg with world-class jades and bronzes, here meeting with avian friends in his garden at Groton Place, Lenox, Massachusetts.

the answer most probably would be, 'From Professor Norton's fine arts courses.' Though there were loafers and athletes who took the courses because they heard they were easy to pass, even for them I think it was a case of 'and those who came to scoff remained to pray.'"

Winthrop went on to earn a law degree at Harvard, but neither the bar nor business mattered as much to him as the allure of art, ignited by

Norton and intensified by Martin Birnbaum, "a lawyer by training, an art dealer by vocation, and a violinist at heart." Together they explored both contemporary Western works and the rarified realm of Chinese jades and bronzes. In his 1960 autobiography *The Last Romantic*, Birnbaum imagined the elderly Winthrop at home: "After a lonely dinner, chiefly of fruit and vegetables, he would read some favorite book, or work on a card catalogue of his treasures. . . . Proust could have done the scene justice. The quiet cork-lined rooms [were] disturbed only by the chimes of a fine collection of grandfather clocks . . . and while their delicate peals vibrated through the house, the master would move about the shadows hanging his drawings or cataloguing them, or rearranging the Chinese jades and gilt bronzes."

It is fair to say that Grenville Winthrop was a recluse who looked inward for the rewards of savoring art in general and Chinese antiquities in particular. But others in the same stream were ebullient extroverts. Indeed, no one better personified the ambiguities of the passion more abundantly than Langdon Warner (Class of 1903).

CHAPTER FOUR

BARRELS OF GLUE

"The British, the French and the Germans and the Russians have so added to our knowledge of the history of the human race, and incidentally enriched their museums with artistic monuments brought back from Turkestan [current Xinjiang province] that it has become almost a matter of reproach that America has contributed nothing in that direction." Thus did Langdon Warner, then director of the Pennsylvania (now Philadelphia) Museum of Art and future curator of Oriental art at Harvard's Fogg Museum, announce in 1922 the advent of a new American collecting spree in China. He ended on an upbeat note: "Little time would be lost in working an unproductive site, the field is so vast and the information we seek is so varied, that the chance of complete failure seems reduced to a minimum. Fully as much should be done above the ground as below it."

A tall, blue-eyed redhead, Langdon Warner was an appealing, Spielbergian adventurer-cum-scholar who, during the 1920s, led two hunting and gathering trips to China for the Fogg. With his trademark boots, Stetson hat, rakish mustache, and swashbuckling demeanor, he is said to have been one of the models for Indiana Jones. Yet by birth and breeding, Warner was not a cowhand but a blood-proud Brahmin descended on his mother's side from Sir John Dudley, Royal Governor of the Massachusetts Bay Colony, and also (with dialectical symmetry) from Roger Sherman, the sole Founding Father to sign the Declaration of Independence, the Articles of Confederation, the Constitution, and the Bill of Rights. His uncle was Senator George F. Hoar (Republican from Massachusetts).

Boy's Own archaeologist: Harvard's Langdon Warner in China.

After entering Harvard (Class of 1903), young Landon rowed, became an editor of *The Harvard Advocate* and a member of the Hasty Pudding Club and the Signet and Memorial Societies, and was named class poet. After graduation, he married Lorraine d'Oremieulx Roosevelt, a daughter of Theodore Roosevelt's first cousin, at the Roosevelt compound in Oyster Bay, New York.

His apprenticeship began in Boston's Museum of Fine Arts under the tutelage of Kakuzo Okakura, a Japanese Buddhist who always dressed in kimonos and is now principally remembered as the author of *The Book of Tea* (1906). Warner revered Okakura as his *sensei,* or master. It was during his MFA years, when the museum assembled the finest collection of Asian art in North America, that Warner sharpened what were to prove his two strongest interests: Japanese and Buddhist art. He made his first study trip to Japan in 1906, but his apprentice spadework really began when he joined the explorer-geologist Raphael Pumpelly's expedition to Turkestan in 1904. He was part of a team that included the climatologist Ellsworth Huntington and the German archaeologist Hubert Schmidt (who had been trained at Troy), under the versatile leadership of Pumpelly, a physiographer and surveyor.

In 1913, having left the MFA, Warner toured Asia by way of Europe to test the feasibility of establishing in Peking a school to train archaeologists, indigenous as well as foreign, broadly similar to American academies in Rome and Athens and to the École francaise d'Extrême-Orient in Indochina. Both the idea and the trip were the inspiration of the Detroit millionaire Charles Lang Freer, but his enlightened plan became an instant casualty following the outbreak in July 1914 of World War I. On the eve of America's entry in April 1917, Warner had been named director of the Pennsylvania Museum of Art. He was granted leave to serve in Siberia as a vice consul in Harbin, where, following the Bolshevik revolution, he became the State Department's liaison with the anti-Bolshevik Czechoslovak Legion, then struggling to exit Russia via the Trans-Siberian Railway. (Warner crossed Siberia four times, and one of his favorite stories concerned his witnessing the proclamation of the White Russian Admiral Alexander Kolchak as ruler of Eastern Siberia in a baggage car.) All this contributed to his Crimson-enhanced self-assurance while searching for Buddhist treasures and navigating among warlords and bandits during China's chaotic 1920s.

But first, the context: "Archaeology is not a science, it's a vendetta." Sir Mortimer Wheeler's oft-quoted admonition was inspired by his own experience as director of the Archaeological Survey of India and excavator

of Bronze Age cities in the Indus Valley. From the final decade of the nineteenth century until the outbreak of World War II, China and much of Central Asia became a dueling arena between rival national art-seeking expeditions. European and Japanese teams, armed with the latest survey and photographic equipment, began combing western China, particularly along the old trade routes known as the Silk Road.

It was the publication of their finds that prompted the Fogg Museum's first "scouting trip" in 1923–24 to Dunhuang ("Tun-huang," in Warner's rendering) in Western China's Gansu (Kansu) Province. To lead its entry into the field, Director Edward W. Forbes turned to Warner and another Harvard man, Horace Howard Furness Jayne. The heir to a patent medicine fortune, "Hoddy" Jayne coauthored the lyrics of the Hasty Pudding Club's 1921 play *Wetward Ho!* [*sic*], a spoof on Prohibition, and swanned about Cambridge in his trademark coonskin coat and patent-leather pumps. He graduated to a job as curator of Oriental art at the Pennsylvania Museum of Art, where he became "the presiding genius at Memorial Hall."

Resisting parental pressure to hold on to his secure post as the museum's director, always averse to administrative chores, and anxious to earn "a name in the field," Warner eagerly embraced Forbes's offer. In seeking funds for the expedition, the director assured potential donors that Harvard possessed "records of certain sites of the early trade route [i.e., the Silk Road] which make it virtually certain that important artistic and archaeological treasures are awaiting to be brought to light." A sum of $46,400 was raised from subscribers—a miscellany of Forbeses, Sachses, Walters, Warburgs, Cranes, and Rockefellers—many of them friends and relatives of Paul Sachs. Although Sachs downplayed great expectations, cautioning that "Mr. Warner may bring back little or nothing," he added a soupçon of optimism: "or he may bring back one hundred times, or one thousand times the value of the money that was put into it."

Once in China, Warner and Jayne sat in their drab hotel in Peking amid maps, medications, typewriters, photographic equipment, and weapons (a shotgun and an automatic pistol), contemplating the problems that lay on their route to Xi'an (Sian), site of the ancient Chinese capital of Chang'an. In Warner's summation: "Bandits on the Honan border and to the west of it; Mohammedans violent in Kansu and possibly to the west of that; rains and seas of mud at first—then droughts and bitter desert cold."

The initial train trip to Honan (Henan), went easily. There they met the local warlord Wu Pei Fu and thirty members of his staff who

dined with the pair while a band rendered military airs. The marshal, known for taking "no back-talk from Peking," provided them with a ten-man armed escort for the next leg of their journey. Accompanied by an interpreter, Wang Jinren, and a cook called "Boy," the expedition announced its nationality with an ersatz American flag, stitched together by four local tailors, which adorned their *mappa,* a springless two-wheeled cart. The team then set out for Xi'an, the former capital of the Qin empire.

Warner and Jayne spent four September days at Xi'an, delighting in the pleasures of rustic hot-spring baths, rummaging among local curio shops, buying a series of rubbings bearing the vermillion seal of the late murdered Viceroy Duanfang, as they obtained introductions to officials and information about the road ahead. Still flying the Stars and Stripes but leaving their armed escort behind, they departed the former capital and its surrounding earthworks, known even then as a rich source of antiquities (and forgeries). "Before many years are gone, either the grave robbers will have ploughed their clumsy way through these mounds again, to recover for the foreign market what their predecessors left; or scientists, by special permit, will be allowed to come with their measuring tapes and their cameras to open in all reverence those kingly tombs by the river Wei." Thus Warner lamented in *The Long Old Road in China,* his 1926 account of the expedition: "To pass among these mounds scattered as far as the eye could reach, big and little, near and far, was an experience in self-restraint for the digger." (This was the area where farmers, while digging a well in 1974, came upon the first of the Qin emperors' terracotta armies, buried two millennia before.) After "some fifteen miles of temptation," Warner and Jayne proceeded west to Chinchow (Jinzhou) at the junction of the Ching River, where they "fetched" some sixth-century Buddhist stone sculptures—mostly heads and a torso—that they found "knocked from their places in the Elephant Chapel."

During the lawless 1920s, bandits and warlords proliferated in China's western regions. Before they set out on the seven-day march from Honan to Xi'an, Warner wrote that "there had been six murders, thirty kidnappings, and countless holdups." Now the province was swarming with government troops poised for a counterattack. In a forewarning of dangers that impelled Jayne to strap an automatic revolver to his hip, the pair witnessed the summary execution of three bound prisoners, whose "three heads rolled off from three luckless carcasses as the soldiers shuffled on, leaving the carrion to be swept up." Now the Americans approached Lanchow (Lanzhou), Gansu's provincial capital, wading

through waist-high, solid black mud. Just as they pulled up at their inn's gate, government soldiers attacked their small caravan and "commandeered carts, drivers and mules," claiming them "for military purposes." Warner demanded to see the *amban,* or local magistrate: "Remembering that I had once been red-headed, I permitted myself the luxury of a real scene, realizing that nothing else would do any good. . . . At the yamen gate I yelled at the top of my shout and sent in my card. His Excellency was in bed. Well, tell H.E. that it was time to get up. H.E. was in bed! Well, tell H.E. that in another minute a foreign devil would come in and help him dress." In five minutes, the magistrate turned up. Alternately threatening and cajoling, Warner presented H.E. with a letter from Field Marshal Wu. "At the mention of that great name, H.E. nearly wrung his hands off short at the wrists"—which produced the desired result: their property was returned.

The Caves of Dunhuang (1924), as photographed by Warner—a magnet for adventurers, monks, and gatherers of Asian art.

Their final objective was Dunhuang, but en route they made a detour to the ruins of Kharakhoto, "the black city of the Tanguts" on the Sino-Mongolian border in the Gobi Desert, the ruins that Sir Aurel Stein identified as Marco Polo's Etzina (Edsina). The Russian explorer Colonel Pyotr Koslov had rediscovered the remnants of the city six years before Stein in 1908. A center of Buddhist art, its walls, in Stein's description, still rose "in fair preservation amidst the solitude of a gravel desert, girdled by living tamarisk cones & two dried up branches of the river." The

Tanguts, a people of Tibetan-Burmese origin, succumbed to Genghis Khan's Mongols in 1226, but the site was only abandoned to the desert a century later after the Ming armies reduced the city to ruins by damming and diverting the river Etzin-Gol. Preceding the Fogg team by more than a decade, Koslov and Stein discovered a trove of Buddhist sculptures, manuscripts, and painted texts that the arid sands helped preserve (now in museums and libraries in St. Petersburg and London).

Upon his arrival, Warner gazed at the melancholy desolation, describing the place "as lovely beyond all my imagination" and deserted:

> No city guard turned out to scan my credentials now, no bowman leaned from a balcony above the big gate in idle curiosity, and no inn welcomed me with tea and kindly bustle of sweeping out my room or fetching fodder for the beasts. One little grey hawk darted from her nest high in the grey wall, her set wings rigid, and sailed low over the pebbles and sparse thorn bushes of the plain. No other life seemed there, not even the motion of a cloud in the speckless heaven nor the stir of a beetle at my feet. It was high afternoon, when no ghosts walk. But, as sure as those solid walls were built up by the labor of men, just so sure was I that the little empty town had spirits in it. And the consciousness never left me by day or night while we were there.

In spite of the isolation of the site, they found that Stein and Koslov had "cleared every wall and gutted every little sealed pagoda." With four diggers, along with a guide and some camels, they nevertheless excavated for ten days, finding fragments of Buddhist wall paintings, small clay ex-votos in the form of stupas, a fine bronze mirror dating (as Warner believed) to the tenth century, plus several small clay sculptures and miscellaneous pottery when a snowstorm stopped their work. (A few years later, an envious Warner would learn from a friend and Mongolian expert, Owen Lattimore, that the Swedish archaeologist Folke Bergmann "was able to camp and dig for months, not only at Khara-khoto but all along the Edsin Gol and along the Han limes. Got some very fine stuff.")

When leaving Kharakhoto, the pair's disappointment turned to disaster when their guide lost the way and, on Thanksgiving night, Jayne's feet froze. When he dismounted from his camel, he fell over, unable to stand. For three hours Warner and Wang scrubbed his feet with snow and grease until his feeling was restored—and Jayne fainted. With Hoddy's feet an enormous mass of blisters and his legs swollen to the knees, Warner feared blood poisoning and the likelihood of amputation as fever and infection finally set in. It was impossible to proceed, and Wang was sent

ahead to find a cart on which Jayne could be placed in his sleeping bags fortified by opiate pills. After a ten-day detour through icy winds across the snow-covered ground along the river, they finally reached Kanchow, where they consulted the local Chinese missionary doctor, who plied Jayne with antiseptics.

After sixteen days' rest, they started out for Suchow, where, after a four-day stay, they came to a "momentous decision." Jayne, despite his determination, was still unable to walk more than a hundred yards. He would therefore return to Peking with several cartloads of spoils and supplies that they had gathered and stored along the way, while Warner would proceed to Dunhuang, accompanied by secretary-interpreter Wang, the carters, and four ponies. At the crossroads of Anxi, where the road branched south, they parted. Dunhuang lay some seventy miles across the desert.

IN ITS HEYDAY DURING the Tang dynasty (618–907 CE), Dunhuang had been a flourishing entrepôt for the Silk Road and a center of Buddhist worship. There, in 1907, Sir Aurel Stein, a Hungarian-born scholar and archaeologist working for the government of India and the British Museum, purchased from a Daoist monk, Wang Yuanlu, 6,500 documents and paintings on paper and silk (twelve packing cases in all, including the Diamond Sutra, the world's oldest dated printed book [868 CE], for £130, or approximately $650). The Daoist monk had been the chance discoverer in 1900 of the so-called Library Cave, and some of the items had already been dispersed, finding their way into the hands of local officials before the provincial government ordered the restoration of the objects to their original cave. By the time Stein arrived, the objects were safeguarded by a locked door in front of the cave, with Wang as keeper of the key.

Sir Aurel spent nearly three months in the precinct of Dunhuang and the Mogao caves negotiating the sale, but local unrest and an outbreak of diphtheria forced Stein, already suffering from fever and a severely swollen face, to leave. Wang was persuaded to sell Stein some of the contents of the Library Cave "on the solemn condition that nobody besides us three [Wang, Stein, and Stein's Chinese secretary, Jiang Xiaowan] was to get the slightest inkling of what was being transacted," and the origin of these "finds" was not to be revealed to "any living being." On May 29, Stein's party spirited away the collection on two nights, avoiding the local supervising soldiers by the screen of a steep riverbank. Stein's offer to buy all the manuscripts had been refused by Wang, and it was Paul Pelliot,

The keeper of the Library Cave in Dunhuang, Daoist monk Wang Yuanlu.

the great French Sinologist, working for three weeks in the same cave in 1908, who acquired a further eight thousand items for the Bibliothèque Nationale in Paris for 500 taels, or $450. The news of these finds would cause a sensation, unsurpassed in archaeology until Howard Carter's discovery of Tutankhamen's tomb in 1922.

Pelliot, who taught at Harvard during the late 1920s, had alerted the Fogg to a Dunhuang collection he was "particularly anxious to have acquired by some serious museum in the West," that is, what he and Stein

had left behind. Writing to his patron, Charles Lang Freer, in 1916, Warner already had Dunhuang in his sights: "We must have some frescoes in this country for study. . . . They are almost the only things we dare not send native collectors after. They would certainly destroy more than they brought out, also we must have perfect records of their position and appearance before removal."

At the Fogg, Forbes readily acknowledged that the results of the "scouting trip" might be "wholly on paper, as to separate sculptures from the living rock would be a vandalism." However, he did not disapprove of Warner's scheme of removing paintings, for which there had been a precedent. Between 1902 and 1914, members of four German expeditions led by Albert Grünwedel and Albert von Le Coq sawed off paintings from the walls of caves along the northern Silk Road.

Warner reached Dunhuang on January 21, 1924, where he found the chapels "perhaps more impressive than any paintings that I've ever seen." But confronted by the hundreds of painted images in the Caves of the Thousand Buddhas, he succumbed to doubts: "Neither chemist nor trained picture restorer, but an ordinary person with an active archaeological conscience, what I was about to do seemed both sacrilegious and impossible." Nonetheless, while in the presence of Wang Yuanlu (the same caretaker who sold the manuscripts to Stein and Pelliot), Warner applied cloths soaked in barrels of thick glue in overlapping layers on the walls, which, when dried and peeled off, allowed him to remove wall painting fragments from six caves.

With the Germans in mind, Warner's preliminary report to the Fogg claimed that they were "the first paintings removed without being seriously marred by saw marks, and they are undoubtedly of an aesthetic and historic value equal to any Chinese paintings which have hitherto come to this country." He described his psychological battle with the monk Wang, which ended with Warner's "abandoning subtlety and asking straight out for fresco fragments."

Warner wrote of the considerable difficulties in the freezing weather of removing the art from the cave wall: "The milk froze on the wall instead of penetrating even when I thinned it with hot water. The glue cloths cooled before I got them in place and altogether I have small hopes." He finally squeezed them between alternate layers of felt and paper tied with rope. All this cost $150 donated to Wang: "merely a large tip that covered food and horse-fodder and services for my soul, duly conducted by the priest. I like to think of the Fogg Museum paying for the last mentioned—especially when I am out of reach of the college chapel."

The Removal of the Bodhisattva from Cave 328 in January 1924 by the first Fogg Expedition.

But the real gem from Dunhuang would prove to be a three-and-a-half-foot-high polychrome Tang bodhisattva, which had to be hammered from its base. Warner recalled spending "five days of labor from morning till dark and five nights of remorse for what I had done and of black despair." He wrapped the bodhisattva lovingly in his own underclothes before lugging it off in his cart for the eighteen-week journey back to Peking. "If I lacked for underwear and socks on the return journey," he reported, "my heart was kept warm by the thought of the service which my things were performing when they kept that fresh smooth skin and those crumbling pigments from harm." After questioning Wang and his acolytes and "ransacking" the Library Cave, Warner and his translator determined that there were no more leftover scroll paintings or manuscripts and left for home.

Warner's oft-repeated justification for his removal of the art was that the Dunhuang caves were inaccessible and had already been damaged. In the nineteenth century, the caves had been marred in Muslim uprisings, and Stein and Pelliot both maintained that the portable objects would be safer in London and Paris, presaging similar justifications by future American collectors and curators. As Warner lamented in a letter to his wife, "[E]verywhere eyes are gouged out or deep scores run right across the faces. . . . Whole rows of maidens in elaborate headdresses pass you by—but you look in vain for a complete head. Elaborate compositions of the bodhisattva enthroned among the elder Gods with a lovely nautch

girl dancing on a carpet before Him contain not a single figure that is complete. . . . But across some of these lovely faces are scribbled the numbers of a [White] Russian regiment, and from the mouth of the Buddha where he sits to deliver the Lotus Law flows some Slav obscenity."

Warner attributed the Slavic graffiti to the indifference of the Chinese, writing to a friend, "As for the morals of such vandalism, I would strip the place bare without a flicker. Who knows when Chinese troops may be quartered here as the Russians were? And, worse still, how long before the Mohammeddan rebellion that everyone expects? In 20 years this place won't be worth a visit."

Still, in his official report to the president and fellows of Harvard, Warner made no mention of the removal of the paintings. At the Fogg, the paintings passed to Daniel Varney Thompson, a student of Forbes and a conservator who had advised Warner on the "strappo technique" whereby the painting surface was stripped from the wall, a process he had used on European frescoes. In a 1974 interview, Thompson acknowledged that his attempts at conservation of the Dunhuang paintings were only modestly successful: "Langdon, instead of using a thin, rather weak glue, had used a glue so very thick as to be almost unmanageable. The wall was cold and the glue had set immediately to a jelly." In Thompson's report, as quoted by a later conservator, Sanchita Balachandran, he cited the case of the *Bust of an Adoring Figure*, "the intelaggio [the pieces of cloth] came away with unusual ease and brought no color whatever with it [but] . . . there was . . . less color than was expected." In fact, the face of this figure is entirely missing. A figure of a dancer, considered the "most hopeless case," was too damaged to be accessioned into the Fogg Collection. After two attempts at liberating the layers of paint from its intelaggio, *Head and Shoulders of a Buddhist Figure* was left unfinished because "the identity of the picture was entirely destroyed."

OWING PARTLY TO Warner's gifts of persuasion, the Fogg's first expedition was judged a success by Sachs, Forbes, and its financial backers. On the basis of its limited results—statuary, rubbings from Xi'an, the fresco fragments of Dunhuang, photographs of various caves—the museum's management persuaded the trustees of the estate of aluminum millionaire Charles M. Hall, who had been a collector with an interest in China, to underwrite at the cost of $50,000 another foray to western China in 1925. The trustees of the estate were primarily interested in funding what the Fogg and Warner referred to as "the Big Scheme," a plan for cooperation between Chinese and American scholars, which

would eventually bear fruit in the founding in 1928 of the Harvard-Yenching Institute, dedicated to the promotion of higher education in China. Nominally, Warner was again leader of the expedition, although he remained behind in Peking seeking possible Chinese partners for the Big Scheme.

Jayne now headed the team that had been spending months in Peking learning Chinese. As their leader explained, he did not want to "head the new group unless he knew the language reasonably well," which in his case included learning "ancient Chinese curses in a number of Chinese dialects." He also amused himself with having himself tattooed on every available inch of his body, making him "an amazing sight in a bathtub." Finally setting off from Peking, Jayne and company headed to Dunhuang with the aim, not divulged to Chinese authorities, of removing more paintings. Besides Jayne, the new team included Alan Priest, future curator of Asian art at the Metropolitan Museum; the conservator Daniel Thompson; a surgeon, Horace Stimson; and a photographer, Richard Starr. Warner was then forty-four; the other Americans were in their twenties.

In Peking, Warner had been able to obtain formal permission only for study and photography at Dunhuang, and was "warned most emphatically . . . that nothing can be removed from the chapels." But the size of the expedition, the presence of Thompson (an expert in fresco removal), and the correspondence between Jayne and the Fogg, clearly indicate that their plans went far beyond creating a photographic record. They discussed the removal of entire scenes from one or more caves. The most audacious solution was "the aeroplane proposition" initiated by Thompson, whereby installments of material were to be sent on a monthly basis to headquarters near Peking: "Ten or twelve hours in an aeroplane are a far safer bet than three months in a cart," he wrote to Alan Priest, who forwarded the proposal to Paul Sachs. "Most important of all, is the fact that we should get each installment of transferred stuff safely put away, out of the reach of rivals or bandits. . . . The sculpture could be carried perfectly in an aeroplane, whereas in the long journey by road it might all go to bits."

An early intimation of trouble occurred on March 25, a month's distance from Peking and eight weeks' travel from Dunhuang. As reconstructed by American University's Justin Jacobs, Jayne and his party, accompanied by Wang Jinren, their interpreter, and a Chinese scholar from Peking's National University, Dr. Chen Wanli, encountered an angry mob of Chinese peasants at Jingchuan, a small village near the

Luohan Caves in Gansu Province. According to Chen's published diary, twenty or so villagers "grabbed the reins of the horses firmly and would not let us leave." More villagers arrived, "making a big ruckus," and they "accused Jayne of breaking some Buddhist statues." The crowd swelled until cash was produced, amounting to two dollars each for one large and eighteen small statues. No sooner had the negotiations concluded than the local magistrate appeared. The deal was voided and the money returned.

The rising anger against the "foreign devils" was fueled by an incident that had just occurred in Shanghai on May 30, 1925, while the Fogg team was en route to Dunhuang. During a strike against a Japanese-owned cotton mill, factory guards fired upon the strikers, killing a worker. Shanghai's British-dominated police force declined to prosecute the managers responsible. A massive student demonstration followed on the Nanking Road, facing the city's international settlement. British police fired on the crowd, killing at least eleven demonstrators and wounding many others. Anti-foreign protests leaped across China; missionaries and foreigners were evacuated; and in the ensuing turbulence, which persisted for months, hundreds were reported as dead or wounded.

This was the setting as Jayne's team arrived at Dunhuang. They were immediately encircled by a mob of angry demonstrators escorted by "a guard of mounted riflemen." Jayne sent this warning to Warner: "After you had left last year the populace was exceedingly displeased with what had been removed, had raised a fearful row and accused the magistrate at TH [Dunhuang] of accepting a bribe to allow you to take things away, and in consequence thereof he had to be removed from office." Warner thus remained at Anxi, three days' distance from Dunhuang, adding, "[I]f I had been there this time, the situation would have been far worse." He now feared "that the few fresco fragments and the mud statue which the Priest gave me last year had grown into whole chapels robbed by me. . . . I was responsible for famine and drought." As Jayne reported to Forbes at the Fogg: "I came to the conclusion that it was folly to attempt to remove any frescoes." Circumstances had changed since the team's previous trip: "[I]t was a very different matter to remove a few fragments of damaged frescoes which could be done swiftly without attracting attention or causing undue distress among the monks or local people, compared with attempting to take away one or more complete caves, a matter of three or four months work at least which would inevitably attract great local attention and probably actual disturbances . . . we would probably

have gotten into an equal amount of hot water, besides thereby jeopardizing future expeditions, either sent out by the Fogg or, which would be even worse, by the Big Scheme."

With the caves fifteen miles from the town, the trip through deep sand was by necessity in daylight, and under guard. It took nearly five hours each way. This allowed for only a few hours on three days, or about ten hours total, of study and photography but with no flashlights allowed. Thus the "foreign devils" barely escaped with their lives, and with "no results" save for a few photographs of caves they passed along their route. Years later, in 1987, in *A Latterday Confucian: Reminiscences of William Hung,* the American scholar Susan Chan Egan revealed that the expedition had been betrayed by its secretary-interpreter Wang. Wang had confessed to Hung (Hong Ye), the American-educated dean of Yenching University in Peking, that he was present when Warner on his first visit removed the paintings from the caves. Hung contacted China's vice minister of education, who then notified officials all along the team's subsequent route that they should provide protection but "on no account allow them to touch any historical relics."

In 1930–31, a final Fogg expedition, this time led by Sir Aurel Stein since Warner was by then persona non grata, was once again blocked owing to Hung's intercession. Headlines of the Tianjin paper *L'Impartial* (*Dagongbao*) claimed that Stein's mission was to plunder Xinjiang's antiquities. The newly founded Chinese National Commission for the Preservation of Antiquities denounced Stein as a vandal and protested that Western institutions were depriving the "rightful owners, the Chinese, who are the most competent scholars for [the] study [of Chinese materials]" of the opportunities of ownership. Fearing that Stein's expedition would jeopardize the future of the Big Scheme, the recently founded Harvard-Yenching Institute called for Sir Aurel's recall.

HIS EXPEDITION-LEADING DAYS OVER, a frustrated and remorseful Warner returned to the Fogg as its curator of Oriental art until his retirement in 1950. Noting that Warner, reluctant to leave Cambridge, had turned down a position at the Met in 1927, a position then offered to Alan Priest, Sachs wrote Forbes a memo that summed up their curator's assets: "Even though you and I know that he is not the best man in the world for office routine or teaching routine or any kind of routine, he is none the less such a vivid person; such a good friend; and such an attractive asset for the long future, that I think it is fortunate that he prefers us to the Met." Exchanging his archaeological garb for Cantabrigian

baggy tweeds, he never ranked as a full professor but was a popular lecturer at Harvard teaching "Chinese and Japanese Art," one of the first courses in this relatively new field offered in America. At the end of his trial run, he "gave a luncheon with beer to twenty youths who took it for a snap. We used to have bully séances in the Art Museum looking at the storage and grinding up the exam together. I told them all the examination questions beforehand, which they thought would simplify life, but it proved to be not so much help as they had thought."

His own writing was distinguished by witty asides, slang, and clarity of thought. He viewed "glittering generalities" as an abomination; his offending students risked finding the comment "glit.gen" penned in the black squid ink their teacher favored. He maintained a lifelong interest in archery and falconry and spent his spare time whittling wooden eagles. A great conversationalist, he was an ornament of two of Boston's Brahmin haunts—the Tavern and the Saturday clubs, patronized by equally distinguished Harvard alums. At Christmas dinners at the Tavern, Warner led the carols "to lift the rafters and make the candles gutter."

Warner served in the military during World War II, and it was claimed—although denied by him—that in rushing to the White House after the bombing of Hiroshima and Nagasaki, Warner was able to persuade President Truman to save the Japanese cities of Nara and Kyoto from bombing. His role, he said, was merely to provide maps detailing cultural sites, but the decision of where to bomb was not his. Nevertheless, the Japanese erected two monuments honoring him in the two cities and posthumously awarded him the Order of the Sacred Treasures, second class, the highest order that may be bestowed on a foreigner. He was also awarded an audience with His Imperial Majesty, Emperor Hirohito:

Yesterday I had an audience with H.I.M. It was remarkable for its brevity. . . . It was the first of its kind and therefore impossible. H.I.M. was most cordial, set me in a chair near him and seemed to understand all my English before it was translated by the Chamberlain. In fact the translation wasn't necessary on either side except for the fact that I don't know the special court forms of address and should have tu toi-ed him quite innocently. . . . At the end he said the weather was very hot and I must take care of my health. (I was clad in a black felt coat bought in London for the Royal Academy lecture, and sponge bag breeks) and no doubt I looked kinder flushed, especially as I knew that no samurai would mop his brow in the Presence, and I have some expanse of brow to mop.

Upon his death, the grateful Japanese held memorial services in Kamakura, Kyoto, and Nara. At the monastery of Engakuji in Kamakura, photographs of Warner were displayed while a dozen Zen priests chanted a chapter from the *Lotus Sutra*.

Yet in China, ignoring the extenuating circumstances, Warner has been deemed a plunderer. At a 2004 conference at Dunhuang, the director of the Dunhuang Academy, Fan Jinshi, requested the return of all objects taken from the site. This seems unlikely, since they are scattered in dozens of collections around the world. The Fogg maintains that they paid in full for Warner's artifacts, as proved by receipts.

Warner operated in a different era, one in which objects were carried off, with great difficulty, and with the stated justification that they were being neglected and vandalized by the Chinese. And it was their appearance in Western collections, ironically, that stimulated today's preservationist initiatives. In a positive epilogue to a contested history, in 1994 the International Dunhuang Project began digitalizing material and now provides online access to thousands of images in an extensive searchable database. The project, involving a partnership of six museums and libraries, records materials not only from the Caves of a Thousand Buddhas but also from other sites along the Silk Road. Conservators in London's British Library restore the manuscripts in climate-controlled facilities, removing the backings, paste, and frames left by previous generations.

When we were last in Cambridge, Harvard's Arthur M. Sackler Museum, where the Fogg's material now resides, was closed for renovation, but on an earlier visit only the bodhisattva and two painting fragments were on exhibit; none of the art collected by Warner was listed among the objects featured in James Cuno's *Harvard's Art Museums: 100 Years of Collecting*. Yet the museum's conservation staff, benefiting from knowledge gained from the Dunhuang restorations, helped oversee and assist the exhibition of Asian wall paintings at other major museums, including the Boston Museum of Fine Arts and the Penn Museum of Art. As for the caves, when we visited them in 1995, we discovered that white rectangles and darkened glue drips remained where the paintings were removed—as the shaming guides invariably point out to foreign tourists.

CHAPTER FIVE
LAMENT FOR LONGMEN

Imagine you are an adventurous traveler, destination China, in 1923. On leaving Peking, outfitted with maps, saddlebags, canteen, tin cup, camera, flashlight, and passport, you are warned about bandits on the border, then given precautionary advice on whether to pack a shotgun or automatic pistol. Finally you board the Ping Han (Peking–Hankou) train for Luoyang in Henan Province. There, assuming you have secured a letter of introduction from a high-ranking member of Peking's foreign community, you take the precaution of meeting with Field Marshal Wu Peifu at his headquarters, an enormous park four miles from the train station. Nicknamed "the Jade Marshal," Wu is the much-feared warlord of the western region. The commander of a hundred thousand men, Wu is said to be the owner of the world's largest diamond.

Ushered into your interview, you cannot help but be astonished by the portrait of George Washington wedged between the maps that cover the walls of the marshal's headquarters. Unexpectedly, Wu is a small, birdlike man. His English, acquired at St. John's University in Shanghai, is fluent. You accept his gracious offer to dine with him, hoping to sample the famed "swallow dish."

The "Shui Xi," the local "Water Banquet," is served at several small tables, each set with six places. Outside, the military brass band is playing a medley of marches. The meal begins with eight cold dishes, and then sixteen warm dishes follow, each in a different-sized blue bowl, each cooked in a different broth. The pièce de résistance is, of course, the

"swallow dish" of shredded turnip, which imitates a bird nest's flavor. The banquet ends, the marshal rises, the dinner is over.

With emoluments to the marshal consisting of an assortment of presents, you now hope to have good *guanxi*—excellent connections—to ease your further travels. Next morning at six, armed with documents furthering your safe passage through the disturbed areas around the railhead, plus introductions to local officials and a cavalry escort provided by Wu, you leave the ancient walled city of Luoyang, now much reduced from its former glory as the capital. You set out in a rickshaw heading a dozen miles south to your destination—the caves of Longmen (Lung Mên), situated at the end of the legendary Silk Road, its grottos once the destination of streams of Buddhist pilgrims. Ferried over the Luo River on a raft, a pony awaits, and you ride to the tiny village guarding the caves of Longmen.

After Emperor Xiaowen (reigned 471–99 CE) of the Northern Wei dynasty moved his capital from Datong (Shanxi Province) to Luoyang in 495, it became the destination of Buddhist monks traveling along the trade routes collectively called "the Silk Road" between northern India, where Buddhism began, and China. Carved into Longmen's dark gray limestone cliffs are 2,345 grottoes intended as hermitages for Buddhist monks. Once home to 100,000 sculptured images and nearly 2,500 stelae, the caves have lost their protective porticos and their outer halls have disappeared. One of the three largest cave complexes in China, the grottoes have long been abandoned for worship but are known and admired by the Chinese, particularly for their calligraphic inscriptions.

The first foreign explorer to visit Longmen was the Japanese scholar Kakuzo Okakura, who was later to head the Asian department of the Museum of Fine Arts in Boston. Okakura stumbled upon the site half by accident in 1893, took some photographs, and returned home to Japan to lecture with his lantern slides of the Binyang (Pin-yang) cave's central grotto. The French Sinologist Édouard Chavannes followed in 1907 and stayed for twelve days surveying, taking ink rubbings, and photographing. Charles Lang Freer, the American connoisseur of Asian art and principal donor to his eponymous museum, visited the caves in 1910. He camped for several days, commissioned photographs on glass negatives by the photographer Utai (now in the Freer archives), and remarked that the art seemed to surpass anything that he had seen before.

When he saw the photographs, Langdon Warner became smitten by two processional reliefs showing Empress Wenzhao and Emperor Xiaowen (the donors who paid for the statues of the Binyang cave). He

forwarded them to Boston's Museum of Fine Arts. "[Y]ou can see what classical Chinese sculpture was in its prime. Look at the procession of figures—it is as well composed as the Parthenon frieze, and for line I have never seen it beaten. . . . Sensei [Okakura] considers it very important that this mine of top notch Chinese sculpture should become accessible to the West—it is an unopened Parthenon or rather the whole Acropolis of Athens waiting to be studied."

Photographs published by Chavannes in 1909 in his monumental work, *Mission archéologique dans la Chine septentrionale,* provided the impetus for the wholesale looting of the site between 1911 and 1949. As Duke's Stanley Abe has written, the Frenchman's scholarly volume "inadvertently provided photographic catalogs from which foreign buyers could chose works to pursue on the open market or in some cases 'special order'—that is, indicate to their agents in China which pieces *in situ* they were interested in acquiring."

Proof was provided by Langdon Warner. On his trip to Europe in 1913, he had dropped by the Musée Cernuschi. Installed in the private home of Henri Cernuschi, but bequeathed to the city of Paris by its owner, an Italian banker, it featured his renowned collection of Asian art. Reporting to his then mentor and employer, Charles Lang Freer, on the dozen sculptures in the museum that had recently been removed from Chinese caves, Warner noted that dealers in Europe were already marking photographs of Longmen for their agents in China, who were commissioning local stonecutters to steal the pieces to order. He worried that his own illustrated publications on China would have the same results, and "such a thing would be terribly on my conscience."

Enter Cheng-Tsai Loo, the foremost dealer in Longmen sculpture, who was to have a long and mutually profitable relationship with America's curators and collectors of Asian art. In an interview with *The Financial Times,* Daisy Wang, the author of a dissertation on Loo, described his business model as "based on America's capitalist and imperialist logic that Chinese antiquities were to be consumed by the rich and the powerful in modern America." In that capacity, Loo served as "an exotic Chinese servant" for his Euro-American clientele. Now viewed by the Chinese as the chief culprit in the West's plundering of Chinese art, Lu Huanwen (shortened by a French curator to C. T. Loo) was born in Lujiadou, an obscure silk-producing village, outside Huzhou in Zhejiang Province, to peasants—an opium-addicted father and a mother who later committed suicide. As detailed by his biographer Géraldine Lenain, Loo traveled to Paris as a cook on a boat arriving in 1902. There he went into business,

The magna-dealer C. T. Loo amid his treasures.

partnering with the commercial attaché of the Chinese mission, Zhang Jingjiang, to found Ton-Ying & Company, which, besides trading in tea and silk, also dealt in Chinese antiquities. Their shrewdest investment was to use their profits, following the 1911 revolution that overthrew the Qing dynasty, to fund Sun Yat-sen's Nationalists. They were able to use this leverage with the Kuomintang to export antiquities, many of them

objects from the Qing imperial collections, despite the government's restrictions, dating from 1913, on the export of antiquities.

Falling in love with a French milliner named Olga, who preferred to remain with her protector who had financed her business, Loo instead married her fifteen-year-old daughter and sired four girls. A ballroom dancer and a connoisseur of cuisine—he once owned a Chinese restaurant on the Left Bank—as well as of art, Loo began his career as a dealer with a small gallery in the Ninth Arrondissement on the rue Taitbout. Initially he found his inventory in Europe, but in 1911 he opened offices in Peking and Shanghai, which made it possible for him to obtain a number of important objects, many with an imperial provenance.

Early on, he sold ceramics to European collectors like Sir Percival David, whose remarkable collection is now housed in the British Museum, but as World War I raged in Europe, Loo broadened his horizons in order to sell to rich Americans like John D. Rockefeller Jr., Charles Lang Freer, Grenville Winthrop, Albert Pillsbury, and Eugene and Agnes Meyer. Just as China was abandoning Buddhism in its efforts to modernize, Americans like Isabella Stewart Gardner and Abby Rockefeller and her sister Lucy Aldrich were developing an interest in the religion. Loo thus found a clientele for his growing collection of Buddhist sculpture, and he shifted his focus to America, opening a gallery on Fifth Avenue in New York.

In 1926, he made an audacious move by renovating a nineteenth-century Parisian town house on the rue de Courcelles, turning it into a five-storied red Chinese pagoda lined with lacquer panels. It was conveniently located in the Eighth Arrondissement near the Musée Cernuschi and the Parc Monceau, the area of Paris that was becoming home to rich collectors. There, Loo "had the habit of not showing his best pieces to every visitor," according to the German collector, Eduard von der Heydt. "Some of his Chinese pieces were hidden away in the cellar. He showed them only to those he believed to have real understanding for Chinese art." Eventually, Loo became the most important dealer of Chinese art in the twentieth century. Dubbed by curator Laurence Sickman "the Duveen of Oriental art dealers," Loo in time would become almost as controversial as Sir Joseph Duveen, the most famous peddler of European masterpieces.

Leading art historians researched and documented Loo's finds; catalogues and exhibitions followed. In the preface to a 1940 catalogue, Loo recalled his initial engagement with Buddhist sculpture:

> I remember one day in the spring of 1909, I called at the Musée Cernuschi
> in Paris to inquire for the director, Mr. d'Ardenne de Tizac, whom I did not

know at the time. During our conversation he showed me a picture of a stone head and the fine stone immediately awakened in me a desire to develop a new line in Chinese Art. . . . I immediately mailed a photograph of the stone head to my partner in China and soon received word telling me that one of his buyers was traveling as interpreter in Sian for Mr. Marcel Bing, a French dealer. While they were talking to a local dealer, Mr. Bing kicked something hard under a table at which he was sitting. This was the head in which we had been interested and Mr. Bing, buying it for ten Chinese dollars, eventually sold it to the Stoclet Collection in Bruxelles.

Loo continues the story of his lucrative mail-order business: "A few months after this, I received a cable from my Peking office telling me that they had secured eight life-size stone statues. Not knowing how to dispose of these, I wired to get rid of them in China, but being unable to do so, they were finally shipped to me in Paris. Upon their arrival, I showed them to all the dealers, but no one wanted to buy. . . . Photographs were presented all over Europe but all in vain and so, in the winter of 1914–15, when I went to America, I took a set of photographs with me to show in this country." And show them he did. Soon clients were checking off photographs, with results still on display in dozens of U.S. museums. Developing an elaborate network of buyers and scouts throughout the 1930s, Loo was able to purchase not only Buddhist sculpture but also entire collections of jades and bronzes from recently excavated tombs and wall paintings from ruined temples. It was his role in stimulating these activities that led him to be regarded as an arch villain by the Chinese. Where Loo led, others were soon to follow.

But we have gotten ahead of ourselves. Let us return to May 2, 1914, when a *Times* (London) editorial commenting on the flourishing market in Buddhist sculpture protested the "ruthless plundering and destruction of the noble monuments of Chinese art." It detailed:

Colossal figures sculptured in relief, which illustrate in their own surroundings the wealth of Buddhist legend and theology, are mangled, sawn asunder or broken into pieces by clumsy thieves, in order that fragments may be taken to Peking and sold to European dealers. They are bought with eagerness by collectors, or by representatives of museums who would shrink from initiating the traffic, but argue that, as the spoil is already at their hands, it is their duty at least to provide it with a worthy resting place. Competition grows, prices rise, and the inducements to further ravage become continually stronger.

C. T. Loo's Parisian pagoda-style gallery on rue de Courcelles.

Warner visited that same month but found there was no possibility of spending even one night. He had been warned by the city magistrate that there were a thousand robbers just beyond Longmen. "[T]roops rode out each night to have a brush with them and to keep things moving. . . . Two days before they had come to a pitched battle and more than a hundred robbers had been killed." When he arrived, he saw the lopped-off heads

of the robbers adorning the walls "each with its foul crow pecking and roosting through the bars of the cave in which it was hung up. There were corpses about, just beyond the walls, on which unnamable and unthinkable outrages had been done." Mongol troops had been brought in, and they were quartered in the caves. "No stranger could stay on the spot, much less pursue the peaceful trade of archaeology." But, as he wrote his wife, whom he had left behind in Kaifeng, "As a whole the place is beyond belief. In my opinion the group of 'ladies' which we know so well is the finest thing in Chinese art. Nothing I have ever seen can touch it. . . . As for the great platform where the seventy-five foot seated Buddha is with his eight attendants—well, that is one of the great places of the earth. . . . The damage that has been done lately is as bad as anything that we have heard—the fresh marks of broken heads both dug out for a purpose and knocked off by the soldiers are everywhere. . . . It was so bad that it made one almost physically sick."

Back home, and engaged in cataloguing Freer's burgeoning collection in Detroit, Warner noted that he was able to match one recently purchased head with the body left in Longmen, thanks to Freer's photograph that showed the sculpture before the vandals beheaded it. Wartime conditions were already reducing the European demand for Chinese art, but the Americans with ready cash, predicted Warner, "will enjoy [an] unusual opportunity to buy things of rarity at considerably lower prices."

When Warner returned to Longmen with Horace Jayne and their secretary-interpreter Wang in 1923, driven in a car provided by warlord Wu, he reported, "the chapels with their huge guardian statues sixty feet high at the portals were much as I remembered them ten years before, except for a few gaps in the sculpture where dealers had chopped figures from the solid rock or knocked off heads for our museums." All such vandalism, Warner claimed, had been stopped, if only momentarily, under Marshal Wu. He lamented the government officials' habit of making gifts of these treasures to foreign dignitaries and travelers.

Although the Chinese government enacted stronger laws, including that of June 7, 1930 ("Law on the Preservation of Ancient Objects"), and established governmental agencies such as the National Commission for the Preservation of Antiquities, the going was good for collectors and their "friends" at Longmen throughout the 1930s. According to Stanley Abe, ninety-six of the main caves were ransacked. Longmen sculptures, not all from Loo, are now scattered in museums from Osaka to Toronto, Zurich to Washington, D.C., and from San Francisco to Boston. Sculpture from Longmen continues to turn up at auction: Sotheby's London

knocked down a figure in 1993, and in April 1996, Christie's Hong Kong offered a Guanyin head from Longmen, its provenance listed only as "an old European Collection." The head was comparable to other examples, already known to be from Longmen, in the Los Angeles County Museum and San Francisco's Asian Art Museum. Nothing, however, was as bold as the acquisition of two processional reliefs of the empress and emperor from the Central Binyang cave by two enterprising American curators: Laurence Sickman, buying in the early 1930s for a new museum, the Nelson Gallery in Kansas City, and Alan Priest, the Met's long-serving mandarin of Asian art.

AT THE TIME OF ITS COMPLETION in the sixth century, the twenty-five-by-twenty-foot Binyang cave was, as Sickman himself described it, both "lucid and coherent." Against the back wall opposite the doorway sits the Buddha, attended by his disciples, and two standing bodhisattvas; on the sidewalls are trios—depictions of the Buddha with bodhisattvas. The front wall is divided into four horizontal registers, and there were two of the largest and undoubtedly most important items, the relief depicting the Dowager Empress Wenzhao and its companion frieze, where Emperor Xiaowen and his court were carved. Below are depictions of monsters; above are scenes from the Buddha's previous lives. A scene at the uppermost level illustrates the Bodhisattva Vimalakīrti in a debate with the Bodhisattva of Wisdom, Mañjuśrī, a popular theme in China.

After the failure of the second Fogg expedition, Langdon Warner returned to China, having acquired, in addition to his teaching and curatorial duties in Cambridge, a lucrative sideline: advising the trustees of the yet-to-be-built Nelson Gallery in Kansas City. As someone who could collect Chinese antiquities on the spot, he recommended his prize student, Laurence Sickman, then in Peking studying on a Harvard-Yenching fellowship, to the Nelson's trustees. At age seventeen, the Denver-born Sickman had developed a precocious interest in the Asian art that he encountered in the gallery of the Armenian rug dealers and Asian art specialists, the Sarkisians, near the Brown Palace Hotel. Midway through his University of Colorado years in the hopes of landing a museum job, he sought the advice of Alan Priest, who recommended transferring to Harvard "because the finest and most dependable single collection of Chinese and Japanese art is in the Boston Museum, and it is only by studying and handling actual objects that you will get any satisfaction out of your work." There his talents were spotted by Denman Ross, who often invited him to his home to inspect his collection, and by Langdon

*Laurence Sickman, still a budding curator
in 1933, shopping in Luoyang, near the
Longmen grottoes.*

Warner, whose course he took, and then confirmed by John Ferguson,
who met and mentored Sickman in China, introducing him to private
collectors and helping him gain entrance to off-limits sites.

In 1931, while Sickman was in China on his fellowship, Warner
broke him in. He accompanied the aspiring curator on visits to dealers in
Peking's antiques district, Liulichang, and to viewings of paintings in the
collection of Henry Puji, China's last emperor, in his temporary "palace"
in Tianjin. On leaving China, Warner turned over to Sickman the five
thousand dollars remaining from his Kansas City funds on deposit at the
Chase Manhattan Bank. Initially working on a 10 percent commission
and subsequently on a hundred-dollar-a-month retainer, Sickman was
charged with acquiring "unusual objects of rare value." As he recalled, "It
was an opportunity heavily charged with responsibility, requiring more
nerve and confidence than I really had at the time. As a beginner one
can safely admire a painting or bronze exhibited in a museum and la-
beled, presumably, by an expert. The same work of art unlabeled, without
provenance and in the market place can be another thing altogether." It
was the beginning of a collaboration that would see a vast Beaux Arts

building, launched with an $11 million bequest from William Rockhill Nelson, proprietor of *The Kansas City Star,* become home to a world-class collection of Asian masterpieces, for the most part assembled by their soon-to-be curator and later director, Sickman.

Bantering letters full of gossip flew between Peking and Cambridge: "[My] Chinese is moving slowly but steadily," Sickman wrote to Warner, "already I am able to get a glass of water out of the boy instead of a hammer." Some detail the richness of the treasures: "liberated" objects from the provinces, and objects that the old aristocracy were obliged to dispose of, found their way to dealers, of which there were perhaps a dozen active in Shanghai and Peking. As Sickman explained in a 1982 interview, "All these people had permanent agents in the larger cities of the interior. These agents would be on the lookout constantly. It was a regular cloak-and-dagger business, of course. [There was] stiff competition among scouts, and then if a local official got hold of a certain number of things, he would know which dealers would be able to handle an object of that quality. These objects were never shown in [the dealers'] shops. They had runners that they would send to your house and they'd say, 'Oh, we just got something I think you might be interested in.'"

Sickman credited the German dealer Dr. Otto Burchard with helping him fine-tune his "unerring eye, akin to perfect pitch." A Heidelberg Ph.D., Burchard lived in Peking but had a gallery in Berlin, where in 1920 he was the first to exhibit Dada art. Burchard initiated Sickman in the art of tracking down important items that were not on display. According to Sickman, he would make the contact and say, "Come on now, let's go down and see what this guy's got. I saw it yesterday and I think it's just what you need." Once there, Burchard led him through the front room, "full of porcelains and jade and knick-knacks, and then two or three rooms behind would be the inner sanctum of the dealer where you would go and be shown the important works." Sickman reflected, "Unless you had pretty close contact with the dealers, you wouldn't get anywhere." Occasionally, Burchard would buy an object and hold it for Sickman until photos were sent for the necessary approval, often withheld, from Warner, who was known not to have a very good "eye," particularly in regard to Chinese painting.

But Sickman proved a fast learner. One anecdote, related by the China hand Owen Lattimore, suffices: "He had a dealer in this morning who wouldn't come down to his price. Then the Japanese sent over an aeroplane and that fixed it; Larry excused himself to the dealer saying that he was very busy as he had a lot of packing to do in the case of having

to move—in the meantime looking apprehensively to the sky—and the dealer revised his price."

Another important figure in Sickman's life was the Methodist missionary John Calvin Ferguson, connoisseur and advisor to the newly opened Palace Museum, whose network included many warlords and officials eager to sell off major collections. Ferguson wrote admiringly of Sickman's intelligence and diligence, his readiness to follow up on the older scholar's suggestions for Chinese books to study, and his "wonderful charm of manner." During his four-year stay in China, Sickman walked over and photographed much of northern China, tracking down village temples and pursuing his scholarly interest in Buddhist art, often for six weeks at a time, accompanied by Hui-jung, his trusted assistant (who was later kidnapped and executed by the Japanese).

Sickman's friends, including the memoirist George Kates (*The Years That Were Fat*) and Oxford's bird of paradise Harold Acton (immortalized in Evelyn Waugh's *Brideshead Revisited* as Anthony Blanche), the author of *Memoirs of an Aesthete,* have described Peking's exotic international community in the 1930s. Acton, who developed a lifelong friendship with Sickman in Peking, and parts of whose Chinese collection remain in the Kansas collection, summed up his youthful colleague as a connoisseur of all things Chinese:

> Some of the most splendid moments of the day were when Laurence walked in with some treasure he had discovered, and he was constantly discovering treasures, from Chou bronzes to jade cicadas, for the fantastically fortunate Kansas City Museum. I marveled at his integrity. Anybody else with so personal a passion for these things, would have appropriated them for himself, and how could Kansas City be any the wiser? In his hands they glowed like sleeping princesses at the wakening touch of a Prince Charming, and he led them as brides to the altar of his charming house in the Hsieh Ho Hutung. I was often privileged to be the best man at these nuptials. But after a brief honeymoon, they were sent to sleep again behind the glass cases of the gallery in Missouri.

The long, unhappy story of Kansas City's renowned *The Empress with Donors* frieze (see color plates, figure 5) is told in a series of letters between Langdon Warner and Sickman that have slept undisturbed in Warner's Harvard and Sickman's Kansas City archives. When Sickman first appeared at Longmen in the fall of 1931, the two friezes, measuring in width nine feet (the empress) by nearly thirteen feet (the emperor) in

the Central Binyang cave, were still intact. Sickman spent a week there, commissioned ink rubbings of the friezes, and took copious notes. In late 1932, he began to see Longmen fragments in the shops of Peking dealers: "single hands, bits of heads, fragments of low relief decoration from niches and inscriptions."

In December, he approached T. L. Yuan (Yuan Tongli), the director of the National Library in Peking and member of the Commission for the Protection of Antiquities: "I told him of the conditions and urged him to do what was within his power to preserve the caves. His reply was that this destruction would not go on unless sculpture fragments were purchased by foreigners. My reply to this was, in effect, that so far as I knew no foreigner had attempted to purchase any sculpture fragments or pieces . . . unless they appeared on the Peking market and that it was useless to attempt to control the traffic from that end, while on the other hand it would be very simple to stop any pillaging at the caves. At this time, I offered to raise funds from foreigners interested in Chinese art to station a number of police at the caves. Mr. Yuan said no such assistance was necessary." A further letter from Yuan asked, "Would it be too much trouble to you to find out the names of the stores which keep the sculptures from Lungmen? The authorities are taking steps to stop the ruthless destruction at the source and I am particularly grateful to you for having informed me about it." Sickman refused to name the dealers. (Yuan would become a pioneer in the tracing and documenting of Chinese art in American collections.)

Revisiting the caves in March 1933, accompanied by a local official and the Harvard scholars Wilma and John King Fairbank, Sickman recalled, "In many of the earliest caves those from the years 500 to 525, heads of images had disappeared and in places whole figures had been chipped from the walls and niches. A large section of the empress relief and several isolated heads were gone."

At the end of January 1934, Sickman reported to Warner that Burchard had purchased the two female heads that had been missing from the friezes in 1933: "We then began to hear of more and more pieces of the frieze being on the market. . . . After talking the matter over carefully with Dr. Burchard, we decided to attempt to assemble as many of the fragments as we could. Our motive was to secure this best example of Wei sculpture and to preserve it as nearly intact as possible. It was too late to report the matter to the authorities. The damage had been done. . . . It was obvious that regardless of what remained at Lung Men, the value of the relief *in situ* had been lost [and] to gather what we could of it then,

and restore it carefully with the funds which we had at our disposal, seemed to be the greatest service we could render."

In February 1934, Kansas City informed Sickman that it had all the sculpture it wanted for the time being. He inquired of Warner, "What are we to do? Of course the entire matter is very secret here." In despair, he writes, "Lung Men is being completely destroyed. It may be that I am fortunate in being on the spot at the time. The caves have lasted since the sixth century. In a year they are lost. This is one year out of one-thousand-four-hundred. Now the shops are full of Lung Men stones, in a few years they will be as rare and valuable as Attic Greek."

At this point it seems that a plan evolved at the instigation of Warner, but approved by Forbes, that the Fogg and the Nelson would jointly purchase the frieze, and since most of it was in small pieces, Burchard would assemble it. By April, Sickman had succeeded in acquiring most of the frieze, for which the initial down payment was to be $13,000. On April 25, Forbes telegraphed Paul Gardner, director of the Nelson: "AM MAILING YOU SIX THOUSAND DOLLARS STOP CAN SUPPLY EXTRA FIVE HUNDRED AFTER JULY FIRST." In May 1934, two large restored sections were due to be shipped in three cases. For this he needed the help of Jim Plumer, then working for Chinese customs, to avoid close scrutiny in Peking's port, Tientsin. Instead he shipped it via Shanghai. Sickman details the yearlong saga of the "Chinese puzzle," in a letter that Plumer was asked to destroy after reading:

> I was then a happy artless young man, I am now gray and bent, and my mind none too clear, but I have the complete relief of the entire procession. From here and there, from shop after shop, from K'ai Feng, from Cheng Chou, yes, from Shanghai, I have collected bit by bit, half a head here, a sleeve there, a hand from Hsia, hundreds and hundreds of small fragments. . . . But at last the greatest single piece of Early Chinese sculpture has been assembled, and I feel that we have done something for the art of China and for the world the value of which can only be estimated in future generations. Three months to put it together. Little boys sit all day long trying this piece and that. Where does it go, how does it fit? Is it an eye or a bit of ruffle?

Nevertheless, by the end of May, he was able to write to Warner, "[T]hree large cases have gone and it was a difficult task. I already feel three years younger."

Yet on his next visit to the caves in June, Sickman was shocked to find he had far less of the frieze than he had thought. Worse yet, he worried that

he had bought some forgeries, which were starting to appear: "Certainly all the heads are original and some of the drapery, other parts of the drapery may still be in Peking and some of the drapery which we have is not in proper order. The difficulty is that one can not send men there to get what is left. . . . It is, in short, something of a mess and I am in the very depths of depression about it." Burchard at the time was in Germany, winding down his Berlin gallery, but as he wrote to his friend Sickman, "I feel so deeply sorry for all the clouds and your sleepless nights and for all the troubles. . . . But be sure I shall repair it all until the last missing pieces will be in your hands. . . . A short while before we left China, I sent the 'original' people from the place to whom I made quite good offers for all the rest still on its place. I made a firm contract and they have sworn to deliver at least the greatest part of it. . . . When I missed and failed in buying a forged drapery so I have only one consolation that even a better expert like [*sic*] me would probably have fallen a victim when acquiring all the small fragments."

Rumors of the demolition of the Empress frieze had reached New York, however, and a rival for the remaining spoils in the guise of the Met curator Alan Priest would arrive in the summer of 1935.

WE LAST LEFT PRIEST in 1925, on the way back from Dunhuang with Horace Jayne and the Fogg's second expedition. The next year found him on a Sachs fellowship in Peking, scouting antiquities for the Fogg and writing to Sachs that he was living in a "perfect love of a Chinese house. . . . I have a cook and a ricsha [*sic*] boy and a white dog and a young Chinese scholar who speaks no English and I am probably the happiest person that you have ever been acquainted with. Mornings an old scholar comes to read Mencius for three hours and evenings a young one comes to read newspapers or art or just gossip. . . . Week ends I visit temples in the city or go over to the Western Hills."

Priest's fellowship allowed him (between rounds of antique shops in Liulichang) to study the language and to pursue his particular interest: Chinese theater. He learned entire plays and entertained his foreign friends and Chinese guests from the Society for Classical Drama with scenes screeched steadily for half an hour in his creaky falsetto. His thespian efforts impressed the Chinese and were the subject of three articles in a Chinese paper, ending with the journalist's tribute: "For the first time have I seen East and West truly happy together in one room, the people of the Middle Kingdom and the people of the outer countries merry together! Who does not believe this? Let him challenge me with his brush! I would defy and smite him!"

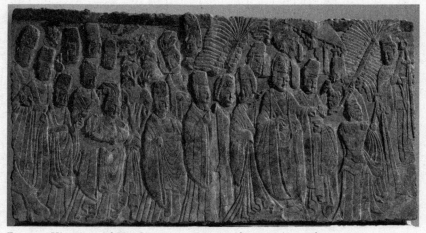

Emperor Xiaowen and His Court, *ca. 522–23, Alan Priest's consolation prize.*

At home in Peking, he was attended by his coterie of nubile house-boys, whom he dressed in Chinese scholar robes, giving rise, as Priest whined to Sachs, to "town gossip to the effect that it is such a pity that that bright young man has 'gone native' and that 'he has orgies of Chinese actors and their concubines.'" But according to his colleague, the Freer Gallery's Carl Bishop, Priest had become "so thoroughly Sinicized, even to the extent of clothes, food, dirt floors, and the immature off-spring of Pekinese poodles running around micturating over everything, that things must have taken a decided turn for the worse, even to pry him loose from those regions."

(Priest identified so strongly with the Chinese during his Peking so-journ that he became a Buddhist abbot and arranged to be buried in China in a Buddhist cemetery. However, World War II and Communist politics intervened, and he was forbidden a Chinese burial. He died in Japan, in quarters provided by the family of Japanese dealers Yamanaka in Kyoto, where he is buried.)

In 1927, Priest was offered the position of acting curator at the Metropolitan Museum as successor to Sigisbert Chrétien Bosch Reitz, who had returned home to the Netherlands. Depending upon your social or working proximity to the flamboyant Priest, he was "witty, urbane and scholarly" or "a crusty, malicious character modeled on the then-popular image of the lovable rogue who insults everybody (see *The Man Who Came to Dinner:* etc.) and played the part well."

In accepting the Met's offer, Priest stressed his hard-won preparation for the position:

But this I know (and it is no vain boast) that every minute I have spent jogging along desert roads in a cart (and consciously thinking only would the boy have eggplant for dinner) and every minute I have spent in the little alleys, the theater, parks, tea-houses and homes of the Chinese has given me the means to greater understanding and sympathy with this great people and gives me a better right to say this painting is Sung, this stone is Wei. I love them—sometimes I could kill them all but still I love them and would like engraved in letters ten feet high on my tombstone "There have been two greatest of peoples, the Greeks and the Chinese."

Bosch Reitz had made do with one forlorn assistant and few funds, but successive curators have lauded his successes, including a large gilt-bronze Northern Wei Buddha and a collection of paintings bought on Charles Freer's recommendation from John Ferguson. The Met's collection was strong in porcelains from the Altman collection and bronzes purchased, again with Ferguson's intercession, from the family of the deceased Chinese connoisseur and collector, Viceroy Duanfang. However, these items were definitely not central to Priest's taste, "because beautiful as the bronzes and porcelains are, they do not seem to me comparable to what I think of as the major arts, painting and sculpture and architecture." He vowed "to develop a collection appropriate to the size of this Museum and of the city. . . . We need to emphasize objects which are both large in size and great in execution." A frieze from the Longmen would fulfill both requirements.

Morality was bent in 1934 when, flicking ashes from his omnipresent cigarette holder, Priest returned to China in search of Longmen stones. He had written to the Metropolitan's director Herbert Winlock that "the great reliefs of Lung Mên (comparable in Chinese art to the Parthenon or Chartres) are being broken up and that some of the frescoes of Tün Huang (the greatest of China's wall paintings) are scheduled to appear in Peking. I should be there and have every scrap of information about them for the museum, whether we can secure them or not." Once he had arrived, he heard, via the Peking gossip mill, that he had a rival in the person of Larry Sickman.

A friend of Priest's who dealt in Longmen sculpture, Yue Bin, confided to him that Otto Burchard had the Empress frieze. Priest then reported to Winlock that Burchard was "carrying on some kind of cabal

with old father Ferguson, dear little Sickman, Langdon Warner and Kansas City. However there is more and we can have some of it if we want it." When Priest questioned Sickman, the latter was put "in a rather awkward position" as Priest was "furious about it as he had hoped to arrive in time to get it." As the final arrangements had not been concluded and the cases had not been shipped, Sickman told Priest as little as possible, treating it as a confidential museum matter that he was not at liberty to discuss.

But the Emperor procession was still up for grabs. In the autumn of 1934, Priest contacted Yue Bin and agreed to pay the dealer $4,000 for six heads of the group that Yue already possessed. The others still on the site were to be hacked from the walls by bandits under contract to Yue's agents. When he obtained another thirteen heads, Yue would get $10,000. The contract with Yue's shop, Pin Chi, would be void "if things occurred at the mountain" and if "conditions no longer obtained." As Amy McNair has noted in her detailed study of the site, *Donors of Longmen,* "This strongly suggests the other pieces had not been stolen."

Hungry villagers cut away the relief, bribed the local military, and loaded sacks, which were delivered to the Baoding prefecture. After they were assembled in Peking, a local agent, storeowner Nellie Hussey, provided a fraudulent bill of lading to deceive custom officials, and then shipped the stones to New York. In spite of the agreement, Priest still had difficulty in obtaining "twenty-one key pieces," probably including the missing heads. When he wrote an article about Longmen in 1944, he feigned shock at the dismantling of the site and announced correctly that many of the items in the marketplace were fakes: "This was the way the things were raped: the little village near Lung Mên stands watch, but from across the river men waded armpit-deep and chipped fragments from the surface at night. These they took down to Chêngchow, where agents of the Peking dealers bought them. In Peking the fragments were assembled, and with zeal copies were made from photographs and rubbings. You will find heads purporting to be the original heads of the male and female donors of Lung Mên scattered broadcast through Europe, England, and Japan, and they are mostly complete forgeries." Nevertheless, the Emperor frieze, when assembled by the Met's minions, retains pride of place in the main Asian gallery.

In a coda to the story, in 1940 the Fogg and the Nelson agreed, in light of the weight and fragility of the Empress frieze, that it should not be separated, nor should it be shipped back and forth to be exhibited alternatively in each museum every few years. Forbes then accepted the Nelson's counterproposal that the money advanced by the Fogg for the

purchase price would be refunded and that the Empress, for which the total bill was $32,000, would remain in Kansas City.

Stealing to order by dealers continued throughout the 1930s, and the efforts to protect the sites frequently failed. One anecdote suffices: Dr. George Crofts, who was initially responsible for Chinese collection at the Royal Ontario Museum, was offered a head from Longmen by a dealer. Thinking that it was a shame that the head had been taken from China, Crofts bought it and gave it back to the Chinese government. But the second time that this same head was offered to him, he bought and kept it.

As demand outstripped supply, these fakes proliferated and greatly complicated provenance research. At the Metropolitan Museum, Priest continued to acquire pieces of Longmen stone sculpture, of which some are now considered questionable. As for the Nelson-Atkins Museum, when Chinese officials attended the opening of the 1975 exhibition "Archaeological Finds of the People's Republic of China," as a nod to the sensitivity of Chinese feelings in the matter, it was decided to erect a temporary wall in front of *The Empress with Donors*.

The Chinese author Gong Dazhong relates that when the Communists came to power in 1949, parts of the Emperor Procession were found at Yue Bin's Peking house. They were reassembled, minus the heads. After the exposure of the crime, more than three hundred people representing the cultural elite of China petitioned the government to punish Yue. He died in prison in 1959. During the Cultural Revolution, the site remained relatively untouched. Protection increased when after the destruction of a local Buddhist monastery, the municipal party committee secretary ordered teachers and students at the Luoyang Agricultural Machinery Academy to provide the site with around-the-clock protection. Declared a protected cultural property in 2000, Longmen was placed on UNESCO's list of World Heritage sites and granted over a million dollars toward restoration.

The founding of the People's Republic of China in 1949 also brought an end to lucrative art dealing on the mainland. Loo announced his retirement the following year. In a letter to his clients he announced: "I am seventy years old now, and since half a century I have been collecting and selling Chinese antique works of art. A very interesting profession which has combined business with pleasure: rarely a day has gone by without some excitement of securing or planning to secure certain objects. The definite confiscation by the new authorities in power at Shanghai of a large collection containing a great number of very important objects, has

made me suddenly realize that dealing in Chinese antiques is at its end, and that I would be deprived of all my enjoyment."

As for the ravaging of Longmen, these statements by the principals provide an instructive postscript:

[China's] National Commission for the Preservation of Antiquities (1931): "The export of archaeological objects from their country of origin can only be justified when (a) the objects are obtained legally from their rightful owners, (b) the taking away of any part of a collection will not damage the collection as a whole, or (c) there is no one in the country of their origin sufficiently competent or interested in studying or safe-keeping them. Otherwise it is no longer scientific archaeology, but commercial vandalism."

Edward Forbes to Paul Gardner (1934): "I think it is an outrage that the Chinese government should have allowed these great sculptures to be hacked off the walls of the cave and to leave the country. But I think as we had nothing to do with hacking them off the walls of the cave and first heard of them when the mutilated pieces were in Peking being put together, we are justified in buying them for posterity in this way even if to accomplish the object of preserving them we have to divide the sculpture into two halves, one for each museum.

"I feel strongly, however, that we are preserving these for the benefit of the human race and that as they really belong in China, if at any time in the future China becomes sufficiently stable and well organized to enable the Chinese government to preserve such objects with safety for the benefit of the human race, it would be a very handsome and proper gesture for the Fogg Museum and the Kansas City Museum to sell these objects back again to the Chinese government."

Langdon Warner (1940): "If we are ever criticized for buying those chips, the love and the labor and the dollars spent on assembling them should silence all criticism. That in itself is a service to the cause of China bigger than anyone else in this country has ever made."

Loo (1940): "I feel so ashamed to have been one of the sources by which these national treasures have been dispersed. . . . China has lost its treasures but our only consolation is, as Art has no frontiers, these sculptures going forth into the world, admired by scholars as well as the public, may do more good for China than any living Ambassador. Through the Arts, China is probably best known to the outside world. Our monuments may be preserved even better in other countries than in China, because of constant changes and upheavals and so our lost treasures will be the real messengers to make the world realize our ancient civilization, and culture thus serving to create a love and better understanding of China and the Chinese people."

Priest (1941): "It has been said that one of the chief functions of a museum is to preserve the monuments of the past and keep them for a more temperate future—that five hundred years from now museums will be said to have played the role in our day that the monasteries played in the Dark Ages when the Roman Empire broke up. . . . The museum can't give you the whole glory of Lung Mên, but it has caught a fragment for you."

Priest again (1944): "These two reliefs, the male and female donors of the Pin Yang Tung, are a lost thing—nothing more wicked has ever happened to a great monument of a race. They are gone—we have only pathetic fragments to show."

Sickman (1967): "The work is rather like a person who has suffered a very severe accident. The skill of the facial surgeon may make him recognizable to his friends but he is never quite the same. . . . All who are concerned with the cultural traditions of China would far rather wish that the relief of the empress were still in far off Ho-nan province, an integral part of the Pin-yang cave for which it was made."

Finally, Sickman again (1981): " . . . the whole project was financed as a salvage operation by Edward Forbes at the instigation of Langdon Warner, and it was only eventually that the Gallery bought the project from Mr. Forbes. As for myself, I would give almost anything if it had never left the Pin-yang cave."

CHAPTER SIX

PENN CORRALS THE TANG EMPEROR'S HORSES

Amerian collectors of Chinese art made their global debut in 1935–36 at an epochal International Exhibition of Chinese Art held by the Royal Academy at Burlington House, Piccadilly. Not only were U.S. museums among the 240 lenders, but for the first time China permitted a substantial number of its "national treasures" (the republic's preferred term) to appear on loan abroad. The admiralty provided a warship, the HMS *Suffolk,* to transport more than eight hundred imperial treasures in ninety-three cases. The two greatest British collectors of the period, George Eumorfopoulos and Percival David, helped gather the artworks, working with Robert Lockhart Hobson of the British Museum and the prominent dealers C. T. Loo and Sadajiro Yamanaka. The exhibition, described as the largest Chinese show ever mounted, was both a popular and a critical success.

The event took place against a background of Japan's occupation of Manchukuo (formerly Manchuria) and its looming invasion of China, and the government authorities hoped they would garner international sympathy for China as well as the world's appreciation of its art. For the first time, Western and Eastern connoisseurship could be matched side by side. To be sure, there were sotto voce complaints: from the West, that the Chinese had held back their best paintings, assuming that foreign experts would not be able to tell the difference, setting back scholarship

in the West for decades; and from China, notably among scholars based at Tsinghua University, that foreigners had been authorized to make the selections, that the borrowed objects were uninsured, "that important and valuable treasures should not be sent abroad," and that "once the art is acquired by the British Museum it will never be allowed to leave its portals whatever may be its value." These objections did not move Chinese authorities anxious to cultivate Western goodwill and burnish their republic's image as a rising power. From November 1935 to March 1936, the crowds came; total attendance (401,768 recorded visits) broke all records. In those pre-blockbuster times, in the very depth of a worldwide depression, Chinese art had arrived!

Harvard's Fogg Museum sent two wall painting fragments, its prize bodhisattva from Dunhuang and, as an invited lecturer, Langdon Warner. America's newest museum, the William Rockhill Nelson Gallery of Art at Kansas City, just opened in 1933, sent twenty-five items, among them its famous jade Bi (see color plates, figure 2), plus its future curatorial star, Laurence Sickman. Abby Rockefeller shipped her Tang bodhisattva from her country home, Kykuit. Objects from Boston's Museum of Fine Arts (MFA) were notably absent. Its omnipotent benefactor and trustee, Denman Ross, adamantly opposed lending art to exhibitions, so America's premier collection was not represented. But the showstopper

Stone bas relief depicting the Tang Emperor Taizong's cherished horse, Autumn Dew, a Penn Museum loan to the Burlington show.

was the prize of the University of Pennsylvania's collection, *Autumn Dew*, one of the museum's pair of carved stone reliefs from the Tang Emperor Taizong's mausoleum near Xi'an.

IN 636 CE, EMPEROR TAIZONG, as he was known posthumously, commissioned a mausoleum for himself and his Empress Zhangsun, fifty-six miles northwest of his capital, Chang'an, (present-day Xi'an) in Shaanxi Province. With a circumference of more than thirty-seven miles, the Zhaoling is probably the largest royal mausoleum in the world. Built high on the peak of Jiuzong Mountain, Taizong intended it to demonstrate his imperial power, but its architects also designed it to prevent looting. An inscription by the emperor reads: "A ruler takes the whole land under Heaven as his home. Why should he keep treasures within his tomb, possessing them as his private property? Now that the tomb has been built on Jiuzong Mountain with no gold, no jade, no slaves or horses within and the household utensils all made of earth and wood, thieves and robbers will cease their attempts, saving trouble for every one."

The celebrated Tang poet Du Fu recalls passing by some years later:

A line of tombs winds skyward up the slope
Where mountain beasts keep to their leafy lair;
I peer along a pine and cypress lane
Only clouds of sunset hanging in the air.

Two famous brothers—Yan Lide and Yan Liben, architects, painters, and court officials—are credited with the design of the tomb, which is tunneled into the mountain and guarded by five stone gates. Abutting the tomb chamber are two wings with stone boxes for sacrificial objects. In spite of the emperor's precautions, Wen Tao, a warlord of the Five Dynasties (died circa 926), broke into the tomb and found that its contents were "no different from that of the living world. The center is the main burial chamber; two side chambers are arranged in the east and west, lined with stone couches, on top of which are placed stone caskets with metal boxes inside. Paper and ink of treasured books and calligraphy of Zhong (Yao) and Wang (Xizhi) were as fresh as new."

Zhaoling was designed to replicate architecturally Taizong's compound at his capital, Chang'an. As such, it was divided into three components: the palace city, the imperial city, and the outer city, all like those of Chang'an. It took thirteen years to construct and included at latest count nearly two hundred auxiliary tombs of nobles, imperial relatives, favored

court officials who had distinguished themselves in the imperial service, and generals.

During his reign, Taizong subdued the Turkish tribes, and when they traveled to Chang'an to offer their fealty, they asked him to assume the title of Heavenly Qaghan or Khan of Khans. He replied: "I who am the son of Heaven for the Great Tang will also deign to carry out the duties of the qaghans." The Turks were subsumed into the multiethnic, multicultural society that was the Tang Empire, in which foreigners—merchants, monks, and members of distant communities—were welcomed to the capital. The rulers of these foreign ethnic groups were also allowed to be buried in the complex, as part of a successful effort of the Tang Empire to reward and consolidate its minorities, treating non-Chinese the same as Chinese. The prospect of an honorary burial in an auxiliary tomb ensured loyalty to the Son of Heaven and the Qaghan of Qaghans.

Ten years after Taizong finally became emperor in 636 CE, in order to commemorate the major events of his military campaigns he commissioned relief sculptures of his favored horses. Excavations at Zhaoling in 2003 uncovered pillar bases that suggested the sculptures were placed along a long corridor with pavilions on each side. The Penn horses appear to have been erected in the fifth and sixth pavilions. Yan Liben (died 673 CE), credited as the painter of the MFA's *Thirteen Emperors* scroll (see color plates, figure 13), is also assumed to have made the drawings for the carved reliefs (six and a half feet long by five feet tall, and more than a foot thick). A text records Taizong's commission for images of his six favorite battle-chargers that he had ridden in his successful campaigns:

> Since I engaged in military campaigns, those war chargers which carried me rushing on the enemy and breaking the line, and which rescued me from perils, their true images should be portrayed on stone and placed left and right of my tomb to demonstrate the righteousness of "curtain and cover."

Penn's senior registrar, Dr. Xiuqin Zhou, the author of a dissertation and several articles on the Zhaoling and its horses, explains this imperial fixation: "In the old days, masters usually saved chariot curtains and covers for the burial of their horses and dogs to show their affections and righteousness."

Taizong, also known by his personal name Li Shimin, meaning "rescuing the world and pacifying the people," composed a eulogy in praise of each horse. He extolled "Autumn Dew," also known as "Whirlwind Victory":

It was as restless as a purple swallow,
It pranced with its high spirits,
It was feared along the region of the three rivers,
It struck awe into the enemy on all battlefields.

The emperor, who spent most of his life campaigning, rode the bay horse during his conquest of the eastern capital, Luoyang (in today's Henan Province), in 621 CE. The relief illustrated a widely known story concerning General Qiu Xinggong. When an arrow hit Autumn Dew, Qiu jumped from his horse, pulled the arrow from the horse's chest, and gave his own horse to Taizong while he pursued the enemy on foot, killing several of them with his sword.

Quan Mao Gua, whose name means "saffron-yellow horse with a wavy coat of hair," earned the nickname "Curly." He was the putative emperor's mount during the battle against a rival, Liu Heida, in 622 CE, when the charger was wounded with nine arrows. The emperor's poem reads:

The moon rabbit grabbed the bridle
The stars of Scorpio crossed the heaven in their course.
The dog-star carried the halberd
The dusty mist brought the end.

"Autumn Dew" and "Curly" are on display in the Penn Museum; the remaining four horses are now in the Beilin Museum in Xi'an. Two of the horses, including Curly, are shown walking; three of the other horses are shown with all four legs extended in the "flying gallop." The tails of all the horses are tied up, and their special dressing of a crenellated mane in three tufts, called the "three flower" arrangement, indicated that the rider was a prince or emperor.

Taizong's reign ushered in a period of peace and prosperity, a veritable Golden Age that lasted nearly four centuries. Thanks to his military successes, he expanded the empire to include much of what is now no longer China: namely, Vietnam, Mongolia, and the lands westward into Central Asia as far as present-day Kazakhstan. Taizong's rule was characterized by a well-functioning administration run by professional bureaucrats chosen for their abilities and education. (Fearing assassination, he is also remembered for killing his two brothers, thus allowing him to become emperor after his father abdicated.)

The success of the Tang dynasty depended on its horses, its mounted cavalry. Spotting a fine horse on the battlefield, Taizong ordered his

general to capture the rider to gain the horse. During the early Tang period, there was an enormous increase in the number of horses, from 3,000 to more than 700,000, mostly bred from Turkic stock obtained through tribute or trade with the tribes in the west, including the famous Ferghana breed from the Kang state. All Taizong's six horses appear to be descended from these imports. Having grown up on horseback, Taizong was inordinately fond of his horses. Angered by the death of one of his beloved mounts, he ordered the groom executed. Only the intervention of his wife saved the servant. During the Tang, horses were needed not only for warfare but also as a means of effectively connecting China with its northern and western frontiers once the trade routes—that is, the Silk Roads—were well established. Postal horses were in demand for these routes, as well as for stations linking Chang'an to the other Tang capital of Luoyang.

TAIZONG WOULD NOT BE THE LAST poet-emperor or the first to love horses. More than two thousand years ago, the Han emperor Wudi faced incursions from the northwest by a group of martial nomads known as the Xiongnu (Hsiung-nu). Living on the steppes in tents or covered wagons, they counted their wealth in livestock and dressed in brilliant, ornamented clothing. Their horsemen, armed with bows, proved their mettle against the Chinese infantry. Now the emperor needed cavalry on mounts swifter than the Xiongnu's steppe ponies.

Attempts at domestic breeding of imported horse stock had failed, apparently owing to the lack of calcium in the soil and water. So Emperor Wudi sent an army forty thousand strong, led by General Li Guangli, the brother of his favorite concubine, westward in hopes of obtaining the "blood-sweating horses" from the Ferghana Valley, and in doing so nearly brought his empire to an end.

First reported by Zhang Qian (Chang Chien), the Han Empire's envoy to the Western Regions, the *tianma,* translated as "heavenly horses," were valued for their stamina, height, and agility and were an improvement over the steppe ponies. Zhang reported that he had encountered wonder horses that sweated blood in the land of Ferghana (now Turkmenistan). A ritual hymn recited in the imperial sacrifices eulogizes the "Heavenly Horse":

Bedewed with red sweat
That foams in an ochre stream,

Impatient of all restraint
And of abounding energy,
He treads the fleeting clouds,
Dim in his upward flight;
With smooth and easy gait
Covers a thousand leagues.

One theory is that the "blood-sweating" resulted from the presence of a parasitic nematode, *Parafilaria multipapillos,* common to the Russian steppes, which burrows into the skin of the horse, causing nodules that bleed. Another theory posits that after a long, sustained gallop, the horses' blood vessels burst.

Initially the Chinese attempted to acquire the horses from the Ferghana ruler by purchasing them with a thousand pieces of gold and a golden horse. He rejected the offer and executed the emperor's envoys. Next, Wudi sent an army under General Li across the Taklamakan Desert, but by the time it arrived at Ferghana (Ta-yuan, Dayuan) it was exhausted and starving. Then the Son of Heaven dispatched another sixty thousand men beyond the Pamirs to conquer Ferghana, culminating in a final forty-day siege when the Chinese cut off the water supply, after which the king of Ferghana was beheaded by his own people. The Ferghanans then agreed to dispatch three thousand horses to Chang'an, the Han capital. But only a few—perhaps thirty—were the "superior" or "heavenly" breed, and along the way two thousand of them died. As Wudi waited for the steeds he had been promised to reach the Jade Gate, he composed the following hymn:

The Heavenly Horses are coming,
Coming from the Far West.
They crossed the Flowing Sands,
For the barbarians are conquered,
The Heavenly Horses are coming
That issued from the waters of a pool.
Two of them have tiger backs;
They can transform themselves like spirits.
The Heavenly Horses are coming
Across the pastureless wilds
A thousand leagues at a stretch,
Following the eastern road.

The Heavenly Horses are coming;
*Jupiter is in the Dragon.**
Should they choose to soar aloft,
Who could keep pace with them?
The Heavenly Horses are coming;
Open the gates while there is time.
They will draw me up and carry me
To the Holy Mountain of k'un-lun [Kunlun mountain range].
The Heavenly Horses have come.
And the Dragon will follow in their wake.
I shall reach the Gates of Heaven,
I shall see the Palace of God.

In 2009, archaeologists found two sacrificial pits within the mausoleum of Emperor Wudi, along with the bones of eighty stallions guarding twenty caves in two huge caverns—horses sacrificed to accompany him on his glorious afterlife, confirming Arthur Waley's theory that the magic horses were more often used in ritual than in warfare. Future DNA tests should confirm whether Wudi's horses were bred from Akhal-Teke stock, a Turkmen horse with excellent speed and stamina.

Wudi's military campaign to Ferghana represents one of the first contacts between the Indo-European cultures and China, leading to the apogee of the Silk Road. Throughout the Tang dynasty, horses were also a staple of tomb furnishings. But what about Taizong's favorite mounts? Upon his death, the stones were placed along the "spirit path" within the northern gateway of the burial complex, which once included the "Rose-finch Gate," a sacrificial hall, and a "Lower Palace" surrounded by a wall and large numbers of houses. Little of these surface structures remains.

Langdon Warner and Horace Jayne, visiting Xi'an in 1924 on their first expedition to Dunhuang, reported that the remaining horses had been "pulley-hauled" from their original site. "Four of them were brought into the town, where we saw them rather meanly set up against the garden wall in the little museum, but happily safe from our American dollars.

* In the duodenary cycle, the year Wudi wrote the poem, 101 BCE, was a Dragon year. Sinologist Frances Wood writes that the heavenly horses were linked with dragons, the mythical beasts associated with the emperors of China. The Ferghana horses would carry the Son of Heaven to the Kunlun Mountains thought to be the home of the immortals. Thus the horses could be a vehicle for Wudi's own immortality.

The other two, somewhat split and battered, are the pride of the University Museum in Philadelphia."

Recognized as incomparable masterpieces, they have been called "China's Elgin Marbles," their plunder often cited as an example of America's predatory imperialism. But how, then, did they get to Philadelphia? Xiuqin Zhou, the registrar of the Penn Museum, drawing on the museum's archives, painstakingly reconstructed the journey of Autumn Dew and Curly from Xi'an to Philadelphia. (Penn has had a laudable policy of revealing the history of its acquisitions.)

The six steeds were still in place when the French scholar Edouard Chavannes saw them in 1909. His photographs are the only documentation of the horses as they were before they were removed from the Zhaoling. During her research, Dr. Zhou found a 1921 letter in the Penn archives from a Paris art dealer, Paul Mallon, stating that he had advanced a large sum of money through an intermediary, a Monsieur A. Grosjean in Peking, who had sent a man, Monsieur Galenzi, to find a way to take them away. "In May 1913, the horses were taken from the Emperor's tomb; unhappily the men transporting them were attacked by peasants and the precious relics thrown down a precipice." (Mallon added that he had lost "a big sum of money" that he had advanced for the purchase.)

The two horses were next taken to the old governor's office in Shaanxi Province and given to Lu Jianzhang, the provincial military commander, "to win his favor." Then President Yuan Shikai, formerly the province's dominant warlord, had them officially removed to Peking. It was then that the Paris dealer C. T. Loo's name appears in association with the reliefs. Some years later, on September 11, 1927, in a letter we found in the Harvard Archives, Loo confided his problems related to the purchase of the horses to Langdon Warner: "You will be surprised to see this letter dated Vladivostock, instead of Peking, well, the reason is that I was notified enroute that actually [sic] Government wants to arrest me because of the sale of the Tang Tai Tsun horses. . . . With regard to the Horses, you know as well as all the world that they were stolen by foreigners in 1912." Loo claimed to have purchased the horses from a Peking dealer named Zhao Hefang, who was acquainted with a son of Yuan Shikai. Zhao proposed that the stones be used to decorate the Yuan family's Imperial Garden, as Yuan Shikai was then making preparations for what was to be his three-month reign as emperor. The Yuan family provided special seals that allowed them to leave Xi'an for Peking. As Loo further justifies his actions in this letter to Warner: "If a thing bought through the President, was not legal, than who would have the authority to sell?

And if it was legal at that time but no more legal now, then how many dealers and collectors would be in the same situation?"

Very likely with the help of the Yuan family, Loo was able to ship the steeds to the Metropolitan Museum of Art in New York, where George Byron Gordon, the director of Penn's University Museum, saw them in storage on March 9, 1918. As a loan to the university's museum, Loo offered "without expense to it, two sculptures representing a pair of horses in high relief which come from the ancient capital of Si'anfu," with an option until 1921 to buy them for $150,000. The wily Loo bid up the price, claiming that his agents had "risked imprisonment and even their lives." The horses were shipped by truck to Philadelphia, where they arrived on May 8. Fund-raising proceeded slowly until an angel named Eldridge R. Johnson, the founder of the Victor Talking Machine Company and a member of the museum's board of managers, anted up $125,000 (the renegotiated 1920 price) and had his name placed under the reliefs. Shortly afterward, Carl Bishop, then curator of Asian art, remarked, "Perhaps no horses existed that have ever become so famous." As for Yan Liben, "Of the artist who wrought these masterpieces, we know practically nothing . . . [but] the sculptures themselves proclaim him one of the greatest artists of any age or nation." Thus did the Penn Museum corral the Tang emperor's horses.

CHAPTER SEVEN

MAD FOR MING

"This scheme," George Kates wrote in 1933 to his friend and mentor, Harvard professor Paul J. Sachs, "had started as an experiment to begin the mastery of Chinese without a teacher. This led on so fast and so interestingly from point to point that almost before I was aware of it, I felt an imperative need to supplement my work on the written language with study in Peking itself. And now, here I am, ready to land in China tomorrow."

"Your letter . . . has just come into my hands," writes an astonished Sachs, who taught a famous course in connoisseurship and mentored a generation of curators and museum directors. "That I am surprised by the contents is putting it mildly. I shall be much interested to hear from you now and again so that I may know how you are progressing, because as far as I can see, it will of course take you years to lay the foundation on which you propose to build a structure."

Few followed a more circuitous path to the Middle Kingdom than George Kates, scholar, connoisseur, collector, lecturer, and briefly curator at the Brooklyn Museum. He might have been invented by Noël Coward. Born in Cincinnati, Ohio, in 1895, he prepped at Horace Mann School in New York but took time out to board a sailing vessel to Australia. Enlisting in the army during World War I, he had a "good war," serving as a translator at General Headquarters in Chaumont (France) and Germany. (He acquired his fluency in several European languages during a childhood spent in Europe and in Latin America with his parents—a Polish industrialist father and a mother of

German ancestry—an English governess, and a succession of fräuleins and mademoiselles,

No career better confirms the breadth and depth of the American addiction to Chinese art and culture. No American loved China with greater fidelity, and in his later years he was a leading enthusiast of and author of a book on Ming furniture—the sleek, unadorned, essentialist chairs, tables, sideboards, and beds fashioned in the sixteenth and seventeenth centuries that were seen to blend felicitously into modernist living rooms.

Young Kates attended Columbia as an undergraduate architectural student, transferring in his junior year to Harvard, where he graduated summa cum laude (Class of 1922). Then began what Kates described as his academic "sandwich years," spent alternating between Harvard as a tutor in history and literature and Queen's College, Oxford, as a doctoral candidate. Kates had been talent-spotted by Sachs, who bolstered his pupil's diminishing family fortunes with a series of successful recommendations for fellowships, the first of which was a Sheldon Traveling Fellowship to study European Renaissance art in England. Introductions to dealers, collectors, and owners of French châteaux like the Sommiers, chatelains of the seventeenth-century Vaux-le-Vicomte followed, as well as an invitation to accompany "P.J." in his great touring car through France: Beauvais, Amiens, Le Tourquet, and finally a Channel crossing. "I am to breakfast with Professor Sachs here at his hotel this morning. . . . Sachs and I went to the dealers yesterday where the quality of things was wonderful. In the evening we went to a gay show at the 'Ambassadeurs.'" So, as he would announce to a friend, the Cleveland curator Henry Sayles Francis, he was launched—"*me voila bien lancé.*"

In the space of a few years, he had vaulted from being a social nobody to being a member of an international set composed of Bright Young Things. His ascent is the more striking since, unlike many of his friends (among them John Nicholas Brown, scion of the Rhode Island family that endowed the eponymous university), Kates was kept on a short leash by his father, who felt entitled to spend what he had earned, leaving George and his sister Beatrice without incomes.

He was rescued from penury by a fortuitous meeting on the steps of the Fogg Museum. The president of Harvard, A. Lawrence Lowell, introduced him to Adolph Zukor, the Hungarian mogul who headed Paramount Pictures. This chance encounter would determine the next five years of Kates's life. Initially, our young scholar arrived in Los Angeles in September 1927, "with a fortune of only 52 cents and a position as

a deputy to producer Walter Wanger." And so, as Kates noted, the pendulum swung from punting on Oxford's Isis River to swimming in Santa Monica's backyard pools.

Dartmouth-educated Walter Wanger was socially a notch above the Jewish moguls running the Hollywood studios. Credited with making Rudolph Valentino a star with *The Sheik,* Wanger had a penchant for producing films with a foreign accent, making stars during Kates's tenure of Pola Negri, Olga Baclanova, and Maurice Chevalier. Hence with time off to complete his Oxford doctoral dissertation (*The Passing of the Middle Ages and the Advent of the Renaissance in French Art*) and gain his degree, Kates spent the next five years delightfully practicing what he termed "applied archaeology." He became a set advisor, suggesting appropriate French *quincaillerie* (hardware) for the doors on Pola's latest film with a European setting, answering questions like "What does an attendant at a French Waxwork Museum look like? How are exhibits labeled? What signs are used outside a good Parisian jeweler's? Does a French gardener wear any specially distinctive clothes?" He burrowed into the studio's research library and toured city streets, private gardens, and the countryside looking for appropriate settings for scenes.

He became the last word on European manners. While a picture was being shot, he remained on the set "so as to keep gestures in character" and possessed veto power when things were done incorrectly—for example, "Florence Vidor is learning to cross herself the Catholic rather than the Greek Orthodox way so as not to puzzle the public." Kates was much taken with Hollywood royalty, particularly by the "ravishing dark beauty" Natasha Galitzine, working as an "extra," who was married to a Romanov nephew of Tsar Nicholas II, and by Paramount's Polish star, Pola Negri, who had recently married a Georgian prince, Serge Mdivani: "Pola holds court like a queen, and has eyes into which one can very easily fall. I was presented, the first morning with a ceremony as meticulous as any I have ever gone through, and she has been very gracious. Four maids wait upon her, or three and a secretary."

The studio royals likewise succumbed to the charms of Kates. His Oxford connection conferred prestige in Hollywood, while Oxford envied the money, the climate, and the glamour of California. Eventually he became director of Paramount's Foreign Department during the years when Hollywood was switching from silent movies to "talkies." His new job entailed shuttling between the new sound stages in Joinville (France), Hollywood, and Long Island, where he was in charge of "plucking various absurdities" for Paramount's foreign market. But it all ended with

the Great Depression. In 1931, Paramount closed its Long Island studios, and finding himself without a job but with some savings, Kates moved to Saunderstown, Rhode Island, where he bought a mid-eighteenth-century yellow clapboard house not far from an old snuff mill.

AND IT WAS HERE, inspired by Arthur Waley's translations of classic Chinese poetry and Pearl Buck's best-selling novels, that Kates settled down to teach himself Chinese—with the "task of making myself a Sinologue." Which is how, the following year, after seeking the advice of Langdon Warner, he found himself sailing from Victoria on the Canadian Pacific's *Empress of Asia*. Once in Peking and enrolled in the College of Chinese Studies, "the Oyster," as he was dubbed by the foreigners whose company he avoided, eventually settled down, with two polite but eccentric servants, in a rented courtyard home of a former palace eunuch, a few minutes' walk from the Forbidden City and the imperial lakes.

"What a pleasure to have one's own steep-roofed, peaked, red gate, a generous courtyard with an acacia in it, square and with plenty of room for flowers in the summer." It was sparse, Kates elaborates: "No electric light, no wooden floors (brick covered with matting sufficed), no heating apparatus except several cast-iron stoves, and no plumbing did I ever install . . . and so my house, while extremely comfortable, remained more authentically Chinese than any that I can recall belonging to Western friends."

Soon he began collecting: "Proud palaces were being dismantled or demolished. Every petty merchant, too, practiced the fine art of conjuring up new desires, which his eloquence sought to turn to urgent needs in just such heads as mine. Yet for the objects of daily use that I wished to buy, if one were known not to be rich and also spoke the language readily, one need never have the uneasy fear of being cheated, or the disgust of finding that imitation had been foisted upon one. Further, I bargained for nothing ruthlessly taken from its setting, nor shorn of its roots. My unpretentious good furniture, the simple pewter or porcelain dishes for my table, were bought unhurriedly as they caught my fancy."

Kates was critical not only of the lifestyle of Peking's expats but also of their taste, the "dull and expensive, porcelains" and "garish Mandarin robes which they condemned to the oddest uses." Yet the very seriousness of his endeavors frequently exposed "the Oyster" to the mockery of the foreign community. His friend and fellow Peking resident Harold Acton, who had embellished the house he had inherited from G. E. Morrison, *The Times* correspondent, with a swimming pool and a carpet of lawn,

satirized him as Phillip Flower, disguising Kates as an Englishman from Croyden in his novel *Peonies and Ponies* (1941):

> His [Flower's] Chinese friendships had been a failure. He had been too assiduous, perhaps, in his cultivation of any Chinese that had come his way. . . . Drudging at the Chinese Classics, sometimes past midnight with a wet towel about his forehead, always he hoped for new light on the elusive spirit of the Chinese people and new guidance for the direction of his life in the land of his chosen exile. He wanted to meet the Chinese on their own ground and be accepted as one of them. He would have liked nothing better than to be adopted by a Chinese family, and in his reveries he fancied himself performing the Confucian rites, setting forth on Ch'ing Ming, or the Festival of Pure Brightness, to sweep the ancestral graves—forgetting that his nearest, if not dearest of kin, were mostly sepulchered in distant Croyden.

Not everyone was as dismissive. John Ferguson, the doyen of foreign Sinologists, commenting to Langdon Warner on the Harvard-Yenching fellows of 1934, an intake that included the distinguished China historians John Fairbank and Derk Bodde as well as Laurence Sickman, described Kates as the best of the lot, "a man of unusual talents" and "wide experience," adding, "I think of his entrance into the field of Chinese art as I did when I first knew of the interest that Bernard Berenson had begun to take a quarter of a century ago in the same subject. I wished at that time that a man with Berenson's background could come to China, undertake to learn the language and make himself proficient in the necessary rudiments of Chinese art. Dr. Kates should have every possible encouragement."

Gossip pertaining to the state visits of Harvard notables is a regular feature of Kates's voluminous correspondence. One visiting celebrity was the writer John P. Marquand (Class of 1915), critic and chronicler of the Boston Brahmins, who drew on this trip for his novel *Ming Yellow*. Marquand was along on the 1934 expedition to the Wutai Shan in Shanxi Province, one of China's four holiest mountains, whose five terraced peaks were each topped by a Buddhist temple. Warner had warned Larry Sickman that Alan Priest was "on his way to Peking with an amazing collection of society traveling companions." Among them was the landscape architect Fletcher Steele, "a person of great intelligence and discrimination," along with three ladies—Mrs. Edward Robinson, the widow of the former director of the Met; Mrs. Murphy, "an intelligent up to date society dame famous for her crazes on art and music etc."; and the

wealthy Bar Harbor and Boston spinster Mary Wheelwright, "who is the patron of all the American Indian arts and has set the pottery and dying [*sic*] and weaving industries of our Southwest back on their feet." Priest viewed this as a collecting trip for the Met—he was searching for the missing "halo" for the great Wei Buddha, acquired by Bosch Reitz—that could be conveniently subsidized by his wealthy charges. Alternately, the elderly widows could perhaps be persuaded to bequeath their collections to the Met. Alan invited George, whose Chinese by this time was excellent, as interpreter. Trailing an entourage of servants and baggage porters, it seemed "a half-mile train when they were on the road." The "circus," as it was called by its ringmaster, "became extremely temperamental in its latter stages," according to Kates. "Many wills, much confinement" added to the stress of being for three weeks in barren country away from the railhead at Taiyuan, the provincial capital, although they traveled in the "greatest of luxury," fortified by "large glasses of morning orange juice" and raisins brought along by Mary Wheelwright in "a green Harvard book bag."

The expedition proved a quasi-comic folly. As Kates recalled thirty-six years later in an interview with Marquand's biographer, Millicent Bell, the party split into two camps: the Rakes and the Frumps, or the saucy thinkers and drinkers and the disapproving stuffed shirts and blouses. Kates disliked all the foreign "society"; he hated their bickering and found them ignorant and arrogant. But he liked Marquand, and he remembered several good moments, notably the day the two of them broke away and climbed one of the peaks alone. At the top, they were met by a priest from the temple, who brought them a picnic lunch staggering under the weight of heavy silver plates. Finally, back in Peking, the two factions tried to reconcile at a grand dinner in a hired palace. It was an absolute fiasco, Kates told Bell, "and ended with smashed glasses and an overturned table."

The trip had been preceded by one to a nearby monastery, again led by Priest with George as his deputy. It included Mrs. Robinson:

> Such regal goings-on-you never did see! Mrs. Edward Robinson went in state. Chairs, bearers, lanterns, runners, even a spring bed carried up the mountain for the lady to sleep on when she got to the top. It was a pageant; especially when the "duchess of Manchester" (for so she was called here) was given Prince Kung's imperial (and rather precariously *old* chair)—to be carried *down* the mountain again.

George Kates (left) with Prince Puru in Prince Gong's garden in Peking.

More to George's taste were the excursions to Peking's gardens and temples with Laurence Sickman and Prince Puju (Pu Xinyu), also known as Puru, the cousin of Puyi, and the last descendant of Prince Gong (Kung). As a painter and calligrapher, Sickman regarded him as the best Chinese artist of the mid-twentieth century. Puru, who specialized in landscapes reminiscent of the Song dynasty painters, rivaled Zhang Dai-qian, a great painter and sometime forger, and was a friend to the expatri-ate aesthetes and aspiring calligraphers—Harold Acton, Sickman, and, of course, Kates. A crumbling palace, the former home of the Qianlong emperor's favorite minister, Heshen, it was occupied by Prince Gong until his death in 1898. It was then that it attained its great splendor, becom-ing what was described as the greatest city garden in North China. Dur-ing the 1930s, it was occupied by his descendant Puru, and it was there that he practiced the scholarly arts of painting and calligraphy. (Prince Gong's mansion and its garden are now a museum.) Puru exemplified the "princely man, this pre-eminent man of breeding" whose very qualities Kates admired in his book. Acton, who was his pupil, described Puru's wrist poised freely with his brush reflecting the slightest pressure:

> The scene he was depicting on a long flat table had already permeated him
> before he touched the papers. Without any external panorama he painted

peak after peak, and a road winding up from the sea to a sheltered hamlet; he peopled the crags with pines and the waves with fishing boats. The peaks receded into the distance and faded away. This complicated vertical scene was transmitted to the paper without hesitation. There was no possibility of making corrections, for each stroke was direct and decisive; it was hit or miss.

Attired in scholar's robes, sitting on hard benches in unheated classrooms while attending lectures in Chinese at Peking University, Kates spent seven-plus years in close quarters to the Forbidden City, as memorably detailed in his classic account, *The Years That Were Fat* (1952), a paean to everyday life in the former capital. When not in class, he enjoyed a special privilege granted to only one other foreign Sinologist, John Ferguson: a special pass that allowed him to use the libraries and imperial archives in the Forbidden City. What would one wish to see? The Great Map of Peking in the reign of the Qianlong emperor, showing almost every single building as it existed in the eighteenth century? No trouble, yes indeed! An eighteenth-century copy of the Song dynasty scroll "Along the River during the Qingming Festival," so famous that "one imperial minister had finally not scrupled to commit murder, to obtain it as his possession." But of course!

His bucolic stay ended in spring 1941, shortly before Pearl Harbor, when it became impossible to live as an American under the Japanese.

> Then the day came when, like a surgical incision, the first object was carted out into my courtyard, and delivered to a waiting crew. . . . I had at least determined not to be separated from my possessions—and how very many they seemed now to have become . . . as the large wooden cases now began swallowing even my tables and chairs . . . My carpets and rugs, my growing plants and flowers, the accustomed piles of books, all the amenities of the way in which I had lived, were gone. . . . Finally we reached bare rooms. Coolies carted the largest cases to a godown in the Legation Quarter, a number of straining figures slowly lifting the heavy boxes together, to get them over the high sills. The effect, at such moments, was uncomfortably like a funeral.

Rounds of farewell visits followed, and bitter tears were shed by his two houseboys at the rail station. "As all Chinese know from poems through their history," wrote Kates, "partings are among the fateful and poignant moments of life." Then they turned and disappeared while he sought his seat.

Kates spent the next two years in the stacks of the Library of Congress as a Guggenheim fellow, speaking more Chinese than English with the staff. He continued his work begun in Peking, which he incorporated into a long article on the origins of the Forbidden City that appeared in 1943, the year he returned to China. Flying from Assam in northeastern India over the Himalayas, the "Hump," via Burma to Chungking (Chongqing), his mission was a tour of duty in the OSS, the forerunner of the CIA, attached to the U.S. Embassy. During this difficult-to-document period, his duties seem to have been collecting Chinese documents of cultural interest for the Library of Congress, and those with intelligence value for the OSS. He remained in Chungking until March 9, 1945, when he returned Stateside as a translator for the fledgling United Nations, at its birth in San Francisco. This led to a post described as "linguistic research" with the UN Secretariat, where among his accomplishments was translating the UN Charter into Chinese.

In 1946, the Brooklyn Museum, where Kates was briefly curator (1947–49), held an exhibit of his Ming furniture, the first such exhibit in the United States. Previously, collecting taste had favored lacquered, ornately carved examples suitable to Victorian interiors, suites of furniture—screens, "thrones," curio cabinets—thought to have been favored by the residents of the Forbidden City. Kates preferred to emulate the taste of the scholar class, the literati, for objects of "elegant if unpretentious domesticity rather than for display at court." His own "sober range of dignified furniture," as he explained, "was one almost unknown to the West, whereas the complicated varieties were only too familiar, in part because of the general level of taste in our stupid nineteenth century, and in part also because of the vested interest of Philistine merchants." A book followed, *Chinese Household Furniture* (1948), written with his sister Beatrice, an interior decorator, who had joined him in Peking in 1937–38, and illustrated with the photos of objects from the collections of friends, among them Gustav Ecke, a well-known authority and author of a book on Chinese domestic furniture.

But he feared that the gods might begrudge him those tranquil years spent in China, since, as he observed, "leaner years might of necessity follow those that were fat." A series of odd jobs followed—consultancies, lectures, the occasional book or article—but the second half of Kates's long life ended in a downward spiral. Chinese curatorial posts disappeared and academic positions vanished. These were the years when Senator Joseph R. McCarthy singled out the "China hands," namely those who had had

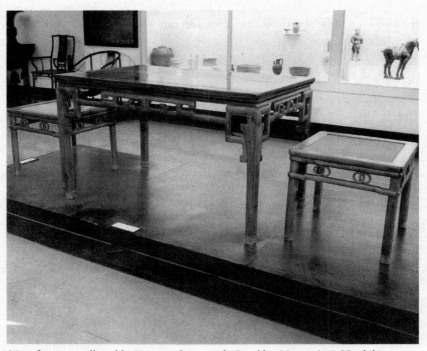

Ming furniture collected by Kates, as shown at the Brooklyn Museum's 1946 exhibit.

the misfortune of serving in Chungking during the war and who were blamed for "losing China" to the Reds.

Three things further contributed to Kates's plight: he was perhaps a homosexual, although closeted; he was Jewish; and there was little interest in China, now closed off by the Communists, in the 1950s. When his funds ran out, he sold his house, donated his books to the Quakers, and stored his slides with friends. His beloved seventeenth- and eighteenth-century Chinese furniture was auctioned at Parke-Bernet Galleries in 1955 after the "starvation summer" of 1954. Kates lamented: "The sale was jammed. Mr. Rockefeller and Princess Ileana came. . . . A few things were thrown away. Others realized impossible prices. My desk went for $1000. Yet it was my own desk, and is mine no longer. Part of me seems permanently frozen. . . ." Another letter elaborates, "The furniture has gone to places like Houston [three pieces from the sale are now in the Cleveland Museum], all bibelots are in a bookcase, or drawers, in reading and classrooms in the Chinese library, at Columbia—dead for eternity— and I sit typing this, punished, in a room filled with cheap furniture."

"For me it is a season of learning how to live without a base, without the pleasures of beauty, the support of books, the fortification of privacy. The price of the Chinese years, which no one felt I was 'entitled' to, has come indeed unexpectedly high." Yet his book has remained an oft-printed classic. "What really matters," he wrote in 1956 after everything was gone, was that he had spent the valid part of his life "resuscitating, discovering, reviving, revivifying one phase of the history of a great people, the form of their classical 'daily life' which I had documented with seven years of reading of their books, and every variety of careful notes and transcripts, as well as all relevant objects large and small."

Kates died, broke and forgotten, in a nursing home in Middletown, Rhode Island in 1990. Thus he was spared the bittersweet experience of witnessing the fad for Ming furniture that was to sweep the antiquities market in the mid-1990s. Part of its appeal lay in the rareness of the wood, much of it now extinct: the most prized objects being made out of a hardwood, known as *huanghuali*, "yellow flowering pear," belonging to the rosewood family and found on Hainan Island in southern China. Robert Ellsworth, the "King of Ming," dean of New York's dealers of Asian art and author of an authoritative book on Chinese furniture, bought some of Kates's pieces and offered them at the Seventh Avenue Armory antiques show in 1961. "The only reason this furniture is not more appreciated is that there is so little of it," Ellsworth explained. "Chinese furniture is the only true cosmopolite of the decorative arts. It fits with any style if you give it enough room to breathe."

Oxford's historian of Chinese art, Craig Clunas, writes that during the Ming period, "furniture was not just a necessary adjunct to civilized living, it was part of a continuous moral and aesthetic discourse. The right furniture could be morally ennobling." A scholar's Ming house might include among its sparse furnishings "a long table for painting, a chair for writing, tall cupboards, stools and chairs, a platform for meditation, a basin stand, a screen, and a canopy bed." George Kates would certainly agree. But during Mao's Cultural Revolution in the 1960s and 1970s, furniture viewed as elitist did not fare well. According to one Hong Kong dealer, Red Guards would "burn it, smash it, cut armrests off chairs, or punch a hole in a cabinet door." As the unique mortise-and-tendon system of joining required little glue or nails, it was easily disassembled and hidden under piles of firewood, put out on the street, or sent to the countryside by owners who didn't want to be caught and labeled bourgeois enemies of the state. Now, although you can buy Ming furniture in China, it is forbidden to export anything more than one hundred years old.

Six years after Kates's death, in 1996, Christie's New York auctioned 107 Ming and Qing chairs, tables, cabinets, and screens, setting a record of $11.2 million, nearly $4 million over the high estimate of $7.5 million. The Metropolitan Museum of Art purchased a classic painting table of huanghuali wood, dating from the late sixteenth or early seventeenth century, while the Minneapolis Institute of Art claimed the rarest object in the catalogue, a large seventeenth-century stationary screen with its original marble panel striated to resemble mountains (purchased with the help of two local collectors, Ruth and Bruce Dayton). As *The New York Times* art critic Rita Reif wrote, "It signaled the coming of age in the marketplace for Chinese furniture, which had long been overlooked by collectors."

Ming furniture, with its rare woods and spare elegance, continues to enchant collectors. Christie's 1996 sale coincided with a special exhibition, "Beyond the Screen: Chinese Furniture of the 16th and 17th Centuries," at Boston's Museum of Fine Arts, curated by Nancy Berliner. George Kates's Ming furniture was no longer the orphan of the art world.

CHAPTER EIGHT

ART ON THE RAILS

What the Internet is to our era, railroads were to the Gilded Age. In both cases, a mega-innovation circled the globe and in unforeseen ways affected everyday life, national priorities and policies, and even the market for fine arts. In the United States, as the historian Stephen Ambrose reminds us, next to winning the Civil War and abolishing slavery, completing the world's first transcontinental railroad "was the greatest achievement of the American people in the nineteenth century." This colossal feat of engineering, for which ground was broken in 1863, in the very midst of the Civil War, was the collective work of risk-taking financiers, war-seasoned veterans used to giving or taking orders, and, crucially, some fourteen thousand job-hungry Chinese migrants who constituted two-thirds of the work force. "After all," one of the financiers is said to have remarked, "they knew how to build the Great Wall."

Viewed globally, the Iron Horse unsettled the established calculus of military strategy, starting with the North's decisive employment of steam and steel during the Civil War. In a remote, very different arena, the young Lord Curzon in 1888 became the first Englishman to book passage on Russia's just-completed Trans-Caspian Railroad. The soon-to-be viceroy of India instantly grasped its sobering military implications, that is, that masses of tsarist troops could move swiftly by rail rather than lumbering horsepower to distant and contested frontiers, thereby complicating Britain's ability to defend India. A few years later, Russia completed the Trans-Siberian Railway, the earth's longest continuous railway

(5,338 miles), built with the essential sweat and muscle of as many as 200,000 Chinese laborers. When Curzon elaborated the strategic implications of all this in a lecture at Newcastle, his onetime Oxford classmate, the geographer Halford J. Mackinder, was mesmerized and soon became the gloomy founding prophet of a new approach to reckoning strategic risks: geopolitics.

As unpredictably, the Locomotive God helped inflate the Oriental porcelain bubble in Western art markets. World grain prices slumped as American wheat from prairie states began flooding global markets in the 1880s, consequently shaving the income of Britain's landed aristocracy, thereby precipitating the sale at auction of inherited artworks, notably including Chinese porcelains.

Yet there was another improbable by-product of the railway revolution: the nurturing of a new breed of affluent American collectors with a passion for Asian antiquities—which, in turn, was linked to the spread of railways in Imperial China, its soil laden with noble tombs that workmen accidentally, or deliberately, unearthed. Leading the way were Baltimore's railroad moguls William and Henry Walters, who in 1886 made headlines by bidding an eye-widening $18,000 at a New York auction for a Chinese "peach-bloom vase."

Charles Lang Freer, wary and ruminative, next to one of his favored Asian progenies.

THERE IS NO MORE COMPELLING example of this new breed than Charles Lang Freer. Self-made and self-taught, Freer earned a fortune as a railroad-car manufacturer, much of which he spent on his travels to Japan and China while gathering a world-class art collection; at the same time, he won approval for establishing in Washington the first federally funded art museum, the essential precedent for seeding the National Mall with six kindred galleries. Finally and not least, he pressed creditably, if vainly, for the sensible road not taken to safeguard China's imperiled antiquities. Yet this improbable industrial magnate fit into no readily defined niche. He was reclusive, fastidious, idiosyncratic, lean in frame, with an immaculately groomed Vandyke beard. As characterized by the art critic Aline B. Saarinen, he was a loner who "isolated himself in a silk cocoon against the showy, boisterous pageantry of his age." Even in the competitive jungle of Detroit, Freer nurtured "a private world of refinement and serenity and excellences." An impenitent bachelor, he sought out strong-willed and unconventional aesthetes like the Museum of Fine Arts savant Ernest Fenollosa, as well as America's crankiest, antimaterialist rebel, James McNeill Whistler (thereby gathering the most complete selection of the artist's works, including his Peacock Room, adorned with the obligatory blue-and-white china).

Nevertheless and incongruously, it was Freer's materialist acumen that enabled him to semiretire in 1900 as a multimillionaire at age forty-four. As improbably, a few years later this maverick art lover somehow persuaded the culturally challenged masters of Washington to approve an unprecedented citadel for his exotic progeny. He earned an epitaph like that bestowed on Sir Christopher Wren, inscribed in the crypt of St. Paul's Cathedral: "If you seek his monument, just look around."

Born in Kingston, New York, in 1856, Charles Lang Freer was the descendant of Huguenots who fled France to escape religious persecution and, like many dissident believers, found welcoming asylum in the Hudson Valley. The son of a ne'er-do-well breeder and trainer of horses, Charles left school at fourteen and worked first at a neighboring cement factory, then as a bookkeeper in the town's general store. There he was hired by the newborn Kingston & Syracuse Railroad, which had its offices in the same building. Freer so excelled as the local paymaster that he became the star protégé of his superior, Frank J. Hecker, joining him when they moved on to Detroit. There they both climbed the management ladder at Peninsular Car Works, a company that, after complex mergers involving a dozen other firms, mutated into the American Car &

Foundry Company, soon to become the country's plenary manufacturer of railroad cars.

Charlie Freer excelled as both a diligent treasurer and a hard-driving vice president. Yet as a rising Detroit executive in the 1880s, he did not accord with conventional norms. While Colonel Hecker (as he dubbed himself after serving briefly in the Spanish-American War) built a gaudy mansion resembling a turreted French château, his junior partner chose understatement on an adjoining lot. Built of purplish brownstone from his native Kingston, Freer's shingle-style residence featured informal built-in seating and open-plan spaciousness, as designed by Wilson Eyre, a contemporary-minded Philadelphia architect. Here, amid woodwork richly lacquered under his personal direction, Freer entertained select friends among Detroit's cognoscenti, dispensing anecdotes about the East Coast art world he had begun exploring. During the 1890s, he not only traveled regularly to Europe, where he met Whistler (turning up unannounced at his Chelsea home in London), but also bought a villa in Capri, a sanctuary for his like-minded aesthetic friends. There he befriended the artist Romaine Brooks, known for her androgynous portraits of women, and along with his male companions, Freer explored the Grotta di Matromania, where they joined in chanting verses by Omar Khayyam.

By then, Freer was incurably infected with the collector's bacillus. During his trips to New York, he began purchasing contemporary European and American etchings and drawings, until his eye was caught by Japanese prints at a Grolier Club exhibition in 1889, the first of its kind in America. His Asian interests were broadened by Fenollosa, recently arrived as curator at Boston's MFA, to whom he regularly paid $200 or more for his "services as an expert" in advising on potential purchases. Freer also diligently sought the counsel of other artists and scholars whom he cultivated in Manhattan. In 1889, having visited the New York studio of Dwight B. Tryon, Freer purchased off the easel his first painting, a misty landscape by that artist depicting a haystack shimmering in moonlight, its style much in the Whistler mode. Over time, Freer's choice holdings of American art came to include paintings or sculptures by Winslow Homer, Albert Pinkham Ryder, John Singer Sargent, and Abbot Henderson Thayer, all well-regarded today.

In his successive European trips, Freer resourcefully explored the new frontiers in the visual arts; he dined in Paris with the American painter Mary Cassatt, sought out the sculptor Auguste Rodin in his studio, and received a highly unusual request from his spiritually close friend, James

McNeill Whistler, whose wife, Beatrix, was stricken with cancer. She was a devoted bird lover, and since Freer in 1895 was en route to India on his first Asian trip, Whistler asked if he could somehow acquire for her a particular blue and gold songbird. Freer volunteered, and on reaching Calcutta he bought a living specimen and then persuaded a British sea captain to care for it on his return voyage and to convey it personally to the artist. Against the odds, the plan succeeded. The Indian songbird joined a white parrot and a mockingbird in the cage at the Whistlers' Left Bank home at 110 rue du Bac. On March 24, 1897, shortly following his wife's death, the grieving artist wrote to Freer: "Shall I begin by saying to you, my dear Freer, that your little 'Blue and Gold Girl' is doing her best to look lovely for you?" During his wife's final hours, Whistler related, "the strange wild dainty creature stood up, and sang and sang, as it had never sung before—a song of the Sun!—and of joy!—and of my despair! Peal after peal, until it became a marvel [that] the tiny beast, torn by such glorious voice, should live!"

AS A COLLECTOR IN THE 1890S, Freer was drawn to the Far East, initially to Japanese art and then to the less well-known paintings and sculptures of the ancient Middle Kingdom. Still, it was not aesthetics alone that guided his purchases. He was by nature a calculating bargainer, and there were few better deals in his prime buying years than Asian art. Freer made four trips to East Asia, in 1895, 1907, 1909, and 1910–11. It was his practice everywhere to seek and inspect both private and public collections as his buying swelled from retail to wholesale. As John A. Pope, a former director of the Freer Art Gallery, justly remarks, "Entries in his diaries and statements from his correspondence from these years reveal how much Mr. Freer learned during these trips, and how modest he was about his own knowledge, even after he was acknowledged as an important collector." It helped that Freer's Far Eastern travels coincided with the literally earth-moving impact of the locomotive on the troubled final decades of the Qing dynasty.

CHINA WAS A RELATIVE LATECOMER to the railroad revolution, principally owing to a deadlocked debate within the imperial household between reformers and traditionalists during the 1880s. Opponents claimed that laying rails would make China even more dependent on foreign powers, whose rivalry had already carved much of the realm into privileged enclaves. Moreover, writes the Chinese historian Cheng Lin, conservatives feared that railroads, by disturbing ancestral graves, "would

facilitate the spreading of ideas and influences subversive to the religion and morality of the Chinese people. The evil influence of railroads was even compared with the devastation wrought by floods and wild beasts." For their part, reformers stressed "the advantages of the railway in the transportation of grain, famine relief, trade, mining, collection of taxes, and traveling. Above all, for military reasons, the building of railways should begin without delay."

Following China's ignominious defeat by Japan in 1894–95, it was the military argument that prevailed. In Cheng's careful calculation, in the seven years from 1897 to 1904 "more railway projects were initiated and loan contracts signed than during the whole of the preceding half-century." Thus by 1898, British concessions totaled 2,800 miles, followed by Russia's 1,530 miles, with Germany and Belgium sharing third place (700-plus miles each), while France and the United States lagged far behind (420 and 300 miles, respectively). This carving up took place, writes Cheng, an advisor to the railroad ministry in the 1920s, without the consent or even the knowledge of the central government. He adds a widely shared Chinese judgment: "The sporadic attacks upon foreign residents in different parts of the Empire during those years must be regarded as demonstrations of popular indignation, and the anti-foreign movement spread until it culminated in the Boxer Movement of 1900, an incident for which the Powers, in their mad struggle for railway concessions, must bear the major part of the responsibility."

The railway upheaval, and its side effects, played a catalytic role in Freer's discovery and connoisseurship of Chinese art. As steel rails wove through the empire, an inescapable by-product was the discovery by workers of richly furnished dynastic tombs, sending streams of high-quality works into an awakening art market. Moreover, the lines enabled Freer to travel through China to study new offerings and to consult two valued advisors, the collector-politician Duanfang in Tientsin and the missionary-turned–art expert John Calvin Ferguson in Peking.

Ferguson was arguably more learned in China's ways and classical canon than any contemporary Westerner. He lived in China for fifty-five productive years, dating from his arrival in 1887 at age twenty-one until his departure in 1943 as a Japanese detainee aboard the Swedish-American liner *Gripsholm* in a wartime prisoner exchange. Born in Canada, Ferguson was an ordained Methodist minister who earned his doctorate in divinity at Boston University. He was sent to China by his church to establish Nanking University, and having done so began a fresh

career as the owner of a Shanghai newspaper and as an enabler for foreign enterprises and art collectors.

What set Ferguson apart, as Warren Cohen writes in *East Asian Art and American Culture* (1992), was his conviction, uncommon among missionaries, "that he could learn as well as teach in China, that Chinese culture was worth studying." He sought not only students for his new university but scholar-officials who could teach him. Ferguson translated mathematics and chemistry textbooks into Chinese, "but also became so knowledgeable about Chinese art and art criticism that he was able to write books on these subjects that are still used by American authorities."

These were attainments not then readily appreciated by American connoisseurs of Oriental art, many of whom viewed the very different genres of Chinese art with Fenollosa's formalistic, Japan-slanted aesthetic. Hence in 1913, when Ferguson, as commissioned, shipped a choice selection of Chinese artworks to the Metropolitan Museum, its staff expressed disappointment. Most especially, the Met rejected a Chinese painting for which its departmental curator said he would not pay ten dollars: *Nymph of the Luo River,* attributed to Gu Kaizhi and now believed to be a Southern Song copy of a fifth-century work. Fortunately, Freer differed. He eventually acquired the *Nymph* as well as other Ferguson offerings found wanting by the New York museum. The disputed scroll is now deemed the single finest Chinese painting in the Freer Gallery collection.

A bachelor without direct heirs, Freer realized early in the new century that his art collection would be his enduring testament. Why not offer it as a gift to the American people? What better place than the nation's capital, at that time shamefully behind London, Paris, Berlin, and Vienna in paying homage to the arts? With that goal in mind, Freer in 1904 visited Washington to sound out Samuel P. Langley, secretary of the Smithsonian Institution, who expressed interest and noted that Congress had in theory approved creating a "National Museum of Art," but only in amorphous principle. In 1905, Freer formally offered his treasures to the Smithsonian's Board of Regents. Freer's proposed gift, numbering around two thousand works, consisted of three parts: antiquities he acquired in the Near East (principally in Egypt); various American works, mostly by Whistler, whose reputation had begun to soar; and Asian paintings, porcelains, and statuary, all of which were (in his view) "harmonious in spiritual suggestion, having the power to broaden aesthetic culture, and the grace to elevate the human mind." His conditions were firm: he would

keep adding to his gift and help finance the museum's construction, but none of his works were to be sold or loaned elsewhere.

Washington then had no internationally recognized art museums. Nicknamed "the nation's attic," the Smithsonian galleries were filled with scientific inventions, natural history specimens, ethnographic and historical memorabilia, salted with a sprinkling of artworks. In addition, the privately endowed, half-century-old Corcoran Gallery featured a miscellany of mostly American art. Taken together, no public gallery in the nation's capital could equal, much less surpass, the holdings of a typical provincial Italian museum.

When news of his offer became public, Freer was agreeably surprised by its favorable editorial reception in major dailies. For their part, the cautious Smithsonian regents appointed a special committee, none of them experts on Asian art, to examine the proffered gift, then stored in his Detroit home. Led by Secretary Langley, the group included Dr. James Angell, president of the University of Michigan; former Missouri senator John Brooks Henderson; and Alexander Graham Bell, inventor of the telephone, along with Bell's daughter, Marian, as an all-purpose expeditor. For five days, the committee members examined Freer's treasures, and their judgment was later described by Marian Bell: "The opinion of all regarding this priceless Oriental art was summed up in Senator Henderson's remark, 'The things were all very well of their kind—but damn their kind!'"

Yet Freer found a formidable ally in the White House. More than any predecessor, President Roosevelt had his eyes on Asia. While still an assistant secretary of the navy, Theodore Roosevelt in 1898 audaciously ordered Admiral Dewey's Pacific Squadron to Manila Bay, thus planting the flag in the Philippines. Speaking as president in 1903, he informed a wildly clapping audience in San Francisco that "our mighty republic" had become a "power of the first class in the Pacific," especially since the Panama Canal was already in prospect. "Before I came to the Pacific slope, I was an expansionist," Roosevelt declaimed amid roars of approval, "and after having been here I fail to understand how any man . . . can be anything but an expansionist."

Thus for reasons geopolitical as well as cultural, Roosevelt met with Freer, endorsed his offer, and on December 13, 1905, sent a letter to the Smithsonian Board of Regents urging accession of a collection with "hundreds of the most remarkable pictures by the best known old masters of China and Japan." Should the regents demur, he added, "I shall then be obliged to take some other method of endeavoring to prevent the loss

to the United States Government of one of the most valuable collections which any private individual has given to any people." He followed up by inviting wavering board members to a White House dinner on December 14, 1905. With an Augustan flourish, Roosevelt minimized the legal perplexities and maximized the gift's symbolic importance. On January 4, 1906—by Washington standards, turbojet speed—a telegram informed Freer that his conditions had been approved.

Freer was once again on the road, sea, and rail, as he often would be until 1911, searching for new treasures for his eponymous museum. As Aline Saarinen writes, "Freer, the ardent, diligent amateur-collector, buying for himself and his nation, had access everywhere. The dapper, fine-grained gentleman, always exquisitely dressed, doffed his derby, his straw boater, his black homburg, his white Panama, and charmed people everywhere. 'I need all the training and coaching I can get,' he wrote home once, 'I don't want to buy promiscuously until I know.'"

He took care not to advertise his affluence, using strategies he confided to his old business partner Frank Hecker. In Peking, his target was the so-called Tartar City, the ramshackle neighborhood where antiquity shops proliferated. There he rented an unprepossessing suite of rooms, explaining to sellers that he was a humble buyer for an American auction house. "I will allow no one with things to sell to see me in my hotel," he reported to Hecker, "thus preventing the guests in this large and excellent hotel [Grand Hotel des Wagon-Lits], excepting two or three reliable Americans, to learn of my plans." As Freer added in a subsequent note, he initially hoped in Peking to find examples of early paintings dating to the Tang, Song, and Yuan dynasties, but the results carried him off his feet: "Had I during all my stay in China secured a full half-dozen specimens of the great men of the dynasties just named, I would have considered myself extremely lucky. But the fact is, I have already in my possession here, over ten times that number." In sum, "It beats California in '49!"

As he also reported to Hecker, "The glimpses I am getting of old China during this hurried trip confirm the impression I have received from various sources. . . . In comparison, Japan seems only an imitative doll!" Hence his determination to widen his travels considerably in what became his final Asian trip, in 1910–11. After consulting with Chinese friends and American diplomats, he planned to explore the interior on his own, by railroad where feasible and otherwise by cart or pack train, with appropriate guides and bearers. Major destinations included the ancient Chinese capitals of Kaifeng and Luoyang, neither of which had foreign "hostelries" but each with a missionary presence. On this visit, he became

one of the first Western travelers to explore the Buddhist cave complex of Longmen, then a battleground pitting brigands against less-than-efficient government forces.

The physical dangers were omnipresent. As Freer wrote in his journal, "En route here my photographer was stoned, received an ugly blow over his right eye . . . the dropping of a pin now startles him. My cook sleeps with the new bread knife I bought in Peking . . . the photographer never sleeps, my servant wept last night when the temple cay mewed outside; so if the brigands overpower the guard, I shall dive under my folding cot."

It is hard not to respect his energy and devotion, yet also to wonder at his daring. The Qing dynasty was already teetering, and Longmen was deep in the remote hills southwest of Peking. Freer's passage was eased by litter bearers, gourmet dinners, thirty attendants, and a guide with a peacock feather. This did not lessen risks. When he finally reached Longmen, his Chinese guides prudently assigned an armed guard to shield him from the opium-crazed bandits then infesting the region. He initially assumed that this was mere politeness and was shaken when local authorities arrested and tortured two murder suspects.

That evening, as he prepared to sleep, he was awakened by the gunfire of his guards. They explained that they were firing blanks to keep bandits at a distance. Freer asked them to desist. The next morning, he found that his guards had taken his order literally and had not used their guns but had silently slit the throats of the marauders, whose corpses lay outside his doorway. Unfazed, borne in a sedan chair, he inspected the celebrated caves. Freer's description, as cited by the art historian Helen Nebeker Tomlinson, deserves extended quotation:

Here two mountains are separated by a narrow and swift running river—the cliffs of rock rising abruptly from the water are pierced by hundreds of temples and grottos, into which thousands of most beautiful Buddhistic figures, from two inches to sixty feet high, have been carved out of the rock. These deities are surrounded by flying angels, floral arrangements, scroll and other designs, all also carved in the rock. These were done 1500 years ago. When the sculptors quit . . . nature completed these masterpieces by softening lines and tones. . . . I quiver, thrill and wonder like an idiot. . . . I am not exaggerating! These supreme things compel reverent and constant attention. . . .

Even as he was astonished and inspired by these Buddhist caves, Freer was also troubled. Before leaving Peking, he had made arrangements with the American legation to export some large stone statues. He

Charles Lang Freer's party, settling in at the Longmen caves in 1911.

confessed to Hecker that he was "ashamed to ask for so great a favor," but in plain fact he knew "it was now or never." He was also aware, while in Longmen, that his battalion of bodyguards, in seeking his favor, might steal whatever objects he seemed to like. Many of the trophy works offered to him were plundered by bandits or other agents for dealers. So what should he do? As Tomlinson phrases his dilemma: "Should he grasp the opportunities, then justify his actions by the care the objects would receive under his guardianship and further by the education they would afford to thousands of Americans? Or should he righteously assist the Chinese government in shutting off the exodus of its artistic heritage?"

The record suggests that Freer leaned both ways. On the one hand, by December his acquisitions filled eleven cases and totaled more than two hundred objects. In his extensive purchases, he sought to distinguish between objects with religious or patriotic significance and those he could acquire with a clean conscience. "One suspects," writes Tomlinson, "that the line wavered according to personal risk, potential for success, and jeopardy to his good name." On the other hand, when he returned to America, he said in an interview with Detroit newsmen that he intended

to "ask the U.S. Government to appoint a commission for the rescue [of] the priceless art of the ancient capitals of the Chinese empire and the bringing of them to the world through American scholarship." And Freer actually did try, at some personal cost, to carry out that promise.

ON HIS RETURN, Charles Lang Freer planned to devote his remaining years to maximizing the benefits of his fortune and his hard-earned knowledge. He undertook three great tasks. He wished to sift and refine his promised collection, eliminating forgeries or works that fell below his exacting standards. In consultation with the Smithsonian, he hoped to reach agreement on a suitable design for his named gallery, to which he had already offered to contribute $500,000 in construction costs. Finally, he also hoped to promote concrete steps toward the preservation of China's imperiled artistic treasures.

In all this, Freer shifted his principal residence to New York, while continuing to store most of his collection in Detroit. He always liked the city, and with the outbreak of World War I, it became the world's leading market for museum-quality Asian art. European dealers upgraded their galleries in New York, the way led by the Chinese-born C. T. Loo. Equally important, following the collapse of the Qing dynasty, streams of high-quality objects with real or bogus imperial pedigrees began flowing to Manhattan. Freer became an active seeker and buyer, along with his new and special friend, Agnes Meyer, then in her early thirties, with whom he had something more than a flirtation but less than an affair. The wife of the financier Eugene Meyer (subsequently proprietor of *The Washington Post*), Agnes was magnetic, voluble, and eye-catching. He joined with her in touring major art showrooms. As to their relationship, the biographer Carol Felsenthal offers this guarded analysis: "Freer had a sexual interest in women—he and architect Stanford White once hired young Italian girls to swim nude before them when they dined in a grotto at Capri—and it was gossiped without evidence that Freer had congenital syphilis and chose to be celibate in his later years. To Agnes he was an 'aesthete in every phase of life—in his home, in his appreciation of good food and wine, above all in his love of beautiful women.'"

Together they combed New York galleries for Asian works, and in his will Freer stipulated that Agnes Meyer was to be a lifetime trustee of his gallery, with veto power on acceptance of future donations of art. As to Freer's purchases, they are documented in detail by the art scholar Daisy Wang. Freer bought no fewer than 1,611 pieces from 1915 to 1919, including 124 premium works from C. T. Loo, priced in total

at $900,840. Presciently, his purchases included a large collection of antiquities predating the Ming dynasty, which then formed the core of the Freer collection—though these earlier works were less popular. When the Freer Gallery opened in 1923, Agnes Meyer commented, "[I]f European scholars must now come to America to see the finest examples of Chinese painting, Chinese jades and bronzes, it was because of Freer."

All Freer's tasks were complicated by his declining health, by America's entry into the War to End All Wars, and by his reliance on all-too-human emissaries. He was stricken in 1917 by a disabling nervous disorder that shrank his weight and led to uncontrollable spasms of irritation and memory loss. He was acutely aware of his mortality, as Wang writes, but found solace in his belief that Chinese jade possessed magical healing qualities and, indeed, could be viewed as a metaphor for an ancient art providing a remedy for the diseased modern West. Dr. Wang quotes Agnes Meyer as observing, "When desperately ill at the end of his life, he would cling to certain pieces of jade with deep satisfaction and with an almost religious faith in its comforting and restorative powers."

Even while stricken, Freer managed to collaborate with John Ellerton Lodge, soon to be the Freer Gallery's founding director (and son of Senator Henry Cabot Lodge), in carefully transferring his collection from Detroit and other venues to Washington. Totaling 15,434 objects, his treasures were grouped into 1,270 paintings, drawings, and sculptures by Whistler, including the celebrated *Peacock Room* (see color plates, figure 1), and by other, mostly American, artists; 3,399 Chinese objects; 1,937 pieces from Japan; 1,095 Egyptian antiquities; 471 Korean works; and 5,847 Near Eastern objects (counting the single pages of illustrated Persian books and minuscule beads). To this founding aggregate, some 10,000 or more objects have been donated since the formal opening of the Freer Gallery of Art on May 3, 1923, four years after its benefactor's death.

On the matter of authenticating and dating each and every item, Freer's attitude can fairly be described as good-humored resignation. As he wrote to Agnes Meyer, he was untroubled by the likelihood that later "lynx-eyed critics" might challenge the authenticity of any prize paintings: "A yell will go up! Good! I hope it will reach me in some spirit way. Then will come what you call the 'reasoning and scientific era' to awaken study, to learn the hows and whys of production in China—the ideals, the materials, the means, the copies, the why. Intelligent people will strive for the knowable—a foolish adventuresome collector will be forgiven even if his flowers prove to be thorns—educational thorns that helped others."

Nor did serious differences arise regarding the gallery's design. A prominent site was chosen, west of the landmark Smithsonian Castle, traditional base of the Institution's governors. Freer abhorred flashy marmoreal ostentation, and agreement was reached on a low-lying, classically austere building, constructed of subdued Tennessee white marble and Indiana limestone. Ample storage space was provided for objects not on display so that they could be studied by researchers. Nowhere was the donor's full name inscribed, nor was Freer's portrait prominently displayed at the entrance. As designed by Charles A. Platt, the gallery exudes calm and dignity and was nicely praised by the artist John LaFarge as "a place to go and wash your eyes."

Freer died on September 25, 1919, a few months after the passing of Theodore Roosevelt, his most potent supporter. He was buried in his hometown of Kingston, New York, but his most fitting memorial, as described by Aline Saarinen, is a monument to his memory erected by the Japanese in a suburb of Kyoto: "It is a natural rock, suave and beautiful in form, about three feet high and six feet long [and] at the dedication ceremonies, the Japanese placed tea and champagne on the rock."

YET AN IMPORTANT LOOSE END remained. It was Freer's plan to help establish a School of Archaeology and National Museum in Peking so that the Chinese themselves would have the skills and incentive to protect their own endangered antiquities. To that end, he recruited Langdon Warner to conduct a wide-ranging scouting mission to test the feasibility of Freer's initiative. Warner traveled 12,385 miles in China, Indochina, and Europe in 1913. In all his interviews, he stressed (as his final report to Freer notes) "that we came to learn from China and the Chinese, not to remove objects of cultural importance, and asked for the goodwill of Chinese scholars in our enterprise." He pointedly added that "I had been expressly instructed to make no purchases of objects of art or antiquity, and that this would be the policy of the School when started." Warner arrived as China's new republican regime had assumed power following the demise of the Qing dynasty. He conferred with the new government's president, Yuan Shikai; its foreign minister, Sun Pao Ch'ih; and a host of other officials, diplomats, curators, and dealers. When meeting with President Yuan, the matter of excavations arose, to which Warner replied: "I was instructed to make clear that nothing of the sort would be undertaken without the official consent of the Chinese government and the good will of the people of the district where I was proposed. The President replied that such consent and goodwill would be

most certainly forthcoming where our plans did not include disturbing the ancestral graves of existing families."

Initially, Freer's project stirred favorable comment, but it all went awry. Freer was a meticulous bookkeeper, and Warner did not share his accountant's mentality in traveling widely with his wife, Lorraine, in Europe and Asia. He was especially irritated by Warner's failure to go to Xi'an, owing to Langdon's concern over local banditry. But it was the escalating and bloody turmoil of the Great War that took initiatives like Freer's wholly off the table.

In a sad and ironic historical twist, the Freer initiative perished, while Langdon Warner would find reasons, elaborated in chapter four, under the guise of rescuing them, of stripping away Buddhist paintings and sculptures from Dunhuang.

CHAPTER NINE

THE PORCELAIN
BUBBLE

Inscrutable are the crosswinds that drive the art market. A short list in Great Britain, for example, would include the vagaries of fashion, the confederacy of dealers, the rivalry of collectors, and, less obviously, the price of grain. The last item played an offstage role in the surge of spectacular art sales during the twilight of the Victorian era. Beginning in the 1880s, as the market for British farm produce waned, so did the income and the electoral authority of the titled families who owned as much as four-fifths of the land in the British Isles. Pressed for cash, the landed nobility began selling ancestral art collections, one by-product being a surge in the supply of Chinese porcelains. What was the underlying catalyst? An informed answer was advanced in 1931 by Lewis Namier, then Oxford's leading anatomist of power: "On a careful inquiry, it will be found that the coming of American wheat wrought a greater change in the composition of the British House of Commons than the first two Reform Acts" (the laws meant to trim back overrepresentation of rural areas).

This was true. As American railroads reached the Western prairies in the 1870s, carloads of cheaper wheat flooded the world's grain markets. Together with bad weather and crop diseases, imported grain undermined the economic base of Great Britain's "senatorial order," an apt phrase devised by the Cambridge-bred historian David Cannadine in *The Decline and Fall of the British Aristocracy* (1990). Great swaths of territory in the United Kingdom, averaging between ten thousand and thirty thousand

acres, were then owned by as few as 750 families and their neighboring gentry. In 1880, as calculated by Cannadine, two-thirds of the elected members of Parliament belonged to the rural oligarchy, but by the 1920s only a tenth had landed roots.

As farm income and legislative power waned, taxes waxed. Death duties rose by incremental jumps, from 8 percent in 1894 to 40 percent in 1930–39. Taxes on landed income and capital gains were introduced in 1909, and during the Great War, a super tax was added to incomes in excess of £10,000. The plaint of a declining caste was pithily expressed by Lady Bracknell in Oscar Wilde's *The Importance of Being Earnest* (1895): "What between the duties expected of one during one's lifetime, and the duties exacted from one after one's death, land has ceased to be either a profit or a pleasure. It gives one position, and prevents one from keeping it up. That's all that can be said about land."

For beleaguered patricians, an obvious and tempting way to rebalance accounts was to sell ancestral art collections whose market value rose even as land values diminished. Leading the way in 1882, the Duke of Hamilton sold 2,213 lots of paintings, glass, enamel, and furniture for an unprecedented £397,562. This was followed by the Duke of Marlborough (uncle to young Winston Churchill), who in 1884–86 sold a pride of Old Master paintings, many going abroad, thus provoking a spirited debate on their loss to the nation. A bevy of art dealers flocked to these sales, the path blazed in 1886 by Henry Duveen and his teenage nephew, the formidable Joseph.

Of all potential buyers, none was more closely watched than the American financier J. Pierpont Morgan, who commuted regularly to Europe, initially as a student and then as a young financier, becoming fluent in French and German. Beginning in 1890, Morgan devoted most of his vast earnings in steel, banking, and railroads to collecting masterworks of art and letters. "The American domination of the world art market in the early 1900's was the work of a single man," judges Gerald Reitlinger, author of an encyclopedic study of prices paid for art in the modern era: "It cannot be doubted that J. P. Morgan formed the greatest single collection comprehending all ages that there has ever been."

Imperious in gaze and words, flourishing his cane like a saber, and averse to haggling, Morgan preferred to buy en bloc collections of rare manuscripts, Old Master paintings or drawings, and especially Chinese porcelains. As a winner's bonus in imperial trade and Asian wars, the ducal estates of Great Britain abounded in this special art of ancient lineage. For buyers like Morgan, it can be surmised that Oriental ceramics

exerted an added appeal owing to their supreme craftsmanship, obvious to sight and touch, and to their association with royalty, since an object's imperial provenance was frequently noted in imperial marks. Nor did it hurt that among the divinities depicted on regal pottery were the plump and cheerful gods of wealth and longevity.

Yet there is a downside. In the Western tradition, high value is ascribed to authenticity, whereas Chinese potters commonly viewed imitation as a form of respect. The fear of being taken in by fakes has long proved a prime source of Western collectors' anxiety, especially since modern technology has sharpened the forger's tools. Moreover, just as Biblical iconography may mean little to those steeped in Confucian or Buddhist creeds, the reverse also holds: many subtle cultural and religious allusions in Chinese art are lost in translation. Imagine, for example, how little visual allusions would mean to an Asian collector of Greek vases who knew nothing of Homeric sagas and Olympian gods.

Even so, having noted these downsides, what might be called Five Noble Truths help explain why Chinese ceramics flourished in Western art markets. To begin with, no special knowledge is necessary to appreciate the genre's outward forms and functions. A Second Truth: age alone confers added prestige; no other civilization has a longer history than China's of turning clay and metallic ores into alluring objects (not until the eighteenth century did Europeans finally learn the secrets of creating porcelain). As early as the Shang dynasty (1650–1050 BCE), Chinese potters were already firing special clays and glazing their works to create what specialists now call "primitive porcelain." In the succeeding Qin and Han dynasties (202 BCE–220 CE), not only pots and bowls but also life-size terra-cotta statues were mass-produced. Soon enough, beginning with the Tang dynasty and continuing through the Song, various specialized kilns were designated as "imperial," meaning, inter alia, that the fierce dragons on their vases could be depicted with four claws, rather than the three authorized for lesser nobility.

In sum, Chinese ceramics by every objective measure constitute the earliest globally prized cultural commodity. More than a millennium ago, China had already developed markets throughout Asia and the Middle East, with Africa and Western Europe soon to follow. Moreover, Chinese potters crafted special wares with an eye to different tastes of foreign buyers—which is why "china" signifies not just a country but the world's most venerable made-to-order export commodity.

Two practical Noble Truths can be added to the list. Save for statuary, most porcelain objets d'art are portable, readily grabbed during military

operations, and convenient for export if carefully packed in diplomatic luggage. This helps explain why Chinese ceramics flooded Western capitals after the 1860 sacking of the Yuanmingyuan (or Summer Palace) and the subsequent occupation of the Forbidden City in 1900. Less obvious is a Fourth Truth: from the late eighteenth century onward, sale prices were recorded by leading auction houses in London, Paris, and New York. This meant that collectors could continuously monitor the changing cash value of their holdings in Chinese porcelains—indeed, a specialized jargon evolved in auction catalogues to distinguish various glazes (i.e., celadon, crackle, or *sang de boeuf*). Soon, collectors focused on favorite periods, the most popular a century ago being the multicolored porcelain identified with the Qing dynasty (1644–1911 CE), especially the brilliant ware produced during the long reign of the most interesting of Qing rulers, Emperor Kangxi (or Kang-hsi). But taste is fickle, and the black-glazed Qing vases once prized for their elaborate decoration were supplanted in the favor of collectors in recent decades by the simpler, purer, often older white- and yellow-glazed ware, notably those crafted at royal kilns in the Song dynasty.

A Fifth Noble Truth is that the rage for Chinese porcelain coincided with the emergence in the nineteenth century of a new calling to address the needs, and status anxieties, of America's rising breed of tycoons. The newly rich, and their families, turned for professional advice to interior designers and/or decorators to create an ambience of wealth in their residences. At the turn of the last century, few objects seemed more likely to charm a visitor, or to find a way into their owner's heart, than a Kangxi blue-and-white garniture of vases and beakers, especially if enthroned on a mantle or displayed in a purpose-built vitrine. (As with much else, the notion of living in harmony with one's surroundings was anticipated in China three thousand years ago in the science of *fengshui,* providing guidelines uniting Five Elements—fire, water, wood, metal, and earth—in domestic design.)

So important was this aspect of modern Western collecting that the Duveen Brothers, preeminent among vendors, showcased Chinese ceramics along with furniture and tapestries in the firm's Fifth Avenue store window, circa 1900. (The window's novel electrical illumination also excited attention.) Joseph Duveen, soon to succeed his uncle, brothers, and cousins as the firm's and his century's leading art dealer, all but dictated the interior design of his client's homes. As a 2007 essay in the *Burlington Magazine* recounts, Henry Clay Frick paid five million dollars in 1915 to Duveen for such items as a chimneypiece, French furniture,

and Chinese porcelains to provide a suitable setting for a series of panels by Jean-Honoré Fragonard. Sir Joseph (as he became in 1919) rarely saw a decorator's niche that he did not wish to fill.

Given the abundance of vacant niches in the instant mansions that sprang up during America's Gilded Age, it is small wonder that Chinese porcelain soon became a standard feature in upscale living rooms. As we have related, beginning in the 1790s, Yankee trading vessels commonly returned from Canton laden with export ceramics. Especially popular were blue-and-white ginger jars, serving dishes, teapots, and vases. But in succeeding decades, Asian porcelain became an investment as well as a novelty. As commerce with the Far East increased, so did Western fascination with the classical arts of China and Japan. This was notably promoted at international fairs, a nineteenth-century phenomenon triggered by the success in 1851 of the Great Exhibition at London's Crystal Palace. In just five months, the exhibition drew an astonishing six million visitors. Successful encores ensued, first in London (1862), then Paris (1867), Vienna (1873), Philadelphia (1876), Paris again (1878 and 1889), Chicago (1893), and St. Louis (1904), plus a half-dozen other venues. At each gala exposition, American visitors armed with curiosity and dollars could examine, not just the arts and crafts of other Western nations, but also the novel and intriguing arts of Asia displayed in thematic pavilions.

Among visitors so smitten was William T. Walters, a Baltimore merchant who, with his son Henry, pioneered the collecting of high-value East Asian ceramics in post–Civil War America. The senior Walters established another benchmark by commissioning the ten-volume, lavishly illustrated *Oriental Ceramic Art,* a catalogue of his holdings annotated by Stephen W. Bushell, one of the genre's preeminent British connoisseurs. And what initially seduced Walters was his first encounter with Sino-Japanese art at London's 1862 Great International Exhibition. (A catalogue by Bushell would thereafter confirm the status of a serious collector.)

Here a step backward is necessary. Self-made and largely self-taught, William Thompson Walters grew up in Pennsylvania and in 1841 moved to Baltimore, where he married Ellen Harper, the daughter of a successful food wholesaler. Walters prospered as a grain merchant and by selling "the finest and largest stock of Old Rye Whiskey in the United States." Yet what set him apart from other self-made magnates was his informed interest in the visual arts. In the 1850s, he began collecting artworks by the Hudson River School, turning for advice to Samuel Putnam Avery, soon to become New York's foremost art dealer. Subsequently, with

*Baltimore's William Walters, a widely
traveled entrepreneur who turned his
mansion into a museum, as portrayed by the
French artist Leon Bonnat (1883).*

acquisition funds provided by Walters, Avery agreed to split with his off-stage partner the sale profits of European as well as American art displayed in the former's popular gallery.

Thus Walters was already an insider in the art world when the Civil War broke out in 1861, engulfing border-state Maryland in angry discord. Though a Northerner by birth, he sympathized with the South, having friends and business ties on both sides of the Mason-Dixon Line. So Walters chose voluntary exile in Paris, the world's art capital, then at the crest of its Second Empire buoyancy. His family, including his wife, Ellen, his son Henry, and daughter Jenny, found suitable quarters in the First Arrondissement, within strolling distance of the Tuileries, the Louvre, and the fashionable cafés in Napoleon III's glittering capital. Walters found an astute guide to the Parisian beau monde in George A. Lukas, an expatriate West Point graduate who acted as an agent for leading American collectors. Soon William not only met leading artists but also commissioned their works, including the celebrated Daumier watercolor, *The Omnibus.*

On a frugal traveling budget, the Walters family toured Italy's canonical cities and then in October 1862 crossed the Channel to inspect the much-discussed London International Exhibition. Here the couple experienced an epiphany, followed by a tragedy. Among the objects showcased in the fair's Oriental Department were the varied arts of China and newly accessible Japan. The exhibit included objects recently looted by British troops during the sack of Peking's Summer Palace, among them a painted screen said to be associated with the imperial throne, a backgammon board, and "a human skull richly set in gold, reported to be the skull of Confucius." Also displayed were Japanese objets d'art assembled by Sir Rutherford Alcock, formerly the British consul in China, then HMG's Envoy Extraordinary in Japan. His collection featured hundreds of lacquers and inlaid wood products, an array of porcelains from Yokohama, pottery from Osaka, and a miscellany of textiles, bronzes, and basketry. As determined by William R. Johnston, the biographer of William Walters Sr., it was this show in London, "unprecedented in the West," that prompted "his interest in collecting Far Eastern art, a field that he pioneered in America."

Yet sadly, it was also during London's damp November weather that Ellen Walters, always frail, contracted pneumonia and died at age forty. William never remarried, and his artworks figuratively became a surrogate family, as they did for his childless son, Henry. Once back in America, father William prospered as a consolidator of East Coast railroads, policies pursued with vigor by his son. Both not only visited but served as patrons or commissioners at successive international fairs in Vienna, Philadelphia, Paris, and Chicago, adding generously to their expanding collections. Although he shunned publicity, the elder Walters, with his formidable girth and drooping white mustache, became a familiar fixture in New York's elite clubs, as did the dapper and (then) leaner younger Walters.

In 1886, father and son generated unsought headlines in New York when William Walters was identified as the unnamed victor in an auction duel for a Chinese ceramic vase, glazed in pink but flecked with green, known as the "Peach Bloom Vase." It was hammered down at $18,000, an eye-widening amount at the time, comparable to around $90,000 in present-day dollars. In the opinion of *The New York Times,* the sale price was ridiculous since the vase's pedigree was suspect and it reportedly had been offered for sale in Peking for 250 Mexican silver dollars. After all, *The Times* commented, "the public does not own peach blow [*sic*] vases, and is in no hurry to, but it sympathizes with those who, owning one or two, therefore seek, with effrontery truly amusing, to boom the peach

blooms as they boom a stock in Wall Street." The comment was followed
days later in the same newspaper by "The Rime of the Peachblow Vase," a
parody of Coleridge's Ancient Mariner, this being the message:

> *Across the ocean, to dealers in notions,*
> *The little red jug then crossed!*
> *And they sold it off at a slight advance*
> *Of fifty times its cost!*

Among less amused readers was Charles A. Dana, owner and editor
of *The New York Sun,* himself a collector of Chinese porcelain (indeed
one of his prizes was a peach-bloom vase). Warmly defending both the
vase and its owner, *The Sun* noted that William Walters had recently
invited the public to visit his ever-burgeoning art gallery adjoining the
family mansion on Baltimore's Mount Vernon Place. Thus the vase was
destined to become yet another stellar porcelain in the Walters Art Gal-
lery (as it formally became in 1934), adorning a collection that ranked
globally with the very best in the West, private or public.

The sale marked the beginning of what can be termed the Great
Porcelain Bubble. On both sides of the Atlantic, wealthy collectors vied
for East Asian ceramics, igniting a market that rose and fell along with
changing tastes, personal rivalry, and speculative risk-taking. Thousands
of objects changed hands. When William Walters died in 1894, his estate
included 2,400 pieces of Chinese ceramics. And successive global exposi-
tions proved to be the vital catalyst for the porcelain market. In America,
as the historian Warren Cohen relates, "The Philadelphia Centennial and
the Chicago Columbian Exposition brought Chinese and Japanese art to
the attention of a mass audience."

Yet Cohen importantly adds that East Asian paintings and prints
were too rigidly judged by Western standards and prejudices: "The Asian
could no more understand perspective than he could understand logic.
Generalized contempt for Asians affected perceptions of Asian art. It was
different, it was Asian, it was therefore inferior." Still, in the century's
closing decades, a select group of American collectors grasped two salient
facts: not only was Far Eastern art aesthetically undervalued; it was also
underpriced.

Beginning in the 1890s, three buyers led the way in collecting Chi-
nese porcelain when the going was auspicious: Benjamin Altman, the
soft-spoken founder of his eponymous New York department store; James
A. Garland, for thirty years a vice president of the First National Bank in

the same city; and John Pierpont Morgan, the only banker whose name is familiar to most literate Americans. All three shopped across the world. Each was counseled by a Duveen—either Uncle Henry, longtime chief of the firm's Fifth Avenue gallery, or the peripatetic Sir Joseph, who was always en route from or to London and Paris. As a result, save for China itself, the United States can claim the most stellar abundance of Chinese porcelains on public display.

SELF-EFFACING TO A FAULT. Benjamin Altman was the son of Bavarian Jewish immigrants; he came of age in Newark, New Jersey, where he worked in a dry-goods store along with Lyman G. Bloomingdale, founder of Bloomingdale's, and Abraham Abraham, cofounder of Abraham & Strauss. After opening his own emporium (rated as New York's second largest in 1876), Altman succumbed to the collector's bacillus in 1882 after viewing an exhibition of Chinese porcelains arranged by Henry Duveen. He began buying at once. As related in a memoir by Edward Fowles, the long-serving right-hand man to Sir Joseph Duveen, Altman studied every piece carefully before deciding whether to buy: "[E]ach item would be immersed in a bath of water for several days so that any flaws of breakages—often carefully disguised by over painting— would become apparent. The porcelain, once relieved of its accretions of dirt and grease, would be revealed in its original beauty." On occasions when several items passed his tests, Altman and Uncle Henry would sit together in shared exhilaration while the collector handled and stroked his new prizes, "marveling at their beauty and their texture." Fowles then offers an insider's tribute to the art-loving retailer:

> Altman's collection of porcelain alone is sufficient to single him out as one of the great collectors of all time—especially when one recalls that it was made only over a period of twenty-six years: from the day in 1886 when he had paid £35 for a pair of Nanking enamel vases from the young Dutchman, Henry Duveen, who had only recently opened a shop on the other side of Fifth Avenue, down from the Altman establishment itself. And thus with the advice of the "best connoisseur amongst the dealers," the Altman collection "was formed before the market became flooded with the clever imitations which were later imported from China in large quantities."

On his death, the reclusive and unmarried Benjamin Altman bequeathed to the Metropolitan Museum his 429 Chinese porcelains plus his Old Master paintings, along with provisions for the continued

employment of their longtime keeper and future lifetime curator, Theodore Hobby. The porcelain collection became the seed of the museum's now-encyclopedic holdings. Altman's total bequest was valued at $20 million (the equivalent of $432 million in 2006, according to Michael Gross's *Rogues' Gallery,* an iconoclastic history of the Metropolitan Museum). Thus, beginning with the two Walters and continuing with Altman, Chinese ceramics began appearing on the art market's big board. With the advent of James Garland and J. P. Morgan on the trading floor, records were broken, opening the way for John D. Rockefeller Jr., who lived to see the Great Porcelain Bubble deflate.

James A. Garland was an otherwise conventional financier and yachtsman whose fascination with Chinese porcelain evolved into a benign form of megalomania. In 1902, Ivy Lee, later to be remembered as the Rockefeller family's public relations mentor, summarized a familiar metamorphosis among driven collectors: "When Garland began collecting Oriental porcelains nineteen years ago, his purpose was only to decorate his home. Year by year, his treasures increased in value and number, however, and he became enthused with acquisitiveness. He determined to gather the greatest collection of such objects in all the world . . . [and thereby] get within his firm grasp the rarest and most beautiful porcelains in all the earth."

Garland's adroit collaborator was (once again) Henry J. Duveen. Over time, the quiet bank executive reportedly spent as much as one million pre–Great War dollars on Chinese porcelain, usually acting on Uncle Henry's advice. Initially, owing partly to James McNeil Whistler's influential enthusiasm, Garland turned to blue-and-white ceramics. However, as the new century neared, a vibrant market developed for Qing dynasty enameled wares known as *famille noire, famille verte,* and *famille jaune* (so named and defined by French dealers). Soon Garland encountered a like-minded competitor in George Salting, an Australian-born London merchant. At major London auctions, surrogates for the two aggregators frequently bid for the same prizes. The jewel in the Salting crown was known as the Red Hawthorn Vase, on which sprigs of prunus blossoms were set against a background of lustrous black.

Yet against the odds, Garland contrived to add the coveted vase to his own collection. How it happened, as related by Uncle Henry Duveen to Ivy Lee, casts a revealing light on the backstage maneuvering in the porcelain market:

> Mr. Salting is a man who will never sell anything. His hobby is always to
> exchange things when he gives them up. He will buy, but no money exists

which will induce him to sell anything he has collected. Hence it was out of the question to seek to purchase this wonderful vase from him. I knew, however, of a dealer in London who was at that time doing a great deal of business with Mr. Salting. At Mr. Garland's request, I said to this dealer: "Watch Mr. Salting. Offer him anything you have for that vase. When you get it, let me know. I must have it at any price." Three years later (in Uncle Henry's telling), he received a cable reading, "The Red Hawthorn is yours."

Salting at the time was investing heavily in black enamel ware, which Duveen had provided him in exchange for the vase—and which the collector assumed he could buy back at a later time. "He never dreamed that it would leave England," continued Uncle Henry. "He begged the dealer and he begged me to let him have it back. But Mr. Garland insisted upon keeping it. Mr. Salting has never forgiven me for this. It cost me a little over $4,000. Mr. Salting would willingly pay more than $25,000 for it today."

Actually, the vase's market value was even greater. Owing partly to the interest aroused by Garland's coup, the banker offered to exhibit his entire collection at the Metropolitan Museum in a named display, marking the Met's initial turn to the fine arts of China. The loan agreement was reached between Garland and the museum's founding director, Luigi Palma di Cesnola, once an Italian cavalry officer, later a Civil War general and then United States consul in Cyprus. (Having sold his collection of just-unearthed Cypriot antiquities to the newly established Met in 1879, Cesnola became director of the museum as a condition of the sale.) When they discussed the Red Hawthorn Vase, Garland confided to General Cesnola, "I paid more for that vase than you did for your house in Fifty-Seventh Street." (The general's house cost $32,000.)

When James A. Garland died in 1902, it was assumed that his collection would be bequeathed to the Metropolitan Museum. But he changed his mind and his will. Garland's heirs—his widow, two sons, and a daughter—now planned to auction the entire collection in London. However, a savior materialized in the imposing form of John Pierpont Morgan, soon to become the Metropolitan's vice president, and two years later its president. It came about in Morgan's trademark fashion. First, Henry Duveen bought the entire Garland Collection, comprising two thousand pieces, for $500,000. The following morning, at nine o'clock, the great financier appeared in Uncle Henry's office, and with a casual flourish repurchased the whole Garland trove for $600,000. As related in a gossipy memoir by another Duveen brother,

James Henry Duveen, when the sale was consummated, Morgan said, "I understand that Mr. Garland did not complete the collection." "That is so, Mr. Morgan," Uncle Henry replied. "Then I shall be glad if you will complete it for me." In Henry's words, "[T]his meant *carte blanche.*"

According to Jean Strouse, Morgan's diligent biographer, the financier's bills from Duveen Brothers in 1902 listed upward of $200,000 for Chinese ceramics, all of which were added to the Garland Collection.

Or so it was called until August 1902, when General Cesnola announced that henceforth it would become "the Morgan Collection" and, thus renamed, would be prominently installed in the museum's nearly completed new wing. As the director explained to *The New York Times,* "Mr. Garland was a very nice man, and I know that at one time he intended to leave the collection to the museum. But he left it out of his will, and his action came very near causing us to lose his collection." Even the labels mentioning Garland's name were to be removed from the display cases. It was now widely assumed that Morgan would convert his loan into a bequest after he became the Met's president in 1904. By then, in the words of Jean Strouse, "Morgan was fully caught up in a romance with art that combined his cultural nationalism, interest in history, sensuous response to beauty, and love of acquisition. Operating on an imperial scale in the early twentieth century, he seemed to want all the beautiful things of the world."

However, his devotion to masterpieces of art and letters was not miserly. J. P. Morgan strove to share, educate, and elevate. He collected not just Oriental ceramics but also paintings, sculpture, ivories, tapestries, carpets, armor, furniture, and antiquities—along with rare books and literary memorabilia. In 1902, the year in which he acquired the Garland Collection, he also approved plans for building a Beaux Arts library and gallery next to his East Side residence. This was done with an eye to its likely future as a public institution and personal monument; true to his wishes, his son Jack donated the library and its collections to New York City in 1924, together with an endowment of $1.5 million.

Morgan lavished particular attention on his Chinese porcelains. Following a precedent set by William Walters, Morgan also published an expensively illustrated catalogue of his ceramics, as annotated by Stephen Bushell and William Mackay Laffan (publisher of *The New York Sun,* also a devoted collector, and author in 1897 of *Oriental Ceramic Art*). All the while, Morgan matched his multimillions spent with multimillions earned. In Jean Strouse's phrase, he served as America's unofficial central banker. His authority was at once palpable and mysterious, so much so

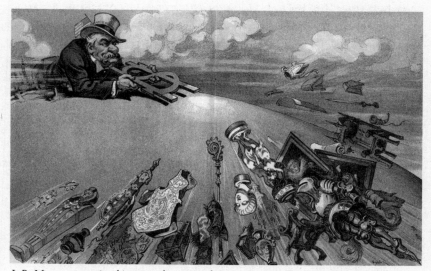

J. P. Morgan amassing his artworks, as seen by a cartoonist in Puck, *an irreverent New York magazine.*

that during the great Wall Street Panic of 1906, President Theodore Roosevelt, ordinarily a critic of financial titans, turned to Morgan for help (successfully).

Yet what might have been Morgan's most spectacular coup—the purchase of the very best of China's imperial art treasures—eluded his grasp when a force beyond even his control intervened. It is a story commonly forgotten, which came to our attention thanks to a Freer Gallery lecture by the connoisseur and dealer James A. Lally. On March 8, 1913, Morgan received this unsigned cable from Francis H. McKnight, an American diplomat posted to China: "Strictly confidential. Imperial family are prepared to sell for own account and in entirety palace collections including pearls, bronzes, porcelains etc." McKnight said Morgan could get "first option" on the entire treasure and that it was "important we should have an answer as soon as possible." Overnight, Henry Pomeroy Davison, Morgan's partner and close confidant, wired back: "Send further particulars." At the time, Morgan and his entourage were aboard a chartered yacht on the Nile, a favored detour on his European holidays.

Subsequent cables itemized the treasures in three palaces—in Peking, Jehol, and Mukden—and suggested that all three troves could be purchased for $4,000,000, an offer that came a year after the collapse of the Qing dynasty. McKnight then elaborated that Morgan could have

the whole trove shipped to London for an appraisal by providing a loan to the now-bereft imperial family equal to half its value and then purchase what he wished. Further telegrams described the credentials of Shi Shu, the Grand Guardian of the Imperial Household during China's chaotic transition into a republic. A flurry of coded cables from Peking informed Davison that the imperial family had agreed to these terms and that China's new president and chief warlord Yuan Shikai also went along, subject to approval of the National Assembly. McKnight, who said he was acting as an agent of the imperial family, elaborated with this message on March 12, 1913:

> I believe vendors acting in good faith and that they can make delivery of goods but impossible to say whether they can give perfectly clear title as it is understood in America or whether purchase money will be equitably divided among the Imperial Family. Owing to existing conditions in China business cannot be considered more than interesting possibility until goods shipped but expense sending expert here would not be great and I believe there is excellent chance of securing valuable collection. . . . Any estimate value collection must necessarily be guess but impression seems to be that Mukden worth 2,000,000 gold dollars, Jehol Peking 1,000,000 each.

At no point was Morgan's name mentioned, and the financier, who already contended with chronic nervous disorders, suffered a severe breakdown on the Nile and became feverish and delusional. When rumors of his illness reached Wall Street, the stock market plunged. Although his physicians urged him to return to New York, he insisted on continuing from Egypt to Rome and then to Aix. All the while he followed the excited sequence of cables and memos discussing problems of title, payment, and the role of China's new National Assembly.

Here the file closes. Morgan had already moved on to Rome, and on March 31, 1913, he died in the Eternal City in his suite at the Grand Hotel, a week after Easter Sunday. During his final days, the hotel lobby swarmed with dealers (as always happened when he traveled) while his staff dealt daily with five hundred or more letters seeking his bounty. His last recorded words were "I've got to go up the hill."

On April 11, the *France* arrived in New York Harbor bearing his casket, which was taken first to his cherished library and then for burial in Hartford, his birthplace. Memorial rites followed in Manhattan at St. George's Church on Stuyvesant Square (thereafter known as "the J. P.

Morgan Church"). The mourners' procession and floral offerings paralleled those for a chief of state. (Germany's Kaiser Wilhelm II, never given to understatement, sent a giant cross of orchids.)

Negotiations thus ceased for the purchase of China's imperial collection, which then passed through a shadowy procession of keepers. Some of its treasures were sold or dispersed, and others were lost or stolen until 1948, when the crumbling Nationalist regime evacuated part of its remnants to Taiwan. The balance remained in China, becoming the permanent possession of the People's Republic, its prizes thereafter exhibited in the Forbidden City.

At the Metropolitan Museum, meanwhile, there were gloomy forebodings about the great magnate's demise. Only the year before, in November 1912, Morgan, who then was the museum's president, summoned the recently appointed director, Edward Robinson, to a confidential meeting at the financier's library. There, according to the director, Morgan "told me that he wished it distinctly understood by City authorities and whoever else ought to know that he had no intention of giving or bequeathing his collections to the Metropolitan Museum." Morgan said that his collection was valued at about $50,000,000, "and he regarded that as much too large an asset to take out of his estate in case it might ever be needed." Robinson added, "This is the first intimation Mr. Morgan has ever made to me of his ultimate intentions with regard to his collections." True to his word, when the financier's will was read, it contained no bequests to the museum from its late president. Instead, John Pierpont Morgan Jr., known as Jack, was instructed to carry out his father's "desire and intention" to make suitable dispositions of "such portions" of the Morgan collections "which would render them permanently available for the instruction and pleasure of the American people."

Jack Morgan began donating selective prizes to the Metropolitan, the Hartford Atheneum, and other institutions favored by his father. But what of the Morgan collection of Chinese porcelains? For two years it remained in Gallery D on the second floor of the museum. Then it was sold in February 1915, in its entirety, to the Duveen Brothers for $3,900,000, at the time a record figure. "The museum and the public are losing something that can never be duplicated," lamented Director Robinson. An allegorical sequel followed; a rescuer materialized in the form of John D. Rockefeller Jr., in most ways save imperious manner Morgan's successor as a celebrator of Chinese ceramics, blue, white, red, green, or black. In circumstances to be related, John Jr. acquired the best of the collection in

a transaction facilitated by its longtime keeper, Theodore Y. Hobby, who would then serve as Rockefeller's principal advisor on Asian purchases. Yet as the decades passed, Junior became both a principal and a spectator as the market value of Chinese ceramics soared up and then down—with this redeeming constant: neither Rockefeller nor Morgan viewed their collections as an investment.

CHAPTER TEN

ROMANCING THE ROCKEFELLERS

America's Gilded Age crested in the year 1900. Not only was the economy buoyant, but from its commanding heights few clouds were visible on the new century's horizon. Abroad, the Stars and Stripes were ascendant, even as the Union Jack was embattled. In October 1899, the British initiated a war in South Africa that was supposed to end by Christmas; instead, it took a half-million imperial troops three years to subdue as few as 88,000 Boer irregulars. By contrast, in 1898 American forces needed only five months to humble Spain in "a splendid little war," the jubilant expression of John Hay, then U.S. ambassador to the Court of St. James's. As Hay later wrote to President William McKinley, "We have never in all our history had the standing in the world we have now." The swift victory led to the acquisition of the Philippines, Guam, and Puerto Rico, signaling America's debut as a global power willing and able to pry open doors, especially in Asia. With the passing of Queen Victoria in 1901, it seemed to many that the United States might rightly share, or even inherit, her expansionist scepter.

Many Americans, but by no means all, were believers. Prominent dissenters included Mark Twain, William James, Andrew Carnegie, and William Jennings Bryan. So divided was the Senate over ratifying the Spanish peace treaty that the nays were but two votes shy of the one-third margin needed to block ratification. (What helped tip the balance was a poem by Rudyard Kipling appealing to Americans to "Take up the White Man's burden," especially in the Philippines; the bard of empire

God of Wealth, famille verte *enameled porcelain, Kangxi period, bequest of John D. Rockefeller Jr. to the Metropolitan Museum.*

had shrewdly mailed his verse to Theodore Roosevelt, who forwarded it for prompt publication in the ardently expansionist *New York Sun*.)

The celebratory mood was given full-throated expression in Philadelphia by New York Senator Chauncey Depew at the Republican National Convention in 1900. "There is not a man here that does not feel 400 percent bigger than he did in 1896," the senator asserted, pausing, one safely assumes, for roars of approval: "Bigger intellectually, bigger hopefully,

bigger patriotically, bigger in the breast from the fact that he is a citizen
of a country that has been a world power for peace, for civilization, and
for the expansion of its industries and products of its labor." (As chief
legal henchman to Cornelius Vanderbilt, Depew himself was president or
board member of a dozen railroads.) By acclamation, the delegates nomi-
nated President William McKinley for a second term, although misgiv-
ings were expressed about his brash running mate, Governor Theodore
Roosevelt. "Don't any of you realize," confided a worried Mark Hanna,
an Ohio industrialist and leading party fund-raiser, "there's only one life
between this madman and the Presidency?"

However, by 1901 the horizon no longer seemed so cloudless. The
act that Hanna feared occurred in September when a deranged anarchist
fatally shot McKinley in Buffalo, New York, elevating "that damned
cowboy" (Hanna's phrase) to the presidency. An activist reformer as
well as fervent neoimperialist now reigned in the White House (a term
popularized by Roosevelt). Theodore Roosevelt's seven years in the
bully pulpit (his coinage) coincided with the peak years of journalistic
muckraking (also his coinage), during which popular national maga-
zines published reams of articles assailing suspected malefactors of great
wealth (ditto).

Moreover, in 1901, two mergers occurred that quickened doubts
about the new plutocracy, yet soon proved beneficial to collectors and
sellers of the fine arts, including Chinese porcelain. On March 3, J. Pier-
pont Morgan informed Wall Street that he had assembled the U.S. Steel
Corporation, capitalized at $1.4 billion, the world's first enterprise to sur-
pass the billion-dollar mark. This meant, as Jean Strouse notes in her
comprehensive biography, that Morgan's "giant holding company would
own steel mills, blast furnaces, coke ovens, ore mines, barges, steamships,
thousands of acres of coke and coal land, and several railroads." U.S. Steel
would thus control and produce almost half of America's steelmaking
output—the equivalent of 7 percent of the country's gross national prod-
uct in 1901. (In present-day values, its capitalization would be as much
as $500 billion.)

On October 9, in a very different but likewise auspicious merger,
John D. Rockefeller Jr., the sole heir to his father's petroleum fortune,
married Abby Greene Aldrich, daughter of Senator Nelson Aldrich, at
a modest church in her father's hometown of Warwick, Rhode Island.
This allied the Standard Oil dynasty with the acknowledged Republican
master of the U.S. Senate. As the muckraking journalist David Graham
Phillips (author of "The Treason of the Senate," an article published in

Cosmopolitan in March 1906) saw it, "Thus the chief exploiter of the American people is closely allied by marriage with the chief schemer in the service of their exploiters." No doubt hyperbolic, but it is relevant to our subject that the aging Morgan and the young Rockefeller shared a common passion for collecting Chinese porcelain. With their encouragement, and to the benefit of all collectors, dealers, and museums, Congress in 1909 approved the Payne-Aldrich Tariff Act.

As crafted by the Senate Finance Committee, chaired by Nelson Aldrich, this otherwise protectionist measure simultaneously eliminated all tariffs on artworks more than a century old. When critics objected that such art was mainly purchased by the rich, who could afford the duties, a rejoinder was offered by Republican senator Henry Cabot Lodge Sr. of Massachusetts: "These works of art, brought in by individuals, have in the history of all countries inevitably found their way to museums and other places where great works of art are preserved for the benefit of the entire public." Less predictable was the approving comment of Senator Benjamin Tillman, a South Carolina Democrat and sometime populist known as "Pitchfork Ben":

> I had the opportunity to visit the great art galleries of Florence, Paris and London. . . . I saw enough to convince me that the American people can afford to encourage the importation of some of those masterpieces, something we can get as a means of elevating the thought and inspiring the artistic genius of our people. . . . If you want to whack these multimillionaires, cut out some of the special privileges you are giving them elsewhere in the getting of money, but if they want to bring anything from abroad here which is worthwhile, let them do it. They will in time die out, and an art gallery will become, in all probability, the legatee of their collection.

So it proved, and the flow of gifts to museums was further widened by the Revenue Act of 1917, which permitted a special exemption from the recently introduced federal income tax for donations to nonprofit institutions "operated exclusively for religious, charitable, scientific, literary or educational purposes." Every American museum thereafter benefited; similar exemptions were then approved from federal inheritance taxes. Whatever the objective merits of these distinctly American incentives, it surely mattered that John D. Jr. and Abby were in family contact with Senator Nelson Aldrich, also known as "The General Manager of the Nation" (David Rockefeller's version) or as "The Political Boss of the United States" (the muckraker Lincoln Steffens's phrase). For his part,

J. P. Morgan had long made clear that the bulk of his art collection would remain in Europe until it could enter American ports duty-free. When Payne-Aldrich was approved, Morgan invited customs inspectors to appraise his works as they were packed and shipped directly for storage at the Metropolitan Museum, of which he was then president. Under the supervision of the prominent dealer Jacques Seligmann, 351 cases of duty-free works arrived at the museum in 1912–13. Indisputably, these tariff and tax incentives approved by Congress became the vital propellant for the dramatic ascent of America's fledgling public galleries.

If the Internal Revenue Service figuratively became the Maecenas of the republic's art museums, in a parallel phenomenon a single family emerged as America's Medici—the apt title of Suzanne Loebl's chronicle of the dynasty and its benefactions. As she reminds us, the landscape of New York City would be very different minus the dynasty's creations, which include the sleek Chase Manhattan Bank in downtown Manhattan and midtown's Museum of Modern Art, Rockefeller Center, the United Nations headquarters, the Asia Society, Lincoln Center, and Rockefeller University, continuing uptown to the medieval Cloisters and Riverside Church. All bear the dynasty's stamp. Museums elsewhere that the family helped create or assisted can be found in California, Rhode Island, Texas, Vermont, and Virginia (including its reborn colonial capital, Williamsburg). To this list, we would add Olana, the evocative riverside home of the master landscape artist Frederic Edwin Church, preserved intact in the Hudson Valley owing to the personal intervention of then-governor Nelson Aldrich Rockefeller.

In the same seignorial tradition, the family jointly created Kykuit (Dutch for "lookout"), an imposing estate crowning 250 hilltop acres in the Pocantico Hills near Tarrytown and Sleepy Hollow in the Hudson Valley. John D. Rockefeller Sr. acquired the land in the 1890s, and Junior and Abby gained his consent to build, beginning in 1904, a three-story Georgian manor house amid elaborate Italianate gardens, designed chiefly by William Welles Bosworth, the eminent Beaux Arts architect. When completed, the gardens included fountains, grottoes, pergolas, temples, running streams, classic statuary, topiary bushes, and a Japanese teahouse—a list that conveys the couple's commitment to any arts project that engaged their enthusiasm. To furnish their manor, Junior and Abby turned for advice to Ogden Codman Jr., coauthor with Edith Wharton of the contemporary handbook for the wealthy householder, *The Decoration of Houses* (1902). Over time, the woods and gardens became the Rockefeller State Park, while the residential complex passed to the National

Trust for Historic Preservation. Hillcrest, a more recent mansion and once the home of Martha Baird Rockefeller, the widowed Junior's second wife, now houses the Rockefeller Archives, where the family's papers are accessible to researchers (who by arrangement are whisked by minibus to Kykuit from the Tarrytown rail station).

There, in meticulously sorted folders, one can trace, invoice by invoice, nearly every purchase made by Junior and Abby, and the extensive correspondence that led to the many benefactions that followed. Both the spending and the giving reflected the bipolar morality of what is remembered as the Progressive Era. On the one hand, the lords of industry and finance flourished as never before, yet on the other hand—also as never before—they were beset by a barrage of critical journalism and indignant oratory. In the case of the Rockefellers, one event in particular proved a powerful catalyst: the Ludlow Massacre, as it was commonly known.

In September 1913, some nine thousand miners went on strike in the southern Colorado town of Ludlow, their principal adversary being Colorado Fuel & Iron, a company whose principal shareholder (40 percent) was John D. Rockefeller Sr. Months of violence followed; the state governor summoned the National Guard, and in the ensuing pitched battle, scores on both sides were killed, including eleven women and children who suffocated in a burning tent. "It was a terrible tragedy," David Rockefeller writes in his memoirs, "and because the name Rockefeller evoked such powerful emotions, Grandfather and Father were dragged into the middle of the conflict. There were even demonstrations outside our West 54th Street home denouncing the Rockefellers for the 'crimes' of Ludlow." Junior spoke vigorously in the family's defense and turned for counsel to Ivy Lee (cofounder, with Edward Bernays, of modern public relations), who advised candidly addressing the grievances of the strikers. "Ludlow was a rite of passage for Father," affirms his son David. "Although not a businessman by talent or inclination, he had demonstrated his skill and courage. What must have impressed Grandfather most was Father's determination and strength of character under very trying circumstances." As a result, Grandfather changed his will; he had intended to bequeath the bulk of his estate to philanthropic purposes, but in succeeding years he transferred most of his wealth directly to his son.

ALL THIS WAS IN THE foreground while John and Abby furnished their residences in New York City and the Hudson Valley, to which a third domicile was added in 1911: the sixty-six-room Eyrie "cottage" in the Norman French style on Mount Desert Island in Maine. As Joseph

Duveen, the prince of art dealers, liked to remind his colleagues, nothing sharpened buying appetites more keenly than an empty living room.

Both Junior and his wife, Abby, lived on an ample but fixed budget after they moved in 1911 into what was (then) the largest private residence in New York City. Its nine floors on 10 West Fifty-Fourth Street included a squash court, a gymnasium, and a private infirmary, as well as ample quarters for their multiplying offspring. "The house was filled with art from many parts of the world," recalls David Rockefeller, the youngest of their six children, "the style and period of which reflected my parents' very different tastes and personalities. Mother's taste was eclectic and ranged from the art of the ancient world to contemporary work from Europe and the United States. . . . Father disliked modern art. He considered it 'unlifelike,' ugly, and disturbing, and discouraged Mother from hanging contemporary art in those areas of the house he frequented." With an irony that Junior probably did not savor, the Rockefeller residence was razed in 1938 and its land made available for the outdoor gardens of the Museum of Modern Art (known in the family as "Mother's Museum," since Abby was its single most consequential patron).

What kind of art appealed to Junior? "Father's pride and joy," reminisces David Rockefeller, "was his comprehensive collection of Chinese porcelains from the Ming and K'ang-hsi dynasties. . . . To this day I have a picture of him in my mind, examining the porcelains he was thinking of buying with a magnifying glass to ensure they had not been broken and restored. Mother also loved Asian art, but she preferred the ceramics and sculptures of the earlier Chinese and Korean dynasties, as well as Buddhist art from other parts of Asia. She had what we called 'the Buddha room' in Number 12, filled with many statues of the Buddha and the goddess Kuan-Yin, where the lights were kept dim and the air heavily scented with burning incense."

This fairly defines the aesthetics of the most formidable American couple to gather and treasure Asian art in the last century. Each had moments of fulfillment that helped define prevailing American tastes, as well as the market value of a then-exotic species of art. Their different tastes reflected their temperaments. Abby was the second of eleven children, and she bonded closely with Lucy, the eldest. The two traveled periodically to Europe during Senator Aldrich's holiday voyages, and early on they shared a fascination with Asia and its art. As adolescents, the sisters began collecting Japanese prints, along with Chinese, Japanese, and Indian textiles—and Persian and Mughal miniatures. As a member of a large and voluble family, Abby was gregarious and impulsive. By contrast, as

the sole male heir of a controlling father known for his boundless wealth, Junior was reserved and cautious.

This difference was evident in the objects they collected. Together Abby and John searched for furniture and ornaments for their just-built brownstone. It chanced that the New York showroom of the Duveen Brothers was but a few blocks away on Fifth Avenue. Junior frequently dropped in at the fashionable gallery. As Suzanne Loebl writes, "One day, as he was searching for objects with which to decorate a large mantelpiece, he was offered two tall Black Hawthorn vases, created in China during the Kang-hsi period, between the 16th and 17th centuries." It was the spark; over a fifty-year period, Junior would purchase more than four hundred Chinese porcelains, continually sifting and upgrading, spending in excess of $10 million.

Most especially, young Rockefeller was enthralled by the peerless collection assembled by J. Pierpont Morgan, then on display at the Metropolitan Museum of Art. In 1915, it developed that the late J. P. Morgan's vast collection of Chinese porcelains, then on loan to the Metropolitan, had been sold in its entirety for more than $3 million to the Duveen Brothers. Junior wished to buy its choicest specimens and appealed to his father for a substantial loan: "I have made many visits to the Museum, and I have studied carefully the important pieces. I have also sought expert advice regarding them. Such an opportunity to secure the finest examples of Chinese porcelains can never occur again, and I want to avail myself of it." Father was not persuaded: "I feel afraid of it. This may be in part because I am not so well informed in regard to their value. It would seem to me wiser not to make this investment now."

In defending his request for a one-million-dollar-plus loan, Junior's justification is both a credible definition of his own character, while more generally expressing the serious collector's eternal cry for understanding in a philistine world:

> I have never squandered money on horses, yachts, automobiles or other foolish extravagances. A fondness for these porcelains is my only hobby—the only thing on which I have cared to spend money. I have found their study a great recreation and diversion; and I have become very fond of them. This hobby, while a costly one, is quiet and unostentatious and not sensational. I am sure that if I had the actual cash on hand, you would encourage rather than discourage my development of so innocent and educative an interest. The money put into these porcelains is not lost or squandered. It is all there, and while not income-producing, I have every reason to believe that even at a forced sale,

I could get within ten percent of what these things would cost, while a sale under ordinary circumstances would certainly realize their full cost value, and as years go by, more. . . .

Is it unwise for me to gratify a desire for beautiful things, which will be a constant joy to my friends and to my children as they grow to appreciate them, as well as myself, when it is done in so quiet and unostentatious a manner? . . . Much as I want to do this thing—and I think you do not realize how much I should like to do it, for you do not know the beauty and charms of these works of art—I want more to do what you fully approve, so I have ventured to write this long letter, hoping that perhaps this fuller statement of the situation may lead you to see it in a somewhat different light.

Deeply moved, Father relented, and $2,000,000 worth of securities was forthcoming. When Junior approached Senior to arrange the terms for the loan, he was told that the money for the porcelains would be a gift. As David Rockefeller relates, following the purchase of a substantial portion of the Morgan collection, "Father maintained his interest in these beautiful objects for the rest of his life. Many of the K'ang-hsi pieces were huge beakers, taller than I was as a boy. They stood on specially made stands and were conspicuously displayed in several rooms on the second floor of Number 10. They looked very imposing—and overwhelming. He also bought many smaller pieces, including figures of mythical animals and human figures that were delicately painted and beautifully wrought."

Concerning the appeal of Chinese porcelains, Ron Chernow, Senior's recent biographer, offers a plausible insight: "For Junior, they represented an ideal art form, for they were expertly crafted and devoid of any subversive themes or sensuality." Yet their allure did have a certain sensuality, Chernow also notes: "When Junior received the porcelains at West 54th Street, he sat down on the floor, rolled them about, fondly studying them and searching for cracks or marks of repair." At the same time, reflecting his rigorous Baptist upbringing, Junior confessed to feeling guilty about his hobby: "I had a feeling that perhaps it was a little selfish. I was buying for myself instead of giving to public need." To this, Chernow adds an interesting observation: "Had Junior not established at this point his right to collect art, free of parental interference, he might never have been emboldened to create The Cloisters or Colonial Williamsburg."

In retracing John D. Rockefeller Jr.'s efforts to upgrade his Chinese porcelain family, no episode is more intriguing than the Affair of the Yellow Beaker. It is a mostly forgotten story, with a sadly dramatic ending. It

began in early 1915, when Junior was invited to examine a yellow-ground vase of the Kang-hsi period, then deemed the acme of the genre. Along with the vase came a letter signed by Edgar Gorer who shared premises with Dreicer & Co., a luxury jeweler. "When studying it," Gorer wrote, "I suggest that you walk slowly around the vase and you will find three distinct subjects, yet all harmonize splendidly. I regard the rocks with pheasants as the front of the vase. Going around to the right of it, you will find the large double cherry tree, and on the back the imposing magnolia. Standing a little distance from the vase and regarding the branch of double cherry which extends over the neck, you will find it gives a distinct feeling that the blossoms are absolutely on their stem in the air."

"I hope I am right in thinking that you and Mrs. Rockefeller will spend quite an enjoyable time in the company of this treasure," Gorer concluded. They were indeed fascinated. But who was Gorer? And how did he acquire this prize? Born in Brighton, England, in 1872, Edgar was the son of a Jewish-Dutch silversmith (origins similar to Joseph Duveen's) who specialized in jewelry, so successfully that Solomon Gorer & Son in 1895 moved their showroom from London's Strand to New Bond Street, the Grand Bazaar for financially privileged shoppers. As the new century commenced, Edgar flourished as a specialist in Chinese art and interior design.

Fine, but were his wares genuine? On February 19, Junior asked Gorer "to state all that you know with reference to the history of the yellow beaker . . . giving the name of the owner from whom you bought it, how long it had been in his possession, where he obtained it, and any further point with reference to its history which you have?" The following day, Gorer replied that he first learned about the beaker from another dealer just eighteen months earlier and was told it belonged to an old French family. When it was shown to him in England, "after a careful examination, I at once purchased it. This is all I can give you as regards the source of its origin."

Unsatisfied and wary, Junior on February 24 informed Gorer that his asking price ($125,000) was excessive. "The large yellow beaker is interesting," he acknowledged, adding, "The color of this glaze is yellow rather than white. This seems unusual; it suggests re-firing. The vase is so perfect in many respects that I cannot rid myself of the feeling that there is a bare possibility of its being modern." Thus prompted, Gorer then sent a copy of this cable to the dealer who sold it to him, Alfred DePinna, at 12 Devonshire Place, London: "Can you give name and former owner of yellow beaker. Also history and further information." On March 8, he

forwarded to Junior the response from DePinna, asserting that the beaker came from the Imperial Palace of Jehol, and had been spirited to England following the outbreak of the Great War. As Gorer elaborated:

> On Saturday I consulted two Chinese dealers, namely Mr. Loo and Mr. Kuan Fu-Ts'u, men of the greatest experience in old Chinese porcelains, and whilst I knew the former, I have never met the latter till two or three days ago . . . and [every] statement I have made to you will bear the strictest investigation. Do please forgive me if you find that I am rather strong in this statement, but I really feel that my own character is being attacked and I have done all in my power to establish my bona fides in every way.

By this time, Gorer was incensed to discover that he apparently was being accused of peddling fakes by his archrival, Joseph Duveen. Possibly as a result, Junior then wrote on March 16 that it was hard to have confidence in someone who tells such different stories about the origin of the yellow beaker: "If at any later time its origin and history were to be established satisfactorily, the question would take on a different aspect. I am sure you understand that I do not for a moment question your belief in the genuineness of the beaker. You know, however, as well as I do, that even the ablest experts may sometimes make mistakes, and where any doubt exists, one's enjoyment of the article in question would be greatly diminished."

Gorer's response was twofold: he secured from John C. Ferguson, a longtime resident of China then living in Massachusetts and an authority of acknowledged expertise, a letter attesting to the yellow beaker's authenticity. The matter was still in the air as Gorer made arrangements for returning by passenger liner to Great Britain. Before departing, the dealer filed suit against the Duveens, claiming $575,000 in damages for uttering allegedly slanderous statements about his expertise, such as this remark reputedly made to Henry Clay Frick by Joseph Duveen: "Gorer knows nothing about porcelains. The real judges are ourselves, my uncle Henry and me, and we intend stopping Gorer putting these fakes on the market." (Frick, too, had been offered the yellow beaker, which Duveen purportedly dismissed as a modern copy.)

News of the lawsuit made the front page of *The New York Times* on May 7, 1915, attesting both to the prominence of the House of Duveen and to the amount sought in damages. However, by grim coincidence, the same day the story appeared, Gorer was among the 1,201 passengers who perished when a German U-boat torpedoed the *Lusitania* as

the great passenger liner neared the Irish coast. He was among nine art dealers on the fatal voyage, of whom only four survived. According to witnesses, as the ship began sinking, Gorer gave his own lifebelt to the opera singer Josephine Brandell, saying, "Be brave."

So what happened to the yellow beaker? It remains an unsolved mystery.

Abby Aldrich Rockefeller, who had a better eye for timeless quality than her husband, with one of his Qing vases.

AS ALL THIS WAS OCCURRING, Abby Aldrich Rockefeller was making her own and very different mark. Junior was outwardly impeccably orthodox in his opinions and habits, so much so that H. L. Mencken, then the country's licensed heretic, wrote of him in 1926: "So far as the records show, he has never said anything in his life that was beyond the talents of a Rotary Club orator or a newspaper editorial writer. [Yet] if he fell ill of gallstones tomorrow, or eloped with a lady Ph.D., or fell off the roof of his house . . . at least a billion human beings would show some interest in it [since] he happens to be the son of old John and hence heir to a large fortune." Still, this does less than justice to Junior, who during the Ludlow Massacre sought to empathize with Colorado's genuinely exploited miners, who took an informed interest in everything Asian, and who took care to share his masterworks of art with ordinary citizens.

Moreover, even Mencken might have allowed that the tired cliché about the attraction of opposites was interestingly confirmed by Junior's marriage to Abby, a social, aesthetic, and political liberal. Concerning their differing taste in art, a truce prevailed. Influenced by her adolescent trips to Europe, and by her exploration of New York's adventurous art world (a highlight being the unsettling 1913 Armory Show), Abby became an early recruit to the avant-garde. She tried repeatedly to open Junior's eyes to the merits of the modernists, a memorable instance being a dinner party she arranged for Henri Matisse during the artist's 1931 visit to America. Frank Crowninshield, a collector and Francophile as well as editor of *Vanity Fair,* was among the guests and later described this singular encounter in an article for *Vogue* (of which he later would become editor). In his account, Matisse was impressed by Junior's excellent French and by his splendid Chinese porcelains and Polonaise rugs in the spacious dining room. Then, after coffee, Matisse turned to Junior and "began half-seriously to plead his cause, to explain that the men who had created the incredibly beautiful green, yellow, red and black porcelains [that surrounded them] were really in pursuit of exactly the same aesthetic goals as those to which Matisse had personally dedicated himself. He tried to persuade him that Braque, Picasso, Juan Gris . . . had merely followed the decorative designs and emotive experience of the Persians who had designed what Matisse called Mr. Rockefeller's 'modern' rugs."

In sum, Matisse concluded, "there was no such thing as modern art or ancient art." Indeed, the "deadliest art imaginable was that of the hack painters who now flourish in so many of our academies." One can imagine

the expectant hush as the guests looked to their host for a response. According to Crowninshield, Junior declined to be convinced, but said that Matisse "must not altogether despair because . . . he suspected that Mrs. Rockefeller, thanks to her very special gifts of persuasion, would eventually wear him down to the consistency of jelly."

Let it be added in Junior's behalf that although their tastes differed, he did not oppose Abby's choice of artworks that he disliked. A revealing instance occurred following the couple's 1921 far-ranging Asian trip that took them to China (to dedicate the Peking Union Medical College, partly funded by the Rockefeller Foundation) and to Japan, Hong Kong, Manchuria, and Manila. As Loebl writes, their trip "proved immensely satisfying and would kindle a multigenerational passion for Asian art. In China, Junior immersed himself in viewing and buying more porcelain. The party visited the Ming tombs, whose majestic Spirit Path was in disrepair. Upon his return to the United States, Junior contributed funds for its restoration."

Also on their return, Abby expanded her Asian collection, much of it acquired from Yamanaka & Co., which had showrooms in both New York and nearby Bar Harbor. In 1924, she persuaded Junior to approve her choice of two Buddhist figures offered by the New York gallery. Abby was captivated by an armless and headless white marble Tang dynasty bodhisattva, said to have been found in the Ling Yen Temple in the Ling Yen Mountains in the province of Chi-li. However, Junior balked at the $30,000 asking price for the pair. As he put it in a letter to Yamanaka, "While Mrs. Rockefeller would like to buy these statues and while I am somewhat drawn to the standing figure of Quan [*sic*] Yin, I have never enjoyed a mutilated statue, and therefore find it hard to reconcile myself to the other figure, without arms or legs." He then offered a net price of $25,000 in cash for both, "in deference to Mrs. Rockefeller's feeling." The offer was accepted.

This single purchase helps define the couple's contrasting approach to Asian art. Junior's preference for porcelain with an imperial pedigree reflected his admiration for the Confucian valuation of rules, hierarchy, and workmanship, while Abby tended to Buddhist elasticity, sensuality, and universality. Not only did the headless bodhisattva fuse these qualities, but its aesthetic harmonized with modern art.

Indeed, the tantalizing Tang figure was special, and it caught the eye of every visitor to the couple's home in Manhattan. In 1935–36, it was put on public display for the first time when it was shipped to London on loan to the Royal Academy Exhibition of Chinese Art at Burlington

House. After examining the sculpture, the Academy's distinguished board of experts informed Abby that it was "without doubt the most beautiful Chinese figure in existence." In the view of one of the board's members, Sir Percival David, the leading Western collector of Chinese ceramics, the bodhisattva's grace and movement owed much to the artistic heritage of Greece: "It is from Greece that it derives the clinging folds of its drapery; it is India which has inspired the swaying poise of the body and its sensuous modeling. But it is the genius of China which has breathed into the figure its vitalizing spirit."

When the Metropolitan's curator of Asian art, Alan Priest, reviewed Junior and Abby's holdings, he singled out the headless sculpture as a work he especially hoped they might donate to the museum. Instead, it was bequeathed to Nelson Aldrich Rockefeller, a fervent admirer, who enthroned it where it now reigns, high above the Hudson River on a pedestal facing the entry to Kykuit. Yet judgments change, and Duke University's Stanley Abe, an expert on Buddhist sculpture, wonders whether the figure is too good to be true. Writing in 2011, he acknowledged that the sculpture is "dazzling," but also claimed that it has been insufficiently examined by specialists. It has no parallel with other known examples of Tang sculptures and thus is indeed "absolutely unique," just as its admirers claim. "The work is a fascinating and breathtakingly beautiful sculpture on its own terms, but not typically Tang by any means. Rather, its appeal to the early twentieth century taste for classical forms belies a modern conception, if not origin."

To which one can justly add that these are familiar shoals that beset art collectors fishing for prize works in muddy waters. Moreover, standards of expertise, no less than of taste, change with passing decades, an example being the porcelains that Junior prized. In Professor Abe's judgment, "No art collection is made without misgivings. In the case of the headless, armless bodhisattva, Junior's lack of enthusiasm may have been as unconsciously prescient as Senior's discomfort regarding Chinese porcelains. Thus, while their misgivings were not based on 'skill made up of cultivation and judgment,' each expressed uncanny doubts about objects that experts with a 'feeling for beauty' touted as masterpieces. It is at such moments that the construction of social distinction through home decoration and art collecting flounders on the inconstancy of judgments of beauty, authenticity, and value—hence the often short-lived appeal and peripatetic lives of so many objects of art."

Thus do monetary as well as aesthetic values fluctuate erratically, no matter how prudent the buyer, as Junior himself discovered. Once

embarked on the collector's winding journey, he was wary of attribution, was suspicious of puffery, and continuously sought the best available advice—in his case, his longtime counselor was Theodore Hobby, the former advisor to Benjamin Altman and the Metropolitan's associate curator of Asian art. (For his services, Hobby received an annual honorarium from Junior in the form of shares; from 1915 to 1955, their total value was reckoned as $40,500.) All Junior's purchases were subject to negotiation regarding prices, with the option of exchanges or returns.

A letter to Mr. Miya at Yamanaka, dated January 20, 1925, is typical of hundreds that a researcher is likely to encounter at the Rockefeller Family Archives:

> My offer of $175,000 for two Chinese Gilt Bronzes was net. This figure is, I am led to believe, above what any museum would pay. Moreover, I think you will agree that another buyer at that price would be difficult to find. I feel sure that if your associates in Japan understood that it is a cash offer and that I will draw immediately my check to your order for the full amount should you find that you can accept my proposition, they will not let the five per cent Government tax cause the trade to fail. As you know, the bronzes do not appeal to me as they do to Mrs. Rockefeller, but I have been willing to buy them at this price to please her. My offer of $175,000 will hold good until Monday.

Yamanaka caved; their response was immediate: "Thanks you for this and congratulating Mrs. Rockefeller on securing these world-treasures for her already wonderful collection." Despite his prudence and bargaining skills, Junior's porcelain collection had, so to speak, a measureable shelf life. A research report on the market's mutability was recently compiled by Daisy Yiyou Wang, for the Rockefeller Archive Center. From the 1910s onward, she found, Junior and Abby were wooed by a network of international dealers of Chinese artworks, including Duveen Brothers Inc., C. T. Loo & Co., Ralph M. Chait, Yamanaka & Co., Dikran G. Kelekian, Ton-Ying & Co., Edgar Worch, Parish-Watson & Co., and the ill-fated Edgar Gorer.

Objects were frequently sent for approval with the hope that familiarity would breed covetousness. To inflate asking prices, dealers provided what appeared to be reputable origins for an offered object, playing down likely looting and adding optimistic imperial pedigrees. Knowing dealers were often short of cash, the Rockefellers for their part sought discounts,

paid in full immediately, and helped publicize and on occasion finance their business; indeed, as Dr. Wang writes, "C. T. Loo ingeniously turned the Rockefellers' impressive family gallery into his show room by placing his objects in their collection and by bringing the buyers to visit their home. Dealers also took advantage of the visibility of the Rockefellers' important art acquisitions; their purchase of a rare bronze from C. T. Loo stirred a media sensation." On one occasion, Loo delivered two choice bronzes to the Hotel Plaza-Athénée, where John and Abby customarily stayed while in Paris, for their study and enjoyment over a weekend. The dealer's romancing of the Rockefellers was accompanied by doses of flattery and hints of his legal difficulties. Thus in 1930, he described a pair of objects with animal motifs, then noted that "because of our troubles last year with the Chinese government, we have kept them without showing to anybody [yet], but they are so rare and great as art. I will be happy to show them to you when I will be in New York; they are in the storage unpacked." As to flattery, in a letter to John Jr. in 1926, he thus lauded the family's collection: "[I]n preserving them for the posterity, you are doing a welfare for the world. I hope [that] rare works will be preciously kept in your great family for ten thousand years."

Still, even though Junior bargained firmly, studied seriously, and kept abreast of changing taste, the sale value of his collections grievously slumped. His most celebrated single acquisition was his purchase in 1915 of the choicest items in the J. P. Morgan Collection for $1,657,234.50. Yet when he had the same objects appraised for estate purposes in 1944, Junior acknowledged that no dealer then would pay more than $25,000 for vases valued at $100,000 or $75,000 three decades earlier. Both prices and taste had changed; collectors were bidding less for highly decorated Ming and Qing vases, and more for simpler, purer, and far older porcelains or stoneware.

This in no way diminishes Junior and Abby's collecting instincts, or the enduring worth of their donations, which enrich the Chinese collections at the Metropolitan Museum of Art and the Asia Society (among others). Among the porcelains in the Metropolitan are figures said to represent the civil and military aspects of the Daoist god of wealth, Tsai Shen (Caishen). As Fong Chow, then an assistant curator, wrote in the museum's *Art Bulletin,* "There is no deity more worshiped than Tsai Chen, for his shrine is found in many homes in China. In a Chinese color woodcut, the civil and military gods of wealth are depicted enthroned; the military god holds a whip-like weapon while the civil god holds the

scepter which grants every wish." Thus in a temple consecrated to the synergy of art and wealth, one can sense both aspects in these royally garbed, shrewdly smiling divinities that gaze cryptically at the museum-goer through the veil of a vitrine. These godlike figurines were said to be among Abby's favorites. And deservedly so.

CHAPTER ELEVEN

THE MANDARIN

China's past is mostly a blank even to otherwise literate North Americans. Understandably so. Typically, the curious, well-intentioned foreigner is deterred by a maze of unfamiliar names clustered into a dozen dynasties, centered in a scattering

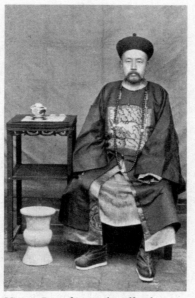

Viceroy Duanfang, in his official
Mandarin regalia, circa 1909.

of capitals, and spread over more than two millennia. Nevertheless, certain truths have permeated the Western consciousness: that China is enclosed within a Great Wall, and that among its gifts to the world (not always acknowledged) are paper and printing, the magnetic compass, canals and locks, gunpowder and rockets, porcelain and silk, acupuncture and herbal remedies, and (arguably) noodles.

Yet too little is commonly said about China's equally interesting and impressively durable political invention: the creation, more than a thousand years ago, of a meritocratic governing elite selected through (theoretically) impartial tests. Our concern in this chapter is with an outstanding latter-day product of this system: the reforming mandarin Duanfang, among China's leading progressive statesmen during the last years of the Qing dynasty, but also an exceptionally discerning collector who did more than anyone to establish the aesthetic merit of ancient bronzes. He was as well one of the last outstanding scholar-officials known as *wenren,* or "literati." They were mostly chosen through an elaborate examination system that evolved into "an enormous and intricate institution central to upper-class life," elaborated in the Song dynasty (960–1279 CE), rated as "China's greatest age" by Harvard's premier Sinologist, John King Fairbank.

What SAT scores are to today's American high school students, imperial exams were to China's ambitious youngsters—a nationwide merit system that (at least in theory) enabled bright male students to leapfrog class barriers. As formalized during the Song dynasty, when printed books were invented and disseminated, pupils were tested locally, regionally, and finally at the palace level. "The examiners had to take precautions against cheating," writes Professor Fairbank, "and so used devices such as searching candidates on entrance, putting numbers instead of names on their papers, and recopying papers to prevent readers from recognizing the writers' calligraphy." The highest rank was that of the *jinshi,* "a presented scholar" (roughly similar to an Ivy League college's summa cum laude), which guaranteed a top-level government position. Held triennially, the palace exams took three days and two nights, during which candidates were isolated as they wrote the "eight-legged essays" meant to show their mastery of Confucian classics. Grading was rigorous. Only 5 percent of those sitting for the examinations passed them.

Yet in reality, the system perpetuated a mostly hereditary governing caste, since incumbents became expert at tutoring their offspring in the Confucian classical texts essential to qualifying for the exalted imperial academy—not unlike France's *grandes écoles,* whose students, often

born of privilege, vie for a diploma nicknamed "the Mandarin's Button." Whatever its palpable deficiencies, China's examination system endured until 1905, when leaders of the embattled Qing dynasty abolished the traditional exams, citing their outdated stress on classical topics and neglect of sciences. Thereafter, students were either taught in newly created Chinese schools or sent abroad to study.

No mandarin better illustrated the paradoxes of the imperial system than Duanfang (Tuan-Fang), a frustrated reformer who came to a macabre end while serving the collapsing Qing dynasty. Just where he stood tended to be ambiguous. According to his recent biographer, Elya Jun Zhang, Duanfang was a gifted networker who earned the title of her 2008 dissertation, *Spider Manchu*. Even his ethnicity remains murky. According to Zhang, his family belonged to the ruling minority Manchu elite, his father having served as a prominent magistrate while his uncle Guiqing (Kuei-ch'ing), a *jinshi* degree holder, had been a tutor to the emperor. Others, notably including the veteran scholar Thomas Lawton, assert that in fact his Han ancestors defected to ascendant Manchuria during the late Ming period, having "naturalized" their surname, Tao, to the Manchu clan name Tohoro, when its males then enlisted in the Plain White Banner, one of the imperial army's eight banners (i.e., military units) in which genuine or putative Manchus were organized.

Still, whatever Duanfang's ancestry, he inarguably excelled as an official during a chaotic era. After surviving the provincial exam, he was awarded the *juren* or "recommended man" degree in 1882 and was serving as magistrate and deputy governor of Shaanxi (Shensi) in 1899–1900, the years of the Boxer Rebellion. During that testing crisis, Duanfang successfully protected local missionaries as well as those fleeing other provinces, ignoring edicts to the contrary from Peking. His ability to switch sides was demonstrated afresh when Western-led forces stormed Peking, slaughtered the Boxers, but allowed Dowager Empress Cixi, Emperor Guangxu, and the court to flee to Shaanxi, in hopes of finding asylum in the celebrated ancient capital of Xi'an. Zhang describes what greeted the bedraggled imperial party when it reached the Huang River, which formed the province's boundary:

Three huge ships decorated with brocades carried them across the waters. When they disembarked on the other side, Cixi and Guangxu were welcomed by cheers of "long live the emperor" from thousands of Shaanxi residents. Duanfang, deputy governor and provincial judge of Shaanxi, handled all the proceedings meticulously. He then guided the Empress Dowager to

a temporary dwelling place in Xi'an, which was like a miniature Forbidden City, and arranged for a sumptuous imperial-style dinner after that. The peaceful situation in Shaanxi must have seemed like a godsend to Cixi and the imperial court after months of fleeing from Beijing to Xi'an. The imperial court finally decided to settle down in Xi'an, where they would end up staying for almost a year until it returned to Beijing on October 6, 1901.

As a token of her esteem, Cixi awarded Duanfang "ginseng candy from Her Majesty's personal handkerchief," a gesture indicating exceptional favor. He rose through the viceregal ranks, eventually reigning in Hubei, Hunan, Jiangsu, Anhui, Jiangxi, and, finally, Zhili. According to Zhang, who delved into imperial archives, he was "at once an avid tinkerer with new technology, the foremost connoisseur of Chinese antiquities, the drafter of constitutional reform proposals, the leader of the Qing international constitutional delegation, a notoriously effective suppressor of revolutionary uprisings, a diplomat, and a statesman—all rolled into one."

In 1905–6, Duanfang was one of five special commissioners who toured Japan, Europe, and the United States for eight months, their

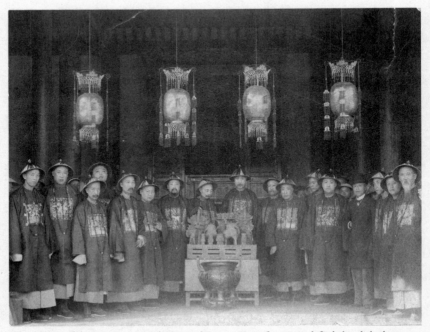

The Chinese delegation visiting the United States; Duanfang is on left, behind the bronze altar, now in the Metropolitan Museum of Art.

mission being to identify usable models for a constitutional regime in China. Yet inauspiciously, when the commissioners gathered at the Peking railway station to begin their journey, a revolutionary terrorist set off a bomb, killing the assassin himself and injuring two of the officials, thereby delaying the mission's departure.

Undaunted, the five emissaries, their fifty-odd attendants, and 750 traveling bags proceeded to Shanghai and embarked for San Francisco, arriving aboard the steamship *Siberia* on January 12, 1906. On arrival, the delegation was greeted with a nineteen-gun salute, streams of welcoming speeches, and a musical reception organized by the city's Chinese merchants. From the Bay Area, the commissioners traveled by chartered rail to Chicago, where their program included meeting Jane Addams and seeing her celebrated Hull House, visiting the stockyards, a hospital for the insane, and the Field Museum of Natural History. Although Duanfang was not formally head of the delegation, he had already become its stellar performer as the mission arrived in New York. Journalists noted Duanfang's tactful judgment in appropriately switching from traditional robes to beribboned military uniforms, depending on the occasion. At every stop, he intuitively knew when to laugh and when to applaud, without waiting for a translator's cue, whether riding a subway car in New York or addressing (briefly) seven hundred guests at a Waldorf Astoria banquet organized by Protestant missionary boards. Though outranked at home by other commissioners, reported *The New York Times*, "Tuan Fang was really the hero of the evening." (A banquet also memorable, the unnamed reporter dryly added, since never before had so many Waldorf diners imbibed "nothing stronger than mineral water.")

In Washington, Duanfang again shone as the delegation met with President Roosevelt at the White House. A letter of formal greeting from China's emperor, bound in yellow silk, was presented to TR, who responded in part, "The kindly sympathy of this country for the Eastern empire has found many opportunities for expression in later years, and I trust that the new century will bring a larger realization of our common desire for peace, prosperity, and advancement of China." One may be sure that during the official luncheon that followed, Roosevelt discussed the proposal for a gallery devoted to Far Eastern art then being advanced by Charles Lang Freer, Duanfang's collecting colleague, in a capital with only one genuine art museum, the privately funded and eclectic Corcoran Gallery (which the commissioners did visit).

Yet there was another, very specific reason for the warm reception accorded Commissioner Duanfang wherever he went. He skillfully fused

politics and art in meeting governors, mayors, educators, and museum directors, frequently presenting ancient ceramics, jades, and bronzes from his own extensive collection. Impressed by the founding plans for Chicago's Field Museum, he went further, sending its curators a Daoist stone stele from his own collection; in return, the Field's staff reciprocated with a small collection of ancient North and South American pottery and baskets woven by the Tlingit Indians. At the Metropolitan Museum, he scrutinized J. P. Morgan's trove of Chinese porcelain and Heber R. Bishop's collection of precious jades. In newspaper reports, a commissioner (most likely Duanfang) is quoted as saying of Morgan's treasures, then on extended loan at the museum, that they probably could not be duplicated at any price.

In truth, Duanfang's curiosity was so voracious, and his networking instincts so strong, that his influence ranged far beyond usual categories. In Chicago, he toured not only museums but also stockyards; he asked questions everywhere about water, canals, and fisheries; while in New York, he visited Standard Oil's refineries in Bayonne, New Jersey. He arranged for a special trip to West Point, in a private railway car provided by John D. Rockefeller Jr., at which he inspected the cadets' dining hall and kitchen (and expressed delight at the automatically opening doors for waiters). Simultaneously, in his dozen visits to major colleges and universities, he stressed the Dowager Empress Cixi's concern with providing scholarships for Chinese women as well as men. The mission, in short, marked the beginning of full-scale cultural exchanges between the newest and oldest of major powers.

His peak years as a collector (1900–11) happened to coincide with China's railroad boom, with the result that workers were uncovering scores of ancient burial sites as they were laying tracks. The Princeton scholar Lara Jaishree Netting cites a highly placed official as saying that "ancient vessels appeared so frequently that one could say they were unearthed in the morning from the farmland and on display by the evening." Rumors circulated that Duanfang was using his position as viceroy to acquire newly excavated antiquities.

Duanfang's collecting interests were various: ancient bronzes, stone steles, jades, rubbings, calligraphy, and painting. He especially favored objects with inscriptions. He was at the center of a circle of friends who researched and collected *jinshi*—objects in *jin* (metal) and *shi* (stone). This interest brought him into productive contact with John Calvin Ferguson, the son of a Canadian-born minister, himself a renowned collector-dealer and an intimate of high-ranking officials. Ferguson met

Duanfang around 1900 and collaborated with him from 1906 through 1909 while serving as a purchasing agent for the Metropolitan Museum of Art. He became a regular guest at the viceroy's gatherings, where specialists viewed and researched the *jinshi* objects.

Many scholars would help the viceroy compile the great 1908 catalogue of his formidable collection (*T'ao Zhai Ji Jin Lu*). Among its distinctions, it was the first Chinese volume to reproduce rubbings of the bronze inscriptions employing the photolithographic process. All this was discussed during Ferguson's frequent visits to the viceroy's residence, of which he later wrote:

> Many an evening in the vice-regal yamên at Nanking, have I sat with him at dinner served on a large Chu-ko Liang drum, ourselves seated on small drums. The uniqueness of such occasions was enhanced by the exhibition of some newly-acquired bronze treasure. He left in his *T'ao Zhai Ji Jin Lu* a complete record of his great collection, but, when looking through this valuable book, I always miss the flashing eyes and nervous movements of the great connoisseur as I can remember him, handling his wonderful bronzes.

These bronzes, it should be stressed, form a special subspecies of Chinese art because of their antiquity, their durability, their inscriptions, and their use as tomb furnishings, thereby becoming silent witnesses to the formative age of a major civilization. Chinese craftsmen mastered the art of making bronze—an alloy of copper and either tin or lead—nearly four thousand years ago. During the Shang and Western Zhou dynasties (ca. 1716–771 BCE), workshops turned out items as diverse as bronze bells, drums, daggers, crossbows, chariot ornaments, surveying instruments, and belt buckles.

Among the most impressive items are the ritual bronzes found in documented tombs, some in royal sites numbering in the hundreds. These were not made for everyday purposes but for use in ritual offerings to ancestors and were placed in family tombs. Ancient ritual texts specified the number and kinds of vessels accorded different ranks of the deceased. Bronze swords, daggers, and axes were also provided to ensure the security of afterlife banquets. But the Shang tombs also bear witness to a grim practice: the immolation of human beings at the founding of buildings as well as at burials. This practice was not reserved for Shang kings, but "spread to other parts of Shang China as well," write Jan Fontein and Tung Wu of the Boston Museum of Fine Arts in their pioneering survey, *Unearthing China's Past*. Nor were the sacrifices commonly voluntary,

since archaeologists in Shensi Province found victims "with bronze bands around their necks to gag them."

In collaboration with Duanfang, John Ferguson led the way in establishing the rules for defining the various genres of Chinese art, especially funerary bronzes. They did so during years when examples of the latter were dismissed by press critics of the Metropolitan's exhibit of Ferguson's purchases as archaeological artifacts, unworthy of being designated as a fine art. In China, Ferguson's expertise was widely recognized, and he became the recipient of many honors, ranging from the Crimson Button, second class, conferred by the Qing dynasty, to the Order of the Sacred Treasure, bestowed by Japan. Yet his honors and his attire were deceptive. As Thomas Lawton writes, "Most people think of John Ferguson as he appears in old photographs—a stately old gentleman, immaculately dressed, an old China hand who spoke elegant Chinese and who had spent the greater portion of his life in China." In the flesh, he was a gregarious political operator, a shrewd entrepreneur, and also a romantic apostle of the Muses (Chinese branch). He startled and annoyed his Methodist superiors by forsaking a missionary career to become a businessman, publish a newspaper, and wage a campaign for non-Christian art. And consequently, thanks not only to his original scholarship but also to his friendship with Duanfang (in Lawton's words), "almost every museum in the world with a Chinese collection contains some artifacts that have passed through Tuan-fang's hands."

As Duanfang's collection waxed, his political career waned. Long disliked by envious rivals, they exacted their revenge following the death in 1908 of Dowager Empress Cixi. Amid a scramble for influence among courtiers, Duanfang was placed in charge of the elaborate funeral rites and then accused of impious sacrilege. Three offenses were cited. Although Cixi and Duanfang on frequent occasions had their pictures taken together, he was now accused of blasphemy for allowing photographers to film the funeral cortege. Worse, he permitted trees surrounding the Sacred Enclosure of the Mausoleum to be used as telegraph poles, offenses capped by his riding horseback while other mourners made their way on foot. According to a contemporary account in *The New York Times,* he had allegedly committed the "greatest breaches against Imperial etiquette," for which his subordinates were given severe prison sentences, even though it was widely believed that jealousy on the part of the consort of the late emperor Tung Chih (Tongzhi) accounted for his "degradation." Duanfang, without fuss, retired as China's most prominent regional viceroy.

Two years later, after Duanfang had successfully promoted a widely praised international industrial exposition in Nanjing, his merits were rediscovered in Peking. Cixi's heirs were now beset by angry reformers, rapacious warlords, mounting debts, and screaming student demonstrators.

In these desperate circumstances, the Qing governors turned to Duanfang, who, the contemporary Anglo-American journalist Edwin J. Dingle writes, "was looked upon as the prince of officials, famous for the tact and ability with which he approached all matters having anything to do with the foreigner." In spring 1911, His Excellency Duanfang was named director-general of railways.

Railways had become a vital component of the new China. An obstacle to the system's growth and modernization was lack of capital, owing in part to the ongoing and punitive Boxer Rebellion indemnity. A loan was essential; it materialized in 1911 when the Great Four (England, France, Germany, and the United States) agreed to a loan totaling six million British pounds. With this funding, it appeared that construction could move ahead, albeit with losses to local investors, many of them merchants who had underwritten existing bonds. For their part, peasants worried that new laborsaving mechanisms would eliminate subsistence jobs, especially of laborers carting goods. Within six weeks, eighteen provinces and regions claimed independence from Peking. In Sichuan, railway investors refused to pay their taxes, a potent and provocative expression of fiscal protest even as streets were thronged with demonstrators. As the designated superintendent of the Guangdong-Hankou-Chengdu national railway, Duanfang now proceeded to Sichuan Province to restore order. He commandeered a battalion in adjacent Hubei to suppress the uprising. His five hundred troops were on the march when a mutiny erupted in October in the city of Wuchang—an event credited with igniting the Xinhai Revolution that culminated in the collapse of the Qing dynasty. Duanfang halted at the provincial border of Sichuan to weigh his next moves. On November 27, 1911, the director-general's own troops joined the rebellion, shouting their outrage at Manchu rule. Confronted by his mutinous men, Duanfang appealed for forbearance, claiming according to some accounts that his ancestors were actually Han Chinese with the surname of Tao, not Manchu. To no avail; the prince of officials was seized, and then beheaded.

There are conflicting accounts of his final moments. One version, reported in *The New York Times,* asserts that in fact Duanfang learned of his planned murder and tried to escape but was captured and slashed by a soldier's sword. "Would you kill me?" he was said to have asked, only

to be met with a shouted chorus of "Yes, kneel!" Duanfang retorted: "I shall not kneel. You may kill me if you choose." He was then hacked to death. A differing version holds that Duanfang indeed learned of the murder plan, then bribed his officers to kill a pig and, while his would-be assassins waved its carcass along with their bloody swords, claiming the deed had taken place, their putative victim, clothed in rags, made his safe escape to Peking—a wholly unproven tale.

There is less fogginess about the event's sordid epilogue. According to Chinese tradition, body parts need to be united in death, and Duanfang's family agreed to ransom his head and body. Thomas Lawton describes what followed:

> According to a story prevalent in Peking in the 1930s, the rebel soldiers demanded a high ransom from Tuan-fang's family in return for his head. While members of the family were willing to pay the ransom, they were uneasy about dealing directly with the soldiers for fear of being captured or killed themselves. Finally, they asked the Swedish engineer Orvar Karlbeck to act on their behalf. Karlbeck, who had been in China for several year, spoke Chinese reasonably well, and most important, he had known Tuan-fang. . . . Karlbeck is said to have gone to a specified destination with the ransom. After counting the money, the leader of the Chinese rebels gestured to one of his men, who reached into a large metal drum filled with kerosene. Grasping Tuan-fang's head by its queue, the soldier held it aloft so that Karlbeck could identify it. In that shocking manner, the head is believed to have been obtained for burial.

A VERY DIFFERENT SEQUEL then did better honor to Duanfang's memory.

After Duanfang's family ransomed his remains, his bereft survivors were impoverished and forced to sell his unique collection. Among Duanfang's prized acquisitions was a bronze altar set, consisting of a table and ritual wine vessels said to have been unearthed in 1901 from a tomb near Baoji, in western Shaanxi Province. Ferguson, who studied the set on several occasions, remembered that Duanfang had bought its pieces in two separate purchases. Its arrangement, as displayed at the museum, is hypothetical (in the words of the Metropolitan's curator Maxwell Hearn) since "all evidence of the age or identity of the burial was destroyed," yet corrosion outlines on the bronze table help make possible a plausible reconstruction.

Duanfang's bronze altar set (late eleventh-century BCE) at home in the Metropolitan Museum.

Just how the deal was consummated is conveyed in a series of excited letters from Ferguson to the Metropolitan Museum beginning in July 1923. "This table with its complete set of sacrificial vessels is unique," he asserts. "The possession of this table and vessels would easily place the Museum in the front rank for all time in the department of ancient Chinese bronzes." British, French, German, and Japanese agents were all in zealous pursuit and, unfortunately, "Mrs. Tuan and her son have an exaggerated idea as to the price which they should obtain for these objects. They have been told that these bronze specimens are worth at least half a million dollars, but I have disabused their minds of this mistake." He asks for a draw in Peking of $125,000, the price he thinks they will accept; he receives $100,000. The negotiations were not going well, Ferguson writes in October: "There is a lady with her son, daughter-in-law, daughter and son-in-law to deal with in the matter. I thought a few days ago that matters were definitely settled, but I could not get all the interested parties together. I am hoping to do so within a few days, but it is quite possible that the lucky time will not come until just before China New Year in January." Fresh difficulties then developed because of domestic problems in the family—mother and son were not on speaking

terms, husband and wife were not living together; the son was the proper heir of his father by a previous wife, meaning that the woman who actually possessed the table was only a stepmother. But the letter ends on a note of triumph: "Fortunately, I have been able to handle the affair on account of my former friendship and association with the late Viceroy Tuan Fang, so that as a result of the sale of the table I have been able to reconcile the mother and son, husband and wife, and the Museum, in addition to having this wonderful object, has indirectly brought about a domestic reconciliation."

This stunning altar set, dating to the Western Zhou dynasty (1122–256 BCE), at this writing has pride of place in the museum's gallery of Bronze Age objects, its provenance duly noted, but the name Duanfang plainly signifies little even to the best-read museumgoers. Only specialists have any sense of the remarkable career and dismaying end of the Qing dynasty official who opened so many doors to connoisseurs and collectors of Chinese art. In particular, he led the way in the study, appreciation, and rising market prices of ancient bronzes.

New York's Asia Week in 2014 once again featured a record-setting sales price at Christie's for this ancient yet teasingly inviting collecting genre—but with a twist. All eyes were on the "Min Fanglei," a massive bronze ritual wine vessel, crisply decorated on four sides, its shoulders cast with pairs of dragons, its D-shaped handle surmounted with a horned dragon mask. Dating to the late Shang or early Western Zhou dynasties, the archaic bronze weighs 92.5 pounds and is twenty-five inches high. Its provenance was said to be "impeccable," having been published in 1928 and handled by well-known dealers, including C. T. Loo, A. W. Bahr, and C. F. Yau. Its estimated selling price was $30 million—yet at the last minute it was withdrawn from the scheduled March 20 sale and reportedly sold to a group of private collectors from China's Hunan Province, reputedly for $30 million.

What happened? Market insiders claimed that Christie's panicked, for fear that at public auction the winning bidder would simply refuse to pay, on the grounds that the magnificent bronze was illegally exported national patrimony. The likely destination of the privately sold ancient bronze is the Hunan Art Museum, which already possesses the lid to the "Min Fanglei" bronze.

Elya Zhang has earned a final word. These old bronzes, globular or angular, tiny or emperor-sized, "were created as emblems of power, and could only be preserved, or excavated. Not reproduced. What other antique could better symbolize the glories of traditional China? What other

group of literati could be nobler than the bronze connoisseurs, who must be masters of history, art, archaeology, and aesthetics?"

To this, one can credibly surmise, Duanfang's spirit could assent with a concurring smile. All those skills were his, plus a strong additive of political savvy. His wit and will were rarely matched, and his assassination occurred at a pivotal moment when his undoubted skills as a mediator between traditional and modernizing China were most sorely needed. He paid dearly for his devotion to moderation and civility, and he deserves to be remembered not just for his connoisseurship but also for his courage during times that proved all too interesting.

CHAPTER TWELVE

CANADA'S TRYST WITH CHINA

On a fine October day in 1922, the ordinarily blasé inhabitants of Peking watched excitedly as carts bearing two immense guardian lions bumped through crowded streets. Bystanders snapped photographs and shouted encouragement to workers struggling to haul the fifteen-ton chunks of stone over streetcar tracks to the imperial city's railroad station. The twinned beasts were then crated for overseas shipment from the trading port of Tientsin to Portland, Oregon, en route to the Canadian city of Toronto. There these fierce but somehow endearing lions would soon become the locally cherished gatekeepers of the Royal Ontario Museum (ROM), itself a late but significant entry in the Western scramble for Chinese antiquities. In the accepted Canadian manner, its staff managed to build a world-class collection without fuss, scandal, or attracting even a moiety of applause south of the border.

Not just authenticity distinguishes ROM's collection. Its suppliers were highly unusual, and their finds cast revealing light on the truly ancient origins of Chinese writing, on the Northern Song dynasty emperors who reigned over a forgotten urban paradise, and on a wandering tribe of Israelites who reached this Eden and stayed for a thousand years.

In these attainments, the Royal Ontario Museum owed much to an unlikely quartet. Its founding director, Charles Trick Currelly, was a proficient Egyptologist who quickly learned that better buys in antiquities could be found in East Asia. A key supplier was George Crofts, a

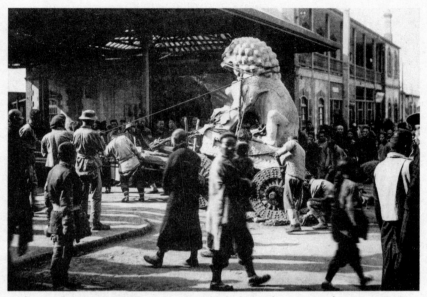

Melee in Peking's streets as Toronto's twinned lions began their westward journey in 1922.

rough-and-ready Anglo-Irish fur trader turned antiquarian dealer. Next came two clergymen: William Charles White, the Anglican bishop of Honan, who befriended tomb robbers and found a second career as a Sinologist. And finally, the quiet, dedicated Dr. James Mellon Menzies, a Presbyterian missionary, also based in Honan from 1923 to 1934, who was among the first foreigners to collect early oracle bones. No other Western museum with an outstanding Chinese collection owes as much to the servants of God, and even the very worldly George Crofts slashed his prices out of admiration for Canada.

It was Crofts who deftly managed the uprooting of the Ontario Museum's trademark lions with minimal controversy, a considerable feat. Originally, so it now appears, the ten-foot-tall lions guarded the entrance to a lavish estate containing a palace, pagodas, and manicured courtyards. This was the home of Prince Su, a powerful Manchu nobleman, one of the select Princes of the Iron Cap, a hereditary imperial order whose titles would be passed on "forever." Unfortunately for Prince Su, his idyllic home adjoined the Legation Quarter, the central battlefield in the 1900 Boxer Rebellion.

After the siege in Peking ended with China's defeat, Prince Su chose exile during the waning years of the imperial era. At some point, his lions

were hauled away by the Italians, who found them too heavy to be used as garden ornaments, and the statues then passed to the Austro-Hungarian Legation. When in 1917 Republican China declared war on Austria and Germany, the government seized the assets of both belligerents. At what price Crofts acquired title in 1922 to the two lions remains obscure. Two facts can be ascertained: the founders of the ROM were anxious to establish their own area of specialty, and Director Charles Currelly was eager to oblige.

THE ROYAL ONTARIO MUSEUM owes its creation in good measure to civic pride, Methodism, and a wealthy banker named Byron Edmund Walker (who became Sir Edmund in 1910). An eclectic collector of everything from minerals and arrowheads to Old Master drawings, Walker yearned to establish Toronto as a globally important destination, an essential step being to found an up-to-date museum. To that end, though he was only formally devout, the banker turned to the city's mostly Methodist financial elite, reminding its members that their social gospel "spoke to the need for enlightenment about the past and consequent social elevation for the future." Walker's prod was productive, and from its birth in 1914, the ROM had a Protestant ethic embedded in its character. Initially, the museum consisted of five separate divisions—archaeology, geology, mineralogy, paleontology, and zoology—but soon the sciences made extra room for the humanities, broadly construed.

This came about after Byron Edmund Walker, having secured the museum's start-up funding, recruited an imaginative, ambitious, and up-to-date founding director. In 1902, wishing to add ancient scarabs to his growing eclectic collection, Walker learned from his son of an Egyptologist named Charles Trick Currelly, then twenty-six. The offspring of a well-to-do Methodist family, Currelly assured him that scarabs were available. It happened that he was as familiar with the Nile Valley as he was with Ontario's prairies; while visiting Britain several years earlier, he had met and impressed W. M. Flinders Petrie, the era's preeminent Egyptologist. Soon the young Canadian joined Petrie's excavation team at major sites. In addition, he routinely accompanied prominent Toronto visitors on their winter tours of Egypt and offered insider advice on buying antiquities. In sum, Currelly was a worldly believer: the perfect mix for his museum career.

So it was no surprise that when the ROM opened its doors in 1914, its guiding director was C. T. Currelly, whose ambitious goals spanned centuries and continents (his memoirs, published in 1956, were aptly titled

I Brought the Ages Home). Yet he looked to the future no less than the past. As the Canadian scholar Dennis Duffy relates, Currelly helped pioneer the child-friendly museum: "Any Toronto middle-class parent can describe in detail every inch of the dinosaur exhibits." It also happened that ROM's early years coincided with the outbreak of the Great War, to which Canada as a loyal dominion volunteered troops and treasure. The budget for acquisitions necessarily diminished, and expansion plans were put on hold. Then in 1918, Currelly encountered the perfect supplier for ROM's postwar rebirth: George Crofts.

An adventurous black sheep born to a respectable Anglo-Irish family, Crofts left Cork County in his twenties to forge a new career in China as a fur trader. By 1896, he was solidly established in Tientsin, where he began dealing in antiquities. While visiting Toronto in 1916, he happened upon a color postcard at his hotel desk depicting a terra-cotta Buddhist figure recently acquired by the still-infant ROM. He recognized it as one of his own antiquities. A correspondence with Currelly followed, and in November 1918 Crofts returned to Toronto for a meeting with the director.

This conversation ensued as the dealer began displaying photographs of his current stock: "I've seen nothing like them. No such objects have appeared in England." "You're quite right, these are the finest so far discovered." "Perhaps you would rather not talk prices, since we have no money, but if you would have no objection, I should very much like to know the prices of these two objects." More such exchanges, and then (so Currelly later related): "Let me have the photographs please. I'm not allowed to run into debt for the museum, but I'll tear the money out of Toronto in ten-cent pieces before we let such a catch slip."

A check followed, as did a flow of purchases, mostly acquired at deep discounts. Over a six-year period, the former fur trader's ROM trove of tomb sculptures, ceramics, and paintings exceeded five thousand items (see color plates, figure 9). In 1922, when the guardian lions arrived, Currelly informed the dealer that he had been awarded an honorary LL.D. by the University of Toronto, "the highest honour that there is, now that knighthoods are done away with [in Canada]." Part of the citation helped explain the provider's success: "With the opening of a railway that had to cut through early tombs, many objects almost unknown were found." The erstwhile fur trader now became Dr. George Crofts, an honorific that smoothed the way for other museum sales. In 1923, Langdon Warner, then director of the Pennsylvania Museum of Art, announced that Charles Currelly agreed to share in Dr. Crofts's latest harvest of Chinese antiquities. Warner called particular attention to "the extraordinary

grave figures of which the collection boasts so many and such splendid examples" (see color plates, figure 9.) As Warner elaborated, the Crofts artifacts complemented Philadelphia's Tang dynasty collection:

> Nowhere in the United States at least are to be seen finer horses and camels or more terrifying demons. One great glazed camel no less than two-feet three-inches high is all accoutered for the march. From his saddle hangs the water bottle . . . and on the other flank a side of dried meat, ribs and all. Even the realism of Hellenistic art is never more vivid than the sculpture of these great beasts, nor more gallant than the pose of the horses where they stand with bent necks and prick ears. So, too, the rows of little human figures, presumably the funeral procession of the dead, are as vigorous as anything from our own classical lands, though never reaching the pinnacles of imaginative art. . . . They present an opportunity for study which we in the United States have never before been offered, and in which the Royal Ontario Museum alone surpasses us.

A generous tribute, yet Warner's words also suggest the perplexities of placing Chinese art within the established Western grid. In the conventional hierarchy, museum-quality art originated in the Near East, ascended from Greece to Rome, ripened in the European Renaissance, and passed by defined stages until the insurgent advent of the modernists. But where did "Chinese art" fit into this matrix? How and why did its richly sophisticated traditions evolve independently? Indeed, the very term "Chinese art" is "a quite recent invention, not much more than a hundred years old," writes Oxford's Craig Clunas in a survey tellingly titled *Art in China*. Hence the diligent effort among both scholars and theologians to puzzle out the origins of Chinese culture and seek possible ties with the Judeo-Christian West.

Canada was to play a conspicuous role in this quest, beginning with George Crofts. Not only his treasures but also his photographs and notebooks passed to the Royal Ontario Museum following his death in 1925. All proved a valuable resource in establishing the chronology, provenance, and authenticity of Chinese antiquities. The bargains thus became jewels.

THE THIRD FIGURE IN ROM's quartet is Dr. William C. White, "Sometime Bishop of Honan, Keeper Emeritus of the East Asiatic Collection of the Royal Ontario Museum," as he identified himself on the title page of his 1956 book, *Bronze Culture of Ancient China*. This followed Bishop White's literally groundbreaking *Bone Culture of Ancient China*. Still earlier, in 1934, he published *Tombs of Old Loyang: A Record*

Bishop William White in clerical regalia; he saved souls and antiquities while in Kaifeng, a former imperial capital.

of the Construction and Contents of a Group of Royal Tombs at Chin-t'sun, Honan, Probably Dating to 550 BC. As improbably, an early highlight was his discovery of the remnants of a near-forgotten synagogue not far from his own Trinity Cathedral in Kaifeng, once a Chinese imperial capital. Workmen were digging the foundation of a new missionary hospital when in 1912 their shovels uncovered three stone tablets commemorating the presence of an ancient Judaic place of worship.

A debate persists as to the dates and meaning of the inscriptions, but it is now widely accepted that Kaifeng for a millennium was home to an Israelite community that originated in Persian lands. The presence of Jews in China had, in fact, been noted by Marco Polo, then by Matteo Ricci and other Jesuit missionaries centuries ago. Sabbath rites in the Purity and Truth Synagogue evidently continued in Kaifeng until the 1850s, when natural disasters claimed the temple. More recently, Jewish scholars and Israeli enthusiasts have located and welcomed putative descendants of this truly Lost Tribe.

Thus sparked, Bishop White soon assumed a second career as an archaeologist. His methods were pragmatic: he felt obliged to socialize, hand and shovel, with tomb plunderers. On this, we have the testimony of Harvard's John King Fairbank and of his artist-scholar wife, Wilma (who sketched the line drawing on the dust jacket of White's last-named volume). "In the archaeological scramble of the 1930's," Fairbank recalls in his 1982 memoir, *Chinabound,* "Bishop White was able to contribute more than most foreigners. A year or more after our visit [with him], we found out what the bishop had been up to—a work of salvage and scientific archaeology achieved by very diplomatic dealings with local Chinese who sought to profit from China's past."

As a result, prizes from the week's illicit digging were frequently left on the bishop's back door. He was thus able to inspect—and acquire—the freshly discovered contents of tombs before they reached dealers in Peking. Of eight tombs described in his last-named volume, only one was scientifically excavated. The rest were commonly entered through shafts penetrated by Loyang spades, a specialized tool suited to the task. As described by Peter Hessler in *Oracle Bones,* the Loyang spade is "a tubular blade, cut in half like a scoop and then attached to a long pole." This meant that larger pieces, such as bronze tripods, were not removed intact but often were forcibly broken. "Plainly this was no fly-by-night or surreptitious thievery but a long-term operation which must have been given protection by local men of substance," Professor Fairbank writes. "The Nanking government had no rice-roots power in Honan." Professional archaeology was still nascent in China. High-value sites were reburied after being stripped, as happened at the Chin-t'sun tomb. "Land for crops was simply too valuable" is Fairbank's rueful epitaph.

What made this unusual collaboration possible was Bishop White's unfrocked manner. Born British in Cornwall in 1873, "Will" (as everybody called him) was four when his father, a mason and contractor, resettled in Ontario. The youthful White was bright and brash, but also a churchgoer who kept a daily diary, each entry headed with a biblical admonition. While a teenager, scenting adventure, Will decided to become an Anglican missionary. He attended Wycliffe College in Toronto, was ordained in 1896, and on turning twenty-one circulated a poem signed "Socrates, Jr.," with these final lines: "Come laugh with me! a boy again I am, / Although my years do say I am twenty-one." (To his surprise and delight, a Toronto newspaper reprinted his verse.)

Dark haired, of medium height, and wiry, with his broad brows and deep voice, Will White remained (as someone said of Goethe),

"an extraordinarily ordinary man in whom ordinary men might see themselves reflected." Or, in the words of his biographer Lewis Calvin Walmsley, "He was driven by a restless eagerness and contagious mental excitement. He possessed an inveterate curiosity. He believed the world's secrets were waiting for him to discover." Such was the novitiate who, in May 1896, having just proposed to his sweetheart Annie Ray, learned that he was to be a missionary in China.

In February 1897, White sailed alone from Vancouver aboard the *Empress of Japan*. Arriving in Shanghai, he was informed that he had been posted to Fukien (now Fujian), a southern province deemed risky for "foreign devils," his destination being a mountain town eight days' travel by donkey carts from the venerable port of Foochow (now Fuzhou).

Once in Foochow, the apprentice missionary promptly purchased a Chinese gown and hat, together with an artificial pigtail. This was the Year of the Monkey, a time of plots and purges within the Manchu ruling elite that culminated in the Boxer Rising, the siege of the legations, and the flight from Peking of Dowager Empress Cixi.

The times were therefore as interesting as Will White could have wished. He now commenced his clerical duties in Kienning, a picturesque mountain town bounded by tea plantations draped in mist. Here White learned to speak and read Chinese, grew his own queue, and acquired a Chinese name, Huyai Li-kuan. In October 1897, Annie Ray arrived in Shanghai, where they wed. Mrs. White, who did not adopt Chinese dress, became the sensible ballast to her impulsive spouse.

Faced with these prevalent challenges at the century's turn, the Canadian Church Missionary Society chose to expand rather than retreat. Its leaders had learned that hospitals and schools were the latchkeys to acceptance. White seemed ideally cast for a broad mandate. He had worked with lepers and had studied homeopathic medicine, he learned to play Chinese instruments, he knew how to make raspberry vinegar, and he was known as "the foreigner who speaks Chinese like a Chinese." This especially mattered when missionaries came under attack as excessively privileged, a common grievance being their extraterritorial immunity from Chinese laws. So when the General Synod of the Anglican Communion assigned Honan to Canada, the dominion's hierarchy turned to the young Ontario missionary to deal with a conspicuously fractious province. In 1909, at age thirty-six, Will White was consecrated as Canada's first Anglican bishop in China, the youngest in his era to acquire the robes, miter, and orb of that holy office.

Within a year, the Whites were en route to Kaifeng, the ancient seat of the Northern Song, more recently capital of the province of Honan

(Henan), encompassing 35 million inhabitants in 68,000 square miles. Borne in a sedan chair, the couple arrived during a blinding March dust storm. They were greeted (as White's biographer relates) by a three-year-old boy holding out an empty rice bowl, who politely inquired, "Have you eaten your rice yet?" (the local equivalent of "How are you today?"). Soon enough, the new bishop seemed to blend into Kaifeng's bustling thoroughfares. "With his slight lithe frame," to quote Walmsley again, "he looked not unlike a dapper young Chinese when he appeared on the street. Fortunately, his hair was black, and his eyes were not so blue as to cause comment." And propitiously, the urban past of his bishopric proved as compelling, though its glories still remain unknown, even to literate foreigners.

KAIFENG'S GLORY PEAKED when it was China's imperial capital under nine Northern Song emperors (960–1126 CE). It is generally agreed that the Song rulers were among the most competent and enlightened in the Celestial Empire. Their reign witnessed the growth of cities, the debut of printed books, a burst of scientific discoveries, and the emergence of an elite political class chosen through rigorous examinations. As impressively, in the twelfth century Kaifeng itself ranked as the world's largest city, its population estimated at 1.4 million, including inhabitants of nine suburbs and garrisoned military families, making Kaifeng three times the size of ancient Rome.

This surge became possible owing to Kaifeng's proximity to the Yellow River and the recently opened Grand Canal. Thus coal and iron mined in North China could be traded for food grains loaded in barges from the fertile rice fields of South China. Kaifeng also became a mercantile crossroads, its bazaars enriched by caravans from Central Asia. Given peace and stability, this now-forgotten capital was for a period an urban paradise, its cheerful civility anticipating by a thousand years the animated street life idealized by Jane Jacobs in her *Death and Life of Great American Cities* (1961). On this, we have a visual witness: a seventeen-foot-long hand scroll attributed to the artist Zhang Zeduan (Chang Tse-tuan), titled *Spring Festival on the River,* believed by most scholars to depict Kaifeng at its apogee. Here is the city bountiful: a mosaic of shops, waterways, arched bridges, gardens, schools, temples, food markets, and theaters, interspersed with camel caravans, street musicians, acrobats, mandarins, and students, plus the Willow Quarter, with its courtesans and singing girls (the scroll is posted online by the University of Chicago).

Yet when the young Canadian primate surveyed his ecclesiastical realm in 1910, he found that this great metropolis had dwindled into a

backwater provincial town. The old walls remained, as did an impressive pagoda and its maze of waterways and gardens. But Kaifeng's monumental edifices had for the most part vanished, swept away in periodic deluges resulting from the city's proximity to the floodplains of the Yellow River. Additionally, since large stones are scarce in Kaifeng's region, earlier builders employed rammed earth and perishable wooden frames for larger structures. More durable were the area's abundant tombs, sustaining the underground economy that enabled the primate to become an authorized supplier for C. T. Currelly's Royal Ontario Museum.

"I soon worked out that we had been students together in Toronto," Currelly recalls in his memoirs. "He presented us with a fine painting of about 1300 or 1400 [CE], a superb piece of drawing in wonderful condition. Owing to a friendship with one of the biggest antiquity dealers in Honan, he had been getting a good training in what was being found. . . . With all his gentleness, he had courage and saved his city from destruction." The last sentence referred to White's skills as a mediator during China's chaotic decades. At one critical point, in the mid-1920s, the bishop sent an urgent message to Currelly, with disturbing news about menacing warlord armies:

> The letter said that Bishop White had learned from an Englishman that, in a temple which he knew well, there was a marvelous fresco that, within ten minutes after these soldiers reached the town, they would pry out the heads from the fresco with their bayonets; the great picture which the monks and their predecessors had cherished for centuries would be ruined. The monks put the men to work to remove the fresco from the wall. The men cut through heavy clay plaster and took the picture down piece by piece. There were eighty pieces and these were wrapped in cotton and put in a cart and taken away; the monks did not know where, so no torture could make them tell. When the warlord arrived, there was nothing but a plain wall.

In Bishop White's estimate, the endangered paintings dating from the Yuan dynasty were of outstanding merit, having been carefully preserved in the Xinghua Si Temple founded in 992 CE in a remote village in Shanxi Province. The monks were frantic. White urged Currelly to buy. In 1928, the director cabled an offer to the English go-between; in due course eighty fragments arrived at the museum and were carefully stored. Currelly sought advice on restoration from Langdon Warner, who recommended George Stout, a specialist at the Fogg Museum. With his counsel, ROM's own technicians meticulously reassembled the forty-foot dry fresco painting, now known as *The Paradise of Maitreya*. At once

devout and disarming, the mural depicts the Maitreya (The Buddha Who Is to Come), surrounded by a bevy of divinities, mortal nobles, and personal attendants, including his barber.

This purchase led to the ROM's acquiring (via Yamanaka & Co.) two more Yuan dynasty wall paintings, also from imperiled monasteries in the same province. Titled *The Lord of the Northern Dipper* and *The Lord of the Southern Dipper,* the latter graphically depicts the twelve birds and beasts associated with the Celestial Empire's named years. Taken together, in Currelly's words, "we now have one of the most impressive groups of paintings I have ever seen." (All have since been restored afresh and remounted dramatically in the museum's Asian gallery.)

At the same time, Bishop White was providing the ROM with objects of a very different kind: ancient bronzes and inscribed bones, finds that together added a new prologue to China's cultural history. It was thus no surprise that after retiring from his clerical post in 1935, Will White commenced a new career as keeper of the East Asiatic Collection at the Royal Ontario Museum. A stream of learned monographs followed, including his elaborately illustrated *Chinese Temple Frescoes* (1940), in which all three paintings are annotated. As John Ferguson (another missionary turned antiquarian) comments in his foreword to White's earlier book on tombs, it seemed "most fortunate" that he was at hand and thus "through trusted agents was able to follow every stage of the operations and secure so many specimens from the contents of the grave." Ferguson, who should know, fairly described the ongoing quandary of professional archaeologists in their struggle to save whatever prizes arise from China's good earth, even at the hands of looters.

Yet his dilemma had a second horn. Not without reason, Bishop White had a high opinion of himself; he knew the value of a wink as regards niceties of the law. In his published works, he is discreetly silent concerning the means by which the objects he purchased came to his attention. And though he learned much about China's Bronze Age from another missionary turned excavator, James Mellon Menzies, he gives scant recognition in his own writings to his colleague's work. All this was freshly debated by the Chinese scholar Linfu Dong, the biographer of the Reverend James Menzies.

According to Linfu Dong, hundreds if not thousands of ROM's Chinese treasures—jade, bronzes, pottery, and paintings—were illegally smuggled to Canada in violation of a 1930 law banning cultural exports. He asserts that Bishop White sent his wares through obscure railway stations, where inspection was unlikely, or packed objects in the luggage of other missionaries. These disclosures fanned a press controversy in

China, although there has been no formal request for the restitution of ROM's trove. And the dispute casts revealing light on the career of James Menzies, who in his professional ethics chose a different path from that of the bishop of Honan.

THE PRESBYTERIAN MISSIONARY James Mellon Menzies is honored, unusually, not only in Canada but also in China, where he is cited as "the foremost Western scholar of Yin-Shang culture and oracle bone inscriptions." In 2004, his longtime home in Anyang was designated a "Protected Treasure," although he was unable to revisit his old residence before his death in 1957 owing to the Cold War. Menzies is of interest not only because of his pioneering role in Chinese archaeology but also because he resolutely insisted that most of his finds belonged to, and ought to remain in, China. In all, Menzies collected 35,913 inscribed oracle bones, as well as 23,000 other ancient artifacts.

Menzies critically helped rediscover the lost roots of the Chinese state and civilization. Until oracle bones were unearthed and deciphered, some speculated that China's oldest dynasties, the Shang and Zhou, were at best amorphous or possibly mythical. But the discovery of "dragon bones," inscribed turtle plastrons and cattle scapula, not only silenced skeptics but also demonstrated that Chinese is the oldest continuously written language.

Among China's imperial dynasties, the Shang was the creative begetter; its thirty rulers reigned for seven centuries until the ascent of the Western Zhou. "With the conquest of the Shang dynasty by the Zhou," summarizes John King Fairbank, "the Chinese state finally emerges. Here again, the new archaeological evidence, such as inscriptions on bronzes and newly excavated Zhou oracle bones fit together with the literary record of ancient places, people, and events long known from the classics and earliest histories." The Zhou and the Shang created a new basis of legitimacy by endowing its rulers with a Mandate of Heaven. Thus a homogenous, industrious, and precocious populace blazed the trail leading to the Celestial Empire's imperial dominion.

IN A SENSE, all this proved the efficacy of ancient oracle bones. Their discovery dated to 1899, according to an oft-repeated story, when a senior Qing dynasty official named Yirong Wang was felled by malaria. His doctor prescribed a traditional remedy known colloquially as "dragon bones," consisting of ground-up tortoise shells. But on visiting his local pharmacy in Peking, Wang noticed that the shells, before being ground

into powder, were inscribed with still-legible characters like those he had seen on ancient bronzes. He was deep in his studies of these strange bones when the Boxer Rebellion erupted. As a newly appointed military commander during the legation siege, Wang faced surrender or flight when foreign armies overwhelmed Peking. He chose poison.

After his suicide, Wang's thousand-odd collection passed to a colleague named Liu E, who in 1903 published the first book of oracular inscriptions but then ran afoul of state authorities on corruption charges and was exiled to Xinjiang, where he died in 1909. The authenticating task then passed to Duanfang, the celebrated Qing mandarin and a leading collector of antiquities, who offered premium prices for oracle bones. As described earlier, Duanfang was decapitated by his own rebellious troops during the successful 1911 revolt against the Manchu/Qing dynasty.

Such was the setting in the 1900s when James M. Menzies, a twenty-six-year-old Presbyterian missionary, arrived in China just in time to witness the final collapse of the world's oldest established imperial system. Born in rural Ontario, trained as a civil engineer and land surveyor, Menzies found his new vocation through a YMCA camp. Once in China, as if by providential accident, he settled in Anyang in northern Honan, the very cradle of the now-vanishing Celestial Empire.

On the outskirts of Anyang, Menzies soon learned, lay a peasant field called the Waste of Yin, known to scavengers for the abundance of oracle bones and smashed pots littering its surface. Beneath this field lay the ruins of the last Shang capital and its royal court, together with quarters for servants and soldiers, and for diviners skilled in reading cracks in animal bones to discern the future. Hence archaeology became an active part of the Menzies ministry. In 1928, he worked with the Academia Sinica, the scientific panel established by the new Chinese government, in launching a decade of excavations in Anyang—the nation's first such extended project. When not shoveling, Menzies pursued his missionary duties as a preacher, promoter of schools and health care, and at intervals as leader of a migratory ecclesiastical band. Even during China's years of turmoil, the prelate and his team traveled from town to dusty town, set up stands loaded with food and literature, summoned the curious with gongs and drums, and then beamed magic-lantern images of Jesus and scenes of rural life in Canada.

Both the digging and the tours halted when the Japanese began their armed onslaught on China in 1937. The year before, Menzies, his wife Annie Belle, and their son, Arthur, left for a furlough in Canada, not knowing they would never return to Anyang. Once in Ontario, Menzies

An oracle bone collected by Menzies, inscribed with humanity's oldest continuously written script.

volunteered his services to the Royal Ontario Museum, registered as a Ph.D. candidate at the University of Toronto, submitted a dissertation on a Shang bronze weapon, and during World War II served in Washington as an advisor on China to the State Department.

Having resettled in Canada, Menzies still confronted an unsettled question: What was to be done with the huge collection of oracle bones and pottery fragments that had been sent to Canada? It was his intention to deed the trove to China, while contributing a representative portion to the Ontario Museum. Postwar, however, Canada had no diplomatic relations with the People's Republic. "Shortly before his death in 1957," according to his biographer Linfu Dong, "his wife Annie and his son Arthur met with the directors of the Royal Ontario Museum to discuss the Canadian portion of the Menzies collection. . . . As the best solution,

the Menzies family agreed to sell a substantial portion to the museum. As part of the agreement finalized in 1960, the ROM and the University of Toronto established The Menzies Fund to publish and promote Chinese studies in Canada." Sixteen books and monographs on the Shang dynasty have since been published, honoring the agreement in letter and spirit. Other sequels followed that would doubtless have comforted Menzies— notably that his son, Arthur, would become the Canadian ambassador to the People's Republic, that Canada was to benefit substantially from Chinese immigrants, and that a family friend, the Hong Kong–born Adrienne Poy Clarkson, would become the first Canadian of Chinese origin to be named governor general, the symbolic surrogate of the British Crown.

Still, an epilogue followed whose dialectical symmetry would likely have pleased this self-effacing missionary. In Maoist times, the Reverend James Mellon Menzies was censured as a cultural imperialist, then gradually rehabilitated, culminating in a laudatory James Menzies Conference at Shandong University in 2000. Indeed, seeking a reconciling synthesis was the abiding theme of his career. As he wrote of himself, "While I had counted 1,000 persons baptized and many more prepared for the catechumens, yet perhaps my work on the bones permeated deeper into Chinese life than my work among the schools and churches of North Honan."

After all, what was the deeper message of those inscribed tortoise shells? "In his studies of Shang religion," summarizes his biographer, Linfu Dong, "Menzies came to the conclusion that the ancient Shang people who lived about the time of Moses in the Bible had worshipped a god they called *Shangdi* (usually translated as 'Lord on High'). This was not a new idea, as it had been promulgated in the seventeenth century by the Jesuits, who, with no scientific evidence, speculated that the Zhou people introduced the idea of *Tian,* or 'Heaven', a supreme impersonal moral force that governs the universe and mankind."

Menzies sided with the Jesuits. He believed he had found scientific proof in the ideograph *Di* or God that appeared in the venerable bones he was studying, sustaining his belief that the God of Moses also reached the Waste of Yin. Moreover, Menzies believed that the "Jesus doctrine" was not very different from the traditional ethical values of China's ancient sages. He would not have been surprised at the gradual rehabilitation of Confucius, notably visible in the sage's hometown, the city of Qufu in Shandong Province. As Evan Osnos reported in *The New Yorker,* "Near the cave where Confucius was said to have been born, a five-hundred-million-dollar museum-and-park complex is under construction; it

includes a statue of Confucius that is nearly as tall as the Statue of Liberty. In its marketing, Qufu has adopted comparisons to Jerusalem and Mecca and calls itself 'The Holy City of the Orient.'" (In 2013, it received 4.4 million visitors.) One can imagine a spectral smile and sigh emanating from the restless spirit of James Menzies, who once wisely said: "Some of us have to school ourselves in Chinese thought, and ideas, so that we know something of the soul and mind of China as well as the outside form."

Still, the four principal creators of the Royal Ontario Museum have a more tangible memorial. The ROM is today Canada's largest museum, with a collection totaling six million objects in all categories (fine arts, antiquities, natural science, and memorabilia). Yet today the museum's members rarely judge it "on whether or not it has recently acquired some hundreds of artifacts." So contends Chen Shen, the ROM's current senior curator of Chinese art, who elaborates: "Rather, they are more interested in seeing what public programs it can offer, or what the next blockbuster exhibition will be." To that end, the museum's slogan is "Engage the World," the aim being to "stay in tune with what new and young audiences seek and what the public expects."

As an archaeologist with field experience in China, Chen Shen had excellent credentials for extending that outreach—not only across the Pacific, but also southward to the passively indifferent United States. This was illustrated in 2002 when Dr. Shen collaborated with three American museums, along with the Chinese People's Republic, in organizing an eye-widening traveling exhibition titled *Treasures from a Lost Civilization*.

Here, for the first time in North America, were showcased a choice selection of recently unearthed artifacts that have radically revised the authorized version of early Chinese history (second millennium BCE). Here were mysterious bronzes, among them elegant wine vessels and grimacing humanoid demons, mixed in with jade pendants depicting hares, tortoises, and tigers—along with inscribed oracle bones and ceramics acquired decades ago by the ROM trinity: Crofts, White, and Menzies. Nearly all the several hundred newly excavated objects emerged from a dozen or more sites in Sichuan Province, campaigns sparked by the discovery in 1986 of two sacrificial pits at Sanxingdu near Chengdu, still as before the capital of Sichuan Province. According to Chen Shen, writing in a companion brochure, these finds unquestionably constituted "one of the great events in Chinese archaeology," eroding the established consensus that "the Sichuan basin was a cultural backwater," a region "that was

under the shadow of cultural dominance from central China" until the Qin-Han dynasties (221 BCE–220 CE).

Two points deserve stressing. First, fittingly, supposedly provincial Toronto led the way in this major revision, since its museum was the first in the West to pioneer the systematic collection of oracle bones and ancient bronzes (as selectively featured in the 2002 exhibition.) Second, *Treasures from a Lost Civilization* helped enhance a collaborative tradition for a new millennium. It was organized with the full partnership of the Bureau of Cultural Relics, Sichuan Province, while its U.S. travels were managed by the Seattle Art Museum. After its West Coast debut, the exhibition moved to the Kimbell Art Museum in Fort Worth, Texas, then to the Metropolitan in New York, and finally to Toronto in October–November 2002. In a double sense, East and West joined in celebrating these amazing discoveries. Equally fittingly, when the ROM marked its hundredth anniversary in 2014, its signature exhibition was *The Forbidden City: Inside the Court of China's Emperors,* focusing on the offstage life of the palace's inhabitants. Some 250 objects never displayed outside of China intrigued an overflow stream of visitors to a show lavishly featured in *Orientations,* the global journal for devotees of Asian art. Once again, in a double sense, not bad for the provinces.

CHAPTER THIRTEEN

PAINTING POWER

Expansion, the second phase of the American encounter with the Asian Pacific, coincided with the global scramble for empire in the nineteenth century. By 1900, most of the world's peoples and habitable lands were under the dominion of barely a dozen countries. The United States joined the scramble, even as its leaders professed their superior political morality. Yet in the American case, it was less trade following the flag than the other way around. Thus in 1851, it was the Pacific mercantile lobby that pressed the otherwise flaccid President Millard Fillmore to boldly send an entire naval flotilla to Japan, where few Westerners had been before. Not everybody applauded. Among Fillmore's critics were the editors of *The New York Times,* who warned against attempts to "knock open a passageway with ball, bullet, and bomb" simply to market "a few annual cargoes of cotton cloth." Congress and much of the country felt otherwise. In 1853, Commodore Matthew Perry's naval squadron set sail, and his "black ships" succeeded in prying open the passage to feudal Japan.

Few could have foreseen the sequel. Within fifteen years, rebellious Japanese modernizers swept away the hermetic old order, and during the Mejii Restoration the sun rose on an outgoing, efficient, and centralized government symbolically headed by an infallible monarch. From that point on, both the United States and Japan vied with Europe for mastery of a decadent China beset by famine, rebellions, corruption, and (in Peking's eyes) missionaries. In 1898, following the triumph in Manila Bay by Admiral Dewey's Pacific Squadron, the United States took

possession of the Philippines (President William McKinley reported that after a prayerful vigil, he was prompted by Providence to place the islands "on the map of the United States").

The expansionist mood in 1898 permeated the debate in the U.S. Congress over the proposed annexation of Hawaii. In addressing doubters in the House, Representative William Sulzer of New York waxed rhapsodic: "Let me say to the business men of America: Look to the land of the setting sun, look to the Pacific!" There lay teeming millions who needed to be fed. There beckoned great markets that Continental rivals were already trying to dominate. "We must not be distanced in the race for the commerce of the world," declared Sulzer, adding, more prophetically than he could have guessed, that in a hundred years the greater volume of American trade "will not be across the Atlantic, but across the broad Pacific."

These were the prevailing sentiments and the consequential deeds that announced America's debut as a regional power in the Asian Pacific. A telling portent of Washington's early-day pivot to the Far East was the prompt emergence of a new caste of diplomats, missionaries, traders, and financiers—and their families—who resided in China. For the first time, there was an expanding American community in Peking and in the treaty-port cities, with a rapidly growing missionary presence in outlying regions. Books about East Asia became a staple in publishing catalogues, and for the first time young Foreign Service officers began studying basic Mandarin. In this chapter, we deal with a neglected aspect of this change: the distaff dimension. Wives of Americans living in China often had a different agenda from that of their husbands'. They not only befriended Chinese women but also became fascinated by Chinese customs, clothing, daily life, and servant psychology. As a result, North American museums today have vintage collections of Chinese robes. How this came about is our focus in this and the following chapter (with a side excursion to Tibet). We begin with the forgotten role of the St. Louis Exposition, which opened a very different door to China.

PERHAPS NOTHING WAS AS EXPRESSIVE of the new American flexing of its formidable expansionist muscles as the St. Louis World's Fair of 1904, the centennial celebration of Jefferson's Louisiana Purchase, which had added parts of fifteen states and two Canadian provinces in what remains the largest territorial gain in U.S. history. The exposition's official journal exuberantly celebrated America's westward progress: "The heroes of Homer's *Iliad* were engaged in petty

achievements when compared with the work of men who wrestled a vast wilderness from savages and wild beasts and made it the seat of twenty great commonwealths in a single century."

Before it opened, 30,000 men worked all day and through Friday night adding last-minute touches to the grounds, removing scaffolding, and arranging exhibits. At 9 a.m. on April 30, dignitaries converged from three directions on the Plaza of St. Louis at the center of the exposition grounds: local grandees, led by a band, met representatives of foreign governments who arrived from the opposite direction; state and territorial bigwigs, including members of Congress brought by special train from Washington, joined them. Two warships, the gunboat *Nashville* and the torpedo boat destroyer *Lawrence,* steamed into the harbor, greeted by a chorus of whistles and shouts from the crowds on excursion boats, adding a touch of martial braggadocio to the occasion.

The weather was fair and pleasant. An estimated 187,000 persons bowed their heads as prayers were invoked, speeches given, and a welcoming offering sung by five hundred voices, "The Hymn of the West," fashioned by the then-famous American poet Edmund Clarence Stedman, concluding with the Kiplingesque flourish, "Land of the new and Lordlier race!" Secretary of War William Howard Taft, attended by a military guard, gave the final speech; a signal was telegraphed to President Theodore Roosevelt, who was standing by in the East Room of the White House. At 1:14:30, he pressed the golden telegraph key, the Morse clicks sped over a distance of seven hundred miles, cascades sent down their floods, thousands of banners were unfurled, and the Great Louisiana Purchase Exhibition, the largest international fair the world had yet seen, opened.

Never mind that eight persons were killed that day when an open switch caused the derailing of six cars on the Iron Mountain Express, a fast morning train from Hot Springs to St. Louis operating as a World's Fair special, or that the bandmaster was badly hurt when his carriage hit a trolley, or that a thirty-gallon coffee machine at the inn exploded, killing one person and injuring three others, or that in celebrating the 1803 purchase, the fair had opened one year late. The expo lasted seven months and boasted exhibits from sixty-two nations and colonies as well as all forty-three states and all the territorial possessions save Hawaii. Visitors gawked at five hundred buildings on 1,200 acres of park transformed by the fair's designers from thickets and swamps. Highlights included replicas of several grand "palaces"—France's Grand Trianon and Germany's Charlottenburg Castle—as well as homier items like Robert Burns's cottage and Abraham Lincoln's cabin.

Although the Chinese had participated modestly at Chicago in 1893 and at Paris in 1900, the St. Louis Fair would mark China's first official presence at a world's fair, complete with an imperial delegation led by a Manchu prince of the blood, Pu Lun, commissioner general for the Celestial Empire. Dowager Empress Cixi underwrote the Chinese exhibits and pavilions, donating 750,000 taels of silver (about $500,000 at the time). A portion of Pu Lun's summer palace was replicated, serving as the Imperial Chinese Pavilion, described by *The New York Times* as "an elegant structure of the sumptuous type—highly decorated, colorful and airy in appearance." A featured attraction was the lotus pond, complete with gold and silver fish, imported from China. Cixi's funds seemed to have been well spent, since it was deemed "the most picturesque of all the foreign structures," its popularity affirmed by the crowds that thronged its precincts. On May 6, 1904, High Commissioner Prince Pu Lun, with the aid of Wong Kai Kah, a Yale graduate (Class of 1883), acting as interpreter and co–vice commissioner, formally dedicated the Chinese Pavilion and then hosted a levee and reception for three thousand guests that evening before leaving on a tour of the principal American cities.

The main Chinese exhibits were located at the Palace of Liberal Arts that featured, amid its furniture, industrial, and agricultural exhibits, "dummy figures of Chinese men and women in their native garb, some richly embroidered, showing the costumes worn in the various provinces of China." But the exhibits seemed "decidedly crowded" to visitors, who complained of "topsy-turvydom." Merchants tailored their wares to what they anticipated was foreign taste—Qianlong and Kangxi porcelains; Han pottery; Ming jars and vases; newer ware from the revived Jingdezhen kilns (destroyed by the Taiping rebels), including copies of "tribute porcelain" made for the imperial court; ancient bronzes; jades; ivories; and myriad bolts of silk.

Chinese art at this time was classified as "applied" rather than "fine art," and only one work, the portrait in oils of Dowager Empress Cixi, by an American, Katharine Carl, was exhibited in the Palace of Fine Arts. Katharine's brother, Francis A. Carl, was then serving in China as a senior official reporting to Inspector General Sir Robert Hart of the Imperial Maritime Customs Service. As vice commissioner at the fair, Carl was charged with collecting and installing the Chinese exhibits, and one suspects that he lobbied for the inclusion of his sister's portrait in the Palace of Fine Arts rather than among the other Chinese exhibits in the Palace of Liberal Arts.

FOR MORE THAN FORTY-FIVE YEARS, the most interesting foreigner in China was Sir Robert Hart, Francis Carl's chief. Sir Robert was in charge of collecting taxes and of monitoring the ports, frontiers, lighthouses, and 2,500 post offices, as well as serving as an intermediary in negotiations between the Europeans and Chinese; he was rumored to be the most powerful person in the Middle Kingdom after the emperor. A friend claimed that if he had not extended the bounds of Britain, "he has done more than any other man to avert the destruction of another empire." He championed international exhibitions and headed the commission charged with preparing for the St. Louis Exposition. Charles Addis, a banker with the Hong Kong & Shanghai Bank and later a director of the Bank of England, left this description of Sir Robert in the 1890s:

> A marvellous man and yet such an insignificant shy man and of bald conversation. Fond of the ladies (pretty ones) in a rather a fawning sort of way . . . He never goes out, lives surrounded by files . . . Lives by rule; rises early; 10 minutes to the classics; 10 minutes to the cello etc. etc. Sleeps every afternoon for an hour. Begins a book and will tell you to the minute when he will finish it . . . a dreamer of dreams . . . a marvelous organizer and the machinery of the enormous service is almost perfect . . . an undoubted egoist; Hart must be everything. . . . Will nourish an injury for years . . . No friends, no confidants. Never takes exercise . . . He is one of the first men in China, but it is too late and he finds himself unable to mix freely with the men now his equals. And so he lives on in solitude.

Although his incorruptibility was often cited, it is noteworthy that Hart, an Ulsterman, retired in 1908 with half a million pounds, the equivalent then of two and a half million dollars. He was also guilty of nepotism. Although his wife, Hester, decamped for home in 1882, her relatives, the Bredons, stayed on. (Hart had noted, on their first anniversary in 1867, that he "could not have a better wife . . . at the same time, matrimony does interfere with a man's work.")

While Lady Hart was in Britain, Hart fathered three children by his Chinese mistress. With his well-known eye for the ladies, it is not surprising that he took notice of his blond houseguest, a Bredon relation of Lady Hart, Kate Carl: "Miss Carl left the Congers and moved in here today," Sir Robert wrote. "She is very breezy—quite a Tornado in fact, and I fear the solitude which suited both my health and my work will

now be interfered with to anything but the advantage of either." Kate
Carl had arrived in October 1902 with her mother from Europe via the
Trans-Siberian Railway to visit her brother Francis in the treaty port of
Chefoo (Yantai). Trained at the Académie Julian in Paris, the favored
atelier of Americans like John Singer Sargent, Kate was short, stocky,
freckled, and self-assured, and she boasted a winsome smile. After Cixi
chose Kate, at the suggestion of Sarah Conger, the American minister's
wife, as her official portraitist, Sir Robert was happy to assist his guest in
her artistic endeavors by ordering express eight yards of canvas and some
oils from Europe.

The court astrologers picked an auspicious date (eleven o'clock on
August 5, 1903) for Kate's first audience with the dowager empress. She
arrived after a three-hour trip from the American Legation, accompanied
by Sarah Conger and the interpreter, Louisa Yukeng, née Louisa Pierson,
the daughter of a Chinese mother and a Boston-born Shanghai business-
man, and now the wife of a government official. Once the preliminaries

Mme. Yukeng, Princess Der Ling, the Dowager Empress Cixi, and Rong Ling.

Fig. 1 J. M. Whistler: Harmony in Blue and Gold: The Peacock Room, *showing blue and white china, 1876–1877. Gift of Charles Lang Freer, Freer Gallery of Art, Washington, D.C.*

Fig. 2 Ritual Disc with Dragon Motifs (Bi), Henan Province (771–256 BCE) Jade, Eastern Zhou dynasty, William Rockhill Nelson Trust, Nelson-Atkins Museum, Kansas City, Mo.

Fig. 3 Heavy Gold Buckle with Inset Jade Dragon ,4th–3rd century BCE, Bequest of Grenville L. Winthrop, Harvard Art Museums/Arthur M. Sackler Museum.

Fig. 4 Bodhisattva, Eastern Wei dynasty, ca. 530 CE, carved limestone, excavated from the White House Monastery at Luoyang, gift of Denman Ross in memory of Okakura Kakuzo, Museum of Fine Arts, Boston.

Fig. 5 Offering Procession of Empress as Donor with Her Court, from Longmen, Binyang Central Cave, ca. 522 CE, Northern Wei Dynasty (386–534), William Rockhill Nelson Trust, Nelson-Atkins Museum, Kansas City, Mo.

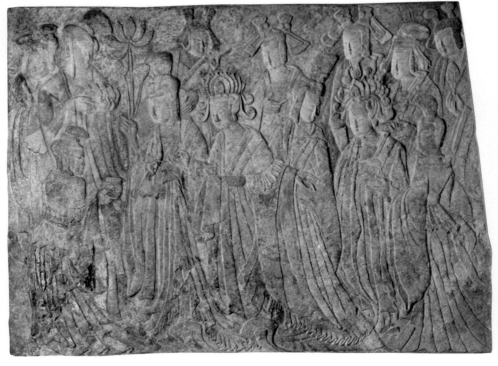

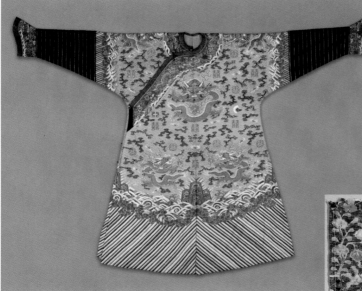

Fig. 6 Imperial Manchu Man's Semiformal Court Robe (1850–1875 CE), woven silk with metal thread tapestry, gift of James P. Grant and Betty Grant Austin, Denver Art Museum.

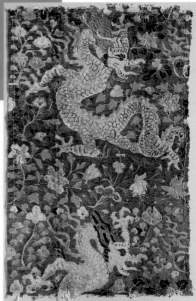

Fig. 7 Silk Tapestry with Dragons and Flowers (1100–1200 CE), Eastern Central Asia, curated by James Watt, Metropolitan Museum of Art.

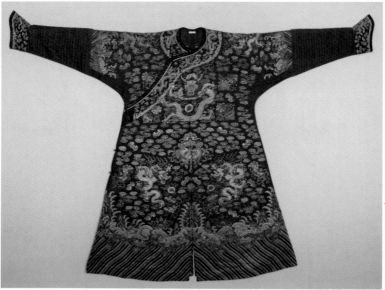

Fig. 8 Coat of a Mandarin for Summer, as described by Berthold Laufer, who purchased it in Shanghai in 1901, American Museum of Natural History.

Fig. 9 Burial Figure
of a Horse, Northern
Wei dynasty, Henan
Province, molded
earthenware, George
Crofts Collection,
Royal Ontario
Museum, Toronto.

Fig. 10 Ritual Vessel in Shape of
a Rhinoceros, ca. 1100–1050 BCE,
bronze, Shandung province, Shang
dynasty, Avery Brundage Collection,
Asian Art Museum, San Francisco.

Fig. 11 Gilt Bronze Buddha
Maitreya, dated 486 CE,
acquired for the Metropolitan
Museum of Art by Bosch Reitz
in 1926.

Fig. 12　Finches & Bamboo *handscroll, painting and calligraphy by Emperor Huizong, Northern Song dynasty, formerly in John M. Crawford Jr. Collection, Metropolitan Museum of Art.*

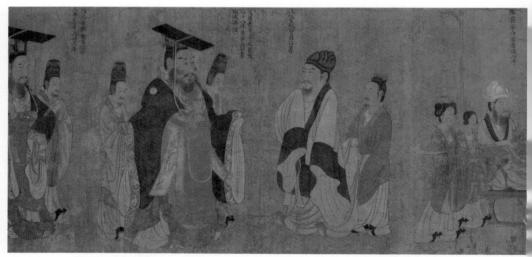

Fig. 13　The Thirteen Emperors *(detail), attributed to Yan Liben, Tang dynasty, ink and color on silk, Denman Ross Collection, Museum of Fine Arts, Boston.*

Fig. 14 Lohans Feeding a Hungry Spirit, *by Lin Tinggui, Southern Song dynasty, 1178 CE, ink and color on silk, Denman Ross Collection, Museum of Fine Arts, Boston.*

Fig. 15 Xu Daoning, Fishermen's Evening Song, *Northern Song dynasty (960–1127), William Rockhill Nelson Trust, Nelson-Atkins Museum, Kansas City, Mo.*

Fig. 16 Guanyin of the Southern Sea, *wood with polychrome, Liao (907–1125) or Jin dynasty (1115–1234), William Rockhill Nelson Trust, Nelson-Atkins Museum, Kansas City, Mo.*

Fig. 17 Carved lacquer dish, "Birds and Hollyhocks," given to Metropolitan Museum of Art by Florence and Herbert Irving, in honor of James C. Y. Watt.

were over and Carl's sketches approved, she found that her artistic vision would be sublimated to court convention, as she recounts:

> Her Majesty was dressed in one of her official winter gowns. Its fur lining rendered the already heavily embroidered satin stiffer than ever, and any stray folds that might perchance have appeared, were pulled out by a heavy fringe of pearls around the hem. . . . She had on her famous pearl mantle over an official jacket. In her coiffure she wore her long tassel of pearls, and many curious ceremonial jewels. She had on fur-lined under-sleeves, which hid half her beautiful hands. The effect of her tiny finger-tips, with their long curving nails and jeweled shields, the palms not being visible, was most unfortunate.

There followed a discussion with Mme. Yukeng as to the pose, but Her Imperial Highness was unyielding. Finally the pose and, eventually, the garment of yellow silk patterned with narcissus and "double long life" characters were approved. Next, they decided on the size of the portrait—a gargantuan six by ten feet. As the palace carpenters were not up to stretching a canvas, the task fell to the artist and an army of palace eunuchs: "I used the iron pincers and pulled the canvas, myself," Carl wrote. "It was held at the corners by eunuchs, also on stools; one eunuch held the tacks, another the hammer, etc. Each order I gave was repeated in a loud voice by the head eunuch, and at every failure to comprehend my directions, the working eunuchs were rebuked and threatened with the 'bamboo.' Finally I accomplished the difficult task, and the great canvas was stretched."

Originally, the number of agreed-upon sittings was limited to two, but Cixi had become enthralled by the venture, and the process dragged on for nine months, with Carl living as an inmate in Prince Chun's palace until the astrologers declared that the portrait must be finished at four o'clock on April 19, 1904. There were problems: Cixi became bored and restless, and Yukeng's daughter, Der Ling, had to pose instead; the dowager objected to Western artistic conventions such as shading: "I don't want people over there to imagine that half of my face is white and half black." She thought jewelry was as easily removed from the picture as it was from the person. The anodyne result was not entirely the artist's fault, as Carl wrote with an Orientalist flourish:

> I had dreamed of painting Her Majesty in one of her Buddha-like poses, sitting erect upon an antique Throne of the Dynasty, with one beautifully rounded arm and exquisitely shaped hand resting on its high side, contrasting in their grace with its severe lines. . . . Her wonderfully magnetic personality

Katherine Carl, the breezy American who charmed the Dowager Empress, wearing an outfit given her by Cixi.

alone should have dominated. At the left of the Throne I should have placed one of those huge Palace braziers, its blue flames leaping into the air, their glow hinting here and there upon her jewels and the rich folds of her drapery; the whole enveloped in the soft azure smoke of incense, rising from splendid antique bronze censers. Across the base of the picture, under her feet, should have writhed and sprawled the rampant double dragon. The Eternal Feminine, with its eternal enigma shining from her inscrutable eyes, should have pierced, with almost cruel penetration, the mystery of her surroundings. Her face should have shone out of this dim interior, as her personality does above her real environment. I should have tried to show all the force and strength of

her nature in that characteristic face, exaggerating every feature of it, rather than toning down one line.

Nevertheless, the empress was pleased with the result, and she urged Carl to remain and continue producing more portraits. This imperial request was politely denied, but for her efforts, Carl received the Order of the Double Dragon, Third Class of the Second Division, conferred on her by Cixi, as well as a Pekinese named Golden Amber and some 1,500 guineas for three portraits. The dowager also thoughtfully provided Carl with two fur-lined dresses upon the occasion of the Chinese New Year, effecting a compromise between European and Chinese clothing: pleated skirts with an embroidered panel down the center of the front, topped by a jacket. Once outfitted, Carl had her picture taken, wearing the sable hat designed by Cixi, which she copied from old prints.

With the portrait finished, the dowager designed a camphor-wood frame and commissioned an enormous matching stand. From then on the St. Louis portrait was treated as if it were a living goddess. At the outset of its imperial progress, the ladies of the legations were invited for a private viewing. They were received first by Her Majesty in the throne room, then they were carried in covered palace chairs to Kate's large studio, which was equipped with proper lighting. There they viewed it while attended by the female members of the court. The next day, the princes and other nobles were invited, but since they were not allowed into the female quarters, the painting had to be carried outside. Scaffolding was erected so that it could be lowered onto its stand and Lady Yu Keng's son, Xunling, could photograph it.

An especially built railway conveyed the portrait to the station, "for it was not considered fitting that ordinary bearers transport the picture of her Majesty." Another special train conveyed the "Sacred Picture" to the port of Tientsin, where it was met by the provincial viceroy and his staff, placed on a steamer for Shanghai, and transshipped to San Francisco, then to St. Louis in a special railway car accompanied by the official entourage. At four o'clock on June 19 (we assume the exact time and date was not coincidental), His Imperial Highness Pu Lun met the "Sacred Picture" at the St. Louis Fair's Art Gallery, where it was opened in the presence of the assistant director and several members of the board of fine arts. The yellow silks and satins were removed and the portrait toasted with champagne.

After the fair closed, the portrait traveled to Washington, where the Chinese minister presented it to President Theodore Roosevelt, who

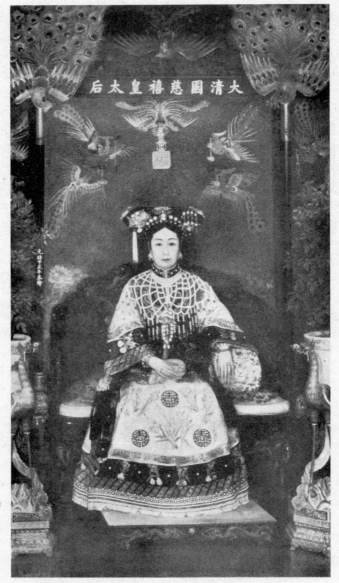

大清國慈禧皇太后

The peregrinating St. Louis portrait of Cixi by Katherine Carl.

accepted it on behalf of the nation. It was later passed on to the Smithsonian, which lent it to the History Museum in Taipei, where it languished until it was discovered in the 1960s and returned to Washington for conservation. Now boasting a new purpose-built frame, it is the property of the Sackler Gallery. As for Kate Carl, she returned to live in New York

City, where she died in 1938 of burns suffered when she was taking a bath. Her book *With the Empress Dowager* (1905), dedicated to Sir Robert Hart, survives as a reprint (2012).

MCKINLEY'S CHOICE for the American minister to China was a law school chum and former Iowa congressman, Edwin H. Conger. He arrived as minister plenipotentiary in July 1898, just as the first attacks on Christians occurred that would spark the Boxer Rebellion. (It would later be his lot to read press accounts of his death at the hands of Chinese zealots.) From today's vantage, his choice as minister was curious. His previous posting had been to Brazil and he had no knowledge of the Far East. Not only did Conger not speak Chinese, but he knew no French, the language in which the Boxer indemnity negotiations would be conducted. Fortunately, he was to be assisted by William Woodville Rockhill, McKinley's special envoy, who by contrast was fluent in French as well as Chinese and was a close friend of Secretary of State John Hay. An awkward situation ensued when it appeared that only ministers would be allowed to attend the formal meetings. Hence Rockhill would have to rely on leaks from the other ministers, but, as he wrote Hay regarding Conger, "We have hit it off admirably, nothing could have exceeded the cordiality of his reception and the gratefulness of his accepting me as a cooperator."

Peking lay in ruins when Rockhill arrived in September 1900, a witness to the horrors still being perpetrated on the northern Chinese. In his own words:

> From Taku to Peking, the whole country is in a beautiful state of anarchy, thanks to the presence of foreign troops sent there to restore order. The "disciplined armies of Europe" are everywhere conducting operations much as the Mongols must have done in the 13th century. Hardly a house remains from the seacoast to Peking which has not been looted of every moveable object it contained, and in half the cases the houses have been burned. Peking has been pillaged in the most approved manner, and from the General down to the lowest camp follower, from the Ministers of the Powers to the last attaché, from the Bishops to the smallest missionary, everyone has stolen, sacked, pillaged, blackmailed and generally disgraced themselves—and it is still going on. Yesterday, my wife and I walked to the Observatory on the wall. The magnificent bronze instruments, some dating probably from the 13th century, were being taken to pieces by French and German soldiers to be sent to Paris and Berlin. These instruments had been left unharmed, untouched for seven centuries but they could not escape the civilized westerners.

"French and Germans could bury the hatchet for once and rob in the most fraternal matter," he complained, but the Americans also earned their share of his scorn: "This expedition will go down in history as the most disgraceful one of this century—and what breaks my heart is that we should be associated with it."

During the rising, the German minister and the Japanese chancellor had been killed, as well as more than thirty thousand Chinese Christians and numerous missionaries; foreign and Chinese Christian property had also been damaged or destroyed. America's foremost anti-imperialist, Mark Twain, responded to missionary calls for blood money to be "used for the propagation of the gospel" in a famous essay, "To the Person Sitting in Darkness." Twain targeted President McKinley, the British secretary of state for the colonies Joseph Chamberlain, the German kaiser, and the Russian tsar as "The Blessings-of-Civilization Trust" intent on "Extending the Blessings of Civilization to our Brother who Sits in Darkness." One stinging citation suffices: the kaiser "lost a couple of missionaries in a riot in Shantung" and "China had to pay a hundred thousand dollars apiece for them, in money; twelve miles of territory, containing several millions of inhabitants and worth twenty million dollars; and to build a monument, and also a Christian church; whereas the people of China could have been depended upon to remember the missionaries without the help of these expensive memorials."

Months of negotiations ensued, and an indemnity of $333 million, to be divided among the powers according to their losses, was agreed upon. In retrospect, Rockhill was the hero of the moment: he earmarked indemnity funds for scholarships to American universities for worthy Chinese male and female recipients, among them a future president of China, a Nobel Prize–winning physicist, and many distinguished educators and public servants. The protocol was signed on September 7, 1901, and the exiled court, which had fled to Xi'an, prepared to return to the Imperial City in January's freezing weather. As *The New York Times* reported, two companies of Chinese cavalry on white horses and two mounted companies from Australia waited at the station for the special train bearing the emperor, the empress dowager, the young empress, the imperial concubine, and the ladies-in-waiting to arrive:

> Two thousand officials, Princes, viceroys and Taotais—a kaleidoscopic field of silks and furs, in which gleamed an occasional yellow jacket were massed on the platform. When the emperor appeared the entire assemblage prostrated itself and remained kneeling until his Majesty had taken his place in his chair. . . .

The entire cavalcade moved off with the Chinese cavalry in the lead. Then followed the great body of officials, riding shaggy Mongolian ponies, the Manchu bannermen, the umbrella bearers, the spearmen, Viceroy Yuan-Shi-Kai in his newly bestowed yellow jacket, and the emperor, with eight bearers carrying his chair, and a guard of infantrymen marching on either side. Then came the Empress Dowager with an equally conspicuous entourage. . . . While their Majesties passed the soldiers lining the route of the procession knelt, holding their guns at present arms, and the buglers sounded their instruments continuously. Although the streets were kept empty, thousands of Chinese crowded the elevations along the line of march, a thing never permitted before.

A series of receptions followed, and Sarah Conger led the way in smoothing relations between the foreign community and the court. On

Mrs. Conger with the Dowager Empress showing the controversial hand-holding.

February 1, 1902, twenty-nine green sedan chairs with bearers and a Chinese cavalry escort made their way to the Forbidden City, where they were replaced by red imperial chairs carried by black-robed eunuchs to the court gate of the palace. There the women and children of the diplomatic corps were presented to Cixi and her nephew, Emperor Guangxu. Sarah, the only member of the group who had been presented earlier, became the spokesperson for the women. She congratulated the royals upon their return and expressed the wish that "the sting of the sad experience may be eliminated" and hoped that future relations would be franker, more trustful, and friendlier. Following the presentations, Her Celestial Majesty took Sarah's hands in both of hers. As Conger wrote, "[H]er feelings overcame her. When she was able to control her voice, she said, 'I regret, and grieve over the late troubles. It was a grave mistake, and China will hereafter be a friend to foreigners . . . and we hope to be friends in the future.'" At the end of the speeches she turned to Sarah and extended her hands, and taking from her own fingers "a heavy, carved gold ring set with an elegant pearl," she placed it upon Sarah's finger and from her wrists she removed bracelets and placed them on Sarah's wrists.

Sarah's handholding and her acceptance of the Old Buddha's personal jewelry opened the minister's wife to sharp criticism. John Otway Percy Bland, the journalist who had for thirteen years been private secretary to Sir Robert Hart, called her "simple-minded" in his scurrilous account of the last days of the Qing Empire, *China Under the Empress Dowager* (co-authored with the equally infamous Sir Edmund Backhouse). His own dissenting view of the meeting of the women was conveyed in a letter he wrote to *The Times* correspondent George Morrison:

> The address which Mrs. Conger incongruously read strikes on the mind like a cold douche of imbecile fatuity. There was no reason why the women should not go to the reception, but there was every reason why they should have there comported themselves as the representatives of that civilization which the Chinese Court and Govt. so lately flouted and bombarded!

Morrison judged the encounter as "the most revolutionary event which has occurred since the Court's return."

Sarah became a friend of the dowager, and as a practicing Christian Scientist, a religion then enjoying a vogue among American matrons, and a correspondent with its leader and founder, Mary Baker Eddy, she was inclined to be more tolerant of the Chinese and their empress than were her missionary acquaintances. She became famous for the tiffins (midday

meals) she hosted for the court ladies, but her "considerable intimacy with the infernal old harridan the Empress Dowager whose portrait is now being painted by an American lady Miss Carl," continued to outrage *The Times*'s Morrison.

It was in fact Sarah who conceived the idea of having the dowager painted because, as she wrote her daughter Laura, "For many months I had been indignant over the horrible, unjust caricatures of Her Imperial Majesty in illustrated papers" and she had "a growing desire that the world might see her more as she really is." A woman who has continued to fascinate a series of biographers, Cixi witnessed successive humiliations by foreigners as her various attempts at modernization in the face of Western and Japanese encroachments failed. Viewed by the foreign missionaries as backward and tyrannical and by journalists as incompetent, greedy, and perverted, the dowager's portrait certainly needed retouching.

Sarah was at heart a collector—of people, furniture, and Chinese art. Of herself she said, "I am a seeker in China, and am interested in Chinese [things]. I recognize their beauty, then I wish to know something of the people who produced them." Birthdays and special celebrations were marked by gift giving, but Sarah writes that after press criticisms of the bracelets and rings she had received from the dowager empress, "the foreign ministers requested that no presents be given to the ladies of the Court." Seemingly immune to this criticism, Sarah noted that Cixi was

A bevy of Court visitors to Mrs. Conger.

not above taking her aside at their next encounter and pressing on her a small jade baby boy with the pantomimed admonition, "Don't tell." Other imperial gifts included two palace-bred dogs, a Shih Tzu named Sherza, and a Pekingese named Tiger, along with presents for her granddaughter.

COMPARED TO AMERICAN MISSIONS in European capitals, Peking in 1898 was not a sought-after posting. "The Eastern Lane of the Mingling of Peoples" (Dongjiaominxiang), as the Legation Quarter was known to the Chinese, lay southeast of the Forbidden City and was bisected by the Jade Canal, disparaged by the foreigners as "the imperial sewer drain." There, according to an account by Eliza Scidmore, who often visited her brother then in the foreign service, "the fine flowers of diplomacy have been content to wallow along the filthy Legation Street, breathing its dust, sickened with its mud and stenches, the highway before the doors a general sewer and dumping ground for offensive refuse of all kinds." Behind the walls of the legations, however, foreign diplomats occupied a different world:

> Official European residences are maintained on a scale of considerable splen-
> dor, and the sudden transfers from noisome streets to the beautiful parks and
> garden compounds, the drawing-rooms and ball rooms, with their brilliant
> companies living and amusing themselves exactly as in Europe, are among the
> greatest contrasts and surprises of Peking.

Before becoming a diplomat, Conger had been a banker, but he was not independently wealthy, and the couple's income was not up to diplomatic standards. In those years, American ministerial positions were deemed an honor that you were expected to subsidize with your independent income. According to one account, in contrast to the trained professionals of Europe, who were "sustained by the certainty of promotions and rewards after a useful term," the American minister lived "crowded in small rented premises, is paid about a fourth as much as the other envoys, and, coming untrained to his career, has the cheerful certainty of being put out of office as soon as he has learned his business and another President is elected."

The American minister had suffered when the Legation was damaged in the Boxer Rebellion, and many of the Congers' personal belongings were destroyed or looted. Very likely the furnishing of their new quarters in a rented temple, the Sanguanmiao or the Temple of Three Officials, was decorated on Conger's dime. But even on her husband's

meager $13,000 annual salary, Sarah accumulated a collection that would become controversial in the wake of the looting of Peking's palaces. (The reader will remember that Herbert Squiers, the American first secretary, and his elegant wife, Harriet, availed themselves of enough booty, according to *The New York Times,* to fill several railway cars.)

"It is not quantity that I strive to collect," Sarah wrote, "but good specimens of the different lines of China's best productions." She was smitten by the colorful clothing worn by the Chinese, and her published letters contain innumerable descriptions of her meetings with Manchu court ladies and what they and the dowager were wearing. She was an early collector of court robes, although she does not seem to have succumbed to the temptation of wearing them. In 1903, Sarah wrote her daughter, "Of late, I have been able to get some very choice things. I have been wanting them for some time, but how to secure them I did not know. The Princesses and Chinese ladies help me to obtain their beautiful robes and other articles not on public sale. Friends—seekers after treasures—bring many things to me from their delving into the unexplored regions, and kindly take me into byways where time, unmolested, has deeply buried things of rare value."

The siege of the legations had taken a toll on Minister Conger's health, and, plagued by dysentery, he submitted his resignation to President Roosevelt. In April 1905, Edwin and Sarah steamed home on the *S.S. Siberia* and settled in Pasadena. He died in 1907, but she lived on, her last few years tinged with scandal over her purchases in China, as detailed by her biographer Grant Hayter-Menzies. First there was the rug bought in Peking for $90 and sold for $6,910. Had she made a "Big Profit on a Fine Rug," as *The New York Times* alleged? Was it cheap because it was looted? Did she pay duty on the $90 or $7,000? *Times* readers wanted to know. In February 1908, 987 pieces were offered at a four-day auction at the American Art Galleries in New York City. Sarah totaled up the proceeds at $36,207.50. Among them were several items with an imperial provenance from palaces and temples. "United States Branded as 'Fence' for Permitting Sale of Goods Stolen from Peking by the Allies and Brought Here by an American Minister," headlined New York's *Evening World.* "True, the American envoy and his young army aide, who afterward became his son-in-law, did not steal the imperial jade, ivory and bronze pieces, or the silks and embroideries"; however, its report accusingly added, "the thieves who did steal them found a market for them under the flag of the United States." Another account claimed that the Congers had struck a deal to bring in their "Chinese loot" duty-free. A

customs official explained, "We admit free of charge all the goods that our own or foreign ministers or ambassadors wish to bring."

But the controversy persisted, with newspapers citing which museums and collectors purchased the "loot." On the sale's second day, the Metropolitan Museum purchased an elaborate yellow banner from a temple and a roll of purple satin with swastika scrolls; Salem's Peabody bought two Korean pillow covers; the highest bidder was J. W. Hoven, who paid $825 for a blue satin mandarin robe. The U.S. Congress was then holding hearings on diplomatic expenses, and Representative James Luther Slayden, a Texas Democrat, denounced Sarah and asked that a newspaper article be read into the record: "'How,' said a prominent foreigner in a New York club on Saturday, 'would you Americans feel if, ten years after a Chinese raid on Washington, you heard of a Peking auction sale at which were offered many of the treasures of the White House and the finest residences of your capital?'" Congressman Slayden cited *The New York Sun*'s statement that her collection "is not the slow aggregation of years of indulgence in the collector's hobby, but represents the timely purchases of a practical woman with a taste for the beautiful, who found herself at an unlooked for emergency in an exceptionally favorable position to obtain objects in which the whole world is interested." As the wife of the minister with imperial connections, she had an advantage: "She was able to bring her carefully selected loot into this country free of duty."

Faced with the public outcry, Sarah tried to sell privately the items that remained. "I have much of old, rich Chinese embroideries. They are *elegant*," she wrote to Charles Lang Freer, hoping to close a sale. "They range in coloring from the most pronounced in strong colors to the dainty of the daintiest. There are imperial coats, spreads, throws, table covers, cushions, covers, banners most beautifully embroidered—all hand work and *wonderfully* wrought." She was not above invoking imperial provenance: a pair of vases "the late Empress Dowager of China presented me . . . I own *many* valuable gifts given to me by Her Majesty. Many of the choice gifts, with the sentiments they bear, are very dear to me." And the rarest of the rare: "three Banners [scrolls] painted by the late Empress Dowager of China. Two she gave me. One she had made and painted herself for Mr. Conger on his departure from China. The Empress Dowager would give a subject to a Chinese Scholar, and he would write a poem, then Her Majesty would illustrate the poem in a picture on the Banner. The poem and the seal of the writer appear on the Banner. Her Majesty's imperial Seal is at the top of the Banner in large size. Her

*William Rockhill, diplomat and sometime
Foreign Legionnaire, cattle rancher, scholar,
and collector, in Tibetan dress.*

private seals appear upon the Banner. These are rare treasures and should
not be packed out of sight. I will part with one of mine." Freer very prob-
ably didn't answer; at the time he was terminally ill.

Sarah spent her final years in Christian Science retirement homes in
Boston and Concord, New Hampshire. She "passed on" in 1932, and her
granddaughter, Mrs. T. Edson Jewell, donated the hundreds of remain-
ing objects, some of them personal gifts from the dowager empress, to
the Metropolitan Museum, the Museum of Fine Arts Boston, Harvard's
Peabody Museum, and the Peabody Essex Museum in 1991.

CONGER'S SUCCESSOR, William Rockhill, was undoubtedly the most qualified of the early American envoys and probably the greatest scholar-diplomat of his generation. He was also an important collector of clothing and accessories, ornaments and ritual objects, weapons, musical instruments, and thousands of books and manuscripts, many of which were purchased by the Smithsonian Institution or given to it after his death by Rockhill's second wife, Edith. They came with commentaries illustrated by the collector. In one example, he drew six different types of boots worn by Khalka Mongols, lay Tibetans, and lamas.

Born in Philadelphia to a lawyer and a Baltimore belle, schooled in France at the preeminent military academy of Saint-Cyr, Rockhill served as an officer in the French Foreign Legion in Algeria, a rancher in New Mexico, and a translator of Tibetan sutras, during a life that was the stuff of a John Buchan novel. His teenage Asian studies were inspired by the lectures he attended by Ernest Renan, the Collège de France's renowned biblical scholar, and by reading the French missionary Abbé Huc's account of his 1846 trip to Lhasa. Rockhill would claim that it was Huc's accounts that ignited his lifetime ambition to explore Tibet. In 1881, Rockhill sold his ranch, moved to Switzerland, and spent the next three years studying Tibetan, Sanskrit, and Chinese. His marriage in 1873 to another Philadelphian, Caroline Tyson, now enabled him (when her cousin died and left her a tidy bequest of $70,000) to take what was initially an unpaid position as second secretary of the American Legation in Peking. By 1886, he had advanced from a (now) paid position of first secretary at the American Legation to acting chargé d'affaires in Korea.

Throughout his life, Rockhill continued to have friends in high places but did not tolerate fools. Aloof, brusque, short-tempered, and given to depression, he struck fear into the hearts of his younger associates. "We stood in holy terror of Rockhill," said Nelson Johnson, a future ambassador to China, who recalled the horror of the "Big Chief's" presence while sitting for a Mandarin language exam. "He was always very pleasant and affable, but he never recognized us on the street as being part of his entourage. . . . He went along in a kind of thought-world of his own." A modest man, Rockhill denied having sought a life of derring-do. As he explained to a questioning reporter, "Some men can have adventures going from New York to Brooklyn, but I am not one of them. I have never had an adventure in my life. . . . [A]dventures come to those who look for them. If a man minds his own business, he doesn't have them."

Not wanting to court adventure, Rockhill personified the Boy Scout motto—"Be Prepared." During his Far Eastern stay, with the help of a lama, he polished his Tibetan until he achieved proficiency in preparation for a trip to China's remotest province with the hope of reaching its capital, Lhasa. There were problems from the start. Tibet, with the support of China, had closed its borders to foreigners. Any Chinese or Tibetan who helped a foreign traveler risked punishment or imprisonment. Sarat Chandra Das, the formidable Indian "pundit," had reached the Tibetan capital from Sikkim in 1882 in the guise of a pilgrim seeking enlightenment, but no Westerner since two French priests, Abbé Huc and his companion Joseph Gabet, had traveled to Lhasa in 1846 and viewed the Potala. Rockhill met Das in 1885 when the Indian explorer accompanied the finance secretary of Bengal, Colman Macauley, to Peking. According to Rockhill's biographer, Kenneth Wimmel, they discussed joining forces on a Tibetan trip, but when this failed, Rockhill decided on the northern route through China followed by the Frenchmen rather than that taken by Das—over the Himalayan passes from India.

Armed with a letter of introduction from the Smithsonian, Rockhill set off for Lhasa from Peking's western gate with a single Chinese servant, Liu Chung-San. "My outfit was simple and inexpensive," Rockhill explains in *Land of the Lamas* (1891), "for dressing and living like a Chinaman, I was encumbered neither with clothes nor foreign stores, bedding, tubs, medicines, nor any of the other impedimenta which so many travelers consider absolute necessities." Passing through bandit-infested provinces by *mappa,* a two-wheeled cart pulled by a mule, he arrived at Xining (Sining) on the Tibetan plateau. But the six-foot-four redhead could scarcely have failed to attract attention. Suspicious police ordered him to appear before the local magistrate. Instead, having shaved his head and face of his telltale red hair, and having exchanged his Chinese clothing for a Mongol *del* (a large coat worn crossed in front and attached to the shoulder and sides with buttons) and a fur cap, he departed at dawn with a Mongolian camel caravan making its way toward Tibet. He describes his companions as "clothed in sheepskin gowns and big fur caps, or else in yellow or red lama robes—the women hardly distinguishable from the men, save those who, from coquetry, had put on their green satin gowns and silver head and neck ornaments to produce a sensation on entering Lusar or Kumbum." The caravan reached Lusar on the eve of the Dragon Festival. There he "strolled through streets crowded with puppet theaters, gaming tables, snack bars, wagons laden with sweets, meats, baked goods, trinkets, pelts, souvenirs, and despite

frequent sweeps by censorious lamas flourishing whips) peep shows featuring titillating pictures of European origin." A few days later, at Kumbum Lamasery, he witnessed large figures twenty feet long by ten feet high, sculpted out of butter and lit by hundreds of tiny butter lamps. Taking up to three months to complete, the display melted after only one night. Rockhill stayed six weeks at Lusar, filling notebooks with material for eight articles for *Century Magazine* and for his subsequent book. But his hopes of continuing to Lhasa were dashed when, even with the help of the Bu Lama, Rockhill's former Tibetan tutor now living in a nearby lamasery, his fearful guides vanished. He therefore set out on his own, accompanied only by a Tibetan mastiff. When he ran out of money, he turned back four hundred miles short of his goal.

A second journey to Tibet followed in 1891, this time with a stipend from the Smithsonian. His $50 monthly salary was sufficient for his scientific apparatus, but he was short of cash: "How to travel on an empty money bag (and an empty stomach, as it turned out in my case) in a strange land, is a more difficult problem than the quadrature of the circle." His route would lead him through present-day Qinghai, formerly Kokonor Province on the Tibetan plateau. This time his preparations included a special passport from the Chinese Department of Foreign Affairs that allowed him to travel to Mongolian and Tibetan areas under the control of the Xining Amban. But he was unprepared for the summer snowstorms, and his baggage animals perished. However, it was food or the lack of it that proved his undoing. There was not enough of it, and what there was proved inedible. He recalled a saying: a Mongol eats three pounds of wool with his food yearly, a Tibetan three pounds of gravel, and a Chinese three pounds of dirt. "I swallowed with my miserable food the dirt, the wool, and the grit, portioned by a harsh destiny to these peoples, and I verily believe that I found enough wool in my tea, my tsamba [ground barley flour and salty butter tea], my meat, and my bread while in Mongolia and Tibet to stuff a pillow. The dirt and the sand could be easily swallowed, but the wool—nothing could be done with it, no amount of mastication could dispose of it." Night temperatures fell to fifteen degrees below zero. When they arrived at Kumbum, in addition to a team of five Chinese, Rockhill hired two Mongol guides who agreed to lead them to Shigatse, a large town in western Tibet, bypassing Lhasa. He had bought clothing and supplies for the long trek northeast to southwest across Tibet to British India, but then he received a letter from a Chinese official in Kanze, in eastern Tibet, which said that a price had been put on his head since the locals suspected him of being a spy for

Lhasa. (Internecine relations among Tibetans were fractious at the time, and there was intense distrust of Lhasa.) Eastern Tibet was too dangerous; three Chinese employees pleaded illness and left for home; and although he struggled on, Rockhill was eventually forced to halt 110 miles from his goal. As he sorrowfully reported: "I am ten days from Shigatse and not more than twenty-five from British India and six or seven weeks from home, but it will be four or five months before I reach there now by the long route I shall have to travel, *T'ien ming,* 'it is heaven's decree.'" Halted in his southward progress by the Tibetans, who supplied him with food and a pony that allowed him to travel eastward by the unexplored Chamdo trade route instead of retracing his steps northward, Rockhill reached Shanghai in October. He had traveled eight thousand miles, crossed sixty-nine mountain passes over 14,500 feet, brought home photographs, sketches, and hampers full of Tibetan clothing, jewelry, and copper-gilt and brass figures to the Smithsonian.

In 1894, the Smithsonian published a full account of his travels titled *Diary of a Journey through Mongolia and Tibet.* (After reading the diary, Henry Adams, usually frugal with his praise, wrote Rockhill, who was his friend, "I am lost in astonishment that anyone should in pure gaiety of heart undertake and carry through such an adventure, and then relate it as if it were a number on Pennsylvania Avenue. . . . I feel quite a new spring of self-esteem that I should be able to treat you with familiarity. It is as though I had lived on intimate terms with Marco Polo, and had Genghis Khan for dinner.")

London's Royal Geographical Society awarded Rockhill its much-coveted Patron's Gold Medal. In Washington, the Five of Hearts, a coterie of government insiders including Henry Adams, John Hay, and Theodore Roosevelt, saluted him. With their help in 1889, Rockhill resumed his State Department career, first as chief clerk and then as assistant secretary of state. An unfortunate posting as minister to Athens followed, where his forty-two-year-old wife, Caroline, died of typhoid fever. But in that same year, Hay came to his rescue. Rockhill was transferred to Washington, where he became chief architect of the secretary of state's Far Eastern policy. His outstanding achievement was to mentor Secretary Hay's "Open Door" policy, through which the United States and five major European powers acknowledged spheres of influence in China but agreed that within China, all countries should trade on an equal basis.

Rockhill returned to China to broker the Boxer settlement, receiving an enthusiastic send-off from Roosevelt: "I feel as if a load were off my mind when it was announced that you were to go to China." When

Roosevelt's second term began in 1905, he appointed his friend as minister to China. At his post, Rockhill and his new wife, Edith, played host to Roosevelt's exuberant daughter, "Princess Alice," during her stay in Peking, where she was received, accompanied by the minister, by the dowager empress and emperor. Alice sketched Rockhill in her diary: "Though he was very tall and of an almost washed-out fairness, he had somehow grown to look curiously Chinese; one felt that China had gotten into his blood; that if he let his mustache grow and pulled it down at the corners in a long thin twist, and wore Chinese clothes, he could have passed for a serene expounder, whether of the precepts of Lao-tze or Confucius, I don't know."

ALTHOUGH HE HAD NEVER REACHED LHASA, Rockhill now became an advisor to Thubten Gyatso, the Precious Protector, the All-Knowing Presence, the incumbent Thirteenth Dalai Lama, describing his role as "the most unique experience I have ever had." The Dalai Lama had fled Lhasa in the wake of its occupation by a British expedition led by Sir Francis Younghusband in 1903–4. Lord Curzon, then viceroy of India, feared that the Russians were advancing on Tibet and convinced Whitehall that such a move on Lhasa was essential to protect India. Younghusband readily defeated the poorly armed Tibetans and marched on Lhasa, only to find there were no Russians present. Now living in exile in Mongolia, the Dalai Lama learned of the American scholar and diplomat who spoke Tibetan and was in Peking, and he looked to Rockhill to intercede on his behalf during difficult negotiations with the Chinese.

Several events occurred that increased His Holiness's isolation. In 1906, a new Liberal government in Britain signed a pact recognizing China's suzerainty over Tibet. The Celestial Empire's authority was further increased with the 1907 Anglo-Russian Convention, in which both signatories agreed to deal with Lhasa only through Chinese mediation. (Although the Chinese acknowledged the Dalai Lama as a spiritual leader, they did not recognize his temporal authority.) The British were still occupying a part of Tibet when friction developed between His Holiness and his Mongolian hosts, resulting in his departure from Urga. He eventually found sanctuary at Wutai Shan, a Buddhist monastery in Shanxi Province. Realizing a lifetime goal, Rockhill hiked as much as twenty miles a day for five days to meet him in 1908.

In a twelve-page letter to Roosevelt, Rockhill described his encounter with the Thirteenth Dalai Lama: "I had imagined a rather ascetic

looking youth, bent by constantly sitting bow-legged on cushions, with a sallow complexion and a far-away meditative look. On the contrary I found a man of thirty-three, with a very bright face, rather dark brown, a moustache and a small tuft of hair under his lower lip. . . . His ears were large but well-shaped, his hands good and thin. . . ." According to Rockhill, the Dalai Lama was dressed in dark red with a vermilion silk shawl over his left shoulder; his yellow boots were bound with blue braiding. The meeting—the first official contact between Tibet and the United States—proved a success.

As Rockhill recalled in a monograph written years later: "He is quick tempered and impulsive, but cheerful and kindly. At all times I found him a most thoughtful host, an agreeable talker and extremely courteous. He speaks rapidly and smoothly, but in a very low voice." An elated Roosevelt fired back, "I think that this is one of the most interesting and extraordinary experiences that any man of our generation has had. There has been nothing like it, so far as I know. Really, it is difficult to believe it occurred! I congratulate the United States upon having the one diplomatic representative in the world to whom such an incident could happen." During a second meeting, at which they discussed Tibet's relations with India and a possible visit to Peking, the Dalai Lama presented Rockhill with gifts, three of them including a *Tangka,* a painting of the scholar saint Tsongkhapa, now in the collection of the Library of Congress.

William Howard Taft succeeded Roosevelt as president, and, as was the custom, Rockhill submitted his resignation. (On his last day in Peking, he wrote in his diary, "Can my work in China be at an end? I pray it be not terminated entirely.") During his travels and residence in China, he had collected hundreds of mostly Tibetan objects, as well as rare books in Mongolian, Manchu, Tibetan, and Chinese in both printed and manuscript form that are now impossible to obtain. Eleven hundred volumes now reside in the Freer Gallery of Art; six thousand items are now in the Library of Congress, making it a leading center for Tibetan studies.

Rockhill was posted to St. Petersburg, having earned his promotion to ambassador, and in 1911 he moved on to Constantinople as ambassador to the Sublime Porte. When Woodrow Wilson was sworn in as president in March 1913, Rockhill tendered his resignation and returned home to Litchfield, Connecticut. As he wrote to a friend, he hoped to "raise poultry and flowers and live exclusively in an oriental atmosphere of the Southern Sung and Yuan periods." Yet eight months later, the sixty-year-old diplomat took part in an expedition overland through Mongolia to

China in order to evaluate conditions in the former empire, now turned republic. While on this mission, China's provisional president, Yuan Shikai, offered him a post as foreign advisor to the Chinese government, but he died on December 8, 1914, in Honolulu, while on his way back to Peking. Berthold Laufer, Rockhill's only American peer as a Sinologist, wrote his obituary: "Mr. Rockhill was a man of extreme modesty and seldom talked about himself or his achievements. He received no honors from this country, but, indeed, he craved none. . . . It is painful to think that at the end of his life, his diplomatic services were valued more highly by China than by his own government."

CHINA'S DIPLOMATIC COMMUNITY witnessed three salient events in 1908. On April 13, 1908, Peking's railway station overflowed with crowds as Sir Robert Hart departed for the last time, leaving his brother-in-law, Sir Robert Edward Bredon, as acting inspector. A military band and Cameron Highlanders piped the crowds while uniforms stretched as far as the eye could see. Sir Robert's guard of honor was composed of American and Dutch marines, Italian sailors, Japanese soldiers, and three detachments of Chinese soldiers newly clad in smart khaki. Hart's personal brass band struck up "Auld Lang Syne" and "Home Sweet Home" while he bowed to the cheering crowds. Although his hoped-for peerage never came, Hart was rewarded with a papal decoration, and the Chinese retroactively appointed three generations of his forebears to "The Ancestral Rank of the First Class of the First Order."

On November 15, 1908, the seventy-three-year-old dowager empress died. Theories abound as to the cause, the most entertaining (if doubtful) being that she succumbed after eating too many crab apples at a picnic given for the Dalai Lama, then briefly quartered in Peking. (The Russians and the British as well as Rockhill had advised him to return to Lhasa, but he chose to accept the emperor's invitation to the capital, where he was demoted and given a new title. "The Most Excellent, Self-Existent Buddha of the West" now became "The Sincerely Obedient, Reincarnation-helping Most Excellent Buddha of the West.") Just before the funeral cortege departed from Peking, paper effigies of the dowager's favorite possessions, including a 180-foot paper barge staffed with paper attendants and floating on paper waves and an entire paper army dressed in modern European uniforms, were burned in order to attend the Old Buddha in her afterlife. Eighty-four bearers carried the enormous catafalque containing her coffin over an especially made road strewn with yellow sand to her mausoleum. There the Old Buddha rested until the

summer of 1928, when her tomb was dynamited and robbed by Chinese Nationalist soldiers. Jewelry was taken from her body—gold, pearls, rubies, sapphires, and diamonds. Some of it ended up in General Chiang Kai-shek's possession—one pearl taken from Cixi's mouth was used, according to a widely believed rumor, to decorate Madame Chiang's shoe. The Manchus who reburied her reported a scene of desolation. Her empty coffin was upended on a wall in a room bare of its usual ritual furniture. Stripped of her robes, the "Jade Body" was lying on her face, naked to the waist, her silken trousers pulled down and her hair disheveled. Sunk into her pale face were her eyes like two black caverns. The body was cleaned, wrapped in rolls of silk, and returned to her coffin, the lid resealed.

The day before Cixi's death, the royal physicians affirmed that her nephew, the Guangxu emperor, had ascended a dragon to be a guest on high. In 2008, forensic examinations confirmed that he had died from arsenic poisoning, most likely ordered by his aunt. Cixi had already taken the precaution of designating another nephew, Zaifeng, as regent for his two-year-old son, the Xuantong Emperor Puyi.

CHAPTER FOURTEEN

THREADS OF HEAVEN

On January 1, 1912, the revolutionary leader and Christian convert Sun Yat-sen returned from foreign exile to be inaugurated in Nanking as the first provisional president of the Chinese Republic. On February 12, the new empress dowager, Longyu (the Guangxu emperor's widow), signed the abdication papers that brought the Great Qing Empire to a close. In the presence of the six-year-old Puyi, with tears streaming down her face, she read the edict that swept away two thousand years of imperial rule. Under the terms of the agreement, the Xuantong emperor Puyi was allowed to remain among his relatives, eunuchs, and the imperial treasures in the Forbidden City on an allowance of four million silver yuan annually for household expenses.

Peking's diplomatic community now faced a period of adjustment. A new American president, William Howard Taft, successor to Theodore Roosevelt and also a Republican, appointed William James Calhoun, an Illinois lawyer, to succeed Rockhill as envoy extraordinary and minister plenipotentiary to China. Calhoun arrived in 1909 with his wife, Lucy Monroe. By his own admission, he unpacked "without knowing a single thing about the country . . . [with] no impressions for or against it," but left in 1913 "with the heart strings pulling a great deal." Until that time Peking had been deemed a difficult and isolated posting, but tourists had begun to appear and the American Legation played host to a procession of distinguished visitors. And by November 1908, according to a Russian diplomat, Dmitrii Abrikosov, the capital had become: "[A] perpetual

merry-go-round of parties. Every Legation tried to eclipse the others: a ballet in the Russian Legation, where the charming daughter of the Minister was a comet surrounded by stars; a musical at the French Legation, where the beautiful wife of the French Minister danced the bolero to the music of Ravel; a fancy dress ball in the French bank with everyone under the influence of champagne, exotic costumes, Chinese lanterns in the garden, and romance in the air."

Lucy Calhoun, diplomatic wife, collector of textiles, artworks, and celebrities, as Peking becomes a fashionable destination.

The minister's wife, Lucy, was the sister of Harriet Monroe, the founder and editor of Chicago's famed literary magazine *Poetry,* a leading force for the avant-garde in American literature. Harriet, while visiting her younger sister in 1910, slipped easily into the foreign colony's routine: the seaside resort of Peitaiho for the summer, pony rides and state dinners in the fall—spinsters and bachelors at the table's end, ministers and wives in strict order of precedence above. Quoting her letters home, Harriet notes two subtle changes presaging the revolution that would bring down the dynasty: "Manchu ladies are accompanying their husbands to foreign dinners, and it is becoming unfashionable for Chinese women of the upper classes to have bound feet."

For well-heeled clients like the railroad magnate Charles Lang Freer, who stayed in a suite in 1909 and 1910, the domain of choice was the "Grand Hotel des Wagons-Lits," built in 1905 to accommodate travelers arriving from Europe on the Trans-Siberian Express. Described in 1919 by the American writer Ellen La Motte as "the most interesting hotel in the world," it was where all the nations "meet, rub elbows, consult together, and plan to 'do' one another and China too." Located conveniently in the Legation Quarter, the Wagons-Lits served the finest in French wines and cuisine. A Dutchman, Henri Borel, conveyed his distaste for the changes that were beginning to overtake Peking:

> A glass of sherry, a cigarette, a French newspaper. Am I in Paris or Peking? Round about me are exactly the people one sees at Ostend, Biarritz, Wiesbaden . . . smart business people and empty *desoeuvres* [the idle]. What in Heaven's name are these people doing in Peking? "How do you like Peking?" I hear . . . the shrill high voice of a lady—"So pretty; so interesting. Yesterday we did the Ming Tombs near Nank'ou; oh it was lovely, lovely." Thus appears Peking to me, the holy city of the Emperors, the Sons of Heaven, tarnished by the snobbery of white globe-trotters and loafers, who have forced themselves by the fuming, screeching train through its sacred ramparts, which can no longer shield its virginity. And outside to the right and to the left, louder than the buzzing of voices, I hear the hammering and knocking going on for ever—as if the Modern had conquered, and were triumphantly erecting a new, vulgar, cosmopolitan town in the ancient holy fortress of the Tartars of the North.

During Harriet's time in Peking, not only did the Calhouns host a reception for Freer attended by American and Chinese officials, but the minister also provided him with logistical help and security escorts for his

travels. Their abashed guest of honor wrote to his business partner, Frank Hecker, "Of course I don't deserve such attentions and as you know, I really don't care for them, but the things I unearthed in China last year and some of those recently secured have got known in Legation circles and they think me either a saint or a fool and I fancy they are trying to learn which." Harriet wrote that, with Freer's guidance, she had made "a sudden and very deep plunge into Chinese art," particularly, it seems, painting. "The good news of high prices was traveling in mysterious un-dercurrents through China and the 'head boys' of centuries-old families were pussyfooting up to Peking from remote provinces with long-hidden precious rolls under their arms," she reports. Freer was "hot on the trail," and "there is blood in his eye; and consequently impoverished mandarins are revealing their rarest treasures." Freer took her to the most famous of the shops and "to his Chinese palace [rooms in the Tartar City] where the new acquisitions were guarded by experts; and for my benefit many of them were unveiled and unrolled."

The former viceroy Duanfang invited them to tiffin and showed them his bronzes that had been dug up in Shaanxi when he was the governor of the province. "He had in mind a project for a museum in Peking," Harriet recalled some years later, "but impoverished heirs were compelled to scatter his collection, and the very temple set he showed us is now in the Metropolitan Museum of Art in New York." The sale of Duanfang's collection following his murder, according to Juliet Bredon, Sir Robert Hart's niece and the author of the guidebook *Peking* (1919), "brought native bidders from every province and caused as great a sensa-tion in the Far Eastern art world as an auction of Greek marbles would in Europe." (Lucy would score her own coup when, as a gift to the depart-ing minister, Dowager Empress Longyu had a hanging scroll delivered to their carriage as they left the imperial palace. Now in the Art Institute of Chicago, it bears Longyu's seal and a brief inscription, describing the painting as a work of the "imperial brush," although the painter of the *Tree Peonies in Full Bloom* remains unknown.)

With interest in Chinese art growing, dealers like C. T. Loo and Yamanaka were sending scouts into the countryside. In Shanghai, the former missionary John C. Ferguson collected paintings that he would soon offer to the Metropolitan and Freer. Ancient tombs were discovered as railways expanded, creating new opportunities for collectors. Soon, professionals competed with amateurs joining in the fun, according to Bredon:

When one has seen all the palaces and 'done' all the temples and tombs, there still remains a never failing source of interest and amusement in Peking— shopping. . . . Few strangers can resist the temptation to bargain for old porcelains, bronzes, embroideries, or whatever appeals to individual taste, and in the resident this habit, sooner or later, develops a special mentality. We shamelessly examine the pictures on each other's walls, turn over our host's dishes at table in search of marks to prove their origin, pick up his lacquer after dinner to feel its weight, boldly inquire the price of his latest acquisition. Such manners, which would be ill-bred in Paris or London, are tolerated and understood in the "old curiosity shop," as a witty traveler once called Peking, and if you stay long enough you will acquire them yourself.

The best time to buy was right before the Lunar New Year, when the Chinese were cash-strapped because of their obligation to lavish presents on relatives and pay their debts to shopkeepers in order to receive credit for the next year. Resident foreigners could shop at home; runners would come bearing blue cloth bundles to be examined while sitting comfortably in an armchair. This method was favored by old customers because the salesman knew their taste—or lack of it—and catered to it. Scroll after scroll would be unrolled for inspection: birds and flowers, rivers and mountains, framed by calligraphy and colophons. The second method was to visit the shops, as Bredon explains, where it was fatal to judge simply by appearances: "The biggest, and the cleanest shops in Peking may not have the best things. Often a merchant hidden away in a blind alley has the rarest treasures—just as his tiny store has the most high-sounding title. . . . A tiny dug-out known as the 'establishment of Ten Thousand Glories,' offers a most admirable box of Yung Cheng enamel. In the filthy local 'Cour des Miracles,' east of Chien Men Street, many a good piece has been picked up." Shops were grouped together on streets with names like Jade, Embroidery, Silver and Lantern Street. The favorite haunt for antiquities was outside the Chien Men in Liulichang, the old glass quarter. Because travelers had by now become familiar with Chinese art in European, Japanese, and American museums, they assumed that treasures overlooked by looters during the Boxer Rebellion still abounded in Peking. Lucy Calhoun explained to American readers of *The New York Times* how you shopped on "the greatest curio street in the world." After you enter the shop, the dance begins when the dealer raises the blue cloth hanging across a beckoning doorway, revealing

bits of Ming bronze, porcelain bowls, and in a glass case under the light ex-
quisite carvings in white jade, brown jade, gray that shades into black, green
that merges into white. Perhaps you make an offer for one of them, far be-
low, but not too far, the price demanded. The dealer, spurning your offer, but
perceiving that you have taste will then invite you to penetrate further into
his domain. He leads you through a courtyard into a larger room. You stand
bewildered before all this beauty—Han bronzes, exquisite medallion bowls
of the time of Tao Kwang and Victoria, Chien Lung enamels, blue and white
porcelain fired under the patronage of the emperor Kang Hsi of unerring taste,
finger bowls of coconut shells covered with little figures in low relief and lined
with silver, a graceful Kuan Yin in white jade, Ming pottery in blue and pur-
ple, a white Sung bowl perhaps or a priceless blue one splotched with purple.

All the while the dealer observes you, seeing if you are worthy of appreci-
ating and buying the best pieces. If he approves, he will welcome you the
next time like an old friend.

BUT IN THIS GOLDEN AGE of art collecting, the Chinese were
already creating expert forgeries with fake temple provenances. As Bre-
don warned her readers:

> Never forget in the enthusiasm of the moment, when some attractive speci-
> men strikes your fancy, that every trick of Western antiquarians, and a thou-
> sand original ones of their own are familiar to Chinese dealers. They peel their
> pearls, bury their bronzes to give them a fine patina, dye their furs, smoke
> their embroideries and ivories, imitate and colour jades, tint rock-crystals,
> forge date marks and cleverly insert old bottoms in new vases. The temptation
> to cheat the novice is generally irresistible, in quality, in price, or both, and the
> most ingratiating and convincing salesman is often the worst offender.

After the 1911 revolution that swept away two thousand years of
imperial rule, pigtails were cut off, feet were unbound, and elaborate
Manchu headdresses were replaced by shingled heads and, among the
Westernized female flappers of the 1920s, bobbed hair. Formal attire be-
came obsolete overnight as the court was dissolved. Officials once garbed
in embroidered silk robes now wore Western clothing. "How horrible,"
opined the visiting William Rockhill. "European dress is intolerable on
them, and it is so with all these attempted imitations." "I am not con-
scious," Lucy Calhoun reported to Harriet, "that the Manchu princes
are selling their treasures, but I have been getting some lovely paintings

of late." She now had a sideline as a "picker" for Chicago's Antiquarian Society, an auxiliary of the Art Institute. Her small allowance, she proposes, would be spent on "an Emperor's coat . . . an exquisite old ko-sse [kesi] coat . . . and some old ko-see temple hangings." She claimed that the MFA's expert, Kakuzo Okakura, then in Peking acquiring Chinese art for Boston, had pronounced them "the finest of their kind." The Antiquarians approved. The articles were shipped from China and received in Chicago with enthusiasm. "I do not wonder that they thought the things modern," Lucy responded in a letter to the chair of the purchasing committee, "they were so wonderfully fresh. But out here everyone knows them to be old. The quality of the silk, the nature of the colors and especially of the gold, the character of the workmanship are all of another age than ours. It is impossible to reproduce them today." But the Calhoun's Chinese idyll was over in 1913, and they returned home.

"THERE IS A STRANGE THING about foreigners who have lived very long in China: they never seem to be contented anywhere else. They are apparently bitten by some kind of bug which infuses a virus into their blood, and makes life in that country the only thing endurable," observed William Calhoun. He might well have been describing his wife, Lucy. Following her husband's death from a stroke in 1916, she spent time in France, working in hospitals during World War I. Afterward she returned to Peking, where as "Aunt Lucy" she reigned for the next two decades as the social lioness of the "expat set," hosting "at homes" in a rehabilitated eighteenth-century Buddhist temple in the Ma Ta Jen Hutung, which she equipped with Western comforts like electricity and plumbing. One of "Aunt Lucy's" parties in 1933, recalled George Kates, involved a barge towed under a full moon along a canal through hundreds of floating lanterns while her guests cavorted in full evening dress.

Not to be outdone by the literary efforts of her sister Harriet, Lucy, who had been an art critic for *The Chicago Record Herald,* contributed two articles to *The New York Times:* "The Streets of Peking" (November 26, 1922) and another on Puyi's wedding (November 22, 1922) to Empress Wan Rong. Lucy described the wedding—one of the last occasions when the mandarins still dressed in their official embroidered robes, their dark plum-colored coats lined with white fox; their outfits crowned by necklaces of jade, amber, or coral; and their official hats with peacock-feather pendants in the back. Lucy was the only foreign woman in the group and, as she noted for her readers, "It was unprecedented even to see her [the incumbent empress]."

Peking's expat community in the 1920s was divided into four groups: the diplomatic set, headed by the six-foot-six British ambassador, Sir Miles Lampson, whom the local wags nicknamed "Tiny," and who behaved like the benevolent headmaster of an English public school; the customs men, headed by Sir Robert Hart's successor, Sir Francis Aglen, thought by the Chinese authorities to exhibit his predecessor's arrogance minus his savoir faire; the missionaries ("mish boys") who included teachers at Yenching University, YMCA workers, and the doctors and nurses at the Peking University Medical College (PUMC); and the civilians—businessmen who had chosen Peking over the more commercially minded Shanghai and, of course, tourists.

PEKING UNIVERSITY MEDICAL COLLEGE had been founded by British and American missionaries to teach Western medicine to Chinese doctors. At the time, American businessmen like the Rocke-fellers viewed China as an important new market, while missionaries saw it as their best opportunity to save millions of heathen souls. Although medicine was secondary to proselytizing, the Protestants had made few Chinese converts, while their medical missionaries rarely lacked patients. In 1914, the Rockefeller Foundation purchased the college from the London Missionary Society, and six Protestant denominations joined to form the PUMC under its resident director, Roger Greene. Over the next few years, with Rockefeller support, the college assembled a faculty of fifty professors and upgraded its facilities with fifty-nine buildings. Designed in an ersatz Sino-European style, with rooftops glazed in green tiles that were meant to blend in with the regional architecture of Peking, it would be known locally by its nickname, "The Oil Prince's Palace." According to Julia Boyd's entertaining account of Peking life, *A Dance with the Dragon* (2012), the PUMC sent scouts to villages to find artisans who still had the long-lost skills to erect this new "palace." In September 1921, John D. Rockefeller Jr. arrived with a large entourage for its opening.

One of its medical recruits was Dr. John Grant, a recent product of the Johns Hopkins Medical School's graduate public health program. Grant had been born to Canadian parents in Ningpo, where his father served as a Baptist missionary doctor. After finishing secondary school at a German gymnasium at Tsingtao (Qingdao), he earned his undergraduate degree at Nova Scotia's Acadia University and his medical degree from the University of Michigan. In 1917, he met and married Charlotte Hill Grant, who accompanied him in 1922 to his post as associate director for medical education and public health at PUMC. In 1925, working with

the Peking police, he created a health station serving the 100,000 people living in Peking's first ward, which surrounded the college. By 1928, he headed the PUMC's Department of Public Health and Hygiene, which promoted fieldwork and established a number of community clinics in which the students could practice.

While John devoted his energies to furthering the research and educational goals of PUMC, Charlotte spent her time engrossed by the social and political history of China. During her fourteen-year residence, she began her collection of Manchu clothing and accessories with an inheritance left by her banker father. A particular Peking source was a Mr. Dai, in whose back room she made her selections. (According to Charlotte's granddaughter Shand Green, when Abby Rockefeller accompanied her husband to Peking, she liked shopping with Charlotte, who, she said, knew all the best shops.)

IN 1644, nomadic warriors from Manchuria precipitated the fall of the Ming dynasty. The Manchus possessed strict sumptuary laws, codified in 1759, under which color and pattern indicated rank and official status. Thus Confucian order also prevailed, in which the robes were indicative of the hierarchy of the universe, with the ruler at the peak. But Daoist and Buddhist symbols were popular as well, with their depictions of sea and land, turbulent waves and mountains, all adorning the bottom of the garments. Golden yellow was reserved for the emperor (and empress), and only he and "princes of the first-degree" were allowed the five-clawed dragon; other princes had to be content with four claws. Qing dynasty officials were permitted two badges on their outer coats: one in the center of the back, and the other at the front: civil servants were identified by different birds, while military rank was indicated by animals, usually mythological creatures. Fur-lined hats also indicated the rank of the wearer—telltale button finials topped them. A woman's status was determined by that of her male relatives. Clothing was strictly governed by edicts issued twice a year, citing the exact day on which winter clothing made of heavy silk satin would be switched to summer garments of lightweight silk gauzes, whose open weaves provided ventilation.

As Alan Priest has written in the guide for the Met's landmark exhibition "Costumes from the Forbidden City," it was not until after Puyi's abdication in 1912 that Manchu robes began to appear on the market (except, of course for those looted in the aftermath of the Boxer Rebellion). In the 1920s, they arrived "in avalanches." First came the items

looted by the imperial eunuchs, and then those that appeared after Puyi and his entourage were driven out of the Forbidden City. From 1925 to 1928, wrote Priest, "the Peking market was as full of court robes as Boston Common was full of sparrows." In 1929, the market was flooded by theater robes reported to have come down from the palace at Jehol.

Charlotte's collection contained more than five hundred items—robes, an extensive collection of badges, pockets, purses and pouches, hair ornaments and headdresses, shoes, fingernail guards, and decorative components of robes like sleevebands, collars, and cuffs. One item, a man's semiformal court robe, or *jifu* (auspicious clothing), was worn at state audiences and bears twelve symbols of imperial sovereignty, signifying the sacred duties of the Son of Heaven (see color plates, figure 6). The other auspicious symbols, such as the round red *wanshou,* the bats, and the swastika fret pattern, convey a wish for longevity and happiness. Other decorative elements are the dragon, prism-shaped mountains on four axes and diagonal bands at the hem, depicting the ocean. According to John Vollmer, a leading authority on Chinese textiles, when the *jifu* was worn at court, the emperor faced the Dragon Throne to the north, the four mountains pointed to the cardinal directions of the compass, thus illustrating the cosmic plan upon which the Manchu government rested.

Charlotte stayed on in Peking until the advent of the Japanese, when she returned to Berkeley, California, along with thirty-nine steamer trunks filled with her collection. Charlotte's children, James P. Grant and Betty Grant Austin, donated the items to the Denver museum at the suggestion of Denver's longtime dealer in Asiatic antiquities and an honorary curator of Asian art, H. Medill Sarkisian, in 1977.

Among foreigners, the *Longpao,* the so-called dragon robes, garments worn on all formal court occasions except for certain designated ceremonies, became much sought-after items. They featured side closures, bottom slits at the sides, and horse-hoof cuffs. Charlotte's collection, acquired during the 1920s and 1930s, contains a large number of robes and decorations from the period of Cixi's reign. "Princess" Der Ling Yu, the dowager's former lady-in-waiting, guided Mrs. Grant in these matters, explaining to her friend the intricacies of the imperial toilet, and Grant's notes, gleaned from these conversations, are now archived at the Denver Museum.

DER LING'S FATHER, YUKENG, had been a minister to Japan and France. His wife was born of a Han Chinese mother and a Boston merchant. Half-castes were not generally well regarded, but even the disapproving Sir Robert Hart conceded that Yukeng had powerful backing

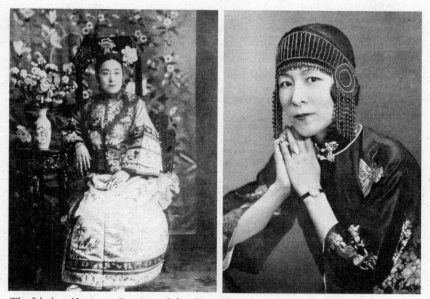

The fabulous Yu sisters: Der Ling (left), dressed for a lecture, and Rong Ling (right).

and that their marriage had been a love match. In Paris, their young Westernized daughters, Der Ling and her elder sister, Rong Ling, studied dancing with Isadora Duncan and acting with Sarah Bernhardt. The family was summoned back to China in 1903, its members retained as translators and intermediaries between the court and the foreign community. The seventeen-year-old Der Ling spent two years at the court attending Cixi, an account of which she published in her much-reprinted memoir, *Two Years in the Forbidden City* (1911). In addition to acting as interpreter for the dowager, Der Ling was in charge of her jewels and ornaments, which proved helpful when she left the Forbidden City. Turning down Cixi's suggestion of a Manchu prince, in 1907, she married a dubious American consular official, Thaddeus Cohu White, took up residence in the Hotel des Wagons-Lits, and, after the fall of the Manchus, pursued her sideline of assisting foreigners, including guiding them on tours through the Forbidden City and Summer Palace. (White, according to Morrison, "undertook many shady dealings as a commercial agent," including trying to sell off the treasures of the imperial palace at Mukden.)

Der Ling's linguistic gifts—besides Chinese and Manchu, she spoke Japanese, English, and French—enabled her clients and friends, among them Westerners like Sarah Conger, Lucy Calhoun, Charlotte Grant,

Gertrude Bass Warner (who left her collection of textiles and antiques to the University of Oregon), and the visiting heiress Barbara Hutton (at the time Princess Mdivani), to collect items that were being sold off by impecunious courtiers. Der Ling, La Motte reported, was often found surrounded by young men holding forth as "the Scheherazade of the Hotel des Wagons-Lits lounge"—"very modern, very chic, very European as to clothes." As Der Ling confessed, "At heart, I was a foreigner educated in a foreign country." Chameleonlike, she changed her fashion to fit the times: in China during World War I, she donned a white Peking Red Cross uniform, then appeared as a flapper while staying at the Wagons-Lits during the 1920s; in the United States, she dressed as a Manchu princess for her popular lectures—"The Modern Woman of China," "At the Manchu Court," and "Chinese Politics of Today."

In California, Der Ling resided at Berkeley's Hotel Carlton while acting as a private curator to Barbara Hutton's growing collection of Chinese art. She was a guest, along with Thaddeus, at the Woolworth heiress's wedding in 1935 to husband number two, Count Kurt von Haugwitz-Reventlow. Fortuitously, Der Ling was able to spirit twenty-five packing cases of her belongings out of China just ahead of the Japanese invaders in April 1937. During the 1939 San Francisco World's Fair, where she was billed erroneously on souvenir postcards as "the last surviving member of the Chinese royal family," she graced her own "Princess Der Ling Pavillion," complete with a "throne room" and life-size mannequins, while dressed in the court costumes she managed to rescue. One of her own robes, decorated with a hundred butterflies, an auspicious symbol associated with weddings and birthdays, is now in the collection of the Metropolitan Museum and was, according to her biographer Grant Hayter-Menzies, a present from Cixi. Her other possessions, including imperial gifts of princess trappings, fell under the auctioneer's hammer following her death in 1944, after she was run down by a grocery truck on her way to teach a Chinese language class at Berkeley.

IN 1927, Peking, meaning "northern capital," became Peiping, or "northern peace," when Chiang Kai-shek moved his Nationalist capital to Nanking. Diplomats remained in Peiping but were faced with the inconvenience of traveling for days, by sea or rail, to conduct business with the Nationalist government. As the Italian minister remarked, "It was as if a foreign diplomat accredited to Washington were to live in London." Now demoted to a provincial town, her red walls painted a Nationalist blue, Peiping was described by one writer as "a deposed empress, still clad

in the remains of her imperial wardrobe, making ineffectual attempts to pose as an ordinary housewife."

THE 1930S FOUND the Peking expatriate community still in the throes of its collecting fever. Helen Snow, a journalist married to another newspaperman, Edgar, reported that it was a paradise for foreigners, who could live royally for as little as $200 per month. With this nominal sum, you could rent a Manchu palace, furnish it with antiquities, and train a large staff of servants to entertain visiting celebrities. On weekends, there were tiffins and treasure hunts at rented temples in the Western Hills, and a stable of ponies at Paomaochang for riding or racing. If it was canines you fancied—perhaps a Tibetan breed made to resemble a small lion—there was the dog show, or you could always find a foursome for tennis at the Peking Club.

Harriet Monroe visited her sister again in 1934, and she found the city changed in many aspects, but the splendor of the royal enclosure was still intact: "[T]he Forbidden City was no longer forbidden; its imperial gardens were parked and tended for us, its palaces were open to citizens of the Republic of China and to wanderers like myself. . . . The streets were cleaner on the whole, and a few great ones were paved out wider to make room for the automobiles . . . and the Legations were still giving dinner-parties in their trim and stately mansions, even though the Government had departed and the business the diplomats came for must be conducted in Nanking."

In between bridge parties, visits to the Ming tombs or the Great Wall, and picnics in the Western Hills, the favorite expat sport was still shopping. In Harold Acton's roman à clef, *Peonies and Ponies,* about Peking in the 1930s, his heroine, Mrs. Mascot, perhaps inspired by his friend Lucy, observes: "In Peking we all have collections. One simply has to collect you know. . . . It's in the air, an epidemic that catches everyone sooner or later." An act of generosity from Acton's Chicago uncle, Guy Mitchell, enabled the Anglo-Italian Oxford graduate to live and collect in China. Harold moved to Peking in 1932, then settled down to study Chinese theater and to teach English at Peking University. Four years later, he moved into George Morrison's luxurious digs at Number 2 Kung Hsien Hutung, owned by a decrepit Manchu nobleman riddled with debt. (Its previous occupant had been the American Museum of Natural History's dinosaur-hunter, Roy Chapman Andrews.) To the one-story buildings connected by roofed and pillared galleries, Acton added a swimming pool in an inner garden surrounded by white lilacs, ornamental rocks, and an

English lawn where the front courtyard had been. Inside, he hung his growing collection of Chinese scrolls and arranged his antique furniture. In the cabinets where the former owner's collection of ritual bronzes—now sold and scattered—had been displayed, Acton arranged vases and brush pots, twisted and carved to resemble specimens of fossilized fungi and roots. Among this coterie of those who had "gone native" were three Americans—"the flitterati," Harvard graduates whom we have already met: the Met's Alan Priest, Kansas City's Larry Sickman, and George Kates.

During the late 1920s, in his pre-Metropolitan days when scouting for the Fogg, Priest resided full-time in Peking. His mornings were spent learning Mandarin, studying Chinese classical drama, or examining the blue-wrapped bundles of silks, paintings, and sculpture brought to him

Harold Acton (top row, center), aesthete at large, hosts a party for his friends in Peking, including Larry Sickman (top row, right) and Alan Priest (bottom row, third from left).

by local dealers. On days when he felt ambitious, he visited the shops or swanned about the Forbidden City. His small house on a moat by the Forbidden City boasted an impressive flagstone courtyard where breakfast was served beneath the branches of an enormous tree. A border of flowers surrounded the courtyard, and every day a gardener brought great panniers of plants, all in full bloom. Large earthenware pots displayed shrubs, bamboo, or a superb lotus. Three servants, about the same age as Alan (late twenties), scuttled about, ready to fulfill his smallest wish. Alan presided at home à la Chinoise, where for special occasions he donned one of his many silk-embroidered Manchu robes while the impressionist sounds of Debussy's *Pelléas and Mélisande* wafted through the air. Priest was enchanted by textiles; he owned a collection of sumptuous brocades and embroideries, which, according to Acton, he understood better than human beings. During his more than thirty years as the Met's curator of Far Eastern Art, he greatly expanded its collection of Chinese textiles and was known as a gifted impresario of the shows that featured them.

Lucy Calhoun and Ma, her number-one boy, provided logistical help to Alan and his guests when they would all traipse to the Chieh-t'ai-ssu (Jietai so), the Temple of the Ordination Platform, so-called because it was where neophytes were admitted to the Buddhist priesthood. The majestic retreat was situated in the cool, wooded recesses of the Western Hills some fifteen miles from Peking. To get there, Priest's party boarded a train for the first part of the trip, then the ladies switched to palanquins and the men to donkeys. Lunch was a lavish picnic, provided by Ma, starting with cocktails and climaxing with strawberries and ice cream. A final hike to the monastery followed, where cots were set up for naps. The highlight of the trip was an evening service in the candlelit great hall of the monastery, the great wood sculptures hidden by incense while monks chanted to the accompaniment of the drums.

Lucy was also a regular at Alan's soirees along with the Yu sisters, Der Ling and Rong Ling, the "Princess Shou Shan," the very Parisian wife of a wealthy Republican army general from Canton known by her married name, Madame Dan Paochao. "Nellie," as she was called by her intimates, lived in the past and missed the pageantry of the Qing court in which she had spent her youth. According to Acton, those who had helped bring down the dynasty "were crowding around the magnificent tomb for relics," but "as time wore on she played up to them and supplied some of the relics herself." She lived in a palace stuffed with Ming porcelains, jade, agate, and crystal snuff bottles, brush stands on lacquered furniture atop thick carpets. Described by the Eurasian writer Han Suyin

as having "a delicate oval face like a melon seed," Rong Ling served as mistress of ceremonies to three-time president Li Yuanhung in the 1920s. In a gossipy letter to Paul Sachs, Priest claims that the opium-addicted Madame Dan "was given to performing terrible pseudo Chinese and Denis shawn [*sic*] dances." She "persists in being a professional court beauty (she must have been lovely) and talks as if she had run the empire for a decade or so. She does not collect antiques like other people—oh no—she collects perfumes—fifteen hundred and seventy three bottles I think and she gets one out to suit her every mood. I have sometimes thought she got them all out at once."

AFTER THE WALL STREET CRASH removed some American buyers from the art market, an opportunity was created for the richly funded survivors such as William Rockhill Nelson, the publisher of *The Kansas City Star,* who donated $11,000,000 to the city's museum, with Larry Sickman working as its scout. Sickman, who arrived in 1930 on a Harvard-Yenching fellowship, lived for several years in a charming house with his mother in the Hsieh Ho Hutung. Not only did he acquire the world-famous dragon Bi, the Longmen *Procession of the Empress,* but also the polychromed wood *Water and Moon Guanyin* (see color plates, figure 16), one of the stars of the Kansas City collection bought from C. T. Loo in 1934. Sickman also collected a number of stellar scrolls, including the masterpiece *Fisherman's Evening Song* (see color plates, figure 15), by the Northern Song painter Xu Daoning (Hsü Tao-ning) purchased in 1933. Colin Mackenzie, Kansas City's curator of Chinese art tells the story: "Late one night there was a knock on Sickman's door and the Chinese servant of the mayor of Peking was standing outside with a scroll that 'the master needs to sell.' The asking price was not inconsiderable, and Sickman had to make the decision very quickly—probably overnight. He borrowed the money from his friend Burchard." As Sickman later described it, it appeared that "the things I seek are seeking me."

Another tale involves a 1931 visit to Puyi in Tianjin, where the former emperor lived together with his Empress Wan Rong, his concubine, his brother, various officials and his Alsatian dogs. Between the fall of the Qing dynasty in 1911 and 1924, when he was deposed, Puyi lived virtually under house arrest in the Inner Court of the Forbidden City. During those years, the legal title to the imperial treasures remained ambiguous. Were they national treasures or the personal property of the Manchu Aisin-Gioro family, as the emperor claimed in his autobiography? Always short of funds to maintain his large household, Puyi began to sell the

imperial treasures or to use them to secure loans. In 1923, he ordered an inventory of the Palace of Eternal Happiness, where the favorite works of the great collector, the Qing Emperor Qianlong, were stored, frightening the eunuchs who had been engaged in pilfering. It has been claimed that they set the palace on fire, destroying a large number of objects. (The origin of the fire is still controversial; it may have been caused by an electrical fire while the former emperor was watching a movie.)

Taking advantage of the "Articles of Favorable Treatment of the Qing Royal Family," bestowed by China's republican government before the court departed from Peking, Puji's brothers, Pujie and Pujia, helped the former emperor smuggle out items that they considered the prizes from the imperial collection. Small items were taken, since they were readily portable. They were wrapped in yellow silk brocades and disguised as their student textbooks. As Puyi confessed, "We have removed over a thousand handscrolls, more than two hundred hanging scrolls and album leaves, and about two hundred rare Sung Dynasty printed books." The removal of still more objects was prevented by the arrival of the Zhili Army under General Feng Yuxiang. Puyi and his remaining courtiers were evicted summarily from the palace on November 5, 1923. Subsequently, the treasures were crated and shipped by rail to Puyi's new residence, the Zhang Yuan garden, in the Japanese concession in Tianjin. Pressed for funds, Puyi sold off his art mostly to foreigners. With the help of courtiers and dealers. Sickman thus acquired two paintings from the imperial collection including *Towing Boats under Clearing Snow,* a Song Copy after Guo Zhongshu (Kuo Chung-shu), and a Ming dynasty handscroll *Life Cycle of the Lotus* by Chen Chun, while their owner was distracted by his new European motorcycle.

ONE FINAL NOTE ON TOMBS AND textiles: In 1934, thieves broke into the royal tomb of Kuo Ch'in Wang (1697–1738), where the scholar-prince, the seventeenth son of Emperor Kangxi, and his consorts were buried. Inside the tomb they found robes, hangings, bolts of brocade, and spirit tablets bearing names of the entombed, allowing scholars to date the articles to the period before 1738. The bodies were dressed in their best ceremonial robes, with additional clothing provided for their afterlife. At the time, they were the only robes associated with a known imperial tomb. Of the group that appeared on the Peking market in the 1930s, Sickman bought six complete robes, three damaged robes, fragments, and cloth totaling some seventy items for the Nelson Gallery in Kansas City. Other robes from this find were acquired by the

Minneapolis Institute of Art, as well as by Priest for the Metropolitan Museum. Because of their fixed date, they serve as a touchstone for Qing robes, enabling scholars working backward and forward to make stylistic comparisons with other textiles. They remain among the finest examples of early Qing textiles in this country, reminding us that "made in China" was once synonymous with luxury.

Lucy Calhoun continued to collect textiles. Most of her collectibles, including some purchases for the Antiquarian Society, are now in the Art Institute of Chicago. She also demonstrated her affection for and appreciation of Alan Priest by donating three Chinese robes and a Tibetan painting to the Met. She remained in China until 1937, when the Japanese marched into the city unopposed and she returned to Chicago, where she died, aged eighty-five.

"CHINA IS NOW A SUBJECT of interest to everyone," the archaeologist Carl Whiting Bishop wrote in 1937. "Recent books about her have attained the rank of 'best sellers.' Her history, her civilization, her language—all that concerns her, in fact—are receiving a steadily growing amount of attention in our universities, our colleges, and our high schools. We find collections of Chinese art in all our larger and many of our smaller cities." Yet older conceptions of an exotic China now collided with a new stereotype of a timeless peasant society beset by natural disasters and human villainy, as epitomized in 1937 by MGM's epic film *The Good Earth*. Based on Pearl Buck's novel, the film nurtured timely support for a China besieged by Japan, but tellingly, none of its five principal actors were Asian, much less Chinese. Popular sympathy for a beleaguered nationalist China, pervasively promoted by Henry Luce's mass-market *Time* and *Life*, and further kindled by Madame Chiang Kai-shek's speaking tours, helped develop a certain proprietorship about China—implicit in the self-flattering charge that America "lost" a country it never owned and barely understood. This was a legacy that would both bedevil and benefit collectors and curators of Chinese art in postwar years to come.

CHAPTER FIFTEEN

THE AUTHENTICATOR

On September 13, 1934, a small, dapper scholar of renown, Berthold Laufer, leaped to his death from the eighth-floor fire escape of Chicago's Beach Hotel, five miles south of the Field Museum, where he had been curator in the Department of Anthropology for more than two decades. What precipitated his fatal plunge remains a matter of surmise (he had recently been diagnosed with cancer); what is inarguable is that Berthold Laufer was among the handful of intellectuals who gave America its head start in the collecting and analysis of Chinese art.

Described by a colleague as "a small-boned European-professorial type with mouse-grey hair parted in the middle, large pince-nez, sallow complexion," Laufer favored somber, dark business suits and wore old-fashioned wing collars. His hand "almost like white porcelain," when extended in a handshake, was "neither firm nor weak but had a tendency towards the latter." His letters reveal him, in his early years, to be a somewhat cranky misanthrope. Writing to his mentor Franz Boas during his early years in Chicago, he laments, "I am becoming mummified for lack of intellectual stimulation; there is not a trace of intellect here." His lack of collegial relations freed him to become a prodigious worker—he boasted of his sixteen-hour days in his office, where he swiveled between two roll-top desks dispensing pedantic corrections in a heavy German accent. But his former colleagues at New York's American Museum of Natural History also incurred his disdain; he once called it a place where "the fossil rhinoceroses have not yet become extinct."

Berthold Laufer, the country's preeminent authenticator.

Extolled by Harvard's Langdon Warner as "our leading sinologist," Laufer boasted to Boas, "I shall place the ethnography and archaeology of this country on an entirely new and solid basis. . . . I shall conquer China . . . [for] the anthropologist." Prolific both as a scholar and collector, he authored more than 450 publications and left behind an extensive library, stuffed filing cabinets, and major collections of artifacts and ethnographical objects in three museums: New York's American Museum of Natural History, Chicago's Field Museum, and its Art Institute. Whether it was a Zhou jade, a Han ceramic, or an Anyang bronze, curators and collectors summoned Laufer to authenticate and appraise, usually for a princely fee of $500 a day, even during the Great Depression. Collectors would then circulate, exhibit, and finally gift their much-appreciated (pun intended) tax-deductible bibelots to museums around the country.

Laufer's reputation, however, undeservedly shriveled. He became an academic casualty who was trapped in the bloodied crossroads between the arts and the social sciences. A pioneer in the newborn field of ethnology, he was viewed with suspicion by those in older disciplines. Yet scholars in Germany, where Laufer was born, led the way in the impartial scrutiny of all social systems; indeed, Max Weber was among the first to single out China's literati as "the bearers of progress toward a rational administration." They were in truth, he wrote, the "ruling stratum for more than two thousand years."

Laufer was a pioneer in another sense. He was a frontline combatant in the ongoing argument over how and where to place China in the rise of modern civilization. Leading academics and political leaders alike tended to view human history as analogous to Darwinian natural selection, with the fittest rising inexorably to the top. On this stepladder, primitive and nonwhite peoples were relegated to the bottom, while innovative, enlightened, upward-striving Euro-Americans commanded the peak. China posed an obvious problem. It was then poor, backward, and fossilized. And yet, somehow the ancestors of the same people independently invented the compass, the printing press, and gunpowder—the triad that supposedly propelled the rise of the West. And where in the annals of exploration do the fifteenth-century Ming voyages rank? Shouldn't the Muslim eunuch Admiral Zheng He, who seven times led the Yongle emperor's gigantic armada as far as Africa, be awarded the same status as Columbus and Vasco da Gama? When London was a swamp and Paris a Roman fort, the Middle Kingdom's merchants were trading with Central Asians and Mediterraneans along the Silk Road. So why not judge different cultures horizontally and not vertically, the test being how each in different ways adapted to its distinctive environment? Like Franz Boas, also a German-educated anthropologist, Laufer sided with the relativists.

There was a second and related question. What should Westerners make of Chinese art? Those strange rolled scrolls, gnomic Buddhist sculptures, and subtly shaded ceramics? Were they ethnographic folk art, trade goods, or just possibly precursors of the aesthetic movements in nineteenth-century Europe and America? All three approaches were evident in displays of Asian art at successive international expositions at Philadelphia (1876), Chicago (1893), and St. Louis (1904). By century's end, there was still no consensus on how to exhibit or categorize Chinese art. In successive expeditions, Laufer for his part was persuaded that ancient Chinese antiquities, especially jades, bronzes, and sculptures, were world-class; and that even the homeliest household wares and artisans'

tools offered perishable evidence of a traditional culture now imperiled by modernizing waves about to sweep China.

BORN TO A WELL-TO-DO JEWISH FAMILY in Cologne in 1874, Berthold Laufer attended the University of Berlin and received his doctorate from Leipzig University, by which time his linguistic skills, acquired at Berlin's Seminar for Oriental Languages, were remarkable. He claimed a working knowledge of more than a dozen Asian languages, including Semitic, Persian, Sanskrit, Malay, Chinese, Japanese, Manchu, Mongolian, Dravidian, and Tibetan, as well as the principal European languages (including Russian). Franz Boas, among the founding deities of anthropology, offered Laufer, then a newly minted Ph.D., a place on the Jesup North Pacific Expedition of the American Museum of Natural History (1898–1900), tasked with exploring ties between Asia and North America. More specifically, he also was to appraise the new and then-controversial theory that the ancestors of North America's Indians originated in Asia, via the Bering Strait. Laufer's travels took him to both mainland Japan and Sakhalin Island, near the mouth of the Amur River in Siberia. Although he contributed little to the Bering Strait debate, he shipped home a large number of objects and the requisite data.

New York bankers were then looking at China, particularly at the possibility of investing in railroads as well as doing a lucrative business financing imports and exports. Thus Laufer's next exploit was promoted to museum officials as gathering "collections which illustrate the popular customs and beliefs of the Chinese, their industries, and their mode of life," collections that would "bring out the complexity of Chinese culture, the high degree of technical development achieved by the people, the love of art, which pervades their whole life. . . . We also wish to imbue the public with greater respect for the achievements of Chinese civilizations." Laufer was to be the museum's sole participant in the 1901–4 China expedition funded by Jacob H. Schiff, another Jewish German immigrant, head of the banking firm Kuhn, Loeb & Company, who had joined with former Ohio senator Calvin S. Brice, the railroad magnate E. H. Harriman, J. P. Morgan, and others in establishing the American China Development Company to procure railway, mining, and other industrial concessions in China.

"Expedition" is perhaps a misnomer, since Laufer's trips were mostly of a solitary nature and he preferred to confine his purchases to the *hutongs* of major cities. Despite Boas's pleas for firsthand interviews with contemporary sources, Laufer preferred to glean his information from

Chinese texts rather than from conversations with craftsmen. Two small cases of reference books would accompany him on his trips to the interior of China. How and where he obtained his wares is surmised, perhaps unfairly, in light of his extensive travels in perilous times, by Jan Fontein and Tung Wu, coauthors of *Unearthing China's Past* (1973). Laufer's expeditions flourished, they write, because "instead of undertaking fieldwork, he spent most of his time in Sian [Xi'an] and Peking acquiring archaeological materials from Chinese antique dealers." In this respect, he had an advantage over Chinese scholars because he lacked the inhibitions created by taboos concerning buying *mingqi,* or tomb figurines.

In the wake of the Boxer Rebellion, Laufer anticipated that China would succumb to the forces of modernization and felt that, as an ethnographer, he had the "duty of rescuing perishing cultures and people from wreck." It was in their humble quotidian objects—everything from medications, to pigeon whistles, cricket cages and pastimes, puppets, and riddles—that the spirit of the Chinese people was revealed, according to Laufer, and not in "the most costly porcelains and the superb treasures of imperial palaces" (see color plates, figure 8). The results, as tallied by the Museum of Natural History's current curator Laurel Kendall, was the most extensive ethnographic collection from pre-revolutionary China in North America. As he exultantly wrote to Boas, "There is no path I did not walkover, no cave I did not enter . . . and no places unexamined by my inquisitiveness."

Arriving in Shanghai in early August 1901, he spent six weeks there, after which he made an extensive tour of Jiangsu and Zhejiang provinces, visiting Suzhou and Hangzhou before arriving in Peking in December. There Laufer lingered for nearly a year, making side trips to the Great Wall, the Ming Tombs, the imperial kilns, and to Chengde (Jehol), the old summer capital in northern Hebei Province. He returned to Shanghai to ship the objects and books that he collected. After further trips by boat to Nanjing and Wuhan and by mule cart to Xi'an, Laufer arrived at the port of Tianjin in October 1903 with a haul of seven cartloads of ancient pottery and bronzes. This was followed by another season's work in Shandong and a final trip to Shanghai, where he shipped another fifty cases before sailing from China in April 1904. Comprising nine shipments in a total of 305 large packing cases, his haul was staggering: 7,500 objects and five hundred volumes of old and rare books, plus five hundred wax cylinder recordings.

By this time he appeared to have gone native, becoming thoroughly "chinisiert," as he wrote Boas, feeling "myself to be better and healthier

as a Chinese than as a European." In another letter to Boas, he enthused: "Chinese culture is in my opinion as good as ours and in many things even better, above all in its practical ethics. . . . If I regret something, it is the fact that I was not born Chinese." But he visited China only once after 1910, and as the Field Museum's curator of Asian archaeology, Bennet Bronson, described it, the paradox of Laufer's life was his "wishing he were Chinese, but not liking China very much."

Although primarily tasked with collecting the mundane and the ethnographic, as Boas was to remind him, Laufer also managed to acquire antiquities—bronzes, stone carvings, Han period ceramics, and a number of paintings from needy collectors, eunuchs, opium-addicted monks, and the occasional dealer. Bargaining was essential, and his letters to Boas are filled with small victories. "Please do not think that making collections in this country merely means to go shopping," he wrote. "[It] requires a great deal of good nerves, the self-control of a god and an angel's patience." Looking back in 1912, a year after the fall of the Qing dynasty and nearly a decade after he returned with his collection, he reflected, "The chances are now upset, the romance of China has died away with the end of the chivalrous Manchu dynasty. The products of home industries will give way to the clatter of machinery and foreign imports. In this rapid period of transition and radicalism, most of the things displayed in our collections now belong to the past and have become, so to speak, antiquities all of a sudden overnight." Nevertheless, not yet appreciated as art, the American Museum of Natural History's Chinese collection was orphaned and subject to "gross neglect," according to Laufer. After Boas quarreled with the museum, Laufer left for Chicago.

HIRED BY CHICAGO'S Field Museum in 1908, Laufer made two more prolonged visits to Tibet and China in 1908 and 1910 as the leader (and only member) of the Blackstone expedition, which had Lhasa as its goal. Permission to proceed was denied by the government of India, controlled by Britain, which had seized Tibet's passes following the 1903–4 Younghusband expedition; his purchases were confined to the bazaars of Darjeeling and Sikkim. Nevertheless, he shipped 634 "Lamaist" objects home from Calcutta. He returned again to China in 1923 on a trip funded by the endowment left by the department-store magnate Marshall Field, the eponymous donor to the museum. The nineteen thousand Chinese and four thousand Tibetan objects acquired on these two trips became the core of the Field Museum's Chinese collection, one that is particularly rich in early ceramics and jades.

While on these expeditions, Laufer also collected for patrons. When he was made honorary curator of Chicago's Art Institute in 1920, Laufer helped the Field Museum's local rival acquire Asian collections from homegrown donors whom he advised. The Art Institute's early collecting of Japanese and Chinese art occurred virtually under his direction. One benefactor of the Institute, Chicago heiress Kate Sturges Buckingham, purchased a set of sixteen hollow bronze fittings meant for an elaborate gateway, complete with a fanciful provenance from Laufer. Starting with snuff bottles, Buckingham's taste became increasingly sophisticated. She would become an early, and important, collector of ritual bronzes and ceramics, known for being more interested in the quality than in a particular attribution or date. Laufer steered her to the Chicago branch of the Japanese dealers Yamanaka & Company, a source for the white Ding ware of the Sung dynasty, which, like her other acquisitions, she donated in honor of her late sister, Lucy Maud Buckingham.

Most of the scholar's three-week vacation was spent appraising jades in private collections for his standard fee. He was not above dealing from his own stock, selling, for example, two paintings to Charles Freer in 1912 for a substantial sum. "Rare and superb," "dirt cheap," "absolutely unique," "just excavated," "choicest and most brilliant," and "grand and adorable" were how Laufer described his offerings to his colleagues and prospective clients, along with his admonitions that acquisitions were of the utmost urgency as the "number of old things is rapidly diminishing" and "I am convinced that these opportunities will not come again." Similar transactions would raise eyebrows a few years later and are strictly forbidden in present-day circumstances. But perhaps fearful of losing a curator of his reputation, the museum appears not to have objected to Laufer's freelance efforts, although he was careful to weed his private business correspondence from his files before leaving them to the museum.

In his peak years, Laufer's were the last words on things "Oriental." To have Laufer catalogue and publish your collections was to have arrived at the pinnacle of the collecting pyramid. Among his clients was a Shanghai-born, London-based coal merchant, importer, collector, and gunner during the Boxer Rebellion, A. W. Bahr. Laufer published a catalogue of Bahr's archaic Chinese jades, which now reside in the Field Museum, thanks to the money raised by Laufer for their purchase. Subsequently Bahr's collection of another 149 works, mostly paintings, was sold to the Metropolitan Museum in 1947 (long after Laufer's death) for $300,000, but as the Met's present curator, Maxwell Hearn, recently commented, only 10 percent of the collection is of museum quality.

"Imperial" was a word Laufer often employed, since one of his sub-specialties was the recovery in Peking's antique shops of loot from the Qing Empire's palaces. Here he was in direct competition with missionaries, diplomats, curators, and collectors, and he was not above expressing outrage over the tactics of competitors, such as Dr. F. W. K. Müller, an employee of Berlin's Ethnological Museum. In 1902, shortly after the Boxer Rebellion, Laufer wrote to Boas: "Do you really, seriously, believe that I would ever sully my hands, to buy war booty and stolen property? To this, I would never lend my name, that glory I leave willingly to such great people as Dr. Müller. We acquire our collections in an honest way . . . we're not vultures, who rob by trailing along in the wake of crude and barbaric militarism. Dr. Müller's large collection consists partly of loot and is a shame and a disgrace for the Berlin museum and not only has he swallowed [actually, the German word is "chewed"] loot but also appropriated loot directly from soldiers and missionaries."

NEVERTHELESS A CURIOUS ITEM, a clipping from a 1931 Kansas City newspaper in the Harvard archives, attests both to Laufer's labile ethics and his considerable clout as authenticator. A U.S. Navy medical officer, Dr. Frederic N. Pugsley, was attempting to sell his collection of Chinese artifacts, acquired while he was posted to China, to Kansas City's Nelson Gallery. Summoned to Kansas City to "give his expert opinion on the Pugsley collection as a preliminary to its probable purchase by a 'widely known Kansas Citian for Kansas City,'" Laufer pronounced it "one of the most remarkable collections of Chinese art in the country."

Among the "souvenirs" in the Pugsley home were palace doors taken from the Forbidden City during the Boxer Rebellion. Mrs. Pugsley expressed regrets that her other "souvenirs" were "probably loot from the imperial palace, secured during the Boxer uprisings." But they were "purchasable loot and might as well have become theirs as anothers." Among the Pugsleys' other acquisitions was an "emperor's chair," which Laufer pronounced "very fine," and two other "throne chairs" used "by an empress of the imperial palace." Mrs. Pugsley acquired one chair when she saw it "being carried swiftly through the streets of Peiping." She followed it into a dealer's rear room. This chair Laufer pronounced a "superb piece" when he saw it ornamenting her drawing room. "I have seen one other like it, but it was in a state of ruin, whereas this is in a perfect state of preservation."

Laufer followed his visit with a letter:

[I] was surprised to find in your residence so many excellent and outstanding pieces of superior quality. The stone statue of the knight or warrior guardian of the Wei period is an imposing monument and a unique document of fundamental artistic and archaeological value. Your bronze drum belongs to the best and most complete in design that I have been fortunate to see. . . . I have never seen any more exquisite chairs from the imperial palaces than those in your possession. . . . The back of the imperial throne of the Ming dynasty with the dragons in open work is simply superb. . . . I likewise admired many of your archaic bronze vessels which form quite a study of ancient beautiful patinas, the large variety of your Han, Tang and Sung metal mirrors, and many exquisite ivories, wood-carvings, and porcelains. Several porcelain plaques with enamel paintings in colors of figure scenes stand out vividly in my memory. Last but not least, I must not forget the pair of marble Bodhisattvas with high coiffures, which vie in grace and beauty with the best products of Greek sculpture, and the large lacquered statue of a Bodhisattva from the temple of Jehol.

He finished the long list with an enthusiastic endorsement:

It is my opinion that these outstanding objects should be permanently kept in a first class art museum. The new Kansas City Art Museum would be the logical place and should set aside at lease three to four rooms for Chinese art. I should be much pleased if my observations would lead to some tangible result in this direction.

When news of the prospective purchase of the collection for $5,000 by William Volker, one of the city's leading philanthropists, reached the ears of Langdon Warner, the Fogg Museum's curator, then also acting as an advisor to the Kansas City museum, he was apoplectic. One of the trustees had written to him complaining that they were "greatly surprised," because Warner had stated that Laufer rejected this collection "with scorn" and had thought the owner of the collection "far from dependable." It was difficult "to understand how Mr. Laufer could talk as he did to you and then reverse himself so completely." Volker did buy the collection, which was weeded out by a new knowledgeable curator, more art historian than ethnologist—Laurence Sickman. A large percentage eventually went to the Kansas City Museum Association, while the Asian department of the Nelson-Atkins kept the rest.

ANOTHER COLLECTION ALSO CASTS a shadow over Laufer's posthumous reputation. The Los Angeles County Museum of History,

Norway's Wilhelm Munthe, a soldier of fortune who fought the Boxers and acquired imperial booty later authenticated by Laufer.

Science, and Art, funded and managed by the county's elected Board of Supervisors, opened in 1913 in Exposition Park, almost adjoining the campus of the University of Southern California. Prehistoric bones from the La Brea tar pits became the draw for the science division. However, the Asian art collection—despite some fine Japanese prints and A. Burlingame Johnson's collection of Chinese ceramics—failed to excite public interest.

This was the situation when, in June 1926, the museum received a catalogue and photographs of the collection of Johan Wilhelm Normann Munthe, a Norwegian who was employed in 1887 as an inspector at the British-run Imperial Maritime Customs Service. After China's defeat in the Sino-Japanese war of 1894–95, Munthe asked to be seconded to the cavalry in what was termed the "Newly Created Army" under the

leadership of Yuan Shikai. During the Boxer Rebellion, Munthe traveled to Tianjin, where, while attached to the Russian forces, he participated in several battles in and around the port. Following the fall of the Qing dynasty, Yuan became China's president and, for a brief period, emperor, while Munthe became a lieutenant general in the Peking gendarmerie.

With his waxed mustachios and self-designed uniform glittering with profligate medals, Munthe was the very model of a Gilbert and Sullivan major general. An admirer of Chinese art, aided by his fluent Chinese and fluid foreign connections, Munthe and his wife were able to collect when objects from the former palace collections were suddenly available. "In the past year I have been able to significantly enrich my collections," he reported in 1915. "After the revolution, the former major eunuchs had to sell their stuff." With his insider's knowledge of the customs service, he was also able to scale the logistical heights in exporting his artifacts. As reported by the scholar Derek Gillman, starting in 1907 Munthe began acquiring and shipping large sculptures and architectural pieces to his hometown museum in Bergen, Norway.

In 1926, he decided to sell the remains. On the basis of Munthe's printed catalogue and three albums of photos of nearly four hundred objects—porcelain, paintings, sculpture, and bronzes—the then director of the Los Angeles Museum, the ornithologist William A. Bryan, without consulting experts, had the collection shipped from Peking to Los Angeles on approval. General Munthe valued his collection at one million dollars, but he offered it to the County Museum at the fire-sale price of $600,000. In a letter to Erwin Furman, an Angeleno who was brokering the deal, the director wrote: "I was convinced from the first examination of the photographic catalogue . . . that it was not only extensive and valuable but that it was a really great museum collection."

Laufer had seen the collection in Peking in 1923 and had studied the catalogue and photos. Furman now flew him to Los Angeles, along with his wife and son for a three-day appraisal. Laufer complied with a report, filed in the Field Museum's archives, detailing the difficulties of collecting, given the new Nationalist government's announced intention to enact laws prohibiting the export of antiquities. "It is no exaggeration to say that this may be the last and only chance to obtain from China a collection of such magnitude and character," he opined. "It will be impossible to duplicate it both as to the quantity and quality." Laufer purported to be particularly dazzled by Munthe's paintings, which he deemed superior to those in the Louvre, the British Museum, and the Metropolitan Museum. In sum: "I believe that the price of $600,000 asked by General

Munthe for the collection is a fair and adequate valuation, and that if exhibited in New York, London or Paris and sold by auction or distributed among private collectors, it would bring at least a million dollars and possible more."

In 1930, the museum supervisors advanced $200,000 in Depression dollars for the purchase of 118 ceramics, with the option to buy the rest of the collection for $400,000. Announced and feted as a turning point for the County Museum, critics and scholars flocked to Los Angeles. An initial warning salvo was fired by Wilson Foss in *The Pasadena Star News:* "[A]nyone who is interested [should] ask such men as Benjamin March, curator of the Oriental Museum, Detroit, or Dr. John Lodge of the Boston Museum, or Dr. Kelly of the Chicago Art Institute, what they know about the collection." It soon transpired that what they knew was that Munthe had shopped his collection around the country and received no other offers. Another German émigré, Alfred Salmony, a solid authority on Chinese art, called it "a farrago of copies, forgeries, and tourist bric-a-brac." The County's supervisors now swiveled around, turned down the option, and refused to approve further money for acquisitions, to the overall disadvantage of the museum for years to come. Nonetheless, the collection, plus optioned objects, remained on display until 1940, when a new director, Roland McKinney, finally consulted experts. Their opinions are preserved in McKinney's 1940 report to the Board of Governors, namely that "the collection is of such doubtful authenticity as to be unworthy of exhibition in this museum."

Yet it remained in the museum until its first curator of Asian art, Henry Trubner, held that beyond a doubt its acquisition was a "terrible mistake." As for the already purchased objects, Trubner found a true believer in the artist Millard Sheets, on the faculty of Scripps College, who arranged for the disputed art to be loaned to his college. There it remained until the 1960s, when, along with the rest of Munthe's now formerly rejected and unpurchased collection, it was returned to his designated heir, the West Norway Museum of Applied Art (Vestlandske Kunstindustrimuseum, now part of an umbrella organization of Bergen's museums known as KODE.)

In a surreal sequel, thieves broke into the Bergen museum in December 2010 to steal part of the Munthe collection. And on Saturday, January 5, 2013, a further twenty-three items were stolen from a "shopping list," or so speculated the museum's director, Erlend Høyersten: "It's entirely clear that they knew what they were after." Since many of the objects were presumed stolen from the old Summer Palace, it is our own

theory that the theft was likely perpetrated by someone Chinese seeking to repatriate the items. But as a pendant to this story, in 2014 KODE announced an historic agreement with Peking University and the museum, brokered by the Chinese real estate developer and philanthropist Huang Nubo, to return seven of its collection of twenty-one columns looted by the British and French at the time of the Opium Wars. Although carved by Chinese masons, the plinths exhibit a strong Western influence and were originally installed in the Xiyang Lou, the Western-style part of the garden. In exchange for $1.63 million, the columns will be displayed at Peking University. For its part, KODE hopes to benefit from the expertise of the university's Chinese art experts in researching their collection and improving their exhibitions. (As recently as 1990, Professor Ma Shizang, an expert from Peking University, argued that many of the museum's items were of low quality, if not outright fakes.)

LAUFER, AND OKAKURA AT THE MFA, were among the very few curators during this early period of the study of Chinese art in America who could read and speak the language fluently, but Laufer's life story illustrates the perils of authentication and attribution that would bedevil later generations of art historians. Rumors have circulated over the years throughout the museum community that his suicide might be attributed to his fear of being denounced for what were at best optimistic attributions or at worst fronting fakes. However, the reason given by his closest colleagues for his untimely plunge was advanced cancer.

Although Laufer had often been fooled himself, he was not above denouncing fakes in rival collections, as for example when he claimed there was a forged inscription on a miniature inscribed Tang sarcophagus now in the Boston Museum of Fine Arts—collected by a Japanese rival. As to his self-proclaimed "practical ethics," when asked to appraise a set of Ming stone carvings gracing the entrance of Seattle's Museum, and purchased by museum director Richard Fuller's mother from Gump's department store, Laufer thought they might have seemed fine in their original location, but, detached from their historical surroundings, "they look meaningless." But foreign dealers were not to blame; rather it was "Chinese vandalism, greed, and lack of patriotism."

CHAPTER SIXTEEN

STREAMS AND MOUNTAINS

The View from the Middle West

I n ways that seem obvious, and others less so, the Second World War and its aftermath deeply affected the collecting, study, and selling of museum-quality Chinese art in America. An interwar generation of curators and scholars not only saw military service in the Pacific, but in postwar Japan its members served as Monuments Men, charged with salvaging and repatriating art treasures. Yet unlike their counterparts in Europe, they have yet to be cinematically celebrated. Initially and opportunely, senior officials in the Arts and Monuments Division of the occupation forces also shopped for bargains in China as well as Japan. With the advent of Mao's People's Republic in 1949, such shopping ended in mainland China. Inventive dealers in Chinese art now sought prizes in private collections, and some even scoured garage sales to feed an ever-growing market. For their part, American curators scrambled for fresh ways to draw visitors to their galleries by promoting international loan shows. The way was led in 1961 by a five-museum tour of "Chinese Art Treasures," featuring superlative works from the National Palace Museum in Taiwan ("inherited from the former imperial court in Peiping"). Finally and more broadly, the longtime hegemony of America's East Coast museums was challenged postwar by a new breed of Midwestern curators.

Cleveland's Sherman Lee, who remarked that he was the first Asian art curator who didn't attend Harvard.

No one better personified the regional shift than Sherman Emery Lee, a confident generalist with a superlative eye and a substantial budget. Through his widely read books, his lectures, and his role as director of the Cleveland Museum of Art, Lee established himself as a connoisseur with firmly reliable views. His friendly rival and frequent collaborator was Laurence Sickman, also a former Monuments Man, whose prewar career in China we have related in earlier chapters. What Lee was to the Cleveland Museum, Larry Sickman was to the Nelson-Atkins Museum in Kansas City; each acquired Asian masterworks in cities that proudly and unexpectedly established public shrines for a genre of art whose appreciation requires patience and study.

Sherman Lee was born in Seattle, where his father was an electrical engineer employed by the government to help midwife the birth of a new, federally encouraged medium: radio. Soon Emery Lee and his family moved to Brooklyn, New York, where Sherman came of age, having attended local public schools. Their next move was to Washington, D.C., and here he developed "a passionate interest in art history," having spent hours examining the Impressionist and Postimpressionist works in the Phillips Collection. He switched his major from science to art history and earned his B.A. and M.A. at American University. There in 1938 he met Ruth Ward, to whom

he would be married for sixty-nine years. "He was a tennis player and she was a sorority girl," according to their daughter Katherine.

Ruth and Sherman are well portrayed by Mary Ann Rogers, a long-time friend of both: "She is a perfect match for Sherman's wit. Her character is solid and strong as steel, yet her words always flow with a magical, irrepressible Southern rhythm and charm, passing over Sherman's silences and stony reserves like a river in summer. 'She civilized me,' says Sherman, a process likely begun after the honeymoon he himself arranged—a trip spent roughing it in the mountains with a tent and sleeping bag as the only amenities." Honeymoon over, the couple moved on to Cleveland, where Sherman earned his doctorate in art history at Case Western Reserve University. His thesis, "A Critical Survey of American Watercolor Painting," was among the earliest dissertations on its genre. At this point he chanced to take a summer course on Chinese art at the University of Michigan. His teacher was James Marshall Plumer, who for fifteen years lived in Shanghai and Fuzhou while serving in the stand-alone and potent Chinese Maritime Customs Service. Ceramics were Plumer's specific passion. He had pioneered the identification of major imperial kilns, and his teaching technique was original. He would explain the differences between major kilns, then hide old Chinese shards beneath a cloth and ask his students to identify, only by touch, the provenance of a given fragment. Through such hands-on techniques, as Lee later recalled, Plumer introduced him to "the mysteries and practicalities of Asian art." Plumer's interests, it should be added, also included Buddhist sculptures, Rajput miniatures, Japanese "flung-ink painting," and ancient Chinese bronzes, enthusiasms that infected Lee.

As a recent Ph.D. and encouraged by Plumer to enter the Asian field, Lee became a volunteer intern at the Cleveland Museum of Art, working with Howard Hollis, then the curator of Asian art. There, under Hollis's tutelage, he helped mount an exhibition of Chinese ceramics that opened in spring 1941. That same year, he moved on to the Detroit Institute of Arts, having attained the rank of curator, and in what became a lifetime hallmark, he began writing short articles on a wide range of subjects: Chinese ceramics, Cambodian sculptures, and American watercolors (among others). Yet at this point, Lee had never set foot in Europe or Asia. His travels began in 1944 after he enlisted in the U.S. Navy, earned a commission as an assistant navigator, and a year later was finally able to reach mainland China. Shortly after the Japanese surrender in 1945, his boat docked in Tanggu, the nearest port to Beijing, with no further orders. Ensign Lee told his captain, a fellow fly fisherman, that he very much wanted to go to

Beijing. He was allowed three or four days but was warned that he risked AWOL charges if he missed his deadline. Here is Lee's firsthand account:

> So I got a ride with a marine up to Tianjin and took a train crowded with people to Beijing. It was during the time when the communist guerrillas, as they were called then, were fighting the Guomindang soldiers in the hills. We had to stop a number of times because of the squabbles, but I was so excited; I was actually going to see Beijing. [The train finally arrived; he was in his naval uniform, but he found a rickshaw and went straight to the imperial palace.] I went to the north gate where the caravans with their camels formed up. The city walls were all still standing, and the walls and all the residences were painted yellow, pale pink, and pale blue, and Beijing was just unbelievably beautiful. Then I found where some of the antique dealers were in Liulichang. . . . I saw this Cizhou pillow . . . decorated with a beautiful landscape and figure painting. I really had so little money, but I just grabbed it and of course it cost nothing—around US $2.50, so it was ordained in heaven that one started with Cizhou.

"That's how it all began," Lee said of his initial purchase, which now reposes in the Seattle Museum of Art. The Cizhou pillow was both a bargain and a splendid crossover piece marking the debut of a curator committed to finding wider audiences for all forms of Asian art. Produced in quantities in kilns in China's northern provinces, Cizhou ware is sturdy, is boldly decorated with incised designs, and dates to the golden era of the

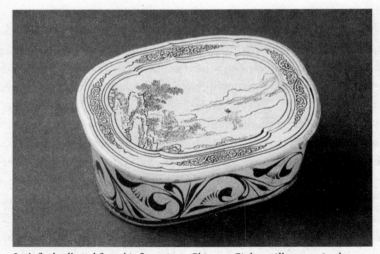

Lee's find collected from his first trip to China, a Cizhou pillow now in the Seattle Museum.

Song and Yuan dynasties. The leaf-size stoneware pillow is intended for use in this life or (perhaps more comfortably) in the next, and its accessible images glow from beneath a transparent glaze. One quickly senses how and why Chinese ceramics so precociously became a global commodity.

POSTWAR, FORTUNE AGAIN favored Sherman Lee. His Cleveland mentor, Howard Hollis, had been recruited to direct the Art and Monuments Division of the Allied occupation in Japan, and he invited Lee, then age twenty-eight, to become his chief aide. A year later, when Hollis returned to the United States, Lee assumed his duties. For two years, it became his task to inspect and inventory the country's great art collections in order to help evaluate what had been destroyed and how to preserve the rest. In a letter to General Douglas MacArthur, the Chinese Nationalist government claimed that a number of objects had been looted during the war and were said to be hidden in the Shōsōin, Japan's greatest collection of ancient treasures, in Nara. Lee was given unique access to the imperial repository. Eventually, an exhibition was held of the looted material, but it proved small pickings. According to Lee: "It filled one good-sized dining room and the chief display was an eight-panel jade screen. It was weird. There really hadn't been much looting at all, and nothing of interest."

Lee used his unique position to inspect sites that had long been closed to the public and to see works of art that had not been on display, thereby forming lasting relationships with Japanese collectors, dealers, and art historians. Moreover, he sealed his friendship with Howard Hollis, who now chose to become a dealer, and he met Laurence Sickman, who, after his wartime service in China as a combat and intelligence officer, also became an advisor to the Monuments Division in Tokyo. And in yet another auspicious turn, as Sherman Lee's own tour was ending, his old Michigan professor James Plumer also joined the team as an advisor. Thus a convergence of like-minded museum curators helped form the groundwork for a significant shift in the collecting priorities of key Midwestern museums. Moreover, owing to postwar economic conditions in Japan, where Japanese collectors were pressed for funds, the Monuments Men were able to collect art at moderate prices and, as important, to export their finds legally.

On his return to America in 1948, Sherman Lee assumed a promising new post as assistant director at the Seattle Museum of Art. The museum's founding director, Dr. Richard E. Fuller, and his mother, Margaret MacTavish Fuller, were the major donors. From the museum's opening in 1933, they had turned their gaze eastward. Initially, European art

was only represented by color prints of well-known masterpieces, and priority was given to acquiring Japanese and Chinese stone sculpture and jade. The Fullers had more enthusiasm than cash, but before Lee arrived, Director Fuller provided his new assistant with $5,000 to shop in Japan, resulting in significant additions to the collection. Lee also persuaded the Kress Foundation to provide works by major European artists. Subsequently, owing to his close ties with Japanese collectors, Lee on a modest budget expanded Seattle's holdings of Japanese and Chinese paintings, the latter notably including *Hawk and Pheasant,* an album leaf attributed to the Southern Song master Li Anzhong (active circa 1120–60), formerly in the Kuroda collection in Japan.

In 1952, he joined the Cleveland Museum, where the legend of Lee as the connoisseur par excellence really began. Unable to read Japanese or Chinese, Lee depended on the assistance of his associate, the Chinese-born scholar Wai-kam Ho, who would succeed him as curator of Oriental and Chinese art in 1958 when Lee became director. Just before Lee's ascent, a local mining and shipping magnate, Leonard Hanna, bequeathed $35 million to the museum: half for operations and half for acquisitions, a wise stipulation in Lee's view, since it ensured the gallery's fiscal health.

As the buying began, according to Wai-kam Ho, Lee rewarded successful treasure hunting with a dry martini, and within a decade the two assembled one of the five great painting collections outside China.

The erudite Wai-kam Ho, who was Sherman Lee's indispensable collaborator in Cleveland.

Their "symbiotic" partnership (as James Cahill has written) joined Lee's eye and phenomenal memory for objects with Ho's remarkable erudition. Wai-kam Ho's unparalleled knowledge of Chinese written sources, seals, and inscriptions bore fruit in a 1980 exhibition, "Eight Dynasties of Chinese Art," featuring three hundred paintings drawn from both the Cleveland and the Nelson-Atkins museums. (Kansas City's director Laurence Sickman and Cleveland's Lee were not above gloating that they had thus stuck a thumb in the eye of the Metropolitan Museum, then boasting its own acquisition in 1973 of twenty-five paintings from the C. C. Wang collection.) Lee and Sickman were among the first to celebrate the beauty, relative availability, and collectability of paintings from the Yuan, Ming, and Qing dynasties, as featured in their joint exhibition.

We owe to Wai-kam Ho an informed assessment of his director's distinctive strengths: "Sherman is one of the very few non-Asians who does not depend on linguistic ability for his connoisseurship in Asian art. He cannot read Chinese or Japanese. Yet without being able to read inscriptions or signatures, he can tell a Shitao from a Zhang Daquin better than most Chinese art historians. His secret is what he calls being born with a pair of good eyes and having a keenly cultivated sense of intuition." Lee rejected the notion that esoteric scholarship was essential to grasping the excellence of Asian art. Yes, knowledge of context was important, but, "We can never see Chinese art as a Chinese does, much less can we hope to know it as it was in its own time." Writing in his well-received *History of Far Eastern Art* (revised edition, 1973), he amplified:

> Again, a broad view, especially of style, is of the greatest importance in recognizing that the art of the Orient, like that of the Occident, is not a special, unique, and isolated manifestation. . . . Seen in this light, without romantic mystery as well as without the paraphernalia of esoteric scholarship, the art of Eastern Asia seems to me more readily understandable, more sympathetic, more human. . . . [H]ere are thousands of still meaningful and pleasurable works of art, part of our world heritage—and we should not permit them to be withheld from us by philologists, swamis, or would-be Zen Buddhists. What are they? How are they to be related to each other? What do they mean to us as well as to their makers? These are proper questions for a general study.

Still, if not a blind spot, Sherman Lee did have deep-rooted preferences. His friends called him "a serious petromaniac," that is, someone fascinated by rocks. This can be discerned in the journal he kept during his breakthrough 1973 visit to China as leader of a North American art

The delegation of North American directors and curators whose 1973 trip to China reopened a long-blocked road; Sherman Lee in middle foreground, Laurence Sickman is on his left, and James Cahill, with glasses, is in the back row.

and archaeology delegation. As excavated (an apt verb) by the scholar Noelle Giuffrida, "incurable petromania" runs through his entire travel diary. It is "dotted with notes about the rocks he saw all over China," she found, "including large specimen rocks in gardens, miniature examples, and desk-sized stones he noticed in galleries and shops." Suitably enough, one of Sherman Lee's earliest and most publicized acquisitions in Cleveland was *Streams and Mountains Without End,* acclaimed as a key monument of early Chinese landscape painting. It is a seven-foot-long hand scroll rendered in ink and subtle tints on silk, with nine colophons recording its history, painted either around 1100 CE or from 1205 to 1380 CE, its artist and provenance both unclear. Lee described the work as a kind of ancestor of the motion picture, since "one can vary the frame by moving the rolled ends from right to left, or left to right, thus creating innumerable small pictures as well." An interesting insight, surely, yet to an untutored layman, the only things that seems solid in this mist-ridden, cloud-blurred landscape are its jagged and jutting rocks, like so many irate thumbs pointing skyward.

As the Cleveland Museum's collections grew, Sherman Lee abjured showmanship and expressed disdain for the term *blockbuster,* a buzzword associated with the Hoving era at the Metropolitan Museum. In the 1990s, years after Thomas Hoving had resigned as director, Sherman Lee was heard praising a special exhibition in New York and remarking, "Isn't the Met great! Not even Hoving could wreck it." Such was the outlook that led John Canaday, then *The New York Times*'s chief art critic, to comment in 1970 that under Sherman Lee, the Cleveland museum had become "the only really aristocratic museum in the country." After Lee's death at age ninety in 2008, a reporter recalled Canaday's remark and elicited this response from Hoving's successor, Philippe de Montebello: "Aristocratic, yes, but in a meritocratic way. [Lee] carried a lot of weight in the community of museum directors. He bought in all fields, his own particularly brilliantly, but in many different fields. He really transformed the Cleveland Museum from a regional museum to a major global museum."

Yet his was far from a solo performance. Not only did he benefit from the learned insights of Wai-kam Ho, but he listened carefully to the observations of leading dealers, whom he praised and respected. This was not unusual. By now, the reader may have noticed that major collections often result from partnerships, typically when collectors, curators, and dealers seek advice from each other. In the case of dealers, there was the notable pairing (among many) of Laurence Sickman with Otto Burchard; Abby Rockefeller with Yamanaka; and J. P. Morgan and John D. Rockefeller Jr. with Joseph Duveen. But perhaps no partnership proved as fruitful as that of Sherman Lee with John D. Rockefeller III and his wife, Blanchette, originating in the early 1960s, when Lee was still curator of Asian art at the Cleveland Museum. In linking Asia to the wider art world, Blanchette led the way; she followed her mother-in-law, Abby, and her brother-in-law Nelson, to the board of the Museum of Modern Art. Yet it was not until she and John III visited Japan in 1951 that they both began collecting Asian art, albeit on "an intermittent and amateurish basis." John was nearly sixty when he turned to Sherman Lee for advice. Unlike his father, John Jr., who favored buying in lots, John and Blanchette concentrated on fewer objects of high quality. Their core collection, which is on rotating display at the Asia Society Gallery in New York, is strong in ceramics, sculptures, and bronzes. While John Jr. collected multicolored Qing dynasty enameled porcelains, his son sought earlier celadons and stoneware. In fifteen years the couple assembled a superlative collection, which they donated to the Asia Society in 1974.

Its selection owed a great deal to a civilized agreement reached between Sherman Lee and John D. Rockefeller III on dividing up the prizes, thus avoiding on Lee's part a potential conflict of interest. As Lee wrote, "He faced the problem with characteristic wisdom and thoroughness. . . . It was both simple and direct: whatever he saw or was offered first was automatically at his option; whatever I or any other museum saw or was offered first was at the option of the museum. Should there be any confusion or simultaneity of offer, it would be decided by chance—in the only case that developed, by the flip of a coin."

After 1949, mainland China was off-limits, so most of their acquisitions came through dealers and auctions, many of them in Europe. Like another great connoisseur, Denman Ross, Lee believed in working directly with objects, building "by comparisons over a long period of time." His letters to Rockefeller are full of comparisons. He cautioned John III against buying an object if there were other good examples around, or if his collection already contained something as good. A letter dated March 4, 1965, from Lee to Rockefeller sets out their criteria for purchases:

A. pieces that are really outstanding in the world, maybe none or only one or two or three others of equal quality;
B. pieces that a first-class museum would be proud to have as part of their collection;
C. pieces that would be acceptable to the better museums; and
D. pieces that neither museums nor ourselves should consider of sufficient quality to include in our collections. . . .

"Based on this proposed system," he goes on, "my feeling is that we should look hard for pieces in the A category, realizing that we will not often find them; and generally speaking be prepared to accept others only in the B category. C it would seem to me would only be considered where we found a piece that had particular appeal such as my pair of Han horses or whatever they are."

When the collection opened to the public in 1974, the Asia Society issued a press release with a quote from Lee: "The rationale behind the collection is one that insists on the highest possible quality in the objects acquired and on their capacity to be understood and enjoyed by the interested layman rather than only to be studied by the specialized scholar. . . . The development of such a collection as this in the relatively short time since World War II was most fortunate and it is doubtful if it could be done again at the level attained."

Among the jewels in the collection is a blue and white platter pro-
duced at the great Jingdezhen kilns in Jiangxi Province, with a very spe-
cial inscription. These large platters were coveted in Muslim lands, where
food was commonly served to groups of diners. What sets this splendid
porcelain dish apart is an inscription, written in Farsi, naming the Mu-
ghal emperor Shah Jahan, who during his reign (1627–58) created the Taj
Mahal, a memorial to his beloved wife. The emperor was known for his
regard for Chinese wares, and this Yuan-era platter is among the few that
had been preserved in India with Shah Jahan's presumed mark of owner-
ship inscribed on its footing—early evidence of a culturally productive
trading relationship between South and East Asia.

A final reminder of this productive modern-day, fifteen-year partner-
ship is on display at the Cleveland Museum. After his patron's death, Lee
received a bequest from John D. Rockefeller III: a Japanese hand scroll by
Shukei Sesson (1504–89) valued at $40,000, which Lee then presented to
the museum in Rockefeller's memory.

To this, a footnote should be added. No one has more closely traced
Sherman Lee's networking with dealers than Noelle Giuffrida, an assis-
tant professor at his own university, Case Western Reserve. In researching
a book titled *Separating Sheep from Goats: Sherman E. Lee's Collecting,
Exhibitions, and Canon of Chinese Painting in Postwar America,* Dr. Giuf-
frida found that Lee also benefited from his cultivation of a little-known
German-Jewish collector named Walter Hochstadter, who escaped from
Nazi Germany in the 1930s and became a dealer in Shanghai and Bei-
jing, specializing in Chinese ceramics and paintings. Just before the
Maoist victory in 1949, Hochstadter managed to export his prize works.
Sherman Lee acquired seventy-five of his best paintings, although nego-
tiations were "tumultuous," according to the author, who contends that
this timely purchase meant that the Cleveland Museum clearly possesses
one of the finest Chinese painting collections anywhere.

Still, this was not the celebrity that Sherman Lee coveted. He liked
fencing with dealers, partly for the love of the game. His respect for his
better adversaries was expressed at the Cleveland Museum's fiftieth-
anniversary fete in 1966, when he said, "When a curator comes back
and says he discovered an important art work, he really means a dealer
discovered it." He also remarked to friends, perhaps in jest, that if had to
start all over again, he would become "a dealer."

A dealer much after Sherman Lee's heart was Robert H. Ellsworth,
the "King of Ming," a self-made and self-taught specialist in Chinese
paintings and furniture, who did exceptionally well by going against the

contemporary grain. The son of a dentist credited with inventing root-canal surgery, Ellsworth entered the Asian market in the 1960s as a protégé of the well-regarded New York dealer Alice Boney. His eye proved accurate and his market instincts sound; he early on built up a stock of post-1800 Chinese paintings, bronze mirrors, and Ming furniture just as the demand for each began to rise.

As the seasoned British auction writer Geraldine Norman reported in 1994, "His achievement in the Oriental field is that of the legendary Lord Duveen," meaning that his own imprimatur ensured premium prices. John III was among his best customers, and in 1974 Ellsworth offered for sale a suite of vintage furniture—cupboards, inscribed chairs, couch, sideboards, tables—priced at $550,000, that he felt deserved display in the newly established Asia Society Gallery in New York. As he wrote Rockefeller, these were among the "truly great pieces that I own," adding that he made the offer because it seemed "that this is the only way to secure a permanent home for my collection as well as to make some contribution to the field of Oriental art, to your museum and the City of New York." Rockefeller's response was favorable; various pieces did go to the Asia Society and the Metropolitan Museum, to which John III later donated Chinese paintings valued at $22 million. When Ms. Norman interviewed him in his palatial apartment at 960 Fifth Avenue, Ellsworth was reputedly the richest dealer in Asian art, having also been named an honorary citizen of China (another premonition of things to come). He died in August 2014 at the age of 85.

IN SHORT, post-1945, the market for Chinese art treasures was buoyant but risky, highly dependent on insider networking, and tilted in Midwestern eyes to the condescending Northeast. When we earlier encountered the younger Larry Sickman, he had parlayed a Harvard degree and a Harvard-Yenching fellowship into becoming a purchasing agent in China in 1931 for the then-under-construction Nelson-Atkins Museum of Art. This was shortly after its trustees in Kansas City chose bravely to develop a small, half-century-old art gallery into a major all-purpose museum, with a collection and budget to match (see color plates, figures 2, 5, 15, and 16). The best buys then were in Asia, and Sickman provided the newborn museum in the 1930s with as much as 60 percent of its collection: 1,500 pieces in 1933 alone. In that year, the completed museum formally opened, Sickman finally met his employers, and he was shortly appointed curator of Oriental art, commencing a forty-year relationship.

After Pearl Harbor, Sickman returned to China as a U.S. Army Air Force major assigned to aerial bombing intelligence. By all accounts, his on-the-ground experience proved invaluable in identifying significant targets. In August 1945, two days after the Japanese surrender, he flew to Beijing to secure intelligence documents from the Japanese high command when an unexpected opportunity arose. Not knowing what to expect, Sickman brought with him $250,000 in cash. The money was not needed—the Japanese generals preferred to surrender to the Americans rather than to the Chinese—but the cash had other uses. What followed was recalled in 1977 by Marc Wilson, Sickman's successor as director of the Kansas City museum: "The return flight to Chungking included a bomb bay packed with surrendered samurai swords and masterpieces by Shen Chou (Shen Zhou), Wen Ching-Ming and Lu Chili (Lu Zhi), the nucleus of the Nelson Gallery's Ming paintings, all purchased with funds hurriedly and irregularly borrowed from a suitcase containing $250,000 belonging to the Quartermaster Corps." Such are the fortunes of war, and Sickman's loan was repaid in full. After the war ended, Sickman served as a Monuments Man long enough to win praise for his service and to forge a friendship with Sherman Lee.

By the time Sickman returned to the United States, his talents were well recognized in the curatorial trade, and prestigious job offers followed. He chose to remain in Kansas City, due to the generous support of the Nelson-Atkins trustees, but also because he had the rare chance to create, nearly from scratch, a world-class art collection. And Sickman was a collector by instinct and upbringing. He had an absentee father and a doting mother, May Ridding Fuller Sickman, a "Colorado Brahmin," who collected Japanese prints and read Charles Dickens to young Larry every night in their Denver home. So enamored of Dickens did the ten-year-old boy become that he started collecting what became a complete set of first editions of the novelist's major works. As to China, when asked by an interviewer what led him in that direction, Sickman responded, "I never wanted to go in any other direction." The seed was planted during a chance visit to an antique shop owned by a family dynasty named Sarkisian, adjacent to the Brown Palace Hotel, then Denver's grandest. "I made my first acquisition there at the age of thirteen—it was a pair of wooden figures, man and wife, Chinese of course. There wasn't any question about it. I wanted to collect. If you are not totally acquisitive, you are not totally qualified to be a director of a museum."

In 1953, Curator Laurence Sickman at age forty-six became the second director of the Nelson-Atkins Museum of Art. By then, he had

published a score of learned papers on Chinese wall paintings, Buddhist sculptures, and on his own museum's Guardian Lion. He also collaborated with the architectural historian Alexander Soper on what became the gold-standard text, *The Art and Architecture of China,* which joined the Pelican History of Art series in 1953. By any standard, he and Sherman Lee played pivotal roles in changing the cultural landscape of the trans-Mississippi West. When Sickman entered Harvard in 1926, it was the only major university in which courses were offered on China's language, art, and history. Yet fifty years later, as Marc Wilson noted in 1988, "there is not a single state in the union where Chinese literature language and history are not taught in institutions of higher education, and with an expertise unimaginable in 1926." And as regards art museums, during that half century the Middle West ceased to be the "Sahara of the Bozart," to use H. L. Mencken's derisive term for Main Street America, South and Midwest, in the mid-1920s.

In this transformation, Sherman Lee and Laurence Sickman played an outsize role. Both prized quality over splash, both were object-oriented, both excelled at an essential trait needed for successful museum directors: waltzing with donors. Sometimes charm did not suffice. Sickman coedited the handbook for John M. Crawford's collection of calligraphy and painting and offered valued advice, this accompanied with much handholding by his successor, Marc Wilson. However, when Crawford died in 1988, the same year as Sickman, the collection went to the Metropolitan Museum, which had enticed him with a newly built gallery.

There was an additional ingredient in the Lee-Sickman formula: each believed in outreach, at home and abroad. Not only did the Cleveland Museum and the Nelson-Atkins offer lectures and guided tours, but both also actively organized school visits so that local children could both learn and help dispel the gloom of empty galleries. But outreach has a wider dimension. So well regarded was Larry Sickman's expertise that the Nelson-Atkins Museum was among the handful of American institutions invited to send high-quality works to the path-creating 1935 Burlington Exhibition of Asian Art at the Royal Academy in London—and this when the Kansas City gallery was but two years old. It would be the first time that China authorized the overseas loan of treasures from its hallowed and secretive Imperial Palace Collection.

It was with the hope that Nixon's 1972 trip to China might similarly reopen doors for cultural exchanges that Sherman Lee helped promote, and then a year later headed, a twelve-member delegation of North Americans on a sixteen-city tour of the People's Republic. The monthlong

pace was rushed and tiring, and Lee later remarked that his role required "the combined talents of a shoe salesman and a diplomat." Chairman Lee in fact excelled in both skills, supplemented by his agility at the Ping-Pong table and as a rock-loving mountain climber. Tall and formidably browed, the director towered over his hosts, but he kept his temper. But the culture gap proved formidable. "What we call the Bronze Age, they call the Slave Age, and what we call Feudal, they call Medieval," he later commented to *The Cleveland Plain Dealer*. "There is no such thing as art for art's sake, divorced from politics. They could not understand when we became excited because something is beautiful. In China, art is part of the revolutionary machinery." And at every point, there was Larry Sickman to soothe, explain, and charm.

There is no doubt that the 1973 visit cleared the way a year later for "The Exhibition of Archaeological Finds of the People's Republic of China," the icebreaking show of shows, which opened for six months with suitable fanfare in Washington. But initially, Kansas City was not on the itinerary. Here is Marc Wilson's account of what followed:

> Through Larry's connections and through Kansas City resident Leonard Garment, an advisor to Richard Nixon, it also came to the Nelson-Atkins. The Chinese then agreed to an extension so the Chinese population in San Francisco could see it. The National Gallery of Art had no Asian art curators, so I served as a kind of curator for all three venues and the Nelson-Atkins did the catalogue and installation. We were very limited as to what we could produce. Every word in every catalogue and label was censored. Things were so scary inside China that the Chinese wanted to see only pictures, so we decided to produce a good picture book with quality images and also a good installation.

Subsequently, a team of Chinese museum experts accompanied the traveling exhibition, their task being to make sure not a letter on the labels was changed. "They wanted desperately to look at our paintings," Marc Wilson relates, "but it wasn't permitted." Still, the ice was broken.

IN DUE COURSE, Larry and Sherman passed into the emeritus status granted ex-directors of distinguished museums. Their relations had been mostly friendly, with a few wrangles over matters of attribution and acquisition. Like the classic millennium-old scroll painting *Streams and Mountains Without End* that both admired, their characters and tempers complemented each other. And like venerable Chinese scholars, both collected rocks. At his core, Sherman Lee was like the rocks rising into

the mist—solid, stubborn, and unpretending. For his part, Laurence Sickman was as fluid as a stream, a seeker of evasive detours in a world abounding in violence and fanaticism. The last words belong to Sherman Lee, who in June 1986 wrote this note to Larry Sickman from his modest cottage in Chapel Hill, North Carolina:

Dear Larry: I have heard that you recovered from dire straits and I write to congratulate you and hope for your continued good health. I enclose a photo to attest to your good influence on our household in retirement . . . the view is of small enclosed garden off our bedroom. The rear rock is your honored gift. The nearer is one we picked up in San Antonio, evidently an outpost of your Ozark petrified garden. In any case, we like it and count it both a blessing and a reminder. You were most kind to give it to us and we hope the usual evidence of its continued use attests to our gratitude for your gift. Petromania is not one of the worst sins—indeed, it is a virtue, or so we believe. I think about Southern Sung and wonder whether it will ever coalesce in my mind. . . . Is it really too sweet or anxious for our taste? We enjoy our garden and retirement from the current version of "art museums." All the best, Sherman.

CHAPTER SEVENTEEN
THE MET'S MARATHON

America's century-long museum boom has no equal elsewhere and is only partially matched by the post-2000 surge in museum construction in the People's Republic of China (as described in our epilogue). The ascent of the public art gallery peaked in 1900–50, when the social, cultural, and political elites in every self-respecting U.S. city gave birth altogether to more than 1,500 museums (mostly devoted to the fine arts, but including history and science museums). As early as 1923 the French art dealer René Gimpel, while stopping in Toledo during a coast-to-coast tour, remarked in his diary that this devotion to art museums was "found throughout the United States, and gives an idea of the fervor that convulsed the Middle Ages when its churches were erected." Thirty-three years later, another French visitor, then minister of culture André Malraux, was asked whether he agreed with Rebecca West that America's cathedrals were her railway stations. "No," he responded, "her cathedrals are her museums."

The mother church in this Great Awakening was, and remains, the Metropolitan Museum of Art. Founded in 1870, the Met long ago became the most popular tourist destination in New York City, nowadays drawing upward of six million visitors annually. The museum's impressive growth was foreseen by Henry James during his American visit in 1905, the novelist's first extended homeward journey since 1883. By 1905, the Met no longer occupied an eccentric mansion on West Fourteenth Street but had moved grandly uptown to Fifth Avenue and Central Park. "It is a palace of art, truly that sits on the edge of the Park," James observed

in *The American Scene.* Here "[a]cquisition, if need be on the highest terms," could bask "in a climate it has never before enjoyed." Here money was in the air, "ever so much money," available for "*all* the most exquisite things," James wrote, adding with qualified approbation, "In short, the Museum was going to be great."

Yet initially, the arts of Asia were at best a sideshow at the Metropolitan. True, the museum was pleased to exhibit Chinese porcelains from the Benjamin Altman and J. Pierpont Morgan collections, but there was no department of Far Eastern art until 1915. That same year, the Morgan trove vanished when the deceased financier failed to leave his porcelains to the Met, even though he had been its president for a decade. The Great War then provided an unexpected opening for a change of course. Spurred in part by rivalry with Boston's Museum of Fine Arts, which had taken a commanding lead in this field, the Met's trustees had for years sought to expand the Asian collection. The problem was to find a recognized authority to launch the Met's new department. Now such a paragon became available: Sigisbert Chrétien Bosch Reitz, an outstanding Dutch scholar whose brother was chamberlain to Queen Wilhelmina (a connection that didn't hurt the Met).

Already known in Munich and Paris as both a scholar and an accomplished painter, Bosch Reitz (or, as we shall alternatively call him, BR) early on was fascinated by East Asian art. He studied major museum collections in Europe and spent a year delving more deeply into Chinese and Japanese art. In 1914, the Asia-smitten Hollander was engaged by the Louvre to care for its Grandidier collection of Far Eastern art, reputedly among the best in the West. (It is now housed in the Musée Guimet.) But with the outbreak of the European war, so *The New York Times* reported, "the French authorities found this inexpedient," and BR instead crossed the Atlantic to study major American collections (the Netherlands being neutral during the Great War). The Metropolitan opportunely invited him to become founding director of its first Department of Arts of the Far East, centering on China and Japan but also exhibiting the allied arts of Korea and the Himalayas. Bosch Reitz immediately accepted, and his arrival at the Met in September 1915, as *The Times* noted, happened to coincide with the final sale of the Morgan porcelains, then a stellar attraction at the museum, giving his department "an entirely new lease of life."

From the first, BR impressed with his disciplined management skills, his exacting eye, and his obsession with order and cleanliness. He quickly earned the nickname "Old Dutch Cleanser" and sometimes exasperated his less-focused colleagues. Yet he strove to make sense of a

very miscellaneous realm. Initially, Asian works had been consigned by the museum to the Department of Decorative Arts. As summarized by Calvin Tomkins, the Met's unofficial historian, in 1915 the museum's large and heterogeneous Asian collection consisted of "objects that had been accumulating since 1879, the year that several trustees and other subscribers banded together to buy a group of thirteen-hundred Chinese ceramics selected by Samuel P. Avery [a Met trustee, an engraver, a connoisseur and dealer in art]."

Yet the most interesting segment of BR's inherited legacy consisted of works purchased in China for the museum by John Calvin Ferguson, the Canadian-born Methodist missionary, scholar, Shanghai newspaper publisher, and Qing dynasty advisor. Ferguson at one point was the secretary of the Imperial Chinese Railway Administration, and along with his mandarin friend Duanfang, mixed his official duties with collecting art. In 1912, the Metropolitan shrewdly (so it proved) named Ferguson a fellow in perpetuity and provided him with a $25,000 budget as its purchasing agent. This was renewed a year later, with a matching additional credit.

Bronzes, jades, and, most notably, Ming and Qing paintings flowed to New York, where Ferguson's purchases were received with more bafflement than praise. The Met's new director, Edward Robinson, who had defected from Boston's Museum of Fine Arts, termed the initial shipment "rather disappointing," a judgment shared by William R. Valentiner, the new curator of decorative arts, just arrived from Berlin's Kaiser Friedrich Museum. The shipment's press reception ranged from negative to a yawn. *The New York World*'s art critic singled out Chinese scroll paintings as "monotonous and nearly formless," their colors faded and uninspiring; the author expressed surprise that "real money was paid" for what seemed to him a patently mediocre collection. For its part, *The Times* offered a poker-faced description of "an exhibition said to be the most noteworthy ever seen in this country," bestowing praise only on the cases (yes!) enclosing scroll paintings and on a Chinese war drum.

PLAINLY THE PROBLEM THEN, as in years ahead, was that Oriental painting was being judged through Occidental eyes, and found wanting. (Who are those old men in nightgowns gazing at pines, rocks, and streams?) For his part, Ferguson strongly defended the quality and authenticity of the paintings he had purchased, which he maintained would put the Metropolitan ahead of its major rival: Boston. Prudently, the museum invited Charles Lang Freer, the country's foremost collector

of Asian art, to appraise Ferguson's offerings, particularly the scrolls, before it ratified its purchasing agent's choices. Creditably, Freer emphasized at the outset that "the Occident contains no expert sufficiently informed to speak authoritatively on these matters." He then recommended purchasing some, but not all, of the paintings, prompting Ferguson's counteroffer: pay $40,000 for Freer's choices and take the rest as a gift. (Ferguson's acumen is still in dispute, especially regarding paintings, one of many measures of the slippery slopes on these contested peaks.)

Overall, the Met's new Department of Far Eastern Art acquired a solid footing under its founding curator, even though he had but one assistant and limited funds. Bosch Reitz weeded out dubious works from the museum's miscellaneous holdings, and he took care to feature Ferguson's scrolls; he installed Benjamin Altman's porcelain collection around the Met's grand staircase, thereby honoring the donor's stipulation that his Asian collection should be adjacent to the European artworks that formed his principal bequest. In a prescient but unconventional decision, BR purchased four hundred Japanese prints from Frank Lloyd Wright in 1918–22, a period when the architect was dogged by marital scandals. (During these lean years, Wright sold thousands of prints, netting him $300,000, in the estimate of Julia Meech, the Met's associate curator of Japanese art.)

In one stunning acquisition, Bosch Reitz in 1926 secured for the museum a life-size gilt-bronze sculpture of Buddha Maitreya, dated 486 CE (see color plates, figure 11), whose kindly demeanor, welcoming gesture, and impressive physique have riveted gazes ever since. It is the largest-known early Chinese bronze sculpture, and to define its identity we turn gratefully to the Met's own exegesis: "He is worshiped both as a bodhisattva and a Buddha, for it is believed that once the current, cosmic era has destroyed itself, he will be reborn as the teaching Buddha of the next great era." All this can be said because the statue's identity is specified in a long inscription on the statue's base, stating that it was made to honor Dowager Empress Wenming, who governed the Northern Wei dynasty during the last three decades of the fifth century CE.

As the Met's holdings grew, BR's mellow humor and disarming manner became renowned in New York's club culture. "The only remembered instance of a lapse of tolerance on his part," a fellow member of the Century Association recalled, "was a painful occasion when his own private brand of tea was not served to him as usual at the Club." Upon his retirement in 1927, thirty members of the Century arranged a farewell

dinner at a table "decorated with a miniature Dutch scene suggestive of the delightful little studio-house, with its minute tulip-garden, which he had prepared for himself in Laren [his home town] with its exquisite oriental porcelains and masterpieces of Dutch art."

Yet the epitaph BR would likely have most prized was two words chanted years later by Cleveland's Sherman Lee, renowned for his exacting eye. As recalled to us by James C. Watt, the emeritus curator of the Met's Asian collection, he was once early in his career taken by Lee on a sweep through the department's holdings. Sherman Lee then pointed at the very best works, including the tall bronze Buddha, and exclaimed, "Bosch Reitz!" "Bosch Reitz!" "Bosch Reitz!"

HAVING RETIRED, the Old Dutch Cleanser lived in Holland until his death in 1938 (after being struck by an automobile) at the age of seventy-eight. The actuarial figures are relevant, because his successor, Alan Priest, who was hired while still a graduate scholar at Harvard, insisted that he had a lifetime appointment. He angrily protested, brought suit, and even appealed to New York's governor, Nelson Rockefeller, to intervene when the museum in 1963 instituted a mandatory retirement policy for staff professionals at age sixty-five. Both his litigation and appeal proved in vain but provided an appropriate finale to a curatorial career in which Alan Priest seemed to view himself as an operatic hero besieged by jealous knaves and dunces. Neither before nor after did the Met employ a curator as brashly egocentric (or, alternatively, "eccentric," to use the milder euphemism favored by his superiors).

His self-dramatizing talents were evident from his boyhood in Fitchburg, Massachusetts, where his father and grandfather had prospered in the lumber trade. A childhood friend, Joseph M. Upton, recalls the adolescent Alan arriving at a high school dance wearing a long curly blond wig, a black gown, a veil, and a peaked hat. Another longtime friend, C. Edward Wells, a dealer in Chinese antiquities, thus describes Priest's demeanor during and after his Harvard years: "He was a slim young man with rather shaggy blonde hair. He walked with a gait somewhere between a slouch and a swagger," with a manner that could be "disconcertingly abrupt." He divided people into two camps: "on the one side were those people who were his friends and whom he believed could do no wrong"; on the other, those whom he disliked and "who could never do anything which could possibly please him."

Priest came to the Metropolitan partly thanks to the warm commendation of Harvard's Paul J. Sachs, whose "museum course" he had

taken. His credentials were impressive: his Cambridge mentors included Denman Ross and Langdon Warner, who recruited him for his second Fogg expedition in China. And now, while but thirty in 1928, he became curator of the Metropolitan Museum's equally fledgling Department of Far Eastern Art.

To track what then transpired, we found several revealing files. Early in the 1960s, James Cahill became a fellowship student in Alan Priest's office, and as he moved on, a collegial correspondence developed. Here, as Cahill had just begun his advanced studies in Taiwan and hoped doors might reopen in mainland China itself, is Priest's career advice, based on firsthand experience:

> Harvard sent me to Tun Huang and got me three fellowships in a row with more waiting. Do not for a moment think I did not work twenty-four hours a day. The first year I was only sure of one year. Language came first. I refused to meet any Chinese who spoke any foreign language. I would only see foreigners on weekends. One scholar lived in the house but did not teach me—he got a free room and a place to entertain—I could listen or not as I liked. My teachers came all day and three evenings a week—one for lunch, one for dinner. . . . After lunch for an hour we saw small dealers with packs on their backs—fun and you learn both things and language. A wonderful old man came twice a week to read the classics. He was wonderful—he came with the proviso he met no other foreigner. He did not like foreigners as they had chopped his father's head in the Boxer goings on in 1900.

Implicit in this was Alan Priest's defensiveness about the recurrent complaint that he lacked depth and seriousness as a scholar. Since it was often hard to establish definite dates and attributions, Priest on occasion described his own conclusions in museum publications as "interesting and harmless opinions, probably not far from the truth," or, as he wrote about a Tang dynasty crown, "if this did not belong to at least an imperial great aunt, it ought to have." A good expression of the insider consensus on Priest's erratic judgments was expressed in a letter to a friend from John Ellerton Lodge, formerly of Boston's MFA and then founding director of the Freer Gallery. Lodge discussed some scroll paintings that were submitted to him, "four of which are of the finest quality . . . the only other person who has seen them is Priest, and he turned them down, bless his silly little heart."

Priest's response to such detractors was pithily expressed in a letter to James Cahill, who asked his advice on shopping for paintings. "And when it comes to paintings, there are many of them in many shops, literally

hundreds and hundreds—some which were very fine, mostly decorative things or copies waiting for the unwary both Occidental and Oriental." Hence Priest declined to supply a list of where and what to buy. He then elaborated:

> An even better reason (for my not sending you a list) is that my Buddhist sect called Chan, and sometimes Ch'an, does not lean to controversies. When it comes to Chinese painting I do not enter into controversies. About all I will ever say about a picture is that I like or I do not like it. And in these matters there is only one opinion that has any real interest for me—mine. "Golden lads and girls all must / As chimney-sweepers, come to dust." This goes for curators too.

It chanced that Department Chairman Priest's most telling critic was his deputy, Ernst Aschwin Prinz zur Lippe-Biesterfeld. Like Bosch Reitz, German-trained but also of privileged antecedents (his brother was Prince Bernhard, the royal consort of Holland's Queen Julianna), Aschwin Lippe studied Chinese in Potsdam and earned his Ph.D. (cum laude) at the University of Berlin, after submitting a learned translation of a classic Chinese essay on bamboo paintings by the Yuan dynasty master Li K'an. In 1949, Lippe began as a senior research fellow at the Metropolitan; a year later he became associate curator, then a senior research curator, before resigning in 1964 after failing to be named as Priest's successor. He published scores of essays, reviews, and commentaries, and his judgments were widely respected.

All this explains why Priest routinely asked Lippe to check the accuracy of his articles and catalogue entries. The prince's responses are now accessible in the Smithsonian Institution Archives, and his factual corrections fill page after page. At one point, in a memorandum dated October 31, 1955, Aschwin Lippe challenges his superior's casual dismissal of "the yap and snarl of scholars as to who painted what and when." In fact, making these determinations "is our job and what we are paid for."

Still, Alan Priest deserves his due. He excelled at dramatic installations, such as his stellar 1945 exhibition, "Costumes from the Forbidden City," comprising two hundred Chinese court robes dating from 1644 to 1911. It required twelve galleries to display its riches, its climactic pièce de résistance being a facsimile of a tomb of a Qing dynasty prince, the son of Emperor Qianlong. In Calvin Tomkins's graphic description:

> The prince had been buried with all his concubines, who had dutifully lain down to die [leaving] them intact but with stains that over the ensuing two

hundred years had turned a marvelous golden-bronze color. Priest had the room painted the same shade of golden bronze, with streaks of suppurating green showing through here and there. Mannequins in various postures simulated the concubines. From a medical supply house, Priest had rented a human skeleton which he painted gold and arranged as though reclining on a couch in the robe of the Emperor's son. The skeleton had one weirdly effective glass eye.

Some days before the show's opening, Director Francis Henry Taylor passed by, was appalled by the skeleton, and ordered its removal. Priest put it in storage, but then replaced the bones just before opening night. It proved a showstopper. Apprised of critical and popular approval, the director grudgingly withdrew his objection.

However, it cannot be said that the museum substantially benefited from its curator's self-indulgence. During the 1930s, Priest began negotiating the purchase of the painting collection of A. W. Bahr, and eventually in 1946 he won approval to acquire, for a stratospheric $300,000, a host of scrolls, which the curator extolled as the finest in America. The Shanghai-born Bahr, was an early-day collector of Chinese art. As Priest excitedly assured the young Nelson Rockefeller, already a Met trustee, "every one of [Bahr's nineteen] handscrolls is a masterpiece, and eight of them cannot be surpassed." When they were finally acquired, Priest devoted a gallery to the Bahr paintings, calling it "the most beautiful room in the world." However, the collector/dealer C. C. Wang, who reputedly had studied every Chinese painting of importance in America, subsequently contended that of 149 works making up the entire collection, barely fifteen were of "museum quality." In his memoirs, Hoving's downgrading was harsher: "The Bahr Collection was a blot on the Met's collecting history." Overall, the contemporary judgment of Alan Priest's legacy was crisply summarized by Cleveland's Sherman Lee. In a memo advising John D. Rockefeller III on the disposition of his artworks, Lee described the Met's Asian collection as being "rather moribund."

Hence when Alan Priest finally departed, many on the Met's curatorial staff hoped that his successor would be the generally respected Aschwin Lippe. It did not happen. Insiders speculate that what may have tipped the balance were allegations concerning his wartime service in the German armed forces, a blot that was said to have especially affronted Dietrich von Bothmer, the museum's longtime curator of classical antiquities. Himself the offspring of a titled German family, von Bothmer had been a German Rhodes Scholar at Oxford and was visiting America

when the Second World War broke out; as a U.S. Army volunteer, he served in the Pacific theater, earning a Bronze Star and Purple Heart.

FOLLOWING PRIEST'S involuntary retirement, the next principal curator of the department was a Chinese-born, U.S.-educated specialist in ceramics, Fong Chow. He lacked Priest's networking skills, especially among influential trustees, and for most of the 1960s, the department was essentially dormant—even as the New York galleries brimmed with privately owned works migrating from Asia. The Met's principal competitors in this area, museums in Boston, Washington, Cleveland, and Kansas City, took full advantage of a fluid market to expand their Asian collections. But America's premier metropolis had stalled in its competition for major prizes of Far Eastern art.

This past was very much the prologue as the Metropolitan Museum approached its centennial observances in 1970. All was in ferment under Director Thomas P. F. Hoving, now in his third year at the helm, having had the firm support of President C. Douglas Dillon in seeking to shake the museum from its regal repose. The son of the retail magnate Walter Hoving (Tiffany & Co.), young Tom grew up among New York's hereditary princelings and their spouses. Having just served as Mayor John Lindsay's park commissioner, which entitled him to an ex officio seat on the Met's governing board, Hoving was present in May 1966 when a trustee questioned Director James Rorimer's ethical judgment in accepting, and passing on to the Medieval Department, a potentially tax-deductible holiday gift from a German auction house. By a voice vote, the board upheld the director. Angry and already ailing, Rorimer died that night of a cerebral hemorrhage.

No such terminal dramas occurred under the diarchy of C. Douglas Dillon and Thomas P. F. Hoving; instead, they jointly managed a virtual doubling of the museum's size and ambitions. In 1970, Dillon succeeded Arthur A. Houghton Jr. (chairman of Corning Glass and a collector of illuminated Persian manuscripts) as the Met's president. Dillon brought to the post his skills as an investment banker (Blyth Eastman Dillon); as a major appointee in the Eisenhower and Kennedy administrations (ambassador to France and then Secretary of the Treasury); as a collector of Impressionist art; and as a widely respected figure in the worlds of philanthropy, society, and high officialdom. Still, though well aware of Asia's strategic and financial importance, Dillon had hitherto shown only lukewarm interest in its aesthetics; as a colleague noted, the only Asian touch in the décor of his Upper East Side apartment was some wallpaper

of Chinese design. Yet Dillon and Hoving now secured board support for a bold turn to the Far East, a shift justified in good part by a talismanic word: *encyclopedic.*

Broadly speaking, from the Age of Enlightenment onward, two kinds of art museums spread through the West: national and encyclopedic. The former generally celebrated a single culture, "seeking to define and legitimize it for local peoples." The latter, again to quote James Cuno, head of the Getty Trust, "direct attention to distant cultures, asking visitors to respect the values of others and seek connections between cultures." From its founding, the Metropolitan was explicitly encyclopedic, and yet its holdings of Asian art were at best routine. Hence the broad mandate accorded by the museum's trustees to Dillon and Hoving to invigorate the Asian department and to venture as well into other neglected realms. The museum's bylaws were rewritten to give its president and key committees greater authority. Under Dillon, the bimonthly closed board meetings generally moved with clockwork precision to ratify the decisions of plenary committees. He became, in effect, the Met's CEO. By the same token, Hoving created a new title, "chairman," to expand the authority of all departmental leaders. Not just Asian art benefited.

For the first time, contemporary art, and what was once termed "primitive" art were accorded their due; ditto photography, films, fashion, and postmodern art. During the Dillon/Hoving decade, the museum added, or initiated, five new wings: the Lehman Pavilion, the Dendur or Sackler Wing, the Michael Rockefeller Wing, the American Bicentennial Wing, and the Western European Wing. The cost of the additional 325,000 square feet exceeded $75 million. Dillon and Hoving's strategy was to avoid a general review by any city agency with veto power; their projects were presented piecemeal, often with a disingenuous promise that no further expansion was contemplated. The board of trustees at no point discussed, or voted upon, the expansion plan in its entirety. In addition to spectacular or controversial acquisitions (i.e., Velasquez's *Juan de Peraja* and the later-repatriated Euphronios krater, both purchased at record prices), the Met also became, in effect, a Foreign Office of the arts. Building on a tradition pioneered by Francis Henry Taylor, Hoving negotiated loan shows with (among others) France, Russia, Italy, Mexico, Ireland, Japan, Israel, Egypt, Spain, Australia, Bulgaria, and East Germany. Some exhibitions were blockbusters, a word popularized during the Hoving era, and many went on national tours.

Moreover, the Hoving/Dillon diarchy opportunely exploited sudden shifts in foreign policy. No sooner had President Nixon and Secretary of

State Kissinger flown back from a reopened China than Hoving became among the first directors to propose an exhibition on the startling new archaeological discoveries in Mao's People's Republic (the Met lost out to the National Gallery, but later squared accounts, in a parallel duel with Washington, by securing for New York the Temple of Dendur, with the backstage help of Jacqueline Kennedy Onassis, a Hoving ally).

Yet how did Asia in general, and China in particular, fit in? From the outset both Dillon and Hoving were determined to upgrade the "moribund" department. In 1973, an informal survey of the museum's trustees found that a majority likewise felt the arts of China were among the museum's weakest areas. On one point, Dillon, Hoving, and the trustees were in wholehearted agreement: money, and lots of it, was needed to rejuvenate the Far Eastern galleries. Yet how to fill those growing galleries, and with what? Dillon pressed successfully for a bold forward strategy: buy entire collections instead of shopping piecemeal and give liberal rein to enterprising and qualified curators. Dillon duly established the "Dillon Fund," which financed both purchases and the creation of the Douglas Dillon Galleries for Chinese Painting and Calligraphy, which opened in 1981. The department's overall expansion during three decades transformed a single gallery for Asian art into a network of some sixty galleries displaying works from China, Japan, Korea, India, Tibet, and Southeast Asia. The exhibition space for Chinese paintings grew so generously that by century's end, as reckoned by *Orientations,* the Metropolitan presented "the largest display area for Chinese art outside Asia." What made all the difference was Dillon's "passionate enthusiasm" and "relentless pursuit of the finest Chinese paintings." So wrote Hoving's successor, Philippe de Montebello, the disciplined and imperturbable scion of a Paris banking family.

But who could implement these ambitious policies? What ensured the reborn department's momentum were three successive and energetic helmsmen, the first being Wen Fong, the Shanghai-born, affably ambitious scholar, who opportunely twinned an academic career at Princeton with serving as consultative chairman of Asian art at the Met. He would preside over the expansion of the Asian department for three decades.

Next came the scholarly, Hong Kong–born James C. Y. Watt, who like Wen Fong began as a consultant, then was named the Brooke Astor Curator before assuming chairmanship of the department in 2000. Watt was succeeded in 2011 by New Jersey–born, Utah-bred Maxwell K. Hearn, known to all as Mike, who joined the department in 1971 as an

assistant researcher, having just graduated from Yale. A few years earlier, he happened to visit a friend's aunt in Kansas City and serendipitously discovered the China treasures in the Nelson-Atkins Museum. Hearn was fascinated, studied Chinese art with Yale's Richard Barnhart, and, with the encouragement of Kansas City's Laurence Sickman, took what became lifetime orders at the Metropolitan—with time out to earn his doctorate at Princeton as a student of Wen Fong. He remains, as of this writing, the incumbent steward of America's most comprehensive collection of Chinese art.

HOW DID THIS DRAMATIC EXPANSION BEGIN? Flash back to the early 1970s. Director Hoving is surprised to see his former Princeton schoolmate, Wen Fong, sitting in his office and charming his chief assistant, Cecilia Mescall. "Wen has to see you," she says. This was a time, Hoving recalls in his memoirs, when "acquisitions and shows became my gourmet tidbits, and I became ravenous for the truly rare object or whole collection of objects." His visitor's first words are: "I may have the greatest acquisition in the history of the museum." In Hoving's account:

> The story fell out of Wen Fong's mouth in a rush. Basically, it involved snatching away from our strongest competitors the finest group of early paintings in private hands. He had been patiently tracking the Sung and Yuan paintings in the collection of C. C. Wang (or Wang Chi-ch'ien) and had reached an agreement to buy 25 for only $2.5 million. The purchase, Fong explained, would rocket the Met to the level of Boston, Cleveland and Kansas City. Overnight we would be on a par with them, at least when it came to these vital early periods. Wen told me that Larry Sickman of Kansas and Sherman Lee of Cleveland had been pursuing C. C. for years and would be flattened by our coup.

It was just such a deal that Hoving and Dillon yearned to consummate. With appropriate fanfare, in 1973 the Metropolitan announced the purchase of C. C. Wang's gemlike collection. A dozen more acquisitions followed, culminating in 1983 with the accession of John M. Crawford Jr.'s scroll paintings and calligraphic art, described as the finest such assemblage in the West. The moribund department had sprung to life.

It was clearly propelled by Wen Fong's acquisition of C. C. Wang's twenty-five paintings, followed in 1998 of twelve more from the same collector, a key work being *Riverbank,* the endlessly debated painting that Wang had held back from the original sale, avowedly because of its rarity.

Who was this formidable collector? Described as "the last of the literati," C. C. Wang was born in 1907, in Suzhou in eastern China, a city rich in history and art, both dating back more than two millennia. At age fourteen, C. C. began painting landscapes, went on to study law and the classics, and then became a serious collector. In Hoving's words, he came up with one of the cleverest ploys in connoisseurship: "[H]e would examine all the chops, or seals, customarily planted on Chinese paintings indicating their ownership. Even collectors who did not want him to see their paintings all wanted to know about the earlier seals. He traveled throughout China recording the seals in private and Imperial collections. Thus Wang was able to scrutinize thousands of the best Chinese paintings in existence."

Having emigrated via Hong Kong to America in 1949, Wang continued his searches, eventually compiling a catalogue of around nine thousand seals. Even so, the Metropolitan's trustees took the unusual precaution of inviting three qualified outsiders to evaluate seven hanging scrolls, ten hand scrolls, seven album leaves, and an illustrated album of poetry that made up his $2.5 million collection. The museum's publicists took care to stress that C. C. Wang's legal title was solid and that all the designated artworks arrived from Hong Kong, where there were no export restrictions. The expert judges—Laurence Sickman, Sherman Lee, and Yale's Richard Barnhart—came, saw, and differed as to the value and authenticity of many items. A media squall ensued over their scoring system and the relative merit of specific works. Yet even the sale's severest critic—Carter B. Horsley, a *New York Times* reporter who resigned after charging that his critical account of the collection had been diluted by nervous editors—agreed that the collection's weakness lay not in forgeries, but in Attributions, with a capital *A*.

All this was a prelude to the firestorm over the subsequent acquisition of C. C. Wang's *The Riverbank*. Seldom in the museum's history has a single painting stirred so much argument for so many years as did *Riverbank* (four decades and counting), a testament to the minefield otherwise known as Chinese art scholarship. For laymen, it is this slithery question of authenticity that baffles and perplexes and makes one sympathetic with Alan Priest's I-don't-care attitude. This is notably the case regarding the clash of expert verdicts regarding the *Riverbank*.

As to its authenticity, three hypotheses can be distinguished: the scroll is a modern fake, very probably painted by the well-known dealer-artist-forger Zhang Daqian (James Cahill's contention); on the contrary, it is a tenth-century hanging silk scroll and is the monumental work of

C. C. Wang, "the last of the literati," a collector and authority on Chinese paintings, whose sale to the Met sowed headlines and controversy.

Dong Yuan, a Chinese artist, comparable to Leonardo (according to Wen Fong and C. C. Wang); or *Riverbank* is indeed a major and vintage work, but "not quite securely documented or attributed, and only approximately dateable" (as expressed by Yale's Barnhart).

Thus challenged, the Metropolitan Museum hosted two full-scale roundtable discussions concerning the merits of *The Riverbank,* and, following the second in 1999, those attending were asked if their minds had been changed; no hands were raised. The last word belongs to Professor Barnhart, who in a sharply worded commentary maintained that the true issue in the controversy was the "grotesque over-inflation of value and historical significance that museums now find it necessary to employ when presenting their collections to the public." Barnhart protested that the Wang purchase was announced "with such hyperbole that even this

writer, one of the few art historians who has written at length and admiringly about *The Riverbank,* had to cringe in disbelief and discomfort." No, he concluded, the scroll is not the "Mona Lisa of Chinese painting," as *The New York Times* excitedly reported, "but it is one of the treasures of world art—and a painting that helps us understand how the art of landscape painting was invented in China a thousand years ago." Yet consistent with the entire dispute, his article in *Orientations* provoked a blizzard of letters, counterclaims, and polemics (which still continue).

HOWEVER MIXED THE EXPERT JUDGMENT on the merits of *Riverbank,* no such discord greeted the culminating acquisition of the Wen Fong era at the Metropolitan. In 1981, the wealthy and quirky John M. Crawford Jr. presented or sold to the museum sixty Chinese artworks, especially including calligraphy, a trove whose value was estimated at $18 million. The works in the Crawford Collection were likened by scholars to the select objects assembled by Charles Lang Freer, which became the core of his named gallery in Washington. One Crawford painting in particular would light up any gallery. Titled *Finches and Bamboo* (see color plates, figure 12), only eighteen inches long and eleven inches wide, it depicts two gray-and-white birds with shining eyes on the branches of a bamboo tree; its execution is precisely rendered on a hand scroll laden with colophons and seals. One colophon, composed by the painter and calligrapher Zhou Mengfu, praises the artist for attaining the ultimate in subtlety: "With an ability almost beyond anything human, he could depict the essential character of plants and animals as they were created by nature. In this scroll he has not labored much with ink and colors, yet all is spontaneous and right. . . . What good fortune for these insignificant birds to have been painted by this sage man!"

And who might this sage painter be? He was in fact Emperor Huizong, who reigned from 1100 to 1125 CE, the final years of the Northern Song dynasty, a time when China's cities were the most populous and culturally advanced in the world. His capital was Kaifeng, where during his twenty-six-year reign he founded schools, hospitals, Daoist shrines, and an arts academy. But through mischance, his own excessive ambitions, and miscalculations, his dynasty foundered as the Jurchens, a warrior people from Manchuria, overwhelmed his lands. When Kaifeng fell, the fleeing artist-emperor was seized and remained captive until his death eight years later. On one point, there is little dispute: while other Chinese emperors also achieved painterly renown, Huizong is judged the most accomplished.

As Wen Fong and Maxwell Hearn summarize, Huizong was "a rapacious collector and artist and calligrapher of great talent, who did more than any other ruler to foster the Academy tradition in China." As to *Finches and Bamboo,* his painting "is more than a faithful reproduction of nature's outward appearances. By showing growth, change and potential movement, it communicates profound insight into the workings of the natural universe. By comparison, an Audubon print or nature photograph seems only a frozen image." The emperor catches the dynamism between the sleek male and the aloof female, "even the dots in the birds' eyes are meant to add life."

In any case, John Crawford Jr. proved a good modern-day match for the Song emperor. Born in West Virginia, the son of a wealthy manufacturer of oil-drilling equipment, John Jr. was from his student days at Brown University more interested in books than bottom lines. As a collector of incunabula (early printed books), manuscripts, and fine bindings, he became active in New York's Grolier Society, the bibliophile's Valhalla. Then he discovered Chinese calligraphy. "The subtleties of typography," he told *The New Yorker,* "paved the way for me to enjoy an art that is largely black and white." In all this, Crawford sought the expert guidance of the unjustly forgotten dealer Joseph Umeo Seo, a former member of the Yamanaka team, blessed with a sure eye for forgeries—a necessity because most of the Crawford scrolls were from the collection of Zhang Daqian, a noted artist but also renowned as a mischievous faker.

In 1962, in what was a creative first for an esoteric genre of art, the Pierpont Morgan Library joined with the Fogg Art Museum and the Nelson Gallery to showcase the Crawford Collection of Calligraphy and Painting. The traveling exhibition marked the public debut of the emperor's *Finches and Bamboo,* whose most recent provenance is identified simply as "the Moriya collection, Kyoto." Thereafter, until the Met prevailed in 1981, Crawford was courted by the Nelson-Atkins Museum. The chase had its dramatic moments, as we learned from Marc Wilson, the emeritus director of the Kansas City Museum.

As Larry Sickman's protégé, the young Marc was told that Crawford had been caught in a trap and blackmailed after being told that he had inherited a hotel in Florida. A bribe was essential to avoid imprisonment. Short of funds, the collector then offered a prize painting, *Poem on the Red Cliff,* to the Nelson-Atkins Museum. In a frantic quest for funds, Sickman prevailed on a longtime female donor to earmark $1 million ($600,000 for the Crawford painting). She duly turned up in a vintage Cadillac and presented Sickman with the needed checks. Wilson flew to

New York, gave the collector his funds, and returned with the painting in a makeshift case. It is, he told us, "the most important Northern Song painting in the collection."

In Wilson's charitable recollection, the Dillon/Fong team did a "brilliant job" in acquiring the rest of the Crawford trove. Although described as a gift in 1981, there were collateral fiscal benefits accorded to the collector as part of the deal, according to Wilson (all but one work was donated, but the last had a generous price tag). Yet in several accounts, what seemingly made the critical difference was the Met's expansion of its Asian galleries. "At last, you have a space big enough to hold my collection," Crawford said after inspecting the new galleries. Here visitors could begin to understand why calligraphy was so valued in classic Chinese art. Thus the Met prevailed, abetted by daily curatorial visits as Crawford's health declined.

In another innovative step, the museum in 1992 unveiled what Director Montebello called "the crown jewel" of the Asia reinstallation: the Florence and Herbert Irving Galleries for Decorative Arts, where a selection of the Met's thousand-plus jades from Heber R. Bishop's collection could finally be properly displayed. Lacquer had been a neglected area, and with the acquisition of the Irving collection of both functional and luxury objects from East and South Asia, the Met addressed the gap (see color plates, figure 17). Both the cost of the spacious gallery and many of its specimens were borne by Florence and Herbert Irving, the enterprising patrons, whose wealth derived from Herbert's early and prescient investment in Global Frozen Foods, whose popular products included fish sticks and French fries.

IN JUNE 2000, the Metropolitan formally announced a long-anticipated succession in its recently reborn Department of Asian Art. As of month's end, Wen Fong was to retire as C. Douglas Dillon Curator Emeritus while James C. Y. Watt, the veteran Brooke Russell Astor Senior Curator, would assume leadership of the department. This signaled a change of emphasis rather than a change of course. Under Wen Fong's leadership, acquisition and expansion had been the paramount priorities; under Watt, it would be education and illumination. Having already curated specialized loan shows on East Asian lacquers (1991) and on the era when commerce opened a road from China to the Middle East, "When Silk Was Gold" (1998), Watt soon added to his credits "China: Dawn of a Golden Age 200–750 A.D." (2005) and "The World of Khubilai Khan" (2010). What helped make these exhibitions possible was Watt's

skill at eliciting the cooperation of collectors and (crucially) of various levels of officialdom and the museum bureaucracy in the complex organism known as the People's Republic of China.

To meet Emeritus Curator Watt is to understand his success as a negotiator. Slight, dapper, and soft-spoken, he blends the civility of East and West. Born in Hong Kong as Qu Zhi-ren, Watt had a classical Chinese scholar's at-home education, burnished in Britain at King's College, Taunton; Queen's College, Oxford; and the University of Hong Kong. While serving as curator of art at various Hong Kong galleries, Watt also traveled through Southeast Asia to study the ceramic trade under a Harvard-Yenching research grant. In 1982, having settled in Boston, he became the MFA's curator of Asian art. All this detail helps explain Watt's multilingual familiarity with the Anglo-Sino-American worlds of academia, museology, and philanthropy—ideal preparation for his twenty-five-year tenure at the Metropolitan Museum, beginning in 1985.

Among the works he exhibited, or helped acquire, Watt is especially proud of a fragment of a silk tapestry titled *Dragons Amid Flowers* (see color plates, figure 7) that the Met purchased in 1987. In vibrant colors, it features a motif originating in Eastern Central Asia that spread through China under the Mongol-ruled Yuan dynasty. Here are fierce dragons, long of tongue and tail, dancing with claws spread in an otherwise peaceful bed of blooming flowers. It is from an era when richly woven textiles, treasures that formed the backbone of international commerce, when "[t]he finest products of imperial embroidery and weaving workshops were among the gifts presented by emperors and imperial family members to other rulers, emissaries and distinguished persons." As Watt points out, in an era when silk was literally worth its weight in gold, these textiles became part of a gifting culture that persists even today in diplomacy, political and cultural.

An important 2010 exhibition, "The World of Khubilai Khan: Chinese Art in the Yuan Dynasty" (1279–1368 CE), also cast a fresh beam on a relevant theme. In Watt's view, there are two ways of viewing Chinese art: "It can be seen as sui generis, its history following a single, continuous line of development that revitalizes itself from time to time by going back to ancient models." Or it is possible to view Chinese art as a continuing integration of cultural influences across frontiers that enter the mainstream of Chinese culture. "Both views can be amply justified and they are not mutually exclusive."

His point is implicitly underscored by the preface and acknowledgments that open the handsome exhibition catalogue. Thanks are expressed

to literally hundreds of persons, institutions, government agencies, conservators, and foundations in various countries, West and East—it obviously took someone with Jim Watt's tact, savvy, and professional authority to bring off the shows that became his trademark. In a perceptive article on the Metropolitan's changing leadership on Asian art, *The New York Times* culture reporter Holland Cotter describes the new pitfalls:

> The general rule is that if you want to borrow from more than two Chinese museums for a show, all the loans have to be negotiated through the government's Cultural Relics Bureau. In the past, that bureau could demand whatever it wanted from provincial museums, without necessarily sharing paid loan fees, and sometimes without returning objects. With the economic boom in recent years, however, provincial museums have become powerful entities, largely independent of central authority. Many treat art as a meal ticket and drive tough bargains to extract money, and for fringe benefits like courier trips abroad, in exchange for loans.

In short, the venerable Chinese tradition of gifting has been updated by needy museum officials in the People's Republic. As of July 2011, this along with other sticky matters ceased to be of pressing concern to the retiring curator Watt. They became problems and challenges for Maxwell K. Hearn, the incoming Douglas Dillon Curator in Charge of the Department of Asian Art. As the third man in the same chair, Mike Hearn had the obvious advantage of being a firsthand participant in the department's dramatic expansion. He had joined the museum as a recent Yale graduate and ubiquitous intern in 1971, then went to study with Wen Fong at Princeton as the department was just beginning its ascent. Now even the Met's longtime detractors would agree that its Asian collection ranks near the top in the West. Hence Hearn has every reason to savor a victory lap in the Met's marathon run.

In person, Mike Hearn's manner seems more Middle American than Ivy League, as evident in his enthusiasm, his willingness to confess error, and his openness to new information ("That's interesting, I'll have to look that up"). With his department about to observe its hundredth anniversary in 2015, Hearn stresses that it has grown not only in size but also in discernment, especially regarding Chinese painting. The accepted canon was very different in the 1970s, when the very best works in Taiwan's Palace Museum were "all that we knew." A decade later, when mainland China's collections could be seen, "a whole other canon," enlarging the range from Song to Ming, finally came within view. Indeed,

"It takes a generation for the canon to be expanded." This, he adds, is also true of Western art, as for example in the changing consensus about Rembrandt's actual works.

Mike Hearn's great strength has been in lifting the gloom from the China galleries. Four decades ago, he and Wen Fong hatched the idea of creating an indoor facsimile of a Chinese scholar's garden; Hearn wiggled into the ceiling crawl space and discovered a covered-up skylight that could shed sunlight on the garden. Then-director Hoving vetoed their plan, arguing that the museum had just installed a costly air-conditioning duct there. "At that point," writes Holland Cotter, "Mr. Fong deployed a secret weapon: Brooke Astor, a Met trustee, who as a child spent time in Beijing. When Mr. Hoving explained to her the impossibility of moving ducts, her reply was simple: 'Well, how much would it cost?' The skylight was soon exposed, and 26 Chinese craftsmen, accompanied by a personal cook, were imported from the garden city of Suzhou to create the Astor Court."

Few in the American museum world are better equipped to contend with the puzzles and paradoxes of Chinese art than Mike Hearn. His strengths were in evidence with the opening in June 2014 of "Out of Character: Decoding Chinese Calligraphy," drawing partly on the collections of Jerry Yang, a cofounder of Yahoo, and his wife, Aikiko Yamazaki. It was a "smart and accessible show," according to *The New York Times,* in which a panoply of devices provides a thread for the unknowing visitors, such as a poem used to teach Chinese characters to schoolchildren. A postcard-size guide helped gallerygoers grasp the difference between the old block-style script and the newer cursive characters. Among treasures then spotlighted is a hand scroll titled *Writings in Praise of a House Boat,* dating to the Ming dynasty, in which thirteen eminent calligraphers offer their examples, and each has an individual character. The show, first curated by Michael Knight of San Francisco's Asian Art Museum, was then remounted in New York by Joseph Scheier-Dolberg, an assistant curator at the Met.

In sum, the great age of acquisition and rivalry has yielded to a new era of elucidation and collaboration. Thus do we view the world through increasingly globalized eyes. Fittingly, the last word belongs to Wen Fong and Hearn, writing in 1981 when the Douglas Dillon Galleries of Chinese Painting opened. Here they seek to explain "the unique characteristic of Chinese painting," namely its close relationship to writing. The common tool is a brush made of animal hair—goat, horse, rabbit, weasel, or mouse whiskers—in "ascending orders of stiffness." And these brushes

show remarkable fluency, with calligraphic results ranging from lustrous black to translucent gray.

For example, the art of writing ideographs with a brush "imitates nature's rhythms" and is regarded by the Chinese "as a purer, if not higher form of artistic expression than painting." As the Met's curators elaborate:

> A superbly executed brushstroke not only is a kinesthetic movement of great beauty and joy, reflecting the artist's delightfully balanced finger, wrist and arm actions, but also comes straight from the writer's belly and mind— thus the Chinese refer to calligraphy as an artist's "mind print." In making thickening-and-thinning, twisting-and-turning lines—simultaneously pushing down and pulling back for heightened tension and internal movement within each stroke—the painter's calligraphic brushwork can be infinitely expressive in an inimitably personal way.

Still, there are deeper challenges confronting not just Metropolitan but the Western museums and preservationists in general. As related by Alexander Stille in *The Future of the Past* (2002), when a team of Italian conservators arrived in Xi'an to advise and help their Chinese counterparts, its members were startled by the chasm of mutual noncomprehension. Why not improve or even remake excavated artworks? What's wrong with truly good copies of ancient works, as contrasted with tourist-shop kitsch?

The team led by Michele Cordaro, director of Italy's Central Conservation Institute, was dumbstruck by such insistent questions. They learned that the famous terra-cotta warriors sent abroad on loan shows were for the most part what the Chinese call *fu zhipin,* meaning high-quality copies, very different from *fang zhipin,* meaning cheap knock-offs. Very much the same plastic attitude extended to preserving historic buildings in Xi'an, or to the Buddhist sculptures of Longmen. As Stille concluded, the richness of China's past, just underneath the belly of soil, "may mean that what we see today may not be what we see tomorrow. Chinese archaeology is still in its infancy, about where Egyptology was in the middle of the 19th century, with many major discoveries ahead. Trying to create a portrait of China now is like photographing a bullet train in motion; whatever one describes will almost certainly be different in five or ten years."

In sum, the Sino-American learning process could well become a two-way street, in which America's oldest encyclopedic museum could likely be a useful traffic cop.

CHAPTER EIGHTEEN
ALIEN PROPERTY

World War II proved a calamitous era for stellar dealers in Chinese Art. C. T. Loo had his stock appropriated by the Chinese in Shanghai; the Japanese firm Yamanaka & Company (with branches in Chicago, Boston, Seal Harbor, and New York) had its American stock confiscated and auctioned by the U.S. Alien Property custodian in 1944. The well-known Peking dealer Otto Burchard, who was so instrumental in helping Laurence Sickman accumulate treasures for the Kansas City museum, was triply unlucky; after he had to flee Germany in 1933, the contents of what had once been his gallery were auctioned off in a two-day sale in March 1935, and then the U.S. government confiscated his American stock as alien property during wartime. But no story is stranger than what befell thirteen Chinese objects, some purchased from C. T. Loo in 1941 and subsequently lent to the Buffalo Museum of Science in 1942—all once owned by the German-Swiss collector Baron Eduard von der Heydt.

A banker by profession and a collector by instinct, Heydt could plausibly have been a character in a novel by Hermann Hesse. He was at once a flamboyant Bohemian, a known homosexual, and a covert enabler of Hitler's Third Reich. A childless divorcé, he left his art collection to two museums. His Asian art became a centerpiece of Zurich's Rietberg Museum, and his collection of European art, including a number of modern masters (following his father August's example), was bequeathed to a museum in Wuppertal, which was renamed the Von der Heydt Museum in

The Northern Wei Bodhisattva, seized as wartime alien property by the United States, and eventually awarded to the Freer Gallery of Art.

1961. But what concerns us here are the eight Chinese works that are now in Washington at the Freer Gallery.

Born in 1882 in Elberfeld (now absorbed into Wuppertal), a center of the textile industry, Eduard von der Heydt was the second son of an old, powerful, and recently ennobled family of bankers—his great-grandfather August was the Prussian minister of commerce, and later, as finance minister in Bismarck's cabinet, he was responsible for building the Prussian Eastern Railway. Although they already belonged to the cream of the increasingly rich Ruhr industrial society, the raising of the von der Heydt family to the hereditary nobility in 1863 meant that their two sons, August and Eduard, had access to important contacts among

members of the Prussian court as well as entrée into Berlin's exclusive salons. (Their magnificent family home in Berlin, purchased by his great-grandfather before Eduard was born, became, by a stroke of fate after August's death, the Chinese embassy.) At home, in Elberfeld, the parents played host to writers, artists, and musicians. They were also collectors of the avant-garde—Modersohn-Becker, Nolde, Kokoschka, Matisse, and the museum world's first Picasso—art left by their son to the Wuppertal museum that still bears their name.

In 1900, after a classical gymnasium education, Eduard spent a gap year in Bonn and later joined the Dusseldorf Hussars. Two years later, he served with yet another cavalry regiment, the even more aristocratic Potsdam Ulans. (These reserve cavalry units functioned as places where the sons of parvenu burghers acquired a Prussian Junker patina.) Eduard attended university in Geneva, and in 1905 he received his doctorate in economics at the University of Freiburg. Instead of following his older brother into the family firm, young Eduard spent a year apprenticing at a New York bank, August Belmont & Company, which looked after the Rothschild family's American interests. But the frivolous gilded life of New York and Newport didn't agree with him and he returned home. In 1909, he was off to London, where at age twenty-seven he founded a branch of the family bank, E. von der Heydt & Company, with capital from his inheritance and that of a regimental friend.

London with its museums and art dealers captivated him. All doors opened for the young banker, who was often seen at Mayfair's best parties and nightclubs dressed in tails. In the summer of 1914, shortly before war broke out, he happened to be in Potsdam, and as a lieutenant in the reserves of the Ulans (lancers), he served on the Western front, seeing action in the Battle of the Marne, for which he received the Iron Cross Second Class. (His comrades nicknamed him "Barönchen," or "little Baron," alluding to his short [five-foot-six] stature.) Wounded in 1915, he was mustered out of the military and served as counselor to the German embassy in The Hague. His military service saved him from internment in Britain, and from probable deportation, but his banking assets were expropriated as enemy property in 1917, and he lost everything, including his art.

At war's end in November 1918, amid the revolutionary turmoil in Berlin, he married a Hamburg banker's daughter, Vera von Schwabach. His new father-in-law, Paul von Schwabach, a converted Jew, was the co-owner of the powerful Bleichroeder Bank, which had underwritten Bismarck's expansion of the Prussian state; thus von der Heydt's financial

future was once again secured. With his father-in-law's help, he opened the Von der Heydt-Kersten Bank in Amsterdam in 1920. But the arranged marriage joined an inexperienced eighteen-year-old bride with a groom twice her age who was attracted to men. He confessed to a friend from his Potsdam regimental days, the German diplomat Herbert von Dirksen, that he was "unsuitable for marriage." Eduard and Vera were divorced in 1927, although they remained on friendly terms. (The baroness became a distinguished Jungian analyst in Britain, one of the last to enter analysis with the master himself in Switzerland.)

In 1942, during the Second World War, Eduard recalled his initial mystical encounter with Buddhist art in 1908: "The autumn wind sweeps through Amsterdam's dark streets. The pounding rain rocks the old Dutch kaebue in the canals. Everything is in motion, even the houses seem to shake. Light streams through a small window . . . a large, quiet, marble head of a Buddha appears, motionless in the storm of elements. I wait, remembering from my student years Schopenhauer, the Upanishads, the Buddhist sutras." He was hooked.

At first, his collection began conservatively: seventeenth-century Dutch paintings, acquired in London. In Amsterdam in 1908, he purchased his first Chinese sculpture and then began to haunt C. T. Loo's and Paul Mallon's Parisian galleries of Asian art. His mantra was "one buys the very best from first class dealers for the reason that they immediately take back a piece that is questionable, or that you may not like." Reminiscing on the occasion of his seventieth birthday, he spoke of his early adventures in collecting Chinese art: "One studies the old dynasties, asks professional art historians, and each gives a different answer. Everything was then in flux. The dynastic names of Han, Sui, Tang and Song were swirling around. They meant nothing to me because I did not want to take a lesson in history. I was fascinated by the works of art. I could not care less who made them, and at what time they were made." His growing collection demanded grander quarters, and the couple acquired a patrician house on Amsterdam's Keizersgracht, which also housed his bank. On the ground floor, they established a private gallery of East Asian art named Yi Yuan, comprising more than four hundred objects, acquired in one stroke from the estate of the Italian-French Sinologue Raphael Petrucci in 1922. Describing Yi Yuan, von der Heydt maintained that it "was not supposed to be a museum, nor a concert hall or a temple, but a combination of all three and, at the same time, living quarters and a place for study."

It was his taste for non-European art that distinguished von der Heydt from his contemporaries, although that same year Eduard and his

brother purchased their father's European art collection, later gifted to the Wuppertal museum. Once when asked why he had collected Asian art, he replied that it was "ridiculously cheap" in its day, particularly in the 1920s in France. His Dutch banking business allowed him to buy art in countries like Austria and Germany during the crushing postwar hyperinflation, which lasted until 1923, using his backed-by-gold Dutch guilders. Von der Heydt employed an interesting investment strategy, which he would tout to his friend Baron Heinrich Thyssen-Bornemisza: buy art. Most of it was purchased from dealers in Paris, London, and Amsterdam, and he was not averse to buying in bulk, such as the collection of Ordos bronzes, a form of Eurasian steppe art, that he acquired from C. T. Loo, whose gallery exhibited it in 1934–35 in Vienna.

Catalogues loom large in von der Heydt's operations. In 1924, the art historian Karl With edited the baron's first: the Yi Yuan objects (*Bildwerke Ost-und Südasiens aus der Sammlung Yi Yuan*). Although Eduard became acquainted with a number of art historians, according to With, "Heydt neither needed or wanted any professional advice and would rather dare to follow his own impulses. Born with an infallible instinct, discriminating taste and sense of quality, he could safely trust his own judgment. In his detective pursuit of hunting for unusual or even obscure art treasures, he often proved his almost clairvoyant foresight."

Although a visionary when it came to his art, as a banker he was often in difficulty. After a falling out with his father-in-law, von der Heydt left the firm. But our *Stehaufmännchen* bounced back, founding yet another private bank in the Dutch spa resort of Zandvoort in 1924. The Zandvoort bank occupies space in a complex that includes a spectacular thirty-room villa, cobbled together from four smaller houses with huge panoramic glass windows overlooking the ocean and the beach. His many private clients now include Edmund Stinnes, whose considerable inheritance from his industrialist father, Hugo Stinnes, von der Heydt helps sort out. The exiled former emperor Wilhelm II is a frequent guest at Zandvoort, allowing the baron to bask in the rumor that he is "the Kaiser's banker." Part of the villa is open to the public as a museum and lunchroom, to which visitors are directed by a discreet signpost: MULURU (Museumlunchroom). Eduard believes that art should be accessible to the public, and at MULURU guests can "drink beer under a Japanese demon" or be "served bread and butter in front of the South Sea sculpture." "*Ars una*," meaning there was only one art encompassing all cultures, is how von der Heydt now describes his omnivorous collecting. Eduard's taste for acquisitions—houses, art, celebrities—remains insatiable.

*Von der Heydt, interwar host to Europe's best and cleverest, in
his nonbanking guise in Ascona, Switzerland.*

Interwar guest books attest to the baron's enthusiasm as a host while
he is fast becoming known as a patron of the arts, financing expeditions as
well as research. Now he discovers a former quiet fishing village, Ascona,
in the Swiss Ticino. In its prior incarnation (1904–26), this artists' colony
had been in the forefront of the *Lebensreform* (life reform) movement; it
was a New Age incubator espousing healthy living, anarchism, free love,
vegetarianism, and nudity. In its first incarnation, Ascona attracted art-
ists (Mary Wigman, Isadora Duncan, Paul Klee, Erich Muehsam, and
Hermann Hesse), politicians (Gustav Stresemann), educators (Rudolf
Steiner), academics (Max Weber), an Indian philosopher (Krishnamurti),
and members of the theosophical circle of Madame Helena Blavatsky.

Introduced to the colony by a Russian-Swiss Expressionist painter
and salonist, Baroness Marianne von Werefkin in 1923, the baron is en-
chanted by its beauty and singular location on Monte Verità ("Mountain
of Truth"). There this tireless Maecenas erects a Bauhaus-style hotel in

1928 designed by the German architect Emil Fahrenkamp. In its halcyon days, guests breakfast on champagne, sunbathe, play tennis, and practice Buddhist meditation in his purpose-built successor to the celebrated art colony. An elastic circle of international acquaintances—including Jewish refugees, fervent Nazis, conservatives, and socialists—inhabit his guest cottages.

Eventually, he chooses Ascona, with its palm trees, camellias, mimosas, and magnolias and its breathtaking view of Lago Maggiore, as his primary residence. Here he installs himself, a few steps away from his hotel, in Casa Anatta, furnished with his Chinese, African, and Indian art. In this lush atmosphere he wanders about in shorts, often shirtless and always with an enormous unfurled red solar umbrella, or visits friends, driven by his chauffer in his blue Plymouth. His close friends and clients include Edmund Stinnes and the Thyssen brothers, Fritz and Baron Heinrich, the heirs of another of the Ruhr's great industrial fortunes. Both Thyssens own nearby villas in Ascona and Lugano.

Heydt shrewdly combines friendship with his business interests. In 1925, he acquires from Stinnes the Nordsternbank AG, converting it into the Von der Heydt Bank AG Berlin. But his bank collides with other Berlin banks that have financed the Stinnes Group, and it also makes speculative investments that fail. Now he is rescued by the Thyssen brothers; they take over his bank in 1927, converting it in 1930 into the August Thyssen Bank (Thyba). Von der Heydt remains on the board but he is spending less time on his unsuccessful banking efforts and more time on collecting—both art and celebrities.

During the thirties, Ascona and his new hotel, opened in 1929, continue to attract an exotic mix of European celebrities, among them the Kaiser's fourth son and royal contender, Prince August Wilhelm ("Auwi"); psychiatrist Carl Jung; sexual researcher Magnus Hirschfeld; philosopher Martin Buber; actor Emil Jannings; artists Paul Klee, El Lissitzky, and Hans Arp; the art dealer Alfred Flechtheim; the founding president of Israel, Chaim Weizmann; statesmen Gustav Stresemann and Joseph Wirth, the head of the Reichsbank Hjalmar Schacht; novelists Thomas Mann, Hermann Hesse, and Erich Maria Remarque; musicians Bronislaw Hubermann and Edwin Fischer; and miscellaneous "Russian grand dukes, Parisian cocottes and English Lords."

One clue to the baron's personality is hinted at by Karl With:

His pleasure was to bring together people of most different social, political or cultural viewpoints. A strange mixture of opposites—of prestigious aristocrats

and radicals, of eccentric bohemians and staid conservatives, of revolutionary idealists and shrewd captains of big business. With the pretext of bridging the gaps of inter-human relationships, he gave me the impression that to him it was more like a human circus, private entertainment and amusing to watch. His tragedy was, that with no talent for friendship, no capacity for love, scared of getting emotionally involved, he remained a very lonely man, a spectator, never a dedicated participant.

After the Nazis fired With from his position in 1933, denouncing him as the "pimp of degenerate art," he spent two years in Ascona shortly before the outbreak of war. Von der Heydt tasked him with inventorying and locating his widely dispersed collection, which entailed making trips to relevant European museums. (In some cases, With reports, he found "several hundred pieces of which he had no record at all, or any recollection.")

AFTER HITLER CAME TO POWER in 1933, many collectors were forced to emigrate, notably those who were Jewish, but they could depart with only a limited amount of their assets. In May 1935, the contents of Otto Burchard's former gallery—1,500 Chinese, Japanese, and Indian works—were auctioned in Berlin. According to one attendee, "The prices were especially low for ceramics of the T'ang period and for paintings, Chinese archaic bronzes commanded the highest prices." Von der Heydt purchased five pieces: a bust of a military officer, a wooden standing bodhisattva, two vessels, as well as a kneeling male figure. The first four objects are now in the Rietberg Museum, the kneeling figure was lost during the war. There were no reserve prices and no estimates; all of the art found buyers. When Goering heard of the auction, he forbade further auctions, fearing that valuable artworks could be bought by foreign buyers.

Art collections were fungible, and it was to von der Heydt's advantage to buy art cheap, using currency that couldn't be taken from the country because of rigid exchange rules. Even though his purchases had to remain in Germany, they could be loaned to eager museums with friendly directors. Since he had his initial art collection confiscated by the British during the First World War, to avoid repeating the experience in the event of another war, researchers estimate that by 1938 von der Heydt had more than 2,560 objects disbursed in sixty-nine different institutions in Germany, Switzerland, Holland, England, France, Denmark, Sweden, and Austria. Each institution had to care for, restore, and house his collections, even as their exhibitions and catalogues also increased

the value of his art, a fact not lost on the lender. Moving his residence from Zandvoort to Ascona, he obtained Swiss citizenship in 1937, after having reportedly made large expenditures of money for the protection of his assets. Interested parties hoped that Swiss museums might be the beneficiaries of the heirless collector. When war came, he worried that Mussolini might invade, since Ascona lay perilously near the Italian border. "The main thing," he wrote to his secretary in Zandvoort in April 1940, "is to distribute everything possible at the present time as there is no real security anywhere."

However, his prewar attempts to aggregate his possessions in Switzerland did not always succeed. He had lent many important pieces to Berlin's Völkerkunde (Ethnographic) Museum and now the director general of the Prussian State Museums, Otto Kümmel, the author of the notorious Kümmel Report, a wish list of art in foreign countries to be "repatriated" by the Nazis for their planned museums, and his assistant, a Dr. Reidemeister, refused to return any of von der Heydt's extensive loans, including many prime objects—such as his large stone Chinese sculptures and a fifteenth-century wooden bodhisattva bought from the Burchard sale in 1935. Von der Heydt suspected that the museum no longer saw itself as a custodian of the collection but as its owner. Nevertheless, he was able to move the larger objects in his collection to a forest house in the Uckermark, fifty miles north of Berlin, Görlsdorf, a property belonging to one of his noble friends, Prince Lynar. The smaller objects, including his valuable Ordos bronzes, he entrusted to the specially built vault of the Thyssen Bank, recently renovated with a special room for paintings and art.

VON DER HEYDT'S POLITICS were monarchial and conservative. In 1926, he became a member of the Stahlhelmbund, a right-wing paramilitary organization, and the Herrenklub, Berlin's most elite association of aristocrats, bankers, ministers, and industrialists, founded in 1924. From 1927 onward, he began to circulate in the upper echelons of the Nazi Party, meeting the likes of Field Marshal Hermann Goering and Joseph Goebbels in the fashionable salon of Hitler's great friend Viktoria von Dirksen. This landowner's daughter, the wife of the newly ennobled art collector and diplomat Willibald von Dirksen, was the stepmother of von der Heydt's close friend from his regimental days and fellow Herrenklub member Herbert von Dirksen—best remembered as Germany's last prewar ambassador to the Court of St. James's. In her villa on Berlin's Margaretenstrasse, old-line conservatives like General Paul

von Hindenburg and German royals such as the Kaiser's sons mixed with Center Party leaders like Heinrich Brüning and up-and-coming Nazis including the Führer himself, with whom von der Heydt reported a brief meeting in the Hotel Kaiserhof in 1931.

The Baron joined the NSDAP on April 1, 1933, membership number 1,561,948, shortly after the German elections that brought Hitler to power. Perhaps he was a true believer; more likely it was for opportunistic reasons. There were business concerns: from 1930 until 1937, he was chairman of the supervisory board of the Thyssen Bank, then a member of the same board until 1943. Its owners were his two friends, the Thyssen brothers Fritz and Baron Heinrich Thyssen-Bornemisza. And family motives: he had a brother and mother in Germany. Finally, he had considerable property there, including a villa in the Berlin suburb of Wannsee and his collection, much of it on loan to German museums. Ever cautious, von der Heydt kept his NSDAP membership secret until he lost his wallet on a Swiss lakefront, where it was found by a future curator of Egyptian art at the Brooklyn Museum, Bernard Bothmer, who turned it in to the local police with the baron's party card and his photograph adorned with a Nazi swastika inside.

Upon obtaining Swiss citizenship in 1937, the baron automatically lost his German passport, and his exit from the party followed. His biography becomes even more complicated and interpretations more ambiguous during the period from 1939 to 1943 when on trips to Germany even as a Swiss citizen he appears to have been under considerable pressure from the Nazis. The flight of Fritz Thyssen, an early financial supporter of Hitler, from Germany to Switzerland in 1939; the cancellation of his citizenship and the seizure of his assets; and his brother Heinrich's forfeiture of his German citizenship—he had been adopted by his father-in-law, a Hungarian count, and was reincarnated a Hungarian citizen, Heinrich Baron Thyssen Bornemisza de Kaszón—and von der Heydt's own Swiss citizenship had assuredly put the Thyssen Bank in a precarious position and susceptible to pressure from the Abwehr, the German military intelligence service. In 1939, Eduard first used his Zandvoort bank, then after Holland had been invaded in 1940 by the Wehrmacht, the August Thyssen Bank (Thyba) in Berlin to handle financial transactions for the Abwehr. Von der Heydt laundered gold and made foreign exchange transactions between 1939 and 1943 through the Union Bank in Locarno, money used, according to U.S. government documents, for the financing of the Abwehr's agents in Mexico and the United States. According to the historian and journalist Thomas Buomberger, there

were ninety payments in more than a dozen currencies, totaling nearly one million Swiss francs. These transfers continued until November 22, 1943, when the Berlin bank was destroyed.

By the fall of 1944, the war in Europe was winding down, with Allied troops driving toward the Rhine and Soviet troops heading toward Berlin. Plans were in the offing for the peacetime occupation, postwar war crimes trials, and an operation called SAFEHAVEN, designed to prevent German industries and banks from transferring assets abroad to neutral countries in Europe and the Americas, thus ensuring that these funds would be available for reparation and the rebuilding of Europe. Directives went out to legations in August and September 1944, instructing U.S. embassy officials accordingly. Although it was originally a project of the Foreign Economic Administration (FEA), the State Department, and the Treasury, eventually the OSS Secret Intelligence Branch, responsible for the gathering of intelligence from inside occupied and neutral Europe, and its counterintelligence branch, X-2, also became involved.

Neutral Switzerland had acted as the main clearinghouse in which German gold stolen from occupied countries, or from fleeing Jews, could be converted to foreign currency in order to purchase raw materials to fuel the Nazi war machine. In Bern, the heart of these banking transactions, the station chief of the OSS was Allen Dulles, soon to become the postwar director of the CIA. In April 1945, X-2 provided an extensive summary of wartime gold and currency transiting through Switzerland. Most of the transactions were done through banks, but private individuals smuggled assets through diplomatic pouches and sold art and other valuables.

Thus it was that von der Heydt's gold and currency exchange activities for the Abwehr brought him to the attention of the Americans. Yet in response to an inquiry from Washington, the American ambassador in Bern, Leland Harrison, on November 25, 1944, cabled the State Department that there was "no evidence for [Heydt's alleged] 'pro-Nazi' activities." Dulles had pronounced the baron, whom he had never seen, as a "somewhat harmless busybody who wants to be on the winning side and protect his property interests. I have reasons to know from a reliable source that the Germans do not care for him any more than we do." Although his attitude was "pro-German and monarchist," Heydt claimed to be "anti-Nazi." Cited as evidence were files stating that he also provided intelligence to both the Americans and British in Zurich.

VON DER HEYDT'S POSTWAR NIGHTMARE began in January 1946 against the background of the war crimes tribunal at

Nuremberg. The trials exposed the horrors perpetrated by the National Socialist government: the deportations of Jews and other unwanted persons, extermination camps, gas chambers, confiscation of assets, and so on. On trial were many of von der Heydt's known associates—Hermann Goering, Rudolf Hess, Hjalmar Schacht, and Joachim von Ribbentrop. One of the chief witnesses was Hans Bernd Gisevius, an Abwehr agent working under cover as the vice consul in Bern who had also served as Allen Dulles's contact to the German Resistance.

On March 27, 1946, the Swiss, acceding to American pressure, arrested the baron at Zurich's four-star hotel, the Baur au Lac, where he lived in princely splendor in Room 327, his quarters adorned with choice items from his private art collection. The police inspectors inventoried the room: golf bags, European paintings, and Chinese artworks were all itemized with Swiss precision. After interrogations, collection of evidence from the hotel and the Ascona villa, and twenty-four days in jail, von der Heydt was charged with "conducting or organizing the conduct of military intelligence gathering services on Swiss territory for a foreign state against another foreign state," thus violating the Swiss Neutrality Law. The Swiss wanted answers to a number of questions: What did von der Heydt know about the financial transactions of the Third Reich? How deeply was the baron implicated with the espionage activities of the Nazis? What had really happened to the millions in gold, the Nazi treasure? Was it hidden at Monte Verità, as the Americans suspected?

The trial before a military tribunal began in May 1946. Von der Heydt was questioned about his activities for the Abwehr and his relationship to high-level Nazis. Finally, the Swiss acquitted the baron for want of "subjective culpability," and he was permitted to retain his Swiss nationality. The court believed that when transferring the Abwehr funds, he had not known who the recipients were nor the nature of the payments. Citing lack of evidence, the Swiss court seemed reluctant to convict "a man of von der Heydt's social and financial standing in the international community," and it is credibly suspected that he had made a deal—1,500 objects to be given to found a Zurich museum—apparently in exchange for the museum's opportunistic support during his trial. If he had lost, he would have been stripped of his Swiss citizenship, and Zurich would have lost the centerpiece of its projected museum. (The refugee German art historian Alfred Salmony reported that the Swiss authorities hosted a banquet in Heydt's honor to celebrate the successful conclusion of his trial.)

In 1949, the citizens of Zurich voted in a referendum for the Villa Wesendonck, the former home of Richard Wagner's paramour, Mathilde von Wesendonck, to be turned into a museum to house von der Heydt's non-European collection. In 1952, the year the Rietberg opened, he bequeathed his collection of modern European paintings to Wuppertal's Municipal Museum, renamed the Von der Heydt Museum in 1961 after its two principal patrons, August and his son Eduard. Postwar, the baron, though financially stressed, continued to support the well-regarded journal *Artibus Asiae*. With funds deriving from his American assets frozen in 1941, the journal had been edited in America but printed in Ascona, until the U.S. government abruptly cancelled the arrangement in 1951. Its editor in chief was Alfred Salmony, who loyally described his patron as "the greatest angel in the world to Far Eastern art."

AFTER HIS TRIAL AND GIFT to the Rietberg, von der Heydt began his quest to repatriate his works of art. Some had been destroyed or taken as trophy art by the Soviet occupiers, such as the items left in the vault of the Thyssen Bank in Berlin. His house in Zandvoort, whose furnishings had been given to Dutch museums, was destroyed during the Nazi blitzkrieg in the winter of 1942–43. His parental home in Wuppertal was also destroyed in June 1943 shortly before the death of his mother, along with part of his father's art collection. Three hundred mostly African objects disappeared from the Musée de l'Homme in the 1939 evacuation of Paris, and sixteen of his paintings, discovered by French troops in storage in Koblenz at the end of the war and "recouped," were retained by the Louvre. After the war, the baron successfully sued for the return of his art then held in Denmark.

More difficult was the art marooned in Görlsdorf, in what became East Germany in 1949. Some choice examples from his Asian collection were presented to their Communist allies by the Soviet occupiers as spoils of war. They remained in residence on Berlin's Museum Island. A bizarre sequel followed. In June 1951, Johannes Itten, the painter and Bauhaus color theorist and subsequently the first director of the Rietberg Museum, read in a newspaper that Vladimir Lenin's Zurich landlord, the cobbler Titus Kammerer, had died. He knew that for years the Soviets had tried vainly to persuade Kammerer to sell the contents of the two rooms on the leafy Spiegelgasse once occupied by Lenin and his partner Nadezhda Krupskaya during their exile in 1916–17 before they departed in a sealed train to St. Petersburg's Finland Station to propel the Bolshevik Revolution. The shoemaker had refused all Moscow's offers. However,

Kammerer's son proved more pliant, and Itten was able to acquire Lenin's teacup, then a tea strainer surfaced and finally magically two butter knives, enabling Itten to obtain from the East Germans in exchange for Vladimir Ilyich's "reliquaries" two truckloads carrying twenty-three Chinese sculptures subsequently ferried to the Rietberg's door.

In 1941, von der Heydt had given Chauncey J. Hamlin, the president of the Buffalo Museum and founder of the International Council of Museums, and his friend Alfred Salmony, who was then residing in the United States, permission to draw $6,000 a year from his frozen American bank account for the purchase of art. The Office of Alien Property approved the transactions, and some forty-four works of art—African, and pre-Columbian, as well as Asian—were acquired and sent directly to the Buffalo Museum for safekeeping, without the collector actually taking possession. Described by Salmony as "lending without losing," the loan was acknowledged by the museum as a "permanent loan." Placed on exhibit in Buffalo, there they remained until 1951, when, under Vesting Order number 18344, they were confiscated by the U.S. government under the Trading with the Enemy Act.

Armed with his Swiss acquittal and now seeking the return of his collection, von der Heydt appealed. But this and a further plea for a rehearing were dismissed after the district court in Washington, D.C., found that the plaintiff had willfully refused to produce material documents relating to his financial transactions during the Third Reich. What the government had in evidence was the testimony of the former director of the Thyssen Bank, Heinrich Luebke, recently returned from five years in a Soviet prison camp. In an affidavit executed in Germany in 1950, he claimed that von der Heydt was well informed as to the exact nature of the Abwehr transfers. Luebke stated that he met with von der Heydt in Lugano (in 1939, according to the records) and asked him whether he was prepared to take care of money transfers to foreign countries that he had to execute for the Abwehr, for which the baron would received the usual turnover commission. Luebke claimed that the baron was aware that the "payments were of a confidential nature and that the identity of the party [the Abwehr] giving the order was to remain concealed." The payments, according to Luebke, continued through Thyba until 1943, when the Berlin bank was bombed.

The chief secretary of the bank, Ilse Butry, further stated that these remittances for neutral and enemy countries were handled only by von der Heydt. Thyba remitted the payments in sealed, registered letters containing exclusively Swiss francs or U.S. dollars, and von der Heydt was

instructed to transfer funds to an account in his name in the Union Bank in Locarno to addresses in a neutral or enemy country for agents designated by the German High Command.

Subsequent investigations in FBI and OSS files indicate that the baron also acted for the Gestapo by receiving ransom payments for Jews held in occupied countries, including Romania. A Romanian couple then living in New York asserted that the baron, notwithstanding his denials, had profited from helping Jewish refugees obtain visas. During the last stages of the war, in 1944, Thyssen Bank employees stated that he had received "large amounts of gold" that had been smuggled into Switzerland and buried in the cellar of his house. Heydt's files state that Swiss police searched his hotel in Zurich and found lists of Germans suspected of bringing valuables into Switzerland. After looking at the American files in the National Archives, German historians Dieter Nelles and Stephan Stracke concluded: "Eduard von der Heydt was not a fellow traveler but a supporter of the Nazi system of injustice. He was an early supporter of the Nazi movement, and as the Abwehr 'banker' played a central role for the Germans and had benefited from ransom payments made by persecuted Jews." At this writing, parts of the von der Heydt files at the National Archives still remain closed.

In spite of the efforts of the Zurich city president, the Swiss ambassador, and a further petition to the U.S. Supreme Court to quash the seizure, the Department of Justice under Attorney General Robert Kennedy ruled that the baron had "exhausted all the legal remedies against the forfeiture of his property provided to him by the Trading with the Enemy Act," and asked the Smithsonian experts to appraise the collection for auction. But, citing the high quality of the objects, the appraisers decided they wanted to keep them, and in 1966 Congress enacted legislation authorizing the legal transfer of the collection to the Smithsonian Museum of Natural History. According to the bill, "the Smithsonian Institution shall have complete discretion to retain, exchange, sell, or otherwise dispose of the objects." All told, forty-four confiscated works of art. Then, in 1973, the thirteen Asian works—were transferred to the Freer Gallery. One of them, the fragment of the sandstone standing bodhisattva, was duly accessioned to its permanent collection in 1978.

VON DER HEYDT WAS NEVER reconciled to his loss, maintaining until the end that he was a victim of slander and intrigue by German spies and that the August Thyssen Bank, since it was owned by a Hungarian citizen, Heinrich Thyssen-Bornemisza, living in Switzerland,

was never a German bank. To the end, this "Buddha with the eyes of a fox" remained inscrutable. He continued to support art and to receive kudos: an honorary doctorate from the University of Zurich, honorary citizenship from Wuppertal, the Grand Cross of the Order of Merit from Germany. In 1998, long after Heydt's death, the director of the Rietberg Museum, Albert Lutz, wrote to the director of the Freer Gallery, Milo Beach, requesting a long-term loan of the thirteen items, but was told that the Freer "prohibit[s] the lending or deaccessioning works in its collection."

Since the misdeeds of the Swiss banks were brought to light in the 1990s, triggering the adoption of the Washington Conference Principles on Nazi-confiscated Art (1998), a number of articles and books have appeared in German on von der Heydt and the war years. Not all the facts agree, certainly not all the interpretations. Eduard von der Heydt has his defenders in Switzerland and Wuppertal.

The 2007 inquiry by Michael Knieriem, the director of Wuppertal's History Center (Historisches Zentrum), into von der Heydt's past resulted in a verdict summed up at a public discussion. Knierem found that Wuppertal's honorary citizen was not a perpetrator, he was not an anti-Semite, nor did he buy looted art. Knieriem and his colleagues present on a panel drew a portrait of a lonely, angst-ridden man of the world, a failed banker whose love of art had been an obsession. This haunted, driven man feared becoming stateless, losing his fortune and his art. He was trying to protect himself from all sides using politicians of all colors in an effort to secure his existence. As Knieriem summed up, "He was a liberal conservative representative of the haute bourgeoisie. His views were not consistent with those of the Nazis." Nevertheless the next year in 2008, owing to the efforts of other local historians opposed to this perceived whitewash, his name was dropped from the city's cultural prize.

His Ascona hotel, Monte Verità, which he bequeathed to the Swiss Canton of Ticino in 1956, has become the ETH Zurich Conference Center, a private facility hosting seminars and meetings. In a final twist, according to Dr. Greg Bradsher, director of the Holocaust-Era Assets Records Project at the National Archives, in 1997 the baron's Ascona hotel hosted an international conference attended by historians and archivists. The subject: Nazi gold and Swiss banks.

THE FREER HAS MADE serious attempts at provenance research for items acquired during the period of the Third Reich. One such item is the *gui,* purchased in 1938 from C. T. Loo, who claimed to have found it

in China. But recent research has shown that it was acquired in the 1935 auction of the items from the Burchard Gallery, the same forced sale from which von der Heydt purchased five items. In 2000, the Freer Gallery received a claim from the heirs of Jakob and Rosa Oppenheimer, who had purchased the gallery from Burchard before he settled in Peking. They fled to France in 1933; Jakob died in exile in 1941, and Rosa was transported first to Drancy and then to Auschwitz, where she was murdered in 1943. Provenance research at the Smithsonian supported their claim and the heirs received compensation. The vessel remains in Washington.

For the Rietberg, the Freer lots remain the last prisoners of war. For their part, provenance research showed that four items donated to the Reitberg by von der Heydt were found to have been bought in the same 1935 sale of the Burchard collection. The Oppenheimer heirs were contacted and paid the current market value for four Chinese pieces. As the historian Ester Tisa Francini, employed by the Reitberg as a provenance researcher, stated in an interview with the *Neue Zürcher Zeitung:* "Museums are a bit like diamonds and today they must be as it were flawless."

CHAPTER NINETEEN

GOING FOR THE GOLD

I f the great China collectors of times past congregated (where else?) at the legendary Long Bar in Shanghai's British Club (now a hostel for sailors), one member would surely stand out: Avery Brundage. He was a muscular six-footer with an icebreaker visage who for decades dominated the International Olympics Committeee (IOC), and his breeding did not conform with the likely art-buying template. Brundage grew up in Chicago when its stockyards and politics were pitilessly chronicled in muckraking novels and criminal statistics. He flourished in the Windy City's rough-and-tumble building trade before vaulting to global eminence during the Olympic movement's most tumultuous decades. Yet throughout, Avery Brundage was drawn to the timeless serenity of Chinese art.

Indeed, even Brundage had trouble defining himself. "I'm a strange sort of beast," he informed Robert Shaplen, who profiled him in *The New Yorker* in 1960. "I've been called isolationist, an imperialist, a Nazi, and a Communist. I think of myself as a Taoist. Actually, I'm a hundred-and-ten-percent American and an old fashioned Republican. People like me haven't had anybody to vote for since Hoover and Coolidge." Still, it seems fair to add that during his tenure as IOC president (1952–72), Brundage consistently seemed to believe that the end (i.e., "Let the Games go on") justified getting along with Hitler, Mao, and Stalin, to the extent of praising their respective regimes' generous support for athletics; and with much-criticized detemination, he ruled that the 1972 Munich Games should continue as usual after terrrorists

Avery Brundage appraises an ancient Chinese mirror in his extensive collection, gathered between his Olympic duties. "It's not a hobby, it's a disease," he once remarked. © Asian Art Museum of San Francisco.

massacred eleven Israeli athletes. He was not a person easy to imagine, or invent.

Born in Detroit, young Avery was six when his father, a mason and builder, moved with his wife and two sons to Chicago, where Charles Brundage joined in the frantic drive to complete the monumental structures for the Columbian Exposition in 1892–93. Son Avery thereafter fondly recalled the Exposition's "splashing fountains" and "handsome buildings," though his subsequent early years were darkened by his father's abandonment of his family. Minnie and her two sons survived in a minimalist South Side flat. She worked as a store clerk in the Loop, and Avery

delivered newspapers while attending the local manual training high school. There he excelled in both his studies and on the track team, as he likewise did upon entering the University of Illinois in 1905, where he also earned extra money as a railway track surveyor in the Chicago area.

In 1909, the same year that he became the Big Ten discus champion, Brundage graduated with a degree in civil engineering. He was promptly hired as a building inspector and construction superintendent by Holabird & Roche, a leading architectural firm. As detailed by Maynard Brichford for the Illinois State Historical Society, the freshly graduated Brundage supervised $7.5 million in construction work, roughly 3 percent of all new building in the city. We may assume that he also acquired a postgraduate degree in Chicago's intricate mesh of zoning, building codes, ethnic politics, and pervasive graft.

During these formative years, Brundage intensified his schoolboy devotion to track-and-field athletics. He resigned his job to compete in the 1912 Stockholm Olympics, in every sense his revelatory moment. While he won no medals in the decathlon contests at the Games, every two years from 1914 until 1918, he earned and held his title as America's "all-around" champion in ten track-and-field events. His face and name adorned sports pages and magazines, which proved an asset as he clawed his way through Chicagoland's entrepreneurial jungle. "Avery Brundage was big, strong, agile and fast," in Brichford's summary of these early years: "Brundage capitalized on his fame as an athlete, but his intelligence and competitive drive carried him far beyond his career as a track man."

He was only twenty-six in 1915 when he founded the Avery Brundage Company. After America entered the World War two years later, Brundage applied unsuccessfully for a commission in the Ordnance Corps, then joined with other firms to speed-build military facilities. Ahead lay the Windy City's phenomenal postwar boom, propelled by Prohibition (a windfall for organized crime), Great Lakes shipping, strategic rivers and waterways, a network of transcontinental rail lines, plus surging grain markets, new factories, expanding stockyards, jazz clubs and strip joints, a flood of migrants, outstanding universities (Chicago and Northwestern), and a pride of prominent writers and poets (e.g., Hemingway, Sandburg, Lardner, Hecht, Monroe) all chronicled by "The World's Greatest Newspaper," as *The Chicago Tribune* modestly described itself. "There is in America an incredible city named Chicago," wrote a discerning British visitor, Rebecca West, in her 1926 preface to Carl Sandburg's poetry, "a rain-colored city of topless marble towers that stand among waste-plots

knee-high with tawny grasses beside a lake that has grey waves like the sea. It has a shopping and office district that for miles around is a darkness laid on the eyes, so high are the buildings, so cluttered up are the narrow streets with a gauntly striding elevator, and a stockyard district that for miles around is a stench in the nostrils."

Chicago's all-round Olympic star, as rendered in 1916 in The New York World's *Sunday magazine.*

Avery Brundage contributed substantially to Chicago's thrusting skyline during this unparalleled building boom. From 1923 to 1928, new construction in Chicago exceeded $250 million each year, peaking at $366 million in 1926. Brundage's company initially concentrated on apartment buildings, many of them gleaming on the North Shore Drive's "Gold Coast." Next came a dozen substantial office buildings, followed by a cluster of hotels, including the Shoreland on Hyde Park's South Side Drive (the city's premier address for pols, mobsters, and visiting celebrities), along with banks, country clubs, and the Baha'i House of Worship in Wilmette, Illinois. His most ambitious industrial project was the Ford Motor Company assembly plant, which spread over sixteen acres under a single roof, its completion requiring 150,000 sacks of cement. The plant initially mass-produced Model Ts, then switched to Ford's other brands, turning out 154,244 vehicles in 1950.

Inescapably, as the bubble burst and Wall Street plunged, so did Brundage's commissions, which all but vanished during the Great Depression. Yet he navigated skillfully through hazardous straits. He founded the Roanoke Real Estate Company in 1932, through which he acquired ownership interest in buildings he had constructed in lieu of payments due him. In Brundage's words, "you didn't have to be a wizard" to "buy stocks and bonds in depressed corporations for a few cents on the dollar—and then wait. I was just a little lucky." Not just luck. In a conversation years later with René-Yvon Lefebvre d'Argencé, the longtime keeper of his art collections, he described meeting a close colleague in Chicago in the depth of the Depression. The two friends started counting the number of people they knew who had recently committed suicide: "It added up to fifty." (He earlier told the same story to Shaplen, but his total then was forty, and he added, "It is interesting to note that not one of them had any sports experience.")

Like many struggling entrepreneurs in the New Deal era, Avery Brundage did not approve of WPA projects and Social Security, which he feared were plunging the country into socialism. On foreign policy, Brundage generally concurred with Colonel Robert McCormick, publisher of *The Tribune,* whose weekly radio broadcasts excoriated liberalism in all its guises. Like the colonel, Brundage was a fervent isolationist and a prominent member of the America First Committee. In August 1940, as cochairman of Chicago's Keep America Out of War Committee, he invited Charles Lindbergh to address fifty thousand like-minded believers in Soldier Field. (The day after Pearl Harbor, both committees dissolved.) So ardent was Brundage's antiwar passion that he unwisely

accepted an invitation to address a German Day rally at Madison Square Garden in New York, sponsored by the pro-Nazi German-American Bund, which he had not previously heard of. He elicited roars of approval when he declared, "[W]e in America can learn much by observing and studying what has happened in Germany," prudently amplifying, "if we are to preserve our freedom and our independence, we, too, must take steps to arrest the decline in patriotism."

THESE AND OTHER REMARKS dogged Avery Brundage during and after his controversial tenure as president of the International Olympics Committee. Yet in our view, his tense and fractious Chicago years are essential to understanding his subsequent career as an Olympian and art collector. Affronted by the sleazy underside of politics Chicago-style, he idealized the playing field as a sanitized arena where strength of character and obedience to rules encouraged a free and fair contest among honorable competitors. He shared the hope that—as in classical times—an Olympic peace might prevail during the modern Games, which seemed to be the case following their resurrection in Athens in 1896. Yet from the first, there were also nettlesome arguments among participants, especially from rival major powers over flags, facilities, gear, rules, emoluments, sideshow features, and the proper role of women and ethnic minorities. For example, at the St. Louis Olympiad in 1904, the American hosts sought to illustrate the contrast between modern-day Greeks and barbarians by staging "native games" during two "Anthropology Days." The "anthropology" competitors were Asians, Africans, and American Indians, all garbed in stereotypical costumes, thereby implying the subordinate role of lesser breeds; the "natives" competed for petty cash, it being assumed they could not grasp the Olympian ideals. Among those dismayed by this patronizing spectacle was France's Baron Pierre de Coubertin, the chief inspirer of the modern Games, who later commented, "In no place but America would one have dared to place such events on a program." Nonetheless, the Olympic mystique proved contagious, and participating in the Games soon became a popular and accepted extension of foreign policy by other means.

Such was the context as Avery Brundage ascended the Olympian heights. Having been elected president of the American Olympic Committee in 1928, Brundage then became the U.S. representative on the International Olympic Committee in 1936. One of his first missions was to sound out Germany's recently empowered Nazi leaders, who were scheduled to host the Summer Games in Berlin, a venue chosen five years

earlier when the country was still a democracy. Would the virulently anti-Semitic regime let qualified Jewish athletes join the German team? A good deal of head-scratching, mumbling, and double-talk followed, but Hitler's spokesmen said they would abide by Olympic rules, as Brundage affirmatively assured the IOC.

By this time, opinion in the United States was closely divided between boycott-the-Nazis advocates and play-the-Games enthusiasts. Complicating the argument over racism was the embarrassing fact that nonwhite athletes (like the legendary Jesse Owens) were barred by Jim Crow codes from competing in mixed trials with whites (in the South) or from staying in the same hotels as white contenders (in the North as well as South). In Washington, President Franklin Roosevelt chose to remain silent, and when the American boycott movement lost traction, so did its counterparts in Britain and France.

Did the democratic world miss a real chance to slow or even derail the German juggernaut? In *Nazi Games: The Olympics of 1936* (2007), the American historian David Clay Lodge, after combing relevant archives, offers this measured judgment:

> We should remember that in 1933–36, the Nazi dictatorship was still a work in progress. . . . In the last parliamentary elections that Hitler allowed, those of March 5, 1933, the Nazis, even with all the intimidation they imposed on voters, had not managed an absolute majority, winning 43.9 percent of the total Reich-wide, and in Berlin only 34.6 percent. The effects of the Great Depression were still very much evident, with unemployment running high. . . . The Olympic Games were important to the Nazis because by hosting a successful festival the Reich could come across as a peaceful nation that was making economic progress at home and winning respect abroad. By deciding to show up in Berlin despite reservations about Hitler's policies, the world's democracies missed a valuable opportunity to undermine the regime's stature not only in the eyes of the world, but also—and ultimately more important—in the eyes of the Germans themselves.

As the storm over the Berlin Games gathered, Brundage commuted frequently to Europe on Olympic business. In early 1936, while stopping in London, he happened to visit Burlington House to inspect what was commonly described as the most comprehensive exhibition of Chinese art yet assembled in the West. He studied the jades, bronzes, ceramics, and painting, including 735 works from the Imperial Collection in the National Palace Museum. "Awed by the splendor of it all and noticing the

availability of Chinese works of art on the market, he began to conceive the grandiose project of amassing a collection of Asian art that would surpass any other private collection." So writes Lefebvre d'Argencé, who adds that Brundage's purchases were initially few and cautious, but gathered momentum during his 1939 trip around the world with his wife, Elizabeth. Their itinerary included Japan, Shanghai, Hong Kong, Saigon, Angkor, Bangkok, Penang, and Colombo. By then, Brundage had retired from active management of his firm, and the childless couple resettled in a spacious suite in the LaSalle Hotel (which he now owned) and acquired as a vacation home La Piñeta, a stylish Spanish mansion in Santa Barbara, California.

All the while he kept buying Asian art. "One of the first of a series of great coups for which he became famous," writes Lefebvre d'Argencé, "was the formation of an unparalleled collection of ancient Chinese bronzes, which particularly appealed to him through their architectonic robustness, intricate delicacy of design and superior craftsmanship." This surely sounds right, but there was another attraction that also seems credible. In filling his homes with Chinese art, Brundage was entering a realm very unlike his own. Here was a tradition and an aesthetic very unlike his everyday world. Here was a magic landscape populated by sage and calm scholars and their deferential female consorts garbed in silk robes, with badges indicating their rank, and here was a social order where rules were sacrosanct, down to the precise form of greeting suitable to each rank.

This is a surmise. Brundage himself did not venture beyond common clichés in explaining his devotion to Oriental art. "It's not a hobby, it's a disease," he liked to say to friends. "I've been broke ever since I purchased my first object." Well, to vary Evelyn Waugh's useful demurrer, "up to a point, Lord Copper." Brundage quickly became known for his ability to judge Asian art, and for his rule: "Top quality, low price." It was also understood that he could return any object if he changed his mind about its merit. Wherever he went on Olympic business, he cultivated scholars and dealers. His official position was anything but a disadvantage. Abroad, he would seek advice on where bargains might be obtained from his host officials, and they in turn would invariably be anxious to please the IOC president—often presenting, in Godfather fashion, "an offer he couldn't refuse."

Brundage was hardly unaware but never acknowledged the confusion that his dual role might cause. Writing in 1960, Robert Shaplen described a typical instance: "Two years ago, when he went to Japan for an IOC meeting, he was able, he feels, to achieve the perfect synthesis of

sports and art that to him represents the true Olympic spirit. He arranged in advance to be met at the airport by four Japanese, two of them Olympic officials and two leading Oriental art experts, and during the next two days he escorted the sportsmen to museums they had never seen and the arts specialists to sports they had never seen. 'It was great fun,' says Brundage, 'and when I saw the Emperor afterward and told him what a service I had done for Japan, he agreed.'"

Abroad or at home, his key purchases required extensive vetting by museum curators, provided gratis or on the cheap in hopes of future institutional rewards. His ample homes were crammed with his prizes; visitors remarked on bathtubs filled with netsuke, while a famous Shang dynasty rhinoceros (later the logo for his collection) was packed in a shoebox. As his trove grew in size and variety in the late 1940s, the staff and director of the Art Institute of Chicago began to wonder what the childless Brundage planned to do with his treasures. "I got Brundage on the board," recalled Daniel Catton Rich, then the institute's director. "His collection paralleled many of the things we already had, and I went to Brundage and asked him for part of it. But he wanted a separate series of galleries. We kept the idea in mind, but meanwhile, San Francisco came along, and I advised Brundage to put his collection on the West Coast— to the great annoyance, I may say, of Charles Keeley, one of our curators, who had been advising Brundage on acquisitions."

These initial soundings were owed in part to an initiative taken by the University of California (Berkeley) art historian Katherine Caldwell, a graduate of Paul J. Sachs's museum course at Harvard. She saw in the Brundage collection an opportunity to fill an embarrassing gap in the city's museum constellation. Despite its large Chinese and Japanese communities, and despite San Francisco's reputation as the "Gateway to the Orient," there was no local museum collection of Asian art of any consequence. Pragmatically, Caldwell realized that City Hall would become interested only if it were approached by a group of socially active and prominent Bay Area residents. She organized just such a group to meet with George Christopher, the liberal Republican who was then mayor of San Francisco.

Duly impressed by the high-powered appeal, Christopher arranged for Brundage to be named an honorary citizen of San Francisco. Next, accompanied by Gwin Follis, board chairman of Standard Oil of California (and likewise a collector of Asian art), Mayor Christopher arrived by private aircraft, with suitable brio, at Brundage's winter retreat in Santa Barbara, a touch the mayor felt would lend the required drama to the

occasion. At dinner, however, Brundage talked about everything except art. Finally, over coffee, Christopher blurted out the purpose of his visit (as the former mayor recalled in a 1975 interview): "Mr. Brundage, Chicago is a great city, Mayor Daley is a great friend of mine, but your collection is too important to go to an already-constructed museum. San Francisco is the Gateway to the Orient, it has large Oriental communities, but we don't have any Oriental art to speak of. I want you to give this collection to us, and to see to it that it is displayed in the way you think best."

Brundage then agreed to donate his collection to a purpose-designed annex to the M. H. de Young Memorial Museum in Golden Gate Park. All costs were to be borne by the city. In due course, the City Council approved a bond issue for $2,725,000, which was submitted to a referendum in June 1960. To promote a "yes" vote, advocates of the museum, Gwin Follis among them, engaged the day's most sought-after political publicists, Whitaker & Baxter. The firm came up with a film presentation, which ended with a flourish: "It is our great good fortune that this wonderful gift—one of the great gifts of all time—is *ours* for the voting!"

Not yet, not quite. The bond issue was approved by a substantial majority, and two days later Brundage initialed the preliminary plans for the new gallery. But after the wing was formally opened in 1966, it became public knowledge that according to the contract signed in 1959, half the collection remained the property of Brundage or the Avery Brundage Foundation. This was partly attributable to tax laws; since the allowable contribution for works of art could not by law exceed 30 percent of the donor's annual income, there were palpable benefits in stretching a gift over a twenty-five-year period. This meant that Brundage could at any time legally withdraw half of his collection, a matter further complicated by the fact there was no agreed inventory of objects added to the collection since 1959.

Hence, until the gift was final, Brundage could withdraw the better half of his collection, a threat he now employed. Still, he could not be wholly blamed for taking advantage of a developing muddle. Brundage insisted that it was he, not the city, who was paying the salary of his handpicked director, Lefebvre d'Argencé. Going further, Brundage contended that his collection should be under the control of a separate board of trustees. He also complained about the lack of adequate humidity controls in his named galleries. He had other grievances as well. During one of his Olympic visits to the Far East, he arranged for art from Japan, South Korea, and Taiwan to be sent to San Francisco; however, he

did not make prior arrangements for the city to pay the transportation costs. When San Francisco refused to pay the shipping bills, amounting to about $60,000, he had the artworks returned unopened to their countries of origin.

George Christopher's successor as mayor was the colorless John F. Shelley, who flew in vain to Chicago in 1967 to appease Brundage. Later that year, a more charismatic mayor, Joseph L. Alioto, was elected. Having received a telegram from Brundage stating that he intended to move half of his collection to Los Angeles, Chicago, or Kansas City, the flustered mayor-elect took the next plane to Chicago. On entering the collector's suite at the LaSalle Hotel, the mayor immediately noticed a framed certificate designating Brundage an honorary citizen of Los Angeles. "All right," Alioto recalled saying, "I've seen the certificate. You can take it down now." Yet despite this bold opening, he then yielded to the donor's demands. He agreed to form a separate twenty-seven-member board to administer the Brundage Collection as an autonomous entity within the de Young Museum; he also accepted responsibility for raising an additional $1.5 million, three-fourths of which would be borne by the City of San Francisco, for the enlargement of the collection.

These were better terms than Brundage could have expected elsewhere. His threats to uproot were mainly bluff, as Alioto might have discovered had he contacted museums in Chicago, Kansas City, or Los Angeles. In political terms, it was not Alioto who entered into the original agreement with Brundage; he could blame his predecessors for the one-sided deal. Still, this was alien terrain for big-city politicians, and in conceding so much, he ensured San Francisco's title to the entire collection. Nor can the civic-minded intentions of Christopher and Alioto be faulted; the city's voters were given a chance to approve or reject the bond issue for the museum. It was the failure of city officials to read the fine print that gave a collector renowned for his bullying tactics the legal right to dismember his gift unless he was given his way on every point.

OVER TIME, the Brundage Collection was embedded in layers of later donations in what was renamed the Asian Art Museum, which was detached from the M. H. de Young Memorial Museum in Golden Gate Park and moved to a grander new site, facing City Hall. Its new home in the Civic Center is an elegant Renaissance Revival–style building formerly used by the central branch of the city's public library. In any case, the Bay Area is no longer bereft of Chinese art, and its Asian Art Museum and its associated Chong-Moon Lee Center for Asian Art are now prestigious

global destinations for scholars and enthusiasts. Brundage's six thousand objects proved to be a magnet for another fifteen thousand works.

Appropriately, the highlight of the Brundage trove is a unique and engaging bronze vessel in the shape of a rhinoceros, dating to the Late Shang era in the early eleventh century BCE. It rises nine inches on odd-numbered toes, its hide puckered, its ears erect, and its tail stubby. According to Jay Xu, the director of the Asian Art Museum, circumstantial evidence strongly suggests that Brundage bought the endearing beast in New York from the Shanghai-based dealer J. T. Tai in 1952 for $20,000 (see color plates, figure 10). "That rhino vessel cost me the equivalent of buying five Cadillacs," he was said to have confided. (In fact, as Xu found, the most expensive Cadillac in the early 1950s was the Eldorado, whose price was $7,750, so "three" seems nearer to the truth.)

Yet in every sense it is fitting that this tough-skinned beast known for its strength and nowadays almost extinct in China should be the emblematic prize of the Brundage Collection. Tests confirm its authenticity, and its inscription, comprising twenty-seven characters, is in quintessential imperial jargon: "On the day *dingsi* [the fifty-fourth day of the sixty-day cycle], the King inspected the Kui temple. The King bestowed upon Xiaochen Yu [an official title] cowry shells from Kui. It was the time when the King returned from Renfang [an enemy of the dynasty]. It was the King's fifteenth sacrificial cycle, a day in the *rong*-ritual cycle."

In another very different sense, the bronze rhinoceros resonated with its purchaser. Brundage saw himself as belonging to an imperiled breed. "When I'm gone," he once remarked, "there's nobody rich enough, thick-skinned enough and smart enough to take my place, and the Games will be in tremendous trouble." Moreover, the beast's horn is widely believed to be an aphrodisiac, which helps explain why it has been hunted to near extinction in China. Perhaps ironically appropriate for a serial womanizer who presided over a global harem, as revealed in 1980 (five years after his death) in an article in *Sports Illustrated* by William Oscar Johnson and a team of researchers in California, Chicago, Geneva, Munich, and Moscow.

"Avery Brundage: The Man Behind the Mask" begins in August 1952 at a lavish banquet in Lausanne, Switzerland, celebrating Brundage's inauguration as president of the International Olympics Committee, over which he then reigned for two decades. On this occasion, Brundage offered an admonition consistent with the dinner's Calvinist locale: "We live in a world that is sick, socially, politically and economically. It is sick for only one reason—lack of fair play and good sportsmanship in human relations.

We must keep the Olympic movement on Olympic heights of idealism, for it will surely die if it is permitted to descend to more sordid levels."

The new Olympic president was roundly applauded as he sat down beside his wife, the former Elizabeth Dunlap, the daughter of a Chicago banker, whom he married in 1927. But just five days after this inaugural dinner, his Finnish mistress, Lilian Dresden, age thirty-three, gave birth to their acknowledged son, Gary Toro Dresden, though his paternity was withheld on the birth certificate. This was also the case a year earlier, when their first son, Avery Gregory Dresden, was also born in San Mateo, California. "The fact that Brundage had fathered two sons out of wedlock was only one of a number of startling aspects of his long and remarkable life," the *Sports Illustrated* article went on. "The sons were not the rare children of rare indiscretions; Brundage, it turned out, was a philanderer of enormous appetite."

MUCH OF THIS WAS KNOWN to his close associates and possibly to the press, but in that era the private lives of politicians and sportsmen were protected by a code of silence so long as appearances were preserved and nothing indiscreet was blurted by the parties involved. What did make news was his remarriage following the death in 1971 of his long-ailing wife, Elizabeth. A year later, his term as Olympic president had expired, and his years of princely travel and sybaritic emoluments were over. "He had a holy fear of being alone then," according to his financial advisor and confidant, Frederick J. Ruegsegger. Brundage found a new companion, a descendant of German royalty, Mariann Charlotte Katherina Stefanie von Reuss, a lissome blonde whom he had befriended during the Munich Games. In the summer of 1973, Brundage married Princess Reuss; he was eighty-five, she was thirty-six, and a prenuptial agreement specified the obligations and benefits due to each. The newlyweds gravitated between Europe and America, they danced and quarreled, voyaged to the Far East, and settled in Garmisch-Partenkirchen, the twinned Bavarian resort town where the 1936 Winter Olympics were held. It was here that Brundage, already suffering from cataracts, was hospitalized for influenza and died when his heart failed on May 8, 1975. His body was flown to Chicago for burial, and his will bequeathed $6,000 a month each to Princess Reuss and to Ruegsegger, plus $100,000 to the Art Institute of Chicago. His artworks, valued at $1.5 million, were left to San Francisco. Only after his two acknowledged natural sons took legal action did they receive $62,000 in an out-of-court settlement with confidentiality clauses. Nothing was provided for their mother.

So how can one sum up so contradictory a life? Through wit and wile, Avery Brundage proved a true professional in exploiting his amateur reputation on what was verily a field of dreams, to the eventual benefit of the Asian Art Museum of San Francisco. As to the merits of his collection, a judicious and carefully calibrated assessment was provided by the seasoned scholar Laurence Sickman, who had once been asked to be its curator. This was his evaluation: "The collections of ancient bronzes, ceramics and jades are of the very highest order. . . . Due to an unusual set of circumstances, bronze sacrificial vessels and other objects of the archaic period were on the market in considerable quantities in the 1930's and early 1940's. These conditions made it possible to assemble a collection of such magnitude." Indeed.

CHAPTER TWENTY

THE GRAND
ACQUISITOR

Ants and birds do it. So do dogs, various rodents, some species of crabs, and so does *homo sapiens*. What all these creatures share is an impulse to gather and put aside material things that are not essential to their survival. Studies have confirmed that among humans this impulse may be hereditary and that a child often exhibits the instinctive actions of a collector from its earliest years. "It clings to bits of material, dolls and lead soldiers," writes Maurice Rheims, once a leading French auctioneer but also an art theorist, "objects are its playthings, offering security as the only tangible matter in its universe." As a child's taste develops, he goes on, "so does its spirit of competition as it learns to discern the quality of material objects. This growing aptitude is the child's first occasion of measuring up to adults." The collecting instinct can also nurture rebellious rejection, sibling acrimony, and scarring memories that endure for a lifetime (as in the loss of a childhood sled called "Rosebud" in Orson Welles's *Citizen Kane,* a film inspired by the career of William Randolph Hearst, himself an insatiable collector).

Strangely, or maybe not so strangely, the deeper roots of the collecting instinct and its obsessive manifestations still elude comprehensive analysis and explanation. Sigmund Freud, a collector of antiquities, traced the compulsion to unresolved conflicts related to toilet training; his colleague/rival Carl Gustav Jung stressed its link to the collective unconscious. Hence it is the more regrettable that Dr. Arthur M. Sackler, whose collecting career we now examine, did not reflect analytically on

Arthur M. Sackler, psychiatrist and pharmaceutical millionaire, who preferred buying in bulk, here puts his best pieces forward.

the sources of his own collecting instinct. Not only was he a psychiatrist himself, but so were his brothers Mortimer and Raymond. Moreover, in foraging for Chinese art treasures, Arthur Sackler teamed up with Dr. Paul Singer, a Hungarian-born, Vienna-bred psychiatrist, and also a self-taught connoisseur of Oriental art. The Sackler and Singer collections today form the core of the Arthur M. Sackler Gallery, which is twinned with the Freer Gallery of Art on the National Mall in Washington—a conspicuous tribute to two licensed explorers of the subconscious.

Indeed, Dr. Sackler's career established an important subsidiary variant to the collecting instinct. Not only can the proud possessor gain personal satisfaction in perusing and displaying his precious hoard, but its existence can serve as leverage for obtaining cost-saving storage arrangements—and through the contacts it encourages, lead to brokering

retroactive tax deductions in deals with major museums. Finally and not least, through dexterous financial donations to universities and libraries, as well as museums, the collector can give his family name global resonance.

All this Dr. Sackler achieved; he himself is immortalized on the National Mall, while there is also (among others) the Arthur M. Sackler Museum of Art at Harvard's Fogg Museum; the Princeton Art Museum Sackler Gallery of Asian Art; the Sackler School of Medicine in Tel Aviv; the Arthur M. Sackler Museum of Art and Archaeology at Beijing University; the Arthur M. Sackler Science Center at Clark University in Worcester, Massachusetts; and, at the Metropolitan Museum, not just the Sackler Gallery of Asian Art but also a supersize Sackler Wing enclosing the Egyptian Temple of Dendur, with its adjoining pool, which he and his two brothers helped underwrite.

Still, Arthur M. Sackler was more than a vanity-obsessed self-promoter. Granted, as a collector of artworks, his enthusiasm exceeded his discernment. Princeton's Wen Fong, while serving as a consultant to the Metropolitan Museum, expressed a common complaint in a 1966 letter to Berkeley's James Cahill. He termed Sackler difficult to manage and excessively ambitious, adding that he failed to spend sufficient time on research. Yet Sackler himself was aware of his deficiencies, which is why he preferred to buy in bulk. "I collect as a biologist," he once explained. "To really understand a civilization, a society, you must have a large enough corpus of data. You can't know twentieth-century art by looking only at Picassos and Henry Moores."

Creditably, Sackler acknowledged the superior learning of other collectors, to the extent of generously subsidizing the purchases of Dr. Paul Singer, whom he first met at an auction in 1957. His fellow psychiatrist was a micro rather than a macro buyer, a self-taught connoisseur who targeted smaller, eccentric objects passed over by others, which he then squirreled away in his cramped two-bedroom apartment in Summit, New Jersey. Sackler conditioned his subsidy on the understanding that the Singer trove would end up in a Sackler-named institution. And following Singer's death in 1997, more than six thousand objects valued at $60 million did pass to the Sackler Gallery, more than doubling the size of its then-existing collection. Much of the added hoard consisted of archaeological objects whose interest and rarity were confirmed after careful scrutiny, sustaining their donor's judgment. Why did Singer collect? "When I see something I like, I feel a visceral excitement," he explained to Lee Rosenbaum, author of *The Complete Guide to Collecting Art*. In fact,

Dr. Paul Singer in his object-crammed New Jersey apartment. As Sackler's collecting partner, he donated more than 6,000 pieces to the Sackler Gallery.

Dr. Singer, speaking as a psychiatrist, confided to her that collecting is "a highly erotic act, totally akin to lovemaking. . . . Any dealer worth his salt knows there should be no interruption while a collector looks at an object: it is a moment of great intimacy."

Besides securing the Singer bequest, Arthur M. Sackler's other less-than-obvious merit lay in the subsidiary benefits of his own gift. For decades, as James Cahill sharply remarked, "Sackler was famous for dangling his holdings and his money in the faces of great institutions, then shifting his benevolence elsewhere. For some time, there was a 'Sackler Enclave' within the storage space of the Far East Department at the Met[ropolitan], presided over by his [Sackler's] curator; even Met curators needed her permission to get in—a situation unheard of in the history of great museums. The Met ended up with nothing."

Two comments seem relevant. First, the Metropolitan Museum of Art has no shortage of works suitable for its showcases. Second, and more consequential, since its opening in 1923 as the first federally funded fine arts museum, the Freer Gallery of Art was hamstrung by its donor's severe conditions: it could neither lend nor borrow. In effect, like Miss Havisham's mansion in *Great Expectations,* the Freer was frozen in time. "Had not a second crucial donation been made by Arthur Sackler," commented the canny reporter Souren Melikian, "leading to the opening of

the Sackler Gallery on the same patch along the National Mall—underground, to respect building restrictions—the Freer would have remained a static academic establishment." Instead, in December 2002, a gala celebration in Washington marked the twenty-fifth anniversary of the Sackler, presided over by the donor's British-born widow, Dame Jillian Sackler. Its director, Julian Raby, had this to say about the unusual institutional marriage: "You have two very different buildings with very different characters. One is almost a temple of calm: the Sackler needs to be much more lively, innovative, risky. What I want is a contrast, as opposed to some undifferentiated style." One million dollars was raised at the gala, and the twinned museums may yet become, in Melikian's phrase, "the Western world's capital of Asian art integrated into [a] living culture."

ALL OF WHICH LEADS to three unaddressed questions: How did Dr. Arthur M. Sackler acquire the wealth essential to accumulating his collection? Why did he turn to the elusive arts of China, and for what purpose? And are American taxpayers getting fair value from federal support of the Arthur M. Sackler Gallery of Art?

As to the first question, Arthur Sackler, like his younger brothers Mortimer and Raymond, benefited generously from, and contributed to, the dramatic surge in American spending on health care owing to new discoveries, an aging population, public and private health plans, and saturation advertising, especially on television. It is commonly reckoned that America, by a huge margin, leads the world in both per capita and overall expenditure on health care. Additionally, beginning in the 1960s, pharmaceuticals were seen as effective medication for depression and other mental disorders. As investors in the health care industry, the Sackler brothers rode the crest of both the overall and the secondary surge, and in Arthur's case, a combative spirit helped propel their rise.

All three Sackler boys were born in Brooklyn, New York, where their father, Isaac, had migrated from what is now Ukraine; their mother, Sophie, was born in Poland. Isaac managed a grocery store. Arthur Sackler financed his medical studies at New York University by working at a pharmaceutical advertising agency, later becoming its proprietor. His brothers independently followed his career path.

Sackler by then had honed his bargaining and promotional skills through years of practice in the pharmaceutical trade. He published journals and financed research, and in 1952, when all three were working at Creedmoor, a state psychiatric hospital, the brothers together acquired

control of a floundering Greenwich Village–based drug manufacturer, the Purdue Frederick Company. What then evolved into Purdue Pharma produced laxatives (Senokot), eardrops (Cerumenex), antiseptics (Betadine), and after Arthur's death, a controversial narcotic painkiller, Oxycontin. In his prime, Dr. Arthur Sackler was known positively as an inventive pioneer in biological psychiatry. Along with his brothers as well as other collaborators, he published 140 research papers, primarily dealing with how bodily functions can affect mental illness. This and much else on the affirmative side was noted in Sackler's 1987 obituary in *The New York Times* by the veteran arts reporter Grace Glueck. Moreover, as she also writes, "He was the first to use ultrasound for medical diagnosis, and among other pioneering activities, identified histamine as a hormone and called attention to the importance of receptor sites, important in medical theory today."

All worthy of note, but Dr. Arthur Sackler's most remarkable nonmedical achievement was then passed over in one short paragraph. At a critical juncture in his collecting career, he managed to outfox the Metropolitan Museum of Art's directors, senior administrators, curators, and attorneys. In this exacting competition, he holds the winning cup. First, the context. What set Arthur apart from his brothers was his intense focus on Chinese artworks. After studying art history at NYU and New York's (until recently) tuition-free Cooper Union, Sackler began collecting in the 1940s, his interests ranging from pre-Renaissance and Postimpressionist works to contemporary American art. As Sackler later related, he then happened upon an elegantly designed Ming dynasty table and other stunningly sophisticated objects in a cabinetmaker's shop. "One wonderful day in 1950, I came upon some Chinese ceramics and Ming furniture. My life has not been the same since. I came to realize that here was an aesthetic not commonly appreciated or understood."

Within a decade, Dr. Sackler met and teamed up with Dr. Singer, whose expertise he respected and whose art purchases he helped fund from the 1960s onward. Singer's eye for small, out-of-fashion, but significant works complemented Sackler's more orthodox taste.

Where Dr. Singer's instincts proved most prescient was in his purchase of early bronzes and smaller archaeological finds—in his words, "the things that looters leave behind." High on the list of his prize finds is an array of fifty bronze bells, dating to the early Shang dynasty, around 1200 BCE. They are important not only in their workmanship but also in the sounds they produce, an audible clue to ancient Chinese music. As of our writing, so we learned from J. Keith Wilson, the curator of

ancient art at the Sackler, an exhibition featuring the bronze bells is in the planning stage. In any case, the combined collections have beyond doubt raised the global profile of the Freer/Sackler galleries. During the twenty-fifth anniversary in 2012 of the Sackler's founding, its curators tallied this box score of contributions: Freer, 3,270 pieces; Sackler, 812 pieces; Singer, about 5,000 pieces. The total includes archaeological specimens, Edo-period Japanese prints, and Persian and Indian paintings, all of which found a worthy home in Washington, amounting to a tenfold increase in the holdings of the Sackler Gallery of Art.

NO WHISPERING GALLERY spreads news more promiscuously than the gossip among collectors, dealers, and curators as to who is buying what. Early on, Dr. Arthur Sackler's resources and purchases came to the attention of the Metropolitan Museum of Art's director, James J. Rorimer. At the time, he was seeking donations to rehabilitate and air-condition the Met's galleries, not a popular project among would-be name-brand donors. On being approached in 1960, Sackler came up with an ingenious prescription: he promised $150,000 for the renovation of the majestic Great Hall on the second floor, thereafter to be named the Sackler Gallery. Once remodeled, it would display a massive wall painting and monumental sculptures already in the museum's collection.

In exchange, Sackler sought what the Met's chief administrator, Joseph Veach Noble, called "nasty" conditions. As recounted by Thomas P. F. Hoving (Rorimer's successor) in his mischievous 1993 memoir, *Making the Mummies Dance*, "Sackler would buy the works in question—all masterpieces—at the prices the Met had acquired them back in the twenties, only to give them back to the museum under his name to be designated 'Gifts of Arthur Sackler.' The doctor would then take a tax deduction based upon their current values. But that wasn't the only demand. He asked for a large storeroom inside the museum to house his private collections, an enclave—rent-free—to which only he and his personal curator would have access. Sackler had figured that he would actually make money on the tax loophole he had discovered—his deduction would be far more than the costs of the works, and his donation."

It was all legal but in Noble's view "shifty," and moreover, as Hoving now learned, none of the Chinese art crammed into Sackler's rent-free enclave was promised to the museum. Under the arrangement he reached with the museum, Sackler obtained a cavernous space for his collection, with the Met paying the costs of insurance, fire protection, and security guards. Sackler chose, and paid the salary of, his collection's caretaker,

Lois Katz, formerly an associate curator at the Brooklyn Museum; he also managed to obtain part-time curatorial privileges for his partner in collecting, Dr. Paul Singer. Very soon the irrepressible Tom Hoving came to like the equally irrepressible Arthur Sackler. In an effort to determine whether the doctor would donate his collection to the Metropolitan, Hoving invited Sackler "for a little chat." We thus have this timeless snapshot of their encounter:

> Within a few minutes after he sat down at the roundtable [I] could tell he liked me and knew also that I could work with him. He was touchy, eccentric, arbitrary—and vulnerable, which made the game much more fascinating. Sackler's accent was cultivated, clearly manufactured. He seemed to parade his voice as a clear sign of his achievements, but his tone wasn't phony or affected. He was proud of the way he talked. I liked that. His first words were, "I used to spend marvelous hours here with Jim [Rorimer]. He'd put his army boots up on the desk, and we'd talk for hours of pure scholarship and connoisseurship. Like two ancient Chinese gentlemen-scholars."

In the days ahead, Tom Hoving did persuade Arthur Sackler to contribute $3.5 million (with the help of his two brothers) for the construction of the enormous new wing that would enclose the Temple of Dendur, which had been rescued from the rising waters of the new Aswan High Dam. But Dr. Sackler would make no promises regarding the eventual destiny of his collection. Meantime, the existence of the collector's unusual private enclave was for years known only to the museum's senior officials. In 1978, Professor Sol Channeles, a specialist in criminal law, made public the existence of the Sackler enclave. A muckraking account by Lee Rosenbaum in *ARTnews* then reported that the New York State attorney general's office had initiated an inquiry to determine whether the enclave constituted an improper use of the Metropolitan's space and funds (from the museum's origins in the 1870s, the Met has relied heavily on New York City for tax benefits and help with housekeeping costs). When asked to comment by Ms. Rosenbaum, then director Philippe de Montebello, President William Macomber, and Board Chairman Douglas Dillon referred all inquiries to the associate counsel, Penelope Bardel, who elliptically said, "It's not appropriate for people being investigated to talk about the subject of the investigation."

Very much to the relief of the above-named personages, the state attorney general's office chided the Metropolitan for its secret deal but proposed no legal action. At the time, the museum's officers were coping

with barbed and angry criticism from Sackler, who was not happy with the presentation and use of the costly Sackler Wing, and he had other grievances. These were itemized by Michael Gross in a gossipy study of the Metropolitan, *Rogues' Gallery* (2009). According to the author, Sackler offered a litany of complaints to Tom Hoving. He believed that Ashton Hawkins, then the museum's legal counselor, had kept him off the Metropolitan's board, and "he was furious over the way the museum was using the 'sacred' Dendur enclosure for parties, calling a recent private dinner for the fashion designer Valentino 'disgusting'; and he thought a photo of Montebello in a fashion magazine denigrated the museum."

In 1982, Arthur Sackler announced that he was giving $4 million and the best of his collection to the Smithsonian Institution, which in turn agreed to create the Sackler Gallery of Art on the National Mall. In the end, as earlier noted, the nation indeed benefited, and the Freer/Sackler are today priority destinations for tourists and area residents alike (admission gratis).

And what possessed Dr. Arthur Sackler? As the French aphorist La Bruyère said of collecting, "It is not a pastime but a passion, and often so violent that it is inferior to love and ambition only in the pettiness of its aims." Or adds the British connoisseur Kenneth Clark: "Why do men and women collect? As well as ask why they fall in love: the reasons are irrational, the motives as mixed." In the end, however elusive the source of these out-of-body affairs, museums all over the world are filled with their progeny. Who or what has the superior moral claim to their possession is a matter we discuss in our epilogue.

EPILOGUE

PROMISING PORTALS
IN THE GREAT WALL

So how does it add up? What are the realistic prospects for a productive cultural interchange between Old China and New America? Or perhaps one should reverse those adjectives and speak instead of New China and Old America, since the freewheeling leaders of nominally Communist Beijing have flipped opportunely and dexterously to market capitalism, whereas America's incumbent chief executive is seemingly hobbled by elderly jurists, an immobile bureaucracy, and a Senate worshipful of seniority, precedent, and a hallowed document composed secretly in Philadelphia by long-deceased Immortals (or so our politics might appear to a baffled Gulliver from Beijing).

Similarly, the anomalies of the Sino-American art world can be viewed very differently, depending on from which side of the Pacific they are perceived. Walls are not only material; they are as formidable when barriers are mostly mental. East-West differences on the value of fine arts have their roots in aesthetics and history as well as economics and politics. All play a part in the four layers on which collectors, curators, and dealers continuously engage. The first and most basic layer concerns radically different aesthetic traditions and referential canons; this is followed by conflicting practices in the art market and among collectors; then by strongly felt legal and ethical differences regarding restitution of antiquities and the protection of sites rich in artifacts; and finally, there are differing views on the role of art museums as tutors, preservers, and arbiters

in the shared task of dispelling the fog of unknowing that besets both China and the Americas, Old or New or whatever.

Our perception, based on our own research, is that promising new portals have indeed opened in the Great Wall, especially in a world where ideas and images are as mobile as the winds and currents of the Pacific. Or, to vary the notion, the cultural differences between China and America exemplify the classical Daoist dualism of yin and yang: what expands also contracts; what appears transparent is likewise opaque; what is populist to some is derided as elitist by others; and the very measures meant to protect ancient sites are seen by others as abetting the looting they are meant to diminish. Even seemingly hard statistics, notably on the meteoric rise of the Chinese art market, start to wobble when examined closely. Still, these polarities often yield an energizing dynamic; opposites not only attract but can serve as breakthroughs in a contested terrain. Take, for example, our foundational layer of East-West differences: the contrary aesthetic perceptions that both civilizations take for granted.

We begin by citing an anxious letter, written in February 1979 by the versatile and crisply fluent Washington columnist Joseph Alsop to a friend, Professor James Cahill at the University of California (Berkeley), a leading authority on East Asian art. Alsop was then completing his monumental book *The Rare Art Tradition: The History of Art Collecting and Its Linked Phenomena* (1982), and he asked Cahill to comment on its section on China. "Dear Jim," he began, " . . . [t]he truth is that I am more apprehensive about this China chapter than I am about any other part of my book." He explains:

> In an intermittent way, I have studied and read about Chinese art for 45 years. But in the first place, it is not a subject one can get on top of by intermittent and rather casual work; in the second place, it appears to me that the basic problems are only beginning to be sorted out, which means that the subject is exceedingly difficult to get on top of by the most diligent work. . . . If I could have, I should have avoided entirely the chapter I now have in hand, but I fear this is really impossible, for the subject of my book is the mysterious way the complex behavioral system that begins with art collecting has developed, almost always entirely spontaneously, in a small but otherwise unrelated group of art traditions. Obviously China bulks large.

This was a telling admission, since Alsop was otherwise known for his certitude on matters political or cultural. Regarding China, his experience was extensive and firsthand. In mid-1941, while a fast-rising,

Harvard-bred journalist in Washington (he had family links with Elea-
nor Roosevelt), Alsop chanced to meet Claire Chennault, a crusty former
Army Air Corps officer then seeking recruits for the American Volunteer
Group, later better known as the Flying Tigers. The AVG was nomi-
nally a special unit of Nationalist China's air force. Alsop signed on as
Chennault's staff historian. He was on a mission in Hong Kong on Pearl
Harbor Day, and when that British colony fell to Japanese invaders, Al-
sop was interned for six months until his release in a prisoner exchange.
While in confinement, Alsop immersed himself in Chinese lore and lan-
guage, mastering four thousand characters (an impressive feat, since that
many suffices to read a newspaper, if not canonical texts). In all, he spent
four years in China.

Postwar in Washington, China dominated the décor of Joe Alsop's
Georgetown home, long an elite salon for politicians, diplomats, and fel-
low journalists. "China silks covered the chairs and sofas," writes his bi-
ographer and colleague, Edwin M. Yoder Jr., "and vapors of Oriental
potpourri perfumed the air. Vases, both Chinese and Japanese, peered
from specially built alcoves, and silk hangings alternated with Alsop fam-
ily portraits and photographs on the walls. Joe patronized many of the
Chinese restaurants, and on occasion kept dinner companions waiting
while he gave jovial parting advice to a maître d'hotel about recipes for
honeyed ham and other dishes."

Still, despite all this, Joe Alsop threw up his hands in trying to de-
code East-West aesthetic differences. In his book, he recalls encounter-
ing eminent Chinese scholars who believe they understood the Western
world, "[y]et what they had to say concerning Western art made it per-
fectly obvious that the whole subject was as foreign to them as Eskimo
survival techniques in the Far North would be to the average inhabitant
of Manhattan Island. . . . [T]hey had almost unerring eyes for the worst
designs the Western world had to offer." And this had its Western paral-
lel in the "unprepared cross-cultural art collector . . . who must in effect
learn foreign languages of art before he or she fully understands the val-
ues prevailing in other societies' art traditions."

A half century on, even as major exhibitions of Chinese art have
proliferated, puzzlement is still apparent in the expressions of consci-
entious museumgoers. How should one judge the style and content of
horizontal hand scrolls or vertical hanging scrolls? Who are the seminal
painters, and were they influenced in any way by European contempo-
raries? How does one interpret funerary bronzes, pottery figurines, jade
carvings, and Buddhist sculptures? Why the taboo in Chinese public art

about depicting the undraped female figure? What constitutes excellence in brushwork or calligraphy? These and other related questions frustrated not just Joe Alsop, but many of today's viewers and collectors as well.

There is, however, a vital and welcome difference between Alsop's era and our own. Instead of appealing by mail to the late James Cahill, today's venturesome art seeker can access his blog and view the same scholar's twenty-seven-part lecture series on Chinese painting. In "A Pure and Remote View," Cahill guides one through his self-chosen photographs illustrating his visits to mainland China and Taiwan, including treasures featured in two Palace Museums, one in Beijing, the other in Taipei. All of which is spiced by Cahill's usually witty, if sometimes repetitious, asides, notably including those recalling the first of his many visits to China in 1973 as a member of a breakthrough delegation of American curators and art historians.

Born in Fort Bragg, California, Cahill became fascinated by Asian art while serving as an army translator in Japan; after studying Oriental languages and art at Berkeley and the University of Michigan, he won a Fulbright to study in Japan. He thereafter joined the staff of the Freer Gallery, authored a landmark 1960 Skira volume on Chinese painting, and gave the Charles Eliot Norton Lectures at Harvard (on "The Compelling Image: Nature and Style in 17th Century Chinese Painting"). In 2010, the Smithsonian Institution awarded him its Charles Lang Freer Medal for his lifetime contributions.

We are fortunate that Cahill devoted his final months to completing his lectures even while bedridden prior to his death at age eighty-seven in 2014. His purpose, he explained, was "to convert what is in my mind, a great store of information and images and ideas that cannot be duplicated in the mind of anyone else alive, into a communicable form so that it is preserved." Cahill's legacy, moreover, is but one entrée on an impressive digital menu. Never before has so much been so readily available to so many. Examples include the Metropolitan Museum's Maxwell Hearn's YouTube lecture on how to read a Chinese scroll; a Frick Collection 2012 symposium on "The Dragon and the Chrysanthemum: Collecting Chinese and Japanese Art"; the scholar-dealer James Lally's 2011 lecture on "Two Great American Collectors of Chinese Porcelain: Morgan and Freer"; the University of Chicago historian James Hevia's "The Afterlife of Ruins," a lecture on the destruction of Yuanmingyuan; and the Central China Television (CCTV) English-language impassioned dramatization of the same event, *The Death of Yuanming Yuan*.

Yet for collectors, besides the satisfaction of learning more about their prizes, there is a generous material bonus. Great art is more than ever a gilt-edged investment, and potentially a tax deduction if donated to a museum. Still, as with aesthetics, there are also ambiguities and pitfalls in the Chinese art market, and it is to these that we now turn.

AN EXCELLENT OVERVIEW of this commercial maze is *Chinese Antiquities: An Introduction to the Art Market* (2012) by Audrey Wang, an arts consultant based in Singapore with eight years' experience in the auction world of Hong Kong. In Ms. Wang's telling, the heyday for collecting Chinese art occurred in the 1920s and 1930s, following the demise of the Qing dynasty, when "enormous amounts of Chinese antiquities—imperial, vernacular and archaeological—flooded the art market." Commencing with the Sino-Japanese war in 1937 and continuing through Chairman Mao's victory in 1949 until his death in 1976 (years when it was illegal to own, inherit, or exchange artworks), the market ebbed. These were the decades when London and New York dominated the international art market.

All this began to change with the rise of a market economy on the mainland. Beginning in the late 1970s and the early 1980s, previously unknown ceramics and artifacts began turning up in fashionable galleries on Hollywood Road in Hong Kong, then still a British colony. Soon the label "Imperial" became talismanic at auctions, the way led by Sotheby's and Christie's. In the 1990s, a new mainland art market was already sprouting as indigenous auction galleries sprang up in Beijing and Shanghai, including China Guardian (presently the most widely respected mainland firm) and Poly International Auction (an offshoot of the People's Liberation Army and today a global powerhouse). The ramp was in place for China's takeoff in the new century. In Audrey Wang's summary: "During the 1990's, buyers in Chinese galleries or auction houses were mainly foreigners, or Hong Kong-based dealers and collectors. The year 2000 marks the beginning of serious art-buying by Chinese collectors and museums, with antiquities starting to make their way back in China. Chinese art auctions around the world are now dominated by China-based collectors and dealer." Simultaneously, Chinese modernist works also became a promising addition to the global market.

As Chinese collectors and dealers multiplied, so did bidders for art funds. Among these buyers is the London-based Fine Arts Fund, which in 2009 reported an average return of 34 percent on assets it sold, while its recently developed portfolio of Chinese art posted a 13 percent gain

based on the directors' valuation of its assets. As Audrey Wang relates, similar funds now proliferate in China, among them the Xiling Group, China Minsheng Bank, Noah Wealth Management, Terry Art Fund, and the Shanghai Tianwuguan Art Fund. Regarding the merits of Chinese art as a long-term investment, she cites the experience of the only major art fund available for a case study: the British Rail Pension Fund, which in 1974 earmarked forty million pounds, or 3 percent of its holdings, for the purchase of art. "The Fund's tenure lasted nearly twenty years," she writes. "The Chinese antiques from the Fund were sold in 1989, making several record sales, including one for a Tang dynasty horse which was sold for £3,740,000 to a Japanese dealer. While there are obviously exceptions to the case, the conclusion from this brief case study is that art, and in particular Chinese art, does make money in the long term, but not necessarily so in the short term."

Still, however rendered in Mandarin characters, a universally understood Latin cliché could prudently be pasted on bidding paddles at now-frenetic auctions: caveat emptor. Suppose, for instance, that you are entranced by a Qing dynasty *famille rose* porcelain vase. It is said to be unique, it has imperial credentials, and its estimated selling price is $100,000–$150,000. But is it genuine? Or is it stolen? Is it legal? And is the bidding surge it stimulates propelled covertly by the auction gallery itself, a practice known to market insiders as "stir frying"?

Hence the raised eyebrows following the sale in April 2014 for a record $36.3 million of a Ming dynasty bowl, described as a "chicken cup," at a Hong Kong auction. As *The Wall Street Journal* reported, "Chicken cups have long been prized among wealthy Chinese, with classical literature referencing the small wares, saying aristocrats and emperors would spend fortunes for a single sample." Owned by a Swiss family, the cup was but one of nineteen of its kind known to exist; all but four are said to be in museum collections, none of them Chinese. But what sent the bids soaring?

The bowl's savvy buyer proved to be Liu Yiqian, a Chinese financier whose worth in 2013 was reckoned at $900 million, ranking him two hundredth in *Forbes* magazine's list of the world's richest persons. A self-made millionaire of working-class origins in Shanghai, Liu never attended college; while accumulating his fortune, he not only became an avid collector but now showcases his treasures in a private museum (admission: $9). "I don't have a specialization," he told David Barboza and Jonah Kessel of *The New York Times*. "As long as it's Chinese, I'll collect it." Yet in his enthusiasm, Liu unintentionally stirred a tempest

in his costly teacup. Liu paid for his prize with twenty-four swipes of his American Express Centurion Card (thus earning 422 million points), then poured tea into his new cup and sipped it. When his image doing so flooded the Internet, a barrage of outrage followed: he had blasphemed a national treasure and confirmed his status as a yahoo. "Such a simple thing—what's so crazy about that?" Liu protested. "Emperor Qianlong used it, now I've used it."

WELCOME TO THE MASKED BALL otherwise known as the Chinese fine arts market, its origins as shadowy as its dancers. So complex and intriguing is this emerging market that *The New York Times* in 2013 assigned a team of its star reporters, including two just cited (both based in China) to research and write a three-part series titled "A Culture of Bidding." Spread amply over the main news section and employing specialists in graphics, videography, and data analysis, their articles describe how a country that only recently had no real art market has acquired global prominence in its once–ideologically forbidden realm. From 2003 to 2012, China's domestic auction revenues soared by 900 percent, totaling $8.9 billion in the latter year, compared to America's $8.1 billion (though China's 2012 total was later subject to downward revision). Not only are there 350 auction houses in mainland China, but collecting is so popular that in 2013, television viewers could sample twenty "reality" programs that "offer tips on collecting and on identifying cultural relics [while] late-night infomercials promise quick riches to viewers who purchase a $2,500 collection of works by former students of renowned masters. Purchase today, the ad declares, and you can immediately secure a profit of $100,000."

As *The Times* team reported, art had evolved into a form of reserve currency, quickened by popular distrust of the Chinese stock market and a slowdown in the mainland housing boom. On its darker side, the market has been blamed for museum thefts and an ongoing illicit trade in looted or smuggled antiquities. At the same time, it has given a fresh twist to China's long tradition of gift giving, providing crafty local entrepreneurs with a seemingly foolproof way to "wash" a bribe. An example of how this works has been credibly described by Hong Kong's well-sourced English-language newspaper, *The South China Morning Post:* "It's not rocket science. A businessman gives a painting to an official, whose relatives auction it off. The businessman buys it back at an inflated price, and the official pockets the cash. This leaves less evidence linking favor to bribe than handing over suitcases of cash." Thus the auction gallery can double as a money laundry.

As in America's own Gilded Age, nouveau-riche rivalry also helps explain volatile bidding. In 2012, the Paris-based market analyst Souren Melikian noted, "Imperial destination and great provenances happen to be the two criteria that make the newly wealthy Chinese go nuts. They love nothing more than buying pieces of imperial aura, and acquiring these in the form of vessels that graced great 20th century collections brings more glitz. On top of that, porcelains from the late 17th to the late 18th centuries are decorated in the bright colors that appeal to Chinese billionaires."

Yet as *The Times* team determined, this ostensible reverence for cultural things past has proved a windfall for forgers: "Artists here are trained to imitate the old Chinese masters, and they routinely produce high-quality copies of paintings and other works, such as ceramics and jade artifacts. . . . It would be hard to create a more fertile environment for the proliferation of fakes." Copying has long been an honored tradition; students at art schools routinely replicate classic examples of various genres, while, more broadly, pirating trademarked products or copyrighted films and books has long been a tolerated offense. In the words of Wang Yan-nan, the daughter of former premier Zhao Ziyang and president of China Guardian, the mainland's most scrupulous major auction house, "This is the challenge right now. . . . In the mind of every Chinese, the first question is whether it's fake."

A personal digression is in order. In 2012, while the authors were attending an Asia Week conference in London, we took time out to inspect a recent four-star attraction at the British Museum: Sir Percival David's collection of Chinese ceramics, reputedly the best of its kind in the West. Long housed in its own building in Bloomsbury, the collection, totaling 1,700 pieces, was reinstalled in a special gallery in the British Museum in 2009. It indeed gleams with flawless specimens, and we were impressed by the flock of young Chinese visitors, of whom many were carefully capturing the best of the best with their smartphones. Back at our conference, we mentioned this commendable interest to a friend who recently retired from Sotheby's Chinese department. "But of course," she said with a laugh, "once back home, the photos will be sent to their chums, who will forge copies for China's own boisterous art market." Were he alive, we imagine that Sir Percival himself, heir to a fortune earned in the China trade and himself the shrewdest of bargainers, would have smiled indulgently.

There are more pitfalls. Not only are the salable objects quite possibly spurious, but often enough so are the winning bids. In a study of the

domestic market during 2010–12, the Chinese Association of Auction-eers determined that around half the sales of artworks fetching more than $1.5 million (a major slice of the market) were not completed because the buyer failed to pay. Yet defaulted amounts were routinely added to pub-licized sale totals, thus inflating China's auction revenues (notably in the case of the much-touted boom year of 2012). Sometimes deadbeat buyers simply lack funds; on other occasions the bidder is actually a surrogate for a collector who then rejects either the price or the object; in other instances payment is refused as a form of protest (especially in auctions elsewhere than mainland China) on grounds that an imperial treasure has been lawlessly plundered.

Disclosure in the Chinese media has already instituted obvious reforms, such as requiring deposits from big-ticket bidders and liber-alizing the rules that for decades barred foreign participation in the mainland auction economy. Sotheby's led the way in 2012 by forming a partnership with a state-run auction house, and in 2014 Christie's became the first international firm permitted to operate independently on the mainland. The expectation is that global best practices will in time prevail in the mainland, with a strong nudge applied by both state officials and auctioneering associations. In the meantime, as we were informed by a Sotheby's Asian hand, sales totals published by mainland auction galleries are being compared with accessible tax figures filed by the same firms, since for tax purposes there is no incentive for inflat-ing numbers. Thus a credible accounting of auction sales now seems in prospect.

In any case, the foregoing illustrates the vaporous nature of the auc-tion world. To the untutored spectator, bidding seems spontaneous and transparent, partly because so much of the machinery is backstage. In reality, the opening at major sales is carefully plotted, estimated sale prices have been negotiated, and leading actors are mostly known to each other. Even so, as in a Broadway season, surprises are always possible. This seems to be the case in the new twist the evolving market has given to the venerable dispute over its links with the looting of ancient sites, a dispute shorthanded in the buzzword *Elginism*.

FLASH BACKWARD to the Sublime Porte, the diplomatic gateway of the Ottoman Empire, in the year 1801. Thomas Bruce, the seventh Earl of Elgin, recently arrived as the British ambassador, is much in favor, since his country's forces have just driven French invaders out of Egypt, nominally an Ottoman province. Freshly honored with a fireworks

display and an aigrette from the sultan's turban, Elgin presses a special request: Can he obtain a *firman* (or permit) to carry out excavations on the then-crumbling Athenian Acropolis? The permit is granted, and Elgin's sizable team, including artists and architects he had previously recruited in Sicily, begin dismantling the sculptures and decorated columns of the Parthenon. By one count, Elgin chiseled off fifty-six slabs from the temple's friezes, seventeen pediments, and fifteen metopes. These he shipped with other fragments at his own expense to Britain so that they might adorn his projected new mansion in Scotland. However, pressed for funds and in ill health, Lord Elgin in 1815 sold his marbles to his own government for £35,000.

This became the universal matrix for an argument without end concerning the care and rightful ownership of things past. Was Elgin's deed an act of preservation or brigandage? Speaking for the latter view was Lord Byron, who resonantly protested on behalf of the Greeks, then still under Turkish rule. After personally inspecting the ravaged Acropolis in 1809, Byron vented his outrage in successive poems, notably "The Curse of Minerva," its message sharpened with ethnic digs (even though Byron's mother was Scottish), as in these lines:

> Daughter of Jove! In Britain's injured name,
> A true-born Briton may the deed disclaim,
> Frown not on England—England owns him not, Athena!
> No—the plunderer was a Scot!

In his volley of verses, Byron literally became an unacknowledged legislator of humankind, the role claimed for poets by his fellow romantic Shelley. On this we have the testimony of C. M. Woodhouse in his history *The Philhellenes* (1969). Until Byron's outburst, he writes, it never occurred to anybody "that the removal of the Elgin Marbles might be seen as an act depriving the Greeks of their historic heritage. Nobody thought it in the least odd that the Greeks were allowed no say in the matter."

Beginning with Byron, protests over uprooted cultural treasures became a potent ingredient of nationalism, our own era's most durable and widespread political creed. "Elginism" is now shorthand for all eruptions stirred by real or perceived pillaging of antiquities by foreigners. Still, to accused offenders, the reality seems very different: the objects in dispute in their eyes were either unprotected or unappreciated at home, and the letter of the law was frequently honored in their migration. Thus successive British governments have consistently maintained that Lord Elgin

received a permit, and in any case that his hallowed relics were safely preserved during violent times in Greece, and as well from a century of corrosive Athenian pollution.

Regarding Chinese antiquities, a similar defense on behalf of dealers was offered by a longtime premier practitioner, C. T. Loo, on announcing the liquidation of his New York gallery in 1950. He explained that his decision was prompted by the seizure in Shanghai of "a great number of very important objects" from his own gallery, which convinced him his dealing in Chinese antiquities was at an end. As he elaborated, "Possibly there are some of my compatriots who are blaming me for having shipped out of China some antique works now recognized as national treasures. I wish they would first blame the past ignorance of the inhabitants, because whatever I have exported from my Country was purchased in the open market, and in competition with others. I can say that not one single object has been removed by me from the original site. . . . I feel happy today that these works of art, that were exported by me, will be safely and carefully preserved for posterity. . . . I also firmly believe that all works of art have no frontier. They go around the World as silent ambassadors, enabling other people to understand the great culture of the Chinese and to love China."

It is fair to add that while C. T. Loo may not personally have "removed" any friezes or sculptures, he almost surely was a willing buyer and even commissioned the actual pillaging. In any case, seven decades after C. T. Loo's retirement, an awakening sleeper might rub his or her eyes in marveling surprise. It's not Westerners who principally fuel the demand for Chinese antiquities, but the Chinese themselves.

A credible witness to this remarkable turnaround is James J. Lally, who since the early 1970s has been a connoisseur, an auctioneer, and a dealer specializing in Chinese art. Lally found his calling after graduating from Columbia University, where he earned a combined degree in economics and diplomatic history. He serendipitously came upon a seductive display of Chinese works at the Boston Museum of Fine Arts, and he was smitten. Shortly thereafter, Lally was hired by Sotheby's, where his initial duties lay in the financial side, but he wheedled approval for a year's leave in London to work in the gallery's Chinese department. Back in New York in 1973, when a similar opening occurred locally, he switched and soon headed the same department. Lally then wrote the catalogue for the first major auction under his supervision. As Souren Melikian relates in a 1987 profile, "It was a landmark in American auctions of Chinese art. For the first time, footnotes and cross-referencing in scholarly style loomed large in contrast to the past, when objects were broadly characterized in

terms of medium, size and period. . . . The other major innovation was Lally's approach to the market. He scouted for objects instead of waiting for them to fall in his lap."

Both his scouting and his sales flourished, and in due course Lally was chosen as president of Sotheby's North America, serving until he resigned in 1985 to launch his own New York gallery, J. J. Lally & Co. Oriental Art. With his donnish manner and disarming humor, Lally became a familiar presence at high-level conferences dealing with the vexed complexities of the China art trade. His current views were spelled out in a statement he submitted to the State Department's Cultural Property Advisory Committee (CPAC) in April 2013. Its members were weighing the renewal of a five-year Memorandum of Understanding (MOU) between Beijing and Washington reached in January 2009, during the final days of the Bush administration.

Among its provisions, the MOU called for improving conservation and museum education programs in China, longer-term loans of artworks, and bilateral educational exchanges; for its part, the United States agreed to make it illegal to import any Chinese archaeological objects dating from the Paleolithic era to the Tang dynasty and to prohibit the importation of all Chinese sculpture and wall art more than 250 years old, absent official approval. This followed similar MOUs with thirteen other artifact-rich countries, each consistent in spirit with the 1970 UNESCO convention barring the illicit trade in cultural property (whose ratification was urged by President Nixon in 1972).

In his statement to the CPAC, Lally stressed that the goals of the MOU were "very worthy" but that the customs restrictions "had absolutely no discernible effect in China because U.S. buying accounts for only a small fraction of the sales of Chinese art in the international market." As he elaborated, having acquired relevant statistics from three international auction houses (with a promise of confidentiality regarding the identity of buyers): "Chinese buyers of Chinese art also dominate markets outside China. Sales statistics for the three leading international auction houses show that over 70 percent of the dollar volume of Chinese art sold by Bonham's, Christie's and Sotheby's in 2012 was sold to Chinese buyers."

Fittingly, this swerve in auction prices has also had an intriguing British angle owing to the multitude of Chinese antiquities exported ages ago by British soldiers, merchants, and missionaries. Among the biggest prizes are objects harvested during the 1860 destruction of the Yuanmingyuan. In 2011, an anonymous Chinese buyer offered £490,000

(about $764,694) at a London auction gallery for a small gold box in-scribed "Loot from the Summer Palace," signed by its taker, Captain James Garner of the King's Dragoon Guards, and put up for sale by his descendants. Very soon, attics, cellars, and garages all around Britain were scoured for similar souvenirs, inspiring a rash of articles in *The Daily Mail*, Fleet Street's anointed voice of the middle class, such as "What a pot we got! I thought that Chinese vase on your sideboard was junk," and "Curse of the Chinese Vase" (about a Ming flask sold for £228,000, but that sowed ill will and lawsuits within the seller's family).

Through all this, it should be noted, the Chinese government did not formally and expressly demand the repatriation from leading museums of specific examples of purportedly looted art. It has on occasion called upon auction galleries to withdraw from offering objects with an impe-rial pedigree. Through its proxies, it has consistently turned the auction block into a cultural tournament, relying on their paddles to buy back art; it has rewarded its own wealthy collectors who successfully bid for "imperial" objects, then donate their prizes to the People's Republic; it has also both encouraged or restrained popular protests. Thus after Prime Minister David Cameron irked Beijing by stopping in Tibet during an Asian trip in December 2013, he was repeatedly needled about things long past.

On arriving in Beijing, Cameron good-naturedly signed up with Sina Weibo, China's version of Twitter; within days, he was reportedly engulfed by as many as 250,000 tweets. Glorious Ming sounded a recur-rent theme: "When will you compensate us for the old Summer Palace?" While on his final stop in the western city of Chengdu, a questioner demanded to know when and if Britain would return twenty-three thou-sand "illegally plundered artifacts" allegedly in the British Museum? And on the street, as *The Daily Mail* reported, the message was "Give us back our treasure!"

TAKEN TOGETHER, China's reclamation campaign has become this century's oddest, least anticipated, and costliest cultural war. Its vari-ous fronts range from back-alley antique shops and college classrooms to upscale auction galleries; its unlikely combatants include Gisèle Cröes, a Belgian dealer who was once a Maoist broadcaster, and the Poly Group, a genetic offshoot of the People's Liberation Army.

Consider the China Poly Group Corporation, which first made head-lines in the year 2000, when with bids totaling $5 million it acquired at Sotheby's/Christie's "Imperial Sales" in Hong Kong three bronze animal

heads that once graced a zodiac fountain in the ravaged Summer Palace. Puzzled art world observers then learned that this state-run newcomer also sold weapons and real estate before becoming a belligerent in the culture battlefield. The year before, the Poly Group founded its own museum in Beijing, now much enlarged, where the bronze heads are now enthroned. Like the museum, Poly's portfolio has steadily expanded, and it presently includes sports cars, movie theaters, and television programming. Its most visible division, subsequently reborn as Beijing Poly International Auction, has become the world's third biggest in its field, its revenues in 2013 totaling $331 million.

In February 2014, Poly International's governors, including retired army officers and the offspring of senior party leaders, announced that they were about to file for an initial public offering on the Hong Kong stock market. As *The Wall Street Journal* recounted, "The retail tranche of the IPO, which originally accounted for 10 percent of the state auction house's offering, was 606 times oversubscribed." On its market debut, Poly shares leaped by 29 percent. But wider goals beckoned. When he announced the impending IPO, Poly's chief executive, Jiang Yingchun, went on to say, "We are big in the art auction market in mainland China, but we still have a long way to go to become the biggest auction house in the world."

As if to underline the Chinese market's momentum, within a fortnight following Poly's IPO, New York's annual Asia Week in March 2014 chalked up a record $200 million in sales ($25 million more than the year before). During its nine days, forty-seven art galleries, a cluster of auctions houses, and a pride of museums drew some six hundred collectors and connoisseurs of Asian art. Generating the most talk was a show at Larry Gagosian's trendy Madison Avenue gallery organized by Gisèle Cröes, the Belgian dealer known to the trade as "The Empress." Titled "Matter and Memory," her exhibition featured an impressive array of massive Chinese bronze and stone statues as well as exquisite ceramics. Over the years, the Empress has remained a top-billing exhibitor. During the 2002 Asia Week, hers was a "stunning show," in the estimate of Souren Melikian, in which "every other work hits you in the face with its sheer size."

The seller is as interesting as her wares. In 1962, while a young Belgian activist who had earned a degree in seventeenth-century literature, Gisèle arrived as a pilgrim to Mao's People's Republic. As she recalled, "My husband and I found ourselves in Beijing, living in the Peace Hotel with three-hundred other idealistic Maoists from all over the world."

Being a foreigner, she was restricted in her movements to four square miles, so that for three years she scoured the ramshackle neighborhoods of Beijing on her bicycle. She found that she could buy precious antiquities for a pittance. This encounter with Chinese art "reoriented my entire outlook on life." Simultaneously, the Ministry of Propaganda was impressed by her multilingual talents, and she became "the golden voice of Beijing radio."

Her disenchantment was precipitated by the outbreak of the Cultural Revolution. Thereafter, having immersed herself in art history, including a spell as a Smithsonian Institution visiting scholar, she commenced her ongoing duel with the Poly Group in seeking major Chinese works. Over the years, from her base in Brussels, she has specialized in befriending major Western collectors (and their heirs), often a step ahead of her chief rival. In her words: "The People's Liberation Army is very rich, very powerful and all-knowing. You must keep looking over your shoulder. This is an exceedingly jealous business, and I find pieces that others can't find. I know people they don't know."

Her success is owed in part to her personality. Early on, she caught the attention of Geraldine Norman, an eagle-eyed observer of the London auction world, who in 1996 described her as "[a] small woman, bubbling with character and enthusiasm for her work." Now in her seventies, Gisèle Cröes remains a vigorous combatant, most especially in her quest for bronze statues. "Possession of great bronze statues is the traditional Chinese symbol of ultimate power," she told a journalist in 2005. "This is why the PLA wants to acquire great art from all over the world. It enhances their power at home."

And lo, in 2014, as if to confirm her prescience, Poly announced that it was prepared to spend as much as $1 billion to buy Chinese and other art works from the Detroit Institute of Art. The museum's varied treasures were seen as a potential source of funds for the bankrupt city of Detroit, which then was seeking $18 billion to pay off its creditors. As of this writing, a coalition of foundations has furnished grants, but it would not startle the present writers to come upon this headline, possibly in *The Wall Street Journal:* "Red China Buys Bankrupt Motor City's Art Treasures."

AS ALL THIS WAS OCCURRING, an important diplomatic agreement was concluded without fanfare on January 13, 2014. Washington and Peking announced the renewal for a second five years of a 2009 ban on the importation of ancient Chinese artworks to the United

States. This followed the recommendations of the Cultural Property Advisory Committee, a State Department panel dominated (in the eyes of the agreement's critics) by archaeologists and antitrade attorneys. Speaking for the dissenters, Kate FitzGibbon, an attorney and author of six books on Asian art, protested that the accord was based on the optimistic premise that such import bans were effective and that the source country would actively protect its own cultural property. "None of these conditions exist in China," she contended:

> There is no evidence that U.S. import restrictions have had the slightest effect on China's internal cultural losses or that cultural exchanges have improved over the last five years. China is capable of enforcing draconian laws against its own citizens, but while it harshly punishes small-time looters, it encourages the elite-run domestic trade. Chinese ministries continue to demand high fees for tightly controlled, often highly censored travelling exhibitions. The only result of the ban is that U.S. citizens and institutions cannot import or collect items traded freely in other parts of the world, including in mainland China and Hong Kong.

Still, since the pact was signed in 2009, there has been an unparalleled increase in (1) Chinese cultural tourism, (2) the construction of mainland art museums, and (3) exchanges meant to promote not only special exhibitions but also professional skills on both sides of the Pacific. Taken together, these interrelated developments may well change the long-standing rules of the game and offer reasonable hope for a new era of fruitful collaboration on matters cultural between America and China. (Or not, we add as a prudent hedge.)

Affirmative hopes were encouraged in November 2012 when two dozen directors of major Chinese and American museums took part in an Asia Society forum in New York to discuss their shared future, doing so with the support of the State Department, China's Central Academy of Fine Arts, and the Chinese People's Association for Friendship with Foreign Countries. The forum's final report stressed a surprising fact: according to a Department of Commerce study, visits to America by Chinese tourists grew by 53 percent in 2010, while arrivals from China between 2012 and 2016 were projected to increase by 276 percent, making China the most important contributor to incoming tourism. As the directors noted, "Chinese tourists already account for the fastest growing segment of the Metropolitan Museum of Art's global audience, approaching the volume of visits by tourists from France." (So great is reciprocal

American interest, the report added, that Mandarin Chinese is "the only language bucking the trend of declining second-language education in U.S. schools.")

A parallel phenomenon is the unprecedented boom in museum construction and expansion in China. In 1949, when Mao attained power, China had forty-nine museums, many of which were vandalized during the Cultural Revolution. However, as the party line changed, the State Council in 2009 decreed that China was to build 3,500 museums by 2015, since culture was "the spirit and soul of the nation," indeed a "pillar industry" worthy of 5 percent of the country's gross domestic product. The five-year goal was in fact reached in three years, and 451 more museums opened in 2012, bringing the total to 3,867. (By comparison, according to the American Alliance of Museums, there are presently 17,500 museums of every variety in the United States.)

The result, as *The Economist* reported in December 2013, is "a building boom so frothy that it is running away with itself." Some new museums are wedged into housing developments, and others are privately operated, purpose-built traditional or adventurously modernist galleries, the way led by the Power Station of Art (PSA) and the Long Museum, both in Shanghai, the latter founded by the wealthy collector Liu Yiqian and his wife, Zhang Kun, while the PSA is the city's first public museum

The Nanjing Sifang Art Museum, designed by Steven Holl and associates, one of several thousand built in two decades in China; it features modernist visions of mist and water.

of contemporary art. The boom is plainly related to China's fast-forward urbanization and reflects the rivalry among cities to promote their special identity.

Yet there is a problem: while Beijing's Capital and National Museums respectively attract upward of thirteen and eight million visitors annually, many if not most galleries lack both artworks and attendance—as well as qualified curators, designers, and catalogues. So what can be done? Long ago, it was remarked that the legendary art dealer Joseph Duveen owed his rise to a seemingly self-evident observation: Europe had lots of art, and America had lots of money. Over the decades, owing in part to Duveen, many U.S. museums possess more art than their keepers can, or wish, to exhibit. In the words of the Asia Society forum's report, American museums "have extensive reserves of exactly what new museums need—massive holdings of objects, many in storage due to lack of exhibition space, along with academic, curatorial, and scientific know-how. U.S. museums and universities can conduct professional training on the scale that China now requires."

Is this realistic? Here a pause is essential to assess the mixture of motives that propel China's astonishing museum boom. Communist ideology cannot be ignored. A national museum is a selective filter, meant to highlight an approved version of the past, with awkward facts ignored. Still, it is part of the complexity and fascination of the Chinese art scene that from the late 1990s onward, a new generation of artists has pressed stubbornly against official constraints. Whether working at home or as expatriates, this avant-garde has also benefited from the booming market in traditional artworks. Their rise has been well chronicled by the art journalist Barbara Pollack, who in *The Wild, Wild East* (2010) confesses that in college she was largely ignorant of all Chinese art, "which was barely mentioned in my courses, which defined civilization as starting with the ancient Greeks and ending with Andy Warhol." And yet, she muses, "[h]ow could I know that in my lifetime I would step off a plane in China, and step into the fastest developing art center on the planet? That China would offer galleries and museums and legions of artists ready, willing and able to grab the spotlight on the world stage? That China, so massive and foreign to me when I was in college, would become my regular beat?" She speaks for an ever-growing new generation of artists, critics, collectors, dealers, curators, and ordinary civilians whose Western members presently can identify, and even correctly pronounce, such stellar names as Ai-Weiwei and Zhang Xiaogang.

Moreover, as we along with others can attest, this new generation often displays a plucky willingness to speak candidly. Thus in 2009, when a delegation of Chinese cultural experts arrived in New York as the first stop in a tour of American museums to hunt for looted art treasures, curators feared the worst. The delegation's first stop was the Metropolitan Museum of Art, where its members asked pointed questions about trophy objects in the Asian gallery (all this being filmed for posterity). However, as journalists reported, absent any eureka moment, the tension ebbed. As James C. Y. Watt, emeritus head of the Met's Asian department, commented, "That wasn't so bad after all." Liu Kang, a professor of China studies at Duke University, commented, "China is like an adolescent who has taken too many steroids. It has suddenly become big, but finds it hard to coordinate its body. To the West, it can look like a monster." As if to confirm his point, a researcher on the visiting team acknowledged that politics tended to upstage scholarship. Even if he found a looted relic, he remarked, he would be reluctant to seek its return to a museum in China that was like an unheated military barrack: "To be honest, if you leave a thermos in our office, it gets broken."

It is this generational shift that opens the most promising portal in the Great Wall. Partly thanks to the worldwide popularity of Chinese cultural centers (as detailed earlier), the governing elite has in recent decades discovered the tangible benefits of "soft power," a term coined in 1988 by Harvard's Joseph Nye to denote "the ability to get what you want through attraction rather than coercion or payment." Tellingly, Barbara Pollack was told that key party officials were impressed by America's diplomatic massaging of overseas interest in Abstract Expressionism, Pop Art, and modern dance (as skillfully implemented by Nelson Rockefeller while serving as President Eisenhower's assistant secretary of state for hemisphere affairs in the 1950s).

IN ANY CASE, the frustrations stressed by opponents of the State Department's renewal of the antiquities accord need to be balanced by weighing the positive testimony of other qualified scholars. Among them is Professor Anne Underhill, a curator at Yale's Peabody Museum. In a 2013 letter to the Cultural Property Advisory Committee, she described both the goodwill and collaborative projects generated by the expiring five-year agreement. "Since 2009, there have been unprecedented bilateral educational opportunities that have enriched both countries." As she amplified:

Archaeology of China is currently flourishing in the U.S., providing numer-
ous fieldwork and research opportunities for American students, both at the
graduate and undergraduate levels. . . . For example, two of my Yale graduate
students in the Department of Anthropology were fortunate to participate in
fieldwork in Shandong during 2011 and 2012, and this summer one will par-
ticipate in analysis of remains from a previous project that is directly relevant
to her dissertation project. . . . At the same time, our program has already
welcomed a number of visiting students from Shandong University conduct-
ing dissertation research in archaeology. . . . Of course the presence of these
talented young people at Yale greatly enhances the education of American
students as well.

Such individual exchanges, in her view, opened the way for institu-
tional collaboration: "No doubt these exchanges involve many compli-
cated issues to sort out, but the willingness on the part of the museum
staff on both sides is there." In fact, such exchanges have been under way
for more than a decade. As early as 1997, the Minneapolis Institute of Art
won permission to dismantle and import an entire provincial reception
hall and scholar's study, which were then reassembled in twelve weeks
in Minnesota by a team of Chinese workers. The rooms are now paired
with a Japanese audience hall and tearoom. All four can be visited via
YouTube. In 2013, the most welcome of Chinese (deceased) visitors, Em-
peror Qin's terra-cotta warriors, became a highlight of the Minneapolis
Institute's fall season.

A very different form of collaboration benefited the Toledo Museum
of Art, which needed 360 glass panels, each weighing 1,300 pounds, to
complete its planned expansion. China quickly produced the required
glass, and from 2006 onward this quintessential Middle American city
secured Chinese investment in two local hotels, a restaurant complex,
and a sixty-nine-acre waterfront project. As of 2013, Mayor Michael Bell,
an African American, visited China four times, resulting in an agreement
to open a Toledo branch of Hua Qiao University for overseas Chinese—
and to provide a special exhibit of rare Chinese antiquities at the city's
museum in 2014. "For little old Podunk, Ohio, it's been pretty phenom-
enal," a local developer told *The New York Times.*

There have also been problems. In 2011, a major exhibition at the
Penn Museum, titled "Secrets of the Silk Road," ran afoul of Chinese
authorities for never clearly specified reasons. Among the loan objects
were a selection of mummies, the prize attraction being "The Beauty of
Xiaohe," a handsome young woman who had been buried in a wooden

boat in the Tarim Basin in today's Xinjiang region. She has auburn hair and a long, protruding nose, and like other nearby mummies, she was buried four thousand years ago, two millennia before the Han Chinese settled in significant numbers in Xinjiang. When Professor Victor Mair, a Sinologist at the University of Pennsylvania, first saw her and other mummies in 1988, he was highly suspicious. As he told Heather Pringle of *Archaeology* magazine, "I thought at first they were from Madame Tussaud's, a ploy on the part of Chinese tourism people to bring in tourists." But over time, as still more European-looking remains were found and after analyzing DNA samples from twenty mummies, Mair changed his mind. He published his findings and in 2009 helped secure Beijing's agreement to permit a loan exhibition of the Xinjiang mummies, then on display in the Urumqi museum.

In America, the Xinjiang mummies were initially exhibited at the Bowers Museum in Santa Ana, California, then at the Houston Museum of Natural History, but when "The Beauty of Xiaohe" and her Bronze Age companions arrived in Philadelphia, their principal destination, the Chinese government refused to allow them to be exhibited. Why? A spokesman in Washington said that the mummies had been away from China too long for their conservation. He denied that the abrupt decision had anything to do with unrest among non-Han Chinese Uighurs, or with the ongoing controversy over who first settled in the Xinjiang region. That the decision disrupted the opening of "The Secrets of the Silk Road"—well, that was mischance (or perhaps an object lesson in the oblique Chinese way of making a point). Add to the foregoing the credible complaints among directors and curators that cultural officials in China withhold top-quality objects for overseas exhibition, that the terms and finances are pressed with ultra-capitalist zeal, and that the paperwork would strain the fictional imagination of Kafka and Gogol.

Fortunately, there is nothing ambiguous about the most original and fruitful example of Sino-American cultural collaboration, fittingly involving Salem, where America's China traders first set sail more than two centuries ago. The story begins in 1996, when Nancy Berliner, then curator of Chinese art at the Peabody Essex Museum, chanced to stroll through the small village of Huang in the mountainous region of Huizhou in China's southeastern Anhui Province. There she happened to notice an impressive merchant's house, also two centuries old. The door opened, and in the courtyard she met members of the Huang family, who explained that they had just decided to sell their ancestral home. They feared it would probably be torn down and sold for salvage. It chanced

Yin Yu Tang, a Qing dynasty merchant's house, relocated at Salem's Peabody Essex Museum in 2003; an augury, hopefully, of collaboration to come.

that Ms. Berliner's museum had embarked on a $100 million expansion plan designed by Moshe Safdie, the Israeli-Canadian architect of Montreal's Habitat 67. Why not relocate the imperiled home so that Americans could compare the sixteen-room merchant house with its contemporary Yankee mansions in Salem, eight thousand miles apart?

The museum's offer is accepted by the Huang family, whose members agree to provide ancestral records spanning eight generations. Thus a cultural exchange agreement is signed by the Huangshan municipality government. In due course, the house known as Yin Yu Tang, or Hall of Plentiful Shelter, is dismantled, and its 2,735 wooden parts and ten thousand bricks are packed into nineteen containers and shipped to New York. Once in Salem, its fragments are reassembled by a crew of Chinese carpenters and masons, who have come over temporarily to assist the reerection process, working with American carpenters and masons,

taking care that its five bays and two fishponds are properly sited under a protective glass skylight. In 2003, Yin Yu Tang makes its debut as the first-ever vernacular Chinese home to be imported intact to the United States. With an audio guide in hand, the visitor now can not only re-live the Huang family's history but also hear a firsthand account by its descendants of what happened in each and every room. It is an original idea, expertly realized, and an augury of things to come. "I think it was a wonderful coincidence that blossomed into a thrilling collaboration," says Berliner, who in 2012 became the Wu Tung Curator of Chinese Art at the Boston Museum of Fine Arts.

In a striking and unremarked way, America and China seem poised to realize a partnership envisioned just a century ago by the collector Charles Lang Freer. His proposal applauded in a prophetic leader (or edi-torial, in American English) in *The Times* of London on May 2, 1914. Under the heading "Chinese Art and Modern Vandals," the newspaper then known as "The Thunderer" deplored the "wanton, ruthless, whole-sale devastation" of "noble monuments of Chinese art." It blamed com-plicit collectors and dealers, together with "the discreditable connivance" of Chinese officials, on whom effective pressure from abroad ought to be seriously applied. "There is yet another thing that may be done," *The Times* continued, "and it is with special satisfaction that Englishmen will acknowledge the efforts of a distinguished American to lead the way." The American happens to be the "well-known art collector and connois-seur," Charles Lang Freer of Detroit, who together with the Smithsonian Institution seeks to establish a school in China, its threefold purpose be-ing to promote archaeological research in East Asia, to provide facilities in China for both foreign and native students, and to preserve objects of interest "in the countries to which they pertain."

Having made these points, *The Times* then notes that Freer, at his own expense, has dispatched a special mission to China led by Harvard's Langdon Warner, who is to report on the whole situation "with the view of setting up a Museum of Art in Peking under the auspices of the Chi-nese Government, but financed and controlled by its originators." Save for the seven just-quoted words, this century-old leader could aptly be published this morning. So we say, "Bravo, Thunderer!" Sadly, World War I put an end to all these sensible suggestions. We thus hopefully echo an adage attributed to Mark Twain: history doesn't repeat itself, but it sometimes rhymes. A century later, America and China may have a sec-ond chance to realize Charles Lang Freer's prescient and generous vision.

A SELECTIVE
CHRONOLOGY

1785	*Empress of China,* the first American mercantile vessel to reach Canton, arrives back in New York.
1787	Salem's Elias Hasket Derby's *Grand Turk* begins regular trade with China. By 1800, Salem's ships make it America's wealthiest city, per capita.
1838	Nathan Dunn opens the "Chinese Museum" in Philadelphia
1839–42	First Opium War, which ends in the Treaty of Nanking, the first of "unequal treaties," which grants extraterritoriality to the British in five specified treaty ports and establishes the cession of Hong Kong.
1845	Massachusetts's Caleb Cushing arrives at Macao aboard the frigate *Brandywine* and secures a treaty according Americans access to five ports, plus extraterritoriality: U.S. citizens subject only to U.S. laws.
1845–47	"The Great Chinese Museum" exhibition in Boston.
1851–64	Taiping Rebellion: China's deadly civil war claims as many as 20 million lives.
1856–60	Second Opium War, also known as the "Arrow War," culminates in the destruction and looting of Yuanmingyuan, or Summer Palace.
1870	Boston's Museum of Fine Arts founded; in 1909, moves to its present location, where it houses one of the country's foremost collections of Asian art.
1870	The Metropolitan Museum of New York founded. In 1905, it moves to its Fifth Avenue site; initially it displays Chinese porcelains from the Altman and Morgan collections, then in 1915 founds Asian art department.
1886	Launch of the "porcelain bubble" when William Walters buys a "peach-bloom vase" at auction in New York for $18,000.
1888–89, 1891–92	William Rockhill's two trips to Tibet.
1897–1904	Chinese railway construction boom.
1898	Harvard's Fogg Museum founded in Cambridge, bearing the name of William Hayes Fogg whose fortune grew out of the China trade.

1898–1905	Minister Edwin Conger and his wife Sarah's sojourn in China.
1900	Boxer Rebellion leads to siege of foreign legations and looting of Chinese treasures as royal family flees Peking. Rockhill plays key role in negotiations, establishing inter alia Indemnity Fellowships for young Chinese to study in America.
1901–04	Schiff expedition, led by Berthold Laufer, for the American Museum of Natural History.
1902	Guangxu Emperor and the Dowager Empress return to Peking.
1903	Isabella Stewart Gardner opens her museum in Boston.
1904	Katherine Carl's portrait of Dowager Empress Cixi exhibited at St. Louis Exposition, informally known as World's Fair.
1905–06	Five Chinese commissioners including Duanfang tour Japan, Europe, and the United States for eight months, their mission being to identify usable models for a constitutional regime in China.
1905–09	William W. Rockhill serves as Minister to China.
1907	French Sinologist Edouard Chavannes visits Longmen.
1908	Four-day auction of the Conger's Chinese collection is criticized in the New York press.
1908	William Rockhill meets the Thirteenth Dalai Lama at the Buddhist monastery of Wu Tai Shan.
1908	Both Guangxu Emperor and Dowager Empress Cixi die; Puyi proclaimed emperor.
1908–10	Blackstone Expedition led by Berthold Laufer for Field Museum of Chicago leads to the acquisition of a large collection of Tibetan objects.
1909	Congress enacts the Payne-Aldrich Tariff Act, exempting artworks over 100 years old from import duties.
1909, 1910	Charles Lang Freer's two trips to China. On second, he reaches Longmen and inspects its caves.
1909–13	William Calhoun serves as Minister to China. His wife Lucy returns after World War I and lives in Peking until 1938.
1911	The great collector Duanfang executed in Wuchang; his set of ritual bronzes is acquired by Metropolitan Museum in 1924.
1911–12	Fall of Qing dynasty. Emperor abdicates in January 1912.
1913	Benjamin Altman dies and bequeaths his porcelain collections to the Metropolitan Museum.
1913	J. P. Morgan offered Chinese imperial works from Forbidden City, Mukden, and Jehol. He dies in Rome; his collection of porcelains is sold by Duveen.
1913–14	China introduces laws banning the removal of "ancient objects"
1914	Royal Ontario Museum opens in Toronto
1915	With two million dollars provided by his father, John D. Rockefeller Jr. buys from Duveen choice porcelains from Morgan collection.
1923	Freer Gallery opens in Washington; first federally funded museum devoted wholly to fine arts.
1923	Laufer returns to China on a collecting trip funded by Marshall Field.
1923–24	First Fogg expedition to Dunhuang, led by Langdon Warner.

1925–26	Second Fogg expedition to Dunhuang, led by Langdon Warner and Horace Jayne.
1928	Royal Ontario museum acquires the first of its three Yuan wall paintings, *The Paradise of the Maitreya*.
1930s	Laurence Sickman, Alan Priest and George Kates reside in Peking; golden age of harvesting Chinese art, including friezes from Longmen.
1930	China enacts law on preservation of ancient objects.
1930	Los Angeles Museum advances $200,000 to General Munthe for a collection of ceramics.
1933	Nelson Art Gallery opens in Kansas City, Missouri. Sickman will develop the museum's outstanding Asian collection.
1935	Denman Ross dies. His collection of 11,000 works, including major paintings and sculptures, goes to the Boston Museum of Fine Arts (1,500 go to the Fogg).
1935–36	International Exhibition of Chinese art held by the Royal Academy at Burlington House, London; American museums well represented.
1942	The U.S. Office of Alien Property authorizes auction of artworks and records of Yamanaka & Co.; this follows 1935 seizure and sale in Berlin of Otto Burchard's Asian holdings.
1943	Grenville Winthrop leaves his collection of early jades and bronzes to Harvard's Fogg Museum.
1949–50	Chinese Communists assume power. In Shanghai, authorities confiscate C. T. Loo's gallery; he retires from the antiquities trade.
1950	Bequest of Alfred F. Pillsbury establishes Minneapolis as one of the important centers for the study of Asian art.
1959	Avery Brundage agrees to donate first part of his collection to San Francisco if the city agrees to fund a named gallery to display it; voters approve bond issue to underwrite costs.
1961	"Ancient Chinese Art Exhibition" from Taiwan's National Palace Museum goes from Washington's National Gallery to New York's Metropolitan Museum, Boston's Museum of Fine Arts, Chicago's Museum of Contemporary Art, and San Francisco's Asian Art Museum
1966	Brundage collection opens in a wing of M. H. de Young Memorial Museum in Golden Gate Park. In 1973, it is incorporated in a new and renamed Asian Art Museum of San Francisco.
1973	After a legal battle in U.S. courts, thirteen Asian works, formerly property of Baron Eduard von der Heydt, are now property of Freer Gallery under provisions of the Trading with the Enemy Act. They are formally accessioned to the permanent collection in 1978.
1973	Delegation of leading North American curators and art historians, led by Cleveland's Sherman Lee, visits the People's Republic of China, signaling a détente in cooperation policies.
1973	Metropolitan Museum acquires key paintings from Chinese-born collector and connoisseur C. C. Wang.

1973–75	Nearly four hundred items from Beijing's Palace Museum travel to museums in Washington, Kansas City, San Francisco, and Toronto.
1974	Asia Society, founded in 1956 by John D. Rockefeller III, opens gallery in New York with a collection of objects donated by JDR III and his wife Blanchette.
1974–75	Exhibition of the Archaeological finds of the People's Republic opens at the Nelson-Atkins Museum in Kansas City, and the National Gallery in Washington.
1981	John Crawford collection of calligraphy and paintings acquired by the Metropolitan Museum.
1981	Chinese Courtyard in the style of the Ming dynasty donated by Brooke Astor opens at Metropolitan Museum.
1982	China enacts Cultural Relics Law designating all antiquities found in caves and tombs as national property.
1987	Opening of Arthur M. Sackler Gallery, twinned with the Freer in Washington.
1992	Metropolitan opens new galleries for the decorative arts donated by Herbert and Florence Irving.
1996	"Splendors of Imperial China" exhibition from the National Palace Museum, Taiwan, tours Washington, New York, Chicago, and San Francisco.
1997	Paul Singer bequeaths extensive collection of early bronzes and ceramics to Sackler Gallery.
1998	"Studio of Gratifying Discourse," a Qing dynasty library and rock garden, is gifted by Bruce and Ruth Dayton to the Minneapolis Institute of the Arts.
2000	Christie's/Sotheby's joint imperial sale in Hong Kong features three heads from the old Summer Palace, all fetched by China's Poly Group for its new museum.
2003	Yin Yu Tang, Qing dynasty merchant's house, makes its debut at Peabody Essex Museum in Salem, MA. Building relocated intact from China in agreement brokered by then-PEM curator Nancy Berliner; proves a magnet for visitors.
2005	Beijing establishes Cultural Relics Recovery Program to identify museum-quality art taken from China between 1860–1949.
2009	State Department approves Memorandum of Understanding (MOU) restricting the importation to the United States of Chinese antiquities older than 250 years.
2009	Sale in Paris of the Yves St. Laurent collection. China protests sale of two bronze heads looted from the Old Summer Palace; sale proceeds, but winning bidder, Cai Mingchai of China's National Treasures Fund, refuses to pay. Heads eventually presented to China by François-Henri Pinault, a French businessman whose firm owns Christie's.
2010	China surpasses New York and London as the world's leading art market, but sales totals later disputed.
2014	KODE museum in Bergen, Norway, agrees to return to China twenty-one columns presumed to have been looted from Old Summer Palace by Anglo-French forces in 1860.

MUSEUMS IN NORTH AMERICA WITH COLLECTIONS OF CHINESE ANTIQUITIES

American Museum of Natural History
Central Park West and 79th Street
New York, NY 10025

Art Institute of Chicago
111 South Michigan Avenue
Chicago, IL 60603

Asia Society and Museum
725 Park Avenue
New York, NY 10021

Asian Art Museum of San Francisco
200 Larkin Street
San Francisco, CA 94102

Ball State University
David Owsley Museum
2021 Riverside Avenue
Muncie, IN 47306

Berkeley Art Museum
University of California
Woo Hon Fai Hall
2625 Durant Avenue
Berkeley, CA 94720

Brooklyn Museum of Art
200 Eastern Parkway
Brooklyn, NY 11238

China Institute in America
125 East 65th Street
New York, NY 10065

Cleveland Museum of Art
11150 East Boulevard
Cleveland, OH 44106

Dartmouth College
Hood Museum of Art
Hanover, NH 03755

Denver Art Museum
100 W. 14th Avenue Parkway
Denver, CO 80204

DePauw University
The Richard E. Peeler Art Center
10 West Hanna Street
Greencastle, IN 46135

Detroit Institute of Art
5200 Woodward Avenue
Detroit, MI 48202

Field Museum, Chicago
1400 South Lake Shore Drive
Chicago, IL 60605

Fogg Museum/Arthur M. Sackler
Museum
32 Quincy Street
Cambridge, MA 02138

Freer Gallery and Arthur M. Sackler
Gallery of Art
1050 Independence Avenue SW
Washington, DC 20439

Honolulu Museum of Art
900 South Beretania Street
Honolulu, HI 46208

Indianapolis Museum of Art
4000 North Michigan Road
Indianapolis, IN 46208

Indiana University Art Museum
1133 E. 7th Street
Bloomington, IN 47405

Johnson Museum of Art
Cornell University
114 Central Avenue
Ithaca, NY 14853

Los Angeles County Museum of Art
4000 Wilshire Boulevard
Los Angeles, CA 90036

Metropolitan Museum of Art
1000 Fifth Avenue
New York, NY 10028

Minneapolis Institute of Arts
2400 Third Avenue South
Minneapolis, MN 55404

Museum of Fine Arts, Boston
465 Huntington Avenue
Boston, MA 02115

National Gallery
6th Street and Constitution Ave. NW
Washington, D.C. 20565

Nelson-Atkins Museum of Art
4525 Oak Street
Kansas City, MO 64111

Newark Museum
49 Washington Street
Newark, NJ 07102

Oberlin College
Allen Memorial Art Museum
87 North Main Street
Oberlin, OH 44074

Peabody Essex Museum (PEM)
East India Square
161 Essex Street
Salem, MA 01970

University of Pennsylvania Museum of
Archaeology and Anthropology
(aka Penn Museum)
3260 South Street
Philadelphia, PA 19104

Princeton University Art Museum
McCormick Hall
Princeton, NJ 08542

Ringling Museum
Florida State University
5401 Bay Shore Road
Sarasota, FL 34243

Rubin Museum of Art
150 West 17th Street
New York, NY 10011

Saint Louis Art Museum
1 Fine Arts Drive
Saint Louis, MO 63110

The Samuel P. Harn Museum of Art
3259 Hull Road
Gainesville, FL 32611

San Antonio Museum of Art
200 West Jones Avenue
San Antonio, TX 78215

San Diego Museum of Art
1450 El Prado
San Diego, CA 92101

Seattle Art Museum
1400 East Prospect Street
Seattle, WA 98112

Smart Museum of Art
The University of Chicago
5550 S. Greenwood Avenue
Chicago, IL 60637

Smithsonian Institution
1000 Jefferson Drive SW
Washington, D.C. 20024

Stanford University
Cantor Arts Center
328 Lomita Drive at Museum Way
Stanford, CA 94305

Toledo Museum of Art
2445 Monroe Street
Toledo, OH 43620

The Trammel and Margaret Crow
Collection of Asian Art
2010 Flora Street
Dallas, TX 75201

Walters Art Gallery
600 N. Charles Street
Baltimore, MD 21201

Willamette University
Hallie Ford Museum of Art
700 State Street
Salem, OR 97301

Yale University Art Gallery
1111 Chapel Street
New Haven, CT 06520

Canada
Art Gallery of Greater Victoria
1040 Moss Street
Victoria, BC V8V 4P1

Royal Ontario Museum
100 Queen's Park
Toronto, ON M5S 2C6

University of Alberta
Ring House 1
Edmonton, AB T6G 2E1

CHINESE DYNASTIES

For the dates of dynasties and objects related to Chinese history please refer to the Metropolitan Museum's very useful Heilbrunn Timeline of Art History online.

Dynasty	*Capital*
Xia (c. 2100–1650 BCE) (disputed)	
Shang (c. 1650–1050 BCE)	Near present-day Zhengzhou and Anyang
Zhou (c. 1050–256 BCE)	Hao (near present-day Xi'an) and Luoyang
Qin (221–206 BCE)	Chang'an, near Xi'an
Han (206 BCE–220 CE)	Chang'an, later Luoyang
Six Dynasties Period (220–589 CE)	
Three Kingdoms Period (220–265 CE)	
Jin (265–420 CE)	
Southern and Northern	
(386–589 CE)	
Sui (581–618 CE)	Chang'an
Tang (T'ang) (618–906 CE)	Chang'an and Luoyang
Five Dynasties Period(907–960 CE)	
Liao (907–1125 CE)	Shangjing
Song (Sung) (960–1279 CE)	Kaifeng and Hangzhou
Jin (1115–1234 CE)	Huining, Zhongou, Kaifeng
Yuan (1271–1368 CE)	Mongol Empire capital Dadu (present-day Beijing
Ming (1368–1644 CE)	Nanjing and Beijing
Qing (1644–1911 CE)	Beijing

ACKNOWLEDGMENTS

Our first and abiding debt is to the many scholars and curators who helped us find our way in a complex terrain; to the archivists, publicists, scholars, and librarians who helped us locate and secure permission to recycle relevant quotations or images; then to friends who offered encouragement and shelter; and finally to our publisher and agent, who enabled us to transfer words from our computers to paper and/or digital pages. In the prologue, we have already described our book's origin at Oxford, where we met senior China hands Michael Sullivan and Craig Clunas, attended conferences on Asian themes, and renewed acquaintance with Frances Wood, at the British Library, and Helen Wang, curator of Chinese coins at the British Museum. Special thanks are owed to America's reigning authority on the British Empire, Professor William Roger Louis of the University of Texas, who first suggested a term's residency at St. Antony's College, and to Warden Margaret MacMillan, who made it possible. In New York, our base was Columbia University, notable for its Avery Library, its rich menu of events at SIPA (School of International and Public Affairs), its outstanding foreign policy seminars, and for Professor Dawn Ho Delbanco's lectures on East Asian art. Other vital New York resources include the archives at the Metropolitan Museum of Art, the Morgan Library, and the Frick Collection.

Invariably helpful were veteran curators and their associates at major museums. Among our patient tutors were Nancy Berliner at Boston's Museum of Fine Arts; the Metropolitan Museum's Maxwell Hearn and his predecessor as chief curator of Asian art, James C. Y. Watt, and for textile advice, Denise Leidy; Emeritus Director Marc Wilson and Curator Colin Mackenzie at the Nelson-Atkins Museum in Kansas City; Laurel Kendall at the American Museum of Natural History; also Daisy Wang and her colleague Karina Corrigan at Salem's Peabody Essex Museum; Ronald Otsuka and Alice Zrebiac of the Asian and textile departments at the Denver Art Museum; Nancy Steinhardt at the Penn Museum in Philadelphia; Chen Shen at the Royal Ontario Museum in Toronto; Anne-Marie Eze at the Isabella Stewart Gardner Museum in Boston;

Elinor Pearlstein at the Art Institute of Chicago; and Adriana Proser at the Asia Society in New York.

Archivists are the unsung enablers of specialized scholarship. Leading our list is David Hogge, chief archivist at the Freer/Sackler galleries in Washington (in whose offices we met Ian Shin, a Columbia graduate student who reviewed our early drafts); and Holly Wright at the Nelson-Atkins Museum in Kansas City, who provided plentiful copies from the Laurence Sickman files. At the Rockefeller Family archives, we were efficiently assisted by Nancy Adgent and her colleagues; and at Harvard, our academic Sherpa at the university's rich art archives was Megan Schwenke; we were also helped by Mai Reitmeyer at the American Museum of Natural History and by James Moske at the Metropolitan Museum of Art. Special thanks to Joy Goodwin at the Smithsonian Archives of American Art; to Maureen Melton at Boston's Museum of Fine Arts; to Bayard Miller and Charles B. Greifenstein at the American Philosophical Society in Philadelphia; to Dr. Manfred Rasch at the ThyssenKrupp Group Archives in Duisburg, Germany; to Wei Zheng, Chinese cataloguer at the C. V. Starr East Asian Library, Columbia University, who vetted our index; and to Esther Tisa Francini, provenance researcher at Zurich's Rietberg Museum.

In obtaining images, we were especially grateful for the assistance of Isabel Donadio at Harvard University; Nicola Woods at the Royal Ontario Museum; Leise Hook at Asia Society; Matt Empson at the Seattle Art Museum; Elizabeth Reluga at the Isabella Stewart Gardner Museum; Elizabeth Saluk at the Cleveland Art Museum; Barry Landua at the American Museum of Natural History; Eric Schnittke at Penn Museum; Jane Burke at the Denver Art Museum; Jennifer Riley at the Boston Museum of Fine Arts; Angie Park at the Brooklyn Museum of Art; Stacey Sherman at the Nelson-Atkins Museum; Henrik Berg at the KODE Museum in Bergen, Norway; Barbara Puorro Galasso at George Eastman House; Jacqueline von Hammerstein at the Pagoda Gallery in Paris; Cynthia Altman at Kykuit; Jonathan Bloom at the Asian Art Museum in San Francisco; and Eileen Travell and Alison Clark at the Metropolitan Museum of Art. In a special category, we are especially obliged to Harold Holzer, director of public affairs at the Metropolitan Museum of Art; to the Peabody Essex Museum's Whitney Van Dyke; and to Miranda Gale of the public affairs department at the Smithsonian's Freer and Sackler Galleries.

We thank as well the heirs and/or descendants of key figures in our book for both sharing information and permitting quotation from personal letters, notably Katherine Reid (Sherman Lee); Anne Warner (Langdon Warner's granddaughter); Elizabeth Winthrop and William Patten (heirs to Joseph Alsop); Dawn Ho Delbanco (daughter of Wai-kam Ho); Sarah Cahill (James Cahill); Pat Pratt (Denman Ross); and Holly Fairbank (John and Wilma Fairbank's daughter). As helpful were principal biographers, notably John Roote (George Kates) and Noelle Guifredda (Sherman Lee). For firsthand accounts of China's past we benefited from conversations with Seymour and Audrey Topping, who lived the history we describe, as did Yale's Emeritus Professor Michael Coe, who was posted in Taiwan while an early recruit in the CIA. Those years were resurrected in otherwise impossible-to-find books on the shelves of the New York

Society Library presided over by its director, Mark Bartlett, the Fort Knox of obscure past popular literature. We likewise were helped by the staffs of the Westport, Pequot, Fairfield, Wilton, and Weston Public Libraries in Connecticut.

What made our travels possible on a frugal budget was the hospitality of friends and colleagues, most especially Michael Horowitz and Gillian Darley (London); John and Elisabeth Onians (London); Bob and Hannah Kaiser (Washington); and in Boston, June Erlick, Carol Cerf, and Judy Chute. As before, we benefited from attending the annual Wellfleet Conferences on Cape Cod, initiated and chaired by Robert Lifton, where among those who counseled us were Isabel Hilton, a longtime and astute British-based China watcher; and Wally and Celia Gilbert, artists and collectors of Western and Asian art. Add to this helpful advice and support from Kathy Kline and Mark Pevsner, at Longbow, a China-oriented production company specializing in documentaries.

Finally, in putting our work between covers (and online), credit belongs to our agent Richard Morris at Janklow & Nesbit, successor to Tina Bennett, who encouraged us during the early stages of our project, as did Peter Osnos. At Palgrave Macmillan, we benefited from the tireless and informing assistance of Elisabeth Dyssegaard, and her associates, Donna Cherry, Lauren Lo Pinto, and Laura Apperson. As they might have said in dynastic times past in China, to all the above, the Order of the Discerning Owl, First Class, although the opinions expressed in these pages and factual blunders are solely the responsibility of the authors.

—*Shareen Blair Brysac and Karl E. Meyer (2015)*

SOURCES

In the preceding chapters, we have tried to address both general and specialized audiences. With an eye to the former, we have avoided footnotes and identify principal sources in our text. Here we list in detail specific references, but since our canvas spans eras, cultures, continents, and occupations, omissions are possible and errors likely. We thus welcome comments and corrections. In what follows, we have employed these key abbreviations: AMNH: American Museum of Natural History; BMFA: Boston Museum of Fine Arts; FSGA: Freer and Sackler Gallery Archives; HAMA: Harvard Art Museums Archives; HLHU: Houghton Library, Harvard University; HUA: Harvard University Archives; LOC: Library of Congress; MMA: Metropolitan Museum of Art; NAMA: Nelson-Atkins Museum of Art (formerly William Rockhill Nelson Gallery of Art); SAAA: Smithsonian Archives of American Art. These are abbreviations for newspaper sources: IHT: *The International Herald Tribune;* NYT: *The New York Times;* WSJ: *The Wall Street Journal;* WP: *The Washington Post.*

Chapter One: The Rules of the Game

7 **"China and its growing class":** press release quoted in "Sotheby's Signs Deal," NYT, September 21, 2012.

8 **The campaign was presaged in 2000:** details in Souren Melikian, "Auction Houses Add Insult to Injury," NYT, May 6, 2000. See also Spencer Harrington, "China Buys Back Its Past," *Archaeology* online, May 11, 2000; as well as numerous news reports, such as Dominic Lau, "Christie's Defies China, Auctions Treasures," Reuters, May 1, 2000.

10 **In the reckoning of James Cuno:** in Cuno, *Who Owns Antiquity? Museums and the Battle Over Our Ancient Heritage* (Princeton, NJ: Princeton University Press, 2008), 93 et seq.

11 **"It really is devastating":** quoted in Tania Branigan, "China's Tomb Raiders Laying Waste to Thousands of Years of History," *The Guardian* (London), January 2, 2012.

12 **Yet in a May 2003 dispatch on the aborted sale:** John Pomfret, "China Uncovers Looted Buddha," WP, May 28, 2003.

13 **"Much of the best work of the 20th century":** Michael Sullivan, *Modern Chinese Art: The Khoan and Sullivan Collection* (Oxford: Ashmolean Museum, 2001, rev. ed., 2010), 5.

14 **"Probably there is no thoughtful collector":** Benjamin March, *China and Japan in Our Museums* (Chicago: University of Chicago Press, 1929), 4.

 These contentions were elaborated . . . by James Cuno: in Cuno, ed., *Whose Culture?* (Princeton, NJ: Princeton University Press, 2009).

15 **In truth, the elder Elgin earned:** on Elgin's misgivings, see Julia Lovell, *The Opium War: Drugs, Dreams and the Making of Modern China* (London: Macmillan/Picador, 2011), 259–262. See also Nigel Cameron, *Barbarians and Mandarins: Thirteen Centuries of Western Travelers in China* (New York: Walker/Weatherhill, 1970), 345–360.

17 **"Neither the British nor the French":** in James Hevia, *English Lessons: The Pedagogy of Imperialism in 19th Century China* (Durham, NC: Duke University Press, 2003), 49–63.

18 **However, on the first afternoon, as goods were being carted:** quoted in Wilhelm Treue, *Art Plunder* (London: Methuen & Co., 1960), 204–205.

19 **Then as now, others in France rose above nationalist jeering:** quoted in Regine Thiriez, *Barbarian Lens: Western Photographers of the Qianlong Emperor's European Palaces* (Amsterdam: Gordon & Breach, 1998), 59.

21 **What this signified for China was presaged:** see "Ecumenical Conference on Foreign Missions, New York 1900," in Burke Library, Union Theological Seminary, Columbia University, Mission Research Archives, Section 12.

22 **Actually, observed George F. Kennan:** Kennan, *American Diplomacy 1900–1950* (Chicago: University of Chicago Press, 1951), 36–37.

23 **"They oppress our people and blaspheme our gods":** quoted in Jonathan Spence, *The Search for Modern China* (New York: Norton, 1990), 233–234. This and other statements attributed to Dowager Empress Cixi are dissected in revisionist biographies, notably Sterling Seagrave, *Dragon Lady: The Life and Legend of the Last Empress of China* (New York: Knopf, 1992), and Jung Chang, *Empress Dowager Cixi: The Concubine Who Launched Modern China* (New York: Knopf, 2013).

25 **"European diplomats as a whole":** William L. Langer, *The Diplomacy of Imperialism* (New York: Knopf, 1951), 704.

27 **Something else had changed: the laws of war:** see John Fabian Witt, *Lincoln's Code: The Laws of War in American History* (New York: Free Press, 2002), passim. See also Frank Freidel, *Francis Lieber: 19th Century Liberal* (Baton Rouge, LA: Louisiana State University Press, 1947), a biography of the German-American legal scholar who drafted Federal Law 100 as signed by Lincoln.
 This vandalism was no doubt deplorable: Peter Fleming, *The Siege at Peking* (New York: Harper, 1959), 242.
 So reported The New York Times: in no byline, "Gift from Peking for Museum of Art," *NYT*, September 3, 1901.

29 **In a further token of changing mores:** these successive auctions were widely reported; regarding 2009 Yves St. Laurent sale, of particular interest are "Chinese Bidder of Looted Sculptures Refuses to Pay," *People's Daily,* March 2, 2009; and Jane Macartney, "Chinese Bidder Can't Pay, Won't Pay, for YSL Statues," *The Times* (London), March 2, 2009.

31 On museum thefts, see inter alia Noah Charney, "Chinese Art Heists Shock Norway," *Secret History of Art* online, January 8, 2013; Katy Pickett and Helen Burchell, "FitzWilliam Museum Chinese Art Thefts," *BBC News,* September 27, 2012; "Break in at Stockholm Royal Palace," *The Local,* August 6, 2010; "UK Police: 2 Arrested Over Chinese Art Theft," *Huffpost Arts & Culture,* February 10, 2013; plus a swarm of related online news reports.

Chapter Two: Pacific Overtures

33 **"In the restricted state":** in Jean McClure Mudge, *Chinese Export Porcelain for the American Market, 1785–1835* (Newark: University of Delaware Press, 2nd edition, 1981), 35.
 the Pennsylvania Packet **noted:** ibid., 25.

36 **"On terms as favorable":** Kuo Ping Chia, "Caleb Cushing and the Treaty of Wanghia, 1844," *Journal of Modern History,* Vol. 5:1 (March 1933), 34.

36 **"Major-General's blue frock-coat":** Jack Beeching, *The Chinese Opium Wars* (New York: Harcourt Brace Jovanovich, 1975), 174. See also Teemu Ruskola, "Canton Is Not Boston: The Invention of American Imperial Sovereignty," *American Quarterly,* Vol. 57:3 (September 2005), 870.

37 **"it was unwise to allow any control":** Claude M. Fuess, *The Life of Caleb Cushing* (New York: Harcourt Brace, 1923), Vol. 1:438–439.
 "a certain amount of opium": Samuel Eliot Morison, *A Maritime History of Massachusetts, 1783–1860* (Boston: Northeastern University Press, 1979), 279.
 "To-day no trace remains": ibid.

38 **"at a glance":** *Boston Atlas,* January 1, 1847, quoted in Ronald J. Zboray and Mary Saracino Zboray, "Between 'Crockery-Dom' and Barnum: Boston's Chinese Museum, 1845–47," *American Quarterly,* Vol. 56:2 (June 2004), 272.
 authored the museum's catalogue: ibid., 274.

"Your excellency": Cushing Papers, Folder 15–24 July 1844, Box 45, quoted in Haddad, *The Romance of China: Excursions to China in U.S. Culture: 1776–1876* (Gutenberg-e.org, accessed December 14, 2013), fn 63.

"models and specimens": Caleb Cushing Papers, Folder 27–31 May 1843, Box 39, Manuscript division, LOC, quoted in Haddad, *The Romance of China.*

40 Emily Dickinson quotations in Hiroko Uno, "Emily Dickinson's Encounter with the East: Chinese Museum in Boston," *Emily Dickinson Journal*, Vol. 17:1 (2008), 52–53; Zboray and Zboray, "Between 'Crockery-Dom' and Barnum: Boston's Chinese Museum, 1845–47," 276; Emily Dickinson to Abiah Root, September 8, 1846, in *The Letters of Emily Dickinson* (Cambridge, MA: Belknap Press of Harvard University Press, 1986), 36.

"That all things originated": Peters catalogue, 47–48, quoted in Uno, "Emily Dickinson's Encounter with the East: Chinese Museum in Boston," 58–59.

"His mind like fabrics": verse 1446 in Thomas H. Johnson, ed., *Complete Poems of Emily Dickinson* (Boston: Little Brown, 2001), 614–615.

Chapter Three: The Crimson Path

41 **"that magic era":** Samuel Eliot Morison, *Maritime History of Massachusetts* (Boston: Houghton Mifflin, Riverside Press, Sentry Edition, 1961), jacket copy.

"In Boston they ask": Mark Twain, "What Paul Bourget Thinks of Us" (1895), accessible online as E book 3117, *Essays on Paul Bourget* (2006), produced by David Widger, 1.

"It's out of season!": Henry Adams to John Hay, June 11, 1886, quoted in Christopher Benfey, *The Great Wave* (New York: Random House, 2003), 109.

42 **"we are not called upon":** quoted in Turner Japes, *The Liberal Education of Charles Eliot Norton* (Baltimore: Johns Hopkins University Press, 1999), 9.

"the Fatherhood of God": Helen Howe, *The Gentle Americans, 1864–1960: Biography of a Breed* (New York: Harper, 1965), 17.

43 **"Numbers of Boston and Harvard men":** Van Wyck Brooks, *New England: Indian Summer* (New York: Dutton, 1940), 358.

"the coming fusion of East and West": Van Wyck Brooks, *Fenollosa and His Circle* (New York: Dutton, 1962), 49–50.

"I've flown from my West": ibid.

45 **"Chinese rooms":** see Alan Chong, *Journeys East: Isabella Stewart Gardner and Asia* (Boston: Isabella Stewart Gardner Museum, 2009), 31 et. seq.; also information provided by Anne-Marie Eze.

On Gardner's trip to China, see Greg M. Thomas, "Dust and Filth and Every Kind of Picturesque and Interesting Thing," and "Isabella Gardner's Aesthetic Response to China," in Chong, *Journeys East*, 423 et. seq.

46 **"Think much, speak little, write nothing":** quoted in Aline B Saarinen, *The Proud Possessors: The Lives, Times and Tastes of Some Adventurous American Art Collectors* (New York: Random House, 1958), 32.

"She was an exhibitionist": John Walker, *Self-Portrait with Donors* (Boston: Little Brown, 1974), 73.

For a description of the Dante Society, see Van Wyck Brooks, *New England Indian Summer*, 24ff.

"Oh no! So overdone": quoted in Saarinen, *The Proud Possessors*, 36.

47 **"Eliots, Perkinses and Bigelows":** in Neil Harris, *The Land of Contrasts 1880–1901* (New York: G. Braziller, 1970), 549–550.

"a scene of medieval splendor": quoted in Curtis Prout, "Vita William Sturgis Bigelow," *Harvard Magazine*, September 1997, accessible as http://harvardmagazine.com/1997/09/vita.html.

"Surf Sir! And sun, sir!": see "Yesterday's Island," *Nantucket*, Vol. 37:10 (June–July 2007), 2.

48 **"a gloom dispeller, corpse reviver":** quoted in Saarinen, *The Proud Possessors*, 32.

"Vain, meddlesome and impulsive": Patricia Vigderman, *The Memory Palace of Isabella Stewart Gardner* (Louisville, KY: Sarabande Books, 2007), 72.

clothed him in a long gray kimono: John E. Lodge to Fredrick Cheever Shattuck, quoted in *Proceedings of the Massachusetts Historical Society,* Third Series, Vol. 75 (1963), 108–109.

"My collection is a diary": quoted in John-Paul Stonard, "Kenneth Clark: Looking for Civilisation," *Financial Times,* November 22, 1013.

50 **"Ross was a great collector":** author interview with James Watt, May 2014.

"My motive was the love of order": Denman Ross, "Notes for an Autobiography," undated, Box 37, Denman Ross Papers, HAMA.

51 On *Thirteen Emperors,* see Tung Wu, *Tales from the Land of the Dragon: 1000 Years of Chinese Painting* (Boston: Museum of Fine Arts, 2003), 127 et. seq. Ning Qiang argues that it is a Song copy of an original early Tang painting in "Imperial Portraiture as a Symbol of Political Legitimacy: A New Study of the 'Portraits of Successive Emperors,'" *Arts Orientalis,* Vol. 35 (2008). We have followed Wu.

"the motivation behind": see Qiang, "Imperial Portraiture as a Symbol of Political Legitimacy," 99.

"he destroyed the Buddha's Law": Kojiro Tomita, "Portraits of Emperors: A Chinese Scroll Painting Attributed to Yen Li-pen (died a.d.673)," *Bulletin of the Museum of Fine Arts,* Boston, Vol. 30:177 (February 1932), 2.

"because of its extraordinary quality": Tomita, ibid., 8.

"'How can I get it?'": see Kojiro Tomita, *A History of the Asiatic Department* (Boston: Museum of Fine Arts, 1990), 14–15.

52 **"I was left as the one and only child":** Denman Ross, "Notes for an Autobiography."

"did not like . . . going into the army": Denman Ross, quoted in Marie Frank, *Denman Ross and American Design Theory* (Hanover, NH: University Press of New England, 2011), 20.

Information on the Ross family fortune provided in a telephone interview with Pat Pratt, November 1913.

"My large collection": Denman Ross, "Notes for an Autobiography," quoted in Frank, *Denman Ross and American Design Theory,* 44.

53 **"massive, rubicund":** Walter Muir Whitehall, *Museum of Fine Arts Boston: A Centennial History,* Vol. I (Cambridge, MA: Belknap Press, 1970), 136.

"Norton came into the classroom": John Voss et al., "Residents of Shady Hill," *Bulletin of the American Academy of Arts and Sciences,* Vol. 35:6 (March 1983), 11.

"His influence on his disciples": Charles Hopkinson, "Denman Waldo Ross (1853–1935)," *Proceedings of the American Academy of Arts and Sciences,* Vol. 71:10 (March 1937), 544–545.

"learn the language": quoted in Warren Cohen, *East Asian Art and American Culture* (New York: Columbia University Press, 1992), 112.

"so superficial": quoted in Denman Ross, American National Biography Online, http://80-www.anb.org.library.nysoclib.org/articles/17/17-00756.html?a=1&n=DenmanRoss&d=10&ss=0&q=1.

54 **"was as determined as Hitler":** in Walker, *Self-Portrait with Donors,* 24.

"We were in the spring and prime of youth": Denman Ross to Joseph Lindon Smith, Venice, June 12, 1935, Joseph Lindon Smith Papers, Box 3, SAAA.

"archaeological or historical considerations": Hervey E. Wetzel, "Denman Ross," *Bulletin of the Fogg Art Museum,* Vol. 1 (November 1931), 2.

55 Biographical information in ibid., and *Harvard Crimson,* October 23, 1919.

"The organization of the Museum of Fine Arts . . . is . . . deplorable": Denman Ross to A. Lawrence Lowell, October 2, 1934, in Joseph Lindon Smith Papers, Box 3, SAAA.

"There was dear old Denman Ross": Oral History Interview with Henry Sayles Francis, March 28, 1974, SAAA.

56 **"He gloated in his discoveries":** Langdon Warner, "Denman Waldo Ross, Collector," *Harvard Alumni Bulletin,* January 10, 1936, 444.

Regarding his "maturity," see Alan Priest to Paul J. Sachs, March 15, 1925, Paul J. Sachs Papers (HC 3), file 540, HAMA.

he proposed that all labels read": Ross note dated August 15, 1912, Denman Ross Archives, MFA Director's Correspondence 1901–1954, Roll 2480.

57 **"in galleries where you could not see":** Memorial Minute of the Faculty of Arts and Science, Harvard University, May 5, 1970, Edward Waldo Forbes General Folder, HUG B F656.50, HUA.

"wander into a formal wedding": Howe, *The Gentle Americans, 1864–1960,* 76.

58 **"I always wanted to be an artist":** *Harvard University Bulletin,* in Forbes General Folder, HUG B 5656.50, HUA.

59 **"Paul Sachs would seemingly at random":** Agnes Mongan, in John Voss et al., "Residents of Shady Hill," *Bulletin of the American Academy of Arts and Sciences,* Vol. 35:6 (March 1982), 24.

"Museum Course" statistics from Janet Tassel, "Reverence for the Object," *Harvard Magazine,* September–October 2002, 50.

"to make of the Fogg not only a treasure house": ibid.

60 **"They were a real team of comedians":** Robert Brown interview with Rosamund Forbes Pickhardt, February 13, 1995, SAAA.

"If it hadn't been for the superb mendacity": Robert Brown interview with Henry Sayles Francis, March 28, 1974, SAAA.

61 **"If you asked anyone who was at Harvard":** in Marjorie B. Cohn, "Turner, Ruskin, Norton, Winthrop," *Harvard University Art Bulletin,* Vol. 2:1 (Autumn 1993), 57.

62 **"After a lonely dinner, chiefly of fruit":** Martin Birnbaum, quoted by Christopher Reed in "Unveiled: For the First Time, a Recluse's Treasures Go Traveling," *Harvard Magazine,* March–April 2003.

Chapter Four: Barrels of Glue

63 **"The British, the French":** Langdon Warner to unknown, undated; Fogg Museum proposal for expedition to China, undated, Paul J. Sachs Papers (HC 3), file 539, HAMA.

"Little time would be lost": ibid.

Biographical information on Warner in Benjamin Rowland, "Langdon Warner Obituary," *Harvard Journal of Asiatic Studies,* Vol. 18:3–4 (December 1955), 447–450; and James Marshall Plumer, "Langdon Warner (1881–1955)," *Ars Orientalis,* Vol. 2 (1957), 633–637.

66 **"the presiding genius at Memorial Hall":** Edward Scott Typescript, Horace Howard Furness Jayne memorial, American Philosophical Society (1976). Paul J. Sachs Papers (HC 3), File 1024, HAMA.

"records of certain sites": Fogg Museum proposal, Paul J. Sachs Papers.

"Mr. Warner may bring back little": unsigned solicitation letter, Fogg Museum proposal, Paul J. Sachs Papers.

"Bandits on the Honan border": Langdon Warner, *Long Old Road in China* (Garden City, NY: Doubleday, 1926), 1.

67 **"no back-talk from Peking":** Langdon Warner to Hamilton Bell, quoted in Theodore Bowie, *Langdon Warner through His Letters* (Bloomington: Indiana University Press, 1966), 107.

"Before many years are gone": Warner, *Long Old Road,* 29.

"To pass among": Warner, *Long Old Road,* 30.

"knocked from their places": Warner, *Long Old Road,* preface, 57 (not included in American edition; Bristol: J. Arrowsmith Ltd., 1927).

"there had been six murders": Warner, quoted in "Letters from Mr. Warner and Mr. Jayne," *Bulletin of the Pennsylvania Museum,* Vol. 19:81 (December 1923), 56.

"three heads rolled": Warner, *Long Old Road,* 25.

68 **"commandeered carts, drivers and mules":** Bowie, *Langdon Warner through His Letters,* 109.

"Remembering that I had once been red-headed": Langdon Warner to his mother-in-law, ibid.

"in fair preservation": Jeannette Mirsky, *Sir Aurel Stein, Archaeological Explorer* (Chicago: University of Chicago Press, 1977), 370.

69 **"No city guard turned out":** Warner, *Long Old Road,* 88–89.

"cleared every wall": Warner, *Long Old Road,* 92.

"was able to camp and dig": Owen Lattimore to Langdon Warner, January 1933, Langdon Warner Papers HUG 4872.1010, Personal Correspondence, HUA.

70 Regarding Library Cave sales, Jiqing Wang gives the figure as "103 miskals (equivalent to 10.3 liang/taels) of silver as compensation for the MSS." See also "Aurel Stein's Dealings with Wang Yuanlu and Chinese Officials in Dunhuang in 1907," in Helen Wang, ed., *Sir Aurel Stein Colleagues and Collections* (British Museum online publication).

"on the solemn condition": Jiqing Wang, "Stein and Chinese Officials at Dunhuang," *IDP News: Issue No. 30,* (IDP is acronym for International Dunhuang Project).

71 **"particularly anxious to have acquired":** Edward Forbes to Paul Pelliot, December 7, 1921, quoted in Sanchita Balachandran, "Object Lessons: The Politics of Preservation and Museum Building in the Early Twentieth Century," *International Journal of Cultural Property* (2007), 5.

72 **"We must have some frescoes":** Langdon Warner to Charles Lang Freer, February 18, 1916, Box 26, Folder 5, FSGA.

"wholly on paper": Warner to unknown, n.d., Langdon Warner Folder, Chinese Expedition 1922–1923, HAMA, quoted in Balachandran, "Object Lessons," 14.

"perhaps more impressive": Warner to Jayne, Tun Huang town [1924] bMS Am 2684, HLHU.

"Neither chemist nor trained picture restorer": Warner, *Long Old Road,* 142.

"the first paintings removed": Langdon Warner, "Preliminary Report of the Fogg Museum Expedition to Western China, 1924," Edward Waldo Forbes Papers (HC2), File 2007, HAMA.

"abandoning subtlety": Warner to Horace Jayne, January 1924, MS Am 2684, HLHU.

"The milk froze on the wall": ibid.

"merely a large tip": Warner to Edward Forbes, February 10, 1924, MS Am 2126 (4), Folder 8, HLHU.

73 **"five days of labor":** Warner, *Long Old Road,* 143.

"If I lacked": ibid., 145.

"Everywhere eyes are gouged out": Langdon Warner to Lorraine Warner, quoted in Bowie, *Langdon Warner through His Letters,* 115.

74 **"As for the morals of such vandalism":** Bowie, *Langdon Warner through His Letters,* 118.

"Langdon, instead of using a thin, rather weak glue": Robert Brown interview with Daniel Thompson, September 25, 1974, SAAA, http://www.aaa.si.edu/collections/interviews/oral-history-interview-daniel-varney-thompson-13166.

"the intelaggio": Daniel Thompson, "Alpha Fragment" treatment report, quoted in Sanchita Balachandran, "Object Lessons," 15.

"the identity of the picture was entirely destroyed": George Stout and Lawrence Binyon, "Transference of Mutilated Chinese Wall Painting," March 1, 1930, Objects, Folder: AC 1924.40-47, Straus Center for Conservation, Paintings Files, HUAM; cited, Balachandran, "Object Lessons," 15.

75 **"head the new group":** Edgar Scott typescript of Jayne's obituary written for the American Philosophical Society, 1976, Paul Sachs Files, Horace Jayne 1024, HAMA.

"warned most emphatically": Warner to Edward Waldo Forbes, April 3, 1925, bMS Am 2126 (1), HLHU.

"Most important of all": letter from Daniel Thompson to Alan Priest enclosed in a letter from Paul Sachs to Edward Waldo Forbes, 1924 Forbes Papers (HC 2), File 370, HAMA.

76 **"grabbed the reins":** Justin Jacobs, "Confronting Indiana Jones: Chinese Nationalism, Historical Imperialism, and the Criminalization of Aurel Stein and the Raiders of Dunhuang, 1899–1944," 65, http://www.academia.edu/772652/Confronting_Indiana_Jones_Chinese_Nationalism_Historical_Imperialism_and_the_Criminalization_of_Aurel_Stein_and_the_Raiders_of_Dunhuang_1899-1944.

"a guard of mounted riflemen": Warner to Edward Forbes, May 28, 1925, Edward Waldo Forbes Papers (HC2), File 362, HAMA.

"If I had been there this time": Warner to Roger Greene, June 13, [1925], bMS Am 1864, Box 28, Folder 1049, HLHU.

"I came to the conclusion": Horace Jayne unsigned to Edward Forbes, April 9, 1925, Langdon Warner Papers, Box 10, HUG 4872.1010, HUA.

"It was a very different matter": ibid.

77 **"on no account allow them to touch":** Susan Chan Egan, *A Latterday Confucian: Reminiscences of William Hung (1893–1980)*, 114–115.

Headlines of the Tianjin paper: Jacobs, "Confronting Indiana Jones."

"rightful owners, the Chinese": see National Commission for the Preservation of Antiquities (1931), copy in Carl Tilden Keller collection concerning Sir Aurel Stein, bMS Am 2532, HLHU.

"Even though you and I know": Paul Sachs to Edward Forbes, February 8, 1927, bMS Am 2126, HLHU.

78 **"to lift the rafters":** Howe, *The Gentle Americans, 1864–1960,* 255.

"Yesterday I had an audience with H.I.M.": Bowie, *Langdon Warner through His Letters,* 175–176.

Chapter Five: Lament for Longmen

83 **"You can see what classical Chinese sculpture":** Bowie, *Langdon Warner through His Letters,* 33.

"inadvertently provided photographic catalogs": Stanley Abe, *Ordinary Images* (Chicago: University of Chicago Press, 2002), 191.

"such a thing would be terribly": Langdon Warner to Freer, July 13, 1913, Charles Lang Freer Papers, FSGA, quoted in Cohen, *East Asian Art and American Culture,* 89.

"based on America's capitalist and imperialist logic": David Pilling, "C. T. Loo: Champion of Chinese Art . . . Or Villain?" *Financial Times,* April 25, 2014.

Biographical material on C. T. Loo from Géraldine Lenain, *Monsieur Loo: Le roman d'un marchand d'art asiatique* (Paris: Editions Philippe Picquier, 2013) and Yiyou (Daisy) Wang, *The Loouvre from China: A Critical Study of C. T. Loo and the Framing of Chinese Art in the United States, 1915–1950* (dissertation, Ohio University, 2007).

85 **"Some of his Chinese pieces were hidden away":** Eduard von der Heydt, "Cheng-Tsai Loo," *Artibus Asia,* Vol. 20:2/3 (1957), 186.

"I remember one day in the spring of 1909": C. T. Loo, *An Exhibition of Chinese Stone Sculptures* (C. T. Loo & Co., 1940), preface.

86 **"A few months after this":** ibid.

87 **"Troops rode out each night":** Warner to Charles Lang Freer, May 22, 1914, Charles Lang Freer Papers, FSGA.

88 **"No stranger could stay on the spot":** report of Warner to Freer, n.d., Charles Lang Freer Papers, FSA.

"As a whole the place is beyond belief": Bowie, *Langdon Warner through His Letters,* 58–59.

"will enjoy [an] unusual opportunity": Warner to Freer, May 26, 1917, Charles Lang Freer Papers, FSA.

"the chapels with their huge guardian statues": Warner, *Long Old Road,* 9.

Regarding caves and looting, see Abe, *Ordinary Images,* 191.

89 **both "lucid and coherent":** Laurence Sickman and Alexander Soper, *The Art and Architecture of China* (New Haven, CT: Yale University Press, 1971), 98.

"because the finest and most dependable": Alan Priest to Laurence Sickman, May 9, 1928, files of the Far Eastern Department, Metropolitan Museum, quoted in Cohen, *East Asian Art and American Culture,* 112.

91 **$11 million bequest from William Rockhill Nelson:** see Laurence Sickman obituary, NYT, May 11, 1988.

"My Chinese is moving slowly": Sickman to Warner, December 13, 1930, filed in Gustav Ecke folder, Langdon Warner Archives, HUG 4872.1010, HUA.

"All these people had permanent agents": "Laurence Sickman in his own words, 1982 interview," in Michael Churchman, *Laurence Sickman, A Tribute* (Kansas City, MO: Nelson-Atkins Museum, 1988), 25.

"unerring eye, akin to perfect pitch": quote attributed to Ross Taggart in Churchman, "Laurence Sickman and the Formation of the Chinese Collection at the Nelson-Atkins Museum of Art," *Orientations,* Vol. 26:4 (April 1995), 50.

"Come on now . . . and see what these guys got": see Sickman, 1982 interview, Churchman, *Laurence Sickman, A Tribute,* 26.

"He had a dealer": Owen Lattimore to Warner, May 19, 1933, Lattimore Folder, Langdon Warner Papers, HUG 4872.1010, HUA.

92 **"wonderful charm of manner":** John Ferguson to Langdon Warner, August 25, 1934, Box 3, Langdon Warner Files, Box 5, HUG 4872.1010, HUA.

"Some of the most splendid moments": Harold Acton, *Memoirs of an Aesthete* (London: Methuen, 1948), 324.

93 **"single hands, bits of heads":** Sickman outline of Longmen vandalism, Langdon Warner Files, Box 13, HUG 4872.1010, HUA.

"I told him of the conditions": Sickman to Warner, August 23, 1935, Langdon Warner Files, Box 13, HUG 4872.1010, HUA.

"Would it be too much trouble": T. L. Yuan to Sickman, December 7, 1932, KC MS 001, Series II, Box 12, NAMA.

"We then began to hear": Sickman to Warner, August 23, 1935, Langdon Warner Files, Box 13, HUG 4872.1010, HUA.

94 **"What are we to do?":** Sickman to Warner, February 5, 1934, Langdon Warner Files, Box 13, HUG 4872.1010, HUA.

"Am mailing you six thousand dollars": telegram from Edward Waldo to Paul Gardner, April 25, 1934, Forbes Papers (HC 2), File 539, HAMA.

"I was then a happy artless young man": Sickman to Jim Plumer, May 2, 1934, (RG 02) Series I, Sub-Series A, 5.18–5.19 "P," NAMA.

"Three large cases have gone": Sickman to Warner, May 28, 1934, Langdon Warner Files, Box 13, HUG 4872 1010, HUA.

95 **"Certainly all the heads":** Sickman to Warner, June 14, 1934, Langdon Warner Files, Box 13, HUG 4872 1010, HUA.

"I feel so deeply sorry": Otto Burchard to Sickman, August 3, 1934, MS 001, Series I, Box 1a, NAMA.

"perfect love of a Chinese house": Alan Priest to Paul Sachs, February 14, 1926, Paul J. Sachs Papers (HC 3), File 540, HAMA.

"For the first time have I seen East and West": as reported to Priest to Sachs, February 26, 1927, Paul J. Sachs Papers (HC 3), in Paul Sachs Archive, HUAMA, China Expedition Alan Priest Files (1925–27).

96 **"town gossip to the effect":** Priest to Sachs, October 1, 1927, Paul J. Sachs Papers (HC 3), File 540, HAMA.

"so thoroughly Sinicized": Carl Bishop to John Lodge, November 8, 1927, Carl Bishop 1917 File, FSGA, quoted in Cohen, *East Asian Art and American Culture,* 117.

"witty, urbane and scholarly": James Cahill, "Fellowship at the Met," James Cahill Blog, http://www.jamescahill.info/the-writings-of-james-cahill/responses-a-reminiscences/146 -24fellowship-at-the-met-1953-54 (accessed November 11, 2013).

97 **"But this I know":** Priest to Sachs, October 1, 1927, Paul J. Sachs Papers (HC 3), File 540, HAMA.

"because beautiful as the bronzes": Priest to Edward Robinson, July 8, 1927, Paul J. Sachs Papers (HC 3), File 540, HAMA.

"to develop a collection": Alan Priest, "Recommendation for Purchase" (1929), quoted in Daisy Wang, "Papa's Pagoda in Paris: The Gift of the C. T. Loo Family Photographs to the Freer and Sackler Galleries," *Orientations,* Vol. 44:2 (February 2013), 140.

"the great reliefs of Lung Mên": Priest to Herbert Winlock, February 15, 1934, 35.146, Curatorial Files Far Eastern Art, MMA.

"carrying on some kind of cabal": quoted in Cohen, *East Asian Art and American Culture,* 118.

98 **"in a rather awkward position":** Sickman to Warner, May 28, 1934, Langdon Warner Files, Box 13, HUG 4872.1010, HUA.

"if things occurred at the mountain": Amy McNair, *Donors of Longmen: Faith, Politics and Patronage in Medieval Chinese Buddhist Sculpture* (Honolulu: University of Hawaii Press, 2007), 43.

"This strongly suggests the other pieces": ibid.

"This was the way the things were raped": Alan Priest, *Chinese Sculpture in the Metropolitan Museum of Art* (New York: MMA, 1944), 26.

99 Regarding Longmen heads, see letter from C. T. Currelly to Edward Forbes, December 23, 1936, Edward Waldo Forbes Papers (HC 2), File 1791, HAMA.

"I am seventy years old": "C. T. Loo, Inc. Announcement of Liquidation," Copy in Langdon Warner Files, Loo Folder, HUG 4872.1010, HUA.

100 **"The export of archaeological objects":** National Commission for the Preservation of Antiquities (1931), copy in Carl Tilden Keller collection concerning Sir Aurel Stein, MS Am 2532, HLHU.

"I think it is an outrage": Edward Forbes to Paul Gardner, April 25, 1934, Edward Waldo Forbes Papers (HC 2), File 1215, HAMA.

"If we are ever criticized": Bowie, *Langdon Warner through His Letters,* 147.

"I feel so ashamed": C. T. Loo, *An Exhibition of Chinese Stone Sculptures,* preface.

101 **"It has been said":** Alan Priest, "A Stone Fragment from Lung Men," *Metropolitan Museum of Art Bulletin* 36, no. 5 (May 1941), 115–116.

"These two reliefs": ibid., 27.

"The work is rather like a person": McNair, *Donors of Longmen,* 43.

"the whole project": Laurence Sickman to Wilma Fairbank, July 21, 1981, courtesy of Holly Fairbank.

Chapter Six: Penn Corrals the Tang Emperor's Horses

104 See *Catalogue of the International Exhibition of Chinese Art, Royal Academy of Arts, London 1935–36* (London: Royal Academy of Arts, 1935), 8; Jason Steuber, "The Exhibition of Chinese Art at Burlington House, London, 1935–36," *Burlington Magazine,* August 2006, 528 et seq.; and Frances Wood, "Paul Pelliot, Aurel Stein and Chinese Opposition to the Royal Academy's International Exhibition of Chinese Art 1935–36," http://www.britishmuseum.org/pdf/15_Wood-(Pelliot).pdf.

"that important and valuable treasures": Wood, "Paul Pelliot, Aurel Stein and Chinese Opposition to the Royal Academy's International Exhibition of Chinese Art 1935–36," 1; and James Cahill, "London 1935/36 Exhibition: 'Early' Paintings from China," James Cahill's blog, http://www.jamescahill.info/the-writings-of-james-cahill/london-1935 36-exhibition-early-paintings-from-china.

Attendance figures from Steuber, "The Exhibition of Chinese Art at Burlington House, London (1935-36)," 528.

105 **"A ruler takes the whole land under Heaven":** China Information Center, "Zhaoling Mausoleum of the Tang Dynasty (618–907)," http://www.china.org.cn/english/features /atam/115391.htm (accessed May 7, 2013).

"A line of tombs winds skyward": ibid.

"no different from that of the living world": quoted in Xiuquin Zhou, "Zhaoling: the Mausoleum of Emperor Tang Taizong," *Sino-Platonic Papers* (2009), 112. We have relied on this work for much of the information on the Zhaoling Mausoleum and the six horses. Unless noted otherwise, references are from this online publication: http://www.sino-platonic .org/complete/spp187_taizong_emperor.pdf.

divided into three components: ibid., 101–102.

106 **"I who am the son of Heaven":** ibid., 17. See also Zhou, "Excavations at Zhaoling, Shaanxi, China: More Light on the Museum's Chinese Horse Reliefs," *Expedition* 47, no. 2 (2005), 38–39.

"Since I engaged": translated in Zhou, "Zhaoling," 78.

"In the old days": ibid., fn 334.

"rescuing the world": ibid., 5.

107 **"It was as restless as a purple swallow":** ibid., 80.

"The moon rabbit": ibid.

108 **"Bedewed with red sweat":** translation by Arthur Waley, "The Heavenly Horses of Ferghana," *History Today,* February 1955, 99.

109 **"blood-sweating":** Hester Pringle, "The Emperor and the Parasite," Last Word Nothing blog, March 3, 2011, http://www.lastwordonnothing.com/2011/03/03/the-emperor-and -the-parasite/.
On the Son of Heaven's horses, see Bill Cooke, *Imperial China: The Art of the Horse in Chinese History* (Lexington, KY: Kentucky Horse Park, 2000), 42–43.
"The Heavenly Horses are coming": Waley, "The Heavenly Horses of Ferghana," 96–97.

110 **archaeologists found two sacrificial pits:** Wang Hanlu, "Discovery Revives Legend of Blood-Sweating Horses," *People's Daily Online,* http://english.people.com.cn/90001/907 82/7295160.html.
"spirit path": China Information Center, "Zhaoling Mausoleum of the Tang Dynasty (618–907)," 25; more details in Frances Wood, *The Silk Road: Two Thousand Years in the Heart of Asia* (Berkeley: University of California Press, 2002), 53–56.
"Four of them were brought into the town": in Warner, *Long Old Road,* 24.

111 **"In May 1913, the horses were taken":** Zhou, "Zhaoling," 94.
"to win his favor": ibid., 95.
"You will be surprised to see this letter": C. T. Loo to Warner, September 11, 1927, Langdon Warner Papers, C. T. Loo Files, HUG 4872.1010, HUA.
Loo claimed to have purchased: Zhou, "Zhaoling," 95–96.
"If a thing bought through the President": Loo to Warner, September 11, 1927, Langdon Warner Papers, C. T. Loo Files, HUG 4872.1010, HUA.

112 **"without expense to it":** see David Pilling, "Visionary or Villain?" *Financial Times,* April 26/April 27, 2014.
"Of the artist who wrought these masterpieces": quoted in ibid.

Chapter Seven: Mad for Ming
113 **"This scheme":** George Kates to Paul Sachs, June 21, 1933, Paul J. Sachs Papers (HC 3), File 1047, HAMA.
"Your letter": Sachs to Kates, July 17, 1933, Paul J. Sachs Papers, HAMA.
Biographical information is from Pamela Atwells's introduction to George Kates, *The Years That Were Fat: Peking, 1933–1940* (Oxford University Press Edition, 1988) as well as her obituary of Kates in *Journal of Asian Studies* Vol. 49:4 (November 1990), 1014–1015; and the introduction to the Kates material in the Henry Sales Francis Papers, SAAA.

114 On the Harvard Class of 1922, see its 25th Anniversary Report, and references to George Norbert Kates, 543, HUA.
"I am to breakfast with Professor Sachs": Kates to Henry Sayles Francis, June 25 (no year), Henry Sayles Francis Papers, SAAA.
"with a fortune of only 52 cents": ibid.

115 **what he termed "applied archaeology":** Kates to Sachs, October 24, 1927, Paul J. Sachs Papers (HC 3), file 1047, HAMA.
"What does an attendant": ibid.
"so as to keep gestures in character": Kates to Russell Hitchcock, January 10, 1928, Hitchcock Papers, SAAA.
"ravishing dark beauty": Kates to Hitchcock, February 19, 1928, Hitchcock Papers, SAAA.
"Pola holds court": Kates to Hitchcock, January 21, 1928, SAAA.
"plucking various absurdities" for Paramount's foreign market: quoted in Pamela Atwell's introduction to *The Years That Were Fat* (Oxford: Oxford University Press, 1988), vi.

116 **"task of making myself a Sinologue":** Kates to Sachs, June 21, 1933, Paul J. Sachs Papers (HC 3), file 1047, HAMA.
"What a pleasure to have one's own steep-roofed": George Kates to Mrs. Frances Francis, February 10, 1935, Henry Sayles Francis Papers.
"No electric light, no wooden floors": Kates, *The Years That Were Fat,* 21–22.
"Proud palaces were being dismantled": Kates, ibid., 24.

"dull and expensive, porcelains": Kates, ibid., 81.

117 **"His [Flower's] Chinese friendships"**: Harold Acton, *Peonies and Ponies* (Oxford: Oxford in Asia Paperbacks, 1983) 79.

"a man of unusual talents": John Ferguson to Langdon Warner, January 15, 1934, Langdon Warner Files, Box 3, HUA.

"on his way to Peking": Warner to Sickman, April 5, 1934, Kansas City Archives.

118 **"a half-mile train"**: Millicent Bell, *Marquand, An American Life* (Boston: Little, Brown, 1979), 216–217.

The "circus . . . became extremely temperamental": Kates to Mrs. Frances Francis, September 23, 1934, Henry Sayles Francis Papers, 217.

"and ended with smashed glasses": ibid. 217.

"Such regal goings-on-you never did see!": Kates to Mrs. Francis, September 23, 1934, Henry Sayles Francis Papers.

119 **"best Chinese artist of the mid-twentieth century"**: Laurence Sickman, "Harold Acton in Peking," in Edward Chaney and Neil Ritchie, eds., *Oxford China and Italy: Writings in Honor of Sir Harold Acton on His Eightieth Birthday* (London: Thames & Hudson, 1984), 70.

"princely man": Kates, *The Years That Were Fat*, 130. In 1940 Kates, together with H. S. Chen, published an article on "Prince Kung's Palace and Its Adjoining Garden in Peking," *Monumenta Serica* 5 (Journal of Oriental Studies of the Catholic University of Peking).

"The scene he was depicting": Acton, *Memoirs of an Aesthete*, 375.

120 **"Then the day came when"**: Kates, *The Years That Were Fat*, 60 et. seq.

"As all Chinese know from poems": ibid., 264.

121 **"He continued his work"**: see Kates, "A New Date for the Origins of the Forbidden City," *Harvard Journal of Asiatic Studies*, Vol. 7:3 (February 1943).

On wartime years, see also the entry for George Kates, *Harvard Anniversary Report* (1947).

"elegant if unpretentious domesticity": Kates, *The Years That Were Fat*, 25.

"sober range of dignified furniture": ibid.

"leaner years": ibid., 26.

122 **"starvation summer"**: George Kates to Henry Francis, January 31, 1955, Henry Sayles Francis papers, SAAA.

"The furniture has gone": Kates to Francis, May 10, 1956, Henry Sayles Francis papers, SAAA.

123 **"For me it is a season"**: Kates to Francis, July 21, 1955, Henry Sayles Francis papers, SAAA.

"What really matters": Kates to Francis, June 26, 1956, Henry Sayles Francis papers, SAAA,

the **"King of Ming"**: see "Talk of the Town," *New Yorker*, February 11, 1961.

"furniture was not just a necessary adjunct": Wendy Moonan, "Ming Dynasty," *Departures*, May/April 1999, http://www.departures.com/arts-and-culture/ming-dynasty.

"burn it, smash it": ibid.

124 For Christie's auction figures, see Wendy Moonan, "Antiques: The Interest in Furniture from China," NYT, September 19, 1997; Rita Reif, "Learning to Love Furniture from China," NYT, October 6, 1996.

Chapter Eight: Art on the Rails

125 **"was the greatest achievement of the American people"**: Stephen E. Ambrose, *Nothing Like It in the World: On Building the Transcontinental Railroad, 1863–1869* (New York: Simon & Schuster, 2000) 17–18.

126 **When Curzon elaborated:** quoted in Karl E. Meyer and Shareen Blair Brysac, *Tournament of Shadows: The Great Game and the Race for Empire in Asia* (Washington, DC: Counterpoint, and New York: Basic Books, 1998), 565–566.

127 **"isolated himself in a silk cocoon"**: Aline B. Saarinen, *The Proud Possessors* (New York: Random House, 1958), 121–122. On details of Freer's early life, see also Thomas Lawton and Linda Merrill, *Freer: A Legacy of Art* (New York: Abrams, 1993), passim.

129 **"Shall I begin by saying":** Whistler to Freer, March 24, 1897, quoted in Helen Nebeker Tomlinson, *Charles Lang Freer: Pioneer Collector of Oriental Art Collector* (doctoral dissertation, Case Western Reserve University, 1979), 236.

 Moreover, writes the Chinese historian Cheng Lin: Cheng Lin, *The Chinese Railroads: A Historical Survey* (Shanghai: China United Press, 1935), v–vii, 12–13, 26–62.

130 **In Cheng's careful calculation:** ibid., 23 et seq.

131 **"that he could learn as well":** see Cohen, *East Asian Art and American Culture,* 65.

132 **"The opinion of all":** Marian Bell, quoted in Saarinen, *The Proud Possessors,* 136.

 "our mighty republic": TR's address at Mechanics Pavilion, San Francisco, May 13, 1903, quoted in Howard K. Beale, *Theodore Roosevelt and the Rise of America to World Power* (Baltimore: Johns Hopkins Press, 1956), 172–173.

 Should the regents demur: see Tomlinson, *Charles Lang Freer.*

133 **"Freer the ardent, diligent amateur collector":** Saarinen, *The Proud Possessors,* 137.

 "I will allow no one": Freer to Frank Hecker, September 17, 1909, quoted in Tomlinson, *Charles Lang Freer,* 544.

135 **"Should he grasp the opportunities":** ibid., 558.

 "One suspects . . . that the line wavered": ibid., 580.

 In any case, when he returned: ibid., 574.

136 **As to their relationship:** Carol Felsenthal, *Power, Privilege and The Post: The Katherine Graham Story* (New York: Putnam, 1993), 25–26.

 As to Freer's purchases: see Daisy Yiyou Wang, "C. T. Loo and the Formation of the Chinese Collection at the Freer Gallery," in Jason Steuber and Guolong Lai, eds., *Collectors, Collections and Collecting the Arts of China* (Gainesville: University Press of Florida, 2014), 151–182.

137 **When the Freer Gallery opened:** cited in Yiyou Wang, *The Loouvre from China,* 168.

 Dr. Wang quotes: ibid., 173.

Chapter Nine: The Porcelain Bubble

141 **An informed answer:** Lewis Namier, quoted in David Cannadine, *The Decline and Fall of the British Aristocracy* (New Haven, CT: Yale University Press, 1990), 182.

142 **Leading the way in 1882:** all figures taken from ibid., passim.

 "The American domination of the world art market": Gerald Reitlinger, *The Economics of Taste* (New York: Holt, Rinehart, 1963), 228. See also Saarinen, *The Proud Possessors,* 56–90.

145 **Among visitors so smitten:** details from William R. Johnston, *William and Henry Walters: The Reticent Collectors* (Baltimore: Johns Hopkins University Press, 1999).

147 **"the public does not own":** quoted in ibid., 98.

148 **as the historian Warren Cohen relates:** Cohen, *East Asian Art and American Culture,* 30–31.

 "The Asian could no more": ibid., 31.

149 **Fowles then offers an insider's tribute:** Edward Fowles, *Memories of the Duveen Brothers* (London: Times Books, 1976), 77–78.

150 Regarding James A. Garland, details from Ivy Lee, "Where Garland's Rare Porcelains Were Found," NYT, March 16, 1902, passim.

 How it happened: ibid.

151 **"I paid more for that vase":** as related by Cesnola's biographer, Elizabeth McFadden, *The Glitter and the Gold* (New York: Dial Press, 1971).

152 **"I understand that Mr. Garland":** James Henry Duveen, *The Rise of the House of Duveen* (New York: Knopf, 1957), 194.

 "Mr. Garland was a very nice man": unsigned article headed "To Rename Famous Garland Collection," NYT, August 6, 1900.

 By then, in the words of Jean Strouse: see Jean Strouse, *Morgan: American Financier* (New York: Random House, 1999), 485.

154 **this message on March 12, 1913:** all quoted cable texts from J. Pierpont Morgan Jr. Papers, Morgan Library, ARC 1216, Box 201, File 322. The sole published account of this episode

that we encountered appeared in an unsigned note in *The New Yorker*'s "Talk of the Town," dated March 18, 1996.

155 **At the Metropolitan Museum, meanwhile:** details from Calvin Tomkins, *Merchants and Masterpieces: The Story of the Metropolitan Museum* (New York: Dutton, 1970), 178.
 his father's "desire and intention": see NYT, February 9, 1915, no byline.

Chapter Ten: Romancing the Rockefellers

157 **As Hay later wrote:** see Walter Mills, *The Martial Spirit: A Study of Our War with Spain* (Cambridge, MA: Riverside Press, 1931), 316, 340. The "splendid little war" phrase was in a letter to Theodore Roosevelt.
 What helped tip the balance: see Christopher Hitchens, *Blood, Class and Nostalgia: Anglo-American Ironies* (New York: Farrar, Straus & Giroux, 1990), 63–76.

159 **"Don't any of you realize":** see Henry F. Pringle, *Theodore Roosevelt: A Biography* (New York: Harcourt, Brace, 1931), 216–223.
 On March 3, J. Pierpont Morgan informed Wall Street: Strouse, *Morgan*, 404.
 As the muckraking journalist David Graham Phillips . . . saw it: quoted in Ron Chernow, *Titan: The Life of John D. Rockefeller Sr.* (New York: Random House, 1998), 358.

160 **"I had the opportunity":** Senator Benjamin Tillman, *Congressional Record* (June 12, 1909), Vol. 4, Pt. 2, 3169; quoted in Karl E. Meyer, *The Art Museum: Power, Money, Ethics* (New York: Morrow, 1979), 32.

161 **When Payne-Aldrich was approved:** see Germain Seligman, *Merchants of Art: 1880–1960, Eighty Years of Professional Collecting* (New York: Appleton, Century-Croft, 1961), 75–76.
 As she reminds us: see Suzanne Loebl, *America's Medicis: The Rockefellers and Their Astonishing Cultural Legacy* (New York: HarperCollins, 2010), xi–xii.

162 **"There were even demonstrations outside our . . . home":** David Rockefeller, *Memoirs* (New York: Random House, 2002), 20–21.
 "Ludlow was a rite of passage for Father": ibid.

163 **"The house was filled with art":** ibid., 23–24.
 "Father's pride and joy": ibid., 25.

164 **It was the spark:** Loebl, *America's Medicis*, 7–8.
 "I have made many visits to the Museum": JDR Jr. to JDR Sr., January 28, 1915, et seq., Rockefeller Archives.
 "I feel afraid of it": JDR Sr. to JDR Jr., January 29, 1915.
 "I have never squandered money": JDR Jr. to JDR Sr., January 31, 1915.

165 **"Father maintained his interest":** David Rockefeller, *Memoirs*, 25.
 "For Junior, they represented an ideal art form": Chernow, *Titan*, 622.

166 **Along with the vase came a letter:** Edgar Gorer to JDR Jr., February 3, 1915; Rockefeller Family Archives, Record Group III: 21, Box 133; Home Series (10 West 53rd Street); Porcelain Invoices, 1908–1932.
 On February 19, Junior asked: ibid., JDR Jr. to Edgar Gorer, February 19, 1915.
 The following day: ibid., Gorer to Junior, February 20,1915.
 Unsatisfied and wary: ibid., JDR Jr. to Edgar Gorer, February 23, 1915; Gorer to Junior, March 8, 1915.

167 **Junior then wrote on March 16 that it was hard:** JDR Jr. to Gorer, March 16, 1915.
 News of the lawsuit made the front page: see no byline, "Rival Sues Duveens/Asks for $575,000," NYT, May 7, 1915.
 However, by grim coincidence: see no byline, "Fifty New Yorkers/Lost in First Class," NYT, May 9, 1915.
 Regarding Gorer's sacrifice, see no byline, "Swam Four Hours/From Lusitania," NYT, June 6, 1915. For further details on Gorer, see essay by Prof. Nick Pearce, Department of Art History, University of Glasgow, "Gorer v. Lever: Edgar Gorer and William Hesketh Lever" (accessible online, no date).

169 **the country's licensed heretic wrote of him:** see H. L. Mencken, *Prejudices: Fifth Series* (New York: Knopf, 1926), 287–288.
 after coffee, Matisse turned to Junior: as related by Loebl, *America's Medicis*, 141.

In sum, Matisse concluded: ibid.

One can imagine the expectant hush: ibid., 149–150.

170 **"in deference to Mrs. Rockefeller's feeling":** JDR Jr. to Mr. Miya at Yamanaka, June 13, 1924, Rockefeller Family Archives.

171 **"It is from Greece":** see Stanley K. Abe, "Rockefeller Home Decorating and Objects from China," in Vimalin Pujivachical, ed., *Collecting China* (Newark: University of Delaware Press, 2011), 112 et seq.

172 **"My offer of $175,000":** JDR Jr. to Mr. Miya at Yamanaka, January 20, 1925, Rockefeller Family Archives.

"Thanks you for this and congratulating Mrs. Rockefeller on securing these world-treasures": Mr. Miya at Yamanaka, January 21, 1925, Rockefeller Family Archives.

"A research report on the market's mutability": see Daisy Yiyou Wang, "Art Dealers, the Rockefellers and the Network of Chinese Art in America," a report presented in 2008 to the Rockefeller Archive Center, accessible online at http://www.rockarch.org/publications /resrep/pdf/wang.pdf, 1–2.

173 **"C. T. Loo ingeniously turned":** ibid., 5–6.

"because of our troubles" and **As to flattery:** ibid., 69–70, 183.

"There is no deity more worshiped": Fong Chow, "Symbolism in Chinese Porcelain," *Metropolitan Museum of Art Bulletin,* New Series, Vol. 21:1 (Summer 1962), 17.

Chapter Eleven: The Mandarin

176 **rated as "China's greatest age":** John King Fairbank, *China: A New History* (Cambridge, MA: Harvard University Press, 1992), 93–99.

finally at the palace level: ibid.

177 **According to his recent biographer:** see Elya Jun Zhang, *Spider Manchu: Duanfang as Networker and Spindoctor 1901–1911* (doctoral dissertation, University of California, 2008).

Others, notably including the veteran scholar: see Thomas Lawton, *A Time of Transition: Two Collectors of Chinese Art* (Lawrence: Spenser Museum of Art, University of Kansas, 1991), 14; and Edward J. M. Rhoads, *Manchus and Han: Ethnic Relations and Political Power in Late Qing and Early Republican China, 1861–1928* (Seattle: University of Washington Press, illustrated reprint), 55.

Zhang describes what greeted: see Zhang, *Spider Manchu.*

179 **"Tuan Fang was really the hero":** see no byline, "Mission Boards Host to Chinese Envoys/'No East, No West,' Dr. Butler Quotes at Dinner," NYT, February 3, 1906.

TR, who responded in part: Lawton, *A Time of Transition,* 53.

180 **At the Metropolitan Museum:** ibid., 10.

In truth, Duanfang's curiosity: for a thorough appraisal of this breakthrough mission, see conference papers in Atlanta (2008) and Philadelphia (2010) of the Asian Studies Association, notably Elya Jun Zhang, "Bronze Diplomacy: Duanfang as an Imperial Commissioner in Europe and America," accessible online at http://asian-studies.org/absts/China /C-19 .htm.

The Princeton scholar Lara Jaishree Netting cites: see Netting, *Acquiring Chinese Art and Culture: The Collections and Scholarship of John C. Ferguson* (dissertation, Princeton University, 2009).

181 **"spread to other parts of Shang China":** Jan Fontein and Tung Wu, *Unearthing China's Past* (Boston: Museum of Fine Arts/New York Graphic Society, 1973), 41–42.

182 **As Thomas Lawton writes:** Lawton, *A Time of Transition,* 65.

"almost every museum": ibid., 132.

"greatest breaches against": see no byline, "Tuan-Fang's Degradation: A Woman's Influence and Selfish Dynasty Responsible for It," NYT, January 2, 1910.

183 **In these desperate circumstances:** see Edwin J. Dingle, *China's Revolution 1911–1912* (New York: McBride, Nast & Co., 1912), 235.

"was looked upon as the prince of officials": ibid., 236.

There are conflicting accounts: see NYT dispatches from China dated December 19, 1911, and December 30, 1911, and appraised by both Lawton, *A Time of Transition,* and Netting, *Acquiring Chinese Art and Culture.*

184 **"According to a story prevalent in Peking"**: see Lawton, *A Time of Transition,* 62–63.
185 **"This table with its complete set of sacrificial vessels"**: Ferguson to Bosch Reitz, July 28, 1923, 35.146 Curatorial Files, Far Eastern Art, MMA.
 "There is a lady with her son": Ferguson to Bosch Reitz, October 29, 1923, 35.146 Curatorial Files, Far Eastern Art, MMA.
186 **"Fortunately, I have been"**: Ferguson to Bosch Reitz, January 10, 1924, 35.146 Curatorial Files, Far Eastern Art, MMA.
 All eyes were on the "Min Fanglei": details from "More Than $30 Million for Massive Ancient Chinese Bronze Vessel at Christie's," Nord on Art Blog, March 30, 2014.
 "were created as emblems of power": Eileen Kinsella, "Christie's CEO was 'Panicked' Over Chinese Buyer Default, Leading to Private Sale of Ancient Bronze," News.Artnet.com newsletter, March 30, 2014.
 Elya Zhang has earned a final word: Elya Jun Zhang, *Spider Manchu,* 363.

Chapter Twelve: Canada's Tryst with China
190 Regarding ROM's guardian lions, see Jennie Thomas Parker, "Chinese Guardian Lions at the Royal Ontario Museum, *Orientations,* Vol. 25:2 (February 1994), 53–57.
191 **The Royal Ontario Museum owes its creation**: see details in Dennis Duffy, "Triangulating the ROM," *Journal of Canadian Studies,* Vol. 40 (2006), 157–169; see also Marguerite Van Die, *Religion and Public Life in Canada* (Toronto: University of Toronto Press, 2001).
192 **"Any Toronto middle-class parent"**: Duffy, "Triangulating the ROM," 158. See also Charles Trick Currelly, *I Brought the Ages Home* (Toronto: Ryerson Press, 1956), passim.
 "I've seen nothing like them": Currelly, ibid., 243–244.
 "the highest honour that there is": ibid.
193 **"the extraordinary grave figures"**: Langdon Warner, "The Crofts Collection," 194.
 As Warner elaborated: ibid.
 "Chinese art" is "a quite recent invention": Craig Clunas, *Art in China* (Oxford: Oxford University Press, 1997), 9.
195 **"In the archaeological scramble"**: John King Fairbank, *Chinabound: A Fifty-Year Memoir* (New York: Harper & Row, 1982), 58.
 "a tubular blade": Peter Hessler, *Oracle Bones: A Journey through Time in China* (New York: Harper Perennial, 2007), 4.
 "Plainly this was no fly-by-night": Fairbank, *Chinabound,* 59.
 "Come laugh with me": quoted in Lewis Walmsley, *Bishop in Honan: William C. White* (Toronto: University of Toronto Press, 1974), 73.
195 **"He was driven by a restless eagerness"**: ibid., 108.
197 **"With his slight lithe frame"**: ibid.
 we have a visual witness: for a partial reproduction and analysis of *The Ching-Ming Festival on the River,* see Bradley Smith and Wan-go Weng, *China: A History in Art* (New York: Doubleday, 1972), 160–169.
198 **"The letter said that Bishop White"**: quoted in Currelly, *I Brought the Ages Home,* 251.
199 **"we now have one of the most impressive groups of paintings"**: ibid.
 As John Ferguson . . . comments: see John Ferguson, "Forward," in White, *Tombs of Old Lo-yang* (Shanghai: Kelly & Walsh Ltd., 1934), xxi.
 All this was freshly debated: see Linfu Dong, *Cross Culture and Faith: The Life and Work of James Mellon Menzies* (Toronto: University of Toronto Press, 2005), passim.
200 **In all, Menzies collected**: see Geoffrey York, "The Unsung Canadian Some Knew as 'Old Bones,'" *Globe and Mail* (Toronto), January 19, 2008, updated March 30, 2009.
 "With the conquest of the Shang dynasty": John King Fairbank, *China,* 39.
201 **When not shoveling, Menzies pursued**: see Dong, *Cross Culture and Faith,* 288–295.
202 **"Shortly before his death"**: see ibid., Chapter Six, "The Search for a New Evangelism," passim.
203 **Sixteen books and monographs**: see Michael Posner, "Arthur Menzies Was a[n] Extraordinary Diplomat for 40 Years," *Globe and Mail* (Toronto), March 21, 2010.

204 **Here, for the first time in North America:** fittingly, the May 2014 issue of *Orientations* (Vol. 45, No. 4) was devoted to ROM's anniversary and to the Forbidden City exhibition, including key articles by Curator Chen Shen.

Chapter Thirteen: Painting Power

208 **"Let me say to the business men":** *Congressional Record,* June 14, 1898, quoted in Meyer and Brysac, *Tournament of Shadows,* 398.

"The heroes of Homer's Iliad": quoted in "1904 World's Fair: Looking Back at Looking Forward," Missouri Historical Society, http://mohistory.org/exhibits/Fair/WF/HTML/Overview/.

210 **Although the Chinese":** information from Kristina Kleutghen, "Chinese Art at the 1904 World Expo," quoting Theodore Hardee, "China's Remarkable Exhibit at the World's Fair," NYT, August 28, 1904, http://kristinakleutghen.com/2010/06/30/chinese-art-at-the-1904-world-expo/.

"dummy figures of Chinese men": Hardee, "China's Remarkable Exhibit at the World's Fair."

"decidedly crowded": *The Louisiana Purchase Exposition* (St. Louis, MO: Universal Exposition Publishing Company, 1905), 287; and Carol Ann Christ, "'The Sole Guardians of the Art Inheritance of Asia': Japan and China at the 1904 St. Louis World's Fair," *Positions,* Vol. 8:3 (Winter 2000), 701.

Information from *The Louisiana Purchase Exposition,* 291.

211 **"he has done more than any other man":** W. A. P. Martin, *A Cycle of Cathay,* 411, quoted in Julia Boyd, *A Dance with the Dragon: The Vanished World of Peking's Foreign Colony* (New York: I. B. Tauris, 2012), 52.

"A marvellous man and yet": Charles Stewart Addis, memoir (n.d., but post-1885), HSBC archives, S016/002c, quoted in Boyd, *A Dance with the Dragon,* 36.

Regarding Dowager Empress Cixi and Sir Robert Hart, see Seagrave, *Dragon Lady,* 452. The *Oxford Dictionary of National Biography* gives Hart's wealth at death as £140,260 4s.6d. See Frank H. H. King, "Hart, Sir Robert, first baronet (1835–1911)," *Oxford Dictionary of National Biography* (Oxford: Oxford University Press, 2004), http://0-www.oxforddnb.com.library.nysoclib.org/view/article/33739.

"She is very breezy": Robert Hart to James Duncan Campbell, Letter 1320, March 6, 1904, John King Fairbank, Katherine Frost Bruner, Elizabeth MacLeod Matheson, eds., *The I.G. in Peking: Letters of Robert Hart* (Cambridge: Harvard University Press, 1975), Vol. II, 1401.

212 On Louisa Yu Keng's family, see Grant Hayter-Menzies, *Imperial Masquerade: The Princess Der Ling* (Hong Kong: Hong Kong University Press, 2008), 197.

ordering express eight yards of canvas: Robert Hart to James Duncan Campbell, Letter 1292, September 6, 1903, and Letter 1301, November 8, 1903, Fairbank et al., *The I.G. in Peking,* Vol. II, 1370–1371, 1379.

213 **"Her Majesty was dressed":** Katherine A. Carl, *With the Empress Dowager* (New York: Century Company, 1905), 216.

"I used the iron pincers": ibid., 217–218.

"I don't want people": Princess Der Ling, *Two Years in the Forbidden City* (New York: Dodd, Mead, 1931), 211.

"I had dreamed": Carl, *With the Empress Dowager,* 163.

215 Information from Robert Hart, Letter 1329, May 27, 1904, Fairbank et al, *The I.G. in Peking,* 1414, and Carl, *With the Empress Dowager,* 55.

"for it was not considered fitting": Carl, *With the Empress Dowager,* 294 et seq.

Transport of the "Sacred Picture," *The Louisiana Purchase Exposition,* 292.

217 **"We have hit it off admirably":** Kenneth Wimmel, *William Woodville Rockhill: Scholar-Diplomat of the Tibetan Highlands* (Bangkok: Orchid Press, 2003), 109.

"From Taku to Peking": William Rockhill to Nannie Lodge, December 3, 1900, quoted in Howard K. Beale, *Theodore Roosevelt and the Rise of America to World Power,* 187.

218 **"Extending the Blessings of Civilization":** Mark Twain, "To the Person Sitting in Darkness," *North American Review,* Vol. 172:531 (February 1901), accessible online at https://www.msu.edu/~mageemal/iah201/darkness.pdf, 116.

"Two thousand officials": see no byline, "The Court Back in Peking," NYT, January 8, 1902.

220 **"Her feelings overcame her":** Sarah Pike Conger, *Letters from China: With Particular Reference to the Empress Dowager and the Women of China* (Chicago: A. C. McClurg & Co., 1909), 219–220.

called her "simple-minded": in J. O. P. Bland and E. Backhouse, *China Under the Empress Dowager* (London: William Heinemann, 1911), 290 fn.

"The address which Mrs. Conger": Bland to Morrison, February 12, 1902, in Lo Hui-Min, ed., *Correspondence of G. E. Morrison,* Vol. 1 (Cambridge: Cambridge University Press, 1976–78), 178–179.

"the most revolutionary event": *The Times* (London), February 3, 1902, quoted in Lo Hui-Min, *Correspondence of G. E. Morrison,* 178.

221 **"considerable intimacy with the infernal old harridan":** George Morrison to Valentine Chirol, September 7, 1903, in Lo Hui-Min, *Correspondence of G. E. Morrison,* 230.

"For many months": Sarah Pike Conger to Laura Conger, in Conger, *Letters from China,* 247.

"I am a seeker in China": quoted in Hayter-Menzies, *Imperial Masquerade,* 193.

"the foreign ministers requested that no presents": Conger, *Letters from China,* 224.

222 **"the fine flowers of diplomacy":** see Eliza Scidmore, *China: The Long-Lived Empire* (New York: Century, 1900), 146.

"Official European residences": ibid., 144.

"sustained by the certainty": ibid., 145.

Very likely the furnishing: "Interesting Life History of Minister Conger," *San Francisco Call,* July 17, 1900, quoted in Hayter-Menzies, *Imperial Masquerade,* 283.

223 **"It is not quantity":** Conger, *Letters from China,* 260.

"Of late, I have been able": Sarah Conger to her daughter Laura, July 20, 1903, ibid., 258.

"United States Branded as 'Fence'": *Evening World,* February 25, 1908, quoted in Hayter-Menzies, *Imperial Masquerade,* 267.

"Big Profit on a Fine Rug": NYT, February 22, 1908.

224 **"We admit free of charge":** ibid.

"'How . . . would you Americans'": *Congressional Record,* April 18, 1908, 60th Congress/First Session, 4930–4931, quoted in Hayter-Menzies, *Imperial Masquerade,* 268.

"I have much of old, rich Chinese embroideries": Sarah Conger to Charles L. Freer, July 28, 1919, Freer/Sackler Archives, transcribed by Hayter-Menzies, *Imperial Masquerade.*

226 On William Rockhill's donations, see Alicia Campi and Denys Voaden, "William Woodville Rockhill's Mongolian Travel Literature of the 1890s: The Image of Mongolia in European and Asian Travel Literature," Ulaanbaatar, Mongolia, July 7–9, 2005, www.mtac.gov .tw/mtacbook/upload/09607/0701/03.pdf.

226 **"We stood in holy terror":** Nelson Johnson, Oral History, Columbia University, quoted in Meyer and Brysac, *Tournament of Shadows,* 400.

"Some men can have adventures": *Saturday Evening Post,* January 27, 1900, quoted in Wimmel, *William Woodville Rockhill,* xv.

227 **"My outfit was simple":** William Rockhill, *Land of the Lamas: Notes of a Journey through China, Mongolia and Tibet* (New York: Century, 1891), 288, quoted in Meyer and Brysac, *Tournament of Shadows,* 406.

"clothed in sheepskin gowns": Rockhill, *Land of the Lamas,* 56.

"strolled through streets": Meyer and Brysac, *Tournament of Shadows,* 408.

228 **"How to travel on an empty money bag":** William Rockhill, "Explorations in Mongolia and Tibet," Annual Report, Board of Regents, Smithsonian Institution (1892), 659.

"I swallowed with my miserable food": quoted in Meyer and Brysac, *Tournament of Shadows,* 410.

229 **"I am ten days from Shigatse":** ibid., 410–411.

"I am lost in astonishment": ibid., 398.

"I feel as if a load": Theodore Roosevelt to William Rockhill, July 21, 1900, Rockhill Papers, MS Division, LOC.

230 **"Though he was very tall":** quoted in Wimmel, *William Woodville Rockhill,* 152.

"I had imagined": Rockhill to Roosevelt, June 30, 1908, Theodore Roosevelt Papers, MS Division, LOC.

231 **"He is quick tempered":** William Rockhill, *The Dalai Lamas of Lhasa*, 90–92, quoted in Meyer and Brysac, *Tournament of Shadows*, 418.

"I think that this is one": Roosevelt to Rockhill, August 1, 1908, Rockhill Papers, LOC, quoted in Meyer and Brysac, *Tournament of Shadows*.

On the Dalai Lama's gifts, see Susan Meinheit, "Gifts at Wutai Shan: Rockhill and the Thirteenth Dalai Lama," *Journal of the International Association of Tibetan Studies*, no. 6 (December 2011), http://www.thlib.org/collections/texts/jiats/?_escaped_fragment_=jiats=/0 6/meinheit/.

"raise poultry and flowers": Rockhill to J. O. Bland, March 29, 1913, quoted in Wimmel, *William Woodville Rockhill*, xv.

232 **"Mr. Rockhill was a man of extreme modesty":** Berthold Laufer, *T'oung Pao*, Second Series 16, No. 2 (May 1915), 290.

For Hart's departure, see Boyd, *A Dance with the Dragon*, 52.

For the Old Buddha's afterlife, see Seagrave, *Dragon Lady*, 462.

Chapter Fourteen: Threads of Heaven

235 **"without knowing a single thing about the country":** quoted in Elinor Pearlstein, "Color, Life, and Moment," in John E. Vollmer, ed., *Clothed to Rule the Universe: Ming and Qing Dynasty Textiles at the Art Institute of Chicago*, Art Institute of Chicago Museum Studies, Vol. 26:2 (Chicago: Art Institute of Chicago, 2000), note 10, 107.

"A perpetual merry-go-round of parties": quoted in Boyd, *A Dance with the Dragon*, 65.

237 **"Manchu ladies are":** Harriet Monroe, *A Poet's Life: Seventy Years in a Changing World* (New York: Macmillan, 1938), 233.

"A glass of sherry, a cigarette, a French newspaper": quoted in Boyd, *A Dance with the Dragon*, 73.

238 **"Of course I don't deserve such attentions":** Freer to Hecker, October 13, 1910, quoted in Lawton and Merrill, *Freer*, 87.

"hot on the trail": Monroe, *A Poet's Life*, 234.

"He had in mind": ibid., 235.

"brought native bidders from every province": Juliet Bredon, *Peking: A Historical and Intimate Description of its Chief Places of Interest* (Shanghai: Kelly & Walsh Ltd., 1931), 455.

239 **"When one has seen all the palaces":** ibid., 443–444.

"The biggest, and the cleanest shops": ibid., 444–445.

"the greatest curio street in the world": Lucy Calhoun, "Streets of Peking," NYT, November 26, 1922.

240 **"Never forget the enthusiasm":** Bredon, *Peking*, 450–451.

"How horrible," opined . . . Rockhill: quoted in Paul Reinsch, *An American Diplomat in China* (Garden City, NY: Doubleday, 1922), 30.

"that the Manchu princes are selling their treasures": Lucy Calhoun to Harriet Monroe, February 26, 1912, Harriet Monroe Personal Papers (note 15), Folder 3, Newberry Library, quoted in Pearlstein, "Color, Life, and Moment," note 22, 109.

241 **"I do not wonder that they thought the things modern":** Lucy Calhoun to Mrs. Charles H. Hutchinson, February 13, 1913, Art Institute of Chicago Archives, quoted in Pearlstein, "Color, Life, and Moment," 6.

"There is a strange thing about foreigners": quoted in Reinsch, *An American Diplomat in China*, 161

One of "Aunt Lucy's" parties: George Kates to Frances Francis, September 5, 1933, Henry Sayles Francis Papers.

242 Details on Peking University Medical College, see "Reminiscences of John Black Grant: Oral History," Columbia Center for Oral History (1961).

243 **they arrived "in avalanches":** see Alan Priest, *Costumes from the Forbidden City*, 1945, MMA, http://libmma.contentdm.oclc.org/cdm/ref/collection/p15324coll10/id/1170.

244 On Charlotte's textile collections, see Alice Zrebiec and Micah Messenheimer, *Threads of Heaven: Silken Legacy of China's Last Dynasty* (Companion to Qing Dynasty Textiles at the

Denver Museum), 12; and Vollmer, *Clothed to Rule the Universe,* (Chicago: Art Institute of Chicago in association with University of Washington Press, 2000), 34.

245 **"undertook many shady dealings":** in Lo Hui-Min, *Correspondence of G. E. Morrison,* Vol. I, 524, notes 3, 4.

246 **"very modern, very chic, very European":** Ellen N. La Motte, *Peking Dust* (New York: Century, 1919), 74.

"At heart, I was a foreigner": Princess Der Ling, *Two Years in the Forbidden City* (New York: Dodd, Mead, 1931), 382.

"the last surviving member of the Chinese royal family": Hayter-Menzies, *Imperial Masquerade,* 327.

"It was as if a foreign diplomat": quoted in Boyd, *A Dance with the Dragon,* 152.

"a deposed empress, still clad in the remains of her imperial wardrobe": quoted in ibid.

247 **it was a paradise for foreigners:** Helen Foster Snow, *My China Years: A Memoir* (New York: Morrow, 1984), 94.

"The Forbidden City was no longer forbidden": Monroe, *A Poet's Life,* 445.

"In Peking we all have collections": Acton, *Peonies and Ponies,* 45.

248 For information on Priest's life in Peking from Joseph M. Upton and Edward C. Wells, *Alan Reed Priest* (privately printed, 1970), 20.

249 For information on temple visit, ibid., 21–22.

"were crowding around the magnificent tomb": Acton, *Memoirs of an Aesthete,* 278–279.

250 **"was given to performing":** Alan Priest to Paul Sachs, February 26, 1927, Paul J. Sachs Files, HAMA.

"Late one night there was a knock on Sickman's door": information from interview with Colin Mackenzie and Stephen Addiss in *Oriental Art,* Vol. 30:2 (Summer 1978), 229.

"the things I seek are seeking me": quoted in Churchman, "Laurence Sickman and the Formation of the Chinese Collection."

251 Regarding the removal of objects from Palace Collection, see James Cahill, "Two Palace Museums: An Informal Account of their Formation and History," *Kaikodo Journal* XIX (2001), http://jamescahill.info/the-writings-of-james-cahill/cahill-lectures-and-papers/236-clp -41-2001-qtwo-palace-museums-an-informal-account-of-their-formation-and-historyq -kaikodo-journal-xix-2001; Willow Hai Chang, *The Last Emperor's Collection: Masterpieces of Painting and Calligraphy from the Liaoning Provincial Museum* (New York: China Institute Gallery, 2008), 2–3; Jeannette Shambaugh Elliot with David Shambaugh, *The Odyssey of China's Imperial Art Treasures* (Seattle: University of Washington Press, 2005), 56 et. seq. On Sickman's acquisitions from Puyi, information provided by Marc Wilson in 2014 interview.

252 On Lucy Calhoun's collecting, see Pearlstein, "Color, Life and Moment," 83 et. seq.

"China is now a subject of interest to everyone": Carl Whiting Bishop, quoted in Daisy Wang, *The Loouvre from China,* 39.

Chapter Fifteen: The Authenticator

253 **"a small-boned European":** Henry Field, "Berthold Laufer," October 6, 1976, in Berthold Laufer, *Kleinere Schriften Publikationen aus der Zeit von 1911 bis 1925,* ed. by Hartmut Walravens (Wiesbaden: Steiner, 1976), 2.

"I am becoming mummified": quoted in Bennet Bronson, "Berthold Laufer," *Fieldiana Anthropology,* New Series, no. 36, *Curators, Collections, and Contexts: Anthropology at the Field Museum, 1893–2002* (September 30, 2003), 121. Biographical information in Bronson, "Berthold Laufer," 118.

"the fossil rhinoceroses have not yet become extinct": ibid., 125.

254 **"I shall place the ethnography and archaeology":** see Laurel Kendall, "China to the Anthropologist: Franz Boas, Berthold Laufer, and a Road Not Taken in Early American Anthropology," in Regna Darnell and Frederic W. Gleach, eds., *Anthropologists and Their Traditions across National Borders* (Lincoln and London: University of Nebraska Press, 2014), 1.

255 **"the bearers of progress":** Max Weber, *Essays in Sociology,* Hans Gerth, ed. (Oxford: Oxford University Press, 1946), 416.

Biographical information from K. S. Latourette, "Biographical Memoir of Berthold Laufer 1874–1934," National Academy of Sciences (1937), 43–44.

256 **"collections which illustrate the popular customs":** Franz Boas to Morris Jesup, December 27, 1902, MSS E973, Library Special Collections Archives, AMNH, quoted in Kendall, "China to the Anthropologist," 11.

Information on Schiff expedition, John Haddad, "To Inculcate Respect for the Chinese," *Anthropos*, Vol. 101:1 (2006), 129.

257 **"instead of undertaking fieldwork":** Jan Fontein and Tung Wu, *Unearthing China's Past* (Boston: Museum of Fine Arts, 1973), 16.

"duty of rescuing perishing cultures": Berthold Laufer, "Modern Chinese Collections in Historical Light, with Especial Reference to the American Museum's Collection Representative of Chinese Culture a Decade Ago," *American Museum Journal*, Vol. 12 (1912), 137.

"There is no path I did not walkover": Berthold Laufer to Franz Boas, November 9, 1901, AMNH, Anthropology Archives, quoted in Haddad, *The Romance of China*, 132.

his haul was staggering, 7,500 objects: see Kendall, "China to the Anthropologist," 9, 10; Haddad, *The Romance of China*, 134. (Their totals differ: Kendall says 7,500, Haddad more than 10,000.)

"myself to be better and healthier": Bronson, "Berthold Laufer," 118.

258 **"Chinese culture is in my opinion":** Laufer to Boas, June 3, 1903, AMNH, Anthropology Archives.

"wishing he were Chinese": Bronson, "Berthold Laufer," 124.

"Please do not think that making collections": Laufer to Boas, February 28, 1902, quoted in Laurel Kendall, "A Most Solitary Expeditionist: Berthold Laufer Collecting China," (to be published in 2015 as part of the Bard College Anthropology of Expeditions).

"The chances are now upset, the romance of China has died": Laufer, "Modern Chinese Collections in Historical Light," 37–138.

"gross neglect": Laufer to Boas, April 27, 1911, Boas-Laufer Correspondence, Ms. Division, American Philosophical Society, quoted in Haddad, *The Romance of China*, 142. The results of Laufer's collecting may be seen digitally on the AMNH website: http://anthro.amnh.org/asia.

For information on the Field collection, see Bronson, "Berthold Laufer," 120.

259 **two paintings to Charles Freer:** Bronson, "Berthold Laufer," 122.

For information on the catalogue of archaic jades, see Elinor Pearlstein, "Early Chicago Chronicles of Early Chinese Art," fn. 12, 35, in Jason Steuber and Guolong Lai, eds., *Collectors, Collections and Collecting the Arts of China*.

260 **"Do you really, seriously, believe":** Laufer to Boas, Peking, February 1, 1902, Boas papers, American Philosophical Archives, quoted in Walravens, ed., *Kleinere Schriften*, Vol. 3, pp. 5, 58.

"I have seen one other like it, but it was in a state of ruin": *Kansas City Times*, November 9, 1931.

261 **"I was surprised to find in your residence":** Laufer to Frederic N. Pugsley, November 9, 1931, enclosed in the letter from H. V. Jones to Langdon Warner, November 12, 1931, Box 12, HUA.

One of the trustees had written to him complaining: H. V. Jones to Langdon Warner, November 12, 1931, Box 12, HUA.

Information on the disposition of the Pugsley collection provided by Holly Wright, NAMA.

263 **"In the past year I have been able":** William Poundstone, "Los Angeles County Museum on Fire," Blou in Art Info blog, April 15, 2010, http://www.blouinartinfo.com/blog/los-angeles-county-museum-on-fire/jwn-munthe-international-man-of-mystery.

As reported by the scholar Derek Gillman: see Gillman, "General Munthe's Chinese Buddhist Sculpture: An Embarrassment of Riches" in Tadeusz Skorupski, ed., *Buddhist Forum IV,* Seminar Papers 1994–96, 98, http://www.shin-ibs.edu/academics/_forum/v4.php.

"I was convinced from the first": Karen Lansky and J. Keith Wilson, "Los Angeles before LACMA: Chinese Art at the Old County Museum," *Orientations*, Vol. 31:6 (June 2000), 48.

"It is no exaggeration": Berthold Laufer, "Report on the General J. W. N. Munthe Collection," in Walravens, *Kleinere Schriften*, Vol. 3, Briefwechsel, 283 et. seq.

264 **"Anyone who is interested [should] ask"**: Lansky and Wilson, "Los Angeles before LACMA," 48.

 "the collection is of such doubtful authenticity": ibid., 49.

 its acquisition was a "terrible mistake": ibid.

 "It's entirely clear that they knew what they were after": News in English (Norway), January 7, 2013.

265 **a forged inscription on a miniature inscribed Tang sarcophagus**: see Laufer, "Chinese Sarcophagi," *Ostasiatische Zeitschrift* I (1912–13), 318–334; and Jan Fontein, "Berthold Laufer and the Case of the Inscribed Sarcophagus," *Journal of the Museum of Fine Arts, Boston,* Vol. 5. (1993), 4–23.

 "Chinese vandalism, greed, and lack of patriotism": quoted in Cohen, *East Asian Art and American Culture,* 108.

Chapter Sixteen: Streams and Mountains

267 **The way was led in 1961**: for details, see catalogue, *Chinese Art Treasures* (Washington, DC: Skira/National Gallery of Art, 1961), with commentary by James Cahill, Aschwin Lippe, and John A. Pope.

268 **Their next move was to Washington**: see Mary Stokrocki, "The Making of a Curator: An Interview with Sherman Lee," *Art Education,* Vol. 36:3 (May 1983), 24–25.

 There in 1938 he met Ruth Ward: quoted in Bruce Weber, "Sherman Lee, Who Led Cleveland Museum of Art, Dies at 90," NYT, July 11, 2008.

269 **Ruth and Sherman are well portrayed**: see Mary Ann Rogers, "Sherman E. Lee," *Orientations,* Vol. 24:7 (July 1993), 46.

 Through such hands-on techniques: see John M. Rosenfield, "Sherman Lee: Early Encounters with Asian Art," *Orientations,* Vol. 36:1 (January–February 2005), 44–49.

270 **Here is Lee's firsthand account**: quoted in Rogers, "Sherman E. Lee."

271 **According to Lee: "It filled one good-sized living room"**: ibid.

273 **We owe to Wai-kam Ho**: see Wai-kam Ho, "Remembrances of Lake Erie," *Orientations,* Vol. 36:1 (January–February 2005), 101–102.

 Writing in his well-received: Sherman Lee, *A History of Far Eastern Art* (New York: Prentice Hall and Abrams, rev. ed., 1973), 7, 9.

 As excavated . . . by the scholar: Noelle Giuffrida, "Paintings, Politesse and Petromania: Sherman Lee and the Art and Archaeology Delegation Trip to China," *Archives of American Art Journal,* Vol. 52:1–2 (Fall 2013), 42.

274 **Lee described the work**: Sherman Lee, *A History of Far Eastern Art,* 350–351.

275 **After Lee's death at age ninety**: see Bruce Weber, "Sherman Lee, Who Led Cleveland Museum of Art, Dies at 90."

276 **A letter dated March 4, 1965**: Sherman Lee to Rockefeller, March 4, 1985, Rockefeller Archives, JDR, 3rd Series, Box 50, Folder 429.

277 **Hochstadter managed to export his prize works**: information provided to authors by Noelle Giuffrida of the Asian Art Department, Case Western Reserve University; see also Steven Litt, "How Sherman Lee Built a Great Chinese Painting Collection," *Cleveland Plain Dealer,* September 24, 2013.

 "When a curator comes back and says he discovered": quoted by Rogers, "Sherman E. Lee."

278 **"His achievement in the Oriental field"**: Geraldine Norman, "An Orientalist in Manhattan," *Independent* (London), June 26, 1994.

 As he wrote Rockefeller: R. H. Ellsworth to John D. Rockefeller III, December 31, 1974, Rockefeller Archives, JDR, 3rd series, Box 50.

279 **What followed was recalled in 1977 by Marc Wilson**: undated interview with Nick Pickard, typed transcript, HAMA.

 "The return flight to Chungking": see Marc Wilson, "Laurence Sickman," in Churchman, *Laurence Sickman.*

280 **as Marc Wilson noted in 1988**: in Churchman, *Laurence Sickman.*

281 **and Lee later remarked that his role:** see Giuffrida, "Paintings, Politesse and Petromania," 38.

"What we call the Bronze Age": as quoted in Helen Borsick Cullinn, "Cleveland Expert Finds China Still Treasures Its Art," *Cleveland Plain Dealer,* December 30, 1973 (among many clippings preserved in Freer archives).

"Through Larry's connections": see James Steuber, "Tradition and Innovation: Director Marc F. Wilson and Chinese Art at the Nelson-Atkins Museum of Art," *Orientations,* Vol. 39:8 (January–February 2008).

282 **The last words belong:** Sherman Lee to Laurence Sickman, June 1986, NAM Archives.

Chapter Seventeen: The Met's Marathon

283 **As early as 1923:** see René Gimpel, *Diary of an Art Dealer* (New York: Farrar, Straus & Giroux, 1966), 216; "Thirty-three years later," quoted in Jean Lacouture, *André Malraux* (New York: Pantheon, 1975), 387.

"It is a palace of art": see Henry James, *The American Scene* (New York: Horizon Press, 1967), 191–192.

285 **But with the outbreak of the European war:** see no byline, "Art of Far East a Museum Feature," NYT, June 18, 1915.

As summarized by: in Tomkins, *Merchants and Masterpieces,* 167.

The shipment's press reception: see "News of the Art World," *New York World,* February 1, 1914; and NYT, January 27, 1914, cited in Cohen, *East Asian Art and American Culture,* 70.

286 **Creditably, Freer emphasized:** ibid., 69–70.

In a prescient but unconventional decision: see Rita Reif, "The Master Builder Whose Other Life Helped Pay the Bills," NYT, March 18, 2001.

287 **"The only remembered instance":** an anonymous appreciation of Bosch Reitz in *Century Memorials 1938* (Century Association Archives, 1939).

As recalled to us by James C. Watt: author interview with Watt, May 23, 2014.

288 **A childhood friend . . . recalls:** Joseph M. Upton and C. Edward Wells, *Alan Reed Priest* (privately published, 1970), Harvard Fine Arts Depository, passim.

"Harvard sent me to Tun Huang": Alan Priest to James Cahill, February 9 1955, Cahill correspondence, FSGA.

289 **Priest on occasion described his own conclusions:** Tomkins, *Merchants and Masterpieces,* 279.

Lodge discussed some scroll paintings: see Cohen, *East Asian Art and American Culture,* 221.

in a letter to James Cahill: Priest to Cahill, February 9, 1955, Cahill correspondence, FSGA.

"An even better reason . . . is that my Buddhist sect": Alan Priest to James Cahill, February 9, 1955, Cahill correspondence, FSGA.

290 **"the yap and snarl of scholars":** Aschwin Lippe, "Friendly Notes: Part II," addressed to Alan Priest, October 31, 1935, SAAA.

"The prince had been buried with all his concubines": Tomkins, *Merchants and Masterpieces,* 280.

290 **As Priest excitedly assured the young Nelson Rockefeller:** Alan Priest to Nelson Rockefeller, March 16, 1933, Box 31, File 324, Rockefeller Archives.

291 **In his memoirs, Hoving's downgrading was harsher:** Thomas Hoving, *Making the Mummies Dance* (New York: Simon & Schuster, 1993), 361.

Insiders speculate that what may have tipped the balance: Our source was a senior staff member who requested anonymity.

Hoving was present in May 1966: as recalled by Hoving, *Making the Mummies Dance,* 18–20.

292 **to quote James Cuno, head of the Getty Trust:** James Cuno, *Who Owns Antiquity?* (Princeton, NJ: Princeton University Press, 2008), xix.

293 **Dillon and Hoving's strategy was to avoid a general review:** see Meyer, *The Art Museum,* 91–125.

Building on a tradition pioneered by Francis Henry Taylor: ibid.; on Geldzahler, see Hoving, *Making the Mummies Dance*, 205.

The exhibition space for Chinese paintings: see Valerie C. Doran, "Art in Context: The New Galleries for Later Chinese Art at the Metropolitan Museum of Art," *Orientations*, Vol. 28:11 (December 1997), 30.

294 **So wrote Hoving's successor:** Philippe de Montebello, "Preface" to Wen C. Fong, *Beyond Representation: Chinese Painting and Calligraphy, 8th to 14th Century* (New York and New Haven: Metropolitan Museum and Yale University Press, 1992), xii.

Lee characterized the Met's collection as "rather moribund," this was Sherman Lee's judgment in a memorandum to John D. Rockefeller III concerning the "Disposition of his Collection," in the Rockefeller Archives, JDR III Papers, Box 8, Folder 41.

"The story fell out of Wen Fong's mouth": Hoving, *Making the Mummies Dance*, 359–360.

295 **"He would examine all the chops, or seals":** ibid., 205.

Yet even the sale's severest critic: see Carter Horsley, "Chinagate," *City Review* (1997), http://www.thecityreview.com/chinapro.htm.

296 **The last word belongs to:** see Richard M. Barnhart, "Commentary: The Spurious Controversy over *The Riverbank*," *Orientations*, Vol. 30:8 (December 1996), 168.

297 **"With an ability almost beyond anything human":** see Laurence Sickman, Max Loehr, et al., *Chinese Calligraphy and Painting in the Collection of John M. Crawford, Jr.* (New York: Pierpont Morgan Library, 1962), 75–77.

298 **Huizong was "a rapacious collector":** see Wen Fong and Maxwell Hearn, "Silent Poetry: Chinese Paintings from the Douglas Dillon Galleries," *Metropolitan Museum of Art Bulletin* (Winter 1981–82), 15.

"The subtleties of typography": quoted in Susan Heller Anderson, "John M. Crawford, Jr. Dies/Eminent Collector of Chinese Art," NYT, December 25, 1988.

Crawford sought the expert guidance: regarding Joseph Umeo Seo, James Cahill, "CLP 199 Early Chinese Paintings in U.S. Museums: An Insider's View," James Cahill's blog, http://jamescahill.info/the-writings-of-james-cahill/cahill-lectures-and-papers/390-clp-199-early-chinese-paintings-in-us-museums-an-insiders-view.

299 **The traveling exhibition marked the public debut:** see Sickman, Loehr et al., *Chinese Calligraphy and Painting in the Collection of John M. Crawford, Jr.*, 77.

"the most important Northern Song painting in the collection": author interview with Marc Wilson, May 2013.

"At last, you have a space big enough": quoted in Holland Carter, "At Met, New Leadership (and Direction) for Asian Art," NYT, March 16, 2011.

300 **"the finest products of imperial embroidery":** see James C. Watt and Anne E. Wardwell, *When Silk Was Gold: Central Asian and Chinese Textiles* (New York and New Haven: Metropolitan Museum of Art and Yale University Press, 2011), 5.

301 **"It can be seen as sui generis":** James C. Watt, *The World of Khubilai Khan: Chinese Art in the Yuan Dynasty* (New York and New Haven: Metropolitan Museum of Art and Yale University Press, 2011), 3.

"The general rule is that if you want to borrow": see Holland Cotter, "At Met, New Leadership (and Direction) for Asian Art," NYT.

302 **"Mr. Fong deployed a secret weapon":** ibid.

303 **"A superbly executed brushstroke":** Wen Fong and Maxwell Hearn, *Metropolitan Museum of Art Bulletin*.

304 **As Stille concluded:** Alexander Stille, *The Future of the Past* (New York: Farrar, Straus), 70.

Chapter Eighteen: Alien Property

307 **became . . . the Chinese embassy:** Francesco Welti, *Der Baron, die Kunst und das Nazigold* (Frauenfeld: Huber, 2008), 27.

For biographical information see Eberhard Illner, ed., *Eduard von der Heydt: Kunstsammler, Bankier, Mäzen* (Munich, London, New York: Prestel, 2013); and Francesco Welti, *Der Baron, die Kunst und das Nazigold* (Frauenfeld: Huber, 2008).

307 **nicknamed him "Barönchen":** Eberhard Illner, "Eduard von der Heydt–ein Leben in vier Epochen deutscher Zeitgeschichte," in Illner, *Eduard von der Heydt,* 25.

308 **"unsuitable for marriage":** Illner, *Eduard von der Heydt,* 21. In 1872 the Germans enacted a strict criminal law against homosexuality (Article 175),

"The autumn wind sweeps through Amsterdam's": in Sabine Fehlemann, ed., *Asien, Afrika, Amerika und Ozeanien: Eduard von der Heydt als Sammler aussereuropäischer Kunst,* exhibition catalogue, April 14 to June 20, 2002 (Wuppertal: Von der Heydt-Museum, 2002), 11.

C. T. Loo reports visit to his Paris gallery in 1912–13, Illner, *Eduard von der Heydt,* 22.

"one buys the very best": ibid., 74.

"One studies the old dynasties": Helmut Brinker, "A Short History of the Museum Rietberg Zurich," *Orientations,* Vol. 38:2 (March 2007), 103.

from the estate of . . . Raphael Petrucci: Albert Lutz, "Die Irrfahrt des Bodhisattvas: Ein Beitrag zur Geschichte der Kunstsammlung Eduard von der Heydt," *Zurich Studies in the History of Art,* Vol. 13/14 (Zurich: Zurich University Institute History of Art, 2006–7), 342.

"was not supposed to be a museum": Karl With, *Autobiography of Ideas. Lebenserinnerungen eines aussergewöhnlichen Kunstgelehrten* (Berlin: Gebr. Mann Verlag, 1997), 105.

309 **"ridiculously cheap":** Brinker, "A Short History of the Museum Rietberg Zurich," 193.

For information on the Thyssens and von der Heydt, see David R. L. Litchfield, *The Thyssen Art Macabre* (London: Quartet Books, 2006), 85.

"Heydt neither needed or wanted": With, *Autobiography of Ideas,* 106.

"drink beer under a Japanese demon": Press release, 1913 exhibition "From Buddha to Picasso," Rietberg Museum, http://www.rietberg.ch/media/380330/pressetext_e.pdf, 2.

311 **"Russian grand dukes, Parisian cocottes and English Lords":** see Curt Reiss, *Ascona: Geschichte des seltsamsten Dorfes der Welt* (Zurich: Europa Verlag,1964), 92–93, quoted in Deirdre Bair, *Jung: A Biography* (Boston: Little, Brown, 2003) 413.

"His pleasure was to bring together": With, *Autobiography of Ideas,* 191.

312 **"several hundred pieces of which":** ibid., 193.

"The prices were especially low": see *Ostasiatische Zeitschrift* (1935), no 11, 66. Details of the auction are in Esther Tisa Francini, "Zur Provenienz vor vier chinesischen Kunstwerken aus dem Eigentum von Rosa und Jakob Oppenheimer im Museum Rietberg Zürich," in Kerstin Odendahl and Peter Johannes Weber, eds., *Kulturgüterschutz*—Kunstrecht—Kulturrecht (Baden-Baden: Nomos, 2010), 314 et seq.

313 **"The main thing . . . is to distribute":** City Archive of Zurich, Eduard von der Heydt to Luise Peets, April 22, 1940, quoted in Lutz, "Die Irrfahrt des Bodhisattvas," 345.

Kummel information is from Illner, *Eduard von der Heydt,* 43.

Meeting with Hitler is from ibid., 36.

314 **the baron's party card:** see ibid., 33.

Information on Thyssens and von der Heydt provided by Professor Dr. Manfred Rasch, ThyssenKrupp Group Archives, Duisburg.

Information on party card provided to Deirdre Bair, *Jung.*

315 **ninety payments in . . . a dozen currencies:** see Thomas Buomberger, "The Baron's Share?" *ARTnews,* November 1998, 76.

Information on SAFEHAVEN from Donald P. Steury, Central Intelligence Agency, "The OSS and Project Safehaven," https://www.cia.gov/library/center-for-the-study-of- intelligence/csi- publications/csi-studies/studies/summer00/art04.html; CIA and FBI information, Peter Kleinert, "Raubgold–Bankier und Kunst-Mázen." *Neu'Rheinische,* April 4, 2006; and FBI report of J. Edgar Hoover, July 7, 1952, in NARA RG 65 FBI, File 029424. All following FBI reports collected by the researchers Dieter Nelles and Stephan Stracke at http://www.wuppertaler-widerstand.de/FBI-Akten_von_der_Heydt_08.pdf (accessed 2013).

a "somewhat harmless busybody": Illner, *Eduard von der Heydt,* 46.

"pro-German and monarchist": Leland Harrison to Secretary of State, February 25, 1944, FBI report.

316 Police inventory in Illner, *Eduard von der Heydt,* 48–49.

"conducting or organizing the conduct of military intelligence": Reitberg Museum, 1913 press release,

"a man of von der Heydt's social and financial standing": in FBI report of J. Edgar Hoover, July 7, 1952, in NARA RG 65 FBI File 029424.

Swiss authorities hosted a banquet in Heydt's honor: Harold A. Hoeg interview with Dr. Alfred Salmony, May 14, 1954, New York, FBI report 349152, 15.

317 **"the greatest angel in the world":** ibid. Information from Illner, *Eduard von der Heydt*, 42; Jürgen Kahl, "Auf der Suche nach den "letzten Kriegsgefangenen," *Neue Zürcher Zeitung*, March 4, 2014; and Laurie Attias "Looking for Loot at the Louvre," *ARTnews*, April 1998, 74.

318 **"lending without losing":** see Esther Tisa Franchini, Illner, *Eduard von der Heydt*, 195, fn 257, regarding "permanent loan," and Buomberger, "The Baron's Share," 75.

Vesting Order number 18344: Freer Provenance Research, "Fragment of a Standing Bodhisattva," https://www.asia.si.edu/collections/downloads/provenance100813.pdf, 213–214.

On Luebke and Butry, see FBI report of J. Edgar Hoover, July 7, 1952, RG 65 FBI File 029424, NARA.

On Thyba funds, see ibid.

319 **he had received "large amounts of gold":** Safehaven Report, London 1, 1945, Intelligence Reports XL Series 1941–46, Entry 19, RG226, Records of OSS, NARA.

Eduard von der Heydt, information from Dieter Nelles and Stephan Stracke, http://www.wuppertaler-widerstand.de/FBI-Akten_von_der_Heydt_08.pdf.

Information on the Chinese bodhisattva from Lutz, "Die Irrfahrt des Bodhisattvas," 353 et. seq.

transfer of the collection to the Smithsonian Museum: Buomberger, "The Baron's Share?," 75–76.

320 **"prohibit[s] the lending":** Buomberger, "The Baron's Share?," 75.

In a final twist, according to Dr. Greg Bradsher: see Bradsher, "An American Archivist at Ascona, Switzerland," October 1997, National Archives blog, http://blogs.archives.gov/TextMessage/2012/10/26/an-american-archivist-at-ascona-switzerland-october-1997/.

321 **But recent research [regarding Loo]:** see Daisy Yiyou Wang, "C. T. Loo and the Formation of the Chinese Collection at the Freer Gallery of Art," in Jason Steuber and Guolong Lai, *Collectors, Collections and Collecting the Arts of China*, 173 et. seq.

"Museums are a bit like diamonds": Francini, "Zur Provenienz vor vier chinesischen Kunstwerken aus dem Eigentum von Rosa und Jakob Oppenheimer im Museum Rietberg Zürich," 316–317; Phillip Meier, "Es geht um den Umgang mit der Geschichte," *Neue Zürcher Zeitung*, July 27, 2013.

Chapter Nineteen: Going for the Gold

323 **"I'm a strange sort of beast":** quoted in Robert Shaplen, "Amateur," *New Yorker* (July 23, 1960), 68 et seq.

325 **As detailed by:** Maynard Britchford, "Avery Brundage: Chicago Businessman," *Journal of the Illinois State Historical Society*, Vol. 91:4 (Winter 1998), 218–231.

"big, strong, agile and fast": ibid., 220.

"There is in America an incredible city": Rebecca West, "Preface" to *The Selected Poems of Carl Sandburg* (New York: Harcourt, Brace, 1926), 15.

327 **"you didn't have to be a wizard":** quoted by Shaplen, "Amateur."

In a conversation years later: see René Lefebvre d'Argencé, "The Avery Brundage I Knew," *Orientations* (January 1998), 63.

"It is interesting to note": quoted by Shaplen, "Amateur."

328 **"We in America":** ibid.

Among those dismayed by this patronizing spectacle: David Clay Large, *Nazi Games: The Olympics of 1936* (New York: Norton, 2007), 16.

329 **this measured judgment:** ibid., 108–109.

"Awed by the splendor of it all": see Terese Tse Bartholomew, "The Avery Brundage Collection: Past and Present," *Orientations*, Vol. 18:1 (January 1985), 119.

331 **"It was great fun . . . and when I saw the Emperor":** quoted in Shaplen, "Amateur."
 "I got Brundage on the board": quoted in Meyer, *The Art Museum,* 201–206.
332 **"Mr. Brundage, Chicago is a great city":** quoted in ibid.
 "It is our great good fortune": ibid.
333 **"All right . . . I've seen the certificate":** ibid.
334 **"That rhino vessel cost me":** quoted in Jay Xu, "A Unique Pair: The Bronze Rhinoceros
 and Its Collector, Avery Brundage," in Jason Steuben and Guolong Lai, eds., *Collectors, Col-
 lections, Collecting the Arts of China,* 205–217.
 Tests confirm its authenticity: ibid.
 "We live in a world that is sick": quoted in William Oscar Johnson, "Avery Brundage:
 The Man Behind the Mask," *Sports Illustrated,* August 4, 1980.
335 **"The fact that Brundage had fathered":** ibid.

Chapter Twenty: The Grand Acquisitor
337 **Studies have confirmed:** see Maurice Rheims, *The Strange Life of Objects: 35 Centuries of
 Collectors and Art Collecting,* translated by David Pryce-Jones (New York: Atheneum, 1961),
 20–21.
339 **expressed a common complaint:** see Wen Fong to James Cahill, November 9, 1966, James
 Cahill Papers, Box 9, Series 2, Folder 23, FSGA.
 "To really understand a civilization": quoted in Grace Glueck, "Dr. Arthur Sackler Dies
 at 73," NYT, May 27, 1987.
 "When I see something I like": quoted in Lee Rosenbaum, "The Crafty Collector," WSJ,
 March 6, 2013.
340 **as James Cahill sharply remarked:** see John Cahill, "Two Famous Collectors-Donors Whom
 I Didn't Like," John Cahill's blog, http://jamescahill.info/the-writings-of-james-cahill
 /responses-a-reminiscences/181-59-two-famous-collector-donors-whom-i-didnt-like.
 "Had not a second crucial donation been made": see Souren Melikian, "Founding a
 Capital of Asian Art in the West," NYT/IHT, October 9, 1999.
341 **"You have two very different buildings":** see "At the Sackler Gallery's 25th Anniversary
 Gala, Happy Ending to Behind-the-Scenes Struggle," The Reliable Source, WP, December
 2, 2012.
 "the Western world's capital of Asian art": Melikian, "Founding a Capital of Asian Art
 in the West," NYT/IHT, October 9, 1999.
342 **This and much else on the affirmative side was noted:** see Glueck, "Dr. Arthur Sackler
 Dies at 73."
 "One wonderful day in 1950": ibid.
343 **As recounted by Thomas P. F. Hoving:** see Hoving, *Making the Mummies Dance,* 93–95.
344 **We thus have this timeless snapshot:** ibid.
 When asked to comment: see Lee Rosenbaum, "The Met's Sackler Enclave: Public Boon
 of Private Preserve?" *ARTnews* (September 1978), 56–57.
345 **"he was furious over the way the museum was using the 'sacred' Dendur enclosure":** in
 Michael Gross, *Rogue's Gallery: The Secret History of the Moguls and the Money* (New York:
 Broadway Books, 2009), 346–347.
 "It is not a pastime but a passion": cited by Meyer, *The Art Museum,* 201; from Kenneth
 Clark "The Great Private Collections," *Sunday Times* (London), September 22, 1963.

Epilogue: Promising Portals in the Great Wall
348 **an anxious letter:** Joseph Alsop to James Cahill, February 7, 1979, Cahill Files, FSGA.
349 **While in confinement:** see Robert W. Merry, *Taking on the World: Joseph and Stewart Alsop:
 Guardians of the American Century* (New York: Viking, 1996), 537.
 China dominated the décor: see Edwin M. Yoder Jr., *Joe Alsop's Cold War* (Chapel Hill:
 University of North Carolina Press, 1995), 50.
 Joe Alsop threw up his hands: see Alsop, *The Rare Art Traditions: The History of Art
 Collecting and Its Linked Phenomena* (Princeton, NJ: Princeton University Press, Bollingen
 Series, and Harper & Row, 1982), 80.
 And this had its Western parallel: ibid., 83.

350 **His purpose, he explained:** see Graham Bowley, "James Cahill, Influential Authority on Chinese Art, Dies at 87," NYT, February 18, 2014.

351 **In Ms. Wang's telling:** see Audrey Wang, *Chinese Antiquities: An Introduction to the Art Market* (Surrey, U.K.: Lund Humphries, in Association with Sotheby's Institute of Art, 2012), 42.
 "During the 1990's, buyers in Chinese galleries": ibid., 43.

352 **"The Fund's tenure lasted nearly twenty years":** ibid., 45.
 "Chicken cups have long been prized": see Jason Chow, "The $36 Million Ming Dynasty-era Bowl," WSJ, April 8, 2014.
 "I don't have a specialization": quoted in David Barboza and Jonah M. Kessel, datelined Shanghai, NYT, December 17, 2013.

353 **"Such a simple thing":** see "Collector Gets 422 Million Amex Points with Purchase of Ancient Cup," *Sydney Morning News,* August 2, 2014; plus a flurry of online reports.
 that "offer tips on collecting": David Barboza, Graham Bowley, and Amanda Cox (with additional reporting by Craven McGinty), "Forging an Art Market in China," NYT, October 28, 2013.
 "It's not rocket science": Anna Healy Fenton, "China Art Auctions: A Great Money Laundry," *South China Morning Post,* January 20, 2014.

354 **"Imperial destination and great provenances":** see Souren Melikian, "A Passion for the Emperor's Seal," NYT, November 2, 2012.

355 **shorthanded in the buzzword Elginism:** for a summary on Elginism, see Karl E. Meyer, *The Plundered Past* (New York: Atheneum, 1973), 170–180.

356 **On this we have the testimony:** see C. M. Woodhouse, *The Philhellenes* (London: Hodder & Stoughton, 1969), 25.

357 **As he [Loo] elaborated:** his statement on the occasion of the liquidation of his firm, from May 1 to December 31, 1950, is in the C. T. Loo File, Langdon Warner Papers, HAMA.
 "It was a landmark in American auctions of Chinese art": see Souren Melikian, "James Lally and the Booming Chinese Market," IHT, January 31–February 1, 1987.

358 **In [Lally's] statement to the CPAC:** James J. Lally to the Cultural Property Advisory Committee, April 23, 2013.
 "The reason is simple and obvious": ibid.
 "Chinese buyers of Chinese art also dominate markets outside China": see Souren Melikian, "Determined Asian Buyers Are Redefining Market," NYT/IHT, March 29, 2007.

359 **inspiring a rash of articles:** see, for example, "Curse of the Chinese Vase," *Daily Mail* online, April 21, 2014.
 "When will you compensate us?": see Qiang Zhang, "David Cameron Joins Chinese Social Site Weiboo," *BBC News,* December 2013.

360 **"The retail tranche of the IPO":** see Prudence Ho, "Poly Culture's IPO, a First for Citic-CLSA," WSJ, March 5, 2014.
 "We are big in the art auction market in mainland China": Alexandra Errera, "How China Is Quietly Changing the Balance of Power in the Art World," *Forbes,* February 27, 2014.
 hers was a "stunning show": Souren Melikian, "Asia Week: For Dealers in Chinese Art, a Lucrative Future," NYT, March 30, 2002.

361 **"the golden voice of Beijing radio":** see no byline, "China Is Racing to Get Its Art Treasures Back," NYT, datelined Hong Kong, October 13, 2005.
 "The People's Liberation Army is very rich": ibid.
 "a small woman, bubbling with character": Geraldine Norman, "Great Walls of China," *Independent* (London), April 14, 1996.
 "Possession of great bronze statues": see "China Is Racing to Get Its Art Treasures Back," NYT.
 And lo, in 2014: see "Chinese Auction House Wants to Buy $1 Billion of Detroit's Art," WSJ, April 10, 2014. Also Marcel Woo, "China's Auction House Bids for Detroit's Art Works," ChinaTopix.com, April 14, 2014.

362 **"None of these conditions exist in China":** Kate FitzGibbon, "Import ban on Chinese art creates an uneven playing field," *Art Newspaper,* March 2, 2014.

"Chinese tourists already account for the fastest growing": see "Toward a New Phase of U.S.-China Museum Collaboration," Summary Report on the U.S.-China Museum Directors Forum 2012 at Asia Society in New York, passim.

363 **"a building boom so frothy":** see "Mad about Museums," *Economist,* December 21, 2013.

364 **In the words of the Asia Society forum's report:** see Asia Society Summary Report.
 "how could I know that in my lifetime": Barbara Pollock, *The Wild, Wild East: An American Art Critic's Adventures in China* (China: Timezone & Ltd., 2010), 8.

365 **"That wasn't so bad after all":** quoted in Andrew Jacobs, "China Hunts for Art Treasures in U.S. Museums," NYT, December 16, 2009.
 As she amplified: Dr. Anne Underhill to Cultural Property Advisory Committee, April 23, 2013, Yale Department of Anthropology.

366 **"For little old Podunk, Ohio":** quoted in Timothy Williams, "For Toledo, Cash to Grow; For Chinese, Closer Ties," NYT, December 27, 2013.

367 **"I thought at first they were from Madame Tussaud's":** quoted in Heather Pringle, "Battle for the Xinjiang Mummies," *Archaeology,* Vol. 63:4, (July–August 2010), 30–34.

369 **"I think it was a wonderful coincidence":** quoted in Tracie Rozhon, "Moving House with 2,000 Chinese Parts," NYT, February 22, 2001.
 "wanton, ruthless, wholesale devastation": see "Chinese Art and Modern Vandals," *The Times* (London), May 2, 1914.

SELECTIVE BIBLIOGRAPHY

As *The China Collectors* is historical and biographical, we have not attempted to cover in depth the many facets of Chinese art. For our readers who wish to pursue further study, we suggest the following books.

Still considered the classic text, Laurence Sickman and Alexander Soper's *The Art and Architecture of China* has been often reprinted (New Haven, CT: Yale University Press, third paperback edition, 1968). Many of the artworks cited in our text are described in more detail in this volume.

Sherman Lee's *A History of Far Eastern Art* (New York: Abrams, revised edition, 1982) is much wider in scope then other books mentioned—it covers India, Indonesia, and southeast Asia as well as China—and is written for the layman. Organized chronologically, it is particularly good on Buddhism and its spread to China from India.

Two other American scholars, Robert Thorp and Richard Ellis Vinograd, have written *Chinese Art and Culture* (New York: Abrams, 2001). They provide a useful annotated bibliography on topics such as painting, ceramics, etc. A classroom favorite, Michael Sullivan's *The Arts of China* (Berkeley: University of California Press, revised fifth edition, 2009) is a comprehensive overview with a welcome section on modern artists.

For the reader interested in a more contemporary offering, Craig Clunas has provided a splendid if somewhat unorthodox guide to Chinese culture in *Art in China* (Oxford: Oxford University Press, 2009), structured around themes "Art in the Tomb," "Art at Court," "Art in the Temple," "Art in the Life of the Elite," and "Art in the Market Place."

For an introductory guide to Chinese painting, we recommend the late James Cahill's *Chinese Painting* (New York: Rizzoli, 1990), written by one of the great experts on the subject. His later take on the same subject is available on YouTube in a series entitled "A Pure and Remote View." A more daunting volume featuring essays on all the principal periods is Richard M. Barnhart, Yan Xin, Nie Chongzheng, James Cahill, Lang Shaojun, and Wu Hung's *Three Thousand Years of Chinese Painting* (New Haven, CT: Yale University Press, 2002). They provide a valuable appendix listing all the important Chinese artists as well as an extensive bibliography. Also, for a closer look at two of the great American collections of Chinese painting, see S. W. Goodfellow, ed., *Eight Dynasties of Chinese Painting: The Collections of the Nelson Gallery-Atkins Museum, Kansas City, and*

the Cleveland Museum of Art (Bloomington: Indiana University Press, 1980). Finally, a worthy testament to the great collection of Chinese painting housed in Boston's Museum of Fine Arts is Tung Wu's *Tales from the Land of Dragons: 1,000 Years of Chinese Painting published by the MFA* (Boston: Museum of Fine Arts, 1997).

Of the many amply illustrated volumes associated with specific exhibitions at the Metropolitan Museum, we especially recommend James C. Y. Watt, et al., *China: Dawn of a Golden Age, 200–750 AD* (New Haven, CT: Yale University Press, 2004), which focuses on the formative origins of the longest and richest of art traditions. On Chinese furniture another useful catalogue is Nancy Berliner, et al., *Beyond the Screen: Chinese Furniture of the 16th and 17th Centuries* (Boston: Museum of Fine Arts, 1996).

ILLUSTRATION CREDITS

Although the objects, museums and donors have been identified in the captions, we have given the acquisition numbers below to help our readers obtain further information about them on the web.

American Museum of Natural History, New York: 254, Fig. 8, Catalog no. 70/2280. Photo Credit: © AMNH/D.Finnin

Asian Art Museum of San Francisco: 324, Fig. 10 B60B1+, © Asian Art Museum of San Francisco, The Avery Brundage Collection

Brooklyn Museum of Art: 122

Caleb Warner Family: 64, 68

Cleveland Museum: 268, 274

Denver Art Museum: Fig. 6 (1977.196) © Denver Art Museum

Dawn Ho Delbanco: 272

© Eileen Travell, photographer: 296

Esther Tisa Francini: 310

Freer Gallery of Art and the Arthur M. Sackler Gallery: 84, 135, 178, 212, 216 (FSA A.13 SC-GR-247), 219, 306 (F1978. 32), 338, 340, Fig. 1 (F1904.61)

© George Eastman House, Rochester: 126, photographer Alvin Langdon Coburn

Harvard Art Museums, Cambridge: 73 Strauss Center for Conservation and Technical Studies; Fogg Art Museum 58, 61, Fig. 3, Harvard Art Museum, Arthur M. Sackler Museum, Bequest of Grenville L. Winthrop, 1943.52.59, Photo imaging department © President and Fellows of Harvard College

Isabella Stewart Gardner Museum: Boston, 44 (P30w)

Library of Congress: 28

KODE, Art Museums of Bergen, Norway: 262

Metropolitan Museum of Art, New York: 96 (35.146), 158 (61.200.12), 185 (24.72.1-14), Figures, 7 (1987.275), 11(26.123), 12 (1981.278) 17 (2011.120.1)

Museum of Fine Arts, Boston: 49 (17.3175), Figures 4 (13.2804)13 (31.643) Fig.14 (06.292) "Photograph © [date of publication] Museum of Fine Arts, Boston"

Nelson-Atkins Museum of Art, Kansas City, Mo.: 90, 96, 119, Figures 2 (33-81) 5 (40-38), 15 (33-1559), photographer, John Lamberton, Fig. 16 (34-30) photographer, Jamison Miller

Pagoda Gallery, Paris: 87, © Jacqueline von Hammerstein

Peabody Essex Museum, Salem, Mass.: 35, 368 (E62499)

Penn Museum, Philadelphia: 104 (object number C395) Courtesy of the Penn Museum, image #194252

Rockefeller Archive Center, Tarrytown, NY: 168

Royal Ontario Museum, Toronto, Canada: 190, 202 (920.5.51), Fig. 9 (920.5.51)

Seattle Art Museum: Eugene Fuller Memorial Collection, 270 (50.157)

Steven Holl Architects courtesy of and © Sifang Art Museum, Nanjing: 363

Walters Art Gallery, Baltimore: 14 (37.758)

INDEX